undergraduate

book fund

contributed by
friends of Stanford

The Lively Audience

A SOCIAL HISTORY OF THE VISUAL
AND PERFORMING ARTS IN AMERICA, 1890–1950

Russell Lynes

Harper & Row, Publishers, NEW YORK
Cambridge, Philadelphia, San Francisco, London
Mexico City, São Paulo, Singapore, Sydney

To
my grandchildren,
in the order of their appearance,
Daniel, Rachel, and Joshua

Photo credits appear on page 493

FIRST EDITION

Designer: Sidney Feinberg

Library of Congress Cataloging in Publication Data

Lynes, Russell, 1910–
 The lively audience.

 Bibliography: p.
 Includes index.
 1. Mass media and the arts—United States. 2. Arts
and society—United States. I. Title.
NX180.M3L96 1985 700'.1'030973 84-48607
ISBN 0-06-015434-9 85 86 87 88 89 10 9 8 7 6 5 4 3 2 1
ISBN 0-06-091254-5 (pbk.) 85 86 87 88 89 10 9 8 7 6 5 4 3 2 1

Contents

Illustrations

Editors' Introduction

Perhaps no area of historical study is more elusive, more difficult to define, to bound, to penetrate, than that which we call "cultural." What, after all, does culture embrace? What does it not embrace? Its contours are vague, its ingredients miscellaneous, its boundaries blurred. Tocqueville, the most profound of cultural interpreters, did not use the term but preferred the French *moeurs;* Emerson wrote of English *Traits;* Troels-Lund's fifteen volumes on Nordic civilization uses quite simply the phrase *Daily Life in the North;* Matthew Arnold accepts the familiar *Culture* and contrasts it with "Anarchy"; Max Lerner accepts the all-embracing term *civilization.* Russell Lynes has surmounted this problem by raising the curtain not so much on the drama as on the audience.

What he has given us in *The Lively Audience* is an account of the adaptation of American culture to the shifting needs and desires of successive American audiences—Highbrow, Middlebrow and Lowbrow and, as the American is essentially a middle-class society, mostly middlebrow.

Mr. Lynes embraces Tocqueville's observation that for Americans "culture was something imported from Europe." We did indeed inherit almost everything subsumed under the term "culture"—language, literature, religion, music, art, architecture, even gardening—from the Old World, as we inherited much of our politics, economy and technology. Because these latter inheritances did not accommodate readily to the American scene we transformed or abandoned them. But it took longer to abandon our notions of culture, in part because culture played, here, a lesser role.

Yet Mr. Lynes does not agree with Tocqueville's conclusion that

> When I survey this countless multitude of beings, shaped in each other's likeness, amid whom nothing rises and nothing falls, the sight of such universal uniformity saddens and chills me.

For where Tocqueville saw uniformity, Lynes sees diversity, and where Tocqueville saw stagnation, Lynes rejoices in incessant and exuberant movement.

Mr. Lynes says, in essence, A democratic people want the talk to be about the present world, mirrored in themselves. Speaking on its behalf, Mr. Lynes' far-ranging "talk" embraces almost every art, from the Fine to the Popular and even the Vulgar. It begins with the derivative art and architecture of the great Columbian Exposition of 1893—an exposition which, characteristically enough, also displayed the Dynamo. It traces modern American painting from the Genteel tradition, to the Ash Can School, to the not-so-shocking "Nude Descending a Staircase." It echoes music from the Blues and Ragtime and Jazz to Virgil Thomson and Elliott Carter and delights in musicals like *Oklahoma!* and *Show Boat* and *West Side Story.* It interprets photography and the movies, radio and television, as the most eclectic expression of democratic art. And it concludes with a fascinating history of the emergence of art galleries in America, under the auspices of both private and public sponsorship—a phenomenon without parallel elsewhere in the history of civilization.

HENRY STEELE COMMAGER
RICHARD B. MORRIS

The Lively Audience

The Emerging Audience

T he love of poetry and the love of art are more widely diffused in America than ever before," Lord Bryce wrote in 1905; "one finds, for instance, a far greater number of good pictures in private houses than could be seen thirty years ago, and the building up of public art galleries has occupied much of the thought and skill of leading citizens as well as required the expenditure of vast sums."

James Bryce, historian, whose *The American Commonwealth*, an examination of our manners, customs, traits, and institutions, is accepted as a historical monument in its own right, was not easily taken in by external appearances. He was an almost compulsive traveler, whose perceptions were informed by a rich historical perspective, and he detected no new Athens in modern America. To be sure, he was qualifiedly pleased by the changes that had taken place in the American temper and culture since he had first encountered them about the time of the centennial celebration in 1876. A people that had its roots in the soil then and the basis of whose economy was its fruits and cattle, its tobacco and cotton, its grain and its market produce had begun to leave the land in increasing numbers to seek the brisker and more seductive inducements of the cities. Not only were the towns he had seen in the 1870s growing into cities, but the cities were growing into metropolises hugged by suburbs. Interurban trolleys and trains, he must have realized, had not only tied towns and cities closer together, thereby reducing the isolation of country people and opening their eyes to the cultural opportunities (and many thought the vices) of cities, but had played a role in turning many Americans from full-time doers into part-time spectators, from makers into consumers, from artisans into potential dilettantes.

Jefferson, Bryce noted, would have regretted the change from rural concerns to "the urban type of mind and life," which was coming to

dominate America. "But it is unavoidable," he wrote, and predicted with accuracy: "It will tend to increase that nervous strain, that sense of tension, which Americans are already doomed to show as compared with the more sluggish races of Europe."

In the development of our culture the sense of strain and of tensions has not been without its uses. There were cultural benefits in the shifting nature of society that should not be underestimated. Look, for instance, at what had happened to higher education. Europeans were apt to go to universities only if they planned to enter one or another of the professions, to become lawyers or clergymen or physicians or to devote their lives to schoolmastering or being college dons. In America an increasing number of young men who had no more likely cultural ambitions than to become businessmen went to college. Between 1870 and the time of Bryce's observations the number of colleges had grown from 536 to very nearly a thousand, not all, of course, of equal quality. There were colleges which by European standards were no better than high schools. There were, moreover, land-grant colleges, a unique kind of educational institution, which came into being when Lincoln signed the Morrill Act in 1862 during the Civil War. (It had earlier been vetoed by President Buchanan, who correctly prophesied that it would tend to encourage the states to keep coming back to the federal trough for educational sustenance.) Indeed, by 1900 there were more than 25,000 students enrolled in these vocational schools for farmers and mechanics, intended to meet local needs for trained men. They were forerunners, in a sense, of the junior and community colleges which were to proliferate with such remarkable speed in the 1950s and '60s to provide the technicians of all sorts that were needed by local factories and laboratories, hospitals, offices, and drafting rooms.

If, however, the land-grant colleges (the "A. and M.s") were trade schools, the quality of instruction in the best of the small liberal-arts colleges, especially in the Northeast, and in the large universities, was beginning to match the very best that European universities could offer. To be sure one could no more trust the lofty verbiage of many college prospectuses then than one can today. It was the simple truth that there were not enough competent scholars to teach the number of students who earnestly sought the keys to wisdom and those who believed that a bachelor's degree would magically unlock the doors to business careers for them. "America has not less than fifteen or perhaps twenty seats of learning," Bryce noted, "fit to be ranked beside the universities of Germany, France, and England as respects the completeness of the instruction which they provide and the thoroughness at which they aim."

There were about sixty-three million Americans at the time Bryce

made this observation; fewer than half of those who were twenty-five years old at that time had had so much as a grade-school education; only one boy or girl in ten went to high school, and of those between eighteen and twenty only one in ten was in a college of any sort. A young man bound for college had a great many more choices than a young woman. There were relatively few young women who thought of college as a goal worth pursuing, for those were still days when a so-called womanly woman found it discreet to conceal her intellectual attainments and ambitions as inimical to her role as wife and mother. It was regarded by nearly all Americans at all levels of society as somehow unfeminine for a woman to engage in intellectual pursuits unless she was willing to resign herself to the life of a schoolteacher, one of the few means of making a living that was considered respectable for middle-class women. A young woman, so inclined, might learn all she needed for such a future by spending two years in a normal school, as such institutions were then called, from which she received a teaching certificate on graduation.

If she was more ambitious, less subject to the restraints of social pressures, and willing to take her chances in a man's world, she could find a college to accept her. Oberlin in Ohio had accepted women from the very first, and it had opened in 1837, though a horrified public looked upon the prospect of coeducation (not yet called by that name) as not only immoral and indecent but a threat to the propagation of the race. Overfamiliarity, it was said, would dampen romance. What was more, the rigors of college education were too demanding for the limited stamina of the weaker sex. In practice it was discovered that educating young men and women together in the same classes tended not to licentiousness but to the "refinement" of young men and to making the young women "more manly" in their independence and in their intellectual attitudes.

Traditionally the American husband had left to his wife the moral, intellectual, and physical upbringing of the children and the surveillance of matters of culture and taste. At the same time, however, the majority of women had been constrained from any formal intellectual training for cultural pursuits beyond what were considered "polite accomplishments" —drawing and singing and the domestic arts. A wife was, in other words, expected to be the custodian of culture (though the word was little used) but protected from it. In practice, however, if she had any inclination in that direction, she was usually far better read than her husband, who spent most of his working hours in pursuit of money. His day at his store or shop or counting room lasted ten hours or more, six days a week, and his Sundays were devoted to taking his family to church and to restoring his vigor for Monday. If he was a lawyer or a physician, his hours were likely

to be far longer than that.

Women of the middle and upper classes, on the other hand, had leisure that was made possible by cooks and maids and laundresses. Even families of moderate means were likely to be tended by more than one servant, and the lady of the household had time to devote to novels and tracts and periodicals, to anthologies of cozy and humorous verse and homilies, to books on household management and decoration, to manuals of polite behavior, and, especially in periodicals, to accounts of far places and primitive societies. She could be well read in the English novelists— Dickens, Thackeray, Trollope, for instance—whose works were published in pirated editions, often as soon as they appeared in England. Even in towns of moderate size there were Lyceums with weekly lectures on all manner of educational and uplifting subjects—on philosophy and temperance, on history and music and science. The principal audience for these evenings of culture were women, as they still are today, and the purveyors of wisdom and knowledge and moral uplift on these occasions were almost without exception men who traveled the Lyceum and lecture circuit as a means of promoting their books and lining their purses. It was at best a cultural smorgasbord that was set before American women, but it was more nourishing than that which their hasty husbands paused to sample. It is not surprising that Henry Adams should have remarked in his *Education* that "the American woman of the nineteenth century was much better company than the American man."

The establishment of Vassar Female College at Poughkeepsie, New York, in 1860 by a brewer, who was very nearly talked out of his far-sighted project by skeptical friends who wanted him to endow a hospital, began to change the pattern of women's education and give it some shape. In its splendid Main Hall, designed by the architect James Renwick in imitation of the Tuileries in Paris,* it offered a curriculum of the arts and sciences which approximated that of the colleges of Harvard and Yale. By the end of the century there were a number of vigorous institutions dedicated to higher learning for women—Smith, Wellesley, Bryn Mawr, Mount Holyoke, and the women's colleges of Harvard (Radcliffe) and Columbia (Barnard), and others. Their academic standards were taut and their faculties excellent.

The fields, in other words, in whose furrows the seeds of a high culture might be sown, though still not great in numbers, were rapidly expanding.

*Renwick (1818–95), one of the most fashionable practitioners of his day, was the architect of St. Patrick's Cathedral in New York; of the original home of the Smithsonian Institution in Washington, now called "The Castle"; and of many other buildings that are enjoying a revival as landmarks of the Victorian era.

There were not only educators and editors and impresarios who toiled to make these fields more fertile but tycoons who were ready to irrigate them with torrents of cash. Matthew Vassar's gift of $400,000 was a pittance compared with what was to come. Andrew Carnegie, the rugged, financially ruthless, white-haired Scotsman retired from the steel business of Pittsburgh in 1901 with a fortune of upwards of $250 million, and nine years later he put up $60 million to build libraries in hundreds of towns and cities that were willing to assume their support. It was the most visible of his gestures toward the public weal and, more specifically, toward raising the level of the public culture. There was also the Carnegie Institution of Washington ($10 million) set up "to encourage in the broadest and most liberal manner, investigation, research, and discovery, and the application of knowledge to the improvement of mankind." That was in 1902, and four years later he gave another $10 million for a Foundation for the Advancement of Teaching, and in a final magnificent gesture he established in 1911 the Carnegie Corporation, with an outright gift of $125 million, and left to it his residual estate. The trustees of the corporation were instructed to use the income of this fund to encourage and support all manner of cultural institutions—colleges and universities, libraries, museums, and centers of scientific research. One hundred twenty-five million dollars would scarcely build a campus today for a medium-size college, but it was a vast sum of money in 1911.

Carnegie was by no means alone in his beneficence, nor was he the first of those who dealt in millions of dollars for the advancement of culture. Johns Hopkins, whose fortune was a mixed bag of banking, shipping, and railroad monies, died in 1873, bequeathing $7 million to found Johns Hopkins University and Johns Hopkins Hospital. In 1891 Leland Stanford, the Western railroad builder, established Leland Stanford, Jr., University in memory of his son and assured its continuance with an endowment of $2.5 million to which his widow added lavishly after his death in 1893. The University of Chicago was founded in 1891 with a gift of $10 million from John D. Rockefeller. He seems to have been almost unique in not insisting that his family name be attached to the institution of higher education that he made possible.

Lord Bryce was impressed by this largess, and no wonder. "In England nothing is so hard as to get money from private persons for any educational purpose," he wrote. "In America nothing is so easy. There is, indeed, no better indication of the prosperity of the country and of its intelligence than the annual record of endowments bestowed on the universities by successful businessmen, some of whom never themselves had more than a common school education."

Bryce was not the only observer from abroad who was impressed by the lengths to which private philanthropy was devoted to raising America's intellectual sights. "Public libraries," wrote Hugo Münsterberg, professor of psychology at Harvard College, in 1904, "have become the favorite Christmas presents of philanthropists. . . . Churches now find that superfluous millions are less apt to go for church windows than to well-chosen book collections." He noted for the German audience to which his book *The Americans* was initially addressed, "In the year 1900 there existed more than 5,383 public libraries having over a thousand volumes; of these 144 had more than fifty thousand and 54 had more than one hundred thousand." Moreover, libraries were growing at the rate of 8 percent a year. As greatly as he was impressed by the quantity of public libraries and their holdings, he was equally moved by their physical elegance and the remarkable speed with which, by European standards, readers could get the books they asked for. "In the National Library at Paris," he wrote, "one has to wait an hour for a book; in the British Museum, half an hour, and in Washington [at the Library of Congress] five minutes." He found the Boston Public Library, with its murals by Edwin Abbey and its delightful library for children, "tempting . . . convenient . . . comfortable . . . surprisingly beautiful." It was a far cry from the stodgy, frigid libraries he had been accustomed to in Europe, and it was completely democratic besides. A "million and a half books," he was astonished to note, were "delivered every year to be taken home and read . . . and all this free to the humblest working man."

His enthusiasm, which crested in a great wave of friendly if scarcely justified optimism and idealism, carried him overboard. "The American tax payer," he wrote, "supports this [i.e. the expense of libraries] more gladly than any other burden, knowing that the public library is the best weapon against alcoholism and crime, against corruption and discontent, and that the democratic country can flourish only when the instinct of self-perfection as it exists in every American is thoroughly satisfied."

Be this as unlikely as it may, libraries and their use had grown rapidly in the 1890s and so had the number of readers of something more than "servant girls' " novels, as the sentimental fictional trash of the day was called. The rapid spread of compulsory school attendance, and the steady increase in enrollments in colleges had raised the general level of literacy. Careers as librarians had drawn women by the thousands to recently established library schools as a respectable alternative to becoming teachers. Extensive private libraries became socially viable tokens of success and frequently misleading symbols of cultural concern in the houses of the rich and fashionable. Often behind leaded glass, shelves glowed with yards of

bound volumes in red and green and blue Morocco leather tooled with gold leaf and richly illustrated. They were as much a part of the setting for the merchant prince or railroad magnate as his crystal chandeliers, his antique globe of the world in its mahogany stand, his Renaissance cassone, and his Aubusson carpet, and like them they sometimes seemed to be (and often were) ordered by the architect and installed by his minions.

The publishing business had been through a period of cut-throat competition and cut-rate literature since the mid-1870s, and the reading public had grown as a result. From the presses issued an avalanche of cheap, paper-bound "libraries," as they were called, some of them trashy dime novels, some of them standard American works, such as Emerson's *Essays* and Thoreau's *Walden*, whose copyrights had expired, and a good many English and a few French novels that the publishers quite openly pirated.* One such publisher was putting out a novel a day. By the mid-eighties these libraries had lifted their sights somewhat and were publishing cloth-covered books of a convenient size to fill the leisure and the shelves of those readers who did not devote their reading hours to periodicals.

At the turn of the century there were more dailies, weeklies, monthlies, and quarterlies published in America than in all the countries of Europe. Americans were then primarily magazine readers, not book readers, and they so remained until television cut deeply into the revenues and circulation of mass magazines after World War II and killed a few of the biggest and glossiest. It was during the 1890s that the mass-circulation magazine came into being, and it was largely the enterprise of a young man named Edward Bok, who in six years raised the circulation of the *Ladies' Home Journal* from 440,000 to an unprecedented million copies a month. His special crusade was to raise the taste of the American housewife—household taste, that is, not literary taste: taste in architecture, decoration, clothes, manners, food, and artifacts. Such popular periodicals along with the cheap novels were considered a threat to any possible literary salvation that might be at hand for the American reader, though, as Münsterberg commented, "the broadly vulgar, must by their numbers excite the disgust of the real friend of literature; and this conscious duty of opposition, which becomes a sort of mission, sharpens the artistic consciousness, fortifies the feeling of form, and struggles against all that is immature."

Culture was newly fashionable with groups of ladies, and one of the

*"Libraries" continue to be an important, staple part of the book industry. The cheap nineteenth-century "libraries" were the precursors of such distinguished literary series as the Modern Library (Random House), Universal Library (Grosset & Dunlap), Everyman's Library (Dutton), Torchbooks (Harper), and many other such series, now published largely as paperbacks and devoted to "classics" and "standard works."

forms the struggle took was organized clubs for the discussion of what the ladies read, for sitting and listening to authors talk about themselves and their works, and for sipping tea and eating paper-thin sandwiches. There were clubs dedicated to the discussion of single authors and single books. The ladies puzzled and sighed over the poems of Robert and Elizabeth Barrett Browning in Browning Clubs; they savored in Omar Clubs the mysticism of Edward FitzGerald's immensely popular translation of *The Rubáiyát,* written in the eleventh century by the Persian poet-astronomer Omar Khayyám. They explored the philosophy of "the single tax" propounded by Henry George in his *Progress and Poverty* (1879), and they formed Bellamy Societies inspired by the utopian novel *Looking Backward* (1888).

It is reasonable to say that the Lyceum, which was founded in Middlebury, Massachusetts, in 1826 and spread across the nation with astonishing rapidity, begat the Chautauqua movement, and that the Chautauqua begat the cultural clubs of various sorts that were so popular in the 1890s, and which had such an effect on the development of the audience for the arts in the twentieth century. The Lyceum, whose intent was to "take up the education of the community where the schools leave it, and by every help and means of self culture to carry it forward to the end of life," went into a decline during the Civil War. It came to life again with considerable vigor in the late 1860s under the skillful hand of James Redpath, an ex-newspaperman with a wide acquaintance among authors of the prominence of Mark Twain, Josh Billings, Wendell Phillips, William Lloyd Garrison, and Julia Ward Howe. Redpath was a clever, reliable, and thoroughly respectable booking agent, but entertainment was more important to his plans than uplift or education.

It was the Chautauqua that was, in a very real sense, the progenitor of what might be called the mass middlebrow audience for culture in America, and it demands more than passing mention.

Chautauqua and the Cultural Sight Raisers

In the summer of 1874 John Heyl Vincent, a vigorous, balding thirty-two-year-old Methodist clergyman, who had a reputation for injecting spirit into the traditionally leaden teaching in Sunday schools, decided that the time had come to set up a summer institute to expand his work. He had been training teachers by walking them through a contour map of Palestine that he had constructed near his church, and he reached those at a distance by a primitive correspondence course, the first such course, it is said, ever devised. It was not, he thought, good enough to accomplish his ends.

With the advice and the business acumen of an Akron inventor and manufacturer of farm machinery named Lewis Miller he rented Fair Point on Lake Chautauqua, in the southwest corner of New York, which had been used for camp meetings of the old-fashioned revivalist, sawdust-trail, "Come to Jesus" sort. That was not at all Vincent's style. His seminars, with practical instruction, demonstrations, and what are now called visual aids, including a three-dimensional model of the Holy Land, were to be not only intellectually serious but lively and humane. Forty students paying $6 each for the sixteen-day session turned up the first year. Their rigorous studies were relieved with organized recreation. In the evenings they gathered around a campfire and sang. They played games and they swam in the placid waters of the lake, and when they went home, they spread the word of the delights of Chautauqua so effectively that, bolstered by Vincent's genius for promotion, the Chautauqua Assembly, as it was called, grew in four years to nearly five hundred.

The Reverend Mr. Vincent (he later became Bishop Vincent) could surely not have foreseen that his Assembly would become a "university" (it was chartered by the State of New York in 1883), that Chautauqua would become a household word in every corner of the nation, and that through its publications and its imitators it would become a cultural phenomenon with some of the sweep and force of a tidal wave.

On the shores of the lake the few shelters for summer students grew into a city of thousands of tents, and the crowds that came to the recitals and concerts, lectures and sermons in the open-air arena sat enthralled by statesmen, authors, singers, divines of many different persuasions, actors, and on one occasion the full New York Symphony Orchestra under the baton of Walter Damrosch. The "star system" was at work, and here was an audience that no public figure of the day seemed able to resist. Indeed, six Presidents of the United States spoke at Chautauqua, the first of them Ulysses S. Grant, whom Vincent had known some years before in Galena, Illinois, and for whom he had written speeches. Grant stayed a week in the summer of 1875, and while many of the godly decried the presence of the whiskey-drinking, cigar-smoking President at this center of moral uplift, the publicity his visit gave Chautauqua was immeasurable. When Theodore Roosevelt spoke there nearly three decades later, the amphitheater was crowded with more than ten thousand persons (this was in the days before microphones, when orators bellowed out their ornate words). According to one observer, "He turned enthusiastically to Bishop Vincent and said, 'I know of nothing in the whole country which is so filled with blessing for the Nation.' And when he had finished, the whole audience gave him the Chautauqua salute: ten thousand handkerchiefs were waved in the air—an extraordinary sight,

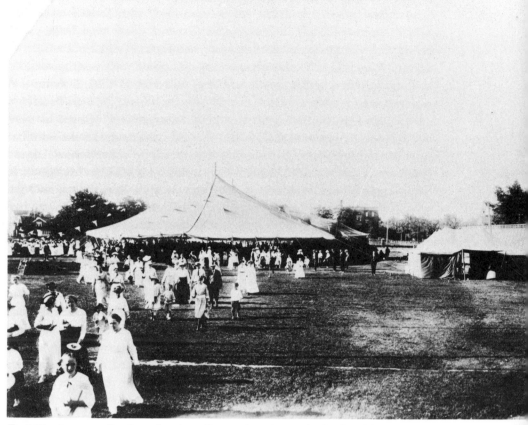

Tent Chautauquas offered rural and small-town America a mixed cultural bag—
everything from political oratory to bellringers and yodelers, opera stars, literary critics,
and comedy and dance teams. Their festival atmosphere enthralled audiences of adults
and children both.

which in Chautauqua signifies the greatest appreciation."

By 1900 the original Chautauqua had more than two hundred imita-
tors, principally in groves of trees by the shores of lakes; most of them were
comparatively small and in the Middle West. Moreover, without any objec-
tions from Vincent, they did not hesitate to call themselves Chautauquas,
and they modeled themselves on the mother assembly. Their faculties were
largely college professors on summer vacation, and they generally booked
their star attractions through the Lyceum bureau. The curriculum of the
Chautauqua expanded rapidly in the 1880s to include a wide range of
subjects—economics, history, literature, political ethics, government, and
the natural sciences—a very different menu from the courses in biblical
studies with which it started. William Rainey Harper, who later became

president of the University of Chicago, had seen to that. Vincent had invited him to join the faculty of the assembly in 1885 and three years later named him principal of the College of Liberal Arts. As the scope of Chautauqua's curriculum broadened, its influence expanded. It was now a cultural institution in breadth, at least, if not in depth.

In the same year that Harper joined Chautauqua, Vincent, who saw no reason why inquisitive minds should hunger for culture in the winter when his assembly was closed, proposed the initiation of the Chautauqua Literary and Scientific Circle. The scheme was for a correspondence course that encouraged its subscribers to foregather, wherever they might be, to discuss with guidance the paperback books provided by a Chautauqua press. Vincent announced his plan for the circles at the fifth annual assembly, hoping that ten of the five hundred who were there might sign up. Within an hour he had two hundred signatures, and within ten years the circles had nearly 100,000 members. Iowa, for example, had over a hundred circles in 1885, and more than half of these were in the capital city of Des Moines. There was even, indeed, a train crew on a Western railroad which constituted itself a circle, and at least one country storekeeper is said to have turned his daily disputants into a circle.

Bishop Vincent's tidal wave was not to subside until well into this century, and it still has not disappeared entirely; a few puddles remain. In the early years of this century a variant on the original Chautauqua took to the road and played, if that is the word, in towns and small cities across the land, pitching a circus tent and stopping a week. An advance man approached the town fathers, enlisted their support and the aid of local businesses and schools and churches, and then with more than a little fanfare not only brought to town a few famous speakers, singers, instrumentalists, jugglers, and magicians but arranged for participation by school children, local singing groups, and amateur thespians. Chautauqua pennants were strung across Main Street and flags flew from the tops of the poles that supported the great tent.

The program was invariably a mixture of serious lectures, debates, readings, and adequate (sometimes distinguished) musical performances, with entirely wholesome albeit lively entertainment. Not just townspeople but farmers with their families in buggies and Model T Fords came to sit and wonder at the elegant music, the rotund oratory, the importance of the visiting personages, the wit of the humorists, the learning of popular scholars, and the citified beauty of the actresses. To millions of Americans this was their only exposure to "culture" that walked and talked and sang, their only view of famous and near-famous persons. No one who has lived long enough to have been exposed to the tent Chautauqua will ever forget its

charms. It met its death in the 1920s at the hands of the moving pictures and radio, which brought vastly superior entertainment and the most celebrated performers to communities everywhere, and with them an increased sophistication.

Temples of Art, Music, and Theatre

Hard times seem in our recent history to have had a spine-stiffening effect on our culture, or at least on the audience for the arts with which we are here concerned. Chautauqua began to flower almost immediately after the panic of 1873, which had sent fifty thousand businesses into limbo, caused the securities market to collapse, and devastated farm profits. Railroad expansion had been headlong and had got out of hand; European demands for our farm produce had sharply declined; the failure of a powerful banking firm had sent securities into a tailspin; incomes had fallen and unemployment had climbed. When commercial values and the material comforts which they produce are shaken, cultural values, it seems, become more important to more people—as a palliative, perhaps, or perhaps as an economy (other forms of entertainment being more expensive), or to some as a kind of penance for worshiping the false god Mammon. In any case the national appetite for culture was whetted. At the Centennial Exhibition in Philadelphia in 1876, the greatest fair the world had ever seen up to that time, millions of Americans had been exposed in Memorial Hall (which still stands above the Schuylkill River) to more works of art than had ever before been gathered in one place in America—thousands of paintings and sculptures from Europe and Asia and some six hundred works by Americans. This world's fair was followed by what was known to the skeptical as "the artistic craze," a new concern mainly on the part of housewives with "the tasteful" in architecture and decoration, and the growth of museums devoted solely to works of art. What it produced in artifacts and buildings, in sculpture and painting and music became the laughingstock of the early years of this century. They were known as the extravagances of the Gilded Age or the Dark Decades, and only in recent years have such virtues as they had (and at their best they were considerable) been reappraised and become valued, collected, and preserved as examples of "high Victorian taste."

The Columbian Exposition in Chicago in 1893 (it was known as "The White City" and was even bigger and far grander than the '76 Exhibition) had been conceived well before a depression but it collided with one head on. The panic of 1893 was even more fierce that the one twenty years before. Three times as many businesses vanished; 550 banks closed their

doors, and big railroads and small ones went into receivership. The conversational value of the arts, on the other hand, appreciated, though that is not to say that American artists profited. Important collectors turned to buying European paintings as more fashionable or as better investments or as socially more viable marks of status than the American-made products.

It was after the fair that the conversation and reading groups begot by the Chautauqua and its circles proliferated at such a rapid rate. If the fine arts had played little part in the Chautauqua scheme of culture, it was not because there was anything about painting or sculpture of the last half of the century in America that even the most strait-laced church elder could have found indecorous. Landscapes were as inoffensive as the cows that so frequently grazed in them. Sculpture celebrated the fully-clothed virtues of blindfold Justice and the fruits of labor. Murals retold the tales of Shakespeare and the *Morte d'Arthur*. In canvases with weighty gold frames figures of the Renaissance rather grudgingly tried to come to life again on parlor walls, and polite ladies drank tea, sang, and played the spinet.

Art associations flowered in such a garden of sweet-smelling art, and they burgeoned most successfully in the Middle West, as had the Chautauqua circles. The quintessential example was the Central Art Association, which was founded in Chicago in 1894. Its declared purpose was "the promotion of good art and its dispersion among the people." Traveling exhibitions of painting and sculpture were organized so that small cities and large towns might be enriched by art, and lecturers were dispatched to explain them. It successfully enticed several thousand schoolchildren, obviously with their parents' connivance, to join a Truth and Beauty League. Its members heard lectures on the mysteries of architecture, painting, sculpture, house decoration, and industrial art. It held annual "art congresses" and weekly discussion groups, and it published a magazine to keep the pot of aesthetic appreciation at the simmer.

Culture was looked upon by the organizers and joiners of such meetings as a kind of group therapy to cure the ills of unsophistication and in useful ways to fill the voids of leisure. It was both a social approach to sharpening the intellect and an intellectual excuse for justifying social occasions. Edith Wharton in one of her short stories introduces the principal character as "one of those ladies who pursue Culture in bands, as though it were dangerous to meet alone." But the American dedication to self-improvement is deep-rooted and tenacious, and with it is a belief that education is (or perhaps used to be) the remedy for all social ills and the means of achieving all aspirations. Out of the Chautauquas, study groups, and cultural associations grew extension and correspondence courses, sum-

mer institutes for adult education, community colleges, subscription concerts, and lecture series, all of which have contributed to broadening the base of the cultural pyramid and to sharpening its apex.

The temples, and in some cases the headquarters, of the art associations were the new museums dedicated solely to the fine and applied arts that opened their doors during the last three decades of the century. There had long been museums in America, but they were miscellaneous collections of portraits, curiosities of nature, waxworks, and other ingenious devices of entertainment and enlightenment. Two of the sons of Charles Wilsson Peale, the great portraitist, naturalist, and friend of Jefferson and Franklin, started a museum in Baltimore in 1814, "an elegant Rendezvous for taste, curiosity and leisure." It was the first building built in America as a museum, but it did not, as it was hoped, shore up the sagging fortunes of the Peales; it was a financial failure. In Cincinnati in the 1820s Mrs. Trollope, whose book on our manners and customs was a best seller that raised the hackles of several generations of Americans, busied herself at the Western Museum by contriving an animated and howling model of Inferno with the help of the young sculptor Hiram Powers.* It attracted town people and country people by the thousands for years, and some of them paused to look at the museum's geological, biological, and archeological displays. The most famous, and surely the most popular, museum of the midcentury (it was opened in 1841) was P. T. Barnum's emporium in New York of freaks and fakes, of what passed for art, of bellowing baboons, and, as he boasted, "500,000 curiosities." It was jammed to the rafters on holidays and Sundays, and long lines formed outside on Broadway. It is said that Barnum, in an effort to move people out of the building, put up a large sign saying "TO THE EGRESS." Many people, not knowing what "egress" meant, thought it was still another strange beast of some sort, and found themselves out on the street.

Such museums as these (and there were many) were commercial enterprises, in which cash came first and Culture (with a capital *C*) tagged along behind. The art museums, on the other hand, were all seriousness. They were organized, as one of the trustees of the Metropolitan Museum proclaimed at the opening ceremonies of its palatial building in Central Park in 1880, for the purpose of "encouraging and developing the study of the fine arts, and the application of the arts to manufacture, of advancing the general knowledge of kindred subjects, and to that end, of furnishing popular instruction and recreation."

*Hiram Powers became one of the most famous sculptors of his day, and his statue of "The Greek Slave" was the sensation of the Crystal Palace exposition in London in 1851, not least because of its daring, but decent, nudity.

During the ten years since its incorporation in 1870, the Metropolitan had been in makeshift homes. Its founding had satisfied an urgent need long felt by civic leaders who were culturally concerned, but not particularly well-informed in the arts. There had been private galleries before and libraries and historical societies, which had displayed paintings and sculpture and were occasionally open to the public, but there was no place that could call itself a museum of the arts. It was apparent to the founders of the Metropolitan that the commercial value to the city, the trade and prestige it could generate, must be emphasized if the museum was to receive the support not only of the city fathers but of the business interests, a situation that the trustees of symphonies and museums and operas find obtains today as urgently as it did then. "Every nation that has tried it," Joseph H. Choate, one of the founding trustees, said, "has found that every wise investment in the development of art pays more than compound interest." It was his way of appealing to "men of affairs and enterprise and executive ability," who, as one of the museum's clerical friends said, "are seldom interested in art, or marked with a taste and appreciation of the delicate interests of the beautiful."*

Art museums for which there had long been schemes became realities in many cities. Boston incorporated its Museum of Fine Arts in the same year (1870) that New York founded its Metropolitan. Sixteen years later Cincinnati led the Middle West when the campaign of a determined organization called the Women's Art Museum Association bore fruit. Its palace for art and art instruction was a massive Romanesque structure of a size and style of which any metropolis in that day could be proud. Before the Art Institute of Chicago moved into its first home, like Cincinnati's a Romanesque structure (those were days before marble Renaissance palaces became the fashionable style for museums and for great public libraries), there were already museums of art in St. Louis and San Francisco. Pittsburgh and Milwaukee were not far behind.

The treasure houses that were to become so lavishly stocked with the arts of Europe and Asia in the twentieth century filled their galleries with casts of antique sculpture, models of ancient temples, pastoral landscapes so popular then, and works by French and American academicians. No

*On August 22, 1983, the *New York Times* reported that the exhibition of "Treasures from the Vatican" at the Metropolitan Museum had brought visitors to the city who, according to a survey paid for by the museum, "poured approximately $101 million into the city's economy" in shops, restaurants, hotel accommodations, and entertainments of various sorts. It would not have been characteristic of Choate to say, "I told you so," but he would have been justified in doing so.

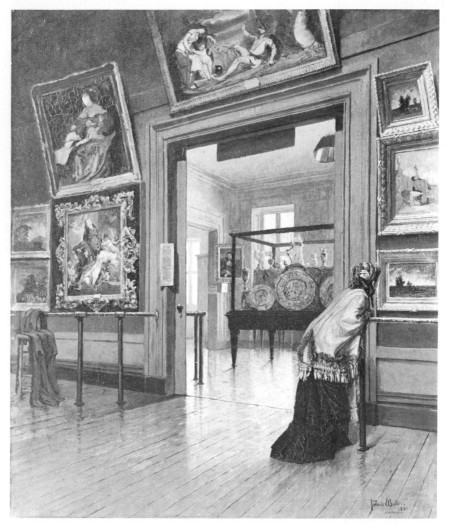

The Metropolitan Museum of Art moved into its second home, on Fourteenth Street, in New York in 1873 in the days when walls were fashionably crowded but galleries were all but empty. It was more important that art should be hung than that it be readily seen. This interior of the Met was painted by Frank Waller in 1881. *(Metropolitan Museum of Art)*

one believed that American museums would ever be able to furnish their large galleries with masterpieces of Renaissance painting and sculpture and with antiquities. Why would the Europeans be willing to let them go? And so they satisfied themselves with copies of known masterpieces and a good many inconsequential works attributed to masters whose hands had never touched them. By comparison with what they have become, museums were

quiet places, where people spoke in whispers and the principal sound was the clicking of heels on marble floors. They were temples of art, and they were meant to inspire awe and reverence and, as William Cullen Bryant, the poet-editor and senior literary sage of his day, said, they were intended for entertainment of "an innocent and improving character."

It was almost surely European paintings that Lord Bryce had in mind when he said in 1905, "One finds . . . a far greater number of good pictures in private houses than could be seen thirty years ago." There had been a time in the first half of the nineteenth century when a few rich collectors like the wholesale grocer Luman Reed in New York and Robert Gilmor, Jr., of Baltimore, whose commanding fortune was amassed by his grandfather in the East India trade, had commissioned paintings from their important contemporaries, such as Thomas Cole and William Sidney Mount. There had also been a flurry of activity in the 1840s when the American Art Union, using a lottery as bait, sent out thousands of engravings of pictures by American artists; some of them turned up as far afield as in the cabins of frontier families. The paintings of the so-called Hudson River School, especially those of Kensett and Church, commanded high prices in the 1870s.

By the end of the century American artists were suffering the anguish of indifference—an anguish both psychological and financial. Photography had all but put portrait painting, the artists' financial staple, on the shelf, and most important collectors had turned from American art to European. The richest of them, like J. P. Morgan, bought with a lavishness that made European dealers boggle, and sent prices for old masters skyrocketing. In general American collectors' tastes were for nineteenth-century French paintings of a kind now looked upon as tame. Mrs. Potter Palmer of Chicago, who was the doyen of the 1893 World's Fair, bought pictures by Degas and Monet with the help and advice of her friend the American expatriate artist Mary Cassatt. But most of her contemporaries were charmed by the Barbizon painters—by Corot, Théodore Rousseau, Daubigny, and Diaz de la Peña. The exhibition of 126 "Foreign Masterpieces Owned by Americans" at the 1893 Chicago fair was mostly paintings of this sort. It is likely that it was pictures such as these that Bryce had in mind and which he saw as he visited the drawing rooms of prominent businessmen on his seventh visit to America. If he knew Charles Lang Freer (whose collection has long been a part of the Smithsonian Institution) he would have seen paintings by Whistler, Thomas W. Dewing (one of his favorites) and John Singer Sargent, but most of Freer's treasures were Oriental. Of the American artists' plight one of the first historians of American painting, Samuel Isham, wrote in 1905: "When the younger men

went abroad to study [in the 1870s] painting was a lucrative profession; when they returned they found it was not possible for a man to live by it, even if he were talented, well taught, and hard working." Isham knew this at first hand. Before he was a writer, he was a painter and a member of the National Academy of Design.

Musicians and actors, composers and playwrights suffered from much the same kind of foreign competition as the painters. The public for the theatre and music cared more about stars with European reputations (as much of it still does) than about what was performed. Even before the master of bunkum, P. T. Barnum, brought Jenny Lind, "The Swedish Nightingale," to America in 1850, the procession of foreign performers was a continual and profitable one both for their promoters and themselves. (Barnum guaranteed Jenny Lind $1,000 a performance plus her expenses for 150 performances, and he is said to have taken in $700,000.) Americans were charmed to open their purses for foreign virtuosi, both vocal and instrumental, and to conductors. The opera was under the control of Italians, and the symphony orchestras, chamber groups, and many choral societies were dominated by Germans, a situation that continued well into this century. Americans had little confidence in the quality of American music, and they looked to Europe not only for performers and conductors but for the scores they should perform. Such American composers as there were tried to emulate the fashions of Europe, with questionable success, and who wanted secondhand Brahms and Rossini and Chopin and Verdi when they could get the works of the masters performed by such pianists as Anton Rubinstein, Josef Hofmann, and Paderewski and the operas sung by sopranos like Calvé, Lilli Lehmann, and Schumann-Heink? "Most of the nineteenth century was merely an extended parenthesis in the history of American art music," Gilbert Chase wrote in *America's Music.* What came before was another, more indigenous matter, as, indeed, was what came within the parenthesis that was not "art" music and was, therefore, not taken seriously outside its largely black circle of makers and consumers until this century.

The audience for "art" music grew as the nation grew. As early as 1810 Gottlieb Graupner, a German musician, established the Boston Philharmonic Society, "the first genuine and regular orchestra in the United States," and it lasted for fourteen years. There had been, and continued to be, less formal orchestral groups. The first American performance of Beethoven's First Symphony, for example, was played by the Mutual Fund Society in Philadelphia in 1821. Twenty-one years later the New York Philharmonic Society came into being, the first so-called "permanent"

orchestra. The Astor Place Opera House in New York opened in 1847, and
by then "grand opera" had been performed in America for more than half
a century. In 1852 both the New York Academy of Music and the Boston
Music Hall were in business, and four years later so was the Academy of
Music in Philadelphia. The New York Music Hall, later called Carnegie
Hall, opened in 1891. Symphonies, chamber groups, singers, and instru-
mentalists as well as opera companies performed in these halls. Chicago
had a Philharmonic Society in 1850, which expired five years later; stabil-
ity, especially financial stability, was not a notable quality of musical
organizations then any more than it is today. In spite of this, the number
of orchestras that played symphonic music increased steadily. By the end
of the century there were nine fully professional symphony orchestras in

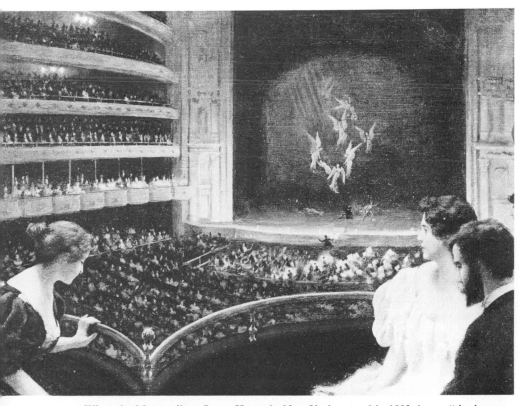

When the Metropolitan Opera House in New York opened in 1883, it was "the largest
opera house in the world," and cost $1,732,478.71. For the first time in America the
orchestra was sunk below the sightline of the audience in the orchestra seats. "Unlike
children," a *Times* reporter noted, "the instrumentalists should be heard and not seen."

the country,* ten community orchestras of amateurs and professionals, and eighteen college orchestral groups, of which thirteen were in the Middle West.

The size of the audience grew not only in numbers but in social prestige. For the rich and fashionable the opera and the symphony were performances less to be heard than to be seen at, a setting for satins and laces, brocades and tiaras, for tail coats and white gloves and gold-headed canes. Crystal chandeliers and velvet ropes were as important to the occasion as violins and tenors, and opera glasses were more useful for seeing who sat in which grand-tier box than for watching the final sufferings of the soprano. Without the social pretensions of the rich, who gave lavishly to build the opera houses to please their wives and daughters and impress their competitors, the portion of the audience that went out of love would have had no place to go. This, to be sure, was no truer of New York or Chicago than of Paris or London; indeed, it was American emulation of the Old World's stratification. The original Metropolitan Opera House in New York, for example, was built by a group of miffed millionaires who were unable to buy boxes in the Academy of Music and felt that they were socially ostracized by families of older wealth who had got there first.

America in the last quarter of the nineteenth century, for all its protestations of egalitarian sentiments, was exceedingly class conscious, and nowhere was there a more public, and quite possibly more brilliant, display of this than at the opera and the symphony. Fashionable women and women who aspired to Society felt impelled to make their presence felt at proper social events not only by their peers but by the public. Fashionable Society enjoyed the kind of adulation that in our century was once accorded to movie stars and still is to athletes and television "personalities." The comings and goings of its members commanded acute public interest and filled column after column of newspaper reporting and speculation—a state of affairs as true in Chicago and San Francisco as in New York or Boston. (In Boston, to be sure, a studied dowdiness was a sign of better breeding than the sort of Parisian brilliance affected in the other cities.) The support of cultural institutions by Society was then, and continues in large degree to be today, a matter of noblesse oblige. As it was true of the orginal Metropolitan Opera House, it has been true of the epidemic of cultural centers with their concert halls and mu-

*The major orchestras with their founding dates were New York Philharmonic, 1842; New York Symphony Society, 1878 (these New York orchestras merged in 1928 as the New York Philharmonic Society); St. Louis Orchestra, 1880–81; Boston Symphony, 1880–81; Chicago Symphony, 1885; Pittsburgh Symphony, 1895; Cincinnati Symphony 1895–96; and Los Angeles Symphony 1897.

seums and theatres that spread across the nation in the 1950s and '60s. This is not to deny that behind all such schemes is a hard core of passionately concerned devotees of the arts, but they could not achieve their ends without playing on civic pride, business self-interest, the competition among cities, indeed among nations, and the knowledge that behind the façades of social aspiration was the wherewithal for the columned façades of culture. It was a sort of cultural diplomacy of open purses openly arrived at that built our lavish opera houses and concert halls and museums, a totally different matter from the royal, aristocratic, and government patronage that built equivalent palaces in Europe.

Attempts to buck the fashion for European music and musicians seem to have been foredoomed. In the 1880s, for example, a wealthy New York society matron, Mrs. Jeannette M. Thurber, set out to establish a National Opera Company. She was filled with schemes to perform opera in English (European opera, of course, since there was no American opera considered worth performing), to challenge what she called "the pernicious star system" with an American conductor, Theodore Thomas, and with "fresh young" American singers and an American ballet troupe. The scenery was to be designed by "the most eminent scenic artists of America." In her prospectus the eagle was screaming; very soon so were the critics. After a single season, which was a financial failure, Mrs. Thurber renamed her group the American Opera Company and, undaunted, set out on a nationwide tour, which would go as far afield as the West Coast. This time the failure was catastrophic. The tour had to be abandoned on the way back in midcontinent. Singers and dancers were stranded when Mrs. Thurber refused to pay their salaries. Even the conductor was out six months' salary, and lawyers were called in.

On July 7, 1887, a theatrical magazine called *Truth* provided a scarcely polite obituary for Mrs. Thurber's dream: "The National Opera scheme," it declared, "from its boastful and vainglorious start to its miserable and contemptible end, has been marked by ignorance, vanity, bungling and failure. It was started to satisfy the desire for notoriety of a half-educated woman, possessed with a bank account but very little brains."

Whatever her private motives, Mrs. Thurber's attempt to give dignity to American musicians, though it was long overdue and it failed, was not without importance as a step toward the popular recognition of native talent. She also founded a National Conservatory of Music for training American musicians, and she had what a great many of her contemporaries unquestionably thought was plain gall when she tried to get support for it from the federal government. She petitioned the Congress for $200,000 nearly half a century before that august body looked with even grudging

favor on patronizing the artist. The reaction of the press was not surprising. "Music is a luxury for the wealthy," the Boston *Gazette* said on February 25, 1888, "and it would seem that Mrs. Thurber should take from her own well-filled pocket all she can afford in the shape of assistance to her pet conservatory." The Indianapolis *Journal* with downright Hoosier distaste for East Coast sophistication, declared: "Imagine a member of Congress facing his constituents after voting to appropriate $200,000 to teach young people how to execute vocal gymnastics, or play on the fiddle. We are not so esthetic as that."

The problems of the theatre, its support and its audience, were in many respects very different from those of the opera and concert stage, in other respects much the same. Music and art were endowed with a wholesomeness and righteousness in puritanical eyes that were lacking in the theatre, and though the theatre was exceedingly popular, it was not considered proper as a recipient for philanthropic or civic support.

It was not to be so considered until the 1930s, when the WPA Theatre Project of the federal government stepped in to keep out-of-work actors, designers, dancers, and stagehands from the breadlines of the Depression. However, by the end of the nineteenth century, as Münsterberg noted with mixed approval and concern, "There is certainly no lack of theatre, for almost every town has its 'opera house,' and the large cities have really too many." The quality of most of what was offered did not impress him. "Artistic productions," he said, "are drowned out by the great tide of worthless entertainments. . . . Everywhere the stage caters to the vulgar taste, and for one Hamlet there are ten Geishas."

In the 1890s the theatre like the opera depended almost entirely on great names for "box office." There were many more American actors than singers who drew crowds, and they had done so for decades. Edwin Booth played Shakespeare to enthralled audiences year after year. His last appearance was as Hamlet in 1891, two years before he died at the age of sixty. That he left a fortune of $700,000 and a splendid house on Gramercy Park in New York (it is now the Players Club) did more toward establishing the profession of acting as respectable than any artistic distinction he achieved. Joseph Jefferson, a beloved comedian, delighted audiences across the nation as Rip Van Winkle from the time he was thirty in 1859 until he retired forty-five years later. Minnie Maddern Fiske, who lived and performed well into this century, was an impeccable professional. ("As soon as I suspect a fine effect is being achieved by accident, I lose interest," she said to Alexander Woollcott. "I am not interested, you see, in unskilled labor.") Julia Marlowe trouped with her

famous partner and husband, E. H. Sothern, in Shakespeare. Maude Adams, "the most beloved actress of her generation," who had a gift for melting hearts, appeared in *All the Comforts of Home* in 1890 when she was just eighteen. The great ladies of the musical-comedy stage were the impish Fannie Ward and the frequently married Lillian Russell, whose last husband was the eminently respectable American ambassador to Spain. She made her debut as Josephine in *H.M.S. Pinafore* when she was eighteen and was considered for several decades the quintessence of blond and, as she grew older, opulent beauty. The theatre and music critic James Huneker said of her that her favorite composer was "Divorceshak."

These ladies of the stage were in many eyes overshadowed by those who came from Europe, and they were an imposing array—Helena Modjeska, who gave the first performance of Ibsen's *A Doll's House* (then called *Thora*) in 1883; Ellen Terry, who played Shakespeare with Sir Henry Irving; Eleanora Duse, mistress of the Italian poet and patriot D'Annunzio, who popularized the "natural style of acting" (as opposed to posturing) to the American audiences. "The Divine Sarah" Bernhardt, whose "farewell tours" were numerous, astonished her American public by affecting a young tiger as a pet and adorning her boudoir with a satin-lined coffin just her size.

The popular stage that Münsterberg decried as vulgar was good-natured, frivolous, often lavishly staged and costumed, and, though many righteous citizens found it shocking, totally harmless. By the last years of the century it was a good deal more sophisticated than *The Black Crook,* which had opened in Niblo's Garden in New York in 1866 and in many transformed versions had delighted audiences for an entire generation. Something approaching the musical comedies of the twentieth century emerged in the 1890s. Their thin semblances of plots were nothing more than cheerful excuses for songs and dances, the antics of comedians with wigs and red noses, and, starting with the Gaiety Girls from London, chorus lines of beautiful and reasonably circumspect young women. They did what were called "skirt dances," in dresses that swept the floor some, but by no means all, of the time.

The first of the comic operas (or operettas) of Gilbert and Sullivan to appear was *H.M.S. Pinafore,* in a pirated version with a questionably orchestrated score, in Boston in 1878. Since no one owned the rights to it, dozens of companies, professional and amateur, put together their own productions, and in Boston alone in the first year it was performed 241 times. Fully aware that New York afforded an opportunity not to be missed, the D'Oyly Carte Company arrived from London the next year to

perform *Pinafore*. It was the beginning of an American love affair with operettas, and especially those of Gilbert and Sullivan, that persists to a minor degree today.

The New York theatregoers of the nineties with a taste for more serious fare (they were a small minority) could see a number of plays by Ibsen with Mrs. Fiske in the leading roles. *Ghosts* was first produced in America in 1891; Mrs. Fiske gave a single matinée performance of *A Doll's House* in a cut version in 1894, and *John Gabriel Borkman* opened in 1897. George Bernard Shaw's *Arms and the Man,* with Richard Mansfield in the lead, opened in 1894 to the disgust of William Winter, the critic of the New York *Tribune*, who considered Ibsen a menace and Shaw a degenerate because they dealt with unsuitable subjects such as social questions and, though circumspectly, with sex. Nothing written by American playwrights at that time was serious about matters more controversial than sentiment, loyalty, and honor.

Seedlings in a New Cultural Garden

Lord Bryce was surprised and pleased that in a nation where "business is king," as he said, there was so great and widespread a concern for education of a liberal as opposed to a practical sort and for cultivation of an appreciation of the arts and letters. The European image of Americans as a fresh-faced, money-grubbing society with social and artistic aspirations that contradicted its democratic protestations (not necessarily its practices) of equality was not shared by Bryce or Professor Münsterberg. They took a more hopeful and sympathetic view of a civilization that in so brief a time had not only opened a continent and tied it together with rails and waterways but had begun to press on a wide scale for values beyond those of money and the increasingly marvelous gadgetry it could buy. They were aware that sharp practices, even ruthlessness in commerce, had a way of paying for the support of the muses—conscience money, some would say. Culture, Europeans believed, because their own experience had demonstrated it since the Middle Ages, could flower only in a rich loam fertilized by centuries of aristocratic and ecclesiastical patronage. They regarded with suspicion the American belief in instant culture, though there was no such convenient cliché then for such miracles. They looked askance, and so did thoughtful American observers such as Henry Adams and Henry James, on the proposition that given enough money to build institutions—colleges, libraries, museums, opera houses, theatres, and concert halls—a cultured nation was bound to follow as day the night. The basic answer to all cultural and social problems was education (though

there were furious arguments about what kind of education), and education could be readily financed.

There was a hitch. The very persons who could afford to finance the institutions were the same ones who built imitation French chateaus,

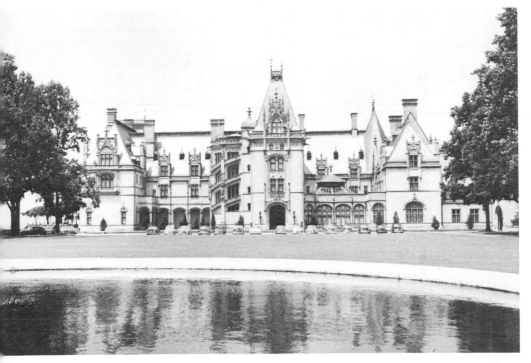

In the 1890s when Richard Morris Hunt designed this French chateau (Biltmore) for George Vanderbilt in Asheville, N.C., the only American thing about it was the Indiana limestone of which it was built. Vanderbilt employed more men on his 130,000 acres of gardens, farm, and forest than the U.S. Department of Agriculture.

Tudor country manors, Rhine castles, or Renaissance palaces in New York and Chicago and San Francisco. Culture to them was something to be imported from Europe and Asia. They filled their houses with paintings and furniture, carpets, porcelains and *objets d'art* chosen for them by dealers and brought from abroad. "Abroad" was synonymous with Culture; domestic manufacture meant the ingenious machinery that had won prizes in European world's fairs; domestic culture was . . . well, was it culture at all? Someday, maybe.

There was no question that by the end of the nineteenth century the audience for things cultural had grown and the seeds of a characteristically twentieth-century and characteristically American kind of culture were

germinating. A new architecture, a new music, a new visual art with the added dimension of motion, a new vitality in the novel and the short story —a revolt against what came to be called "the genteel tradition"—were ready to attack the old sensibilities and established attitudes toward culture. Such a revolution (for that is what it turned out to be) was the last thing on the minds of most Americans as they greeted the new century with a pealing of chimes and a blare of band music, a wailing of sirens and a burst of fireworks in a splendid clamor the likes of which had never been heard on this continent before.

Rumblings

T he age of technology was at hand at the turn of the century, and its by-blow, "mass culture" was in the incubator waiting to be hatched. Though there was one new kind of art and several new purveyors of the arts in their infancy, neither Bryce nor most of those who considered themselves sensitive to the winds of creation and taste were more than casually aware of them. If the sophisticates were aware of them at all it was not because they were thought to have any cultural significance. There were, moreover, rumblings of revolt in the established arts of painting and architecture and literature, upon which only a very few connoisseurs of the unconventional looked with interested sympathy. As for the new devices which were to make such a vast difference in the audience for the arts (and indeed in how the arts were created and in their character), those who noticed at all regarded them as ingenious mechanical toys only for popular amusement. They were not to be taken any more seriously than the recently invented rollercoaster or Ferris wheel. If, however, the two learned and sympathetic foreign scholars of our culture with whom we have become acquainted had taken a step further in assessing the American character and its ruler ("Business is king"), they might have guessed that a way would be found for business to make art one of its industrious (and industrial) subjects. It would make of the public a consumer of the arts on a scale unknown since the Middle Ages, when the Church was the ruler and everyone was its subject and in one way or another paid for its remarkable embellishments in architecture and the sister arts, painting and sculpture, gold and silver smithing and illumination of texts.

Since it is impossible to divorce technology from the arts of this century or draw any but a wavering and indistinct line between "mass" culture and what is sometimes called "high" culture (a blurring of distinctions which has deeply distressed some critics), let us look at what the

tinkerings of scientists and inventors without a high cultural thought in their heads had contrived by the time the century opened.

First the purveyors—

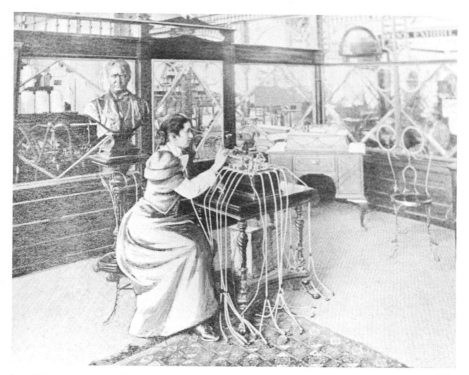

In 1893 a historian of the Columbian Exposition in Chicago observed: "When it was first reported that Edison had constructed a machine which would store conversations, speeches, songs, orchestral music . . . and reproduce them at any future time . . . many refused to believe it." Here is a skeptic at the fair in the process of conversion, with a bust of Edison scowling at her.

In 1901 an English firm called the Gramophone Company recorded a number of prominent singers of the Imperial Opera in Russia, and in the following year issued disks of the performances. They were expensive, they were pressed on only one side, and they had red-and-gold labels to distinguish them from the usual black or purple labels then commonly in use. The Red Label series, as it was called, was the first serious attempt to treat a recording device as a musical instrument. Twenty-five years before, in 1877, Thomas A. Edison had recorded sound quite by accident, an act of serendipity, of which he may have foreseen some of the consequences but, as he was not a man much interested in music, not its artistic ones. He was

attempting to record the vibrations of a telephone disk by means of a needle that cut a groove on tinfoil. Accidentally the needle moved along the groove that it had already cut, and to Edison's surprise, the machine said just what the telephone voice had said. "I was never so taken back in all my life," he said some years later. "Everybody was astonished." He had invented the "talking machine." In the following year much to his profit Edison exhibited his "phonograph," as he called it, and within a few years it had been developed primarily as a dictating machine for office use. Other inventors discarded the wax cylinder that Edison had devised (and which was long in use in offices, as they could be shaved and reused) and experimented with flat shellac disks. Though the fidelity of the cylinder was superior to that of disks, which lost quality as the needle approached the center, it was disks that were commercially viable and prevailed.

At La Scala in Milan a talent scout for the Gramophone Company in 1902 heard a young tenor named Enrico Caruso and was impressed not only by his mellifluous and powerful voice but by the enthusiasm with which his audiences thundered their applause. The scout engaged him to make recordings of ten famous arias. The technical quality of these records (as the disks quickly came to be called)* was far superior to any that had been made before, and when the Victor Talking Machine Company put them on sale in America in 1903, they were an immediate success. The Columbia Record Company, Victor's principal competitor, answered the challenge with American-made disks of America's favorite opera stars, Edouard de Reszke, Marcella Sembrich, and the indomitable Madame Schumann-Heink. To this Victor replied with the establishment of a recording studio in Carnegie Hall in New York and there they made the first Victor Red Seal recordings in this country.

There were soon ten thousand authorized Victor dealers across the nation, and many more thousands of families, who had never before heard an opera, were listening to "La Donna è mobile" and "Celeste Aïda" on machines that they cranked by hand and in whose pickups they screwed steel or bamboo needles. (The bamboo ones could be sharpened with a little cutting gadget and were preferred for use on expensive records because they were less likely to leave scratches on the surface.) All records spun at the rate of 78 rpm's, and the forgetful who did not wind the machine before playing were reminded of their carelessness by hearing the sound slow down gradually and mutter to a stop. The sound that issued from the gold-and-black and sometimes flowered metal horns was exceedingly thin

*It has become fashionable to spell *disks* in a manner derived from the French word *discothèque*, which literally means a collection of phonograph *disques* or records. So *disc* is now in fairly common use. Tapes now come in another French package as *cassettes.*

and tinny by modern standards, but the talking machine had for the first time become a musical instrument worthy of the name, and collections of Red Seal records became as *de rigueur* for libraries of the well-to-do as prized sets of morocco-bound Shakespeare, Thackeray, and Dickens.

By no means were the early recordings that sold in vast quantities in the early years of the century limited to arias and duets made by distinguished virtuosi of the voice. Quite the contrary. Sears, Roebuck's mail-order catalogue for 1905 not only sold talking machines called Graphophones that would play both cylinders and disks but offered a great variety of popular marches (none more popular than Sousa's "The Stars and Stripes Forever"), sentimental ballads, dramatic incidents (such as "Flogging Scene from *Uncle Tom's Cabin* with incidental music effects," and "Blazing Rag Concert Hall. Introducing the bouncer, the tipsy soubrette, the professor, and the fight—very realistic"), "coon songs," "bright, catchy dance records," selections of music and jokes from minstrel shows, then still popular but in their declining years, and comic songs and dialogues of a sort that persisted well into the 1940s in such radio shows as the almost universally popular *Two Black Crows*.

Recordings of symphony orchestras, though still unsatisfactory to the musically sensitive and knowing, were first made in Germany in 1913 by acoustical techniques superior to those that Edison had developed. They fell far short, however, of the dynamic volume and frequency range that were achieved by electrically recorded sound, a process developed by the Bell Telephone Laboratories between 1919 and 1924. This method was made available to all recording companies. "People who had formerly dismissed the phonograph as an unmusical toy," one historian of recording has said, "began to look upon it with a new respect." The music critic Ernest Newman observed,

> Those who have heard these [electrical] records for themselves will have probably felt, as I did at my first hearing of them, that at last it is possible for the musician to sit at home and get the thrill of the real thing as he knows it in the concert hall. The records have their weaknesses, but they seem trifling in comparison with the great mass of their virtues.

One of the most annoying weaknesses of the records was their brevity. A twelve-inch disk played for only four minutes, a reasonable length for most songs, but an ineluctable chopping-up of most chamber and all symphonic works. The RCA Victor Company (as the Victor Talking Machine Company became) issued the first long-playing records in 1931 and boasted that an entire movement of a symphony could now be heard uninterrupted. The quality was poor, however, and the records quickly wore out. The

record business, moreover, had been badly stung by the Depression (sales fell from 104 million records in 1927 to about 6 million in the black year of 1932), and Victor, for the time being, gave up its experiments. Columbia Records, however, did not. It set up a laboratory and put Peter Goldmark and a staff to work on a solution of the long-playing-record problem. By 1948 they found the answer in the microgroove and a record that turned at 33⅓ rpm; with slight loss of fidelity it played for twenty-three minutes.

It was not until the early 1950s, after World War II had ended, that the public began to buy record players that could handle the new speed, and there was considerable argument and confusion over whether the Columbia 33⅓ rpm or the system developed by Victor for 45 rpm records would prevail. As a result, turntables then as now were manufactured that could be operated at both of those speeds and at the old 78 rpm of pre-long-playing recordings as well. The era of jumping up every few minutes had ended, and unresolved passages were no longer held hanging in mid-air until the other side of the record was started. (Jacques Barzun recalls of his late colleague at Columbia University, the philosopher Irwin Edman, that "having become familiar with a certain overture from the records of the old slow kind . . . [he] was shocked in the concert hall when the conductor failed to stop on a high note at the midpoint.")

A mass market for the music of high culture had, in a manner of speaking, sprung from the brow of a machine. To a new generation a vast repertory of music, from the Gregorian chant to the twelve-tone scale, was available on records, and the names of Palestrina, Monteverdi, and Vivaldi on the one hand and Stravinsky, Bartok, and Schoenberg on the other were to be as familiar to them as Beethoven, Wagner, Verdi, and Sousa (who was, in fact, an arch enemy of recorded music) had been to their parents.*

The phonograph did more than bring the world of the stage and the concert hall into the living rooms of farm families, townsfolk, and city dwellers, and more than expand the range of serious music available to those who were hungry for it and create a new appetite in millions of Americans to whom such a banquet had never been available. It helped to change the nature of recreation from active to passive. Families that at the turn of the century had bought pianos and "parlor" organs that they pumped with their feet, banjos and "vitaharps" and other instruments, on which they performed for their own entertainment and presumably for that of their friends, let the phonograph do their entertaining for them. It was just one of the mechanical toys that played a role in making a mass

*In *Appleton's Magazine* for September 1906 John Philip Sousa published a diatribe against recorded music in an article called "The Menace of Mechanical Music."

audience out of what had been a people who, by and large, seem to have preferred to do rather than be done by, to participate rather than to listen or watch.

Pictures That Seem to Move

Once again it was Thomas Edison who was to create a new audience and inadvertently to serve the cause of both mass and high culture. Again he was more interested in making money than in uplift, for he was above all, as his friends liked to call him, a practical wizard. He was also hard-headed. He developed the incandescent lamp because he was determined to beat the gas companies that had a virtual monopoly on city lighting, and, of course, he succeeded. His Kinetoscope was an entirely different and frivolous matter. He thought so little of its potentialities beyond its novelty as an amusement that, when his lawyers advised him to pay an additional $150 for European patents to supplement his American patent, he declined. "It isn't worth it," he said.

The Kinetoscope was a small machine scarcely larger than a Las Vegas slot machine (and mechanically far less complicated) and like it made to amuse and take money from one person at a time. When Edison sought his first patent in 1887, he had no notion of projecting a moving image on a screen. It was an instrument, he wrote in his patent application, "which does for the eye what the phonograph does for the ear, which is the recording and reproducing of things in motion, and in such a form that is to be both cheap, practical, and convenient." Without George Eastman's invention of flexible film on celluloid that could be made into long strips and coated with a gelatin emulsion, the Kinetoscope would never have been, as one historian put it, "the grandfather of all later motion-picture machines." There had, indeed, been a long line of experimenters with photographing things in motion, some in Europe and several in America. At the root of these experiments was a principle enunciated by an English physician and lexicographer, the author of *A Thesaurus of English Words and Phrases* (1852), Peter Mark Roget. Put in simple terms, his theory was that the eye retains for a small fraction of a second any image it beholds; he called it "the persistence of vision with regard to moving objects."

There is obviously a distinction between the motion picture, which gives the illusion (for it is an illusion) of continuous motion, and the sequential photographs of objects in motion such as those conceived by Eadweard Muybridge. He devised a way to photograph Leland Stanford's favorite mare, Occident, at full gallop by means of twelve cameras, placed at regular intervals, with shutters triggered by electrical impulses. After

many false starts Muybridge froze the motion of the horse on film in a sequence of twelve positions (the shutters had a speed faster than one two-thousandths of a second) and demonstrated, to win a bet for Stanford, that a horse's legs are all off the ground only when they are bunched beneath its belly and not, as painters of hunting and racing pictures and of cavalry had always believed, when they were in a hobby-horse position with forelegs stretched forward and hind legs stretched back. The illusion of continuous motion was heightened in photographs by one of America's greatest painters, Thomas Eakins, who on a single negative made many exposures of men pole vaulting or jumping. The Muybridge and Eakins sequential photographs, beautiful themselves as works of unintentional art, were part of the nineteenth-century impetus to capture the sense of continuing motion not just to stop it; any ordinary camera could do that if given sufficient light and a fairly fast shutter.

Edison went further. Mindful of Roget's principle, he sought the illusion of flowing motion created by exposing a series of photographs to the eye in rapid succession (there had been gadgets before that had done the same thing with drawings), and he attempted to synchronize sound with visual illusion. He achieved the motion with his Kinetoscope, but synchronized sound, though it did not elude him entirely, he decided was not worth pursuing. He tried to combine his gramophone with a moving-picture machine he made in 1889, but the effect was unconvincing.

He first offered the public a peepshow suitable for penny arcades, and they returned a pleasant profit to him just as his phonographs in arcades had. What the peeper saw when he pressed his eyes against a viewer that protruded from the standing box was a roll of positive film that was driven by an electric motor between a light bulb and a slotted whirling disk. What he thought he saw was a vehicle or a person in motion; it was the movement not the subject that fascinated. Edison exposed his films with a camera about the size and weight of a small upright piano at a speed of forty-eight exposures a second, and the illusion was astonishing if brief; a penny produced a show that lasted only a minute. The first Kinetoscope Parlor, as it was called, opened in New York in April 1894, and it was so successful that before the year was out men in bowlers and celluloid collars and ladies with pompadours and wasp waists were peeping into machines in all the principal cities of America and in London and Paris as well, amazed at the flickering image they beheld.

It was two Frenchmen, the brothers Louis and Auguste Lumière, who were generally credited with devising the first successful projector for casting a moving image on a screen. (A certain chauvinism still persists, as many nations claim priority for this cultural phenomenon, which no one

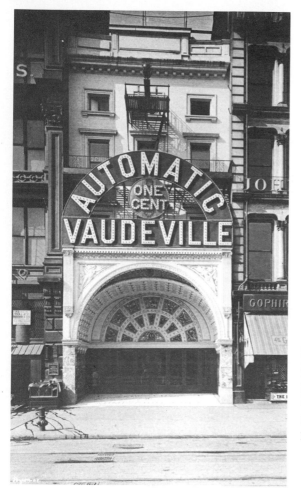

Inside this "penny theatre" on Fourteenth Street in New York about 1900 were rows of peepshows with titles like "French High Kickers" and "A Ride with the Motorman on the L." They were the first kind of moving pictures that most people saw.

at the time thought of as cultural.) In 1895 the Lumières showed a delighted audience, which could scarcely believe its own eyes, snatches of objects and figures in motion—a train chuffing into a station, a fishing boat sailing into a harbor, a gardener with a hose, and workers from the Lumières' own factory going out to lunch. In the same year American inventors produced several sorts of machines that could project Mr. Edison's films, but he adopted (and adapted) the Lumières' Cinematograph and called it a Vitascope. In April 1896 he showed his films, some of them in color (hand-tinted, to be sure) at Koster & Bial's Music Hall at Broadway and Thirty-fourth Street (the present site of Macy's department store) in New York. On April 26 the *New York Times* reported a "triumph" for "the Wizard of Menlo Park." It found the films "almost the acme of

realism." There were brief sequences of dancing in which "every movement was as natural as if living dancers were working their way toward salary day." But the hit of the evening, which "caused the spectators to cheer and to marvel most of all," was "waves tumbling in on a beach and about a stone pier." Mr. Edison had placed two projectors, in case one failed, in the second balcony of the theatre. "Double locks keep inquisitors away," the *Times* said, as the Wizard was "afraid lest somebody should steal his first principles . . . and beat him in the race."

As there were immediately enthusiastic audiences for the new sensation at Koster & Bial's, so were there also immediately determined competitors for their nickels. The American Biograph Company opened its show at Hammerstein's Olympia Music Hall just a few months later, and before the year was out people were gaping at this new "marvel of human ingenuity" in cities across the nation and, of course, in the sophisticated capitals of Europe as well.

What followed was a surge of makeshift theatres known as nickelodeons, usually set up in hitherto legitimate places of business. (The movies were not then and are still not considered legitimate by theatre people, and they share this aspersion of illegitimacy with vaudeville, burlesque, and musical comedy.) Such theatres were sometimes former "opera houses," as playhouses for vaudeville and traveling stock companies were commonly called, but more often they were old butcher shops, furniture stores, or tailor shops furnished with benches or chairs hired from a caterer or undertaker. Any long, narrow, windowless room would do if it could accommodate from one hundred to four hundred customers. The rooms were commonly ill ventilated, and frequently the lingering smells of their previous uses pervaded them. Their fronts on the street were tinned-over show windows plastered with gaudy, circus-like posters promising marvels to be seen inside. Audiences had a way of trying to stretch their nickels for more than one performance, and the proprietors hired the equivalent of saloon bouncers to see that the rooms were cleared after each performance. The usual show lasted twenty minutes.

Nickelodeons were likely to cluster cheek by jowl in the poor sections of large cities, for the poor were their mainstay. Since there were no titles* (or virtually none), illiterates and recent non-English-speaking immigrants were at no disadvantage in front of the flickering image, which was cast on a taut white curtain, usually above a raised platform. (The "silver screen" was a refinement that came later.) In the early days of the movies,

*In silent films, titles, as they were called, served to explain the action, when it did not explain itself; to indicate shifts in place and time ("meanwhile back at the farm"); and most importantly they were a substitute for dialogue.

music, in a manner of speaking, was a substitute for verbal language. Below the stage was a piano on which a piano player (usually not dignified by being called a pianist) improvised a patchwork of mood music to go with the action on the screen. His music galloped to horses, sighed to lovers, stormed to battles, thundered to downpours, minced to children, and wept at deaths and departing sons, a vocabulary of sound that soon became familiar to movie audiences, who could very nearly tell what was going on with their eyes closed. In February 1908 the *Independent Magazine* reported, "Between 1906 and 1908 moving picture theatres . . . have opened in every town and village in the country . . . every city from the Klondike to Florida and from Maine to California supports from two or three to several hundred." One informed guess at the time (there were no records kept) estimated that some two or three million people were going to the movies each week. Another contended that "With 10,000 theatres playing to a nationwide audience of 10 million weekly, they were doing a greater volume of business by 1910 than all the legitimate theatres, variety halls, dime museums, lecture bureaus, concert halls, circuses and street carnivals combined."

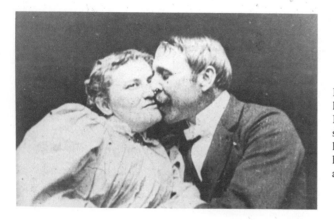

In 1896 when John C. Rice lingered on the lips of May Irwin in a kiss as big as a movie screen, the moralists were horrified; *The Widow Jones,* however, broke all previous attendance records.

Not for long had the nickelodeon been drawing crowds of people, who never before could have got so much fun for a nickel or seen entertainment of such a spirited quality, before soldiers of righteousness began to close in on them, with pious pronouncements and the weapons of censorship. Anthony Comstock, a staunch shaker of the finger of puritanism (he founded the New York Society for the Suppression of Vice in 1873), was deeply disturbed by the potential assault on the public morals in the peepshow parlors and the nickelodeons. But it was the first kiss to be blown up to monstrous size on the screen in a film called *The Widow Jones* in 1896

that brought howls of indignation and threats of suppression. The clergy denounced it as "a lyric of the stockyards." *Chap Book,* a small Chicago magazine, said: "The spectacle of the prolonged pasturing on each other's lips was hard to bear. When only life size it was pronounced beastly [it was a scene from a play]. Magnified to Gargantuan proportions and repeated three times over it is absolutely disgusting. . . . Such things call for police interference."

A dozen years later on Christmas Eve 1908 the mayor of New York closed down 550 movie houses by revoking their licenses. He acted in response to objections of the aroused clergy. By and large, however, the public and the press were tolerant of "the nickel madness," as the sweeping vogue was called, and thought it, as a writer in *Review of Reviews* said, "an innocent and on the whole rather wholesome delirium."

By 1908 the images thrown on the screen were no longer mere snatches of action, as they had been when the first audiences in the nickelodeons to see a train roaring toward them had screamed and a few had fled in terror from the theatre. The films now told stories and had plots to add humor, tension, and sentiment to motion. The Lumière brothers in their first showing had included a short anecdote called "The Sprinkler Sprinkled," in which a gardener is watering the grass and a small boy jumps on the hose. The gardener picks up the nozzle and looks into it to see why the water has stopped, the boy jumps off the hose, water shoots into the gardener's face, whereupon he pursues the boy, catches him and spanks him. Thus the movie scenario came into being, and so, indeed, did that staple of the movies, the chase. Still another Frenchman, Georges Méliès, a professional magician, who was delighted by the illusion of magic inherent in the moving picture, produced a series of short, imaginative, and trickish narrative films, the most famous of which was *A Trip to the Moon* in 1902. Essentially these were theatre performances filmed from a single stationary point of view.

It was in the hands of the American Edwin S. Porter that the movies became a distinct, nontheatrical, visual medium with its own flexible techniques for telling a story, creating moods, and expanding experience. Porter's film *The Great Train Robbery,* made in 1903, as the film historian Arthur Knight put it, "provided the key to the whole art of film editing, the joining together of bits of film shot in different places and at different times to form a single, unified narrative—a principle that Méliès, with his theatrical background, was never able to grasp."

Neither did those who first tried to introduce the movies to the dignity of high art. It was a company in Paris calling itself Film d'Art that first set out in 1907 to capture the most famous actors and writers of the day

and make their performances, plays, and stories available to the populace instead of remaining, as they had been, the more or less exclusive province of a narrow *haut bourgeois* and élite audience. The brilliant Sarah Bernhardt and the elegant Madame Réjane and many other members of the Comédie Française, even ballet troupes, postured and gestured and mouthed their lines before hand-cranked cameras on stages elaborately set for theatrical performances. Scenarios were adapted from stories by Sardou, Victor Hugo, Anatole France, and Rostand. It was the first attempt by the moviemakers at lifting the public taste, and not surprisingly the public would have none of it. They much preferred the slapstick comedies, the sentimental tearjerkers, and the cops-and-robbers chases that had become the common fare of the French equivalent of the nickelodeons. The audiences that came to see the *films d'art* in Paris were very much the same as those who could well afford to go to the legitimate theatre, and at first they were disconcerted by the musty, make-do places in which the films were shown. If, however, the art of the film was not advanced in any cinematic way by these attempts at tastemaking, their producers discovered that such films could make money by attracting an audience with what were regarded as genteel manners and refined tastes. Soon the English, the Germans, the Italians and the Americans were pursuing similar audiences with similar means (there was an American production of "the whole of Hamlet in ten hectic minutes") and renowned actors of other countries besides France were participating in the new and, until they condescended to take part, disreputable form of amusement.

If the incipient, albeit unselfconscious, art of the film which Porter had introduced with *The Great Train Robbery* was lost on the makers of the self-conscious art films and their audience, the art films paid historical dividends. They not only recorded the theatre of the first decade of this century, its methods and mannerisms, its styles and settings, but made snatches of performances by distinguished actors and dancers permanent. (When Sarah Bernhardt at the age of sixty-five was asked to film *Elizabeth* and *Camille*, she is reported to have said, "This is my one chance for immortality.") Furthermore, they introduced to the repertory of the films substantial scripts, as they came to be called, and in so doing they released the movies from the confinements of comedy and melodrama and opened the medium to narratives and documentaries far broader in gauge, more subtle in texture, and to many people far more satisfying. As the scenarios of films became more sophisticated, so did the audiences that flocked to see them, so did the quality of the acting, and all classes of people found themselves with a common source of pleasure and gratification. The upshot of the attempts at uplift tended to work both ends toward the middle—

a middle which, to be sure, often produced mediocrity but more importantly also produced a new and genuine and unsuspected visual art.

The Sound of Distant Voices

First it was the phonograph, then the movies, and then the radio that revolutionized the character of the cultural audience. These robots, which could be anywhere that there was money to pay for them, not only changed the geographical nature of the audience but its intellectual and social structure and range as well. Concerts, recitals, and theatrical performances were no longer confined largely to auditoriums, theatres, and opera houses in large cities and small ones. The great performers no longer could be heard and seen only by the urban well-to-do, many of whom were in the audience for reasons of social prestige, by the dedicated members of the musical and theatrical audiences, and by the eager, inquisitive, and impressionable young. The great performers were wherever there were gramophones, radios, and movie houses. It was these that created the new geographically and socially undefinable mass audience. That is not to suggest that this new mass shared common tastes, though they could share common experiences. The way had been prepared for the arrival of loudspeaker music and two-dimensional theatre by the proponents and proselytizers for universal education. Free schools, Chautauqua, reading societies, lyceum lectures, mass-circulation magazines, inexpensive books, public libraries, art associations, municipal museums, and other come-to-culture middlemen all had played their parts in readying the public for the robots.

But the new audience was an invisible audience, an audience inconceivable in the nineteenth century. The "live audience" is a twentieth-century concept. Until this century all performers were face to face with those for whom they played, sang, read aloud, or lectured. One can say that there was no such thing as a "live audience" until technology created the "nonlive" audience. The cultural robots radically altered the relationship between performers and their public. With each new mechanical device for reproducing sound and sight, the entertainer and the artist, the playwright and the composer became more remote from audiences that could respond to their artistry. With increasing frequency artists performed for faceless audiences, whose applause (or hisses) they could not hear and whose reactions they could not measure with their guts. They sang or played or recited into a horn until the electronic microphone was invented. They acted for lenses from which there was no human response, and the performances the invisible audience heard or saw were increasingly edited versions of what had taken place in the recording or movie studio. The

audience became "the people out there," which soon meant "anywhere." With the invention of the wireless telegraph and its legitimate offspring the radio, "anywhere" became "everywhere."

On December 14, 1901 a young, narrow-faced Italian named Guglielmo Marconi sat in a tweed Norfolk jacket and fedora hat in St. John's, Newfoundland, and listened as equipment he had devised and set on a wooden table picked up a signal from his wireless transmitter at Paldhu on the coast of Cornwall in England. The signal was the Morse code letter *S* (dot, dot, dot) repeated over and over. The Washington admirals of the United States Navy were impressed, and the Naval Bureau of Equipment promptly made a recommendation that very neatly seems to draw the line between the nineteenth and the twentieth centuries. It read:

1. That the use of homing pigeons be discontinued as soon as wireless telegraphy is introduced into the Navy.
2. That, pending such action, no new pigeon-cotes be established."

Marconi was twenty-seven when his wireless signal first leapt the Atlantic, and only five years had gone by since he had invented a workable antenna and "a sensitive tube" (as the *New York Times* called his vacuum tube) and had sent a long-wave signal over more than a mile of Italian landscape. Like Edison he was an organizer as well as an inventor, and the year after he had first demonstrated his device, he went to London and patented it and set up the Wireless-Telegraph Company. Within two years he had astonished the public by transmitting a signal across the English Channel, and on October 18, 1907, the *New York Times* devoted a large portion of its front page to announcing the "First Wireless Press Message Across the Atlantic." In somewhat the same manner as the eighteen-hour transatlantic passenger flights in the days before jets, it made several stops on its way from London. From London it went to Ireland, from Ireland to Cape Breton, Nova Scotia, and thence to New York. Ten thousand words were transmitted on the first day and the first messages were from Georges Clemenceau, the Premier of France, and Lord Avebury, the English Lord Privy Councillor, both of whom looked on this "prodigieux mode de communication" (in Clemenceau's words) as a further means of cementing ties between the old world and the new. Not to be outdone, Marconi himself sent a message: "Congratulate New York Times on having received first westward press message."

The year before these messages inaugurated a new era of intercontinental communication, which was far broader in its implications than the

forty-one-year-old Atlantic cable, wireless had transmitted the sound of a man's voice. This remarkable occasion had been the result of experiments by Sir John Fleming, who devised a diode rectifier tube, and by Lee De Forest, an American inventor, who produced the triode amplifier tube. The first use of voice transmission (called wireless telephony) was "ship to shore." Those amateurs who for a few dollars put together crystal sets and fiddled with a wire called a cat's whisker until it found a sensitive spot on the crystal could, if they were lucky, hear in their earphones a ship's radio man conversing with his counterpart in the harbor. Some of them might have caught the first broadcast of a musical composition on March 5, 1907, when Lee De Forest transmitted the "William Tell Overture" from Telharmonic Hall in New York to the Brooklyn Navy Yard. During World War I voice radio was used by flyers telling artillery officers the position of enemy transmitters, but it was not until 1920 that Dr. Frank Conrad of the Westinghouse Company, fussing with his wireless equipment in a barn near Pittsburgh, decided to play phonograph records for the amusement of amateurs. Four years before in 1916 David Sarnoff, then assistant general manager of the Marconi Wireless Telegraph Company of America, sent his immediate boss a memorandum in which he said: "I have in mind a plan of development which would make radio a household utility in the same sense as a piano or phonograph. The idea is to bring music into the house by wireless."

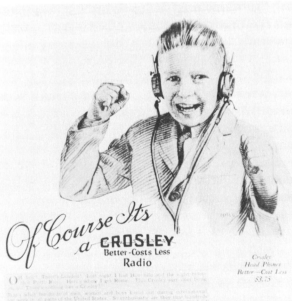

The excitement of hearing voices (not just Morse code) on radio earphones was intense in the early 1920s. Loudspeakers were not yet common, and when someone captured a signal from a distant city, it was the talk of the neighborhood. This advertisement appeared in the *Saturday Evening Post* in 1925.

Sarnoff's proposal, it appears, was premature if prophetic, and his colleagues looked with skepticism on his vision of a "radio music box," as he called it, in every home. Westinghouse, on the other hand, latched on to Dr. Conrad's diversionary musical broadcasts and decided that by promoting them they could also promote the sale of radio equipment. On November 2, 1920 (a date that Frederick Lewis Allen in *Only Yesterday*, published in 1931, said was one "which school children may someday have to learn), Westinghouse began operation of the first commercial radio-broadcasting station. Its call letters and location, "KDKA Pittsburgh," were quickly on the lips of nearly everyone within the broad range of its signal.* KDKA's first broadcast reported the returns of the Harding-Cox presidential election, but its listeners were few as few families had sets. For the first year its programs were almost exclusively phonograph records, and amateur wireless operators found the music distracting and complained that it interfered with what they considered the important business in which they were engaged. Within a year radio had escaped from its parochial beginnings, and there were stations sprouting broadcasting towers all across the country. By the winter of 1921–22 a San Francisco newspaper reported what millions of Americans already took for granted: "There is radio music in the air, every night, everywhere. Anybody can hear it at home on a receiving set which any boy can put up in an hour."

The extremely rapid spread of radio's popularity spurred an equally rapid improvement in the quality of receivers, which soon came equipped with loudspeakers to replace the earphones that were standard with the earliest factory-made sets. As the sets improved, so did the techniques of broadcasting and so did the variety of fare which the stations seeking for novelty fed into the air waves. Broadcasting studios completely draped with cloth inside, and looking like pavilions fit for a royal excursion, became the regulation setting for musical programs and readings. The cloth absorbed the vibrations that otherwise would have made the "enunciator" (as the microphone was generally called) reverberate so that sounds ran together. In such studios it was possible to broadcast musical groups with reasonable verisimilitude. But music was by no means all. Plays were read, sermons were delivered, and by 1926 twenty-five stations reported the first World Series game to some fifteen million listeners in the United States and Canada. It seemed incredible, as the *New York Times* reported, that

*How broad the range was depended not only on the power of the transmitter but on the capabilities of the receiving set that captured the the signal from the air. KDKA's broadcasts were clear on a seven-tube superheterodyne Atwater Kent receiver in Englewood, New Jersey, where I lived in the 1920s.

the listeners "were hearing the beginnings of plays before the announcer himself knew the conclusion."

Here was the invisible audience to a fare-thee-well; here, too, was the penultimate step in broadcasting before the total immediacy of television "live coverage." The radio announcer in the ball park had no more idea than did his invisible audience in their living rooms and clubs what would happen in the twinkling of an eye. The very medium that boasted to its audience that "you are there," as radio did, made it unnecessary to be anywhere but in your own armchair. It would be another twenty-five years before television finally reduced audience participation to an absurdity.

The New Unseen Audience

No one, as we have noted, had ever heard of a "live" audience or a "live" performance until the invisible audience and the technologically entrapped performance came into existence. All audiences were "live" and so were all performers. The only invisible audiences had been the readers of books and magazines and newspapers, who could, like the radio and television listeners and viewers, "turn off the set or switch stations" by putting down what they were reading and, if they felt like it, turning to another page of another sort. As a method of communication, edification, amusement, or uplift, in spite of the predictions of the twenties that radio would kill books and of the fifties that television would bring about the end of magazines, the printed word has proliferated, not shrunk, in our century. Reading aloud as a family recreation has unquestionably declined, just as evenings of homemade recitals of music have declined, but the rate of increase of printed matter—serious, frivolous, and merely palatable— has been neck and neck with the growth of the population. So has the number of readers in public libraries. As the percentage of Americans who have extended their education beyond the high-school level has greatly increased, and the college and postgraduate enrollments have swelled, so has what David Riesman calls the "class-mass production" of books and, with the growth of the paperback book industry, so has the availability of "out of print" books which not long ago one could find only in libraries.

The creation of the mass audience, especially the sophisticated audience for which the universal educationists strived, has become increasingly unwelcome to many members of the intellectual community because, as one of them put it in the 1950s, "Never before have the sacred and profane, the genuine and the specious, the exalted and the debased, been so thoroughly mixed that they are all but indistinguishable." Another said a decade earlier: "Culturally what we have is a democratic free-for-all in

which every individual, being as good as every other one, has the right to question any form of intellectual authority." And still another, an art critic, observed, "It becomes increasingly difficult to tell who is serious and who is not."

The argument between the proponents of mass culture and those who believe that it serves to muddy the waters of an élite culture has become a perennial tournament of pundits. They first entered the lists in the 1940s after the Second World War; the contest continues today and, I have no doubt, will be resumed at intervals for the indefinite future. The debate, however, has been carried on principally among critics and sociologists, and is little regarded by artists other than a few men and women of letters. (T. S. Eliot's *Notes Towards A Definition of Culture*, 1949, was an important early call to arms.) The visual artists (painters, sculptors, moviemakers), and composers, concerned though they are with audiences for what they create, seem not to be concerned about the conflict between mass and class, though that is not to say they haven't a healthy disdain for what they dislike. In the late 1950s at a symposium at the MacDowell Colony, the retreat for artists, composers, and writers in New Hampshire, the subject under discussion was "Who does the artist work for?" The participants were the painter Ben Shahn, the novelist and poet Robert Penn Warren, and the composer and music critic Virgil Thomson. Shahn said that he worked for the approval of a few friends whose judgment he trusted. Warren said that he wrote entirely for himself without regard to any audience however small. Thomson said, "It is like Spanish boys playing bull fight. It takes three of them. One to be the bull, one to be the matador, and one to stand by and shout, 'Olé!' "*

These three men were not in revolt against mass culture or even concerned with it; its existence was a fact of life with which they were well acquainted. An audience for their work existed, and they were better off in this respect than many comparable artists at the beginning of the century. The mass (or popular) arts and the serious (or high) arts had grown as the public for all the arts of whatever degree or intention had grown. If the high and the mass sometimes met on middle ground (Virginia Woolf had called that ground "middlebrow"), they did not meet without a certain tension, a tension which has proven to be beneficial, or in any case productive, to both high and mass.

*The symposium has not been published, though the discussion was recorded on tape. I had the privilege of being the moderator on that occasion, and I report this from memory.

Architecture
and Fantasy

To Easterners in the 1890s Chicago was not just a cultural upstart but a social backwater—that is, to Easterners who set great store by "family" and "background" and who fashioned their manners and tastes on what was considered proper in European capitals. Ward McAllister, who may have been the most consummate social snob of the nineteenth century (he coined the term "The Four Hundred" to set the limits of "anybody who is anybody" in Society), wrote about Chicago in 1893 at the time of the Columbian Exposition: "The leaders of the Windy City, I am told, are the successful soap makers, pork packers, Stock Yard magnates, cottolene manufacturers, Chicago gas trust manipulators and dry goods princes. These gentlemen are undoubtedly great in their way, but perhaps in some cases unfamiliar with the niceties of life. . . . It takes nearly a lifetime to educate a man how to live."

In those days the roaring city of Chicago was still more than sixteen hours away from New York; the Twentieth Century Limited, that crack train, did not make its first run until 1902. It was farther than that culturally. According to the novelist Henry B. Fuller, Chicago was "the only great city in the world to which all of its citizens come for the one common, avowed object of making money." The architect Louis H. Sullivan called the city "magnificent and wild: a crude extravaganza, an intoxicating rawness, a sense of big things to be done." He recalled in his *Autobiography of an Idea* that Chicago's men "were the crudest, rawest, most savagely ambitious dreamers and would-be doers in the world," and he added, "These men had vision. What they saw was real." In the twenty years after the fire of 1871 that laid the city waste, Chicago doubled its population, jammed its business district, the Loop, with new buildings, and became, "the center of architectural development not merely for the United States, but for the whole world." In its haste to accomplish everything at once,

Chicagoans with cultural aspirations sought the trappings of a nostalgia for what never was in America or, for that matter, anywhere else. The Columbian Exposition of 1893 was as truly the image of Chicago as were its skyscrapers. If the citizens of Chicago wanted it both ways, for better, or as a few architects and critics believed at the time, for worse, they had it.

There is a dispute about whether the skyscraper was a New York or a Chicago invention, a reasonable dispute if it is only height that counts. But there is no dispute that the steel frame on which walls were hung like curtains (instead of thick masonry walls which support the interior structure of the building) made the modern skyscraper possible. The steel cage belongs to Chicago, and it was there that what we today call "modern" architecture was born. Chicago was given to such innovations. It had been Chicago's invention of the "balloon frame," a structural inspiration that used two-by-fours and nails instead of heavy timbers joined by dowels and by mortise and tenon, that had made it possible for Chicago to grow from a village of a few scattered huts to a city of several thousand houses, stores, and warehouses in just eighteen months in the 1830s. The strong but speedily constructed balloon frame became standard for houses and small buildings everywhere in America, just as the steel frame sixty years later was to make booming Chicago the most important architectural seedbed in the world. With one or two exceptions even Chicago architects were unaware of the importance of what they had sown or the harvest that their successors would reap.

The very word "skyscraper" was a Chicago coinage. It first turned up in print in the Chicago Tribune in January 1889, and a few weeks later a New York publication, *Engineering News*, used it in referring to Chicago buildings. New York had its tall buildings then, even taller ones than Chicago's, but they were not true skyscrapers, in which the number of stories was determined not by structural limitations but by commercial ambition (or prudence) about rentable space. They were still constructed with bearing walls which could rise effectively just so high without becoming impossibly thick at the base, especially in cities with downtown real estate at a premium. (In the 1880s a quarter of an acre in Chicago's business district rose from $130,000 to $900,000.) The steel cage was under no such constraints. Even so the first tall buildings in Chicago were essentially of masonry construction, with interior supporting members of iron. Such were the Home Insurance Building by William Le Baron Jenney (1884–85) and the remarkably handsome sixteen-story Monadnock Building (1889–91) by the architects Daniel H. Burnham and John Wellborn Root. The Monadnock at this writing still stands (and is being refurbished), though many of its tall contemporaries do not. The first building

constructed entirely on a riveted iron and steel frame was the twelve-story Tacoma Building by the architects William Holabird and Martin Roche, designed in 1886, three years before the Monadnock was conceived. Burnham and Root's Masonic Temple at La Salle and Monroe streets (which Burnham's biographer called "the last and most beautiful of all the great buildings that Root designed") was twenty-two stories high on an all-steel frame and was called "the tallest building in the world." It has long since disappeared.

While the Monadnock, the Temple, and the Tacoma were under construction, the "savagely ambitious dreamers" were scheming to make Chicago the site of a world's fair to celebrate the four-hundredth anniversary of the discovery of America. They were in competition with New York, Washington, and St. Louis, and they dispatched a committee headed by an engineer, Octave Chanute, to Paris to report on the French Universal Exposition of 1889, where Alexandre Gustave Eiffel had erected his soaring tower, 984 feet high, double anything in Chicago or New York at that time and taller than any structure anywhere for four decades more. (The Chrysler Building in New York topped it by 62 feet in 1930.) At the same time they invited Burnham to "consult with them as to the location to be proposed in support of Chicago's claim before Congress." For months little was accomplished except talk (the committee of three politicians and four businessmen, characteristically, couldn't make up its collective mind). Then James W. Ellsworth, who initially had thought that fairs in general were nonsense but now felt that, since the city was involved in it, some positive action should be taken, suggested that the great landscape architect and planner Frederick Law Olmsted be consulted. Olmsted, who had established his reputation with the design of Central Park in New York, had a hard-headed way of getting politicians to accede to his dreams. He was reluctant to accept until he was convinced that here was an opportunity to develop six hundred acres, with a budget of $15 million, into an area of permanent usefulness to the city.

Extravaganza on Lake Michigan

The Congress succumbed to Chicago's blandishments in April 1890, much to the annoyance of New York, who, as one wry Chicagoan said, "did not see the hand of Providence in it, and had her doubts about the wisdom of the choice—doubts she did not regard as confidential." New Yorkers with characteristic insularity, he accurately implied, could not bring themselves to believe that any city west of the Hudson, and most especially the upstart Chicago, could represent to the world the progress

The Monadnock Building, designed by the firm of Burnham & Root and
built in 1891–93, was one of Chicago's earliest skyscrapers and is still one
of its handsomest. It has recently undergone careful interior restoration
and is economically as well as structurally sound.

of the American genius for invention and commerce in a culturally or socially appropriate manner. Chicago was less than a man's life span old, a bumptious adolescent, if not just a child, in the company of Boston and Philadelphia and New York. Indeed, it was because Chicagoans, or in any case their tastemakers, were made to feel this inferiority that they succumbed to the cultured manners and aesthetics of the coastal cities of the East when they built their gigantic "White City" on the shore of Lake Michigan.

Burnham, more an energetic and skillful organizer than a richly gifted architect, led the way. He pursued a path for which his contemporaries, most of them, greatly praised him at the time, and for which he has subsequently been criticized, as having done the cause and development of American architecture a great disservice. He was given charge of all construction at the fair (which meant the final word on design as well as building): "all other officers . . . were to report to him directly and could make no communications excepting through him." It was a lack of confidence in his own taste and a lack of conviction about Chicago's inventive vigor that caused this usually self-confident man to invite the old architectural guard to design the major structures at the Columbian Exposition. It has been said that Burnham's social ambitions, and his eagerness to be accepted by the members of the established fraternity of architects and their fashionable clients, colored his judgment. There is no question that he was apologetic about the ways in which the Chicago architects had turned their backs on the classical traditions preached by the École des Beaux-Arts in Paris. It was Beaux-Arts ideals that fashionable architects in the East imported for academic and commercial buildings and for the homes of the rich in cities and sumptuous resorts.

With the somewhat reluctant approval of the committee (the three politicians voted against his proposal), Burnham invited a number of well-established Eastern architects to divide the planning of the fair's main buildings with five Chicago practitioners. The chief among the old guard was Richard Morris Hunt, the first American architect to study at the Beaux-Arts, one of the original organizers of the American Institute of Architects, and the darling of the Vanderbilts, for whom he built French chateaus on Fifth Avenue and in Asheville, North Carolina, and vast marble "cottages" in Newport. He was a man of commanding charm and a no-nonsense attitude toward work, and he was as well liked by his masons and carpenters as by his clients and colleagues. It was he who, in effect, became the central member of the team that designed the White City. Others from his coterie joined him. His pupils Henry Van Brunt, then practicing in Kansas City in the firm of Howe & Van Brunt, and George

Post of New York were happy to join. Charles Follen McKim, of McKim, Mead & White, at that time the leading New York firm, agreed reluctantly, and his partner Mead was dispatched to Chicago to consult. In addition there was Robert Swain Peabody of the Boston firm Peabody & Stearns. When they first met in Chicago with the local architects, Burnham started to apologize, as Louis Sullivan recorded it, "for the presence of their benighted brethren of the West." "Hell," said Hunt, "we haven't come here on a missionary expedition. Let's get to work."

Indeed they did. Mr. Peabody from Boston, where transformations happened more slowly than in Chicago, looked at the site with the committee on an overcast, windy, cold day in January 1891 and said to Burnham, "Do you mean to say that you really expect to open a fair here by '93?" and Burnham replied, "Yes, we intend to."

The speed with which Olmsted and his young partner, Henry Sargent Codman, transformed what was to all intents dead land and untamed water into a system of islands and lagoons and canals and the celerity with which the architects built a vast fairyland of white, frothy palaces seemed a miracle. It was not only instantaneous architecture, built to dazzle briefly and vanish, but instantaneous culture, summoned as the French novelist Paul Bourget said, "with Aladdin-like magic by the shore of this free inland sea."

It is not surprising that the architecture of the fair should have been to the Frenchman's taste, inspired as it was by the École des Beaux-Arts. Hunt had been there as a young man in his twenties, and when he came home to America in the 1850s he brought with him not only the Beaux-Arts doctrine of "classical" design as it was interpreted by the French architectural theoreticians, but the Beaux-Arts method of teaching architecture as well. The first architectural school in America at the Massachusetts Institute of Technology was organized by Hunt's pupil W. R. Ware, on Beaux-Arts principles and procedures. The school was looked upon as of very great importance because it attempted to put order into training for a floundering and disorganized profession. Up to then architecture had depended on what was tantamount to an apprentice system, in which a young man who wanted to become an architect went to work in a builder's or an architect's drafting room. It became the dream of almost every young architect to study at the Beaux-Arts, which looked across the Seine from the Left Bank toward the Louvre, a romantic setting for a romantic attitude to architecture. H. H. Richardson, generally acknowledged to be the presiding genius of American architecture in the 1870s and '80s, went there in his twenties and came home to impress his personal version of Romanesque building on weighty red stone churches

and libraries and railroad stations. Charles McKim followed soon after and became wedded to the fashionable Renaissance style, which he and his partner Stanford White designed with great elegance, as in the Public Library on Boston's Copley Square. Louis Sullivan, one of the Chicago architects of the Columbian Exposition, was at the Beaux-Arts briefly but found it little to his taste. He was not a man to look backward for his inspiration; those who controlled the style of the White City were.

Hunt dominated the architects, who looked on him as the dean of their profession (he was sixty-six in 1892), and his Administration Building presided over the great lagoon. There fountains played their electrically propelled jets around a plaster-garlanded plaster ship rowed by scantily clad maidens and steered by Father Time. An angel stood in the prow holding a trumpet in one hand and a wreath in the other, and on a pedestal Columbia sat enthroned, as erect as any proper Victorian lady but by no means as properly clothed. Swan-prowed gondolas wafted their cargoes of tightly corseted ladies in leg-o-mutton sleeves, with flowered and feathered hats perched forward on their pompadours like birds about to take flight. With them children in middy blouses and straw boaters held on by elastic bands under their chins, and gentlemen in bowlers or top hats and high starched or celluloid collars that chafed their necks wondered at the magnificence that surrounded them. At the far end of the lagoon from Hunt's building, which was outlined at night with electric bulbs (the first world's fair to bedazzle with a display of incandescent lights), rose from the water a gigantic female figure, sixty-five feet tall, swathed in golden raiment and holding aloft a gilded sphere on the top of which an eagle spread its gilded wings. She was called "The Republic" and was the work of a New Englander named Daniel Chester French, who in 1874 had achieved instant fame at the age of twenty-four with his statue of "The Minute Man" in Concord, Massachusetts.

The buildings that faced on the lagoon and the colonnade and peristyle, through which flowed a canal from Lake Michigan, were all in very much the same Beaux-Arts-inspired style. They all had a common cornice level; they were all sheathed in a temporary material called "staff" (a mixture of plaster and straw) and sprayed with white paint, a new process invented for the occasion. The result was a delightfully harmonious unreality. Agriculture displayed its earthy prowess behind classical columns and beneath a shallow dome on which, somewhat incongruously, stood a statue of Diana, goddess of the hunt, which Augustus Saint-Gaudens had designed for the top of the Madison Square Garden in New York. (He was too busy directing the work of other sculptors at the fair, he said, to run

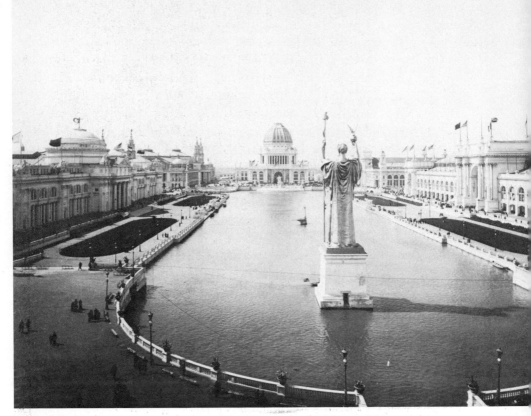

"The White City," as the Chicago Columbian Exposition of 1893 was nicknamed, was Beaux-Arts architecture at its most romantic. Many critics were dubious; the public was enchanted. The sixty-five-foot figure of "The Republic" that towered above the lagoon was called, with characteristic world's fair bravado, "The best colossal effigy ever molded in human form." *(Chicago Historical Society)*

up something special for the occasion.) Across the lagoon the marvels of electricity hummed and whirred and flashed behind elements of classical orders, and the mechanical genius of America flaunted itself in an elegant architectural pastry that would have done credit to the courtiers who had lolled at Versailles.

Only two architects who designed major buildings for the fair departed from the Beaux-Arts mannerisms. Henry Ives Cobb's Fisheries Building was in the Richardsonian Romanesque convention, and Louis Sullivan's Transportation Building was in a style all its own, richly incrusted by Sullivan's seemingly inexhaustible gift for designing ornament. Its "golden doorway," of semicircular arches-within-arches, was one of the sensations of the fair (though there were those who disapproved of the

nonconformity of the building), and, it should be added, it was the only structure of which most modern critics have had a good word to say.

The White City was more than just an architectural confection on a vast scale; it was a cultural banquet. Never before in America had there been such a profusion of sculpture. Buildings were fringed with white figures—single figures, groups of figures in allegories, bears on columns, rampant horses. Hunt chose Karl Bitter of New York to produce twenty-two pieces of colossal size for his building, and with a crew of eight Bitter turned out for the base of the building eight "angelic groups that trumpeted the victory of peace." Another of his groups was called "The Elements Controlled and Uncontrolled." Such personifications, liberally sprinkled about the fairgrounds, were dear to nineteenth-century hearts and here they had their fill. It was a time when public sculpture was meant to be uplifting as well as ornamental.

By no means all the art was outdoors as incrustations on buildings or as complements to lagoons and canals. The Art Palace, which was designed by Charles Atwood, an expert and facile young architect, who took Root's place in Burnham's office (Root died soon after the plans for the fair got under way), was, according to the enthusiastic Saint-Gaudens, "unequalled since the Parthenon." It was one of no fewer than sixty buildings that Atwood designed for the fair. On its 143,852 square feet of wall space in its 188 rooms and alcoves and corridors, were hundreds of sculptures and more than a thousand paintings sent by the governments of the principal countries of Europe, by Japan and Mexico, along with a large selection of works by Americans chosen by the fair's Art Committee. Most of the artists, greatly praised as geniuses by their contemporaries, have long been forgotten. (As a rule, there is no better measure of official taste to be found than books of illustrations of the "masterpieces" exhibited at world's fairs; there is also no more dreary measure. They are like graveyards filled with the elaborate tombs of persons whom time has found unimportant.) In the French exhibit, for example, there were no paintings by Daumier or Degas or Courbet, but there were works by Bonnat and Jules Breton, which were called "triumphs of art." On the other hand among the American works were those of men then very much in fashion whose reputations lapsed and have quite recently been revived—Eastman Johnson, Abbott Thayer, William Merritt Chase. Thayer's "Virgin Enthroned" was called "the best work yet produced by an American artist." The landscapes of George Inness were declared by a critic from the New York *Tribune* to be "rivals of the great landscape work of France on its own ground." He also noted that "three of the nation's fifteen rooms are filled with foreign pictures loaned by foreign collectors," by which he meant American collectors of

foreign works. It was a time, of course, when it was more fashionable to buy pictures by foreign artists than by one's compatriots, just as it was more fashionable to read foreign novels and listen to foreign music and attend imported plays.

The fairgoers could indulge their curiosity about foreign ways and customs, if they had the pertinacity, in dozens of ways. Outside the official center of the fair was an area called "The Midway Plaisance," an adventure in exotica with a slight dash of erotica (namely a belly dancer named "Little Egypt") thrown in. There the ladies could ride on camels in a reproduction of a Cairo street. They could indulge their curiosity in "villages representing life in Austria, Germany, Turkey, China, Morocco, Holland, and other countries," a reporter for *Harper's Weekly* reported, "and those who live in these villages and keep the shops will be natives of these several countries." There was free tea in the Indian village and Turkish coffee at the Turkish village. There was a model of St. Peter's in Rome and a model of a Roman house to inspect. "The primary purpose," the reporter noted of the Midway Plaisance "is not educational, but rather to amuse."

Quite probably the greatest source of amusement and astonishment was a newly man-made object, the Ferris wheel. It was the first seen anywhere, and it was the invention of an engineer named George W. Ferris from no further away than Galesburg, Illinois. This was the moment when the bicycle craze was at its apex and it was remarkable indeed to see a wheel of apparently familiar construction that was 270 feet in diameter, just a few feet less than the length of a football field. It was a long way from the place where one boarded one of the cars to where the highest car hung and swayed. It was looked upon as "undoubtedly one of the most remarkable examples of modern engineering skill" and as more of a wonder even than the Eiffel Tower. The problem of its construction impressed reporters as far more "complicated and extraordinary." On the descent, when one hung out over space, the sensation was as close to flying as any but those who had been aloft in the baskets of balloons had, up to that time, experienced.

One exotic exhibition was to have far more influence on American culture than anyone could have foreseen at the time. It was the Dahomean Village, which is recorded as being "uniquely authentic among the spurious curiosities of the midway." All day long its native West Coast Africans drummed and chanted and danced the rhythms that had been brought to this continent first by slaves and whose magic was as yet not understood outside the black culture. Little Egypt's gyrating hips inspired a dance called the hootchie-kootchie; the Dahomeans were responsible for the

bomboshay. The fair was, moreover, a magnet for musicians from the cribs and sporting houses of New Orleans and St. Louis, and ragtime pianists converged on the Midway and on Chicago's vast red-light district (it "extended from 18th Street to 22nd and from Dearborn all the way to the Illinois Central tracks"). Scott Joplin was one of those who came and so was Otis Saunders. Such were the hordes of people drawn to Chicago for the excitement of the fair that dozens of ragtime "professors" found work. As Rudi Blesh wrote in *They All Played Ragtime*, "All amusements, both licit and illicit, flourished."

The Midway was a cacophonous riot. Corps of "authentic and awful bagpipers caterwauling" competed with German brass bands and Turkish, Egyptian, and Algerian orchestras, "all of the same model and comprising a giant mandolin and a violin played like a cello and drums beaten by hand." To this and the Dahomean drums were added the formal band concerts conducted by the most famous of all band leaders and composers of marches, John Philip Sousa. It must have been happy bedlam.

To many the experience of the fair was invigorating, to others it was overwhelming. To only a few thoughtful observers, who attempted to put it in the context of the American experience and who wondered where this splendor would lead, if anywhere, it was depressing. To the swarms of people the architectural ideas which inspirited it meant nothing; the grandeur meant everything. Hamlin Garland, a Midwestern novelist, wrote some years after the fair of taking his aging mother in a wheelchair to see it. They briefly visited the Midway, with its "polygot amazements," as he called them, and peered at some of the exhibitions in the main buildings. Mrs. Garland's stupefaction, as her son described it, must have been the reaction of many of the twenty-seven million persons who went through the fair's gates. "In pursuance of our plan to watch the lights come on," Garland wrote,

> we ate our supper in one of the big restaurants on the grounds and at eight o'clock entered the Court of Honor. It chanced to be a moonlit night, and as lamps were lit and the waters of the lagoon began to reflect the gleaming walls of the great palaces with their sculptured ornaments, and boats of quaint shape filled with singers came and went beneath the arching bridges, the wonder and the beauty of it all moved these dwellers of the level lands to tears of joy which was almost as poignant as pain. In addition to its grandeur the scene had for them the transitory quality of an autumn sunset, a splendour which they would never see again.
>
> Stunned by the majesty of the vision, my mother sat in her chair, visioning it all yet comprehending little of its meaning. Her life had been spent among homely small things, and these gorgeous scenes dazzled her, over-

whelmed her, letting in upon her in one mighty flood a thousand stupefying suggestions of the art and history and poetry of the world. She was old and she was ill, and her brain ached with the weight of its new conceptions. Her face grew troubled and wistful, and her eyes as big and dark as those of a child.

At last utterly overcome she leaned her head against my arm, closed her eyes and said, "Take me home. I can't stand any more of it."

One of the remarkable qualities of the fair was its unity—a completely planned and magical city with cornices that tied it together above and long vistas that tied it together on the ground. Only Americans who had been to Europe had ever seen anything remotely like it. It was, as one architectural historian described it, "a cross-axial, neo-baroque spatial composition in a pictorially classicizing form." It seemed, to those who relished it, to promise a future of beautiful cities and towns planned with orderliness and rich with visual delights and satisfactions. Burnham was as confident as anyone. "The influence of the Exposition architecture," he said, "will be to inspire a reversion toward the pure idealism of the ancients. . . . The intellectual reflex of the Exposition will be shown in a demand for better architecture, and designers will be obliged to abandon their incoherent originalities and study the ancient masters of building. . . . The people have the vision before them here and words cannot efface it."

Words did not, indeed, efface the superficial message of the fair's architecture for many years. Louis Sullivan, on the other hand, found this "classicism" ridiculous "in a land declaring its fervid democracy, its inventiveness, its resourcefulness, its unique daring, enterprise and progress." He prophesied that "the damage wrought by the World's Fair will last for half a century, if not longer. It has penetrated deep into the constitution of the American mind, effecting there lesions significant of dementia." Henry Adams was of two minds. "Since Noah's Ark," he wrote, "no such Babel of loose and ill-joined, such vague and ill-defined and unrelated thoughts and half thoughts and experimental outcries as the exposition have ever ruffled the surface of the lakes." On the other hand he tried to put Chicago in a mercantile perspective. "Critics had no trouble in criticizing the classicism," he declared, "but all the trading cities had always shown traders' taste, and, to the stern purist of religious faith, no art was thinner than Venetian Gothic. All trader's taste smelt of bric-à-brac; Chicago tried at least to give her taste a look of unity."

The Belgian engineer Vierendeel, who had traveled a long distance to see what Chicago, already famous abroad for its fresh structural accomplishments, had wrought, felt badly let down. "The constructions were only imitations of what we have known in Europe for a long time," he

wrote. "We expected better, much better, from the well known audacity, initiative, and originality of the Americans. We have been deceived. . . . In a new world they dared no innovations. They had doubts of themselves." The Swiss historian and theoretician of technology, Sigfried Giedion, said that the architecture of the fair was a demonstration of America's "national inferiority complex," a Freudian phrase more fashionable at the time he used it in *Space, Time, and Architecture* than it is today. "It was to France," he wrote, "that the builders of the Fair turned in their search for beauty. Its beauties were taken out of the preserve jar of the Académie des Beaux-Arts when they had been laid up during what was certainly its worst period." He called the style "mercantile classicism." Henry Adams would have nodded his approval.

The Reign of the Eclectic Architects

The fact was that essentially no architect in America had any training but that which was first- or secondhand French. Either he had been to the Beaux-Arts in Paris to work his way through some, if not all, of its rigorous curriculum; or he had been to an architectural school in America (there were very few of them), where the methods of teaching as well as aesthetic theories were adopted from the Beaux-Arts; failing that, he had worked in an office as an apprentice to architects imbued with the École's traditions. Any young architect who could find a way to get to the Beaux-Arts grasped it. Architectural schools encouraged (indeed demanded) that their students compete for the Prix de Paris, which provided a scholarship and stipend to the École for those who won it, and any student looking about him could see that the way to make a living and a reputation was to employ Beaux-Arts mannerisms whatever the practical demands of the project might be.

The teaching and influence of the Beaux-Arts, sometimes remotely and crudely applied, were nearly everywhere visible in America at the turn of the century, and still are. They provided the ornamental envelopes and plans of all manner of buildings, from the great public libraries of Boston (McKim, Mead, & White) and New York (Carrère & Hastings) to the columned and pedimented county courthouses of Texas. Many bankers still go about their business behind Beaux-Arts façades, the rich lie buried in Beaux-Arts mausoleums, legislators caucus in Beaux-Arts office buildings in Washington, and art lovers climb the marble stairs of Beaux-Arts museums from Baltimore to Seattle. In America from the 1860s to the 1930s the Beaux-Arts traditions dominated public building and some domestic building, just as they did in Paris. So-called "modern" architecture

was not widely promoted here until the 1930s. Then the influence of the German Bauhaus, a school of design first in Weimar (1919–25) and later in Dessau (1925–32) made itself felt, largely through the missionary zeal of the Museum of Modern Art in New York, which spread its gospel far and wide.

The seeds of dissent were sowed many years before that, some of them on paper and some in the design and construction of buildings. The paper dissent made its appearance in the pages of *The Architectural Record* in November 1907 with an attack on "the strongest influence [on architecture] now operating in the United States . . . the modern French school." The structural dissent was evident in the buildings of Louis Sullivan and his protégé Frank Lloyd Wright and in the work of Greene & Greene in California, Bernard Maybeck, also on the West Coast, principally in San Francisco, and a number of lesser-known but generously talented men outside the influence of Eastern Seaboard conventionalism.

The paper dissent was essentially ineffective because it did not get to the root of the matter, which was less stylistic than technical. The dissenters' quarrel was with externals, with mannerisms. They distrusted foreign affectations and resented "the French method of thought," which was regarded as an emphasis on the artistic solution of a problem rather than on a practical answer to the client's needs and desires. It did not seem to be concerned with whether architecture reflected the technical demands of construction; that is, it was not concerned with architecture that revealed and made a virtue of the mechanical means by which it was constructed. That came later.

The argument developed more heat than light. The attacks on the Beaux-Arts were at least partially chauvinistic. One critic professed that he had no objection to "the French system of training *when applied to Frenchmen themselves*" (his italics), but that it did "not apply to our modern requirements." Another took exception to the French method because "it is primarily the artistic considerations that are emphasized" not the "practical" demands of problems, though he regretted that "the atmosphere of American city life is not artistic" and that "utility and cost are dominant considerations in nearly all public enterprises." "The whole pressure of our feverish material activity," he wrote, "tends to crush out the vital sparks of imagination [which the Beaux-Arts fostered] and to relegate beauty to the lowest place among the factors of design." What happened to the returning Beaux-Arts student, he said, was that he tried to apply the externals of ornament, "bewitched by the artistic jargon and cant of the ateliers into glorifying the superficial . . . and forgetting the eternal and fundamental principles which give whatever is valuable to their

foreign training." In other words, it was not what was taught or how that was wrong, but how it was applied.

On the other hand Paul Cret, a distinguished French import to Philadelphia, wrote in defense of the Beaux-Arts in America: "The simple fact that it has been brought in without a single protest from the general public . . . is proof enough that the general public could not get along without it." The fact was that the American public cared so little about architecture as an art that it would not have protested any style so long as it looked expensive and seemed to possess a quality of grandeur that they expected of public buildings. On surfaces of functional buildings which satisfied their pragmatism and the strictures of cost they liked to add an artistic frosting, often very clumsily applied, though they could and frequently did "get along without it." Indeed the only time that the public vigorously raised its voice about architecture in anything that might be called a chorus was when the "functionalists" in the 1930s began to strip buildings of their cornices and cartouches and columns, which the Beaux Arts had helped the public believe were what made the difference between mere building and architecture.

"At first glance," an architectural historian wrote in the 1960s, "the period from 1900 to 1930 [in America] appears to be an esthetic wasteland: and a closer scrutiny of the individual buildings of the period does little to correct that first impression." During that period Americans were little interested in the aesthetics of architecture and greatly concerned with "good taste," a situation that was surely not new to American culture. They were interested in surfaces not structure, in what was correct not what was aesthetically inventive. It was the era in which skyscrapers grew taller and taller to the delight of the people, no matter that they were made into architecture by the superimposition of architectural frosting. No matter that the Chicago Tribune Tower was "gothic" in its ornamental features or that the Woolworth Building, for some years one of the wonders of the world and the world's tallest building, had an almost dainty elegance about it that after 1933 was looked upon by many critics with scorn as being "dishonest."

The simple fact, repeated again and again in our cultural history, is that by and large Americans do not give a hoot about architecture but take structural prowess and display to their hearts—a matter that I believe to be true by and large of any society on whatever scale. Architecture is, and has always been, built by the rich to impress each other, primarily, and to awe their financial and social inferiors with their power and wealth, whether the rich are churches or governments, prelates or princes or

tycoons. It is interesting, possibly even significant, that Mark Sullivan in *Our Times*, his six-volume history of the American people from 1900 to 1925, mentions only one architect—Cass Gilbert, the designer of the Woolworth Building. Sullivan wrote: "In this field [architecture] the one greatest achievement was a building called the Woolworth Tower, erected with profits from the sale of five and ten cent articles, and devoted to the housing of lawyers and business offices—a cathedral of trade." To Mark Sullivan it was the symbol of America's contribution to the art and technology of architecture, and Gilbert was "a pioneer in whom imagination was combined with fine restraint, [who] had more to do than any other person with overcoming the fixed conviction of architects and critics that buildings devoted to business, especially skyscrapers, could not be made beautiful." To the critic who found the first three decades of this century a "wasteland," the Woolworth Tower was merely one, with the Chicago Tribune Tower, of those "buildings . . . so colorless and without significance, so manifestly sterile, as to leave one nonplussed."

The architecture of business that Giedion called "mercantile classicism," like the "collegiate gothic" of education and the "girder gothic" of religion and most of the houses and apartment buildings people lived in, continued well past the 1930s to reflect the pervasive influence of the Beaux-Arts. To win the Prix de Paris was the ambition of almost every architectural student in the country. Only one a year was chosen, and the jury that selected the winner was appointed by the Beaux-Arts Institute of Design in New York, an organization of former Beaux-Arts students. There was another prize, established in 1894, that was very nearly the Beaux-Arts' rival, the Prix de Rome, awarded to architects by the American Academy in Rome. The academy was a modest establishment to start with, conceived by McKim of McKim, Mead & White and initially financed by him and his friend Daniel Burnham. They each put down $3,000. McKim did not want the academy to be thought of as a protégé of Eastern Seaboard architects but as a nationally supported institution whose prize fellowship was open to young Americans wherever they might hail from. McKim persuaded J. P. Morgan, the financier who dominated banking in America and who was a collector of commanding acquisitiveness and unusually sound judgment, to sponsor the young academy. He did so originally to the tune of $100,000 (more was to come), and other financiers joined him, so that in time the academy occupied a splendid complex of buildings on the Janiculum hill overlooking Rome. It joined forces with the American School of Classical Studies (also a Morgan protégé), and ever since it has been a coveted haven for young architects, painters, sculptors, composers, writers, art historians, and classicists.

Thus European standards (which were essentially nineteenth-century standards) continued to provide the models on which American architects, with a few notable exceptions, based their designs. They persisted in these traditions, often turning them into mere mannerisms, long after the roots of "modern" architecture had been firmly planted in Chicago in the 1880s. The young American architects of the first years of this century looked with respect verging on awe at the creations of McKim, Mead & White, at the palace built in the Renaissance manner by the railroad magnate Henry Villard (five large houses in one for himself and four of his friends), at J. P. Morgan's marble library, a dozen blocks farther down Madison Avenue, at the Boston Public Library and the Pennsylvania Station in New York.* They respected the work of Carrère & Hastings, whose major monument is the New York Public Library, and whose mansion for Henry Clay Frick (he was a colleague of Andrew Carnegie's in the steel business), built in 1914, has long been a museum of such high quality and dignity that it makes the competitive spirit of most municipal museums these days seem frantic. This was "gentlemen's architecture" built for "gentlemen." The tradition was continued, indeed reached its utmost refinement, at the hands of Charles A. Platt (who is said to have told a client that he would build him a house if he could have a million dollars for the house and another million for the garden; Platt had started his career as a landscape architect), Bertram Goodhue, and the firm of Delano & Aldrich. Their style is referred to with reason as "eclectic" and their houses are of undeniable elegance. They were capable of designing in any style a client might like and performed with restraint and delight in detail. Their houses were the epitome of "good taste" in the era of "suitability." One of these elegant designers, Albert Kahn of Detroit, had another, stronger string to his bow. He not only designed "suitable" houses for automobile tycoons, he also designed factories that were as "modern" as glass and steel could make them and as handsome, long before the influence of the Bauhaus hit America. In 1938 Kahn, who said that "architecture is 90 percent business and 10 percent art," was "responsible for 18 percent of all architect designed buildings in the United States."

The eclectics were not, to be sure, unaware of the fact that the art of architecture was undergoing a basic structural revolution, though they saw nothing "dishonest" about covering structure with a suitable envelope of style (one might say "stylishness"), if that was what the problem seemed to suggest as logical and their clients were pleased. Goodhue, who

*All of these buildings with the exception of the Pennsylvania Station are, as of this writing, still standing.

was regarded as a master builder and an intellectual by his contemporaries, wrote to his friend and fellow architect Paul Cret, a Beaux-Arts-trained Frenchman, who practiced mainly in Philadelphia in the 1920s and '30s.

> As for theories—and professionally—I hold that while architecture should represent a decent reverence for the historic past of the art, that we should only ignore our rightful heritage for the most compelling reasons, and that one of these compelling reasons is the modern invention of the steel frame, or reinforced concrete, construction. That this form of construction does abrogate practically all known forms—at least definite construction forms such as columns or arches, it is not enough that a building should be beautiful, it must also be logical. Fortunately most of my buildings are honestly built.

Sullivan, Wright, and the Dawn of a New Order

While the architecture of these eclectics is again finding favor with architectural historians and critics (it never lost favor with the larger public) and evoking the loving attention of the conservationists of "landmark buildings," the most solid reputations belong to other men who were their contemporaries. Louis Sullivan, the philosopher-architect who is credited with the phrase "form follows function," which became a three-word architectural creed, continued to practice well into this century.* By the time of the Chicago fair Sullivan was well established. He was in his mid-thirties and the partner of Dankmar Adler, a man twelve years his senior. He had studied briefly at the École des Beaux-Arts in Paris but found it not at all to his taste. "Its perfect flowers of technique," he wrote in his third-person autobiography, "lacked the profound animus of primal inspiration." After a brief stint with the Philadelphia firm of Furness & Hewitt, he had lit out for Chicago, where, he wrote, "in spite of the panic [of 1873] there was stir: an energy that made him tingle to be in the game." Adler recognized him as a young man of extraordinary gifts and took him on as a partner at the age of twenty-four.

Sullivan's reputation was secured by the Auditorium, which had delighted Chicagoans with its ornament and the elegance of its elliptical arches, its murals, its decorative metal screens, its mosaics and polychromed pargeting. He believed that there must be an American style, but

*Functional design without furbelows was not new to the philosophy of American structure. Horatio Greenough, a more formidable writer and theorist than sculptor, had discussed it with great precision and perception in a collection of essays entitled *Travels of a Yankee Stonecutter,* which was published in 1852. He wrote: "If there be any principles of structure more plainly indicated in the works of the Creator than of all others, it is the unflinching adaptation of forms to function."

that it could not be defined by examining the bits and pieces of influences from abroad that had shaped so much American building. "I do not believe the origin of style is outside, but within ourselves, and the man who has not the impulse within him will not have the style." He believed, moreover, in a democratic architecture and that "the so-called average mind has vastly greater powers and immeasurably greater possibilities of development than is generally believed." His clients, however, were not the "average man" of whom so much is made by Mark Sullivan in *Our Times,* but the rich and powerful—bankers, businessmen with enough self-assurance and adventurousness to be willing to depart from the eclectic stereotypes in which business saw itself suitably clothed. If the Otis elevator and Bessemer steel were the agents of democratic building, Sullivan knew how to use them without concealment, but his was a style that was exceedingly personal. It was surely not the product of "the so-called average mind." His functional design was anything but puritanical or self-effacing or ascetic. He delighted in ornament, for which he had a special genius, and used it to embellish the surfaces of his skyscrapers; the designs in terra cotta in some cases covered them like strips of brocade. When, in 1890–91 in St. Louis, Sullivan built the Wainwright Building, a structure that emphasizes the verticals, his disciple, Frank Lloyd Wright called it, "a new thing under the sun . . . a building born tall."

Sullivan's success continued only as long as his partnership with Adler, a far less original and distinguished designer but a practical, tolerant, and protective friend. It was the depression of the 1890s that dissolved the partnership (Adler took a job as head of the sales staff of the Crane Plumbing Company), and Sullivan's fortunes and his faith in his fellow man dwindled if his talents did not. He built some of his best buildings after that, the Bayard-Condict Building (1897–99), a New York skyscraper topped with terra-cotta angels supporting a terra-cotta cornice on their wings; the store for Carson Pirie Scott and Company (1904) in Chicago, in which the horizontals are emphasized with the use of wide areas of glass, which became known as "Chicago windows"; a bank that was a far cry from the suitable be-columned edifice that was usual in that time in Owatonna, Minnesota (1908). He found clients as adventurous as himself, but there were not enough of them to keep him going. He finally came to conclude that "American architecture is composed, in the hundred, of 90 parts aberration, eight parts indifference, one part poverty and one part Little Lord Fauntleroy. You can have the prescription filled at any architectural department store, or select architectural millinery establishment."

Sullivan's architectural heir was Frank Lloyd Wright, the only archi-

The Wainwright Building that Louis Sullivan designed for St. Louis (1890–91)
evoked from Frank Lloyd Wright, his protégé, "a new thing under the sun
. . . a building born tall." Sullivan preached the doctrine "form follows
function" years before the "functionalists" adopted it as their own.

tect besides Thomas Jefferson to have had his face printed on a U.S. postage stamp.* Wright, who was born in Richland Center, Wisconsin, in 1869, believed, as he put it, that "the real American spirit capable of judging an issue for itself upon its merits, lies in the West and in the Middle West, where breadth of view, independent thought and a tendency to take common sense into the realm of art, as in life, are more characteristic." He deplored the manner in which Burnham had caved in to the fashionables of the Eastern Seaboard in planning for the Chicago fair of 1893, and he felt that if Burnham's partner, John Wellborn Root, had lived he would have agreed with Sullivan that the way to the future was not the route of the fair's frothy eclecticism.

Wright went to work in Sullivan's office in Chicago at the age of twenty and by the age of twenty-two he had designed a house for an Adler and Sullivan client. When he was twenty-five, in 1893, he opened his own office and started on a career as America's most independent and inventive practitioner of architecture, one of the most arrogant in a profession not notable for modesty. ("I had to choose between honest arrogance and hypocritical humility," he wrote. "I chose arrogance, and have seen no reason to change.") He was also the architect during the long span of his active life—and he was never inactive—with the greatest number of virulent critics and the most dedicated admirers. No Wright building appears to be quite like any other Wright building and least of all like anyone else's building, but the signature of his genius is on them and even the most casual dilettante of architecture can spot a Wright at once.

That is not to say that he did not have his imitators and devoted followers, but whereas they are inclined to be timid Wright was always bold. He was the prophet of what he called "organic" design, in which the building grew from the inside out, from the function of its internal spaces to its external statement. He believed that spaces should flow into other spaces, as they do in nature, and the "open plan," now an entirely accepted concept in the design of houses, found its prototype in Wright's design for what he called "the Prairie House." He decried any building whose external statement was that of a decorated box (as he believed Renaissance buildings to be) and hence the products of the Beaux-Arts. No one was more sure that a structure should appear to grow from its site—that is, spring from the earth and yet belong to it—and no one was more successful

*It was printed against what was, when it was built in the 1950s, his most controversial building, the Solomon R. Guggenheim Museum in New York. The fact that any architect who was not a statesman should be thus commemorated said something about the need for cultural heroes in the 1970s and, of course, something about the influence of lobbyists and philatelists on the cultural conscience of the postal department.

in achieving this marriage of place and structure.

Wright's career was an extremely long one. After more than seventy years of practice he died at the age of ninety in 1959, with buildings on his drawing board and still other buildings in the process of construction. The Guggenheim Museum was such a building, and its director, James Johnson Sweeney, had a frantic struggle to make the snail-like construction of its central gallery accommodate itself to the exhibition of paintings. Essentially Wright wanted nothing to interfere with the interior forms or surfaces of his buildings, whether they were paintings or books or, indeed, persons. The textures of the materials he used were of primary importance to him in achieving the surface effects he wanted, and he was furious if anyone who inhabited one of his houses took the liberty of altering or painting it. During his long career he designed houses for many clients dedicated enough to submit themselves to his genius and faithful enough to abide by it. ("People will come to you and tell you what they want," he wrote, "and you will have to give them what they need.")

The Prairie Houses were by no means always near a prairie; indeed the most famous of them, the Robie House, sits in a stately manner near the University of Chicago, and there are five Wright houses in and near Buffalo, New York, their long, low construction, strips of windows, and wide eaves standing like beacons among suburban houses that Wright called "Queen Anne in front and Mary Anne behind." They differ radically, as their situations do, from Fallingwater, built in 1936 over a waterfall in Bear Run, Pennsylvania, for the Pittsburgh department-store magnate Edgar Kaufmann. Kaufmann's son, Edgar, Jr., was a Wright disciple as a young man and became a distinguished architectural historian and critic. It was he who persuaded his father to commission Wright, and the two men, much of an age and firmness of character, worked amiably together to produce one of the most famous American houses of the twentieth century and, in my opinion, not only one of the most original but the most beautiful. He built research centers and stores, factories and office buildings, colleges and museums, and to each he gave the stamp of his individuality and his genius, which, one cannot help but think, was as much sculptural as architectural. His successors, who have tried to carry on in his own workshops under the imperious eye of his widow in Taliesin West, his establishment in Arizona, though they try to maintain his methods of teaching in a cultish manner (one is tempted to say "The Wright cult for the wrong reasons"), produce buildings which turn the magic of a master builder into clichés and mannerisms.

At the same time that Wright was making his reputation in Chicago, three young architects, Bernard Maybeck and the brothers Charles S. and

The Ward Willitts' House in Oak Park, a Chicago suburb, is known as the earliest of Frank Lloyd Wright's Prairie Houses. It was built in 1902. There are twenty-eight early Wright houses in Oak Park and its neighbor River Forest.

Henry M. Greene, were establishing themselves in California. Maybeck made his mark (and an impressive mark it still is) in San Francisco, where he built houses, churches, university buildings, and a temple to art, while the Greene Brothers, as they are commonly called, made their mark in Pasadena, most notably with houses for the rich. All three of them were trained at the Beaux-Arts in Paris; all three broke sharply with that polite tradition to adapt to the climate and mood and materials (largely wood) of California. Maybeck, who had worked for Carrère & Hastings as a young man, skipped over the Renaissance back to Romanesque and Gothic boldness and adapted them to a style that was individual, grand, and eccentric. He used redwood and rough stone, gothic tracery and wrought iron to make an architecture that was uniquely his own, though his most

famous structure, the Palace of Fine Arts, set in a lagoon for the Panama-Pacific Exposition of 1915, is essentially Beaux-Arts in inspiration. Maybeck was surprised when he was told in the 1930s that he was a "modern," surprised and, I dare say, amused. He was very much his own man, a romantic at heart.

The Greene Brothers, when they were setting out in the 1890s, worked in the "shingle style," after the manner of H. H. Richardson, whom they learned to admire when they were students at the Massachusetts Institute of Technology. Unlike Wright, who did not like to admit the influence of any other architecture on his own, they were openly and frankly affected by the Japanese uses of wood, as Wright was, in ingenious and respectful ways. Like Wright they believed in suiting their architecture to the land of which it became a part, not a contradiction to it or an excrescence on it as, for example, the palaces of Newport were. Their most original and successful houses were built like Wright's for adventurous clients who cared more about comfort and flowing space than about the conventional accouterments and ornaments that men such as Charles Platt and Bertram Goodhue provided their clients. The ways in which the interiors of their houses incorporated and became part of the outdoors, as Maybeck's also did, the ways living rooms flowed into gardens and pergolas to become outdoor interiors foreshadowed, as nothing had before, a popular style for building and for living in more or less seasonless climates like those of southern California.

The Greene and Greene houses were the progenitors of the American bungalow much as Wright's Prairie Houses can be said to have sired the ubiquitous ranch house. The bungalow, employing many of the Greene Brothers' characteristic uses of boulders and shallow roofs supported by large timbers that extended under the eaves, spread like forest fires from California all across the continent. Its principal prophet and promoter was not a Californian but a Chicagoan named Henry L. Wilson, who called himself "The Bungalow Man" and who published a slim book of photographs and plans with the title *The Bungalow Book, a Short Sketch of the Evolution of the Bungalow from Its Primitive Crudeness to Its Present State of Artistic Beauty and Cozy Convenience, Illustrated with Drawings of Exteriors, Floor Plans, Interiors and Cozy Corners of Bungalows Which Have Been Built from Original Designs.* It was in such houses that Mark Sullivan's "so-called average man" found his comfort and solace and in which, if he considered himself sophisticated, he would have applied the tenets of Gustave Stickley, the editor of *The Craftsman.* In the 1890s it was an influential magazine that promoted the virtues of handcrafts, the four-square virtues of Mission furniture, and the philosophy of William Morris,

the English leader of a revolt against the machine-made taste of Queen Victoria's era. The fashion for Mission lasted only into the first decade of this century, but with the energetic rebirth of the crafts movement, as it is called, in the 1960s and the redeification of Morris and his tradition, the American predilection for reviving sometimes better-forgotten styles has exercised its whims, and Mission has its enthusiasts and collectors again.

CHAPTER *4*

What's in the Ash Can?

The epithet "genteel tradition" was deposited in the language in 1931 by the Harvard philosopher-novelist George Santayana, who coined it in a small book of lectures which he called *The Genteel Tradition at Bay.* The literary historian Van Wyck Brooks found it a "reverberant name"; it continues to reverberate to this day.

The year 1931 was a time when the genteel tradition, which blossomed in the Victorian era and continued to flower pleasantly in the early years of this century, had for some time been a laughing matter to the rebellious young concerned with the arts and letters. The unmannerly 1920s had come and gone, and their frivolity had bogged down in the fearsome beginnings of the Great Depression of the 1930s. It was a time of artistic as well as social reappraisal, and the connotations of the genteel world were stuffy. It smelled of lavender and potpourri; it was inspirited by smelling salts, comforted with tea, and fed with paper-thin sandwiches. It was tightly corseted and gently cosseted, amply served by maids in black or maroon dresses with lace-bordered aprons and starched lace caps, and it wore veils and carried parasols to protect itself from the damaging rays of the sun. It was a time of elaborate social rituals—when ladies wore their gloves and carried their fans to the dining-room table, when the mystique of calling cards and a knowledge of their proper use for each occasion was as important as knowing which fork to use with the fish mousse.

In the genteel world the ultimate measure of manners, fashions, music, education, architecture, decoration, and art was *suitability*—suitability to the time, the place, the circumstance—suitability to status, to season, to income, to city, to country, to the time of day. Elsie De Wolfe, the first professional woman decorator (or so she claimed), wrote in her book *The House in Good Taste* in 1913, "My business is to preach to you the beauty of suitability. Suitability! SUITABILITY! SUITABILITY!!" Miss

De Wolfe (who was not in fact always as genteel as she might have been; in her later years, after she became Lady Mendl and was living in Hollywood, she liked to stand on her head at parties) was launched on her career by no less redoubtable an architect than Stanford White, at the time when he designed the Colony Club (its first, not its present, building) in New York. Miss De Wolfe's predecessor as an authority on the decoration of houses, the novelist Edith Wharton (her first book was with the architect Ogden Codman, Jr.), had taken very much the same line. She also believed that if those who were rich, or merely well-off, would demonstrate "good taste," the lower classes would follow their example. What was suitable to the rich, in other words, was suitable to the poor on a more modest scale —a dictum followed at the turn of the century by the house-plan books and household magazines with their little palaces for all pocketbooks.

By and large the arts of the genteel tradition—its paintings, architecture, sculpture, novels, poetry, and music—can be described as eminently suitable to a society that set great store by proper manners, by formalities, traditions, conventions, and social fastidiousness, and that, moreover, always kept one eye on Europe as the source of good taste, and most particularly on England for good manners. This is an art of approval, not of revolt, of acceptance not of inquiry, of self-satisfaction not of search. Its values are face values (though often the faces are subtle), its substance is charm, its adventures are games. Nothing was further from its intention than to shock. It did not look into dark corners or under well-swept Oriental rugs. In its public buildings—its libraries, railroad stations, museums, and courthouses—it sought to provoke awe for its scale, its grandeur, and its refinement of detail, but in its painting it meant to arouse no emotion more profound than poetic sentiment, often overlaid with a comfortable idealism, especially in its murals for public edifices. The artists of the genteel tradition had no intention of putting any tacks on the seats of a well-upholstered society; they merely wished to make its members lift their eyes to heaven or at least to the slopes of Parnassus. In so doing they strove to convert what Thorstein Veblen called the "conspicuous consumption" of the American leisure class into an American renaissance, and so to direct the ostentation of self-made millionaires, who imported cultural artifacts from Europe by the shipload, to the European-inspired art made at home.

The genteel turned their backs on the vigorous and searching arts made in America. It was they who excluded Thomas Eakins's remarkable painting of "The Gross Clinic" from the art exhibition of the Centennial world's fair in Philadelphia and relegated it to the medical displays because it was too tough for polite sensibilities. There was blood on the great

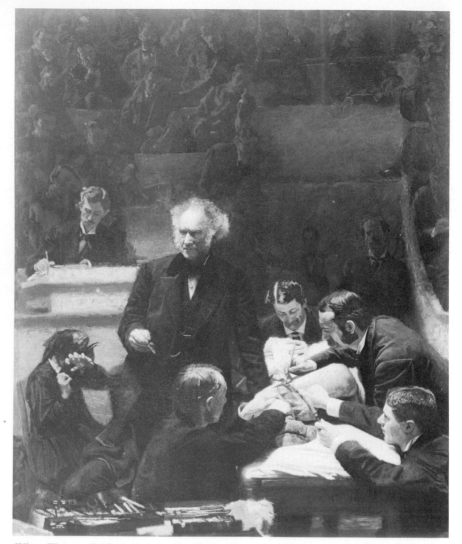

When Thomas Eakins painted "The Gross Clinic" in 1875, he may well have had Rembrandt's "The Anatomy Lesson" in mind. The Philadelphia physicians who commissioned the painting were moved; the polite public was profoundly shocked by its bloody realism. *(Courtesy of the Jefferson Medical College of Philadelphia)*

surgeon's fingers, and a woman in the painting shrank in terror from the sight of the operation which she was required, as a relation of the charity patient, to witness. The works of George Caleb Bingham, who painted the bargemen on the Mississippi and back-country political rallies, were considered so lowbrow that they were consigned to oblivion for nearly seventy-five years. Samuel Isham in his *History of American Painting* published in

1905 did not deign to mention him. He was too robust for a generation that failed to recognize the poetry of his vision, and saw only that he was dealing with people who were then spoken of disparagingly in polite company as "common."

In some respects the Columbian Exposition was the epitome of the genteel tradition, with its froth of architectural fantasies, its lagoons and swan boats and gondolas, its "ideal" sculptures by Daniel Chester French and Frederick MacMonnies and Lorado Taft. In the Horticulture Building Taft's two pieces called "Sleep of Flowers" and "Awakening of Flowers" seemed close to the minor works of the composer Edward MacDowell, also a master of the genteel tradition, "To a Water Lily" and "To a Wild Rose." Charm was the aim, and charm was achieved.

Even in a society as mobile as ours and one which has been as adaptable to changes in styles of domestic life, a tradition of manners and tastefulness, to use a genteel word, dies slowly. The procession of country folk to the cities started in the nineteenth century and gathered converts at a rapid rate in the early twentieth. As the cities spilled over into the suburbs and filled up with middle-class families escaping the pressures created in part by the influx of immigrants, the suburbs became clusters of imitation English manor houses and little chateaus and replicas of colonial dwellings of a most genteel sort. Servants, so essential to the genteel life, became fewer, to be sure, but their places were taken in some degree by mechanical contraptions. The concept of "gracious living" persisted, as the mass-circulation magazines for women and homemakers still attest. Dozens of their color pages are filled with "traditional" furniture of European origin and with "Early American." Gilt-framed mirrors and flower prints ornament the walls and cut-glass decanters whose silver labels hang on little chains about their necks, totems of a genteel concern, take the place of the once ubiquitous silver tea service. The fashion for Victorian "antiques" and turn-of-the-century Art Nouveau and the conservation movement, which seeks to save all manner of buildings that until quite recently were considered abominations of nineteenth-century taste, speak for genteel nostalgia. These objects and buildings look today like monuments of an age of individuality, a time before persons became people and people became numbered beings, before consumers were computerized— wooed but not loved, seduced but not satisfied, flattered but not complimented, cosseted but not comforted.

In painting, if less so in architecture and sculpture, the genteel tradition was reduced to a trickle (the young thought it treacle) by the turn of the century. The two most famous American painters of the genteel tradition, James McNeill Whistler and John Singer Sargent, both lived in

England. Whistler, who had flunked out of West Point in his third year because he refused to learn chemistry, left for Europe when he was twenty-one in 1855 and never came back. Sargent, on the other hand, was born in Florence, Italy, of American parents, and in his mature years came frequently to America, not only to paint portraits of fashionable persons, for which he was best known, but also to execute the elaborate series of somewhat mystical murals for the Boston Public Library. These men were the antithesis of the American tradition of genre painting which had occupied such talented artists as William Sidney Mount, Bingham, and East-man Johnson, who depicted men and women going about their daily business and relaxing from their work. Work, it appears, was not fashiona-ble as a subject in the genteel era; relaxation was. Paintings of ladies at tea or visiting galleries or yachting abounded along with gentlemen coaching or sailing or shooting. Ladies in flowing dresses with hats perched on their pompadours, seated in flowering meadows or on beaches under parasols, were popular, as were cityscapes when they were as agreeably painted as those of Childe Hassam in the Impressionist manner. These paintings by academicians (for all of the ablest of them were associates or members of

Thomas W. Dewing, a New England artist, painted this delicate scene, which he called "The Recitation," in 1891. It epitomizes the genteel tradition as it was expressed in paint. *(Detroit Museum of Art Purchase, Picture Fund)*

the National Academy of Design) were expertly contrived and often filled with light and charm. Many of the artists who created them, men famous at the turn of the century, such as William Merritt Chase, Kenyon Cox, Thomas W. Dewing, Edmund C. Tarbell, and Childe Hassam lived and worked well into this century, long after their reputations had dimmed

The elegant William Merritt Chase was a wizard with the brush and with his numerous clients, many of whom visited him in his studio, of which this is a depiction. "Tenth Street Studio" was painted in the 1880s at the peak of his career. *(Museum of Art, Carnegie Institute, Pittsburgh)*

to near obscurity.* However, as so frequently happens after the passage of sufficient time (and as the world moves faster the time grows shorter), they became fashionable again in the 1970s. Young collectors began to buy them and curators exhumed them from museum storerooms, looked at them with fresh eyes, and rehung the best of them in their galleries,

*William Merritt Chase, 1849–1916; Kenyon Cox, 1856–1919; Thomas W. Dewing, 1851–1938; Edmund C. Tarbell, 1862–1938; Childe Hassam, 1859–1935. Whistler died in 1903 at the age of sixty-nine; John Singer Sargent died in 1925 at the same age.

an aspect of the whims of taste that can be called "the revival of the fittest."

Gentility Defied—the Ash Can School

As the tradition of the ideal and the genteel in the arts was abating, a group of young artists, who came to be known as "The Ash Can School," were, whether they knew it or not, getting back to the older tradition of painting the life of the common man—not just the farmers and woodsmen and back-country men and women who interested Mount and Bingham and Johnson, but the man, woman, and child of the city streets, their sidewalks, stoops, alleys, parks, and saloons.

The genteel world was an upper-middle-class and upper-class world, a world to which William Dean Howells's Silas Lapham, who made a quick fortune in paint, aspired and in which the wife of Sinclair Lewis's Babbitt about forty years later felt secure. It was a world of social climbing and at least surface respectability. The world of the Ash Can School (no one seems to know who coined the name) was the world of what Mark Sullivan in *Our Times,* his six-volume history of the first quarter of this century, called "the average man." These painters were not engaged in social protest or reform movements, to which the muckrakers of the day devoted themselves, or in mocking (if one can mock with a sledgehammer) the moral order as Theodore Dreiser did in *Sister Carrie* (1900). They enjoyed watching the vitality of the life around them, and most particularly city life. They were urbanites. "It seems that the basis of future American art," said the painter Robert Henri, "lies in our artists' appreciation of the value of human quality all about them, which is nothing more or less than seeing the truth, and then expressing it according to their individual understanding of it."

The human qualities on which their eyes dwelt and the surroundings in which they saw them were not at all what those who admired the polite products of the academicians thought of as suitable subjects for art— children playing on dirty sidewalks, laundry lines strung from the backs of tenements, derelicts sleeping under bridges, or draymen going about their business with their carts and teams. What they saw was not sordid, neither was it picturesque; it was alive with human energy. The vaudeville house was as important as the Sixth Avenue El and its drowsing passengers at midnight. Everett Shinn, one of the younger and saucier members of the group, writing many years later, described official taste as "swaddled in accessories, fenced in with tasseled ropes and weighted down with chatelaines of bronze name plates." Academic painting, he said, was "effete,

delicate and supinely refined, lockstepped in monotonous parade in a deadly unbroken circle, each canvas scratching the back of the one in its lead."

The "revolution" which the "rebels" of the Ash Can School precipitated looks from the distance of three-quarters of a century to be scarcely more than a corner demonstration, with no special consequences and interesting at the time only to a few critics and a handful of collectors. If it upset any sacred applecarts, the fruits were hardly bruised, and yet the spirit of rebellion was a useful one. By its impudence (as the academicians would have it), by its challenge to what it regarded as bourgeois tastes, it helped to clear the air for ruder shocks to the public sensibilities and a more adventurous and less conventional attitude among American artists and their patrons.

The acknowledged leader of the group of rebels (they did not coin a name for themselves any more than the Impressionists did; they had an epithet pinned on them by unfriendly critics) was Robert Henri. He did not consider himself a rebel either artistically or socially, though he came to deplore what he regarded as the tight, self-serving academic circles. He was interested in getting back to first principles, in painting what he saw, and he saw it as the masters he most admired saw it. His career as a painter started when he entered the Pennsylvania Academy of the Fine Arts at the age of twenty-three, or so it is assumed. It was not until Van Wyck Brooks wrote the biography of Henri's friend and follower John Sloan that the story of Henri's childhood and youth became known. In fact, there was no one named Robert Henri until 1883, though he was born in 1865. His father was a Mississippi River gambler and real-estate developer named John Jackson Cozad, who got involved in a quarrel with a cattleman in a town called Cozaddale, which he had started in Nebraska from scratch. The cattleman pulled a knife on Cozad, who replied with a gun, and Cozad fled town to avoid being lynched. The cattleman died of his wound several months later and Cozad was accused of murder (the charge was later withdrawn). He changed his name and settled with his family finally in Atlantic City with the name Richard H. Lee. He called one of his sons (whose name had been John) Frank L. Southern and the other, who had been Robert Henry Cozad, Robert Henri. ("His new name was pronounced Hen-rye, like buck-eye, and he never let you forget it.") When his brother John went to Philadelphia to enroll in the Jefferson Medical College, Robert went to the academy to turn what had been a hobby into a profession. As a child he had filled the margins of his school books with drawings and had done sketches with colored crayons and pencils to illustrate stories of his own devising. A

friend of the family in Atlantic City, who had studied at the Pennsylvania Academy, thought well enough of his work to recommend that he be properly trained, and he found himself in the foremost art school of that day in America.

The genius of Thomas Eakins hovered over the academy, one might almost say the scent of his being permeated its atmosphere, though he was no longer there. He had been its guiding spirit, its most searching and demanding teacher, and its director for a number of years until he had a falling-out with its board. His insistence on studies from the nude were offensive to late nineteenth-century sensibilities, and not just those of the board and the parents of students but of many of the students themselves. The issue became more important than the practice, and since Eakins was a man of principle to the point of pigheadedness, as seems to be generally agreed by his biographers, he withdrew, leaving the supervision and teaching to his pupil Thomas P. Anshutz.

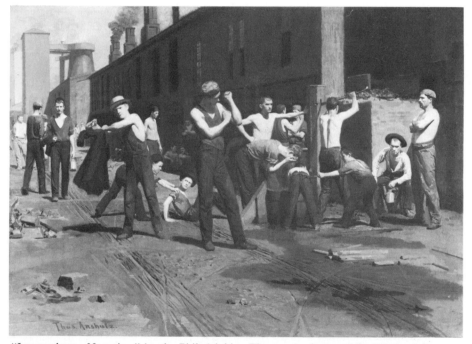

"Ironworkers—Noontime" by the Philadelphian Thomas Anshutz anticipated the Ash Can School. It has been called the first "labor" painting by an American. Happy farmers had been popular subjects for artists; factory workers in the 1880s were considered a shockingly ungenteel subject. *(The Fine Arts Museums of San Francisco)*

Anshutz was a most exacting teacher and rigorous critic; his students called him "a file dipped in acid." Outside the studio, however, he was a relaxed and congenial companion to his students, who seem to have been fond of him and greatly respectful of what he painted and what he taught. His manner with a brush was much like that of his master, Eakins, and so was much of his subject matter, though he was more inclined to be anecdotal in that tradition of American genre which liked to inject not only a bit of sentiment but a gentle moral in its depictions of everyday life. There is one of Anshutz's pictures that appears to have had a marked effect on the work of Henri and the Ash Can school, a painting called "Ironworkers —Noontime,"* though this is a matter of conjecture. It is regarded as the first depiction of industrial laborers not in the course of being industrious but acting as everyday people doing everyday things. None of the figures is gesturing for artistic effect, nor clothed to look picturesque, and the setting is anything but romantic—the men are washing at a pump or taking off their undershirts or rubbing sore muscles; behind them is the factory wall and beyond that the factory's chimneys. Anshutz painted this picture almost thirty years before his pupils shocked the New York art audience with their ash cans and laundry lines and alleyways, but it was fairly fresh when Henri went to the academy to study. Anshutz found him a promising student, not for any remarkable facility with a pencil or brush, but because he was unusually diligent, determined, and intelligent.

Henri, as John Sloan wrote of him, was "a catalyst . . . an emancipator"; he was also a magnet that attracted other artists. In Philadelphia in the 1890s he held open house in his studio one evening each week and was surrounded by men who, though they were only a few years younger for the most part, called him "the old man." Among them were four newspaper artists, skilled in reportorial drawing and able to transpose notes made quickly at public occurrences into detailed illustrations for their papers. They were George Luks, William Glackens, Everett Shinn and John Sloan, and it was Henri who prodded them into painting for their own gratification, to become artists, serious and independent, not for fame or fortune but for personal satisfaction. "We came to the realistic conclusion," Sloan wrote, "that an artist who wanted to be independent must expect to make a living separately from the pictures painted for his own pleasure. We could attack the art academies and public taste with freedom honestly earned."

*Paintings of farmers and their hired help taking their leisure were common in the nineteenth century, but this picture is generally regarded as the first such depiction of industrial workers, thereby giving "labor" the same dignity as farm workers. It is now in the de Young Museum in San Francisco.

Twice in the 1890s Henri went to Paris, first to study, then to study and teach, and by the time he returned in 1900 he had decided that "almost any other place would be better" than Philadelphia to pursue his career. "New York is so different from here [Philadelphia]," he wrote, "one feels alive over there." Philadelphia, which in many respects had been the artistic center of the nation in the nineteenth century, had lost its grip on young artists. Glackens and Luks had already moved to New York while Henri was in Paris; Sloan and Shinn soon followed.

If Henri had not quarreled openly with the National Academy of Design,* the Ash Can painters and what they represented as a symbol of revolt would not have enlivened the first decade of this century. Neither would the press have had such a delightful chance to make publicity for the visual arts, which characteristically suffered from public indifference. In newspaper terms Henri was "copy." He had become a member of the National Academy when it absorbed the Society of American Artists, an organization of which he was a member and which had been started in 1877 by a group of earlier rebellious artists as a gesture of defiance against the academy's authority. Henri had hoped to guide the academy to a more liberal attitude toward the young artists who were painting the life of the city as they saw it. But, when his friends' work was rejected by the academy's selection jury for its annual shows, and when several who were up for election were passed over, and moreover when he, himself, was dropped from the jury on which he had served for several years, he gave up. "This action," he said to a reporter for the New York *Evening Mail*, "shows that the Academy is hopelessly against what is real and vital in American art. What the outsiders must now do is hold small or large group exhibitions, so that the public may see what the artists who have something important to say are doing."

And that is precisely what ensued. Henri and five of his friends and followers formed themselves into a sort of committee to explore the possibilities of holding an exhibition of the work of "the crowd," as they called themselves. Six of what turned out to be "The Eight" met at Henri's studio in April 1907, four of them ex-Philadelphians (Henri, Sloan, Luks, and Glackens). The other two were Arthur B. Davies, a painter of cool and idealized landscapes inhabited by decorous nymphs and occasional unicorns, and Ernest Lawson, who cared more about wooded hills and winter-bound rivers than ash cans and painted in the Impressionist manner. Henri

*The National Academy of Design had been founded in 1826 as a protest against the American Academy of Fine Arts, presided over by Colonel John Trumbull, painter. The moving spirit and first president of the National Academy was the artist-inventor Samuel F. B. Morse.

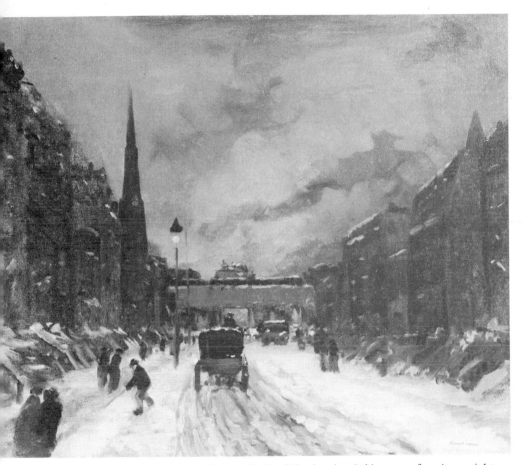

Robert Henri, the leader of the Ash Can School, painted this scene of a winter night, "West 57th Street," in 1902. "All art that is worthwhile," he wrote, "is a record of intense life." *(Yale University Art Gallery, Mabel Brady Garvan Collection)*

acted as spokesman, Sloan as secretary-treasurer, and Davies, who a few years later at the time of the Armory Show revealed himself to be something of a genius as an organizer, was in charge of the catalogue and of negotiations with a gallery. Sloan, with not much difficulty, persuaded Everett Shinn, who had drifted away from "the crowd," to join them; Maurice Prendergast, another artist who seemed to fall into no acknowledged category but was surely an independent, made the eighth member.

Each artist was asked to contribute $50 toward the rental of exhibition space, and the Macbeth Gallery on Fifth Avenue just south of the Public Library agreed to take them in for two weeks in February 1908. All this was settled in May, and the buildup began almost at once. Henri made it

John Sloan painted "Backyards, Greenwich Village" in 1914. Clotheslines, a cat,
children making a snowman, even if no ash can is in sight, were typical of the subject
matter of the so-called (but not by them) Ash Can School artists. *(Collection of Whitney
Museum of American Art, New York)*

clear that they had "come together because they were so unalike," and not
because they represented "any cult of painting" or aesthetic front. (It did
not occur to them that they might be regarded as a social or political front.
As Sloan said, they "took no part in these things and were little inter-
ested.") They were "independents" and "progressive," and there were
eight of them because that was the way it fell out. Henri declared that they
were "similar only in that they all agree that *life* is the subject and that
view and expression must be individual." He may well have been putting
ideas into his companions' heads (he often did) when he is reported to have
said, "It is the fashion to say that skyscrapers are ugly. It is certain that
the eight will tell you: 'No, the skyscraper is beautiful. Its twenty stories
swimming toward you are typical of all that America means, its every line
is indicative of our virile young lustiness.' "

Skyscrapers were new in New York when he said this. The beautiful building that was swimming toward him was almost surely the Flatiron Building at Twenty-third Street and Fifth Avenue, built just five years before by the Chicago architect Daniel H. Burnham. But the chest thumping of "our virile young lustiness" was nothing new. American artists had been trying to assert their independence from Europe for several decades and to win recognition for American art. In fact the painters and sculptors were far behind the architects, and especially the designers of skyscrapers, in achieving an American idiom. Presumably Henri's "lustiness" was meant as a slap at academic prissiness, as it might also have been against the expatriate "fashionables" like Sargent and Henry James, and the mimics of French Impressionism, though all but one of The Eight owed something to them—Henri especially to Manet, Lawson to Monet, Glackens to Renoir, Shinn to Degas, Sloan and Luks to several of them, and Davies remotely if at all to any of them. Their debt was sometimes in subject matter, sometimes in composition but most frequently in the keys of their palettes.

On February 1 "the crowd" hung the exhibition in two small galleries at Macbeth's. Each was allotted approximately twenty-five feet of hanging space and each hung his own paintings. The effect, they thought, was brilliant, but Henri was apprehensive about its public reception. He need not have been. The press rose to their brightly ornamented hook; the old and wary sniffed at it and rejected it; the young and adventurous swallowed it with pleasure, just as he might have expected. What he did not expect was the crowds who came. He wrote to a friend, "It was packed like an academy reception from morning to night." Sloan, a couple of days later, telephoned the gallery to see how things were going and noted in his diary: "They tell me that 300 people were coming in every hour, about 85 people constantly in these two small galleries." A young artist, Guy Pène du Bois, who wrote criticism for the *American* was, not surprisingly, "most enthusiastic over the Show," Sloan said (du Bois was a pupil of Henri's), and so was the eminent, all-purpose critic (music, theatre, art, literature) James Huneker, who "strips off the idea of 'rebels,' 'outlaws,' 'outcasts,' etc. . . ." and supported the work of The Eight for what it was, a fresh breath in a murky art climate. One critic complained that Davies couldn't draw, another said that the Prendergasts looked like "an explosion in a color factory." The Eight acquired a new nickname, "The Black Gang," because their subjects were "inartistic." What, the conservative public and press wanted to know, was beautiful about steaming horses and dirty tenements and ragged children, and what was art if it wasn't beautiful?

There was no doubt that The Eight had made an impression, that they had the satisfaction of slapping the academy's face, and what was perhaps

less important financially than emotionally, they had sold $4,000 worth of paintings, seven in all. Four of these were bought by the sculptor Gertrude Vanderbilt Whitney, who later founded the Whitney Museum of American Art and can reasonably be called the most eminent and influential private patron of American art in the first half of this century. The exhibition attracted attention outside of New York. A dealer in Boston asked for it, but was not willing to pay the transportation and insurance. The Philadelphia Academy was willing, however, and the exhibition traveled from there to Chicago, Detroit, Toledo, Pittsburgh, Cincinnati, Bridgeport, and Newark, making friends and enemies wherever it went.

The importance of The Eight was less in themselves than in what their energies led to. The success of the show at the Macbeth Gallery whetted their appetites for larger exploits, and in March 1910, with the initial funds provided by Henri, Sloan, and Davies, abetted by a number of Henri's pupils (and most especially by the vigorous young Walt Kuhn), they rented loft space on West Thirty-fifth Street in New York for an Exhibition of Independent Artists. This show was to have no jury selection and there were no prizes to be handed out. (They made it quite clear that by "independent" they did not mean just independent of the academy but independent in spirit.) The exhibition filled three stories with the works of 103 artists, "invigorating stuff . . . full of force and interest," as Sloan noted in his diary. On the opening day the crowds were such that a small squad of riot police had to be called out to keep order in the street, where more than a thousand people milled about waiting to replace the nine hundred who had already got there before them and were in the galleries. "It was terrible but wonderful," Sloan wrote, "to think that an art show could be so jammed. A great success seemed assured of." There were 210 paintings, 20 sculptures, and 219 drawings and prints, and in a manner that assured that no one played favorites, they were hung alphabetically by artists. Such a thing was unheard of at the academy, where jockeying for position for oneself and one's friends was taken for granted.

The crowds continued to come in numbers that astonished Henri and his friends. The critics appeared to take sides much as they had at the exhibition of The Eight. The critic of the *Sun* called the artists "insurgents, anarchists, socialists," and Frank Jewett Mather in *The Nation* observed that "there is more green, yellow, and red sickness about than positive talent." A painting by Sloan called "Three A.M." was said to be "too frank and vulgar." The critic of the New York *Evening Mail* found a "great deal of good and promising work," and was quite accurate when he also said that the show included work by "artists now unknown whose work may someday be famous."

Whether those who pressed into the makeshift galleries found the pictures and sculptures distasteful or exciting, ugly or beautiful, interesting or dull, they did not buy them. Three small pictures were sold on the opening day and just two more during the twenty-six days the show was installed. On April 27, the day after it closed, Henri wrote in his diary: "The exhibition was a great success as far as general notice and attendance —the crush at the opening and continued full attendance to the last day. Financially nothing happened." The total sales came to $75.

Invasion by Invitation—the Armory Show

Something was stirring, obviously, but in the opinion of the young artists it was not enough. There was some public curiosity about what now was going on in the studios of New York painters; the crowds at the Independents show demonstrated that. But the pot needed stirring continuously and there seemed no one to stir it but the artists themselves. Four young men who hung out in the late afternoons at the Madison Gallery, which existed because of the good will and bank account of Gertrude Vanderbilt Whitney, felt moved to form a society of artists to do something about putting on an exhibition more selective but no less experimental than the Independents show. They were Walt Kuhn, who liked to paint circus figures; two artists who drew and painted New York streets, Elmer Mac-Rae and Jerome Myers; and Henry Fitch Taylor, a landscape painter. On December 14, 1911, they formed a society, which they called the Association of American Painters and Sculptors, and invited sixteen other artists to join them. If they had known what they were letting loose on themselves and the American arts, they very probably would have dropped the scheme like knife. It was out of their efforts that the most famous exhibition of art to take place in America in this century came into being. It was called The International Exhibition of Modern Art. It was held at the 69th Regiment Armory on Twenty-sixth Street and Lexington Avenue in New York, and it was known simply as the Armory Show. It still is. No single event had as stunning an effect on American taste or did so much to set back the cause of American artists or raised such wrath, such glee, and such continuing debates (they still continue) as this explosion on Twenty-sixth Street.

The original intention of the society, as stated in the minutes of its first formal meeting, was a series of exhibitions of "the works of progressive and live painters both American and foreign—favoring such work usually neglected by current shows and especially interesting and instructive to the public." Primarily they were interested in making a market for their own work, but they decided to show, as Walt Kuhn said, "a few of the radical

things from abroad to create additional interest." A few things turned out to be a large number of paintings, drawings, and sculptures from Europe—a smashing success for the foreign avant-garde artists and a shocking setback for the Americans, whose work looked safe and tame by comparison.

While the plans for an initial exhibition seemed to drag along without much direction, and it seemed impossible to find a proper exhibition hall, and there seemed to be no money to mount a show even if a place was found, Myers and Kuhn in desperation decided to ask Arthur B. Davies if he would be willing to take on the presidency of the society and breathe some life into it. They were surprised when he accepted, and astonished when this shy, retiring, excessively private artist (only under pressure would he give the address of his studio or show his work to his contemporaries) turned into a driving, dictatorial, "severe, arrogant, implacable" operator, who "governed with something equivalent to the Terrible Ivan's iron rod."

It was Davies's fascination with what the radical artists in Europe were up to that changed the nature of the show. He was one of a handful of American painters and sculptors who had worked in Paris and had watched with sympathy the aesthetic revolution in the making. They knew the work of the post-Impressionists Cézanne, Gauguin, and Van Gogh, which the American followers of the Impressionists could not stomach. Neither, indeed, could the members of the Ash Can School, though they thought of themselves as rebels. The only place in New York where the advanced work from Europe could be seen was the Little Gallery of Photo-Secession at 291 Fifth Avenue, which occupied the former servants' quarters at the top of a brownstone house. It was more commonly called the "291 Gallery" and was presided over by the redoubtable photographer Alfred Stieglitz, with Edward Steichen, a much younger man, as his sidekick and energizer. (We will meet both of these men again as two of the most pervasive influences in the history of American photography.) Stieglitz was a photographer first, but he was also a dealer, who cared little about making money and was generous to artists, a perennial guru, and finally a cult figure, whose influence on taste and the careers of artists was in inverse proportion to the size of his gallery. The painter Marsden Hartley called it "the largest small room of its kind in the world." It was Stieglitz who first exhibited Cézanne in America. In 1911 the first drawings and watercolors by Picasso to be seen here were on the spare, white walls of the little gallery; they illustrated on paper the full range of his work through his development of Cubism. In 1908 Stieglitz had exhibited fifty-eight drawings by Rodin, which one historian calls "the first exhibition of a modern artist in America," and he had shown Toulouse-Lautrec, the

Douanier Rousseau, and a collection of Matisse drawings which provoked a sufficient number of raised eyebrows to gratify him. "The New York art world was sorely in need of an irritant," Stieglitz wrote in his magazine *Camera Work*, soon after the exhibition closed, "and Matisse certainly proved a timely one." The gallery was very nearly pretentious in its cell-like unpretentiousness. "Take the smallest elevator in town," the critic Huneker wrote in the New York *Sun*, "and enjoy the solitude of these tiny rooms crowded with the phantoms of Stieglitz and Steichen. No one will be there to greet you, for Stieglitz has a habit of leaving his doors unlocked for the whole world to flock in at will."

Flocking seems not to be precisely what the world did, but it was there that the avant-garde American painters of the first decades of this century found a haven, encouragement, and an outlet for their work. The reputations of the artists who belonged to Stieglitz's "stable" appreciated over the years as those of The Eight diminished. (The Eight only recently have been revived.) They had been to Paris, or come from there, had seen at first hand the movings and stirrings which produced the "Wild Beasts" (Les Fauves, so called for the wildness of their colors), whose guiding spirit was Matisse and whose spiritual father was Cézanne. They had seen the evolution of Cubism at the hands of Braque and Picasso and read the manifestos of the Italian Futurists. They had visited the exhibitions of the Independents and the annual Salon d'Automne, where the Fauves showed. They were familiar with the hard-surfaced still lifes and portraits of Derain, with the incrusted landscapes of Vlaminck, with Rouault's palette that was like medieval stained glass, and with the sophisticated naïveté of the primitive Rousseau. Some of them had sat in Gertrude Stein's living room looked down on by the unframed portrait of her by Picasso (now in the Metropolitan Museum in New York), by the work of Renoir and Cézanne, Matisse and Daumier. What Stieglitz demanded of the artists who came to him was craftsmanship of a high order, a free spirit and the complete conviction that what they were doing was their salvation. To him came Marsden Hartley, Georgia O'Keeffe, John Marin, Max Weber, Arthur Dove, Abraham Walkowitz, Oscar Bluemner, Alfred Maurer, the sculptor Elie Nadelman, and Stanton MacDonald-Wright.

Very nearly all of these artists were exhibited at the Armory Show, but unlike the members of the Ash Can School there was no unifying concept of what they should paint or how they should see the world about them. They shared, if they shared anything, a release from representation of the external world and an admission to the new concepts of art's function as the transcription of the artist's personal vision—a remaking, one might say, of the world from within, without regard to verisimilitude or,

in some instances, as in the canvases of the Synchromists, whose abstractions were arrangements of color, without regard to natural forms at all. It is logical that Stieglitz, who, as a photographer, believed that the camera had once and for all done in the realists with the brush, should have been a magnet for those artists who were haring off after a new freedom from traditional restraints and dogmas.

It was not these men or Stieglitz himself who was responsible for the ultimate nature of the Armory Show. Davies, to be sure, was a friend of Stieglitz and a contributor to *Camera Work*, but he was not one of the stable at 291. Nor was Walt Kuhn part of that coterie, and the influence of Stieglitz on the Armory Show was negligible if, indeed, he had any at all. It was Kuhn who took off for Europe to see an exhibition of modern work in Cologne. Davies had seen a catalogue of the show and had said to Kuhn, "I wish we could have a show like this one." From Cologne Kuhn went to The Hague, from The Hague to Paris, acting like a euphoric vacuum cleaner, buzzing with excitement at his discoveries, and gathering in paintings and sculptures by the dozens. In The Hague he first encountered the aging and mystical Redon, and promised him a whole room at the exhibition. In Cologne he first met the work of Van Gogh head on, and there, too, he found Lehmbruck, the sculptor of elegantly elongated, classically restrained and poetic figures.

Paris was too much for Kuhn, and he cabled Davies to join him there, which he promptly did. With the American artist and writer Walter Pach, who was then living in Paris, they bolted from studio to studio, seeing artists and asking to borrow their work. It was Pach who introduced them to the brothers Duchamp-Villon, and thus to "Nude Descending a Staircase" by Marcel Duchamp, which became the sensation of the Armory Show. Such has been the remarkable change in attitude to painting since that time that it is impossible to believe that a single picture today could cause such a violent reaction as that one did, or even that an exhibition could. American sensibilities are far less shockable in most respects than they were at the turn of the century.

"All society was there; all the art world," Kuhn wrote of the opening of the Armory Show on the evening of February 17, 1913. Indeed, some four thousand somewhat bewildered souls wandered through the exhibition while a band played in the balcony. Art students at the entrance sold catalogues and gave away badges printed with the symbol of the show, the pine-tree flag of the American Revolution, and the slogan "The New Spirit." There were some sixteen hundred exhibits for the crowds to look at, by no means all of them "modern." They included the work of earlier pioneers and revolutionaries, Ingres and Delacroix, Daumier and Corot,

This deceptively peaceful scene is part of the Armory Show in 1913. New Yorkers were shocked by what a *New York Times* critic called an exhibition of "cubistic, post-impressionist, futuristic, neurotic, psychotic and paretic" art. When the show traveled to Chicago, the director of the Art Institute called it "a toss-up between madness and humbug." *(Photo courtesy The Museum of Modern Art, New York)*

Puvis de Chavannes, Renoir, and Monet. There were, too, the Post-Impressionists Cézanne, Van Gogh, and Gauguin, then still looked upon with great suspicion even by many who considered themselves to have advanced tastes.

But it was the highly colored and distorted figures of Matisse and the Cubist experiments of Picasso and Braque, the bright abstractions of Picabia and Kandinsky and Léger, and the fractured forms of Duchamp that were most puzzling to those who wanted to understand and most revolting to those who did not. By comparison the work by the Americans looked conventional, like the paintings of The Eight, or timid, like those of Hartley and Weber and Stuart Davis. The early abstractions and imitations of the Fauves by Americans seemed like searchings not findings alongside the assurance of the Europeans.

Marsden Hartley, who painted "Portrait of a German Officer" in 1914, was a member of Alfred Stieglitz's "stable" of artists. He was among the first Americans to go to Europe to explore the new Expressionist and abstract painting. *(The Metropolitan Museum of Art, The Alfred Stieglitz Collection)*

There had been in France, after all, an intellectual and aesthetic progression from the early days of the Impressionists and their experiments with light. Cézanne's geometric researches into forms in nature led with logic to the Cubist experiments of Picasso and Braque. They in turn led to abstractions with no basis in natural forms, at which point the picture became its own subject matter. On the other hand, Gauguin's and Van Gogh's use of intense and unconventional color and of carefully distorted drawing led quite logically to the highly keyed palettes and the charged drawing of the Fauves. This was a meal that the European artists had worked their way through over decades; it was one which the Americans tried to digest, in a manner of speaking, all at one sitting, and without

knowing what had gone on in the kitchen. This was as true of the artists as of the audience for the arts that came to the armory.

The critics responded to the Armory Show with considerably more anguish and vituperation than they had to The Eight. The *New York Times* called it "pathological . . . hideous," and the New York *Herald*'s critic, Royal Cortissoz, wrote: "Some of the most stupidly ugly pictures in the world and not a few pieces of sculpture to match them. . . . This is not a movement and a principle. It is unadulterated cheek." The "Nude Descending a Staircase" elicited more wisecracks and cartoons than any other piece in the show. The New York *Sun* ran a drawing entitled "Seeing New York with a Cubist" with a subtitle "The Rude Descending a Staircase (Rush Hour at the Subway)," and Julian Street called it "an explosion in a shingle factory," taking a cue from the critic who had called Prendergast's work "an explosion in a color factory."

It took two weeks for the public to catch on to the fact that there was something worth looking at and talking about at the armory, but once they did, they flocked in. "Actors, musicians, butlers, and shop girls . . . the exquisite, the vulgar from all walks of life" turned up, according to Kuhn, to gape at the exhibits. Not all of the criticism was invective. An article in the *Outlook* which, though it was critical of many of the exhibited pieces, said: "There was one note entirely missing from the exhibition, and that was the note of the commonplace. There was not a touch of simpering, self-satisfied conventionality. . . . There was no stunting or dwarfing, no requirement that a man whose gifts lay in new directions should measure up or down to stereotyped and fossilized standards." The author of the piece was Theodore Roosevelt, writing fewer than four years after he ceased to be President of the United States.

As the crowds increased so did the purchases, and as the purchases mounted, the spirits of the American artists fell. It was the foreign art that was being bought; of the 174 works that were sold, 123 of them were by European artists and only 51 by Americans. In cash this represented better than $44,000 for foreign works and a little short of $14,000 for American. The largest purchaser was John Quinn, a New York lawyer who acted as legal counsel without fee for the society that put on the show. He was an ardent patron of the Irish theatre and had brought the Abbey Players to New York, and he became the owner of one of the most distinguished collections of modern art in America. He bought about $6,000 worth of works at the armory, eleven of them by foreign artists, four by Americans, two of which were by his friend Walt Kuhn. Bryson Burroughs, the curator of paintings at the Metropolitan Museum, bought Cézanne's "Colline des Pauvres" for $6,700. It was the first Cézanne bought by any American

SEEING NEW YORK WITH A CUBIST

The Rude Descending a Staircase
(Rush Hour at the Subway)

The most notorious (now perhaps the most famous) painting in the Armory Show was Marcel Duchamp's "Nude Descending a Staircase." More than any other it evoked derision. This cartoon, "The Rude Descending a Staircase (Rush Hour at the Subway)," appeared in the New York *Evening Sun* on March 20, 1913. *(Photo courtesy The Museum of Modern Art, New York)*

museum, and it was kept sequestered for a number of years because the trustees disliked it.

When the show closed in New York, much of it went on to the Art Institute in Chicago. There the poet and editor of *Poetry: A Magazine of Verse*, Harriet Monroe, attempted to explain the meaning of the new art in the columns of the *Tribune*, while the *Record Herald* ran a full page headed: "Hark! Hark! The Critics Bark! The Cubists are coming to town, with Cubist Hags, and Cubist Nags and Even a Cubist Gown." The mayor of Chicago put in his bit by publicly saying of Picabia's abstraction "The Dance of Spring," "I see it now. Plain as day. It's Charlie Merriam attacking the traction merger." The president of the local Law and Order League declared, "There ought to be a law prohibiting it." A high-school teacher denounced the show as "nasty, lewd, immoral, and indecent," and the chairman of the Vice Commission felt called upon to see what all the furor was about. Whatever he thought of the art, he found nothing to object to on moral grounds. From Chicago the exhibition went to Boston, where it was greeted with rather more indifference than dismay. It stopped there.

The final accounting of the Association of American Painters and Sculptors was presented to its members at the Manhattan Hotel in the autumn after the Armory Show finally dissolved. A few members like Kuhn and Pach and Davies had done very well for themselves; they had paid off the costs of the show and pocketed commissions on sales. But in general the members were disgusted at the upshot, and one after another they resigned from the association. The European artists had not only sold their wares, they had captured the imagination of the art world in America, and though no one could foresee it at the time, they were to hold it for nearly half a century. "Our land of opportunity," Jerome Myers said, "was thrown open to foreign art, unrestricted and triumphant."

The effects of the Armory Show on the work of American painters and sculptors belongs in another chapter, though it is well to remember that those who had worked abroad, like Stieglitz's stable, were already imbued with the new "modernism." The effects on the public taste in general were almost entirely negative. The number of converts to the new aesthetic was very small indeed, though a number of important collections of modern art were affected by the show, most notably the Quinn collection, which we have mentioned; the Gallatin collection, now in the Philadelphia Museum of Art; the Root collection at Utica; the Louise and Walter Arensberg collection (they bought the "Nude Descending a Staircase"), also in Philadelphia; the Eddy collection in the Art Institute of Chicago; and the Katherine Dreier collection that Duchamp named "the Société Anonyme" at Yale. So, to be sure, was the Lillie P. Bliss collection, which became the

core of the Museum of Modern Arts' collection in New York. It was not until 1929, sixteen years after the Armory Show, that "The Modern" (or MoMA, as it is frequently called) came into existence, and its first exhibition, considered shocking even then, was of Cézanne, Seurat, Gauguin, and Van Gogh, all of them long accepted in Europe as the "old masters" of the modern movement.

It is a truism that time tames the wild beasts of art and makes them socially acceptable. The art that was regarded as an attack on the genteel tradition in the first decades of this century is now the apple of genteel eyes. Cézanne and Gauguin are as safe as John Singer Sargent and William Merritt Chase, and Lehmbruck and Brancusi are as acceptable as Daniel Chester French and Frederick MacMonnies were in their heyday. On the walls of polite parlors, as quiet, well behaved, and dignified as any Constable landscape or Chardin still life, are yesterday's rascals, the abstractions of Braque, the "blue period" and cubist Picassos, the back alleys of the Ash Can painters, the "Odalisques" of Matisse, the watercolors of Marin. It was not the Armory Show that brought this about. That was merely the camel's nose under the edge of the genteel tent.

And now the camel has been invited in, it would seem, and made a generally tolerable member of the family of man.

From Ragtime to Riches and All That Jazz

In 1973 Edward Kennedy ("Duke") Ellington wrote in his autobiography, *Music Is My Mistress:*

> This City of Jazz does not have any specific geographical location. It is anywhere and everywhere, wherever you can hear the sound, and it makes you do like this—you know! Europe, Asia, North and South America, the world digs this burg—Digsville, Gonesville, Swingersville, and Wailingstown. There are no city limits. no city ordinances, no policemen, no fire departments, but come rain or come shine, drought or flood, I think I'll stay here in this scene, with these cats because almost everybody seems to dig what they're talking about, or putting down. They communicate, Dad. Do you get the message?

Twenty years before, in the mid-1950s, the trustees of the Metropolitan Museum of Art in New York had most certainly not yet got the message. In setting the rules for the museum's new Grace Rainey Rogers auditorium, the trustees declared that no jazz concerts would ever be tolerated in that quietly elegant hall. Jazz by that time had been sufficiently respectable to be played in Carnegie Hall, then the home of the New York Philharmonic (Lincoln Center was still to come), and Benny Goodman had rocked its dignified rafters with his big band. Indeed, that happened in 1938, and by then Goodman had made "swing" a household word, with musicians whom the jazz world likes to call "legendary"—Harry James, Lionel Hampton, Gene Krupa, Teddy Wilson, and Ziggy Elman. It was the era of bobby-soxers and jitterbugs, of the Lindy Hop, the Shag, and the Big Apple, of abandon on the dance floor that was unknown even in the Jazz Age of the 1920s, with its bell-bottomed "smoothies" and flat-chested "flappers" knocking their knees and kicking up their heels in the Charleston and slapping their behinds in the Black Bottom. By 1960 jazz was so much a part of the American culture, both folk and highbrow, that sophis-

ticated prophecies about its place in the spectrum of acceptable art were more or less taken for granted.

It has, of course, not always been so. Jazz was a below-stairs child of the Gilded Age, a byblow so little regarded at first by the custodians of high culture as to be no more than a minor embarrassment, something to amuse "the lower orders" in pool halls, brothels ("sporting houses"), and other disreputable arenas of questionable self-indulgence. Not even Mark Sullivan's "average man" gave it heed; there were other tunes and ballads to lift his spirits or fetch his sentimental tears, "After the Ball" and "She's Only a Bird in a Gilded Cage." Not just the custodians of tradition and the genteel tradition disapproved of it; it was anathema to scholarly musicians and to such popular figures as John Philip Sousa, the paragon of band conductors, who thrilled the crowds at the Columbian Exposition and established himself as an American immortal with his stirring march "The Stars and Stripes Forever." He disapproved because, he said, jazz's "primitive rhythms . . . excite the basic human instincts," and in the Jazz Age, when he made this observation, instincts were not proper subjects for polite conversation among respectable people and even commanded a certain verbal reticence, whatever their behavior, among "flaming youth."

Ragtime established itself in the sporting districts of New Orleans and Memphis by the early 1890s and had soon spread across the country like an underground fire beneath the lawns of respectability. It had almost no defenders among critics at the turn of the century, but Rupert Hughes, a novelist, biographer, dramatist, and inexhaustible magazine writer, was one of the few who spoke up on its behalf. His defense of ragtime in an article in the Boston *Musical Record* in 1899 was prescient. "Ragtime music meets little encouragement from the scholarly musician," he wrote. "It has two classes of enemies: the green-eyed, blue-goggled fogy who sees in all popular music a diminution of the attention due to Bach's work; and the modern scholar who thinks he has dismissed the whole musical activity of the Negro by a single contemptuous word." They called it, he said, "a distorted reminiscence of Spanish and Mexican dances: behold the syncopation," or they said of its lyrics that their origins were Scotch, "behold the Scotch snip." Hughes, who considered this nonsense, said: "I feel safe in predicting that ragtime has come to stay, that it will be taken up and developed into a great dance form to be handled with respect, not only by a learning body of Negro creators, but by the scholarly musicians of the whole world." His confidence has been more than justified.

The origins of ragtime are no longer as debatable as they were at the time Hughes wrote about the rhythms and melodies that were becoming popular beyond the black (then Negro) world in which they had been

nurtured. In recent years anthropologists and musicologists and social historians have explored ragtime's African and American roots and the plants they put forth; they need not be scrutinized in detail here. It is sufficient to say that ragtime's complex syncopated rhythms are distantly traceable to the music of West Africa (one should say the many musics of West Africa, as they varied greatly from tribe to tribe), where the drums were not an accompaniment to melody but quite the other way around. It was the drums that took the lead, with the melody as accompaniment. The slaves who brought their musical traditions with them and worked to their rhythms were encouraged by their owners not, it is evident, for any interest in their "primitive" music (which in fact was extremely sophisticated in its own terms) but because of its effect on their production in the cane and cotton fields, on the levees and in the tobacco plantations. They chopped and hoed and heaved to the rhythms of their work songs, and they sang in times of leisure and worship to keep their spirits up. Black music may have amused the slave owners and their families, but essentially it was good for business.

The melodies and harmonies and the piano techniques to play them came as much from exposure to imported European traditions, which was the music of the masters and the clergy, as from West Africa, but as Ernest Borneman has written, "The whole tradition of syncopated popular music owed its origin to the slave." Out of play songs, work songs, ring shouts, spirituals, hollers, and blues came the syncopated rhythms of ragtime and their sometimes mournful lyrics. One historian says that the word "ragtime" may have come from the "ragged effect produced by the syncopated melodies"; another found the origin in the fact that "Negroes call their clog dancing 'ragging' and the dance the 'rag,' " but, like the origin of the word "jazz," as we shall see, its coinage seems to be a matter of anybody's informed guess. Ragtime came to mean that part of black music which was neither work songs nor blues nor spirituals. "The spiritual yearns to God; ragtime yearns to the Devil," Isaac Goldberg wrote in *Tin Pan Alley* (1930). "The spiritual is holy; ragtime in its unleafy state is, more than profane, obscene. The spiritual translates the Bible; ragtime translates the other six days of the week."

The music that became ragtime first made the feet of white audiences tap in the days after the Civil War, when the extremely popular and ubiquitous minstrel shows (there were hundreds of minstrel companies) played in local opera houses wherever they existed, which, to be sure, was in nearly every town with any pretensions of someday being a small city or a large one. The minstrel groups were whites in blackface; they specialized in sentimental ballads, "coon songs," badinage, and jokes with the

interlocutor feeding lines to the end men ("Mr. Bones" and "Tambo"), and characteristically ended a performance with a "walk-around" or "cake-walk," which was an imitation of the Negro "strut." Initially the cakewalk was a plantation dance performed to a banjo (banjos and tambourines were *sine qua nons* of a minstrel show), a high-kicking, prancing walk-around, which was usually a parody of the hoity-toity manners of the white folks. On the plantations it was customary for the master "to give a cake for the proudest movement," and in the hands of the minstrels, or more precisely in their feet, it evolved into the not altogether genteel dances, such as the turkey trot, that were popular in the first decades of this century. Gilbert Chase in his admirable *America's Music from the Pilgrims to the Present* says, "The combination of the cakewalk rhythm and banjo technique is a direct forerunner of ragtime."

That was not all. Ragtime combined the hot rhythms of Afro-American music, the coon songs of the minstrel shows, and the ragging of the Negro brass bands which had sprung up after the Civil War. Its characteristic syncopated melody, over a constant two-four beat in the bass, lurked, albeit noisily, in the sporting houses and dance halls in the "Darktowns" (as black sections of cities were then called by whites) of the cities of the Middle West, through which flowed a constant stream of itinerant piano players. The cities along the Mississippi (New Orleans, Memphis, and St. Louis principally) were its strongholds until in the 1890s it came "riding in on the cakewalk," as one critic put it, and by 1900 was "an overnight national obsession." By the beginning of World War I it had become a fully developed, if critically despised, art form and was passing its peak of excellence both in composition and performance. It suddenly dropped out of sight, swamped by the popularity of jazz, and was not revived until the 1940s, when some jazz pianists, most particularly Wally Rose, began to play it for their own pleasure, and it soon evoked some cultish enthusiasm among sophisticated record collectors. It retired once more until the 1970s, when largely through the popularity of the movie *The Sting,* and the recordings of Joshua Rifkin, Gunther Schuller, and William Bolcom, it was suddenly on record players everywhere again. Scott Joplin, generally acknowledged to be the greatest ragtime composer of all and one of its most accomplished performers, became, as he had been seventy years before, a name to be reckoned with.

Joplin's career had the romantic attraction and the classic shape and inevitability of "poor boy makes good." His achievements were the result of hard work, talent and dedication to artistic principles. His self-confidence was clothed in external modesty, and his intelligence was of the sort

that made the most of the breaks he created for himself. He achieved a kind of perfection in the art to which he devoted his life, and his ambition led him to experiments which produced music that puzzled his contemporaries and left them unmoved. His dreams far outran the acceptance of his music, and he died at the age of forty-eight poor and insane.

He was born in Texarkana in November 1868, the son of a faithless railroad worker who played the fiddle and a mother who played the banjo. His father made off with another woman when Scott was a small child, and his mother supported her brood (Scott had several brothers and sisters) as a domestic servant. She took her small, obviously gifted son along with her to her jobs, and he was permitted to play the piano in the homes where she worked. The word got around that young Joplin was a prodigy on the keyboard, and a German music teacher gave him free lessons and introduced him to European music. At about sixteen or seventeen* he hit the road and became one of the drifting legion of piano players (they were called "professors") who went from sporting house to sporting house, saloon to saloon in the boom towns of the Southwest and Midwest. He was a thoughtful and attractive young man with magical fingers, and his reputation grew. For a time, starting in the mid-1880s, he settled in St. Louis, but in 1893 he was one of the horde of piano players who gravitated to Chicago and the periphery of the Columbian Exposition.

The following year Joplin moved to Sedalia, Missouri, which was the launching pad from which his career took flight. The city was a railroad center and site of the state fair and boasted (or more likely tried to ignore) one of the biggest red-light districts in the state, but it also boasted (openly) the George R. Smith College for Negroes. Joplin enrolled there to study harmony, counterpoint, and composition, supporting himself the while by playing piano in a sporting house called The Maple Leaf Club. He was to implant its name firmly in the annals of American music. In 1899 he fell in with a white piano salesman and occasional music publisher named John Stillwell Stark, who had heard him play at The Maple Leaf. Stark was a man of catholic tastes, whose predilection for genteel music did not obliterate his delight in ragtime or deafen his ears to innovation, and he published Joplin's "Maple Leaf Rag" in 1899; it is quite probably the most famous rag of all. Stark, who was a man of principle as well as perception, gave Joplin $50 and a royalty contract, rather than pay him a flat pittance for his piece and buy all the rights to it, as publishers of all kinds so frequently did in those days. They both profited richly; "Maple Leaf Rag" sold a

*Although a good deal of conscientious scholarship has gone into recreating Joplin's career, the dates of his early progress are still (and will probably continue to be) uncertain.

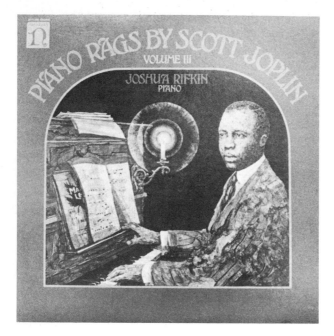

Scott Joplin, master composer and performer of ragtime, a predecessor of jazz, was all the rage at the turn of the century. A very popular revival of ragtime in the 1970s was due largely to Gunther Schuller, the musicologist, composer, and conductor, and to Joshua Rifkin, who made brilliant recordings of Joplin's rags.

million copies, the first piece of popular sheet music to do so in America. It was not the first ragtime to be published; in fact, it was not Joplin's first. Thomas M. Turpin, also a black rag pianist and the three-hundred-pound owner of The Rosebud, a club in St. Louis in which he played, in 1897 started a rush of rags on paper with a piece called "Harlem Rag." Joplin's first piece, "Original Rags," appeared earlier in 1899 than "Maple Leaf." It was the first of thirty-nine rags that he published, seven of which were composed in collaboration with others.

Joplin's career ultimately brought him to New York, with his sights set on higher things than ragtime, though he wrote, "What is scurrilously called ragtime is an invention that is here to stay." He had given up the life of sporting houses and honky-tonks for respectability, contemplation, composition, and teaching music to others in Sedalia, and in about 1909 he followed Stark to New York and went to work on his ill-starred opera *Tremonisha.* Like many composers of popular music (fortunately not too many, considering the record of their failures) he wanted to step over the barrier which separated "popular" from "serious" music and prove himself as a composer who could combine the black and European traditions into high art. *Tremonisha* never reached the stage in Joplin's time; its only performance was an uncostumed runthrough in 1916, which he paid for himself in hopes of finding a sponsor. It is said that "It was at once musically beyond the reach of unsophisticated audiences, either black or

white, and it was too simplistic for the experienced opera goer, particularly in a day when 'folk' music was not taken very seriously. . . . The Harlem audience was bored and silent and sat on its hands." It was a far cry from Puccini's *La Bohème,* which had first enchanted audiences in New York in 1899, the same year that "Maple Leaf Rag" had hit the honky-tonks, the parlor uprights, and the player pianos. In 1975 *Tremonisha* was given a full-scale production on Broadway to rave notices and by and large inadequate audiences. It lasted only a very few performances.

Hundreds of rags were published between 1900 and 1914, and as with all popular music (and serious music too, of course) their quality was as varied as the talents and pretensions of their composers. The names that survive are not many—James Sylvester Scott, Louis Chauvin (whose melodies were, it is said, pirated by Turpin and Joplin; Chauvin could neither read nor write music), Joseph Lamb, Artie Matthews, Eubie Blake (who published "Charleston Rag" about 1899 and who lived until 1983), and a few others. By all odds the greatest number of ragtime composers were blacks, but there were also some whites from the South or Midwest who listened to the genuine ragtime played where they lived, became expert performers themselves, and wrote their own rags. The first published ragtime is credited to Ben R. Harney, a white from Middleboro, Kentucky, whose "piano accompaniment and . . . concluding instrumental 'dance' section are," according to the authors of *They All Played Ragtime,* "bona fide, if elementary ragtime." The piece was a song called "You've Been a Good Old Wagon but You've Done Broke Down," published in Louisville in 1895. He was also the composer of "Mister Johnson, Turn Me Loose," which these same authors say was the "first archaic beginnings of the universal, migrant Negro lament that we now call the 'blues' to be committed to paper." Harney, who had no reluctance, as most black performers did, to perform ragtime full strength to white audiences, is credited more than anyone else with starting the ragtime craze. When he performed at Keith's vaudeville house in New York, he billed himself as "Creator of Ragtime," an epithet which also became his epitaph and is carved on his tombstone.

Nice distinctions are made between "authentic" and "imitation" ragtime, between St. Louis ragtime and the New Orleans brand, between the ragtime players whose virtuosity was in the speed of their fingers, and who played "fat and flashy," and those to whom the subtleties were important and who followed Joplin's dictum, which he printed on several of his rags, "Do not play this piece fast. It is never right to play 'ragtime' fast." The ragtime of Joplin was "authentic"; "Alexander's Ragtime Band" by Irving Berlin, which was published and caught fire in 1911, and which many still

think started the ragtime craze, was a latecomer produced by a New York Tin Pan Alley writer, who climbed onto the caboose of the fast-disappearing ragtime train. The great men of New Orleans ragtime were Tony Jackson and Ferdinand ("Jelly Roll") Morton. Jackson, like many black musicians since, refused to let his pieces be published, as he was damned if he would let publishers and white musicians cash in on his creations. According to Morton, "New Orleans was the stomping grounds for all the greatest pianists in the country," and none, he said, (though modesty was not one of Jelly Roll's few non-musical virtues) was greater than the "incomparable" Jackson. Jelly Roll belongs more properly in the history of jazz, which he claimed to have invented, than of ragtime.

Ragtime didn't stop and jazz start; but as the blood ran thinner in ragtime, it grew more robust in jazz. The demise of ragtime was predicted long before it happened and for the wrong reasons. The magazine *Metronome* in 1901 said, "Rag Time's days are numbered. We are sorry to think that anyone should imagine that ragtime was of the least musical importance. It was a popular wave in the wrong direction." To the editors of *Musical America,* "it exalts noise, rush, and street vulgarity. It suggests repulsive dancehalls and restaurants. . . . There is no trace of racial idiom in ragtime." Feeling ran so high among musicians at the turn of the century that in 1901 the American Federation of Musicians took a lofty position and instructed its members to stop playing ragtime because, as its presid' declared, "The musicians know what is good, and if the people don't, we will have to teach them." To this the Cincinnati *Post* replied, "If you hear music and like it, be sure that somebody will explain to you that it is popular and therefore immoral; that it lacks soul and technique and verve." Fifteen years later an anonymous writer in *Opera Magazine,* which was dedicated to the genteel tradition, took a quite different line from the Federation of Musicians. "If any musician does not feel in his heart the rhythmic complexities of the *Robert E. Lee"* he wrote, "I should not trust him to feel in his heart [those] of Brahms." At just about the time when Europe exploded into war in 1914, ragtime died of overexposure (call it commercialization, if you like), though its spirit has haunted all popular music since. It was the expression of an exuberant era, of optimism, of an increasing reaction against the gentility and surface restraints of the Victorian age, whatever excesses went on behind its ornate façades. It was a fanfare for the twentieth century, and a great many Americans felt it in their bones and in the tapping of their toes.

A New Sound Called Jazz

To put effect before cause, the transition from dances like the turkey trot (a "one-step") and the bunny hug to the foxtrot marked a transition from ragtime to jazz. It was the music that evoked the dances, to be sure, and, as Alexander Woollcott wrote, it was Berlin's "Alexander's Ragtime Band" that "set the shoulders of America swinging with syncopated jubilance." The one-step was danced to the rags that Joplin and his contemporaries played, and in general it was looked down upon by God-fearing white folks who lived on farms and in towns and by city folk who regarded themselves as custodians of public morals and defenders of decent social behavior. Ragtime, Mark Sullivan records, was considered to be "vulgarizing the young, undermining respect for sacred things, and . . . 'responsible for deterioration of manners, taste, and right thinking.' " With admitted skepticism he refers to a story (it may have been a reporter's fantasy) in the New York *Sun* of May 29, 1912, which "described the turkey-trot as 'taboo at the office of the Curtis Publishing Company; fifteen young women were dismissed today after they had been detected enjoying the suggestive dance at lunch time by Edward W. Bok, editor of the *Ladies' Home Journal.*' "

Whether the story about Mr. Bok's explosive indignation is true or not (he was an ardent crusader for "good taste"), there is a bona fide record of a trial in Paterson, New Jersey, at which "the court imposed a fifty-day prison sentence (as the alternative of a $25 fine) on a young woman for dancing the turkey trot." Another complaint was brought by a judge in Millwood, New York, who disliked hearing a young woman sing "Everybody's Doin' It Now" and seeing her dance the turkey trot as she went past his house. In this instance the young woman's lawyer got the court's permission to sing a chorus of the song for the jury. The spectators in the courtroom joined in, and the jury called for an encore. "Again taking out his tuning fork to pitch the key," Sullivan reports, "the lawyer sang the second stanza with more feeling and expression, and as he sang he gave a mild imitation of the turkey trot." The jury was delighted, clapped vigorously, and quickly concluded that the defendant was not guilty of a misdemeanor.

The ragtime composers no more contrived the physical movements of the dances that were done to their music than Stravinsky designed the choreography for *Firebird* or *Petrouchka,* except, of course, that in both cases the physical performance was a reaction to the musical rhythms and forms and reflected their moods. The rag steps were called "animal dances"

The Maxixe, here danced by the theatrical producer John Murray Anderson and his wife, was a hit in 1914, part of the "dance mania" that had America gyrating in the early days of the Jazz Age. It reached its frantic peak with the Charleston and the Black Bottom in the 1920s.

—the horse trot, the chicken scratch, the bunny hug, the kangaroo dip, the camel walk, the fish walk, the crab step, and the lame duck. The animal dance that persisted was the foxtrot, a rapid, sure-footed dance of short steps with ample opportunity for variations (the hobble skirt unquestionably had something to do with the short steps), as contrasted with the turkey trot, which was "a springy walk with little or no bending of the knees, and accompanied by a swinging motion of the body with shoulder movements up and down." The turkey trot was popular when skirts were full and topped with shirtwaists.

Americans are footloose in far more important ways than how they shuffle their feet and kick up their heels to dance bands. Their restlessness, their mobility, both social and geographical, played an important role in the history of jazz, a word which popularly encompasses a number of kinds

of music that strictly (perhaps pedantically) speaking are not jazz at all. When the War and Navy departments, under pressure from whom I do not know, insisted that Storyville, the red-light district of New Orleans,* be closed down in 1917, a great many out-of-work "professors" of the piano, horn players, drummers, guitarists, bassists, and banjoists took off for other parts of the country. Some stopped in Kansas City and Oklahoma City, which had their own lively jazz traditions; some went on to the West Coast, and many headed for Chicago and stayed there. Jazz was, and is, an urban art, and it thrives in crowded places. Its fire spread rapidly and soon it was accepted at every level of society, if not by every standard of morality or tradition of musical purity.

Jazz was a child of New Orleans, of blacks and Creoles, and it was there that the jazz band emerged in the 1890s from the Negro bands that played for parades, that whooped it up for merchants in advertising wagons, with the slide trombonist sitting on the tailgate (hence "tailgate" trombone), that played for weddings and solemnly accompanied the mourners to the graveyard and played the music hot on the way back. They improvised on familiar march tunes, they ragged them, they played them hot ("Hot means something spicy," Jelly Roll Morton said), and they had the instruments on which to perform, the residue from Civil War bands, bought cheap. These were the true progenitors of jazz bands, though no one seems to be sure how they came to be called that or where the word "jazz" came from. Like ragtime its etymology is more obscure than its musical origins.

F. Scott Fitzgerald was quite sure of its evolution, how it changed, and what it became by the 1920s and "the jazz age." "The word jazz," he wrote in *The Crack-up*, "in its progress toward respectability has meant first sex, then dancing, then music. It is associated with a state of nervous stimulation, not unlike that of big cities behind the lines of a war." Ralph Ellison, the novelist, who was once a jazz trumpeter, when I asked him about the origin of the word, said, "It meant 'screw.' " It has been traced variously to "a corruption of the Elizabethan *jass* which had survived in the vernacular of bawdy-houses," and to a probably mythical New Orleans drummer named Charles and nicknamed Chaz. Jelly Roll Morton told Alan Lomax, his biographer, "Ragtime is a certain type of syncopation and only certain tunes can be played in that idea. But jazz is a style that can be applied to any type of tune. I started using the word in 1902 to show people the difference between jazz and ragtime." In any event the first advertised

*Storyville was named for an alderman, Sidney Story, who in 1896 "initiated the city ordinance to have this section of the city set aside for organized vice."

Ferdinand "Jelly Roll" Morton, "the inventor of jazz," started his career as a child playing piano in the sporting houses of New Orleans, where, he said, "the birth of jazz originated from." He was twenty-two when in Chicago he sat still for a moment for this photograph.

public use of the word was in 1915, when a New Orleans band turned up in Chicago and played at the Lamb's Café and called itself "Brown's Dixieland Jass [sic] Band." Two years later the *Literary Digest,* a nationally circulated weekly that was neither literary nor a digest, as those words are now used in magazine parlance, noted that "a strange word has gained widespread use in the ranks of our producers of popular music. It is 'jazz,' used mainly as an adjective descriptive of a band."

The spirit and the style were there long before the name. Charles ("Buddy" also called "King") Bolden's band was the most famous in New Orleans in the 1890s, and in it Bunk Johnson played second cornet to Bolden's first. Bolden, by legend a prodigiously expert and imaginative performer on his horn, was unable to read music, and according to Johnson, "Here is the thing that made King Bolden Band be the first that played jazz. It was because he did not read at all." Improvisation was the blood

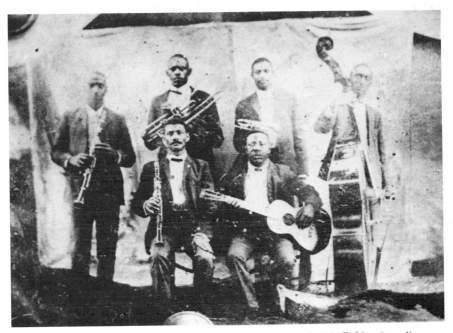

This is the only known photograph of the early jazz legend Buddy Bolden (standing second from the left) with one of his bands in the early 1890s. It is said that in New Orleans he had as many as seven bands playing in different halls at the same time, and would make the rounds blowing his trumpet fit to raise the dead.

and bone of jazz, and in the classic, New Orleans jazz it was collective improvisation in which each performer, seemingly going his own melodic way, played in harmony, dissonance, or counterpoint with the improvisations of his colleagues. Quite unlike ragtime, which was written down in many cases by its composers and could be repeated note for note (if not expression by expression) by others, jazz was a performer's not a composer's art. More often than not bands were not organized; they happened by a kind of spontaneous combustion, the accidents of who happened to be on hand at any given moment, and after the musicians had finished their night's work in the sporting houses they would sometimes meet in one of the houses and play the rest of the night and into the middle of the next day. When Buddy Bolden wanted to get a group of musicians together to play for a party in Lincoln Park, "He'd turn his big trumpet around towards the city and blow his blues, calling his children home," and the boys would grab their instruments and come running. Most of the jazzmen, as they later came to be called, practiced trades for a living and played partly for the pleasure of it, partly to add a few dollars to their wallets. (The leader of a pickup band would get $5, the others $2 or $2.50.) They were

barbers and painters and cigar makers; they worked as butlers and long-shoremen and tinsmiths. To some music was a refreshment and a release, to others it was the core of their being and their trades were their anchors, their ball-and-chain. Life was frantic and often dangerous in the sporting houses, from the cheap, two-bit brothels to the mock-elegant and fancy "mansions," where light-skinned Creole girls catered to white sports and the only blacks to frequent them were the hired musicians.

The earliest jazz is preserved only in the published memoirs of those who played and heard it. It was Edison's experiments with the talking machine that led, some thirty years after Bolden's first jazz band, to the capture and dissemination of what once mingled briefly with the sounds of laughter and dancing feet and the clink of glasses, and disappeared for good along with the cigar smoke and perfume of the honky-tonks. Jazz began to move out of New Orleans soon after 1909, when Bolden "went crazy because he really blew his brains out through the trumpet." Freddie Keppard, whom Morton called "the greatest hot trumpeter in existence," organized in 1908 what Morton called the "first Dixieland combination," five pieces—a trombone, cornet, clarinet, drums, and piano. A few years later he took his Olympia Band (which, among other "legendary" performers, included Sidney Bechet on clarinet and Joseph "King" Oliver on cornet) on tour for five years (1912–17) and got as far afield as the Pacific Coast. Oliver replaced Keppard, who, according to Jelly Roll, "always was after women and spent every dime he had on whiskey," before the tour was over. Oliver's reputation, unlike that of Bolden and Keppard, is based not just on legend and hearsay but on some thirty-five recordings which are basic documents of classic jazz. He played with his own Creole Jazz Band in Chicago off and on for ten years between 1918 and 1928, and then took off for New York. "King Oliver was so powerful," Louis Armstrong, who played with him in Chicago, wrote, "he used to blow a cornet out of tune every two or three months."

A rather blurred distinction is drawn between Dixieland and classic New Orleans jazz, and it is at least partly one of color, physical and musical. Dixieland was originally white jazz, and it dates back to the first (or said to be the first) white ragtime band, led by Jack ("Papa") Laine in New Orleans in the early 1890s. The "jass" band that Tom Brown took to Chicago in 1915 was also a white band, and had already made a splash there before King Oliver's arrival three years later. Still another white group, which called itself The Original Dixieland Jazz Band and played briefly at the Casino Gardens, left Chicago and in 1917 swept into Reisen-weber's Restaurant on Columbus Circle in New York. It created a sensation from which the city has not yet entirely recovered. (Jazz that goes by

the name of Dixieland is still heard in Manhattan every night of the week, and the men who play it are by no means segregated by color.) Indeed, the world has not recovered. It was The Original Dixieland Band that, according to one historian, "carried jazz into world markets," made it commercially viable, caused it to be taken up by the recording companies and Tin Pan Alley, and in forms that its connoisseurs consider impure, changed the nature of popular music. Dixieland was not, of course, a white band "exclusive." The greatest Dixieland bands were black, as were almost all of the greatest individual virtuosi of the trumpet, saxophone, clarinet, piano, and strings. The magic of the pure New Orleans jazz bands was in their improvisation, their collective inventiveness, their seemingly unerring ability to go their separate ways while never losing touch with the basic harmonic structure and rhythm of the music or with each other. There are those critics who contend that, when the performers learned to read notes and depend on them, what was good and pure about New Orleans jazz gave way to competitive and egotistical solo playing, cut loose from the traditions of the native American black music and fussed up with European mannerisms.

Chicago, where "you could go anywhere you wanted regardless of creed or color," became the principal center of jazz as performers figuratively "moved up the river" from New Orleans and Memphis and St. Louis, though few of them except those who played in river-boat bands came by water.

During the First World War there had been a mass migration of blacks from the South to cities in the North where there were industrial and service jobs hungry to be filled. In a period of five years about fifty thousand of the half million who moved north settled in Chicago. Duke Ellington, when he went there with his big band in 1930, found "a real us-for-we, we-for-us community . . . a community of men and women who were respected, people of dignity . . . everything and everybody but *no* junkies." This was the Chicago of Al Capone and the racketeers who in the 1920s controlled the night spots as well as the booze and music they marketed. The jazzmen who entertained the customers played hot (Jelly Roll complained that "some people play like they want to knock your ear drums down") but they kept cool or felt the savagery of the white hoods who let them work and whose "protection" they needed.

The "Chicago style" (and there are critics who, while praising the vitality of what went on in jazz in Chicago in the 1920s, question that it can be called a "style") is said to have "derived from listening to the early New Orleans emigrants." There was an eruption of enthusiasm of very young white musicians, "high school kids," many of them, who hung on

the notes of the jazzmen from the South and played their records until they were worn out. They had their own bands, and they made records full of impudent and inventive vitality and drive. Among the young men then in Chicago who went their own distinguished ways were Jimmy McPartland, Lionel Hampton, Bix Beiderbecke, Gene Krupa, and Benny Goodman. In general the Chicago School seems to have had about as much cohesiveness in style as the Ash Can School, which, as we have seen, was a tag for a disparate group of New York painters who happened to be interested in the urban landscape and were friends. If the styles differed, they had in common a time and place and similar circumstances of performance. They also shared, like the painters, a common artistic tradition.

If ragtime was a collateral forebear of jazz, the blues were its legitimate parents, whose genes determined its corpus and its character. "There would be no jazz without the blues," Martin Williams wrote, "or, to put it a bit differently, without the blues jazz would be a sterile music." As ragtime was fading in popularity and in vitality of invention and New Orleans jazz was first getting under the public's skin, there was a "blues craze." W. C. Handy, a more than adequate performer on the cornet with some formal musical schooling, has been called "the father of the blues," but was not, anymore than Jelly Roll Morton was, as he claimed, "the inventor of jazz." But Handy, like Morton, was an innovator, and like Morton's, his music was magnetic and drew millions of people to it. He was essentially responsible for making the blues, born and nurtured as an essential ingredient of black musical culture, a significant part of what has come to be called mass culture. "The blues," Handy wrote, "is a thing deeper than what you'd call mood today. . . . The blues comes from the man furthest down, the blues comes from nothingness, from want, from desire, and when a man sang or played the blues, a small part of the want was satisfied from the music. . . . The blues goes back to slavery, to longing." Ralph Ellison said, "The blues is an impulse to keep the painful details and episodes of a brutal expression alive in one's aching consciousness, to finger its jagged grain, and to transcend it . . . by squeezing from it a near-tragic, near-comic lyricism."

The blues, to put it differently, were spontaneous folk songs, as universal in the South as spirituals, closely allied to gospel singing, but often filled with irony and humor as well as despair. They were not political, not complaints against the black man's lot but against any man's lot, concerned not with man's social condition but with his fate, with his loves gained and lost, with weariness of spirit and of body. Hugues Panassié, the French jazz historian, says of the blues that "they bear very definitely the stigma of the yoke of slavery to which the black races were subjected in the U.S.A." But

Albert Murray, in his remarkable book *Stomping the Blues,* finds this "gratuitous for all its unquestionably good intentions." The blues, he writes are "a synthesis of African and European elements in an American main-land situation," and he emphasizes that the blues are not just "a type of mournful, haunting, Negro folksong," but are often a lively, toe-tapping, get-up-and-swing kind of music. Folk music everywhere in every nation has its blues elements. They are as characteristic of Portuguese *fado* as of much country-and-western. Negro blues, it is believed, were originally a kind of "slow, rhythmic chant or lament," but by the time the blues became generally known in the teens, they had established a basic form of twelve bars. If not rigid in their lyric verses and musical structure they were consistent enough to be recognized as quite different from ragtime and from jazz. Essential to the blues' character was the "blues scale" with its "bent" or flattened or quavered notes, echoes of African music, that gave a minor quality, often but by no means always mournful.

If Handy was not the father of the blues, he transformed them (some critics would say degraded them) into a music that spoke and still speaks to a vast and raceless audience. He used melodies that he gathered in his boyhood, and he heard music everywhere. ("Whenever I heard the song of a bird and the answering call of its mate," he wrote, "I could visualize the notes in the scale. Robins carried a warm alto theme. Bobolinks sang contrapuntal melodies. . . . There was a French horn concealed in the breast of the blue jay. . . . The bullfrog supplied an effective bass." He played with pickup bands from the time he was a child, much against his preacher-father's wishes. ("Son, I'd rather see you in a hearse. I'd rather follow you to the graveyard than to hear that you had become a musi-cian.") He left the town of Florence, Alabama, where he was born in 1873, and rode the rails, worked at laborer's jobs, played his cornet or guitar, when he was given a chance, in bars, at parties, with minstrel shows. By 1903 he had a band of his own, and six years later when he was thirty-six he wrote a piece called "Mr. Crump" to promote the ambitions of a Memphis politician who had hired Handy's band to whoop it up for his candidacy. Three years later the piece was published as "Memphis Blues," and two years after that in 1914 Handy established himself indelibly in the history of American music with "St. Louis Blues." This piece made a bridge between the dying popularity of ragtime and the emergence of jazz, and in musical terms between the free-flowing form of the traditional blues and the rigid sixteen-bar strain that is the basis of most popular songs and what a purist called "the pseudo blues of tin-pan alley."

The blues that Handy produced were something between lowdown and genteel, neither too tough nor too tender, which made them palatable

to a large audience and especially to the young. Mark Sullivan refers to this kind of blues (it seems unlikely that he knew the original blues) as "a kind of gargoyle on the cathedral of American music," though he apparently had nothing particular against gargoyles or anything particular in favor of cathedrals. It was the norms of taste that interested him. It was only ten years later that the blues donned white tie and tails and George Gershwin's "Rhapsody in Blue" was performed by Paul Whiteman's orchestra in Aeolian Hall in New York as part of a program pretentiously and inaccurately called "Experiment in Modern Music." The blues had gone genteel.

Paul Whiteman, popularly and erroneously called "The King of Jazz," conducted this sweet-sounding "orchestra" (he didn't call it a band) in "Experiment in Modern Music" at the Aeolian Hall concert on February 12, 1924. It was on that evening that George Gershwin first performed his *Rhapsody in Blue,* composed for the occasion.

So in some respects had jazz, but not the true jazz, whose roots stayed in New Orleans. It was so-called "commercial jazz," the products of New York's Tin Pan Alley, the sweet jazz of the musical comedies, the vaudeville stage, and after 1932 the movies that charmed vast audiences. It

provided the melodies and rhythms that debutantes and prom trotters and dancers of all ages and most classes dreamed and necked and swooned and shuffled their feet to in the foxtrot or kicked up their heels to in the Charleston. Classic jazz and Dixieland were tough and stayed tough and true to their origins through the 1920s.

In some respects Jelly Roll Morton was to classic jazz what Handy was to the blues. He brought to a traditional but not static music a new sense of form, an analytical intellect that encompassed its subtleties, a musicianship that could enlarge its harmonic possibilities, and a dexterity and inventiveness with instruments, especially the piano, that could give the music new tonal qualities and a swinging vitality. Morton's biography is a ragged romp through whorehouses, pool halls, pimping, gambling; a melodrama of arrogance and bitterness, of dust and diamonds (he had one implanted in a front tooth), of flights of fame and fortune, of times of penury and neglect, and finally of revived fame if not fortune. It is about as important to his contribution to music as the murder of Stanford White by a jealous husband, which was the best-known thing about him, was to architecture.

Morton was a Creole born in New Orleans in 1885, seventeen years younger than Scott Joplin, twelve years younger than Handy. The fact that he was a Creole was a matter of pride to him in a society where shades of color were regarded as measures of social status. But, when he was a young man, it was his dexterity and style as a "professor" at the piano that set him apart from many other gifted Negro musicians of New Orleans. He played in sporting houses that catered to whites, and black musicians other than professors were not permitted to enter those doors. "Piano keys opened doors into a white world where the other boys in the band could not follow," Alan Lomax wrote in *Mister Jelly Roll.* Morton was a wanderer, whose wizardry at the piano and devastating skill with a pool cue could get him a living, often a flamboyant one. "I can always play up some food and a place to sleep," he said.

In 1907 he headed for Chicago, where, he told his biographer, "there were more jobs than I could ever think of doing, but these jobs paid much less than in New Orleans so I decided not to stay." He moved on to Texas, from there to California, then back to Memphis and a string of southern towns and cities, and in 1911 he went north to New York, but not for long. For several years he was in Los Angeles, and then went back to Chicago in 1922. It was there that he organized his recording band, Jelly Roll Morton and His Red Hot Peppers, and with them made recordings of, among others, "Doctor Jazz," "Sidewalk Blues," "Grandpa's Spells," and "Bottom Stomp." Of them Lomax said, "There may be more deeply emo-

tional and moving jazz records . . . but none more subtly designed and brilliantly executed, none with such a rich rhythmic and harmonic texture, none touched with such true fire." It was in Chicago, too, that he fell in with the Melrose brothers, who published twenty-six of his tunes in the next decade (they bought all rights for a flat fee). Among them were "King Porter Stomp," which Benny Goodman in the 1930s made into a hit with an arrangement by Fletcher Henderson; "Dead Man Blues," King Oliver's standby; and "Milenburg Joys," Jelly's most famous piece, which everybody played. By the later twenties and early thirties Morton and his Red Hot Peppers were playing at proms and in hotel ballrooms and were the hottest, in several senses, band in the Midwest.

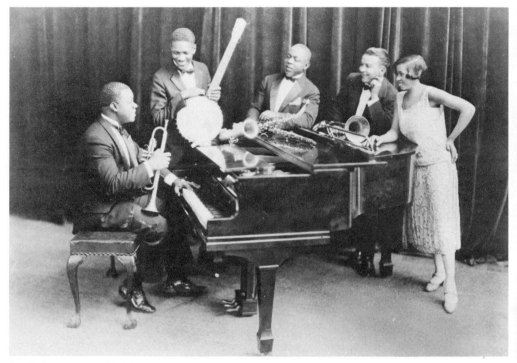

Louis Armstrong with his trumpet and his Hot Five—including Johnny St. Cyr, banjo; Johnny Dodds, clarinet; Kid Ory, trombone; and Armstrong's wife, Lil Hardin, who was the organizer of the group and the pianist. This photograph was taken in Chicago in 1927 when Armstrong was twenty-seven.

Fifteen years younger than Morton, Louis Armstrong (1900–71), who learned to play the trumpet in a home for wayward boys in New Orleans (he was picked up for firing his father's pistol at a New Year's Eve celebra-

tion), turned up in Chicago in 1922, summoned by King Oliver. He had made a reputation playing with Kid Ory's Brown Skinned Babies in 1918 and in riverboat bands on the Mississippi, and he was twenty-two when Oliver picked him to play second trumpet. His was a career that nothing could stop. In 1923 he married Lillian Hardin, a composer, arranger, and pianist, who was also an organizer. Briefly in 1924 he joined Fletcher Henderson's big band at Roseland in New York (Coleman Hawkins, "Hawk," one of the great saxophone virtuosi and innovators, was also in the band). Then he came back to Chicago and made recordings with "Louis Armstrong and His Hot Five" and his "Hot Seven" and with a group organized by his wife, "The Dreamland Syncopators." By 1929 his reputation as a trumpeter of unparalleled imagination, and as a singer with a gravelly voice as hot and nearly as inventive as his instrument, was secured by his records, not just in America but with the rapidly growing jazz audience abroad. In 1932 he took the band he had put together in Chicago to Europe and toured there for three years, as important and as influential a cultural export as any that America made before the Second World War, and quite possibly has made since.

Armstrong's contribution to the development of jazz was partly that of stylist and innovator, partly one of pure virtuosity, both technically and imaginatively, and partly one of showmanship. There was a strong streak of ham in Armstrong, and his comic patter and posing, while it endeared him to many, embarrassed others, including Benny Goodman who thought his music superb and his "horsing around" catchpenny, corny, and unworthy of him. From the historian's point of view, he was "more responsible than anything else for the fact that jazz irrevocably became not so much a collective ensemble style [as it was in classic New Orleans jazz] as a soloist's art." He was the bridge, moreover, between Dixieland and swing, the next important development in jazz. As Martin Williams has written, he "inspired musicians of all kinds all over the world. Within jazz, he inspired composers and arrangers of all kinds, ensembles both large and small, and individual soloists on all instruments." Eric Larrabee said, "His trumpet spoke with a voice after which nothing else sounded the same. He transformed the sensibility of jazz, in musical terms, but with such clarity that no listener could mistake it then or since." To Duke Ellington, who was born the year before Armstrong and outlived him by a few years, "Louis Armstrong was the epitome of jazz and always will be." And he added, "I loved and respected Louis Armstrong. He was born poor, died rich, and never hurt anyone on the way."

A dance step casually introduced at the Savoy Ball Room in New York's Harlem might find its way around the world in six months. The Savoy was the mecca of the big swing bands from 1926 to 1959 and the inspiration for Edgar Sampson's still popular "Stompin' at the Savoy," first played in 1934.

Blues, Boogie-woogie, Swing

The number of Americans who heard jazz not on records but at first hand was very limited indeed. The real jazz was being performed in what to most good citizens were disreputable places—nightclubs, speakeasies, roadhouses, dance halls, and other "low dives" of one sort or another. The prosperous young, who cavorted in the Jazz Age and who were the despair of their shocked and anxious parents, drove, especially if they lived in the suburbs or the country, in their roadsters or touring cars to roadhouses—restaurants and speakeasies with small bands and napkin-size dance floors. Ostensibly one had to have a card to get in, but a self-assured look was usually enough to convince the man who peered through the peephole in the door. In the more expensive roadhouses colored lights played on a revolving, many-faceted, mirrored ball above the dance floor and cast flickering patches, like an animated stained-glass window, on the walls and

on the customers who sat at their little tables, sometimes with their liquor in teacups, and on those who jostled each other on the dance floor. (It was a primitive version of what in the 1960s became "light shows," usually with strobe lights, that were sometimes exhibited as avant-garde art in museums.) In most such places the music was a sweetened and diluted version of jazz—a far cry from Morton's Red Hot Peppers or Armstrong's Hot Seven. The tunes were from musical comedies and Broadway "revues"— the *Ziegfeld Follies* or *George White's Scandals,* or *The Garrick Gaieties.* It was the era of tunes like "Tea for Two," "Indian Love Call," "Who?" and the perennial "Alexander's Ragtime Band." It was also the time of hip flasks and bathtub gin and bootleg booze "right off the boat," when young women affected short skirts and the "boyish form" or "flat-chested" look, when young men in bell-bottom trousers and brilliantined hair played the ukulele or, if they were clever enough, the banjo. (The mandolin went out of fashion before World War I and the guitar wasn't to become a youthful status symbol for at least another thirty years.) They knew the words of the popular songs by Irving Berlin ("Always"), Cole Porter ("Let's Do It"), George Gershwin ("The Man I Love"), Rodgers and Hart ("My Heart Stood Still"), and Walter Donaldson ("Yes, Sir, That's My Baby"). (Everyone knew Paul Whiteman's twelve-inch record of Donaldson's "At Sundown" with its "smooth" trumpet solo, which was regarded as "perfectly swell.")*

A good deal of this music was heard from a distance by the young necking in their cars in the dark privacy beyond the porch lights of the country club. (There were no radios in cars then.) Or they heard it on the phonographs which they cranked by hand in the family living rooms (where they rolled up the rugs to dance) or on nickel-in-the-slot player pianos (the precursors of the ubiquitous juke boxes) in the short-order restaurants which began to dot the highways in the 1920s. In 1921 Americans bought more than 100 million gramophone records; they spent more money on them than on any other kind of recreation. Records all but put out of business the manufacturers of player pianos, which had been so popular in the first decade of the century and until the First World War, and which had introduced ragtime to so many people who would not have thought of going into the dubious emporiums where it was a steady diet. Almost all of the early jazz disks were sold as "race records," and they were aimed primarily at the Negro market. They were cheap to make (the

*Almost all jazz, dance, and popular song records were ten-inch disks and lasted for about three minutes, a musical fact of life which played an important role in the shape of the music. Twelve-inch "popular" records were rare, though most "classical" music was on twelve-inchers, which lasted about six minutes.

musicians got about $5 each for a session, with $10 for the leader) and cheap to distribute. The first recordings of King Oliver; Bessie Smith, the great blues singer; Jelly Roll; Louis Armstrong; and Duke Ellington were all sold as race records, "guaranteed to put you in a dancing mood" and "tickle your toes." But they quickly jumped the borders of the Negro communities (which were not called "black ghettos" in those days) and spread by the millions everywhere.

The depression of 1921, which we would call a recession today, put a crimp in the record business, and the arrival of commercial radio almost did it in, but only temporarily. As we noted earlier, the first commercial broadcasting station, KDKA went on the air in Pittsburgh in 1920. Two years later there were more than two hundred stations, and receiving sets occupied the evenings of some three million households, many of the listeners with earphones clamped to their heads, as speakers were not yet in general use. In 1926 there were nearly seven hundred stations and by 1931 approximately fifteen million sets. It is recorded that during this period more than three-quarters of broadcasting time was devoted to music, most of it to popular tunes and commercialized jazz. (One "serious" musician called radio "De Forest's prime evil"; they resented the static that interfered with their performances and they deplored the instrument as a threat to their livelihoods.) The most popular musical broadcasts were the sweet sounds of "The Cliquot Club Eskimos," "The Ipana Troubadours," and the "A & P Gypsies," promoting respectively ginger ale, toothpaste, and groceries.

Jazz evoked a moralistic counteroffensive much as ragtime had. It was regarded in strait-laced, middle-class, and predominantly Protestant circles as responsible for the ostensibly outrageous behavior and collapsing morals of the nation's youth. Since records had spread jazz everywhere and its low origins were not for a moment forgotten, it was looked upon in some quarters as a disease of epidemic proportions, a plague, indeed, a scourge. It was equated with sexual promiscuity and hard drinking. Any popular music, no matter how watered down by polite jazz bands and crooners, male and female, if even remotely connected with the genuine article, was considered jazz, and was therefore deeply suspect. Jazz was blamed for the increase in illegitimate births and an alarming increase in white slave traffic (one frantic source reported with dubious accuracy that "65,000 girls had disappeared from the United States in 1921 'without leaving a trace,'" and a clergyman declared that "in 1921–22 jazz had caused the downfall of 1,000 girls in Chicago alone"). The music journal *Etude* declared that "Jazz at its worst is often associated with vile surroundings, filthy words, unmentionable dances and obscene plays." Its editor might have been

accurate if he had said "at its best"—at least in its origins. It was called "nigger music" and "whorehouse music" by those who deigned to sully their lips with such epithets.

One aspect of the evil of jazz was embodied in the saxophone, which in the 1920s and '30s was widely vilified. W. C. Handy, who loved the instrument, said that "the tenor sax . . . moaned like 'a sinner on revival day' " and found it the perfect interpreter of the blues. On the other hand, Sullivan accounted for its popularity among the young by the fact that it could imitate "the yowl of a cat, the baa of a calf, the whinny of a horse . . . a yawn, a grunt, a belch." It was not the comic but the sensuous sounds that bothered the elders. To them it was "music in the nude." The saxophone was as alarming as the husky voice of Libby Holman singing "Moanin' Low," "Body and Soul," and "Am I Blue?" or the plaintive, small, but "dirty" voice of Helen Morgan, wondering "Why Was I Born?" or the voice of the gangster's moll Ruth Etting, with her sultry ballads, "Ten Cents a Dance" and "Mean to Me."

The popularity of the blues, primarily, but other jazz as well, in the twenties has been explained as the natural reaction of youth to the disillusionment that followed the world war, the aimlessness, the disregard for law (almost everyone seemed to be in cahoots with the bootleggers), to the cornucopia that would never be empty but whose fruits were tasteless. Handy explained it this way:

> In the first World War, all Americans got a taste of what we had had for years —people being torn from their families and sent to far away places, sometime against their wishes, and blues and jazz began to have more meaning for more people. Then the depression [of the 1930s] was a new experience for many. But we had been hungry for years and had known hunger and hurt. So the blues helped to fill the longing in the hearts of all kinds of people.

But if the blues of the twenties and thirties were melancholy, swing, which took over from Dixieland, was frenetic, essentially joyful, and physically intoxicating.

In the winter of 1937–38 Benny Goodman and his big band, by then the delight of a tremendous audience that knew them from the radio and records, were booked at the Paramount Theatre in New York. So many teenagers turned up that the local precinct had to dispatch ten mounted policemen to Broadway and Forty-third Street to keep the crowd in order while they waited in the cold for the doors to open at eight in the morning. The Paramount was a movie palace of unparalleled splendor, which challenged credulity when it opened in 1926, the latest in a splurge of ornate, luxurious, awesome temples of the silver screen, with crystal chandeliers,

When Benny Goodman, "King of Swing" (standing at the left), played with his big band at the Paramount (movie) Theatre in New York in January 1938, the police were called out to keep the crush of his enthusiasts outside the theatre in order. Once inside they danced in the aisles and on the stage. The "GK" on the bass drum is for the great drummer Gene Krupa.

deep carpets, gilded prosceniums, Wurlitzer organs, and murals. Such theatres had first started to appear in 1914, when the Strand astonished even New Yorkers with its ostentation. It was part of the attraction of these palaces that they not only gave "first run" to Hollywood's latest offerings but that the films were preceded by "stage shows," a form of variety entertainment left over from the great, but then waning, days of vaudeville. Benny Goodman and his band were the heart of one of these shows. This was just one of many famous swing bands (the traditionalists called them "Mickey Mouse bands") that played as special attractions in movie houses, many of which in the thirties were converted legitimate theatres. Goodman made headlines that winter because the young shrieked and swooned and danced in the aisles of the Paramount, with an unprecedented display of what seemed to be teenage tribal rituals, inspired by worship for "the King of Swing."

Goodman was one of the boys who had hung around the bandstands in south Chicago listening to Dixieland in the teens and twenties, and his first paying jobs were on excursion boats on Lake Michigan. He was sixteen then and already a prodigiously gifted and expert clarinetist, equally proficient in jazz and "classical" music. When he was twenty-five, a veteran of Ben Pollack's Chicago Band and Red Nichols's Five Pennies, he formed a band of his own with the encouragement of John Henry Hammond, Jr.

Hammond was a professional (he still is at this writing) of a kind who played a very special and particular role in the spread of jazz and in the preservation of its history. He was an "A. and R. man" (Artists and Repertory) for recording companies, several of them, and something more than that. He was a year younger than Goodman and born to wealth. He latched on to jazz as a schoolboy, and as an undergraduate at Yale (he left after his sophomore year to pursue the swinging muse) he began to collect jazz records. He is said to have bought three of each: one to play, one to hold in reserve if the first one wore out or got broken, and the third to be kept unplayed in mint condition, a practice which stood him in good stead when the time came to transfer the 78s to long-playing records in the late 1940s and early '50s.

He was a jazz historian and critic, a promoter, an organizer, and a discoverer of talent. It was he who brought Count Basie to New York with his "Kansas City sound." ("I don't go for that two-beat jive the New Orleans cats play," Basie said, "because my boys and I got to have four heavy beats to the bar and no cheating.") It was Hammond who broke the color barrier on New York's Fifty-second Street, which, in the thirties was the jazz mecca. He booked Basie into a night spot called The Famous Door and offered to pay for installing air-conditioning if he was allowed to get a good table and bring black guests. So far as jazz "downtown" was concerned, Fifty-second Street in the thirties and forties was "where it was at" for the true believers. The Onyx, Jimmy Ryan's, and Eddie Condon's were just down the street. (By this time Prohibition and speakeasies were things of the past, and radio broadcasts of jazz were emanating from Fifty-second Street.) It was Hammond who "found" Billie Holiday, regarded by many as the greatest of jazz singers, and it was he who was responsible in the thirties and forties for launching the vogue for boogie-woogie, a piano style with variations played on a blues theme over a constantly repeated bass. The story is that he found a record in a junk shop called "Honky Tonk Train Blues," composed and played by a pianist named Meade Lux Lewis. He tried for two years to find Lewis, and when he was on a talent search in 1936 in Chicago, he heard a pianist, Albert Ammons, who sounded like Lewis and who turned out to be his "very best

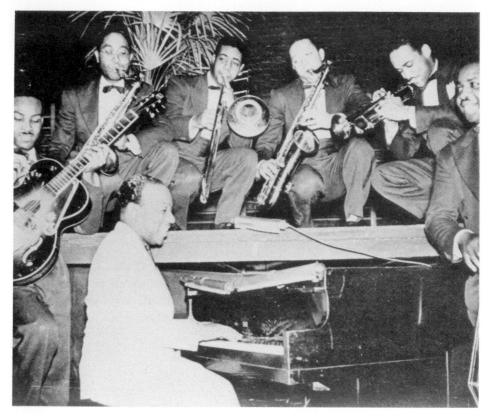

A radio announcer first called Bill Basie "Count" because Bill sounded commonplace. This photograph was made in 1937 when Basie, who epitomized Kansas City jazz, made his first records for Decca. When he died forty-seven years later in 1984, he was mourned as a "master of swing" and as one of the subtlest of jazz pianists.

friend." Lewis was working in a taxi garage, and Hammond persuaded him and Ammons to go to New York with him. When the night club Café Society opened in 1938, Lewis and Ammons and a pianist from Kansas City, Pete Johnson, played boogie-woogie to astonished audiences and started what one critic has called "the whole modern rumpus."

Jazz Becomes Respectable

If the fashion for boogie-woogie was relatively brief, swing dominated the jazz scene up to the Second World War. Goodman's Carnegie Hall concert on January 16, 1938 (it was Hammond who suggested and organized it), was by no means the occasion that launched swing. It had been growing at the hands of Louis Armstrong and Count Basie and a legion of others. Fletcher Henderson, a pianist from Georgia, was more responsi-

ble than anyone else for what the big swing bands came to sound like—big, disciplined, sophisticated, and subtle. Henderson was an arranger with few peers, and one of jazz's most thoughtful historians has written of him: "Henderson's music, its effect, and its influence were an important cultural event in American (and world) history." What the Goodman concert achieved was to mark a new kind of acceptance for jazz. The stigma of jazz's association with low life, if not erased (jazzmen were proud of the heritage if not the habitats of jazz in the early days), most certainly had a polite if transparent curtain drawn across it. This was a kind of respectability that musicians like Goodman and Duke Ellington, the cleverest and musically most sophisticated of all the big band leaders and a composer unequaled in the annals of jazz (and some say of all American music), had striven for. Jazz was a serious not a frivolous business.

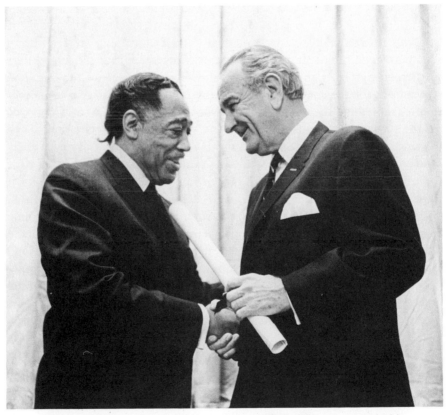

"When President Johnson was in the White House," Duke Ellington wrote in his autobiography, "I had the pleasure of being invited seven times, twice to entertain." This visit was on November 21, 1968. He also played there for Presidents Truman, Eisenhower, and Nixon, who awarded him the Medal of Freedom in 1969.

There are critics who contend that Ellington is "outside the tradition of jazz entirely." But no one can say that he did not evolve from and develop in its tradition, or, indeed, that he did not add his own sturdy structural members, dimensions, and subtle ornaments to its architecture. He was not only an accomplished performer on the piano but "he composed with an orchestra in a way no one else knew how to, using tone colors as others used solo instruments." He not only held together for years a remarkable group of musicians but he delighted audiences of all degrees of sophistication and innocence. Martin Williams called him "the great composer-orchestrator of jazz, and the great leader of the large ensemble, the master of form in jazz and the great synthesizer of its elements." He stood a little aside from the other jazzmen of his time, neither quite one of them nor aloof from them, a jazz aristocrat and intellectual, an innovator and refiner, the organizer of a subtle revolution accomplished without tumbrils.

If the line between jazz and popular music ("commercial jazz") is drawn with a chisel by scholars and dilettantes, in the public view it is fuzzy and with good reason. It was the jazz musicians as much as the songwriters of Broadway, Tin Pan Alley, and Hollywood who blurred the line, and they did it for the commonest of reasons. They wanted to make a decent living, something the honky-tonks did not provide them. Artie Shaw, one of the most famous of big band leaders, who, like Benny Goodman, was called a "white popularizer," said of his fellow musicians, "I never knew one of them who didn't feel exactly the same as I did about what we were doing. Which could be put in the following words, 'Sure it stinks, but it pays good dough so the hell with it.'" It has been said by Nat Hentoff, a critic and reporter of impeccable credentials, that while "most young players feel that jazz has become primarily to be listened to rather than a background for dancing or drinking," it was in dance halls like Roseland and the Savoy Ballroom, in nightclubs and bars, in theatre pits, on radio, and at college proms that musicians had to make their living. Commercial jazz, in other words, replaced ragtime and New Orleans and "classic" jazz as the people's music, and jazz became a far cry from what it had been in the days of the Storyville of Joplin, the Chicago of King Oliver, and the Kansas City of Count Basie; it became concert music listened to for its subtleties, its solo performances, its idiocyncrasies much as one listens to Pergolesi or Telemann or Mozart. What had started out as folk or "uncultivated" art, as spontaneous art not intellectual art, a gut art, a primitive art, became an "art form" with a respectability it once neither dreamed of nor worried about.

It is worth noting that in the "golden age" of jazz and in the

"golden age" of the movies, in what might be called their green and salad days, neither had yet begun to worry about being "art." Their job was entertainment, which is not to say that they underrated themselves or their product, or especially their inventiveness. "We New Orleans musicians," Jelly Roll said, "were always looking for novelty effects to attract the public, and many of the most important things in jazz originated in some guy's crazy idea that we tried out for a laugh or just to surprise the folks." Jazz, like the movies, was continually discovering new things about its potentialities—not just new ways to catch the public but new excitements in its very existence, its individuality and interplay, especially in private, after-hours jam sessions. Jazz was distinct from established artistic conventions and standards, and bent on the creation of new conventions of its own. They were not concerned that no one thought of them as "cultural" or worried about their "artistic integrity" or whether their music was "serious." Jazz and the movies each had a life of its own, each had to make an audience, not inherit one from other conventions. As they grew in technical and social sophistication, they did not necessarily grow in stature or performance. They became smoother and in some respects richer in texture, (like the difference between a corn pudding and a soufflé), and more subtle in their messages and methods; they most assuredly became more self-conscious. While they may not have taken themselves more seriously (no one can say that the early jazz musicians and moviemakers were not serious explorers and inventors), they expected others to take them more seriously. From being artifacts they became cultural arts.

Of all the arts in our society only jazz and the movies have been self-supporting. They have had no aristocratic patronage (unless the patronage of fashionable nightclubs can be called that); they have had no museums or libraries (except to preserve their past); and until the National Foundation for the Arts started a small pilot program for jazz in 1970, they gave government as wide a berth as possible. They have needed no apologists, though they attract them today. Like the movies, jazz since World War II has been treated in academic circles as an "art form." Its study has become part of the curriculum in the music departments of several universities and in such institutions as the Juilliard School of Music, where jazz instrumentalists rub elbows with chamber music, symphonic, and solo performers as members of the faculty. In 1970 the National Foundation for the Arts set up a pilot program for jazz musicians and organizations and gave out $20,500 to encourage them; by 1984 the amount had climbed to $1.3 million.

But jazz, like the movies, has made it on its own out of an internal

drive on the part of those who play it, compose, improvise, arrange, and continually reinvent it. Jazz has produced as many heroes and heroines (composers like Mary Lou Williams, singers like Billie Holiday, Bessie Smith, Ella Fitzgerald, Sarah Vaughan, Jo Stafford, Lee Wylie, and dozens of others) as the movies have, though the names of many of the greatest jazz innovators and performers are not household words to the same degree as those of movie stars. Unlike symphony orchestras, chamber-music groups, dance and opera companies, jazz and the movies have been regarded by and large as outside the public responsibility, and this has, it can be argued, contributed to their vitality and democratic character. Their independence has certainly not stood in the way of their restless and vigorous search for new dimensions or stood between them and their audiences. Quite the contrary.

In some respects jazz reached the apex of its respectability with the big bands in the 1930s (which in the 1980s are enjoying a revival), and in the process many innovative individuals were swallowed up in ensembles. Jazz had become as much white and integrated as it was once black and segregated, it had become an artistic export that had captured audiences and inspired imitators very nearly everywhere, unlike our "fine arts." It was the only American art that could claim to be indigenous, and it inspired a certain amount of chauvinism and possessiveness. When, for example, the French disciple of New Orleans jazz Hugues Panassié disparaged the skill of the guitarist Eddie Condon, Condon retorted with a quip that has become part of jazz legend. "How come," he said, "the French cats are telling us how to play jazz? Do I tell Panassié how to jump on a grape?"

Time was running out on the big bands toward the end of the thirties, and they were largely swallowed up by World War II and disbanded. Duke Ellington's orchestra, which was almost entirely a concert organization not a dance band in the usual sense, persisted, but there were new ideas stirring which were not swing in the Armstrong or Teddy Wilson or Gene Krupa or Goodman sense. There were new rhythms, new kinds of melodic improvisation, and new sounds that emerged in the 1940s, along with a new name for the new music, bebop, and new names of musicians who were to become legends—Charlie Parker ("Bird"), Thelonious Monk, Dizzy Gillespie, John Lewis and his Modern Jazz Quartet, and many others. It was a new era in jazz which carried over from the age of swing into the age when rock-and-roll took over the dance business and the teenagers who had once belonged lock, stock, and barrel to the big bands. Rock filled them with the same frenzy if it did not inspire the same athletic kinds of dances that Goodman and Artie Shaw and Tommy Dorsey had inspired.

Their shrieks and swoons were of a different, more melancholy and disenchanted sort.

The analogy between baseball fans and jazz fans is closer, it seems to me, than that between other audiences. The aficionados are aware of and concerned with the refinements of performance and the particular kinds of poetry in both solo and ensemble performances. (A beautifully executed double steal is as elegant as a Goodman arpeggio.) Like baseball fans, jazz fans know who played where and with whom and to what effect; they talk a rarefied language and drop the names of clarinetists and percussionists as baseball fans do the names of long-forgotten (except by them) shortstops and spitballers. Their retention of detail is prodigious. While the most casual fans of baseball know the names of Cobb and Ruth and DiMaggio, just as casual jazz fans know Armstrong and Goodman and Ellington, it takes the true believers and the professionals to know Dave Tough, Muggsy Spanier, Sonny Greer, and Max Kaminsky and to put in words the distinctions among the various Dixie styles and the idiosyncratic rhythmic nuances of, say, Teddy Wilson and Count Basie. But most jazz fans, especially young ones, like most baseball fans, are content to stand by and shriek their enthusiasm, which is as much a manifestation of the herding instinct, with sexual overtones, as it is of musical or athletic appreciation.

Not long before he died in 1974 Duke Ellington published his autobiography, *Music Is My Mistress.* It is a story entirely different from the story of Scott Joplin. Ellington moved from success to success, triumph to triumph. Joplin died insane and was buried in a pauper's grave. Ellington wrote in his book, "I have been received by presidents, first ladies, kings, queens, maharajas, champions, chief justices, *chefs de cuisine,* painters, sculptors, screen stars, butchers, bakers, doctors, lawyers, dishwashers, and street-cleaners." He had received fifteen honorary doctorates, the President's Gold Medal, the Presidential Medal of Freedom, and a list of other honors that occupies eleven pages in the appendix of his book. Joplin did not write a book; he wrote an opera that he conceived as the apotheosis of his career and that left him penniless.

Forty years elapsed between the publication of Joplin's "Maple Leaf Rag" in 1899 and Ellington's "Concerto for Cootie," a piece that has been called "the ultimate refinement of the influence of ragtime structures on later jazz composition."

The music that was born in the sporting house wound up in the White House, suitably dressed in white tie and tails. It was an extraordinary cultural journey: the only indigenous American music traveled in half a century from ragtime to riches with nothing for baggage but all that jazz.

Show Biz
with Music

Audiences," wrote Brooks Atkinson, for thirty years the theatre critic of the *New York Times,* "are composed largely of brainwashed egotists who cannot be bothered with anything that is not fashionable."

He was speaking of the audiences in New York in the 1920s at the time of the founding of the Theatre Guild. Atkinson, whose business was to be critical, was not often petulant. Speaking of the same era, Arthur Hopkins, a producer and playwright who also took the theatre seriously, thought even less well of the audience, but he blamed the diet that was fed to it, especially by the Broadway theatres.

> The theatre in America today is adapted in general to the understanding of the eight-year-old mind. It is too much to expect that it can be fully developed at one bound, but at least we are justified in demanding that it measure up to the comprehension of the age of sixteen. The trouble with our present theatre is a ceaseless repetition of a familiar and time-worn formula, a bag of tricks which anyone with skill can play and assure himself of a certain amount of success.

In more recent years we have heard frequently of the "thirteen-year-old mind" of the television audience, and the reference is not to the millions of thirteen-year-olds who look at "the tube" but to their parents and grandparents, that misleading and amorphous myth called the cross-section.

The nature of the audience for the theatre (and we confine ourselves here to what happens on stage and not on the movie screen or the television set) does not lend itself to such easy definition by derogation and never has. The audience is just as elusive of definition as the arts to which it devotes its attention and for which it opens its purses. All the things that happen

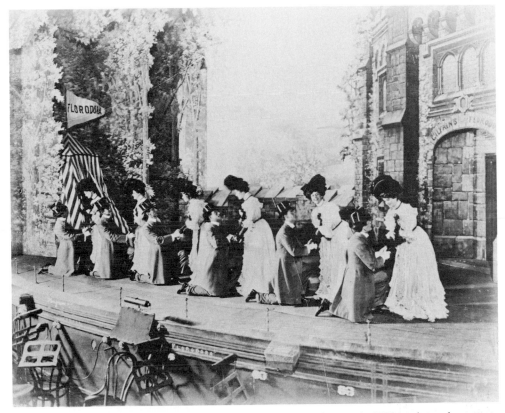

The "Florodora sextette" appeared on the New York stage in 1900 to the enchantment of audiences, who left the theatre humming the show's hit song, "Tell Me, Pretty Maiden, Are There Any More at Home Like You?" *Florodora* ran in New York for 547 performances, toured the country, and returned to New York for a reprise.

on the stage are formalized illusions of fact or thought or emotion or movement or of all of these—dishes conceived, cooked, and served up by playwrights, composers, choreographers, designers, and performers to be suggestive or evocative, often both. Sometimes they are illusions of what we call "reality," and the results are called "realism"; more often they are intentional distortions of what we regard as "fact" for aesthetic or social or dramatic reasons; and sometimes they are fantasies.

Their purposes differ as, it is assumed, their audiences differ. As any performer will tell you, there are "good" audiences and "bad" audiences, and which they are depends on how they accept or reject or are indifferent to the illusions presented to them. Just as there are "popular" and "serious" offerings, so there are "naïve" and "sophisticated" audiences, and audiences that are "vulgar" or "refined." The audience for the arts and

entertainments has been categorized as highbrow, upper-middlebrow, lower-middlebrow, and lowbrow, and such categories have some validity, but only up to a point. Such are the attractions of what happens on stage that any audience at any given time is likely to be a mixture of all of these, whether it is the audience for burlesque, ballet, opera, farce, or tragedy.

The art of the theatre, its engagement with society, and its place and significance in our culture can be explored only by setting aside the snobbishness with which it is frequently viewed by critics. However, if it were not for a certain healthy snobbism, the theatre in its many manifestations would not have the variety and vitality that it and its audiences have enjoyed and profited from. It is conflict of opinions and demands for satisfactions that have nurtured quality of performance in all hues of the theatrical spectrum.

High Jinks at the Opera House

In 1904, as we have noted, Professor Münsterberg of Harvard observed that while "opera houses" were in every town and city, the fare they offered the audiences that patronized them was largely "worthless" and "catered to the vulgar taste." The professor did not know that the songs then being sung in most of them were swan songs; neither did the impresarios, if that is not too flamboyant a word for local operators in bowlers and celluloid collars, whose first concern was to keep their theatres occupied and profitable. The movies, as popular entertainment of more than just a gadgety sort, were just over the horizon, and most opera houses would soon become movie theatres, some of them movie "palaces." The 1880s and '90s had seen a boom in the construction of opera houses. They proliferated in much the same way that "cultural centers" were to proliferate in the 1960s and '70s, monuments as much to civic pride and urban rivalry as to the arts they were intended to foster. What we now call "the public sector" was at best minimally involved in their financing. And yet undreamed-of were the tax-deductible dollars and grants from foundations and arts councils which have played and continue to play Maecenas-like roles in the creation and support of today's cultural enterprises. No one thought then to call the performing arts "the culture industry," as some have in recent years. Opera houses were private business, sometimes one-man gambles, sometimes the optimistic ventures of a group of local businessmen. They were meant to make money or at least to break even; they were not meant, like most of "the industry" today, to create deficits.

In small cities and large towns opera houses, sometimes incorporated into business blocks and sometimes located on second floors, did not serve just for "one night stands" by touring theatrical companies and vaudeville troops. They were also auditoriums for lectures in the old Lyceum tradition, for performances of local "amateur theatricals," for recitals, band concerts, and political debates. They were community centers as much as they were theatres. It has been estimated that in the first years of this century there were about two thousand theatrical stock companies on the road making one-night stands in small cities and somewhat longer stays in larger ones, and business was not just good, it was excellent. The plays they took to "the sticks" were most often recent Broadway successes or standard works like *Hamlet* or Sheridan's *The Rivals.* When the stars who originally played in them traveled, they did so only with firm guarantees of fat payments for their performances. "Rare were the performers, however famous," Howard Taubman wrote, "who did not travel across the land. A profitable tour became as important in a producer's calculations as movie money decades later. . . . Tours were the equivalent of subsidiary and residual rights."

If all good things theatrical were assumed to come from New York, the cities of the West were not to be outdone when it came to places for the stars of Broadway to twinkle and shine, gesticulate and glower. When Denver opened its Broadway Theatre on August 18, 1890, the Denver *Republican* described it as "one of the most luxurious playhouses in the world." It seated 1,670 and had "an artistic drop curtain and beautiful lights"—the new electric lights, a startling innovation that had it all over the familiar chandeliers lighted by gas jets. In December 1889 the Chicago Auditorium, designed by the architects Dankmar Adler and Louis H. Sullivan, opened with ceremonies that had Chicagoans wide-eyed and boastful, none of them more so than the reporter from the Chicago *Tribune.* He called it "the largest playhouse in the world," and it may well have been.

President Harrison was on hand for the opening, and so were "wealth and fashion from all parts of the country." The mayor spoke, sounding like "a preacher in a country church"; a chorus sang a cantata composed by Frederic Grant Gleason with a text by Harriet Monroe, a young poet who later founded *Poetry: A Magazine of Verse,* a publication of great importance to literary Chicago, indeed to American letters. When it came to the climax of the evening, the reporter could scarcely contain his euphoria. It was the appearance of "the petted plaything of two continents, the warbling [Adelina] Patti . . . how soft she is, how caressingly inviting, how essentially feminine." She sang "Home, Sweet Home," "not the way your

mother used to. She sang it better."* The reporter concluded that the Auditorium was "the Greatest Building in the World." He omitted, however, to mention the names of the architects.

There was a kind of healthy absurdity about much of the theatre in the 1890s that spilled over onto the stage of the twentieth century, a flamboyance combined with smugness that echoed P. T. Barnum's remarkable showmanship in the 1840s and '50s. Bedazzlement spoke to the public in the same hyperbole as the Chicago World's Fair ("The White City"). The theatre like the fair combined fantasy and art and ostentation together with evidence of material progress. It set out to make Americans feel good about themselves and about the future. The most ambitious theatrical enterprise, designed to capture the imagination and patriotism of the fairgoers, never materialized. It was Steele MacKaye's dream, and it is worth mentioning because it was aimed at the bull's eye of the day's taste for magnificence and spectacle.

MacKaye was a producer, a playwright, and an actor with large plans that would have appealed to the chief architect of the fair, Daniel H. Burnham, who had pronounced, "Make no little plans. They have no magic to stir men's blood." In the 1870s MacKaye had founded the first acting school in America, which in 1884 became the American Academy of Dramatic Art, and he took delight in theatrical gadgetry as well as in truly professional performances. In 1879 he got control of the Madison Square Theatre in New York, put an elevator stage in it, folding chairs (a new convenience), overhead lights (installed with the help of Thomas Edison), and an attempt at proper ventilation. His plans for a Chicago theatre, which he called a "Spectatorium," to be constructed just north of the fairgrounds, were grander than anything that existed anywhere. It was to be big enough, according to the Chicago *Journal,* "to contain the story of the epic voyages of Columbus and his men" in an enormous pool that served as a stage for ships. He commissioned Anton Dvořák to write the music for this epic and *The New World Symphony* was the upshot. The theatre was under construction when the financial panic of 1893 blew it away. The reporter for the *Journal* called it "the most colossal fiasco of the age." What had been built cost half a million dollars, and a wrecking company bought it for $2,250. MacKaye had to be satisfied with a scaled-down version of his Spectatorium in a building on South Michigan Boulevard. Even so, he managed a

*Patti was a coloratura soprano, born in Madrid of Italian parents. "She made her debut in New York in 1859 (at the age of sixteen) and eventually became the most popular and most highly paid singer of her day." She died in 1919. *(Viking Desk Encyclopedia.)*

pool six feet deep with a 400-horsepower cyclone machine and a wave maker.*

The editor of *Musical America* wrote in the 1950s of the theatre in America in the late years of the nineteenth century: "The American audience was completely overawed by the marvelous. Give any assembly of Americans a series of realistic, large-scale productions of famous or familiar spectacles, and it would remain rooted to the spot for an entire evening." It was on this well-proven predilection for grandiose theatrics that MacKaye had counted, and no doubt, but for the panic, he would have succeeded. The noun "extravaganza" was as much a part of the vocabulary of the theatre in MacKaye's day as "spectacular" (also used as a noun) became in television in the 1970s and meant much the same thing. In New York in the 1890s a show called *1492 Up to Date*, produced by Edward E. Rice, who had made his reputation and his fortune with *The Black Crook*, was billed as a "musical, historical, mellow drama" (puns of this quality were theatrical essentials then), and it combined scenes of *opéra comique*, magic-lantern shows, "extravaganza," farce-comedy, vaudeville, comic acts with local allusions, burlesque, and even minstrelsy.

This sort of tossed-salad show, known as musical farce-comedy, had a flexible theme or story that could be stretched to include almost any sort of performance. It was a forebear, if not the immediate parent, of musical comedy and the revue, which did not come into their own until a quarter of a century later. The farce-comedy was quite distinct from the vaudeville show, which was a series of "acts" without a theme to bind them together. Vaudeville was the highly respectable child of thoroughly disreputable parentage, the offspring of the variety shows that enticed customers into the saloons of the Bowery in New York, where the principal attractions were the always willing "waiter-girls." Their charms were supported by burlesques and by comedians whose jokes were scatological and whose double entendres would have made a maiden (if any gentleman were "cad" enough to bring one there!) blush. As famous as any song of the 1890s was "The Bowery" from a farce-comedy called *A Trip to Chinatown*, which opened in New York in November 1890 and ran for 650 performances:

The Bowery! The Bowery!
They do such things, and they say such things

*The Spectatorium anticipated the Hippodrome in New York (it opened in 1905 and seated 5,000), one of the great twentieth-century vaudeville houses. It too had a pool, into which, as a climax of each performance in alternate years, lines of show girls in glittering bathing suits walked down steps and disappeared beneath the water not to be seen again. In other years the pool became a skating rink and the climax an ice show.

On the Bowery; the Bowery!
I'll never go there any more.

By contrast with the Bowery's variety shows, vaudeville at the turn
of the century was "the people's theatre." It set out to appeal to all but
the most refined tastes, and was what we now call "a family show," suitable
to all ages and degrees of sophistication and morally offensive to no one
except those who thought that all theatre was the work of the Devil. It was
a great comedian, Tony Pastor, who rescued variety from the dives. He
moved it uptown to Fourteenth Street and cleaned it up, and in 1864
opened his new Music Hall, where no class of New Yorkers, even the most
fastidious, need fear that their sensibilities might be threatened. Tony
Pastor's variety ran for years and spawned many stars, none more famous
than Lillian Russell, the breaker of hearts, a girl from Cleveland whom he
billed as an "English ballad-singer." She was the quintessence of what was
then regarded as "feminine pulchritude." She was a hard-working profes-
sional with a reputation for generosity and solicitude toward other actors,
and an accomplished lyric soprano if not an accomplished actress.

In the eyes of New Yorkers, no
one could hold a candle to the
much-married Lillian Russell,
the epitome of blond, richly
dressed, opulent female
pulchritude in the 1890s. She
was an accomplished singer and
actress, a generous friend, and a
breaker of hearts.

At the century's turn there was no more famous vaudeville team than Joe Weber (foot in hand) and Lew Fields. They managed their own Broadway Music Hall, and on their stage in 1900 figures as famous as Lillian Russell and DeWolf Hopper exchanged sophisticated banter. "A host of comely women" soothed the proverbially "tired businessmen" in the audience.

Vaudeville had something for everybody of every age, and at its best the quality of performance was magical. There were acrobats and jugglers and animal acts (more often trained dogs than caged tigers) straight out of the circus. There were comic monologues and skits on topical subjects, male and female singers of sentimental ballads, comic dancers, tap dancers and "aesthetic" dancers, known disparagingly by troupers as "gauze fluffers." There were celebrated actors and dancers "strutting their stuff" —even Sarah Bernhardt performed in short scenes from *Cleopatra* and *La Tosca* in 1893. The most famous of all Russian ballerinas, Anna Pavlova, performed, starting in 1910, on the vaudeville stage in what were known as "two-a-days," afternoon and evening performances six days a week. It was on the vaudeville stage in theatres all over America that audiences were enthralled by the comedy team of Weber & Fields, by Harry Houdini, the magician and escape artist, by the young Eddie Cantor, who made his first success in London, by Will Rogers, Jimmy Savo, Ed Wynn, W. C. Fields, and Fannie Brice. It was in vaudeville and burlesque that Jimmy Durante and the Marx Brothers first appeared. It was there, too, that Annette Kellermann started a revolution in 1910 by appearing in a skin-tight one-piece bathing suit. She made eyes pop the way they were later

to pop at the sight of the first bikinis. There was scarcely a star of musical comedies and revues of the 1920s who had not first made a reputation in vaudeville. A dancer who billed herself as Rahda, for example, flopped when she appeared at Proctor's in New York but was a great success when she turned up as Ruth St. Denis at Hammerstein's for $2,000 a week a few years later. She became one of the most famous and innovative dancers of her day. Even "great ladies of the theatre" like Ethel Barrymore and Maude Adams were not above appearing on the circuit.

The circuit was primarily controlled by a few men, notably B. F. Keith and E. F. Albee of Boston, F. F. Proctor of New York and Martin Beck, also of New York, who owned and managed the Orpheum circuit. The

The Marx Brothers (from the top clockwise—Harpo, Chico, Zeppo and Groucho) were a successful vaudeville team before they romped in *The Cocoanuts* in 1925, their second Broadway show. The critic Howard Taubman called it "a harebrained panic." Most Americans met them in such movies as *A Night at the Opera, A Day at the Races,* and *Duck Soup.*

names Keith and Proctor and Orpheum were synonymous with the best and most extravagant, not just of the vaudeville but the theatres in which it was performed. B. F. Keith set a standard of opulence when he opened his New Theatre in Boston in 1894; he had the other tycoons of the circuit scrambling to match the grandeur of his gleaming marble and rococo frippery, his lavish use of gilt and rich color schemes, his murals of symbolic females and, more practically, his up-to-the-minute ventilating system, his electric lighting, and his fire-protection devices. In the genteel spirit of the age he provided "gentlemen" with smoking and reading rooms "and the finest toilet and retiring rooms in the country" and "suites of rooms for the use of lady patrons furnished with dressing cases and every toilet requisite—all free." His motto was "Cleanliness, comfort and courtesy." Respectability was good for business in this theatre for the people, and so was the illusion of riches piled on just for their delight. The New Theatre was welcomed by the Boston *Herald* as "the handsomest and most costly theatre in America and the finest place of amusement in the world owned and controlled by one individual." A lady visitor from Augusta, Georgia, noted of it that "the age of luxury seems to have reached its ultima Thule." Theatres like this one were not the forerunners of the movie palaces of the 1920s; they became the early movie palaces, once vaudevillians gave way to the blandishments of Hollywood.

There were, to be sure, dozens of lesser owners and operators of vaudeville circuits who booked acts into theatres on which the tycoons of the industry did not have an iron grip. The circuits were so varied that, as a historian of vaudeville wrote, "One actor, booked for a circuit he had never heard of, asked his agent, 'What is it? Small time, medium small time, big small time, little big time, medium big time or big time?' "

Even as early as 1904 two million people a day were stopping to see the brief shows in nickelodeons and by 1909 the movies had become "a first-class headache" to producers of vaudeville. Variety actors had begun to make their way to Hollywood, where the work was less arduous than the two-a-day circuit and the promise of fame was more seductive. For a time vaudeville and films were on the same programs: a few acts, a "short subject," usually a newsreel or cartoon, and a feature film; and except for such famous vaudeville houses as the Hippodrome and the Palace in New York, both of which gave up the ghost in the 1930s, the Keiths and the Proctors and the Orpheums had become movie theatres. Gilbert Seldes in *The Seven Lively Arts* suggests that it may have been its attempts to raise its artistic sights that contributed to vaudeville's decline. "Put on professionally, high-class vaudeville showed all the weaknesses of the commercial kind, and had a dullness of its own." When a Russian version of vaudeville

turned up in New York in the 1920s as Balieff's *Chauve-Souris,* Seldes noted that "in Russia, too, refinement could corrupt and stultify." But he also wrote:

> the vaudeville stage makes such demands upon its artists that they are com-pelled to perfect everything. They have to do whatever they do swiftly, neatly, without lost motion; they must touch and leap aside; they dare not hold an audience more than a few minutes. . . . They have to establish immediate contact, set a current in motion, and exploit it to the last possible degree in the shortest space of time. . . . The materials they use are trivial, yes; but the treatment must be accurate to a hair's breadth . . . there is no second act to redeem a false entrance; no grand climacteric to make up for even a moment's dullness.

It seems impossible today to evoke the quality of vaudeville, its kaleido-scopic nature, its corn, its perfection, its glitter, and the way its "cultural" acts were usually followed by "low" (but not indecorous) comedians to even the score. Vaudeville's audience was of the critical, "show me" sort that expected and delighted in exquisitely timed performance. If vaudeville died as theatre, it did not die as entertainment. It was revived on television, perhaps in its purest form on *The Ed Sullivan Show,* but also in lesser shows where prominent "hosts" and "hostesses," usually performers themselves, presided over a variety of acts, which they commonly interspersed with fatuous conversations with their "stars." The "war horses" of radio and television variety, stand-up comics like Bob Hope and Jack Benny, ballad singers like Frank Sinatra and Ella Fitzgerald, dancers like Fred Astaire and Gene Kelly, worked in the traditions of vaudeville, and of the cabarets, nightclubs, and speakeasies which hit their gaudy peaks in the 1920s. It is a solid theatrical tradition, as old as jongleurs and troubadours, mimes and clowns, and it is not likely ever to vanish so long as there are audiences to enchant, deceive, beguile, and make laugh.

Musical Comedy, an American Art Form

It is frequently observed that America's only important contribution to the theatre is musical comedy, a claim that may be arguable if one considers that medieval miracle plays were enlivened with music and comic characters, that the commedia dell'arte was a musically abetted romp, that comic opera (as opposed to grand opera) and operetta were so close to musical comedy in spirit as to leave little room for it as a separate "art form." Nonetheless, the words "musical comedy" summon to mind a kind of theatrical confection that is distinct from other forms of musical

drama. Drama, indeed, has little to do with it. Overtones of seriousness did not enter into musical comedy at all until 1957, when a semblance of the Romeo and Juliet story turned up in Leonard Bernstein and Jerome Robbins's *West Side Story,* a sentimental but dramatically compelling confrontation of Puerto Rican street gangs in Harlem that ended with the hero's death by stabbing. Musical comedy is almost by definition the antithesis of problematical in its intent.

Cecil Smith in his comprehensive study *Musical Comedy in America,* published in 1950 when musical comedy had developed a set of recognizable characteristics, defined it as follows:

> Musical comedy may be distinguished from other forms of entertainment as comic opera and burlesque by its direct and essentially unstylized appropriation of vernacular types of song, dance, and subject matter; and it may be distinguished from its chief source of inspiration, the variety show, by its employment of a plot and, at least in some degree, of consistent characterization.

Musical comedy did not suddenly take on this roughly definable shape; it emerged over a period of about four decades from *The Black Crook* (1866), from variety and farce-comedy and also from operetta, which was a favorite with American audiences from the 1890s until well into this century, when musical comedy rivaled it and came to overshadow it.

Operetta (also called "light opera" and "comic opera"—the terms are interchangeable) was a European importation that Americans, who liked to be able to hum the tunes they heard from the stage, took to their hearts in the 1880s. They were happy to take it in large doses, as they took grand opera in small ones (and often more for social and fashionable reasons than for pleasure). If grand opera dealt with profound emotions in stirring arias and duets, operetta dealt with many of the same emotions (love, jealousy, anger, ambition, and so on) in sentimental or catchy tunes that had audiences humming as they left the theatre, dry-eyed, and convinced that what they had heard and seen was the way life should be—pretty, comical, romantic, and predictably happy. This was escape not catharsis. If the emotional impact of operetta was only skin deep, that was deep enough. Librettists spun their cotton-candy plots in make-believe Graustarks or imaginary noble courts peopled with handsome men in glorious uniforms and brilliantly costumed and coiffed ladies of ineffable beauty. Authenticity was whatever the set designer and the costumer wanted it to seem to be. This was theatre of light-hearted fantasy, visually, emotionally, lyrically.

The first operettas in America were European importations in the late 1870s and 1880s, and they were produced in German and French by

Maurice Grau to small, enthusiastic, and presumably sophisticated audiences. They were the work of Edmond Audran and Jacques Offenbach and were of a raciness, spiced with double entendres, that would not have been tolerated, in spite of the charm and elegance of the music, if they had been sung in English. Lillian Russell made her comic-opera debut in Audran's *The Snake Charmer* in 1881. Offenbach's *La Vie Parisienne,* which appeared two years later, met with a cool reception, though its score is an abiding favorite and still a part of the standard repertory for "pop" concerts. There were operettas by Johann Strauss, Jr. (*The Merry War,* 1883) and his fellow Viennese Karl Millöcker (*The Black Hussar,* 1885), with DeWolf Hopper, a gangling comic and the favorite of his day. Edward Solomon, who came to America from England and was talented enough to have given Messrs. Gilbert and Sullivan a run for their money in London, turned Lillian Russell into a full-fledged operetta star in *Polly, the Pet of the Regiment* (and subsequently married her). In this piece Polly, who ostensibly had pledged her heart to a major general, with unseemly (so it must have seemed) romantic opportunism switched her affections to Private Mangle when she learned that he was, in fact, a German prince!

But no one rivaled the perennial success of Sir Arthur Sullivan and W. S. Gilbert. They made their unexpected debut in Boston in 1878, as we have noted, with a pirated version of *H.M.S. Pinafore,* and they were so infuriated by this larceny that the D'Oyly Carte Opera Company deserted the Savoy Theatre in London for a month and opened its authentic version of *Pinafore* on December 1, 1879, at the Fifth Avenue Theatre in New York. Sir Arthur himself was on the podium, and Gilbert inconspicuously sang his own lyrics as a sailor in the chorus. This was followed immediately on New Year's Eve 1879 by the first performance of *The Pirates of Penzance* (it had not yet appeared in London) and soon after by *Patience, Iolanthe, The Sorcerer,* and *Princess Ida.* "From *H.M.S. Pinafore,*" Cecil Smith wrote, "the American audience began to learn, whether it recognized the fact or not, the difference between hack work and first-class professional skill and integrity." By the time *The Mikado* was first produced here in 1885, the operettas of Gilbert and Sullivan were being produced by all manner of companies, amateur, professional, semiprofessional, and even by church choirs, from Boston to San Francisco.

It was a comic opera written by the Viennese composer Karl Millöcker that in a most unlikely manner turned the tide against the Graustarkian tradition and the exoticism of such operettas as *The Mikado.* In doing so it opened the way for musical comedies to set their flimsy plots in the present and in the United States. Millöcker's *Poor Jonathan* had delighted Viennese audiences by its exotic setting. America under any circumstances

would have been exotic enough, but in its original version the first-act stage directions read: "Rubygold's plantation; happy darkies picking cotton along the Battery, New York." *Poor Jonathan* was the first so-called "dresscoat" comic opera, by which was meant that it was set in the present and acted in contemporary costumes. When it opened in New York in 1890 there were no longer darkies picking cotton on the Battery. The scene was moved to West Point (no cotton picking there either). "Breaking away from many of the expected conventions of comic opera," Smith wrote, "it paved the way for later musical comedies that adopted the informality of farce-comedy, yet strove to reach the better musical standard of comic opera."

By no means all operettas were imported from England, France, Germany, and Austria, though even those composed in America before the turn of the century and some after it were either by Americans whose training was European or by Europeans who migrated and became American citizens. "Culture" to most Americans was not home-grown; if it was of any importance, it came from the Old World, where there were traditions to which this youthful country (as it still thought of itself) could not yet aspire, though it could seek to emulate them. Just as painters and architects went to Düsseldorf or Paris, and most particularly to the École des Beaux-Arts, to learn their professions, so musicians, and especially composers, went abroad to study with the "masters."

Reginald De Koven, the composer of many successful operettas, is an example. He was born in Middletown, Connecticut, in 1859, but his education was largely European. He graduated from Oxford in 1879 and immediately took off for Stuttgart to study composition. From there his pilgrimage led him to Frankfurt; to Vienna, where he worked with Franz Genée; and to Paris, where he studied with Léo Delibes, both of them masters of comic opera. When he came back to America, he married and settled in Chicago, where, when he was thirty-one in 1890, his operetta in three acts, *Robin Hood,* was produced. It was the most successful production of his long career, and it was very successful indeed. It ran for three thousand consecutive performances. He wrote many other operettas with unmemorable scores and moderate runs.

He was no match for Victor Herbert. Herbert was not an American by birth but he came to be America's most respected (indeed beloved) composer of operettas. He was born in Dublin, studied cello in Germany, and came to the United States in 1886 when he was twenty-seven as first cellist at the Metropolitan Opera House in New York. (Anton Dvořák wrote his famous Cello Concerto for him.) His first operetta was *Prince Ananias,* which was produced by a group called The Bostonians in New

York in 1893; his last was *The Dream Girl* in 1924. There were *Babes in Toyland* (1903), *Mlle. Modiste* (1905), *The Red Mill* (1906), and *Naughty Marietta* (1910), and thirty others less famous, and they left behind them a happy trail of song hits, many of which even now seem more than just period pieces.

The next generation of operetta composers (though a full generation by no means separated them; their careers overlapped) produced two of the most masterly creators of this happy union of song and story, which was then at the apex of its popularity. They were Rudolf Friml and Sigmund Romberg. Friml's greatest successes came in rapid succession, first *Rose Marie* (1924), peopled by Canadian Mounties in red coats and best remembered for a song called "Indian Love Call"; and in the following year *The Vagabond King,* set in medieval France, the hero a poet who became king for a day. Romberg's triumphs were *The Student Prince* (1924), set in Heidelberg, where a prince falls in love with a barmaid, and two years later *The Desert Song,* a romantic piece set in Morocco and involving a sort of Robin Hood character and his abduction of the girl he loves. If these successes were not exactly Graustarkian in their settings, they had as little to do with reality as highly sentimentalized romance could contrive. Both Romberg and Friml invented songs and choruses that were stirring when bombast or uplift were called for and lyrical when hearts called for melting. They were composers soundly grounded in the European, Strauss-Lehár-Herbert tradition, well-trained and inventive, and they had very large followings not only on Broadway and through stock companies on "the road" but in buyers of gramophone records and sheet music. They were, however, the last of their breed to captivate American audiences.

Girlie Shows with Class

In 1923 Oliver M. Sayler, a generally respected critic of the New York theatre in its serious as well as its frivolous aspects, wrote of "Revue, Variety and Dance" in *Our American Theatre:* "Despite our amazing development in these genres in the last fifteen years, they are not really provocative enough to tease the appetite, to tempt the taster further into the theatre. They may someday. That is their logical development, but today they are oftener desserts—*tours de force* in French pastry; hasty pudding; mince pie; bittersweet bonbons; nuts!"

The popular musical theatre was, quite frankly, dessert, and those who produced it had no reason to believe that it should be anything but as frothy and delicious as they could make it. Nourishment of the soul or the intellect was not its business; entertainment of the spirit was. What the

producers offered the willing public was a four-ring circus of song and dance, some of it with a dash of plot, and all of it with a large pinch of discreet sex and sentiment. Musical comedy was beginning to assume a recognizable shape; operetta went its tuneful, romantic ways unabashed and unsullied by licentiousness; vaudeville was thriving; and there was a new style of variety called the "revue" with just a touch of Parisian naughtiness as spice. The revue (its very name was French) was distinguished from vaudeville not only by its pretensions to sumptuousness and/or sophistication (the most sophisticated revues were by and large the least lavish), but by the recurrence of the star performers in various skits and acts during the course of the show. What was more, though they sprinkled their acts with topical allusions and parodies of current shows and celebrities, revues were planned to last a season and did not, like vaudeville, change acts every week or two as new "artists" replaced old ones—new sword swallowers for old fire eaters, this week's acrobats for last week's jugglers, a new team of Irish comedians to replace last week's Yiddish ones.

By the 1920s the revue as a species of gorgeous entertainment was at its most extravagant, and it was Florenz Ziegfeld (known in the trade as "Ziggy") who made it so.* In 1907 he staged the first edition of *The Ziegfeld Follies* in the roof garden of the Broadway Theatre, which he called the "Jardin de Paris." His star attraction was Anna Held, a showstopper with turn-of-the-century proportions (large bust, small waist, wide hips, slender legs, and tiny feet) and a Parisian wickedness that she brought with her from the Folies Bergère. She was, as Brooks Atkinson described her, "five feet of sizzling personality." She reputedly bathed in milk to preserve her luminous skin, and she made male eyes pop with coy songs like "Won't You Come Play wiz Me," and "I Just Can't Make My Eyes Behave."

The Ziegfeld Follies prospered for twenty-seven years, with a new "edition" each season until it ran out of favor if never out of fame. Ziegfeld had a remarkable ear and eye for show-stopping talent, a caliper-like mind for measuring the public taste, and a very lavish hand with money to create sumptuous effects. He did not invent the American version of the revue, but he gave it a name and made it his own. *The Passing Show,* produced by the Shuberts, was the first of its kind when it opened in New York in 1894, but *The Follies* meant Ziegfeld. It meant "the most beautiful girls in the world," who moved slowly and sensuously to music to make elabo-

*Ziegfeld got his start in show business as a sharpshooter in Buffalo Bill's Wild West Show (though he had never been west of Chicago) and as the promoter of a strong-man act at the Columbian Exposition of 1893.

rate patterns on the stage in languid, disciplined parades, showgirls in elaborate but revealing costumes sprinkled with paillettes and on their heads fountains of ostrich plumes and sparkling sequins. They were godlettes of magnificent height, inviting but untouchable, with smiling eyes, half-parted lips, powdered limbs, and obscured bosoms. (American moralism then insisted that bosoms not be revealed as they were in the *Folies Bergère.*) From Ziegfeld's "long-stemmed American beauties" and chorus line came a surprising list of famous movie stars—Marion Davies, Barbara Stanwyck, Irene Dunne, Paulette Goddard, Mae Murray, Peggy Hopkins Joyce, and many others hardly less famous.

The Follies was more than a "girlie show" to sweeten the tempers of tired businessmen. Here were Eddie Cantor and W. C. Fields to make them laugh. They listened to Will Rogers prick the balloons of political and business pretense and Fannie Brice sing her outrageous songs with outrageous antics. They watched Gilda Gray shake her lithe body in a dance which, if she did not invent it, she made famous as "the shimmy." They went away with the quotable dialogue of Gallagher and Shean, and one can be sure they quoted it. Ziegfeld's music was not scored by a single composer as was the formula for operetta and musical comedy. He staged individual "numbers" by Irving Berlin, Rudolf Friml, Victor Herbert, and many other "tunesmiths" to make his shows as whistleable as they were eye-filling.

None of the other revues that flourished in the 1920s matched Ziegfeld's in glamour and extravagance, not *George White's Scandals,* nor *The Earl Carroll Vanities.* They each had their share of beautiful showgirls and comedy stars and dancers and singers, and they did good business. There was something of the *Folies Bergère* in all of them and something of old-time vaudeville, which by the 1920s was on its last legs.

But there was another kind of revue that was not concocted for the tired businessman or the susceptible starry-eyed young but for the upper-middlebrows, whose sophistication presumably rose above follies and vanities and scandals. They started as what have since come to be known as "Off Broadway" productions, modest in staging and immodest in content and intention. They were saucy and racy in an unvulgar way, and while essentially respectable were disrespectful of the pretensions of everything in sight, from Bernard Shaw and Ibsen to politicians and serious dance troupes. (Martha Graham on "twinkletoes" made her debut in the *Greenwich Village Follies* of 1923, and Florence Moore in the *Music Box Revue* of the same year parodied the Denishawn Dancers with a pantomime of a starfish.) Informal revues, good and bad, came in a torrent. The *Grand Street Follies* of 1923 was the most disrespectful of all. It called itself "A

Low-brow Show for High-grade morons," and it gave "first exposure" to a series of performers who later became stars—Aline MacMahon, Dorothy Sands, James Cagney (as a tap dancer)—and to the theatrical designer Aline Bernstein, the novelist Thomas Wolfe's Egeria and love. In 1925 the Theatre Guild produced the first of several *Garrick Gaieties,* with scores by Richard Rodgers and lyrics by Lorenz Hart. It was a British revue in 1924, *Charlot's Revue* that in one fell swoop introduced Beatrice Lillie and Gertrude Lawrence, two brilliant comediennes with totally different styles, and Jack Buchanan, "a suaver song and dance man," one reminiscing critic recalls, "never existed."

There were dozens of such small revues, lively ones and dreary ones, most of them forgotten. There were black ones which moved downtown from Harlem and white ones that scarcely moved at all. But among the best of them was *The Little Show* ("a piece for an audience with a respectable I.Q."), which was pivotal in changing revues from the casualness of the *Grand Street Follies* to slick productions. It had stars of the caliber of Fred Allen, Clifton Webb, and Libby Holman and sets by one of this century's great stage designers, Jo Mielziner. It was followed by *Three's a Crowd,* which, successful as it was, was eclipsed by *The Band Wagon* in 1931 with a book by George S. Kaufman and lyrics and music by Howard Dietz and Arthur Schwartz; in it were the youthful Fred and Adele Astaire as romantic singing and dancing leads. There were two revolving stages to dance on and to add to the gaiety, and the chorus girls seemed to be more than dolls. Percy Hammond, the critic, was charmed. "They look," he wrote, "as Miss Laurette Taylor used to say, as if they all had mothers."

Of the revues that moved down to Broadway from Harlem, the only one with a sustained success was Lew Leslie's *Blackbirds of 1928* and its several successors. Bill ("Bojangles") Robinson, the legendary tap dancer, was first seen on Broadway in the 1928 *Blackbirds,* and two years later Ethel Waters was its star. Earlier Harlem revues had only brief Broadway runs, quite probably because it was fashionable for whites to make their way to Harlem to the Apollo Theatre, where musicians like Duke Ellington held forth, to the Cotton Club, and to the Savoy Ballroom. To some of the sophisticates from downtown it was, of course, "slumming"; to others it was their first introduction to a world of honest jazz that they knew only in its watered-down musical-comedy and polite ballroom versions. *Blackbirds* was not only a Broadway success; it was a theatrical sensation in London and in Paris.

Musical Comedy—Pure and Very Simple

In 1901 a new male phenomenon hit Broadway, full of vitality, enthusiasm, cocksure optimism, breeziness, "ginger," and conceit, and he landed, as they say, like a lead balloon. He was George M. Cohan, and if his presence on the Great White Way was scarcely noticeable at first, he was very quickly to become a force to be reckoned with, a self-made myth in a business where everyone tries desperately to become legendary and mythical. Cohan came from a family of vaudeville troupers and first appeared as a solo performer at the age of nine. He was a composite of many theatrical facets—a comic actor, a song-and-dance man, a song writer, playwright, and sentimental jingoist, who worked at lightning speed both when he wrote and when he was on stage. He was a "charm boy" and, as Howard Taubman said, "Imagine someone who combines the gifts of Bing Crosby and Fred Astaire, and you have a notion of Cohan." As a writer he was without any literary pretensions, but as a performer he was a perfectionist, and perfection meant a very high gloss. Sparkle and surface brilliance and sentiment were the essential elements of his success, and his success, once it got underway, made critics respectful of his showmanship if patronizing of his intellect. To them he was not "theatre" but "show business." To his public (and to himself) he was "Mr. Broadway."

He wrote musical comedies that were fast, wholesome, and filled with the sweet odor of sentimental patriotism. He said of himself that he was "the idol of middle-class playgoers." "He became the king of Broadway," Brooks Atkinson wrote. "Broadway was his favorite subject—in 'Hello, Broadway!', 'Broadway Jones,' 'Forty-five Minutes from Broadway,' and 'The Man Who Owns Broadway.' He had a profound influence on the popular theatre for the next fourteen or fifteen years," until, that is, about 1920.

James S. Metcalfe, the critic for *Life,* a comic weekly that preceded the picture magazine of the same name, called Cohan "a vulgar, cheap, blatant, ill-mannered, flashily-dressed, insolent, smart Aleck, who, for some reason unexplainable on any basis of common sense, good taste, or even ordinary decency, appeals to the imagination and apparent approval of large American audiences." The critic for the *Dramatic Mirror* said of Cohan's plays, "They are clean; they are spirited; they are inspired with a variety of slang patriotism which may not be the less serious because it is not of superior elevation. Yet . . . they must be classed, so to speak, as high-grade, second-grade productions."

But it was none of these that made them either important or unimportant to the development of the musical theatre. They had what we now set

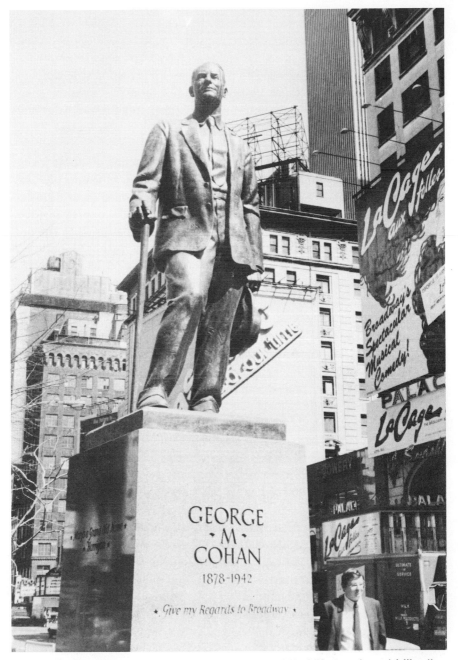

"What the fifteen-year-old, clean faced, fresh minded, full of life American girl likes," George M. Cohan said, "the average American audience will like." Cohan, to whom this statue was erected on Broadway at 46th Street in 1959, seventeen years after his death, revolutionized the musical comedy early in the century. He was known as "Mr. Broadway."

such store by, and they came at a time of ebullience when spirits were high, humor was broad and heroines were winsome, when the automobile was beginning to increase the speed of life as well as of transportation, when change was electrically charged and pictures no longer stood still. Cohan's shows had pace. Cecil Smith called it the injection of "a wholly new conception of delivery, tempo, and subject matter into a form of entertainment [musical comedy] that was rapidly dying for want of new ideas of any kind."

Cohan's popularity was coincidental with the decline of ethnic jokes, which had been so much a part of nineteenth-century vaudeville and variety. Such standard brands of humor began to be looked on as distasteful, and Paddy and Ikey and Yonny Yonson and Sambo expressed their resentment at being made fun of, coarse fun generally, even when the fun was made by Paddy and Ikey and Yonny and Sambo. In 1907 rabbis and priests in Cleveland "united in condemning Jewish and Irish stage comics." San Francisco did more than condemn: hoots and eggs greeted an actress playing a slatternly Irish girl drinking beer out of a tin can. As the several immigrant minorities made economic and social headway during the years of prosperity before the First World War, they also gathered a sense of dignity and demanded that their dignity be respected. If ethnic jokes and parodies did not entirely disappear from the stage—and it is unlikely that they ever will—their tone changed from ludicrous and demeaning slapstick to affectionate playfulness, from an attempt to isolate to an effort to reassure that "we're all in this together, and we're all Americans." It was social and economic classes of Americans that were kidded by the likes of the genial Cohan and not what we now think of as "ethnic groups" and "minorities" but which in the early years of the century were called "yids," "wops," "darkies," "micks," and, most particularly on the West Coast, "Chinks."

From the end of the First World War until the depression of the 1930s musical comedy skittered and giggled its tuneful way to books that did nothing more than provide excuses for comedians and that special breed of singer known only to musical comedy, light of voice and innocent of pretense, girlish on the one hand and manly on the other, carefully avoiding any hint of operatic style or posturing. Musical comedies such as these, often delightful to audiences but always flimsy, were, along with revues, the theatre of the Jazz Age, though genuine jazz had little to do with them. They were the products of what was known disparagingly as "Tin Pan Alley," a mythical Broadway back street where piano players (not dignified by the name of pianists) thumped out tunes and where their collaborators scribbled lyrics for musicals and for dance bands and their singers, or as

they were always called, "vocalists."

It was to "show tunes" not jazz that young couples danced belly to belly and cheek to cheek to the alarm and horror of the older generation, which had been brought up in a kind of gentility that had disappeared or been greatly modified, depending on the place and the class, after the world war. Musical comedies reflected the spirit of frivolity that was let loose in the 1920s when hemlines went up, "nice" girls wore lipstick as their mothers had not, the pocket flask was the college boy's symbol of sophistication, and the rumble seats of roadsters were "necking parlors." It was a time of revolution in morals and manners like, in some ways, and quite unlike in others, the revolution of the "younger generation" in the 1960s and early '70s. Prohibition against the sale of alcohol undoubtedly created some of the same kinds of defiance that prohibition of the sale of "grass" did later and for the same reasons.

Discontent with parental styles of manners and standards of success had something to do with both revolutions, but it is a mistake to draw too close comparisons. Both were revolts against wars that seemed to prove little or nothing, both were explosions of individuality (or so it was thought), which took the form of substituting new uniforms for old ones —the uniforms of dissent for the uniforms of conformity. Jeans for flannels, long hair for the crew cut, rock and country-western for jazz and big-band music. In both the twenties and the sixties it was a question of establishing an identity in defiance of what had become convention and in doing so to establish another conventionalism.

The dances that the young performed to the tunes from musical comedies evoked a reaction from moralists very like that which ragtime and early jazz had provoked. Frederick Lewis Allen wrote in *Only Yesterday:* "The new style of dancing was denounced in religious journals as 'impure, polluting, corrupting, debasing, destroying spirituality, increasing carnality.'" The president of the University of Florida "cried out with true Southern warmth, 'The low-cut gowns, the rolled hose and short skirts are born of the Devil and his angels, and are carrying present and future generations to chaos and destruction.'" Nobody paid much attention to such cries of shock any more than they had to the denunciations of ragtime, and the old morality went on with the new in much the same way that the conventional light operetta did with the fast-paced, irreverent, lightly sexy musical comedies which brightened the twenties.

In the 1920s, audiences were still attracted to Cohan's musicals, as "fast-moving, yet relaxed; modern, yet corny, breezy, yet sentimental" as ever. But what were called "book musicals," like Jerome Kern's *Sally* in which the book scarcely mattered and the characters were patently stereo-

types, were playing to eager audiences and sent them away from the theatres smiling. Many of them paused in the lobby to buy the "sheet music" and "souvenir programs" ("Here they are folks. All the song hits of the show!"). It was not until after World War II that "original cast albums" of long-playing records were sold in lobbies, as the sheet music once had been; more people had upright pianos and baby grands in their homes in the twenties than have them since the arrival of hi-fi and television. The twenties were still an era of do-it-yourself recreation, when the young rolled up the living-room rug and danced the foxtrot, and record players were gramophones and Victrolas and had cranks to wind them up.

Figures who have become legendary in the annals of American popular music were turning out musical-comedy scores at what now seems a prodigious rate. Richard Rodgers was working with his college friend Lorenz Hart, a witty lyricist who had a very different tone of voice from the somewhat sententious Oscar Hammerstein II with whom Rodgers collaborated after the war. Rodgers and Hart turned out six musical-comedy scores between 1925 and 1929 and two editions of *The Garrick Gaieties* as well. There were such hits at *Dearest Enemy* (1925); *The Girl Friend* (1926), whose hit song was "Blue Room"; *A Connecticut Yankee* (1927), with two hits that are still played, "Thou Swell" and "My Heart Stood Still," by dance bands and jazz musicians as the basis for improvisations; *She's My Baby* (1928); *Present Arms,* remembered only for "You Took Advantage of Me," and *Spring Is Here* (1929); and *Heads Up!,* which was running when the stock market crashed and many heads were anything but up.

It was in this same decade that George Gershwin, with his brother Ira as lyricist, was in full swing, turning out show after show, hit after hit. Gershwin wrote a miscellany of tunes for *George White's Scandals* ("Somebody Loves Me" and "I'll Build a Stairway to Paradise" were among them), but he hit his full stride with a musical comedy, *Lady Be Good* (1924), starring the Astaires, in which there were songs such as "Fascinating Rhythm," "The Half of It, Dearie Blues," and "Lady Be Good." ("The Man I Love" was written for *Lady Be Good* but was dropped as it couldn't find a place to fit; it obviously made an independent life of its own.) *Oh, Kay!* followed in 1926 with Gertrude Lawrence and the comedian Victor Moore, and with songs like "Someone to Watch Over Me," which moved men to tears, and "Clap Yo' Hands," which made them fidget. The next year there was one of the best of all twenties musicals, *Funny Face,* again with the Astaires and songs like " 'S Wonderful" and "My One and Only."

When Ella Fitzgerald, the paragon of jazz singers, recorded the *George Gershwin Song Book* on five long-playing records in the 1960s, she

included fifty-four songs, all of them hits in their day, a record not achieved by Richard Rodgers or by Cole Porter, in most respects the subtlest and wittiest of the composers for musical comedy. He was also the naughtiest and the slyest and most original as a writer of witty not just gimmicky light verse, for that is what his stylish lyrics were. More of his best-known songs come from the thirties, forties, and early fifties, though he wrote "Let's Do It" (a cleaned-up version of a pornographic set of stanzas that appeared in the nineteenth-century underground magazine *The Pearl*) for a show called *Paris* in 1928 and "You Do Something to Me" for *Fifty Million Frenchmen* in 1929. One of his shockers was "Love for Sale," which was written for *The New Yorkers* in 1930 and was generally banned from being played on the radio. The best known and most durable of all his songs, "Night and Day," was written for *The Gay Divorce* in 1932; it was stamped with a permanency not accorded many musical-comedy tunes when it became one of the most famous (justly so) dances ever recorded on film, the "Night and Day Dance" by Fred Astaire and Ginger Rogers in *The Gay Divorcee* in 1934. It was an otherwise notably unmemorable movie, though it has a way of being revived on television for "old movie buffs" (like me).

Musical Comedy Grows Up

There were other extremely successful composers of musicals, none more durable or more famous than Irving Berlin, who, it seems, scarcely knew how to write a tune that was not a hit, though all of his songs had to be scored by someone else. He was a tunesmith not a musician, the equivalent, you might say, of a two-finger typist. Vincent Youmans was a name to conjure with, principally because of his hit show *No, No, Nanette,* which included "Tea for Two," and Ray Henderson was another whose name is remembered by few but who wrote tunes such as "You're the Cream in My Coffee" and "Button Up Your Overcoat," which have become part of what might be called the "standard repertory" of popular songs of the Jazz Age.

A dazzlingly ambitious musical comedy called *Show Boat,* based on a novel by Edna Ferber with a score by Jerome Kern and a book and lyrics by Oscar Hammerstein II, is looked on as a watershed in the history of the musical theatre on Broadway. It was the redoubtable Mr. Ziegfeld who produced it in 1927, and it was so unlike the musicals of its day that to produce it at all took nerve and a sure confidence. Even he had his moments of doubt, and in one of them he threatened to back down. Here was a musical that entailed men and women in whose veins there seemed to be

Show Boat, with Oscar Hammerstein II lyrics, a score by Jerome Kern, and a book based on an Edna Ferber novel, opened on Broadway on December 27, 1927, in the brand-new Ziegfeld Theatre. The *New York Times* called it "just about the best musical piece ever to arrive under Mr. Ziegfeld's silken gonfallon." The sets were by Josef Urban, and the cast included Charles Winninger, Edna May Oliver and Helen Morgan.

some blood, not just glucose and vegetable dye, who were involved in rickety marriages, and failing show business, and there was even "a hint of miscegenation." Here were blacks ("darkies") on the levees of the Mississippi and a song, "Old Man River," a dignified wail of desperation. Here Helen Morgan perched on an upright piano declared her love for a drunken, deceitful lover ("Can't Help Lovin' Dat Man" and "Bill").

On the other hand *Show Boat* was touchingly sentimental, splendidly performed, and often very funny, and thanks to the sets and costumes by Joseph Urban and John Harkrider respectively, very good to look at. Its

story line, ridiculously filled with happy coincidences that made everything possible and nothing quite believable, was at least a story not a patchwork of comedy acts and songs out of nowhere. Lehman Engel, the conductor of a great many musical comedies, wrote of *Show Boat* forty years after it was first produced: "Its score and lyrics are among the best ever written in our theater, but it nevertheless suffers from the serious weaknesses of the period in which it was written. The characters are two-dimensional, the proportions are outrageous, the plot development is predictable and corny, and the ending is unbearably sweet." Weaknesses or not, it ran for 595 performances on Broadway, toured successfully for many months, and has been revived several times.

The tonic effect of *Show Boat* on musical comedy was not immediate. The 1930s saw fewer contrived and frothy musicals than the twenties (many of them were by the same composers and lyricists, to be sure), but this was because the atmosphere had changed. Breadlines were long, soup kitchens were crowded, and the apple sellers on city street corners reminded even those who had jobs and had not lost their savings in the crash that it was not a moment for extravagance. The economic depression by no means wiped out expensive entertainment, though it curbed it; the theatre flickered but its lights did not go out. It did, however, change its tone of voice somewhat, more particularly in the serious theatre but also in the frivolous (or comic) theatre as well.

A show written by George S. Kaufman and Morrie Ryskind, with a score by George Gershwin and lyrics by his brother Ira, was the next musical to push the medium up a rung on the ladder of adulthood, or so it seemed. *Of Thee I Sing* (1932) was a satire that made biting, albeit hilarious, fun of presidential politics, elections, the Supreme Court, cabinets, and most of all the sad plight of the Vice-President, whose name, when it came time for the inauguration, no one seemed able to remember. The role was played by Victor Moore, a consummate interpreter of diffidence and ineffectuality, a character burdened with the name Throttlebottom. It was a stroke of satire from which the vice-presidency has not yet recovered and may never. *Of Thee I Sing* was the first musical comedy to win a Pulitzer Prize, but such were the rules of that particular game that there was no provision for rewarding the composer: the prize went to Kaufman, Ryskind, and Ira Gershwin as authors. Posterity, however, gave its award to George Gershwin, and the success of the show changed the direction of his music.

The same team of authors and composer tried to repeat the success with another satire. This time their target was the politics of the depression, and the show was called *Let 'Em Eat Cake*. The class struggle, which had

never occupied much of the thought or talent of the theatrical world, became fashionable in the thirties, and Marxism, some of it fairly pure but most of it fancifully diluted, if it did not permeate did somewhat infiltrate what happened on the Broadway stage, even on the musical-comedy stage. *Let 'Em Eat Cake* misfired; it lasted only three months. But from Gershwin's point of view it was a successful break with what evidently seemed to him the routine kinds of music he had written for routine kinds of musicals in the twenties. "Gershwin's score," a critic of the day wrote, "was subtler and bolder, with harmonies and contrasts that were remarkably advanced for the popular theatre."

Gershwin's next musical show was *Porgy and Bess.* He called it a "folk opera," because, he said,

> *Porgy and Bess* is a folk tale. Its people naturally would sing folk music. When I first began work on the music I decided against the use of original folk material because I wanted the music to be all of one piece. Therefore I wrote my own spirituals and folk songs. But they are still folk music—and therefore, being in operatic form, *Porgy and Bess* becomes a folk opera.

When George Gershwin's *Porgy and Bess* arrived on Broadway in 1935, he wrote for the *New York Times:* "The reason I did not submit this to the usual sponsors of opera in America was that I hoped to have developed something in American music that would appeal to the many rather than the cultured few." This set, by Serge Soudeikine, is Catfish Row. Porgy, a cripple on the ground pointing up, was played by Todd Duncan.

The opera was based on a novel by DuBose Heyward, which Dorothy Heyward, his wife, was converting into a play when Gershwin wrote asking what Heyward thought of using his novel as the basis for an opera. This was in 1926, nine years before *Porgy and Bess* opened on Broadway to mixed reviews. Both drama and music critics attended the opening night, and as one might expect the music critics were less impressed by what seemed to them the work of a Tin Pan Alley tunesmith turned serious composer than were the drama critics, who saw here a new dimension in American musical theatre.

Gershwin's pretensions, if that is what they were, to serious composition were not new. He had written and Paul Whiteman had performed *Rhapsody in Blue* in a concert of modern music at Aeolian Hall in New York on February 12, 1924. At Whiteman's request the piece was run up in three weeks as a piano score. It was then orchestrated by Ferde Grofé and performed with Gershwin at the piano. The concert went by the title of "Experiment in Modern Music," and it was a howling success. "There was tumultuous applause for Mr. Gershwin's composition," Olin Downes, the *New York Times* critic wrote the next day, but though he obviously enjoyed himself and said that "the composition shows extraordinary talent," he felt that Gershwin was "struggling with a form of which he is far from being master." Of Paul Whiteman he said, "He does not conduct. He trembles, wobbles, quivers—a piece of jazz jelly, conducting the orchestra with the back of the trouser of the right leg, and the face of a mandarin the while."

The upshot of the Whiteman concert was that not only did Gershwin feel justified in regarding himself as a "serious" composer* but so did others, among them Walter Damrosch, the conductor of the New York Symphony. In 1925 Damrosch commissioned Gershwin to write a piece for a full orchestra, and the result was his Piano Concerto in F. This was followed in 1928 by a tone poem called *An American in Paris.* It is not surprising that Gershwin was determined to write an opera and that the public were ready to welcome it as they welcomed *Porgy and Bess.*

George Gershwin died of a brain tumor in Hollywood in 1937. He was thirty-eight and had been in analysis. He suffered from persistent headaches, which were thought by his psychiatrist, so it was rumored at the time, to be neurotic in their origin. "If only. . . ." people said. His death was a shock to Broadway and well beyond. He was young, greatly gifted, and, though his production had already been prodigious, there seemed a

*"He was also full of humorless selfconfidence. . . . Oscar Levant, pianist, wit and friend, once remarked sardonically, 'Tell me, George, if you had it all to do over again, would you still fall in love with yourself?' " *Broadway* by Brooks Atkinson, p. 329.

remarkable career still ahead of him. He was a bridge between Tin Pan Alley and "serious" music, a sort of legitimizing force for popular music. At a memorial service for him Irving Berlin declared:

> As a writer of serious music
> He could dream for a while in the stars,
> And step down from the heights of Grand Opera
> To a chorus of thirty-two bars.

Porgy and Bess was revived in 1942 during World War II, and after the war it was sent abroad by the Department of State on a "good-will mission." It was enthusiastically applauded (partly, no doubt, out of politeness, partly because of its oddity) in Sweden, Germany, Austria, Denmark, and most particularly in Russia. Its songs, among them "A Woman Is a Sometime Thing," "Bess, You Is My Woman Now," "Summertime," "I Got Plenty of Nuttin'," and "It Ain't Necessarily So," have taken their place in the repertory of American popular music with what seems aplomb equal to those of Stephen Foster, who was writing songs for black-face minstrel shows a century earlier. Not everyone anticipated this when the show opened. Lawrence Gilman, the music critic of the New York *Herald Tribune* heartily disliked "the song hits . . . scattered through his score. . . . They mar it. They are its cardinal weakness." They were, he wrote, "sure-fire rubbish." (To be sure, the operas of Mozart, Verdi, and Puccini have song hits "scattered through" their scores.) The public, however, were delighted to see and hear an opera in a vernacular both musical and verbal that left no doubt of its story, its humor, and its lyrical and dramatic intent. In February 1985, fifty years after its opening, it finally took its place in the repertory of New York's Metropolitan Opera Company.

There were other operas by American composers that caused considerable comment in the 1930s, though they played to relatively small audiences of special (one might say highbrow) tastes for very short runs. They are mentioned here because they were not in the "grand opera" tradition, though neither were they in the orbit of musical comedy. Two are still remembered (and deserve to be), and their scores are occasionally performed as concert pieces. Virgil Thomson's *Four Saints in Three Acts*, with a libretto by Gertrude Stein, was first produced in Hartford, Connecticut, by The Friends and Enemies of Modern Music in 1934, and Marc Blitzstein's *The Cradle Will Rock* was produced by Orson Welles and John Houseman in 1937 as the last gasp of the Federal Theatre Project of the WPA in New York. The opera was just barely posthumous in that politically racked and bureaucratically timid and bedeviled effort to provide work for theatre people. These two pieces could not have been more different in intent, texture,

Virgil Thomson's opera to Gertrude Stein's libretto, *Four Saints in Three Acts,* opened in 1934 to a recherché coterie in Hartford, Connecticut, under the aegis of The Friends and Enemies of Modern Music. Its sets were designed by Florine Stettheimer. John Houseman directed the all-black cast and Frederick Ashton did the choreography.

or temperament. Thomson's lyrical fantasy, with an all-black cast of singers and sets by Florine Stettheimer, was a confection whose libretto was not meant to be understood, merely enjoyed for its sounds and rhythms.* It was pretty to look at and sweet and subtle to hear.

Blitzstein's *Cradle,* which he called "a play with music," was called by others, as Houseman recalls, "an opera, a labor opera, a social cartoon, a marching song, and a propagandistic tour de force." Blitzstein wanted there to be no doubt about what his words meant (he wrote the libretto,

*In the introduction to a broadcast of *Four Saints* in 1942, Thomson said of it: "Please do not try to construe the words of this opera literally or seek in it any abstruse symbolism. If, by means of the poet's liberties with logic and the composer's constant use of the simplest elements in our musical vernacular, something is here evoked of the childlike gaiety and mystical strength of lives devoted in common to a non-materialistic end, the authors will consider their message to have been communicated."

if it can be called that, as well as the music), and they were militant, scathing, and vituperative attacks on steel magnates and their "whores." ("The Moll, though a prostitute [with whose song the show opened]," Lehman Engel, the show's conductor, wrote, "is a victim of society and a kind of heroine. The Dick (cop), Reverend, Editor, Painter, Violinist, Bugs (gangster), Prexie, Mamie, and Trixie (professors) and Doctor are presented as the *real* whores who do whatever they can" to please the steel magnate who goes by the name of Mr. Mister. The hero was a union organizer. *Cradle* was part vaudeville, part polemic, part Tin Pan Alley, part minstrel show, but it was not in any sense a musical comedy like *Of Thee I Sing,* a very different satire, any more than Thomson's *Four Saints* was "grand" opera. Thomson and Blitzstein were serious composers (Thomson still is), and if no one remembers their tunes (no one ever did) they have a place in serious repertory.

The Blitzstein's mentors were Kurt Weill and Bertolt Brecht. It was Brecht who said to him when he showed Brecht the dramatic sketch about the streetwalker, "To literal prostitution you must add figurative prostitution—the sell-out of one's talent and dignity to the powers that be." It was Kurt Weill who had composed the score for Brecht's version of Gay's *The Beggar's Opera* called *Die Dreigroschenoper,* which had so shocked officialdom in Berlin in the late 1920s that Weill and Brecht got out of Germany to save their skins. This musical play, under the name *The Threepenny Opera,* turned up briefly in New York in 1933. It lasted only twelve performances, though in the 1950s it was revived "Off Broadway" and ran for years, with Lotte Lenya, Weill's widow (he died in 1950 at the age of fifty), in the role she had created in the original Berlin production. Weill was one of those few composers whose work declines to be pigeonholed as "popular" or "serious." He wrote the scores for a number of extremely successful musical comedies (among them *Lady in the Dark,* with Gertrude Lawrence and Danny Kaye; *Knickerbocker Holiday,* in which Walter Huston sang "September Song"; and *One Touch of Venus,* with Mary Martin), an opera based on Elmer Rice's *Street Scene* and *Mahagonny,* which is in the Metropolitan Opera's repertory, though infrequently performed.

Lehman Engel evidently put a computer to work (probably a human one) and arrived at figures that dramatically bespeak the decline in the production of musicals of various sorts (revues as well as comedies) between 1920 and 1950. In the twenties, Engel says, 423 musicals opened, most of them only fleetingly. In the Depression decade of the thirties there were 179, or fewer than half as many as in the "roaring twenties." This

is not surprising considering the state of the economy, the numbers of unemployed, the cautious ways in which people approached entertainment. Movies were cheaper and the movies of the thirties were just as mindless and gay and entertaining as the best of the musical comedies and revues, and many of them were better. In the decade of American participation in the Second World War, and during the ebullient recovery after the war, the number was 152, or roughly a third what it had been two decades earlier.

The effect of the war on the nature of musicals was negligible, with one exception. In 1942 Irving Berlin wrote a show called *This Is the Army.* He had written one in the First World War, called *Yip, Yip, Yaphank* (1918), "a musical mess cooked up by the boys at Camp Upton" with Sergeant Berlin singing "Oh, How I Hate to Get Up in the Morning." Like its predecessor, *This Is the Army* was entirely performed by enlisted men and was a rousing success on Broadway and on its long tour to other cities. It was probably the only musical during the war years in which there were more men in uniform on the stage than there were in the audience, though free theatre tickets were often handed out to servicemen on leave or about to go overseas.

Only two musicals that hit Broadway between the Nazi onslaught on Poland in September 1939 and the bomb on Hiroshima in August 1945 need to be mentioned and paused over. In both cases the scores were by Richard Rodgers. The first was *Pal Joey,* with a book by John O'Hara, the novelist, and lyrics by Lorenz Hart; the second was *Oklahoma!* based on the play *Green Grow the Lilacs* by Lynn Riggs, with lyrics and book by Oscar Hammerstein II, his first collaboration with Rodgers and his most memorable.*

Brooks Atkinson called *Pal Joey* an "acrid antic." Its hero was a heel and its sentiment was anything but the usual sweetness and light. Gene Kelly danced and sang the heel, who acted tough and murdered the language and wasn't as smooth a number as he thought he was. The book for the show was based on a series of sketches that John O'Hara had written for *The New Yorker,* and Hart's lyrics were his last successful collaboration with Rodgers. (Hart died in 1943 at the age of forty-nine.) The lyrics were taut and witty; the one that has survived most particularly is "Bewitched, Bothered and Bewildered," but there were others almost as durable, "In Our Little Den of Iniquity" and "Take Him." Rodgers said of the show that it "wore long pants and in many respects forced the entire musical-

*They had collaborated on a show while they were undergraduates at Columbia University. *Oklahoma!* was their first professional collaboration.

comedy theatre to wear long pants for the first time." The critic Howard Taubman said, "It looked unblinkingly at a heel, a self-indulgent rich woman and a sleazy world, and did not romanticize." The public was pleased. Twelve years after it was first performed it was revived, hailed as a classic, and ran for 542 performances, 168 more than its original run.

The Rodgers and Hart collaboration had been a stormy one. Their feud was not a personal one but their attitudes toward their talents were quite different. Rodgers was a quiet perfectionist, Hart a headlong and brilliant versifier, who, according to Rodgers, "hated doing it and loved it when it was done. . . . His pencil would fly over the paper and soon the most difficult part of all would begin: the material had to be edited and he loathed changing a word once it was written down. . . . Our fights over words were furious, blasphemous and frequent, but even in their hottest moments we both knew that we were arguing academically not personally." Rodgers's collaboration with Oscar Hammerstein II was more peaceable and, in a very different tone, even more successful, if indeed any comparison is not misleading. Hammerstein was a quiet, gentle, and generous man, whose wit was not mordant, as Hart's was, but was none the less lively for that.

Oklahoma! was as wholesome as *Pal Joey* was otherwise. It had a pleasantly rambling story, based on Riggs's play set in Indian Territory, and a cheerful spirit of open-air sporting, good to look at but unfancy. It had pace but seemed not to be in a hurry. The characters were affable or playful or funny, and over it all was a kind of gentle naïveté that charmed audiences for longer than any musical comedy ever had run on Broadway. It played for 2,212 performances. (It had been running for about four years when I saw it, and it still seemed fresh as a daisy.) It was a "people's opera," Cecil Smith said, "unpretentious and perfectly modern, but of interest equally to audiences in New York and Des Moines." There was no stilted chorus line, but singers and dancers performed flowing and romping dances devised by one of the geniuses of American dance, Agnes De Mille, with something of square dance, something of modern ballet.

It was lucky to reach Broadway at all. When it opened in New Haven, at that time the standard tryout city, one wit reported to his paper, "No legs, no jokes, no chance." Its title was *Away We Go!;* when it moved to Boston it became *Oklahoma!* Someone was smart enough to rescue the exclamation point, which gave it an emphatic and enthusiastic quality. *Oklahoma* without it would have been about as inviting to theatregoers as, say, *Rhode Island* or *Delaware.* Its advance press was so cool that, on the opening night, Rodgers's and Hammerstein's names notwithstanding, there were empty seats. It was, however, a hit from the moment the curtain

Oklahoma! blew into Broadway like a breath of fresh air from the prairies in 1943 during World War II, and it kept blowing for more than five years. It was the first of many Broadway collaborations between the composer Richard Rodgers and the lyricist Oscar Hammerstein II. The choreography of Agnes De Mille brought a new sophistication to musical comedy.

went up on a simple stylized set, with a woman sitting on a porch rocking herself while the voice of a baritone was heard from offstage singing "O, What a Beautiful Mornin'." The song continued as he strolled onto the stage, and the pleasant tone of the evening was set. There was a kind of enveloping warmth that kept it running and running. It made a profit of $5 million on a reluctantly invested $83,000. Its backers had considered it a very long shot and only the names of Rodgers and Hammerstein had parted them from their money.

It arrived at a moment when relief from the sour war news from North Africa, from the Pacific, from Britain and France was more than welcome. It was an escape into a world where what was not simple and wholesome was funny and dreamlike. In many respects it was more operetta than musical comedy, but it was not standard in either mode. Its success encouraged Rodgers and Hammerstein after the war to push still further away

from the happy formulas of musical comedy to more ambitious but no less lyrical shows, such as *Carousel* (1945), based on Ferenc Molnár's play *Liliom* but transplanted from Hungary to a New England fishing village, and *South Pacific.* James Michener's *Tales of the South Pacific* and most particularly the story of the civilian coast watchers, who informed the American fleet of the movements of Japanese ships, provided the basic story. Ezio Pinza, the great basso of the Metropolitan Opera, played the middle-aged hero (opera buffs were afraid he would ruin his voice by performing eight times a week) and opposite him was Mary Martin as a spirited perky nurse who was bewitched by him. She in turn bewitched her audiences with "I'm Gonna Wash That Man Right Outa My Hair," and "I'm in Love with a Wonderful Guy," and most particularly in the duet with Pinza "Some Enchanted Evening." The war was over. It could safely be sentimentalized and made humorous, so long as the humor was affectionate. The show ran for nearly two thousand performances.

In 1956 Julie Andrews and Rex Harrison, in sets and costumes by Cecil Beaton, and with a score and lyrics by Alan Jay Lerner and Frederick Loewe, magically transformed George Bernard Shaw's *Pygmalion* into *My Fair Lady,* one of musical comedy's wittiest and most durable hits.

The years immediately following the war were bedazzled with musical comedies. Ethel Merman belted out the songs that Irving Berlin wrote for *Annie Get Your Gun.* Harold Rome, who had written the score for a revue called *Pins and Needles* in the 1930s (it was produced and performed by the ILGWU), wrote the music for *Call Me Mister,* a musical comedy about a soldier's withdrawal symptoms after leaving military life, both funny and touching. There was *Finian's Rainbow,* an Irish fantasy about the silliness of burying gold, with social and political satire as pepper and salt. *Brigadoon,* a Scottish fantasy, made the reputations of Alan Jay Lerner and Frederick Loewe, who in the next decade contrived the magical *My Fair Lady* from Bernard Shaw's *Pygmalion.* *

Jo Mielziner designed the remarkable sets for Frank Loesser's *Guys and Dolls* in 1950. Brooks Atkinson called it "a carnival of shoddy Broadway innocents lost in a furtive but fabulous world." This is the below-street crap game (access by manhole) with Robert Alda belting out "Luck Be a Lady Tonight." Loesser's score and lyrics are as fresh today as they were when he wrote them.

**My Fair Lady* played more than 3,000 performances in New York and ran for more than five years in London. It took in more than $50 million at the box office, sold millions of records, and the movie rights brought $5 million. It is probably running somewhere now.

The final fling of 1940s' musicals (actually it opened on November 14, 1950) was *Guys and Dolls,* which, like *Pal Joey,* its progenitor, was a "long pants" show. It was tough, it was naughty; it was about a bunch of heels (not just one) and a Salvation Army lass. It was based on a story by the reporter and short-story writer, Damon Runyon, whom Louis Untermeyer called "the laureate of the illiterate," by which he meant "the safe-blowers, hard-boiled (but sentimental) sports, beer barons, crap-shooters, horse-players, gangsters and slangsters of Manhattan-on-the-subway." The book was credited to Jo Swerling and Abe Burrows, but George S. Kaufman and Michael Kidd had a hand in it. The dances, which were of an eccentricity unfamiliar to musical-comedy fans, were by Kidd, and the score and the lyrics were by Frank Loesser. Jo Mielziner did the sets. The tunes were pretty and vigorous, the lyrics were funny and spirited, the dances were filled with vitality, and the cast for the New York production had things and the audience firmly in hand. When *Guys and Dolls* was produced in London three years after it opened in New York, "There it both pleased and puzzled the Britishers—Runyon's books had to be supplied with glossaries so that English readers could follow his rapid-fire Broadwayese."

Musicals with a Message

Until Oscar Hammerstein II came along just after World War II and occasionally interjected a missionary message into his lyrics, the musical theatre had done its best to distract its audiences from everything that might concern them elsewhere. It was the theatre of escape, of noninvolvement, of relaxing euphoria, and except for a certain pepper of social and political satire, which was meant to pique rather than persuade, it left serious matters to other departments of the theatre. In exploiting low-life, as it did in *Pal Joey* and *Guys and Dolls,* it was not attempting to create realism but merely to discover a formula that had not been done to death. Blitzstein's *The Cradle Will Rock* was a "sport" so far as the musical theatre was concerned, a creature of the pseudo-Marxism which had a moment of theatrical chic and which led to some extremely unpleasant consequences for playwrights and producers in the red-baiting era of Senator Joe McCarthy and the Committee on Un-American Activities.

Through three wars (the Spanish-American War and the two World Wars), from the time Adelina Patti sang "Home, Sweet Home" at the opening of Louis Sullivan's Auditorium in Chicago in 1889 and Steele MacKaye dreamed of his Spectatorium to bedazzle the crowds at the Chicago World's Fair of 1893, until 1949, when Joshua Logan produced *South Pacific,* the musical theatre danced and sang its merry way, waving

an occasional American flag. Since a great deal of first-rate talent and a few minor geniuses were involved, it created a form of entertainment that, whatever its progenitors in the commedia dell'arte, in German and Austrian and French operetta, in English farce-comedy, and French revues, was finally and essentially American. It was often "as corny as Kansas in August," as Mary Martin sang in *South Pacific*, and as American as apple pie, but it kept moving in new directions.

Leonard Bernstein thought of musicals a step toward something more serious, a step he took himself in *West Side Story* in 1957. In *The Joy of Music* he wrote: "The American musical theatre has come a long way, borrowing this from opera, that from revue, the other from operetta, something else from vaudeville—and mixing all the elements into something quite new, but something which has been steadily moving in the direction of opera." It seems also to be true that opera has been moving in the direction of the American musical comedy, adopting some of its conventions, or, perhaps, reverting to the conventions out of which they both originally came, the theatre of the Greeks.

The "Legit" Theatre

At the turn of the century no American playwright understood his audiences as perceptively or entranced them more deftly than William Clyde Fitch. He pleased them with his sprightly wit, titillated them with his discreet naughtiness, and persuaded them that they were seeing character beneath the surface of personality and agile dialogue. He was a consummate playmaker, a compulsive worker, as swift as he was sure. He lived elegantly in an apartment above Carnegie Hall, and owned two houses in Europe, which he filled with bibelots and furniture he bought with a delicate and confident taste on his frequent trips abroad. His travels were not escapes from work; he wrote wherever he happened to be (it is recorded that he wrote a play called *The Truth* in a gondola on the Grand Canal) because producers were always after him for new scripts. "He seems to have been a psychotic about work," Brooks Atkinson wrote in *Broadway*. "Archie Bell remarked that he 'lived like a sultan and worked like a dock laborer on an eighteen hour shift.' "

Actors "adored" Fitch.* He knew the qualities, foibles, and aspirations of those he worked with, and he wrote to suit their special skills, charms, and idiosyncrasies. He worked "at lightning speed, never fearing to rewrite and capable of doing it overnight"; so Diana Forbes-Robertson wrote in her biography of Maxine Elliott, her aunt and one of the stars for whom Fitch was a "tailor." Maxine, a famous beauty, "found him comfortable. With him she could discuss her beauty and her clothes in an impersonal way with no man-woman fencing." This "dock laborer," wit, tailor of plays, fastidious collector, and dandy with "airy manners, prettily coiffed locks and a curly moustache" died in 1909 at the age of forty-four.

*In the language of the theatre "adore" can mean anything better than "tolerate."

It was thought by his friends that he killed himself with overwork.

Fitch plied his trade at a time when "stars" were all important to the theatre; without them audiences were indifferent, no matter how stirring or profound or entertaining the play. If actors and actresses, however eminent, were not regarded as "socially acceptable" by genteel society,

Clyde Fitch was the master play-maker of the turn of the century. He was as elegant a figure ("airy manner, prettily coifed locks, and curly moustache") as he was an obsessively productive writer, director and collector of bibelots with which he surrounded himself. He posed for this undated picture in his apartment in New York's Carnegie Hall.

they were idolized nonetheless. Fitch got his start working for such an idolized actor. He had been a student at Amherst College, where he devoted a good deal of time to the college dramatic society. He played Lydia in Sheridan's *The Rivals* and Peggy Thrift in *The Country Girl* (an adaptation of Wycherley's *The Country Wife* made by David Garrick in 1766, with some of its bawdiness removed). It was a *New York Times* drama critic who recommended him to Richard Mansfield. Mansfield was one of the matinée idols of the late-nineteenth-century American stage, a name and face to conjure with, and he wanted to perform in a play about Beau Brummell, the quintessential dandy, a friend of the regent who became George IV. Fitch wrote the play, which Mansfield doctored to suit himself, as he did whatever play he was willing to be seen in.

The association with Mansfield and the success of *Beau Brummell* sped Fitch on his way. He was off to a career that saw plays tumbling from his pen at an astonishing rate. In the season of 1900–1901 there were four plays by him running simultaneously on Broadway, and in the following season there were three more.* Ethel Barrymore made her reputation, if not her debut, in one of his most successful (because of her) confections, *Captain Jinks of the Horse Marines,* which a sour anonymous reviewer for the *New York Times* (presumably not the one who recommended Fitch to Mansfield) panned. He called it "as weak stuff as we have been inflicted with lately . . . the piece lacks verity or logic, is deficient in wit and humor, and has to commend it only a sort of frisky juvenility."

The public disagreed, as it frequently did with criticisms of Fitch's plays. What they wanted and what he gave them was not profundity but "well-made plays," a term that is frequently applied to the plays of the turn of the century by historians of the theatre. The year after Fitch died, Walter Prichard Eaton, who had been the drama critic of both the New York *Tribune* and the *World* (many years later he became director of the Yale Drama School), wrote with perception and measured enthusiasm about him in *At New Theatres and Others.* What Eaton had to say puts the finger not just on Fitch but on the theatre of the day:

> To take Clyde Fitch seriously always surprised the serious people. To take the theatre seriously always surprises many serious people . . . the theatre . . . not the printed page, not the so-called "literary drama," but the actual playhouse . . . where trivialities of all sorts jostle with Shakespeare and Ibsen in the long effort to amuse. . . . Clyde Fitch was a man of that actual

*1900–1901: *The Climbers, Captain Jinks of the Horse Marines, Barbara Fritchie,* and *Lover's Lane;* 1901–1902: *The Way of the World, The Girl and the Judge,* and *The Marriage Game.*

Ethel Barrymore (sometimes called "Ethel Baritone" because of her deep voice) here with H. Reeves Smith made her first hit as Madame Trentoni in Clyde Fitch's *Captain Jinks of the Horse Marines,* produced by Charles Frohman in 1900. For years Miss Barrymore was one of the "great ladies" of the theatre. She and her brothers John and Lionel Barrymore and their uncle, John Drew, were known as "the royal family" of the stage.

playhouse. He wrote to amuse, to entertain . . . he was willing to be a dramatic tailor, to cut a part to measure for a star. . . . He belonged to Broadway, not the library or the classroom.

His plays were never concerned with large personages nor profound passions. . . . Nevertheless that work at its best caught truthfully the surface of the life depicted and occasionally with a kind of smiling irony, plunged down below the crust.

The stage literature of today in this country is more truthful, more carefully observed, closer to life and more consistently a comment on it . . . than it was before Mr. Fitch began to write.

Fitch's plays were comedies of the manners of the upper classes, with something in them of the modern soap opera, something of Cole Porter, and a dash of Noel Coward. They were plays that delighted the same people who devoured the novels of Edith Wharton and Booth Tarkington

and probably found Henry James turgid and tiresome, and Theodore Dreiser unreadable, and who were oblivious of the "muckrakers." They attacked problems, not in the way Ibsen did or in George Bernard Shaw's way, but cleverly probed the surface in a teasing way. In one of his plays, *Sapho,* produced in 1900, Fitch so shocked the defenders of the public virtue by having his male lead carry a young lady upstairs, with what were obviously not honorable intentions, that the police closed the show. Gentility frowned on such ungentlemanly antics—at least in public places.

If Fitch's plays are unproducibly dated today, they have their merits as social history of a limited sort for those who are willing to pursue them. To quote Walter Prichard Eaton once more:

> In the long array of his plays, stretching over a period of almost twenty years, will be found a varied record of the foibles and fashions of the hour, the turns of speech which characterized the fleeting seasons, our little local ways of looking at things, the popular songs . . . the topics . . . in social chat, our taste in decoration, our amusements, the deeper interests, even of our leisured classes; and always a portrait gallery of vividly drawn minor characters of great historic interest . . . [an] authentic and vivid record of our American life from 1890 to 1910 so far as it was lived in the gayer parts of town.

To dwell at such length on Clyde Fitch may seem to give him an importance he does not warrant, but "he made the actual theatre a better place within his own too brief lifetime, he helped to increase respect for it, and to refine popular appreciation."

Two of Fitch's contemporaries, like him practitioners of the well-made play (Atkinson calls them "play carpenters"), were as different from Fitch in temperament as they were from each other. They were Augustus Thomas, who turned out fifty-seven plays between 1875 and 1934, and Langdon Mitchell, prolific if not *as* prolific. Thomas came from the Middle West and knew how America worked in ways of which Fitch neither had firsthand knowledge nor cared about. He had been a railroader, had read law, been active in politics (he seconded William Jennings Bryan's nomination for the presidency at the Democratic convention in Denver in July 1908), managed a theatre and traveled as extensively in America as Fitch did in Europe. He was not concerned merely with the social undercurrents of the drawing room but with social issues—impolite subjects such as the tensions between capital and labor. He wrote a play called *New Blood* that was inspired by the Pullman strike which shocked the nation in 1894 not so much for new blood as for spilled blood, and in a play called *The Capital* he dealt with the pressures on government and on politicians (if that is not a redundancy) by financial and religious groups.

Langdon Mitchell, by contrast, was a clever, witty, and satirical commentator on social behavior (more particularly on misbehavior); he was more probing than Fitch. Mrs. Fiske, one of the truly great stars of her day, a woman of tough intellect, independent spirit, a professional to her fingertips, and a fighting defender of her theatrical independence against odds that many stars succumbed to, declared, "I consider the most vicious influence of the day is the chambermaid-society drama." If she had Fitch in mind she did not say so, but she was glad to appear in Mitchell's *The New York Idea* in 1906 because it was "satirical not snobbish." It concerned the touchy subject of divorce, then regarded as a step to be taken only in the most extreme circumstances. (In New York the only ground for divorce was adultery, and it had to be proven in court by producing or naming a corespondent, real or fictitiously contrived with the aid of a private detective and a photographer to catch the offending party in what was called a "compromising situation." Rigging such a situation was still considered good farce in the 1930s when Fred Astaire and Ginger Rogers danced and sang and cavorted in the film *The Gay Divorcee*.) Mitchell's "merry comedy romp," as Percy Hammond called it, bothered the critic who wrote for *Life,* James Metcalfe, not for Mitchell's attitude toward the frivolous ways that New Yorkers went about shedding their spouses but because of what the influence might be of plays like his. "Gentlemen like Mr. Mitchell," he wrote, "do not appreciate the power of the medium they command, and, therefore, do not stop to think that they should be careful, very careful, how they use it, lest they sow evil in minds not able to understand the good they intend." (Brooks Atkinson's sly comment on this was: "Since 1906, divorce has been common in America. Did Mr. Metcalfe put his finger on the man who was to blame?") In general the playwrights of the turn of the century saw to it that virtue triumphed over vice, constraint over lust, happiness over sorrow and that heroes and heroines were gentlemen and ladies at heart.

Mrs. Fiske was only one of the stars who then dominated the theatre. The theatre was star-ridden as it had been for many decades. It was the bright, lustrous names of actors and actresses, not the quality or even the fame of plays, that enticed audiences to box offices in New York and Boston and Philadelphia and to opera houses from Maine to California. Audiences did not go to see *Hamlet,* they went to see Edwin Booth as Hamlet. A generation later they went to see John Barrymore as Hamlet, as they went to see his sister Ethel in anything she might deign to play. If an actor hit on a good thing, he stayed with it, as Joseph Jefferson stayed with *Rip Van Winkle,* in which he toured for thirty years and more. It was *he* they went to see, not *it*. Stars were made slowly and their careers often

Minnie Maddern Fiske ("Mrs. Fiske"—only the most revered actors and actresses were known to audiences as "Mr." or "Mrs." or "Miss") was a power in the American theatre, not just as a remarkably versatile and subtle performer but as a fighter for the rights of actors and playwrights. Here in 1925 she appears as Mrs. Alving in Ibsen's *Ghosts*.

began early. Maude Adams, a heartbreaker or, perhaps more accurately, a melter of hearts, in the early years of the century, first appeared on the stage in her mother's arms at the age of one. She learned her profession as a trouper, doing one-night stands and living in theatrical boarding-houses, of which every city had at least one. Mrs. Fiske, who played as Minnie Maddern before she married Harrison Grey Fiske, the publisher of a theatrical sheet called *The New York Dramatic Mirror,* first appeared on the stage as a three-year-old; when she was five she played in *Uncle Tom's Cabin, Richard III* and *King John.* She was red-headed, firm-chinned, small of stature, and full of persuasive vitality. By the time she was fifteen she was playing leads, but when she married she gave up the stage out of deference to her husband's position and set about, unsuccess-

fully, to be a lady of leisure. It was a one-shot performance done for charity in Ibsen's *A Doll's House* that brought her back to the stage. She was more than an actress and a star, she was a movement and a force, and when it came to fighting "the Syndicate" for the freedom of her profession, she was a dragon.

If famous actresses were not socially acceptable in the homes of the genteel they lived like queens, lavishly courted, each with her entourage of dressers, press agents, and what were then called "swains" and "stage-door Johnnies." Famous actors made fortunes, and some of them, like Richard Mansfield, who gave Fitch his wedge into the theatrical world, lived arrogantly and lavishly. Mansfield refused to speak with the players with whom he performed, rode from city to city in his private railroad car, from which the cast was excluded, complained of poor performances but never praised good ones. Perhaps only Sarah Bernhardt, whose repeated American "farewell" performances and tours with her tiger cub and coffin outdid him in off-stage theatrics.

There is no way for us to tell how great the stars were as performers (since few of them appeared in films and consequently there is no visual or aural record of their skills). They can be measured only by the press they received and the money they earned at the box office for themselves and producers. A name can be a press agent's contrivance, magnified in the public imagination by the lights a producer uses to put it on the marquee. Even so it is pleasant to contemplate the legends, earned or contrived, and names like Eleanora Duse, Réjane, Modjeska, Julia Marlowe and E. H. Sothern, Otis Skinner, and Maxine Elliott have the magic to enliven the imagination and lend glamour to nostalgia.

It is well to remember that the reputations of these performers were made, by present measurement, a drop at a time. A few thousand people might see a performance of extraordinary brilliance during the run of a play in New York. More thousands might see it on the road. In a lifetime an actor might be seen by as many as a million people, quite probably not as many as that. Today, a single performance on television, much less a series of performances, exposes an actor to twenty to seventy million pairs of eyes and ears at once. The "overnight sensation" at the turn of the century had a few hundred people to thank, those who happened to come on opening night, not as today a fifth of the population of the nation, who happened to turn their dials to a particular channel. In one respect what the actor gains from exposure by films and television tubes is offset by what he loses in response. No audience is as cold as the lens of a camera or as impersonal as a laugh track.

Unpleasant Noises Offstage

The Syndicate that brought out the dragon in Mrs. Fiske was a combine of producers that in essence was a trust, a monopoly. It aimed at and almost succeeded in controlling the American theatre by coercion, bribing critics, boycotting newspapers, blackballing actors, and hogtying managers and owners of theatres. This slavery of the theatre, as it might reasonably be called, was primarily the work of two producers, one with the unlikely name of Abraham Lincoln Erlanger and the other appropriately called Marc Klaw, and a handful of businessmen, whose only interest in what appeared on the boards was to turn a fast buck. The Syndicate came into being in 1896, and its original scheme was to book shows in theatres outside New York in a systematic, and hence economical, way that reduced and, it hoped, might stifle competition completely. It did this by signing contracts that gave the Syndicate the exclusive use of "quality" theatres in city after city outside New York and a good number of theatres on Broadway. The intention was to make it impossible, or nearly so, for independent theatre companies to find stages on which to perform.

The result, as you can imagine, was a pitched battle, and the weapons used by the Syndicate were anything but those of a chivalrous or gentlemanly sort. Erlanger and his backers "bought" the press in some subtle and some bullying ways. They hired critics to rewrite scripts or gave them "consulting fees" in order to assure good reviews. They kept shows running on Broadway at a loss so that they could bill them as having long runs in New York when they sent them on the road. So great was their volume of advertising in newspapers that threats to withdraw it ensured that whatever they offered would have favorable reviews. A consequence of this was that good plays not produced by the Syndicate were panned, and the Syndicate's bad plays were praised. A financial hammerlock on the theatres outside New York and control of what their managers would show meant that an independent actor or producer could not find respectable theatres in which to perform. So they were forced to hire second-rate houses in rundown neighborhoods, where audiences were used to paying a quarter for a ticket. There were two disadvantages to this: first, that "class" of patrons used to pleasant, clean theatres in the center of town were uneasy about venturing into unfamiliar territory, and, second, the theatre managers were afraid that if they raised the ticket price to $2, which star performers could entice, their regular customers would disappear for good.

The Syndicate could operate its monopoly successfully only by per-

suading star actors and actresses to sign contracts that gave the Syndicate exclusive rights to their services. This meant not only that the players went where the Syndicate told them to go and booked them but that they performed in plays the Syndicate told them to perform in. There were few holdouts among the well-known actors. Mrs. Fiske, whose husband's paper fought the Syndicate, was one of the most outspoken and influential and firmest of the opponents. She never gave in. The Syndicate regarded her husband and his *Dramatic Mirror* as a fly to be swatted, and posted a notice on the call boards of its theatres that anyone caught reading the *Mirror* would be fired. (Maurice Barrymore, who was playing in a Syndicate theatre in Boston at the time, sent a telegram to Erlanger: "Have rarely read a dramatic newspaper but will read the *Dramatic Mirror* regularly hereafter.") Richard Mansfield was one of the holdouts, and was eloquent in his opposition, assuring his fellow actors that he would never bow to the blandishments and threats of the Syndicate. He summoned a number of actors to his office "to draw up papers for an organized opposition," but he failed to turn up. Instead he sent a message that he had signed a contract with the Syndicate. It was a fat one. But there were those who persisted in holding out: Nat Goodwin, Maxine Elliott's husband, and Joseph Jefferson, "the most celebrated, beloved, and talked-about comedian of his day," and among the foreign contingent, Sarah Bernhardt. When she was refused theatres by the Syndicate, she played to delighted crowds in circus tents. Her defiance of the Syndicate not only pleased audiences but inspirited other actors in their crusade.

The most complete and revealing account of the power of the Syndicate was written by the critic Norman Hapgood of the *Commercial Advertiser* while the Syndicate was at the peak of its power. It appeared in 1901 in Hapgood's book *The Stage in America, 1897–1900.* * He wrote from the point of view of a man to whom the art of the theatre was of paramount importance. He quoted from several of the Syndicate's opponents, including Mansfield. (It was after Hapgood's book appeared that Mansfield caved in.) "Art must be free," Mansfield said. "I consider the existence of the Trust or Syndicate a standing menace to art." (It was a pose he struck, not a stance he took.) Mrs. Fiske put the case more strongly and proved that she meant it: "The incompetent men who have seized upon the affairs of the stage in this country have all but killed art, worthy ambition, and decency." William Dean Howells, the novelist who made an occasional excursion into writing for the stage, is recorded by Hapgood as saying:

*The piece was reprinted in London, where it created "a storm of indignation," and in newspapers out of New York. The Syndicate tried unsuccessfully to get Hapgood fired.

"Not merely one industry, but civilization, itself, is concerned, for the morals and education of the public are directly influenced by the stage. Everyone who takes a pride in the art of his country must regret a monopoly of the theatre, for that means 'business' and not 'art.' "

There were producers as well as players who held out against the Syndicate. Among them was David Belasco, one of the great overblown legends of our theatre, and he was joined by the Shuberts, Sam, Lee, and Jake, who, once they had brought Erlanger down, built an organization not unlike the one they had fought. "If the brothers were less rapacious than the Syndicate," Brooks Atkinson wrote, "it was because Lee Shubert loved the theatre. Erlanger loved nothing but the box office." One of the most interesting aspects of the fight against the Syndicate by the professionals of the theatre was their concern with theatre as art, its intellectual bite, its nature as a mirror of society, a "force for good." Seen from this distance, the theatre of the turn of the century seems to have been dedicated almost entirely to the revival of Shakespearean plays as vehicles for star performers, to operettas and vaudeville, and to well-made plays performed by glamorous actresses playing up to ineffable matinée idols.

It was more than that, but in quality not a great deal more. There were a few players, Mrs. Fiske and Mansfield among them, who were eager to bring the public plays that were neither revivals of the standard repertory of Shakespeare and Sheridan nor pleasant drawing-room farces like *Sapho* or sentimental, melodramatic costume pieces like Belasco's *The Girl of the Golden West.* * Mrs. Fiske braved Ibsen, as we have seen, and Mansfield gave the first performances of George Bernard Shaw in this country in 1894 when he played in *Arms and the Man.* A theatre of ideas, however, was as foreign to the taste of American audiences at the turn of the century as the revolt in the visual arts, as publicized by the Armory Show, was to the man in the street—or, for that matter, to the critics who told the genteel public what was art and what quite assuredly was not art.

While the theatre went its own cheerful cosmetic ways, novelists like Theodore Dreiser, William Dean Howells, Edith Wharton, Hamlin Garland, and Stephen Crane were getting their scalpels deep into society's flesh, exposing the innards and nerves of American life in their very different ways. Moreover, neither the playwrights nor the audiences were interested in the revolt in the theatre in Europe, where Ibsen, called "the father of modern drama," and his followers, if not necessarily his disciples, August Strindberg, Gerhart Hauptmann, Maxim Gorki and others, had

*In 1910 Puccini made this "Western" into the first grand opera based on an American theme. It continues as a staple of the Metropolitan Opera's menu.

turned against the well-made plays typified by such a writer as Eugène Scribe (1791–1861). They were exploring what is variously called "realism" and "naturalism" in plays—to use Shaw's terms—more often "unpleasant" than "pleasant."

Ibsen produced a flurry of controversy when his plays were first performed in New York. If it had not been for Mrs. Fiske's conviction in the face of the smugness and gentility that pervaded what might be called the "uptown" atmosphere of the polite theatre, it is unlikely that his somber plays would have appeared here as early as they did. Such is the very nearly unshockable state to which the arts have led (some would say bored or benumbed) us, that it would be impossible today to create the kind of furore that Ibsen caused in the early years of the century, any more than it would be possible to repeat the sensation created by the Armory Show. *A Doll's House,* the earliest of the Ibsen plays to be exposed to New Yorkers and the one that brought Mrs. Fiske back to the stage after a brief retirement, roused a feminist-antifeminist storm. It dealt with the problem of a trapped wife who slams the door on her husband and children to seek her salvation in freedom. *Pillars of Society,* which Mrs. Fiske performed in 1910, took on the hypocrisies of a wealthy businessman and raised the hackles of genteel audiences. Ibsen's forthright and searching *Ghosts,* also with Mrs. Fiske in the lead, was first produced in New York in 1926. It dealt openly with a family beset by an inherited "social disease." It had taken forty-four years, from the time of its world premiere in Chicago, where it was played in its original language (Norwegian) to Scandinavian audiences, to reach Broadway and audiences sophisticated enough to take in stride Ibsen's attack on the outdated conventions (the "ghosts") which had split the family and driven the husband to a dissolute life. His assault in *An Enemy of the People* on the dangerous self-interest of the city fathers who refused to allow a physician to expose the fact that the town's famous and profitable public baths were polluted and must be shut down for expensive repairs was almost equally shocking.

The critic William Winter, writing of "Ibsenites and Ibsenism" in *The Wallet of Time* in 1913 was appalled that Mrs. Fiske, who "possesses a good repertory of old plays and has shown judgment and taste . . . in acquiring new ones" should have been so involved and effective in "encouragement and practical support of Ibsen." Winter declared that Ibsen "is not a dramatist in the true sense of that word and Ibsenism is rank, a deadly pessimism, is a disease, injurious to the Stage and the People and therefore an evil to be deprecated. . . ." "Since when," he wanted to know, "did the stage become a proper place for a clinic of horrors, and the vivisection of moral ailments?" He might have thought of *Macbeth* as such a clinic and

vivisection, but he went on to say, "The preserve of art is the ministry of beauty and beauty is inseparable from morality." He did not concede that there was any morality in the exposure of immorality in plays like *Hedda Gabler, Rosmersholm,* and *Ghosts,* which to him "fill the mind with disgust and gloom" and "pervert life." And so on. . . .

It seems that there is always a phalanx of conventional citizens in every age itching to counter-attack what they regard as an assault on public morals, whether in fact there is any moral basis for their wrath or not. What changes is not morality; but fashions in what is considered respectable and socially digestible change, and if Ibsen did not measure up to the standards of the phalanx, neither did George Bernard Shaw. It was the same sorts of people who thought that jazz would wreak havoc among the youth of the nation and corrupt their innocence who attempted to defend the public from Ibsen's intensely moral plays (it may have been their intensity that bothered them) and what they regarded as Shaw's witty devilishness. It is conventional in artistic circles to call all those who take umbrage at change "philistines," though one man's philistine is often another man's honest skeptic.

Just as there were those who looked on Ibsen's naturalism as being anti-art, but who took in stride and with pleasure Belasco's "realism," which was only stage deep, so there were those to whom Shaw was unpalatable. He made fun of cherished beliefs and mores and treated seriously and openly problems that should be unmentionable in genteel circles. In *Arms and the Man* he ridiculed the romantic conviction that war is noble, and in *The Devil's Disciple,* which was set against the background of the American Revolution (though it was the British he scoffed at), he made fun of the profession of soldiering.

The first performance of *Arms and the Man* was given in New York in 1894, several years before London audiences were thought to be ready for it. Richard Mansfield chose to play the lead, and the service he performed in introducing Shaw to American audiences was a notable one. (In 1909 *Arms and the Man* became the basis of a very popular operetta by Oscar Straus called *The Chocolate Soldier,* as much of a hit in its day as *My Fair Lady,* based on Shaw's *Pygmalion,* was half a century later.) Mansfield's enthusiasm for Shaw, though he appeared also in *The Devil's Disciple* in 1896, evaporated when he found himself matching egos with a master egotist, and he turned down *Candida,* which concerned a young poet who fell in love with a clergyman's wife some years his elder. He dismissed it as a tiresome sermon. Another actor, Arnold Daly, produced *Candida* in 1903, in what was intended as a trial matinée performance, and found himself with a minor hit.

Shaw became a cult figure. Audiences began early to choose up sides, the Shavians who were all for him and a great many others who were, to say the least, contrary minded. There were those who thought his wit and invention and insights were a tremendous breath of fresh dramatic air in the stuffy atmosphere of superficial playmaking and tendentious moralizing, and there were those who were alarmed and disgusted by what seemed to them his cynicism and smart-aleck attacks on cherished middle-class beliefs. The same Mr. Winter who despised Ibsen dismissed Shaw as "a man of very little importance. . . . I do not care to waste thought on him."

When *Man and Superman* opened in New York in 1905, Police Commissioner McAdoo wasted not only thought but fury on Shaw and declared that such a play deserved no place in New York theatres because it ridiculed marriage, and marriage, as everyone knew and President Roosevelt had recently declared, was the foundation of American society, the "basis of any healthy civilization." The police commissioner to the contrary notwithstanding, *Man and Superman* ran for months to piqued and surprised audiences. The New York Public Library put copies of it on restricted shelves lest it corrupt the morals of the young.

It was *Mrs. Warren's Profession,* produced in 1905, that blew the lid off. The play opened at the Shubert Theatre, in New Haven, where many Broadway shows had their tryouts, and the local police chief threatened to close it, a happy notoriety that caused it to be sold out for two weeks in advance when it arrived in New York. Mrs. Warren was a madam, and the play dealt with the exploitation of prostitutes by which Mrs. Warren had managed to bring up her daughter, Vivie, as a proper young lady in comfortable circumstances, unaware of the source of her mother's income. When Vivie learns what her mother's profession not only was but continues to be, she spurns her and sets off on her own. Anthony Comstock of the Society for the Prevention of Vice exploded in a volcano of invective, which the *New York Times* was delighted to publish on October 25, 1905, under the headline "Comstock At It Again." The exchange of letters between Comstock and Arnold Daly, who produced the play, went in part like this:

> *Comstock to Daly:* I am informed that it is your intention to put upon this stage one of Bernard Shaw's filthy products entitled "Mrs. Warren's Profession." I also understand that this play has been suppressed in London. In order that you not plead ignorance of the law and its interpretation of the laws of this state, I beg to call your attention to the following decision by the Appellate Division in the case of People vs. Dorris. . . .
>
> *Daly to Comstock:* You call "Mrs. Warren's Profession" a "filthy" play. I

cannot believe that you have read it; but, if so, your use of adjective is decorative, but not descriptive. It is a strong sermon and a great moral lesson, and I cordially invite you to come to the Garrick Theatre on Wednesday or Thursday of next week, when I shall be pleased to have you see a rehearsal of it.

Seven days later on November 1, the *Times* headline read, "Shaw's Play Stopped; The Manager Arrested/McAdoo Calls the Piece Revolting and Indecent/Warrants for the Players/Tickets Still on Sale Late in the Day, Notwithstanding Condemnation by the Press."

McAdoo informed the mayor that the play was not only "revolting" and "indecent" but "nauseating when it was not boring." (Did McAdoo want a little more indecency and a little less boring dialogue?) The play was closed and the cast was hurried off in paddy wagons to night court. It reopened a year later in October 1906, by which time the controversy had evaporated and no one was much interested. Shaw's reaction was: "To prohibit the play is to protect the evil which the play exposes." It was not until about twenty years later that Mrs. Warren exposed her profession on the London stage.

Shaw looked upon America (and what he looked upon he put into words)* as provincial, which must have come as no surprise to Americans at the turn of the century. They were used to being patronized by Europeans, not that they enjoyed it or believed it to be justified. Nonetheless, it was they who gave Shaw his first recognition and went right on producing and enjoying his plays, an example his compatriots were laggard in following. Among his virtues gratitude, the rarest of them all, seems not to have been notable.

A Four-Dimensional Art

Beyond the superficial gloss of the Broadway theatre and the sparkle of its stars, there was more than a passing concern with the theatre as a discipline and as an art. There were those who cherished it as a place of experimentation, of social and literary exploration, as well as of entertainment, a complex of intricately interwoven skills of movement and sound, of acting and articulation and controlled space. Star performers to the contrary notwithstanding, the theatre was a composite affair, a four-dimen-

*Shaw coined the word *comstockery,* which displeased the reformer, of course. It is defined in *The Random House Dictionary of the English Language* (1966) as "overzealous moral censorship of the fine arts and literature, often mistaking outspokenly honest works for salacious ones."

sional art that occupied time as well as place, and could only be success-
fully created by a confluence of writer, designer, actor, director, and the
invisible hands and ears and eyes that made the unified result possible.

The stages on which the dedicated acting companies of the little-theatre movement
struggled to keep the art of the stage from commercial stagnation were often minimal
and makeshift. Such was the Provincetown Playhouse on MacDougal Street, New York,
in 1917.

The "little-theatre" movement, which was an attempt to snatch the
art of the theatre from the commercial burning, had its ostensible origins
in Chicago in 1912. It is never safe to say that any movement in the arts
starts at one moment or in one place or is the inspiration of one individual.
Movements are rumblings, the bubblings up of caldrons that have been
long over slow fires of discontent, little volcanoes erupting from intellectual
and aesthetic unease and from disapproval of what is on the surface, what
pleases the "vulgar" (lowbrow) or the merely "complacent" (middlebrow)
public. Productive rumblings, in other words. Like the eruption in painting
and sculpture that happened in a New York armory in 1913, the little-
theatre movement was inspired by what was going on in Europe. Like so

many of the sophisticated arts that attracted the cognoscenti at the turn of the century, it had nothing to do with the vernacular American experience and not much to do with what John A. Kouwenhoven in *Made in America* has called "the cultivated taste" of Americans. The little-theatre movement was born in poverty (but not of the soil) and to all intents and purposes sustained its life on an urban shoestring. Nonetheless, the number of actors, designers, and playwrights who had their first exposures in little theatres and emerged as important theatrical personages with their names in lights was not insignificant.

"The little theatre movement . . . has run away with itself in the United States," a critic wrote in 1923. "In a decade its original impulses have been greatly altered; its direction has swerved from the esoteric to the popular."

The term "little theatre" was first used, historians seem to agree, by Maurice Browne, who had "a tiny experimental stage" and very little financing in Chicago in 1912. His theatre seated only a hundred patrons, and it was "housed in a nook in the Fine Arts building." Its stated aim was to create "a new plastic and rhythmic drama in America." The bill of fare with which it set out to nourish American audiences and lead them to a higher understanding of this drama was constituted of offerings by William Butler Yeats (Irish), Arthur Schnitzler (Austrian), Henrik Ibsen (Norwegian), George Bernard Shaw (English), August Strindberg (Swedish), Euripides (classical Greek), and other works that spoke to Europeans as they did not speak to many Chicagoans. It was a reflection of the poor regard in which the dedicated intellectuals of the little-theatre movement held the native product, and not without reason. According to Sheldon Cheney, the founder of *Theatre Arts Magazine* in 1916, Maurice Browne's Little Theatre was "the most typical art theatre in the country."

Browne's experiment, as Cheney implies, was by no means an isolated one. In 1913 the Toy Theatre, backed by Mrs. Lyman Gale, started a brief life in Boston, and Winthrop Ames, a Bostonian of aristocratic background and private fortune, opened the Little Theatre in New York, an attractive, friendly small playhouse with a fireplace in the lobby, a tearoom on the floor below, and string quartets to charm audiences in the intermission as they took sandwiches and coffee courtesy of the management. Three years later the Provincetown Players came into existence in a building on a fisherman's wharf owned by Mary Heaton Vorse, a vigorous journalist and all-purpose crusader. "We had a building fifty feet long and a hundred wide with a door in the back which opened on the sea," Mrs. Vorse wrote forty years later.

I contributed a curtain which had been the curtain in our attic of Amherst, where as children we had given plays. . . . We made our own benches and our own scenery. The first performances were lighted by oil lamps. . . . Suddenly everyone took to writing plays; the beginning of the Provincetown Players was an organic thing like a plant growing. No one said, "Come let's found a little theatre."

And she added, "We had no idea that we were to help break through the traditions of Broadway and revolutionize and humanize the theatre of America."

In the same year (1915) the Washington Square Players bravely if briefly attempted to cause a ripple in the complacent commercial pond of the New York theatrical scene. The ripple it caused was not the one intended: the Washington Square Players were the progenitor of the Theatre Guild, which became more of a commercial wave than an aesthetic ripple. In the next year two important art theatres opened a long way from Broadway, the Pasadena Playhouse and the Cleveland Play House.

As though to give respectability to the maverick little-theatre movement, the drama became in several universities more than just a study of literary history. In Pittsburgh at the Carnegie Institute of Technology, for example, Thomas Wood Stevens opened a theatre school with an auditorium, a stage, workshops, and a faculty. It provided a substantial four-year curriculum that qualified students for a Bachelor of Arts in Drama. The players were, obviously, amateurs and so were the production crews, but they gave Pittsburghers a chance to see seventy-five to a hundred performances during the college year "for the price of a street car fare." The repertory was classical and "experimental," and in the first nine years the group performed fifty plays that had never been seen before and, no doubt, many that have never been seen since.

Better known than the Carnegie Tech drama curriculum was (and still is) the "47 Workshop," organized and for many years presided over by Professor George Pierce Baker at Harvard. The workshop grew out of a course in playwriting at Radcliffe College (not then absorbed by the university as it now is), but as early as 1905–1906 it became Harvard's English 47 and was soon famous. Competition to be allowed to take the course was fierce among undergraduates, and the 47 Workshop, which by 1912 had its own stage and workrooms in Lower Massachusetts Hall, became known as a seedbed of theatrical talent.*

*Among the students in the 47 Workshop who later became important as critics, playwrights, designers, and producers were Eugene O'Neill, Edward Sheldon, Philip Barry, John Mason Brown, Donald Oenslager, George Abbott, Theresa Helburn, and Elia Kazan.

Somewhat earlier than the rash of little theatres there was a serious fad (it must be called that) for outdoor theatres, especially at colleges and universities. Cheney noted in 1914 that "the open-air theatre has become such a factor in dramatic progress and is so full of promise for the future . . . that the day will probably come when the majority of universities and many experimental producing societies will have outdoor theatres." They did, indeed, become chic things for colleges to boast of. They were built or dug out of the landscape in colleges large and small, and many campuses still have remnants of them.

Cheney considered the outdoor drama "the most democratic of the arts." "When the commercial theatre brings together a few people in a business venture, the open-air theatre brings together many in a spontaneous and pleasurable pursuit of beauty," he wrote, and he added that low admission prices and "no boxes from which to exhibit jewels and expensive gowns" also contributed to its democratic qualities. It was also part, he said, of the "hygenic and economic considerations which have led to the widespread outdoor movement in all departments of human life." Americans were getting out of their stuffy parlors to play games such as tennis and golf and polo, exotic and expensive upper-class games all three. The example of Teddy Roosevelt's hearty indulgence in "roughing it" as a hunter of game and as a sportsman, while it cannot have had much to do with the aesthetics of the open-air theatres, had something to do with the new enthusiasm for outdoor recreation.

The little-theatre movement was by no means a spontaneous "made in America" product or a merely cliquish reaction against the commercial theatre by a high-minded group of American directors and actors who wanted something of more substance than the contrivances and slickness of Broadway. It was inspired by what was going on in Europe, examples of which arrived in New York to present audiences with something of a shock, some critics with dismay, some with the promise of new theatrical vitality. Here was a new kind of realism, not the fussy David Belasco kind contrived out of a mass of staging details. It was a search for the truth that lies behind the façade of personality, "the dog beneath the skin." It sought to reveal the substance and nuances of emotion with subtlety and without conventional histrionics. In the first years of the century, Max Reinhardt, the impresario of the Deutsches Theater of Berlin and the Kammerspiele, Konstantin Stanislavsky, with the Moscow Art Theatre players, and the Abbey players, organized by Lady Gregory and William Butler Yeats, brought their performances to the New York stage. If Broadway reacted slowly to these remarkable innovators from Europe, the little theatres welcomed their examples at once and with vigor.

No one's influence was more strongly felt than that of Gordon Craig. He was an English actor, writer, director, and designer, born in 1872, the son of Ellen Terry. Hers was one of the names to conjure with for many years in the theatre, an actress of commanding charm and talent who frequently performed in Shakespeare with Henry Irving before American audiences. Craig was the author of two books, *The Art of the Theatre* (1905) and *Towards a New Theatre* (1913), which were as revolutionary in their way as the Futurist manifestos of just the same time. They were pored over and argued about and proclaimed as doctrine by those who were involved in the "aesthetic movement." Craig was known and respected as an innovator in Europe. He first came to public notice with his revivals of operas by Handel and Purcell, with his sets for Ibsen's *The Vikings of Helgoland* and Shakespeare's *Much Ado about Nothing*, and somewhat later with sets for *Hamlet* that he designed for the Moscow Art Theatre. Like the Futurists, who were dedicated to abstract painting and sculpture, Craig was interested in an abstract theatre. In 1913 Gino Severini, one of the leaders of the Futurist movement in Italy, wrote: "We must forget exterior reality and our knowledge of it in order to *create* the new dimensions, the order and extent of which will be discovered by our artistic sensibility in relation to the world of plastic creation."

Craig called for "a drama stripped of every unnecessary detail of story and setting." What he regarded as "archeological detail" was of no account.

He called for sets that were decorative but did not assert themselves, that through the use of color and form set the tone of the production, in which lighting and costumes were used, not for reality, but to become merely part of a decorative effect and consistent design. Actors, he said, "must realize the value of directed movement and give up the inartistic attempt to appear 'natural'. . . . Rhythm of line and form should make the movement and grouping of the actors a valuable decorative feature. In fact decorative movement should be the very essence of the production." Over this the director should have complete control, and a theatre without actors was the only way to achieve this. He wanted to use what he called "super marionettes" in their places. The spoken word was a distraction. If no marionettes, then mime would do.

It is apparent that the abstract theatre which Craig envisioned as the ultimate accomplishment and purification of the drama has been realized in the dance, where the movement of "actors" is entirely at the discretion of the director (choreographer) and his dictation. Ballet, in its various forms, is theatre without words, with no danger of the "natural" impinging on abstraction, and where sound and color (light, sets, and costumes) are

abstractions in themselves. Dancers are personified fantasies, and such emotions as they display are stylizations, usually exaggerations, of human behavior.

There was one play produced in New York in January 1912 that reflected Craig's doctrine of theatrical purity and abstraction. It was *Sumurun,* an Oriental pantomime of nine tableaus performed by a company of actors from Max Reinhardt's Deutsches Theater in Berlin. Reinhardt, who directed it and was the intelligence behind it, was known as an autocrat (after Craig's own heart), an innovator, and a "master of spectacle."* Diaghilev's Ballet Russe, with sets and costumes by Bakst, was surely known to Craig but not yet to the American audience. (The company did not perform here until 1916.) While Americans wondered at the grace and consummate technique of Anna Pavlova, who played the vaudeville circuit early in the century, and were puzzled and put off by the "artiness" of Isadora Duncan's barefoot evocations of classical Greece, the dance theatre as a serious matter was unknown. To be sure, the musical theatre from vaudeville to musical comedy to opera, both grand and comic, was punctuated by dance, less for its artistic merits than as a diversion (often mildly erotic) and a change of pace. It was some years in the future before the classical ballet and modern dance had more than a token following in America, and George Balanchine, Martha Graham and Agnes de Mille took command.

The little-theatre movement, according to Howard Taubman, "reflected an improbable commingling of idealism, practicality, snobbish estheticism and social climbing." He conceded that the little theatres "at their best . . . accomplished useful things," but "at their most ludicrous [they] were pretentious and inept." The movement had its cultish aspects; it saw itself as a crusade against the commercial theatre and its star system, against the well-made plays and their superficial social comment, their drawing-room morality and gentility. But it was also part of a revolt against what it regarded as the dead hand of Victorian academic art, the same revolt in which painters and sculptors were also engaged. It attracted to it considerable talent, which used the little theatre as a steppingstone to a more worldly theatre. Along with the usual pretentious hangers-on it brought together men and women with intellectual bite and the desire accompanied by the talent to enliven the ways the stage was used, how it looked, and what was performed on it—directors, designers, and play-

*After World War I Reinhardt made the Salzburg (Austria) Festival a "world theatrical center." A victim of Nazi persecution of Jews, he fled Germany in 1933 and became a United States citizen in 1940, three years before he died.

wrights. With the falling off of traveling and stock companies because of the rising cost of rail travel and the increase in the popularity of the movies, the little theatres became the principal training ground for young actors, stage managers, directors and designers, modest but serious schools of theatrical arts. Off-Broadway and Off-Off-Broadway continue to fulfill many of these functions today, but there are in addition literally hundreds of colleges and universities that incorporate the theatre arts in their curricula and turn out hopefuls by the thousands. A few of them may become professionals, some as performers and directors and designers and some as teachers. Many more thousands, it is hoped, will become the intelligent audience whose enthusiasms and critical judgments are important to maintaining the theatre's drive for excellence.

Drama for Art's Sake

The most highly visible and in many respects most influential offspring of the little-theatre movement was the Theatre Guild, which behaved something like an art theatre and something like a Broadway commercial venture or, more likely, an adventure. It was the child of the Washington Square Players, which originated in 1915 in the Washington Square Bookshop on MacDougal Street, a hangout for writers, intellectuals, and highbrows. The Washington Square Players never played on or near Washington Square. They rented a tiny theatre, the Bandbox, uptown on East Fifty-seventh Street for $35 for Friday and Saturday nights. The theatre seated just 299 patrons (who paid fifty cents admission); more customers than that and the company would have been in trouble with fire regulations and licenses. The company's first program informed its audience: "We have our policy in regard to the plays we will produce. They must have artistic merit. Preference will be given to American plays, but we will also include in our repertory the works of well-known European authors which have been ignored by the commercial managers." The first evening was three one-act plays, one about birth control, then a very impolite topic for public discussion, by Lawrence Langner, a hard-driving, effective young patent attorney bitten by the theatre bug and one of the organizers of the Washington Square Players, one by Edward Goodman, and one by the Belgian dramatist Maurice Maeterlinck, perhaps to be safe, perhaps to add "class." (Maeterlinck was well known to American audiences. He had won the Nobel Prize for literature in 1911.) The organizers of the Washington Square Players became the cadre which, once the distraction of World War I was disposed of, launched into the founding of the far more ambitious Theatre Guild. As Brooks Atkinson wryly

observed: "In May of 1918, the Washington Square Players reluctantly acknowledged that World War I was taking precedence over the amateur theater. Too many of its people were being drawn off into the irrelevant occupation of fighting for their country."

None of the organizers of the Guild was a theatrical professional;* if any of them had been it is unlikely that they would have had the gall to embark on an ambitious professional program which threw down the gauntlet to Broadway's established producers. It was not their goal to make money; their aim was to create an art theatre whose professional polish would compete for audiences with the slick, popular Broadway productions of which they were scornful, and with luck break even. The cadre was a group of highly articulate, intensely individualistic, and often stormy temperaments whose leader, if not formally acknowledged as such by his associates, was Langner. The group went into what might generously be called "business" with a capital of $2,160, of which Langner had contributed three-quarters. It rented the Garrick Theatre from the banker Otto H. Kahn, a knowing and sympathetic patron, who guided the Metropolitan Opera as chairman of its board. Kahn said that the Guild could pay the rent when, and only when, it could afford to.

The Guild's first production, Jacinto Benavente's *The Bonds of Interest,* lasted only three weeks, but the second, St. John Ervine's *John Ferguson,* a tragedy laid in Ireland, had a surprising success. The lines at the box office were there not just because of the attractions of the production or the quality of the play. Professional Broadway inadvertently obliged; it was being stifled by an actors' strike, the first of its kind on the Great White Way.

Six years before in 1913 Actors' Equity had come into existence to protect the rights of actors with a standard contract that guaranteed a minimum wage, set limits to unpaid rehearsal time, and provided assurances that, no matter how short a run a play might have, the actors would be paid for at least two weeks' work. Musicians were already well organized, and so were stagehands and grips, in an AFL union. When it came time to renew the contract that Equity had negotiated earlier with the producers, the actors did not get what they felt was due them. Agreement was reached on everything except that they be paid for extra matinées on legal holidays and for other extra performances. The producers were curiously adamant on this small point and the actors struck on August 6, 1919.

*With Langner were Helen Westley, Philip Moeller, "who had some academic training in the theatre," and Josephine Meyer, a patron of the Washington Square Players. Maurice Wertheim, a banker, and Theresa Helburn, both ex-Baker students at Harvard's 47 Workshop, also joined the company.

Their action closed down a dozen Broadway productions. A few shows, including Ziegfeld's *Follies,* stayed open until the stagehands and musicians decided to back the actors. Finally the only show on Broadway that was open was the Guild's *John Ferguson.* Equity did not strike the Guild because of its arrangement to share its profits, if any, with the members of the company, one of Equity's declared aims.

The history of the Guild was a stormy one, principally because those who participated in its management were stormy ones. However energizing and essentially salutary was the Guild's effect on the American theatre, those who were dedicated to the little-theatre movement felt that the Guild had abandoned its initial high purpose and let the art side down.

"Whatever it may hope to accomplish with more elaborate equipment," Sayler wrote after the Guild had been in business for four years, "the Guild on its record is not an experimental theatre. It has taken no more chances than the average earnest Broadway producer, not as many as Arthur Hopkins, the Neighborhood Playhouse, the Provincetown Players or its own earlier self, the Washington Square Players."

Drama for the sake of art, and experiment for the sake of aesthetic gain, Saylor and others dedicated to the experimental theatre believed, were being jilted for the blandishments of popularity and perhaps, though they did not say so, for the democratic idea that art could serve the intelligent many and not just the dedicated few. Walter Prichard Eaton, one of the early and influential supporters of the Washington Square Players, had written in 1916 that it had "started in poverty and that it is comparatively poor yet—thank heaven. We hope it always will be. Then the workers in it will always be its lovers. We don't want them to work for nothing; but better for nothing than for great riches." Eaton, however, changed his mind, and when The Theatre Guild wanted to build its own theatre in 1923, it was Eaton who chaired the half-million-dollar-bond campaign.

The Guild Theatre opened in April 1925, a splendid building that cost more than a million dollars to build and whose façade would have been at home in Renaissance Florence on a palace for a prince of modest pretensions. The theatre seated six hundred and provided them with more than the usual room to stretch their legs. Its walls were decorated with Gobelin tapestries, considered suitable to the cultural nature of the Guild's intentions.* The Guild was a subscription organization, and it had 30,000 New Yorkers as members and an equal number of out-of-towners, as New

*The tapestries were purchased with the profits from the Guild's first musical, *The Garrick Gaieties.*

Yorkers call everyone else. But the Guild Theatre, partly because of the heavy carrying costs of its indebtedness to bond holders and partly because its six hundred seats were fewer than an economically viable number, was continually on the verge of financial catastrophe.

The 1920s and '30s were the most productive, influential, and prestigious years of the Guild's life, which lasted until the mid-'50s. In spite of its financial troubles during the depression years of the '30s, "it remained," according to John Houseman, whose experiences with it as a director were filled with frustrations, "the country's most active and distinguished theatrical organization."

The Guild was not the seedbed of the new American drama in the sense that the Provincetown Players were (they staged, for example, the first performance of a play by Eugene O'Neill) or even as Arthur Hopkins, who gave Elmer Rice his first public exposure. It did, however, set a sophisticated table at which increasingly knowing audiences were pleased to nourish themselves on fare prepared not only by European playwrights but by Americans such as O'Neill, Rice, Maxwell Anderson, S. N. Behrman, Philip Barry, and Robert Sherwood. In the 1930s the Guild was the most active producer on Broadway, sometimes with as many as four productions on the boards at the same time. Art, or what was accepted as art, had become good business, though, in spite of its activities and its eager audiences, the Guild continually sailed precariously close to the wind. The Guild was fashionable, and the "brainwashed egotists," as you will recall Atkinson described the audiences, came religiously to watch plays whose virtues they may have found tedious but had no doubt were important, and whose examinations of the human condition were profound. The Guild varied the menu, making sure that there were desserts as well as roasts, amusing and prettily presented salads as well as nourishing vegetables.

When in doubt, the Guild's motto seemed to be "Serve Shaw." It produced more than a dozen of Shaw's plays, bravely including *Back to Methuselah,* which was so long that it was divided into three parts, each part of which was performed for a week, followed by the next part. It was a play that Atkinson found "dogmatic, ponderously jocose, prolix, and on the whole intolerably boring." The production lost $20,000, but on the whole Shaw was a money maker for the Guild. On the profits from Shaw it was able to produce plays like Ibsen's poetical *Peer Gynt* (which to its surprise had a good run) and to experiment with plays by Americans. European playwrights—Ferenc Molnár, Franz Werfel, Karel Čapek, and Shaw, of course—were presented to the Guild's audiences as often as not with English actors in the leading roles. When the Guild was early accused of not giving American playwrights a hearing, the answer was that there

were none of any consequence. In the first four years of its existence the Guild produced only two plays by Americans, neither of which has survived.* In 1923, however, it produced Elmer Rice's *The Adding Machine,* a satire on the humdrum of American life as lived by a bookkeeper, an impressive step forward in the maturing of the American drama.

The well-made play as the standard product of American playwrights, while it has never disappeared and is not likely to as long as audiences continue to be amused and titillated by it, was being challenged, just before and in the decade after the First World War, by serious experiments. These experiments were concerned with every aspect of the theatre—with staging, with literary form, and with content. The kind of realism that Belasco so effectively used to create sets that audiences found delightfully believable was challenged by designers like Robert Edmond Jones and Lee Simonson and Jo Mielziner with a kind of expressionism that was stylized and suggested a great deal more than it depicted—a highly charged, dramatic unreality. What was regarded as natural dialogue took on an edge, in O'Neill's early plays of seamen in the Caribbean, that seemed rough and unliterary to audiences. It became downright shocking in Maxwell Anderson and Laurence Stallings's postwar, antiwar play *What Price Glory?,* in which soldiers spoke the profane vernacular of the trenches, dialogue that would seem tame by today's standards on the stage or the screen. A joke current at that time concerned two proper suburban ladies leaving the theatre after *What Price Glory?* One says, "Let's get the hell out of here," and her companion responds, "Wait till I find my God-damned gloves."

The way the stage was dressed and the dialogue was undressed was less significant, however, than the attitudes and aims of a new breed of playwrights. Men like Rice and O'Neill and Maxwell Anderson were the antithesis of the practitioners, such as Clyde Fitch and Langdon Mitchell, of the well-made play. In their quite different methods of play making, with their different tones of voice (Rice's voice was sharp, O'Neill's was grave, Anderson's tended to be eloquent and on occasion poetical), they sought to throw light into the dark corners of society (the human condition, that is) and of the soul. Sigmund Freud's investigations and writings had added a new dimension to the writer's vision and had infiltrated the attitude, and to some extent the vocabulary, with which he probed and dramatized the motivations of his characters. It may be an oversimplification to say that what was once regarded as the soul became to a new generation of writers

*A play by Lillian Sabine based on William Dean Howells's *The Rise of Silas Lapham* and *Ambush* by Arthur Richman.

the subconscious—the invisible, little understood but compelling core of behavior, according to Freud, the seat of anxiety and desire and drive and guilt.

At the same time that Freud provided a clue and a key to character, to behavior and to the underpinnings of personality, Marx provided a system for examining the nature of society, and Marxism, which deplored religion as the opiate of the people, became, in a sense, an opiate for many, but by no means most, intellectuals, playwrights among them. It can be said that Freud and Marx were convenient tools for probing, and formulas for explaining, the psychological and social condition of man, and that playwrights, determined to create a theatre of substance rather than just of entertainment, found them useful. The playwrights of the years after the First World War were looking at a very different America from those of a generation earlier, a nation that was surprised to find itself a world power but had not been willing to recognize, as President Wilson urged it to, its international responsibilities. It was industrially cocky and culturally shy, proud of its political institutions but unsure of its ability to compete with Europe in the international cultural sweepstakes. Business was its business, know-how its native genius, and practical inventiveness its key to civilization. It prided itself on being pragmatic and materialistic, albeit God-fearing, and except for a few big-city highbrows it was smug about its cultural provincialism. The writers of the twenties were determined to let a little fresh air into this stuffy, self-satisfied atmosphere, and they did.

Eugene O'Neill, a Man Alone

No two playwrights could better demonstrate the change that had come over the American drama than Clyde Fitch and Eugene O'Neill. The only characteristics that they had in common were a consuming obsession for work and a dedication to the theatre. Fitch was fastidious, as we have seen, and lived the sybaritic, ornamental, and sweetly scented life of the rich. In his work he was concerned with the manners of morals rather than with morality and with the tidiness of his craft rather than with character. O'Neill, on the other hand, was concerned with the obverse side of life, with conflicts within the characters he devised and with the society that they moved within and against. If Fitch was driven by the desire to be a consummate and obliging cabinetmaker, O'Neill was driven by a need to explore and expose what was in the cupboards. There was no tailoring of his plays to fit the graceful talents of star performers, no compromise with fashion or with box office.

O'Neill was born on October 16, 1888, in a small hotel called the

Eugene O'Neill was fifty-eight and at the peak of his powers in 1946 when this photograph was taken by F. Roy Kemp soon after the opening of *The Iceman Cometh.* It was his first play to appear on Broadway since *Days Without End* twelve years before.

Barrett House on the corner of Broadway and Forty-third Street. His father, James O'Neill, was a well-known, hard-drinking "Shakespearean" actor of the bombastic school of posturing and sweeping gestures, who spent his declining years trouping as the lead in *The Count of Monte Cristo,* a romantic piece of no literary consequence but of perennial popularity. As a small child O'Neill trouped with his parents from city to city, town to town. When he was old enough, his parents packed him off to boarding schools, where in all he spent ten years. He grew to be a restless, rebellious young man, "a belligerent, romantic, and merciless egotist—ruthlessly selfcentered." Nothing about American society pleased him, and he thought the nature of the contemporary theatre contemptibly shallow. He bought passage to South America on a Norwegian bark in 1910; it may have been escape from America but not escape enough. He signed on as a hand on ships that plied the Caribbean and on one occasion crossed the Atlantic to England. He was variously a beachcomber in Buenos Aires and a mule hand on a cattle boat that took him to South Africa. Conventionally

he was "irresponsible," as hard-drinking as his father and at loose ends. He toured briefly with his father's troupe as an assistant stage manager; he played bit parts in a vaudeville version of *Monte Cristo;* he worked as a reporter for a New London paper; and he spent six months in a Connecticut sanatorium with tuberculosis.

The theatre was in his blood, an invitation and an irritant, a fury that pursued him. When he was twenty-six, he enrolled in Baker's course in playwriting at Harvard, and two years later he became part of a group that was putting together the Provincetown Players. They were looking for something fresh and serious, the antithesis of the Broadway formula, and O'Neill found them eager to stage the one-act plays on which he had been working. It was a marriage of discontents, whose progeny laid the groundwork of a revolution in the American theatre. It was a revolution with enthusiasm but without a dogma or a program except, as Joseph Wood Krutch wrote: "They wanted to present life as it is, even if that meant a good deal that was shocking and unpleasant, and they wanted also to expose the injustices, hypocrisies, and cruelties of society."

The Provincetown Players, both at their original home, the Wharf Theatre, and at their Playhouse in Greenwich Village, produced a number of O'Neill's one-act plays in 1916 and 1917—*Bound East for Cardiff, In the Zone, The Long Voyage Home,* and *The Moon of the Caribbees.* The first of his pieces to reach Broadway was his first full-length play, *Beyond the Horizon,* an examination of the futilities of a farmer's life. It was produced in 1920 by Richard Bennett, first in special matinée performances at the Morosco Theatre, where Rice's *For the Defense* was running, but it took on a life of its own and ran for 111 performances. Alexander Woollcott, a critic better known for his acerbity than his generosity,* wrote in the *New York Times,* "The play has greatness and marks O'Neill as one of our foremost playwrights." By comparison with the intensity and sweep of his later plays, such as *Mourning Becomes Electra* (1931), *Strange Interlude* (1928), and *A Long Day's Journey into Night* (before 1941), *Beyond the Horizon* is a routine, realist tragedy that lacks the compelling drive O'Neill came to achieve. It was, however, sufficiently surprising as a tragedy with an unlikely American setting (Americans were accustomed to European tragedy) to mark him as a native iconoclast, at a time when smugness prevailed in the theatre, and to win for him the first of three Pulitzer Prizes. (The other two were for *Anna Christie* in 1922 and *Strange Interlude* in 1928. *Anna Christie* twenty-five years after its first perform-

*Woollcott later became the prototype of the leading character in a play by Moss Hart and George S. Kaufman, *The Man Who Came to Dinner,* in 1939.

ance was made into a musical comedy and produced by George Abbott. *Strange Interlude* was successfully revived on Broadway in 1963.) The plays that followed in the next three decades, and there were many, earned for O'Neill a reputation as America's foremost dramatist, and a solid international reputation that won a Nobel Prize for him in 1936.

O'Neill experimented with theatrical forms and challenged the patience, tolerance, and endurance of his audiences and forced them to consider with him the profoundest passions of man. "Most modern plays," he wrote, "are concerned with the relation between man and man, but that does not interest me at all. I am interested only in the relation between man and God." It was only through the contest between man and man, man and the social order, man and his conscience and his place in the historical order that he could achieve his purpose. "The playwright today," he said in a letter to the critic George Jean Nathan,

> must dig at the roots of the sickness of today as he feels it — the death of the old God and the failure of science and materialism to give any satisfying new one for the surviving primitive religious instinct to find meaning for life in, and to comfort its fears of death with. It seems to me that anyone trying to do big work nowadays must have this big subject behind all the little subjects of his plays or novels, or he is simply scribbling around the surface of things and has no more real status than a parlor entertainer.

A "parlor entertainer" was the last thing he was (and the first thing Clyde Fitch had been), and he made his audiences work for their satisfactions longer and harder than they were used to. On one occasion the Theatre Guild asked him to shorten a play because it would run to such a late hour that commuters would miss their trains. "I'm not writing for commuters," O'Neill said.

Strange Interlude, a play in nine acts that lasted for five hours with a break for dinner, was a stream-of-consciousness examination of a strained relationship between a father and daughter in which the characters speak their thoughts in asides, in contrast and often in conflict with their dialogue with other characters. It was a stand-off success when the Theatre Guild produced it at the John Golden Theatre, as there was no way to fit it into the repertory with which the Guild was then experimenting at its own theatre. (*Strange Interlude* was the second O'Neill play the Guild put on in the 1928 season; the other was *Marco Millions.*) Three years later O'Neill took audiences down a different unfamiliar path with *Mourning Becomes Electra,* another extremely long play (one critic headed his review "Evening Becomes Interminable"), which was based on the *Oresteia* of Aeschylus. It was a tragedy in three parts (a trilogy), in which the puritan

Eugene O'Neill's *Mourning Becomes Electra,* produced in 1931, was a five-hour performance with a break for dinner. It was a harrowing challenge physically and intellectually that New York audiences were ready to accept from America's master playwright. Here Alla Nazimova stands above Alice Brady in an appropriately Greek Revival set designed by Robert Edmond Jones.

New England conscience is pitted against romantic passion. A wife poisons her husband, the wife's lover is murdered by the husband's son, the wife commits suicide, and so eventually does the revenging son, while his sister Lavinia (the Electra of *The Oresteia*) retires to the seclusion of the family mansion.

It is impossible here to do more than hint at the scope and intensity of O'Neill's dramatic range. The last of his plays to be produced, *A Long Day's Journey into Night,* was not the last to be written. It is an autobiographical piece, though those who knew O'Neill's parents and brother found it grossly exaggerated, a "harrowing domestic tragedy," so harrowing, indeed, that when O'Neill showed it to his son Gene, Jr., a distinguished young classical scholar, his son asked him not to let it be played as it put O'Neill and his family in such a bad light. O'Neill wrote a note saying that the play was not to be produced until twenty-five years after his death, but Gene, Jr., committed suicide, and in 1956 O'Neill's widow, Carlotta, released the play, as the reasons for its being withheld no longer were pertinent. The play was written "sometime before July 22, 1941," when O'Neill dedicated it to his wife on their wedding anniversary with a note which read:

> I give you the original script of this play of old sorrow written in tears and blood. A sadly inappropriate gift, it would seem, for a day celebrating happiness. But you will understand. I mean it as a tribute to your love and tenderness which gave me the faith in love that enabled me to face my dead at last and write this play—write it with deep pity and understanding and forgiveness for all the four haunted Tyrones.

The Iceman Cometh was written after *A Long Day's Journey* and was produced by the Theatre Guild in the 1946–47 season; it has become one of O'Neill's more durable plays. It was almost surely seen by a great many more people when it was produced on television, divided in two for airing on consecutive evenings, than all the rest of O'Neill's plays put together. The very fact that television should broadcast such a serious and lengthy drama was something of a sensation in 1959, and it caused a buzz of interest not just among highbrows but across a broad spectrum of the viewing audience. This was before the days when "culture" was considered to be the business of public television.

O'Neill plays better than he reads. In other words, the ear is more responsive to his language than the eye. His dialogue sounds authentic rather than grand, earthbound rather than soaring, and he was aware of this. Of *Mourning Becomes Electra* he wrote to Arthur Hobson Quinn: "It needed great language to lift it beyond itself. I haven't got that. And, by

way of consolation. I don't think . . . that great language is possible for anyone living in the discordant, broken, faithless rhythm of our time." In assessing the quality of O'Neill's tragedies as comparable to the greatest in our language, Joseph Wood Krutch wrote:

> But no modern is capable of language really worthy of O'Neill's play [*Mourning Becomes Electra*], and the lack of that one thing is the penalty we must pay for living in an age which is not equal to more than prose. Nor is it to be supposed that I make this reservation merely for the purpose of saying that Mr. O'Neill's play is not so good as the best of Shakespeare; I make it, on the contrary, in order to indicate where one must go in order to find a worthy comparison.

The vitality of the theatre does not depend alone on masterpieces or on the genius of an occasional playwright of commanding stature, though it feeds on them. It is, like other arts, a cumulative affair, which mixes elegant craftsmanship with intelligence and wit, experiment with respect for tradition, and an ability to hold up a mirror to the taste of its times as well as to its perplexities and problems. In his way Clyde Fitch was a perfect exemplar of the early years of the century, the so-called "good years," when social problems did not mean the problems of society as a whole but Society with a capital S. O'Neill, on the other hand, saw society through a glass darkly, using the new tools for human inspection (and introspection) forged by Freud and those for social inspection devised by Marx. (Politics and social problems interested him less, to be sure, than individuals and their internal conflicts, but he saw his characters against the malaise of a nation growing out of smug optimism into self-knowledge and an awareness that all was not well at home or abroad.)

Theatre with a Social Conscience

In the early thirties Mussolini and Hitler were clenching their fists and shaking them at their neighbors as they also tightened their grips on their compatriots. The Great Depression had settled on America and on much of Europe as well. The promise of an ever-expanding capitalist economy had, for millions who had been thrown out of work, seemed to collapse. The high-wide-and-handsome 1920s became the desolate 1930s, though the desolation was by no means all-encompassing. The apple sellers on street corners and the gray hopelessness of the breadlines and soup kitchens contrasted achingly with the gentlemen in white ties and tails and the ladies in mink, who arrived in limousines and "town cars" for opening nights on Broadway. The drift of intellectuals toward Communism that

had started in the 1920s as the utopian solution to the problems that beset capitalism increased in the thirties as Spain was driven into civil war by Franco's determination to overthrow the democracy of the young Spanish republic.

There was a growing social and political awareness in the theatre in these years, though not a great deal of it reached Broadway. The commercial theatre was concerned with minding its own business, with pleasing audiences not with reforming their politics, with lifting their spirits not their social awareness. But some playwrights, like Elmer Rice and Maxwell Anderson, both of them expert playmakers, translated their social convictions into highly successful dramas. Anderson, who was haunted by the cruel farce of the Sacco-Vanzetti trial that led to the execution of two "radicals" for an unproven murder, wrote two plays, *Gods of the Lightning* (with Harold Hickerson) and *Winterset,* in which the influence of this notorious case appeared. Playwrights like Rice and Anderson, who would not have thought of joining the hard-line clergy of the new anti-religious Communism, used the theatre to plead for social justice. Some playwrights became involved with the Communist party as members, some did who later repudiated it. Many more, whose sympathies leaned toward the Communists only because they were anti-Fascist, anti-Nazi, and anti-Falangist, were dubbed "parlor pinks." They were considered "unreliable," to use a then current term, by both the card-carrying left and the conservative right. In the hearings of the Un-American Activities Committee in the 1940s and early '50s the epithet "premature anti-Fascist" surfaced to describe the early critics of Hitler and Mussolini.

There were several by-products of the Depression which invigorated the American theatre and changed its course, just as the legislation of Roosevelt's New Deal of the 1930s changed the course of how the nation's business was conducted—and still is. Progress in the arts is more often than not inspired by dissatisfaction with the prevailing "good taste." While The Theatre Guild prevailed as the standard of theatrical taste and became a prosperous and safe commercial venture little given to experiment, there was bound to be in its midst a group of actors, designers, and directors eager to break away and press forward with what they regarded as a serious approach to the dramatic arts. In the 1930s this meant theatre with a socio-political bias. The basis of this bias was a dedication to the worker as hero, the oppressed masses as victims, capital as the enemy, and organized labor as the way to salvation through socialism, sometimes of the Russian variety. What was lost in subtlety was made up in fervor. There were a number of organizations, principally the Theatre Union and the New Theatre League, that were frankly and militantly left-wing organs of

social protest, and left-wing productions in the 1930s enjoyed a certain fashion with the "bourgeois" audiences whose sources and standards of well-being the Union and the League vigorously attacked—a sort of arms-length sado-masochist relationship that titillated but left no scars and probably few converts. The effect of the protest theatre, however, if for no other reason than its serious commitment, was salutary to the state of the drama.

For the most part the protest theatre was energetically solemn, but, as we have noted, there was one show, a musical revue, which was as filled with gaiety as it was with social message. It was *Pins and Needles,* with a score by Harold Rome, which included "Sing Me a Song of Social Significance" and "One Big Union for Two." It was sung and danced and frolicked by the International Ladies Garment Workers Union with a cast almost entirely of amateurs from the union's ranks. It ran for 1,108 performances in New York, and there was a successful road company as well.

The most influential of the spin-offs from the commercial theatre (in this case from the Guild) was less politically concentrated than the Theatre Union or the New Theatre League, though, in the prevailing spirit, it took its social duty seriously. This was the Group Theatre, and at its core were Harold Clurman, Lee Strasberg, and Cheryl Crawford, all of whom had occupied minor positions in the Guild's organization and had burned with indignation at what they regarded as the Guild's surrender to upper-middlebrow commercialism. With a minor handout (conscience money?) and a blessing from the Guild they formed a company that, after a summer in the Connecticut countryside spent in getting organized and in refining its intentions, produced *The House of Connelly* by Paul Green, to which the Guild had given them the production rights. It was only a moderate success when they produced it in New York, but they followed it with *Success Story* by John Howard Lawson, a highly political piece by an author who later was rusticated by the movie industry and blacklisted.

The Group Theatre's most memorable contributions to the theatre of its time were the establishment of a permanent acting company that was modeled on the companies that performed in repertory in Europe, and the discovery of a member of the company of actors who distinguished himself as a playwright, Clifford Odets. Elmer Rice wrote of the Group: "The company worked together as a cohesive unit. . . . As is always the case, this teamwork and continuity gave the Group and its productions a distinctive flavor and individuality that is necessarily lacking in units that are arbitrarily assembled for the production of a single play." Odets's first play to reach Broadway (1935) was his best-remembered, *Waiting for Lefty,* which Taubman said had an "explosive debut" that "sounded and looked

like a great white hope of American drama." His greatest commercial success was *Golden Boy* (1937), a piece about a young violinist who gave up his fiddle to become a prize fighter. There were others, *The Country Girl* and *Awake and Sing!,* which was well thought of in 1935.*

Odets did not realize his promise, and he went the way of many gifted theatre people to Hollywood and a frittering of talent. The Group Theatre lasted for ten years and died of poverty in 1941. The best of the actors who joined it were already established professionals. Those who joined to become actors and who were steeped in what was known as "The Method," a system of acting based on the principles of Stanislavsky, the great director of the Moscow Art Theatre, did not, according to Elmer Rice, rise above mediocrity.† "The basic defect of our activity," wrote Clurman, who became a distinguished director and critic, "was that, while we tried to maintain a true theatre artistically, we proceeded economically on a show-business basis. Our means and our ends were in fundamental contradiction." It is an explanation of failure (financial) which is not uncommonly heard today, but in the 1930s there were no charitable foundations which would listen, no state arts councils nor any National Foundation for the Arts.

There was, however, the Works Progress Administration (the WPA) and its Federal Theatre Project, one of many life jackets thrown by the federal government to the unemployed, who were floundering by the millions in the Depression. It was America's first adventure into patronage of the arts, other than the commissioning of federal buildings and the erection of monuments to national heroes—projects such as the Washington Monument (1884) and the Lincoln Memorial (1922)—and many minor tributes to statesmen and politicians. The WPA was concerned with more arts than just the theatre. Painters and sculptors, musicians and writers came within the circle of its patronage, but the uneasy (albeit productive) marriage between government and the arts is a topic that we will examine more closely elsewhere.

So far as the theatre was concerned the program came into being in 1935 with a plucky, determined, extremely intelligent, imaginative, and

*This was the season (1934–35) in which the unknown Humphrey Bogart and well-known Leslie Howard appeared in Robert Sherwood's *The Petrified Forest,* Helen Hayes distinguished herself as the queen in Laurence Housman's *Victoria Regina,* the Theatre Guild produced *Porgy and Bess,* and Lillian Hellman's abrasive *The Children's Hour* was a hit. In 1935 the Pulitzer Prize went to a dramatization of Edith Wharton's *The Old Maid* by Zoë Akins, so much to the disgust of New York critics that they established an award of their own for the best American play. In the following year they awarded their first plaque to Maxwell Anderson for *Winterset.*

†Two of Stanislavsky's books, *An Actor Prepares* and *Building a Character,* were the bibles of "The Method," which continues to be taught in drama schools.

well-organized woman, Hallie Flanagan, as its head. It was Elmer Rice
who persuaded Harry Hopkins, appointed by Roosevelt to take charge of
the Federal Emergency Relief Administration, that a program for theatre
people—actors, technicians, and directors—was needed. It was not to be
confined, as the commercial theatre essentially was, to New York but
would be national. It would not only rescue a great many individuals but
spread the benefits of live theatre to small cities and large cities from one
coast to the other. The concept of a theatre for all people in all parts of
the country was attractive to Hopkins, as were the comparable projects for
art, music, and writing. Hallie Flanagan was the director of the Experimen-
tal Theatre at Vassar College in Poughkeepsie and a friend and neighbor
of Mrs. Roosevelt, whose home was in Hyde Park, just up the Hudson.
Mrs. Flanagan, it is generally agreed, was an excellent choice for the job
of administering what could not help but be, considering the temperaments
involved, an explosive agglomeration of individuals representing all shades
of political and artistic conviction, and all levels of theatrical talent.

Mrs. Flanagan took the large view. "We need throughout America,"
she wrote in *Theatre Arts* magazine in November 1935,

> a number of theatres, experimental in nature, specializing in new plays by
> unknown dramatists, with an emphasis on regional and local material. We
> need Negro theatres in Harlem, St. Louis, Alabama; vaudeville and specialty
> acts in connection with some of the great recreation centers where dance
> orchestras, recruited from the ranks of unemployed musicians, will play for
> unemployed youth. We need a theatre adapted to new times and new condi-
> tions; a theatre which recognizes the presence of its sister arts.

She wanted repertory theatres, traveling Shakespeare companies,
companies playing Restoration drama in universities and colleges of the
Midwest. The money was to be spent where it was most needed—"80%
of all money allocated [to the project] must be spent in wages to theatre
people now on relief rolls," she wrote, "another 10% to other theatrical
workers in directorial and administrative capacities. The remaining 10%
on production costs." It was a complex business. Theatres had to be found
and in many cases made usable after long periods of neglect. Space for
designing, rehearsing, and promotion and persons capable of reasonable
performance had to be found. Directorial talent that could command jobs
in the commercial theatre had to be wooed away from Broadway with little
money and large promises of opportunity and freedom to experiment and
create a new kind of theatre. Rice, who was put in charge of the New York
project, wrote, "Had I known what was ahead, I should probably have
declined."

A year after Mrs. Flanagan embarked on her mission, the project had 12,000 on its payroll, some of them scarcely more than amateurs, some of them seasoned and expert professionals, some of them run-of-the-mill competents and incompetents. The wages they received (a maximum of $24 a week) were barely enough to subsist on, and they were the constant target of those to whom the New Deal was anathema. They were sneered at as boondogglers and, what was worse, they were feared as "radicals." To be sure, some of those employed were loafers and some of them were card-carrying Communists. The few gave the many and the project a bad name in conservative circles especially, but they did not prevent the project from accomplishing many essential rescues of individuals from the relief rolls and from making impressive innovations in the nature of the American theatre.

One of the project's most extraordinary productions was a play based by J. C. Moffitt on a novel by Sinclair Lewis, *It Can't Happen Here.* It dramatized the disquieting proposition that a native brand of Fascism could take over America from within. The play opened on October 27, 1936, simultaneously in twenty-one cities in seventeen states. Nothing like this had happened before (it could happen here only as part of a federal project), though simultaneous openings of new films were even then not uncommon. The details of production and casting were left to the individual companies, with the result that the impact and quality varied greatly. But even if it was a one-shot accomplishment, the fact that there could be such a thing as a nationwide simultaneous theatre production was impressive.

In the three years of its existence the Federal Theatre Project produced about a thousand plays—some classics, some new works, some traditional in manner, some experimental. About 12,500,000 people saw them and paid $681,914 in admissions in New York alone, much to the dismay of some, but not all, Broadway producers. Those who objected complained to their congressmen, but, as Atkinson said, "The Federal Theatre did not compete with Broadway, it supplemented Broadway." It did more than that; it invigorated Broadway as well.

The most experimental productions of the project originated in New York under Broadway's nose. Orson Welles and John Houseman, with what was called the "Classical Unit," produced Marlowe's *Doctor Faustus* starkly on a bare stage. It ran for four months. Welles directed *Macbeth* with an all-black cast in Harlem and with strong injections of authentic voodoo. Together they did *Julius Caesar* in modern dress with unmistakable overtones of Mussolini's Italy. They shook the administration of the project to its heels with a production of Mark Blitzstein's "opera" *The*

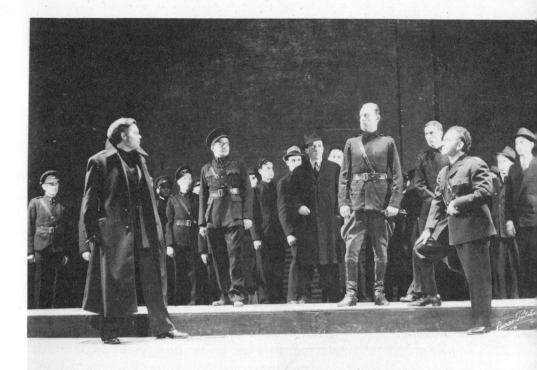

Orson Welles (far left), the *enfant terrible* of the theatre in the 1930s, produced with John Houseman at their New York Mercury Theatre Shakespeare's *Julius Caesar* in modern dress. In the Fascist era of Mussolini it became, in Houseman's words, "a political melodrama with clear contemporary parallels."

Cradle Will Rock, a headlong attack on the magnates of the steel industry and a paean of praise for the labor movement. When the Project, forced by the government, disowned them at the last minute and refused to let them use the theatre in which they were scheduled to open, the cast and crew and Welles and Houseman marched off to another theatre rented on the spur of the moment by telephone and opened anyway. The musicians, however, backed out and Blitzstein played the score on an untuned piano at the side of the stage. John Mason Brown in the New York *Post* said, "The most exciting propagandistic tour de force our stage has seen since *Waiting for Lefty* burst like a bombshell on this town." Welles and Houseman were a defiant and extremely gifted pair, who after their experience with the Federal Theatre continued to startle and impress Broadway audiences with the Mercury Theatre, a short-lived attempt at that perennial temptation and financial dog-in-the-manger, a repertory company.

There seem not to have been in the history of the American theatre

any productions that caused as much excitement, consternation, wrath, and political furor as those of the Federal Theatre Project. It was a series of documentaries under the masthead of *The Living Newspaper* that caused the most trouble and created the greatest excitement. This brand of theatrical journalism, new to America but not to Europe, was Elmer Rice's contribution. It was a series of documentaries tied to events of the day and to national and extra-national problems. Not surprisingly it trod on many politically sensitive toes. Its first production was to be *Ethiopia,* which excoriated Mussolini's ruthless expansionist diversion in Africa. This was too much for a vacillating State Department, which was then conciliatory toward Fascism, and the department demanded that the play not open. Elmer Rice resigned in high dudgeon and with a flourish, but *The Living Newspaper* continued with other matters. It employed very large casts and it attracted large audiences, who paid 50 cents or $1 to see them perform.

The two issues of *The Living Newspaper* that were found most objectionable by the opponents of Roosevelt's New Deal were *Triple-A Plowed Under* and *One-Third of a Nation. Triple-A* thundered about capitalist exploitation of farmers and consumers, and *One-Third* took its title and its thesis from Roosevelt's statement in his second inaugural address that one-third of the nation was ill-fed, ill-clothed, and ill-housed. The play was set by Howard Bay in a dingy street against a cutaway tenement, whose rooms were open to the audience, and it concluded with a frightening fire ingeniously contrived with moving lights. It ran for 237 performances, and to all intents and purposes it sealed the doom of the Federal Theatre Project. Voices were raised in Congress. It was declared to be flagrant leftist propaganda, though, in fact, it was not radical beyond the policies promulgated by the New Deal. It was, however, disquieting to the loyal opposition and just too much for the likes of Congressman Martin Dies of Texas and the members of the Un-American Activities Committee, which he chaired and which saw Communists scheming behind every New Deal project. The committee was determined, by whatever means and at whatever cost to civil liberties, to ferret them out and expose them.

In November 1938 Mrs. Flanagan at her own request appeared before the Dies Committee, as it came to be called. (It was an echo of the "red scare" of the 1920s and a pre-World War II harbinger of what was to become McCarthyism in the 1950s.) She was cool and competent and clever. She was accused, because she had visited Moscow in the 1920s to see and learn from the traditional Russian theatre, of being under Soviet influence. When a member of the committee cited the article from *Theatre Arts,* quoted above, in which she had included the phrase "Marlowesque madness," he wanted to know if "this Marlowe" was a Communist. Mrs.

Flanagan explained that she was referring to Christopher Marlowe, and the congressman insisted that she tell him who he was. "Put it in the record," Mrs. Flanagan said, "that he was the greatest dramatist in the period of Shakespeare, immediately preceding Shakespeare." The audience at the hearing burst out laughing and the congressman thereafter held his peace.

The Federal Theatre Project expired when the Congress voted down its appropriation on June 30, 1939, just two months and a few days before the Nazi panzer divisions invaded Poland and the Second World War was suddenly not just a threat but a fact. The project had done much of what it had set out to accomplish: it had saved the careers and the self-respect and possibly the lives of a great many actors and artists and artisans of the theatre at a desperate time; it had taken the living theatre into out-of-the-way places that had not enjoyed such entertainment since the movies had preempted the old small-city opera houses. It had conducted experiments that left a permanent and invigorating residue in the American theatre as a whole; it had unquestionably encouraged the proliferation of drama departments in universities and colleges; and in so doing had raised the quality of audiences for the future.

On the other hand it had demonstrated that a federally subsidized theatre with experimental ambitions and a social conscience was a very risky business, a doll in which politicians took particular delight in sticking pins and ultimately daggers as well. The project died of such wounds, some of which, it cannot be denied, were eagerly invited, almost, it seems, self-inflicted. What the project did not accomplish was to spread, as some had hoped, a nationwide desire for professional repertory theatre companies. The old polarization of Broadway as the mecca of actors and playwrights and directors and of Hollywood as the capital ("the illusion factory," as some called it) of the movie industry prevailed. What went on between the Broadway stages and the Hollywood "lots" seemed scarcely to matter except to college drama departments and amateur groups.

Why Repertory Fails

There have been many attempts to make repertory self-sustaining, but a fact of theatrical life seems inevitably to be that professional repertory in America can survive only with generous subsidies and even then only precariously and not for long. At any time, the box office manages to keep only a very small percentage of the plays in which "angels" invest their money from failure. The Rockefeller report on the performing arts published in 1965 declared that, of the $10 million invested in Broadway

productions in what was then an average year only a quarter of those who invested got their money back, much less made a profit. Seventy-five percent of the plays were flops, if not artistically, at least financially. Paid admissions have not been able to support an ongoing company of actors, as the Group Theatre demonstrated and as Eva Le Gallienne discovered on several occasions.* She first tried with the Civic Repertory Theatre in 1926 in a playhouse on West Fourteenth Street. It was her ambition to put on classical repertory interlarded with what she considered distinguished contemporary plays. She managed to get about $100,000 a year in subsidies from private patrons, but the Depression dampened her patrons' enthusiasm, and when she tried again after World War II she had little success in spite of favorable reviews and the performances of well-known actors.

In 1943 Mayor Fiorello La Guardia of New York took over the Mecca Temple, a large auditorium that had foundered and could not pay its taxes, and established the City Center of Music and Drama. "It has to succeed," the ebullient mayor pronounced, "because the players love it, the ushers love it, the public loves it. And what's more—it's good for them." It may have been because it was "good for them" that the plays were not a success, and as a repertory theatre for the drama the City Center petered out. Audiences by and large do not want their intellects stimulated or their emotional withers wrung. They want to be amused and have their minds set at rest. It is in the meadow on the other side of the fence they want to graze, where the grass is deliciously green and the flowers are wild and sweet-smelling.

There have been, indeed are today, many attempts to establish and maintain repertory companies, but few have succeeded; most of those that have survived have been attached to cultural institutions such as universities. But in all cases they have needed to be subsidized. There is no better example of both the excellence of repertory and its precarious existence than the Metropolitan Opera in New York. (Because it is lyric theatre does not remove it from the family of theatrical repertory; music only increases its burdens because of the size of the company it requires for its existence and the expense of mounting its productions.) For years "the Met," as it is always called, has been subsidized, originally by private donors willing to meet its sometimes staggering annual deficits and more recently with private subsidies supplemented by grants from private foundations and from the New York State Council on the Arts and the National Founda-

*Eva Le Gallienne (1899–) was a success on Broadway as an actress when she was in her early twenties. Her father, Richard Le Gallienne, was a well-known English poet, and her mother, Julie Norregaard Le Gallienne, a Danish author. Miss Le Gallienne, a woman of fierce convictions, was an eminent figure in the theatre for many years.

tion for the Arts. Repertory of any professional kind demands a devoted and versatile company of performers and a dedicated audience as well. It also requires that the performers be paid enough to live on decently, not just marginally, and that the demands of unions, which could not be less concerned about the theatre as art, be met, in spite of what seem to producers and backers to be their outrageous and in many cases self-defeating proclivities for featherbedding.

In the years before the Second World War, except in the case of the Federal Theatre Project, the performing arts were almost entirely creatures of free enterprise and dog-eat-dog competition. To be sure, some artistic institutions like the Theatre Guild and the various civic opera companies traded heavily on social cachet and snobbism; it was fashionable in various ways and for various reasons to be associated with them. Part of the problem faced by the experimental and what Clurman called the "true theatre artistically" was that its gifted members (actors, playwrights, directors, designers) drifted away to what unquestionably was "the big time" of the commercial theatre. Part of the attraction was unquestionably money and fame, but part of it was that in the commercial theatre there was a challenge and a vitality very different from the challenges of the experimental and "art" theatres. It was the challenge of facing the world, not of confronting and impressing only one's peers. It must be a truism, that wherever and however humbly and high-mindedly talent starts in the theatre, it aspires to popular recognition and the tangible as well as the psychic benefits and dangers that fame bestows. Ambition drives artists as surely as it drives businessmen—the ambition to be recognized and to exert influence on others, however different in character and intent the artist's influence may be from that of the businessman. This is not to denigrate the experimental and "laboratory" theatres or their importance as testing grounds and schools for young theatre people or as seedbeds for the germination of new talents and new concepts. Far from it. Talent needs all the help and encouragement and opportunities to test itself and to grow that it can get. But marked talent in the theatre (the romantic view of the unrecognized genius to the contrary notwithstanding) does not, the record seems to indicate, go unrecognized, unpraised, and unrewarded.

An Abundance of Playwrights

If this is most spectacularly so in the case of actors, it is only a little less so for playwrights, whose names, like those of performers, may never be household words but whose reputations are likely to be more enduring. There was a spate of talented playwrights in the 1930s, men and at least

one woman of very substantial gifts if not of genius, a matter that time will decide. While Broadway was undergoing a financial slump (the number of productions had dropped from 187 in 1930–31 to 70 in 1940–41) and the Federal Theatre Project was saving bodies and trying to save souls, a group of five playwrights, disaffected with the state of Broadway producing, organized the Playwrights' Company to produce their own plays and a few others. They were all dramatists with sound, well-established reputations and assured futures—as assured as reputations are likely to be in the unpredictable behavior of the theatre. They were Elmer Rice, Robert Emmet Sherwood, Maxwell Anderson, S. N. Behrman, and Sidney Howard. They were playwrights, not heavy-handed propagandists—fluid writers, expert craftsmen, and subtle observers of the human condition, who could entertain as well as instruct. They wrote of current preoccupations —of psychiatry, threats of Fascism and impending war—but they were as far from the pulpit as they were from the Federal Theatre Project's *Living Newspaper.* It was persons they were concerned with, not polemics. It would be incorrect to imply that they constituted a school either of ideas or of methods.

Sherwood was the best known of them and quite probably will continue to be. This may have equally to do with his eminence as a playwright and with his political involvement during World War II. He was one of Roosevelt's most eloquent and influential speechwriters, and he became the director of overseas operations for the Office of War Information, America's propaganda machine. He won four Pulitzer Prizes, three of them for plays and one for *Roosevelt and Hopkins: An Intimate History* (1948). The three plays were *Idiot's Delight* (1936), *Abe Lincoln in Illinois* (1938), and *There Shall Be No Night* (1940). Sherwood was a man who believed that "the world is largely populated by decent people," and at a moment when many in the theatre looked to Russia as mecca, he called Marxism "the ultimate ant-hill." He celebrated the miracle of democracy in *Abe Lincoln in Illinois,* and though he had emerged wounded from World War I and a dedicated pacifist, as millions of young men did, he came to use his eloquence most passionately against totalitarianism and used his energies in the war against it. Although he lived for a decade after the end of the Second World War, his theatrical vigor did not survive it.

There were many women who played influential roles in the theatre of the 1930s, many more as actresses than as producers, but only one woman emerges from that decade as a playwright of commanding talent. She was Lillian Hellman. Her first notice on Broadway was provoked by *The Children's Hour* in 1934, a play whose demure title belied a corrosive exploration of small-town viciousness prompted by a false accusation by

a schoolgirl of a lesbian affair between two of her teachers. Lesbianism was not a subject that audiences of the thirties took in stride and any mention of it was shocking, but small-town malice was Miss Hellman's theme, and she made it sting. Her next success was *The Little Foxes,* five seasons later, with Tallulah Bankhead as the bitchy lead. The play dealt with a Southern family of singular gifts for destroying itself and whatever and whoever came within its orbit. It subsequently became a film starring Bette Davis, and it continues to attract distinguished actresses, as a vehicle for their virtuosity, and audiences, who sit entranced by their display of evil. Two other plays by Miss Hellman made more than just a dent on public sensibility. *Watch on the Rhine,* an anti-Nazi polemic, was produced in 1941, seven months before Pearl Harbor, when there was still a surprising (in retrospect) division of opinion about whether America should engage itself in the war against Hitler or pretend that it was none of our business. The second was *Another Part of the Forest,* produced in 1946, which took up where *The Little Foxes* left off, or more accurately went back to the depredations of an earlier generation of the same vicious family. Miss Hellman was strongly committed to the political left, though her plays were not political. She became embroiled in the witch hunting of the 1940s and '50s as a victim, and many years after that unfortunate period had been at least temporarily laid to rest, she resurrected it in an autobiographical book, *Pentimento* (1973), by defending her engagement with the Communists as a moral stand. For her pains she was pounced upon by intellectuals of her generation who had not been seduced by Marxist blandishments and promises of utopia, and who found her self-justification both impudent and imprudent.

It is difficult to say why the 1930s and '40s were decades in which the theatre in America produced so many able playwrights, only a few of whom are mentioned here, or so many innovations in the ways in which plays were staged. The best of the plays that have survived were not concerned primarily, and in many cases not at all, with the problems of the Depression or the war, or the arrival of the atomic age at Hiroshima in a burst of horror and euphoria. They were not, with exceptions that we have already noted, concerned with political and economic realignment, with the attractions of panaceas to cure either public or private ills (Marx on the one hand and Freud on the other), though social reform was in the air either as a promise or a threat, depending on one's political stance. The theatre should have been suffering from the inroads of the films, and, if it was financially, it does not seem to have been intellectually. It may, indeed, have been the flexibility and extravagance of the films that caused the legitimate theatre to experiment with simplification, with theatre-in-the-

round and disregard of the conventional proscenium, with the abandon-ment of realistic (in the Belasco sense) dressing of the stage, in favor of letting the audience create its own illusions, as Thornton Wilder did with his bare set described by the Stage Manager in *Our Town* (1938).

It may have been the generally frivolous quality of the films before the Second World War that encouraged serious playwrights to more nourish-ing alternatives. The theatre of psychological insights and probings took the place of melodrama and the well-made play, which Lillian Hellman defined in her day as "the play whose effects are contrived, whose threads are knit tighter than the threads of life and so do not convince." "Took the place of" is an obvious overstatement. Melodrama is unlikely ever to be replaced so long as sentimentality and palatable violence, customarily relieved by comedy, satisfy our need for escape and so long as comedies of manners continue to make people laugh not at themselves but at their neighbors. The thirties and forties demonstrated that the theatre of ideas and the theatre of escape can not only thrive side by side but, as usual, exchange favors that benefit them both.

Theatre During World War II and After

The theatre got through World War II with a minimum of flag waving and patriotic cant and a maximum of concern for the men and women in uniform. Actors and actresses, singers and dancers, comedians and band leaders took their acts wherever there were military establishments on this continent and in Europe and the Pacific under the auspices of the USO (United Service Organization). The mood was very different in 1942, when Irving Berlin wrote the score for *This Is the Army,* from the mood in 1918, when he had written *Yip, Yip, Yaphank.* GIs cheered for touring compa-nies headed by such eminent stage personages as Ethel Barrymore, Helen Hayes, Raymond Massey. Maurice Evans took Shakespeare to the troops with what he called *GI Hamlet;* Katharine Cornell and Brian Aherne gave them *The Barretts of Wimpole Street,* a sentimental piece about Victorian England, not what you might expect that GIs would cheer for, but they did. Perhaps they did not cheer as loudly as they did for Bob Hope, but actors, they have said, rarely had such enthusiastic audiences anywhere. This was live theatre in theatres of war, and the GIs loved it. In New York at the Stage Door Canteen, operated entirely by theatre people, famous and not-so-famous stars not only worked at their trade as entertainers but waited on tables, washed dishes, and danced with all comers. The place was packed every night with men in uniform from England and Free France and Russia and from wherever Americans came to town on leave.

Actors, entertainers, and musicians turned out in force to provide amusement for the most appreciative of audiences, men in uniform on leave during World War II. No place jumped like the Stage Door Canteen in New York. On the evening in this photo, a group of "long-stemmed American beauties" from *The Ziegfeld Follies* turned up to enliven the party.

The war left no remarkable plays in the literature of the theatre; indeed only in long retrospect are wars likely to produce literary master-pieces. Soon after the anxiety and boredom and anguish and excitement had died down, however, theatregoers turned their attention to two new playwrights whose first productions appeared toward the end of the war and who became well known soon after V-J Day. They were Arthur Miller and Tennessee Williams (Thomas Lanier Williams). They were almost exactly of an age (Williams was born in 1914, Miller in 1915), but that is nearly all they had in common, except a determination to satisfy their theatrical hunger. They were both playwrights who "looked back in anger." Williams's view and style were essentially those of the introspective poet, Miller's those of a polemicist and activist. The ills that Williams uncovered and exploited in the society from which he sprang were, to oversimplify, self-made by his characters. Miller's ills were imposed by society and its moral standards and shibboleths, its gauges of success, its

slogans, and its conventions—by external pressures, in other words, that formed character and constricted it. Williams's characters were victims of their own desires and frustrations and middle-class gentility. By contrast Miller's characters were victims of society's desires and frustrations and middle-class morality.

Williams established his reputation with *The Glass Menagerie* in 1945,

When *The Glass Menagerie* by Tennessee Williams was produced in 1945 it announced the arrival of a very gifted young playwright. Laurette Taylor (right) played the role based on Williams's mother (he called it "a memory play"); with her is Julie Haydon. It won the Critics Circle Award, but the Pulitzer Prize that year went to a comedy about a man-sized rabbit called *Harvey*.

a play without a discernible plot, a vignette of great intensity about the closeted life of a mother and daughter and their doomed attempts to make a world out of small, fragile, and imagined triumphs and symbols of hope. It was followed two years later by *A Streetcar Named Desire,* for which Williams was awarded his first Pulitzer Prize. The *New York Times* critic wrote of it: "It has no plot, at least in the familiar usage of that word. It is almost unbearably tragic," and later in his review he said: "He [Williams] is an incomparably beautiful writer, not because the words are lustrous but because the dialogue is revealing and sets up overtones. Although he has confined truth to one small and fortuitous example, it seems to have the full dimensions of life on the stage. It almost seems not to have been written but to be happening." If Williams's plays are without "plot," they are certainly not without a kind of narrative unfolding that gathers momentum quietly so that when a climax is reached the effect is usually far more devastating, for all its inevitability, than the nature of the occurrence. *Streetcar* was followed in 1951 by *The Rose Tattoo* and in 1955 by *Cat on a Hot Tin Roof,* for which he won his second Pulitzer Prize. Williams was a busy writer, the author of a novel and short stories and many one-act plays.

Arthur Miller's first successful play was *All My Sons,* produced in 1947 and characteristically "right" for the moment. It was philosophically topical: it concerned a manufacturer who knowingly sold airplane engines to the military which resulted in the deaths of pilots, the son's betrayal (if that is the word rather than "exposure") of the man to the government, and the father's subsequent suicide. As Miller perhaps hoped, but in any case could have expected, the right attacked him as a Communist for his stance at that moment when the Russians, who so recently had been our "noble allies," had become our "enemies." It was an epithet readily applied to liberals by those who, as it was then commonly said, "suspected Communists under every bed." His play was not licensed, as were others like Wilder's *Our Town* and O'Neill's *Mourning Becomes Electra,* for performances abroad under the auspices of the Civil Affairs Division of the American Military Government, the occupying forces.

Miller's reputation as a playwright of commanding talent was secured by what has remained the best known of his plays, *Death of a Salesman.* It was produced in 1949, directed by Elia Kazan, with remarkable sets by Jo Mielziner. It won both the Pulitzer Prize and the Critics Circle Award, and the play put the name of its principal character, Willy Loman, in the language as the archetypical traveling salesman, who both lives and is deceived by slogans, is fed and starved by his belief in the empty enthusiasms demanded by his sales pitch. He was in T. S. Eliot's phrase a

"hollow man," but no less truly tragic for that. In some respects *Death of a Salesman* is comparable as a comment on the values of our society to Dreiser's *An American Tragedy*. *The Crucible*, which was produced in 1953, was another topical play, but only in the sense that it paralleled, but did not play upon, the witch hunts of the McCarthy years and the literal witch hunts and witchcraft trials in Salem in 1692. It was a consideration of freedom of conscience which, as the political and moral pendulum swings and social tolerance waxes and wanes, is a recurrently passionate concern of democracy. When Miller applied for a passport to go to Brussels to an opening of *The Crucible*, it was denied by the State Department. He was politically *persona non grata*.

From the perspective of the 1980s both Tennessee Williams and Arthur Miller are playwrights whose stature remains undiminished, though their literary reputations persist largely on the basis of their early plays. The soil they broke (if Williams's soil was loam, Miller's was hardpan) has since been cultivated by many playwrights of less energy and substance than theirs.

The audiences for which Clyde Fitch wrote and whom he charmed by his wit and artfulness were presumably the same kinds of middle- and upper-middle-class theatregoers who attended the somber doings of Williams and Miller, and in the 1960s were to be wrung by Edward Albee's *Who's Afraid of Virginia Woolf?* and were left guessing by Samuel Beckett's *Waiting for Godot* in 1955. But two wars had intervened, the one characterized by mass slaughter in the mud of trenches, the other civilian slaughter from the air. There had been high-kicking frenzy of a sort after the First World War, followed by a dark passage through a blighted economic landscape. There had, moreover, been two "red scares"—the IWW ("Wobblies"), the bomb-carrying Bolsheviks, so dear to the hearts of political cartoonists, and the bitter labor battles and after the Second World War the less violent but more subtly debilitating era of the Un-American Activities Committee and the guilt-by-association crusade of Senator Joe McCarthy in the 1940s and '50s.

To say that audiences in general were more serious in their taste for intellectual drama after World War II than before it is probably unjustified, but they were willing to accept premises that were of no concern to Fitch's audiences. They took Freud in stride and social criticism as a legitimate function of the theatre as of the novel. Everything was not going well in the best of all possible worlds, as it had been assumed to be going in the good years of Teddy Roosevelt and William Howard Taft. To look critically at the state of society, its foibles, and its often hollow standards and

to mock the mighty and sympathize with the humble, the confused, and the oppressed, poor or rich, was considered fair game for the stage. Ibsen, Chekhov, and Shaw had left their imprint not just on American playwrights but on American audiences too. The little-theatre movement had freed the stage from many weary old conventions of staging, writing, and acting. The Theatre Guild and to a lesser degree its offshoot the Group Theatre had made thoughtful drama fashionable, not just with the fussy city audience but with the suburban Wednesday matinée matrons, in much the same way that book clubs had brought what its experts said was literature into homes that found bookshelves had other uses than to display bibelots and pottery. Plays and novels that might not have been likely to succeed on their own made it because they had the seal of good taste and intellectual respectability pasted on them by the Guild, the Pulitzer Prize, and the judges of the book clubs.

What was fashionable in the theatre by 1950 was the result of what Harold Clurman said had defeated the Group Theatre: "the fundamental contradiction" of trying to "maintain a true theatre artistically . . . on a show business basis." It seems, however, that art and business were not irreconcilable and that conflict between them need not be unproductive. While it may not have created a theatrical utopia, the conflict between serious artistic effort and hard financial fact did create an audience that supported experiment, albeit sometimes grudgingly and slowly. This audience saw to it, often to be sure with prodding, that our most gifted playwrights (even in their darkest moods), actors, directors, and designers not only were heard and seen but honored and prospered. Though the art of the theatre has had to struggle to protect and forward its ideals—as what art has not?—it seems unlikely that any major talents, much less geniuses, have been squeezed into oblivion between the fragile art of the theatre and the brittle economy of show business.

Photography

t can be argued (and increasingly is) that photography in its various manifestations—scientific, journalistic, recreational (as a toy) and cultural (as an art)—has had a greater impact on society and how it sees itself than any of the other arts, fine or not so fine. For the last century and a half, and somewhat more, it has made a record of the physical and social world such as no medium before its invention ever did. Until photographs preserved our forebears for us and recorded how they lived and what they looked like and saw about them, we had only hearsay and see-say (drawings, that is, and paintings and sculpture, usually seen at secondhand through engravings) to rely on or to speculate about. Photography has changed that and our understanding of our surroundings (we saw in two dimensions for the first time ordinary things we had never noticed before), of the past and of our contemporaries everywhere, no matter how remote they might be. It has changed the methods of scientific investigation and the character of journalism and of merchandising; it has speeded up changes in fashion and manners and even moralities; and it has revolutionized the function and nature of the fine arts. It has preserved the outlandish, the disagreeable, and the disgraceful along with the ordinary, the casual, and the pleasant, and in so doing it has increased our understanding of man and his history. Photography has penetrated where eyes cannot see and has made a three-dimensional world in some degree comprehensible by reducing it to two-dimensional images on paper and screen and television tube by the billions every day.

Prints on paper concern us here, and what might be called "modern" photography in America was personified at the turn of the century by an artist whom we have already met briefly as a promoter and purveyor of the avant-garde in painting. He was Alfred Stieglitz, the proprietor of the 291 Gallery in New York, where work by Cézanne, Picasso, and Matisse

first appeared on this continent. He was, more importantly, the grand panjandrum and philosopher of a mechanical gadget that was turning with his help into a medium of "art." Stieglitz's name was known and generally looked upon with respect that in some cases approached awe.

As a seer he was not always clairvoyant. His crystal ball was not infallible, clouded sometimes by personal pique, though he saw in it more than most of his contemporaries saw in theirs. He was somewhat ahead of most Americans in his taste in the arts, and he was a dedicated objector to the nature of American society and what he regarded as the nearly universal philistinism that surrounded him. He was given to pronouncements on life and art and patronage of the arts (or lack of it), which rolled off his agile tongue like the torrents of spring. He spoke in manifestos, and what went on in the American arts outide his circle he dismissed as unimportant and often contemptible. He found nothing, for example, to recommend the Ash Can painters except that they opposed "the vapid romanticism" of the nineteenth century and the Beaux-Arts tradition. It is possible that this was because they were not as impressed with him as he thought they should be and because they reflected the current European avant-garde less than did his own stable of artists: John Marin, Alfred Maurer, Marsden Hartley, Arthur G. Dove, Max Weber and others. "When it came to a showdown," he said, "I could not see anything truly revolutionary or searching in their paintings. Their line, form, and color seemed mediocre. Certainly they lacked freshness or a sense of touch. I could not feel committed to what was mere literature, just because it was labeled social realism."* He was left out of the excitement of the Armory Show, and he was miffed that it had been accomplished without him. He needed to be the centerpiece at the feast or not there at all. He did, however, buy the work of four artists in the show, including a large "Improvisation" by Wassily Kandinsky for $500, a daring purchase, which is now, like many of his own photographs, in the Metropolitan Museum in New York.

If Stieglitz's fame as a tastemaker has dimmed somewhat over the years (though it is by no means forgotten), his reputation as a photographer and philosopher of the lens has become as solid as a bronze monument to which time has added a patina of mellowness, which this often testy but essentially generous man seems not to have possessed.

One of Stieglitz's clouded pronouncements was made in 1897:

Photography as a fad is well-nigh on its last legs, thanks principally to the

*"Social realism" was not a term used by The Eight. It did not come into currency as applied to painting in America until the 1920s and '30s, according to Milton W. Brown, the principal historian of that period of American art.

bicycle craze. Those seriously interested in its advancement do not look on this state of affairs as a misfortune, but as a disguised blessing, in as much as photography has been classed as a sport by nearly all of those who deserted its ranks and fled to the present idol. . . .* It was, undoubtedly, due to the hand camera that photography became so generally popular a few years ago. The climax was reached when an enterprising firm flooded the market with a very ingenious hand camera and the announcement, "You push the button and we do the rest."

Photographs—Man's Unedited Vision

For about fifty years before the Eastman company of Rochester, New York, started to market a box camera in 1888 (it was loaded with a film that made one hundred exposures and advertised with the slogan that made it famous), photography in America had been a great deal more than a fad for amateurs. It had been brought to America from France in 1838 by no less a personage than Samuel F. B. Morse, the "inventor" of the telegraph (a claim that is open to argument) and of the Morse code (a claim that is not). Morse, who was a very capable portrait and "history" painter by profession and the founder of the National Academy of Design, was fascinated by what Louis J. M. Daguerre and Joseph Nicéphore Niepce had contrived to do in fixing an image permanently on a thin sheet of metal by means of a *camera obscura*. The science of optics, applied by the ingenuity of an inspired tinkerer (Niepce had invented a hot-air engine) and the chemical experiments of an ingenious designer (Daguerre, a "special effects" man in our jargon, devised and painted theatrical scenery and dioramas that gave the illusion of great depth and motion), produced an instrument that fascinated Morse as it had astonished the Parisians who first witnessed the remarkably detailed images it captured.

Morse saw the daguerreotype, the forerunner of the photograph, as a tool for artists, a way of making exact records of faces and places and objects that a painter or engraver could store for future reference. The serious business of picture making, of fixing the appearance of persons (and particularly personages), events (commonly romanticized or schematized or both), and places had always been the artist's acknowledged function, and it did not occur to him that a gadget could replace the sensitive perceptions of man's eye and the skill of his hand. The daguerreotype, indeed, was, like a painting, a one-time thing. It was a picture on a thin

*The "bicycle craze" hit America in the 1890s. There were hundreds of bicycle clubs even before the "bike" became much like the machine popular today. "High wheelers" were the rage, and bicycle costumes were as de rigueur as jogging costumes in the 1970s and '80s.

metal plate, not on a transparent negative from which many prints could be made. In that sense it was a unique record, and for the dissemination of pictorial images it could not compete with the hundreds of prints that could be made from a steel or copper engraved or etched plate or from a lithographer's stone. Neither the daguerreotype nor its child, the photograph, replaced the artist with burin or brush; if it had, painting would be dead today. But photography had a profound effect on the ways artists worked, on what they saw and painted and why, and how they composed their pictures. More important was the increase it provided in man's knowledge of his immediate surroundings, the world beyond his reach, and things he never dreamed his eyes could penetrate, beneath the flesh and beyond the sun.

When Morse, who basked in the title of Professor of Fine Arts at New York University (it carried no stipend with it) set up a camera on the roof of the university building and made "sun pictures," as they were called, of his young daughter Susan and friends of hers, he was unaware that he was taking a first step toward depriving American artists of their most reliable economic bastion, the portrait business. The new process for making likenesses was a slow and clumsy one. Susan and her friends sat with their eyes closed facing the sun for ten to twenty minutes, their heads held still by metal clamps behind them. The camera was so slow that Daguerre had not thought that it would ever be satisfactory for making portraits. But the rage for daguerreotypes soon put the painters of miniatures out of business and put a severe crimp in the livelihood of most portrait painters. "As the portrait painter vanished," E. P. Richardson wrote in *Painting in America,* "there appeared the impoverished bohemian artist, insecure, embittered, earning his living by teaching instead of by practicing his art, and dependent for the sale of his work upon the whims of fashion." The arrival of the camera, in other words, set off not just an aesthetic revolution in the visual arts but a social one as well.

More important than either of these revolutions was the emergence of a tool by which an unedited vision of man's world could be not only made but disseminated to the corners of the earth. "The nineteenth century began," wrote William M. Ivins, Jr. "by believing that what was reasonable was true, and it wound up by believing that what it saw a photograph of was true—from the finish of a horse race to the nebulae in the sky." (Today it is the "instant replay" that is believed to reveal the ultimate truth in sports and disclose the errors of the spectator's and especially the referee's vision—not a single photograph but a series of pictures taken simultaneously from a variety of points of view.) The daguerreotype was the first step toward providing everyone, the poor as well as the rich, with "ancestors,"

once the prerogative of those who could afford a painted or drawn portrait. For the first time every man could possess a permanent image of his parents and grandparents, his wife and children, his house, the street he grew up on, his childhood playmates, and his first love. He was assured of a kind of immortality, and he could pick and choose, but only up to a point, how posterity would see him. (We know what Lincoln looked like from the great variety of photographs of him by Mathew B. Brady and others, but we only know what George Washington and his contemporaries wanted him to look like, from the "official" portraits by such flatterers as Gilbert Stuart and hero worshipers like Charles Willson Peale.)

The mechanics and chemistry of photography (if not the art of the photograph, which has changed but not substantially improved, if at all, since the very first prints were made) grew gradually over many years. It was the invention in the late 1830s of the negative-positive process that first made it possible for photographers to print many positives from a single negative. The inventor was an English scientist, mathematician, and linguist with a hungry eye who wanted to capture and keep scenes that pleased him. He was William Henry Fox Talbot (generally referred to as Fox Talbot), and he devised a process by which an exposure on paper became a negative through which he could print a positive on another piece of sensitized paper. These prints were called calotypes or, as his friends insisted, talbotypes, and prints from his paper negatives reveal him to have been an artist as well as a scientist. At first the prints were fugitive, and prolonged exposure to light made them fade. It was a friend of Fox Talbot and a fellow scientist, Sir John F. W. Herschel, who discovered a method of "fixing" calotype prints and daguerreotypes with a solution he called "hyposulfite of soda." The word "hypo" is still part of the everyday vocabulary of anyone who uses a photographic darkroom.

The next giant step was the discovery that prints from glass negatives were truer and less diffused than those made from paper negatives. These were first introduced in 1851, and by 1854 daguerreotypes, which had been made by the millions, and calotypes were the victims of progress. They were relegated to commercial shadow if not to obscurity by what was called the collodion or "wet plate" process. By modern standards it was an extremely awkward method of preparing and developing a photographic plate, but it recorded more detail than either the daguerreotype or the calotype. (The reports of the Civil War by Brady and his team were made on wet plates; Brady had a darkroom in a wagon that went wherever they did.) By 1879 "gelatin plates" replaced wet plates to the great relief of photographers. These dry plates could be prepared well in advance of their use and, after being exposed, could be held until it was convenient to

develop them. Photographers had to prepare their own wet plates, a process of seven steps filled with pitfalls, but, with the invention of gelatin plates, manufacturers were able to produce and market them, much as film is marketed today.

It required one further step to make photography an amateur sport. This was the development of the roll film, a process tinkered into existence by George Eastman and his colleague William Hall Walker, in 1884. This film could be used in a small hand-held camera which Eastman, who was living and working in England at the time, first put on the market in 1888 as the Kodak. It was a name, he decided, that was unlikely to be misspelled and would be pronounced in much the same way in any language.* The Kodak was a box camera, which was loaded with film at the factory. When the film had been exposed the snapshooter sent the camera with the film still in it back to Eastman, who removed the film, developed it, made prints (which were circular at first), mounted them on cardboard, reloaded the camera, and sent it and the pictures back to its owner. The slogan "You push the button and we do the rest" was precisely accurate. This hand camera (or "detective camera" as early small cameras were called) was refined, and its film was made of transparent celluloid which could be processed in any darkroom. It was followed in 1897 by the Folding Pocket Kodak and three years later by the Brownie, a box camera "especially popular with children."

The Craze That Became an Art

Photographers like Stieglitz, who regarded themselves as artists, looked on the universality of the hand camera (though they used such cameras themselves with care) as a threat to the seriousness of photography's aesthetic purpose. It was as though every child with a Brownie could draw as accurately as the greatest draftsman. Indeed, the photograph revealed details which the sharpest eye could not record with equal accuracy. Even the most "realistic" painter edits what he sees, discarding what is irrelevant to his purpose and emphasizing what he considers pertinent. The camera made no such choices. Whatever was within the range of its lens and its depth of focus was of equal value. It mattered, of course, where the photographer stood in relation to the subject he chose and how (and

*"In *American Photography* (1924) Eastman, describing the origin of the word, concludes: 'Philologically, therefore, the word "kodak" is as meaningless as a child's first "goo." Terse, abrupt to the point of rudeness, literally bitten off by the firm unyielding consonants at both ends, it snaps like a camera shutter in your face. What more could you ask?' " Eder, *History of Photography,* Dover ed., p. 489.

how much) natural or artificial light fell upon it. Even the child with a Brownie had choices to make about place, subject, and light.

Such a magical machine in the hands of one who could not draw or paint was an irresistible temptation to make "art"—instant art, as we now say—on the supposition that he had "the soul and temperament of a painter." Just because a man has facility with his fingers, has he any better right than another man with a camera to be an artist? Thousands of photographers answered with a resounding "no!" Painters were amused or indignant according to their intellects and temperaments, and probably according to the extent to which they depended on their expertness as depicters of "truth."

When Henry Peach Robinson concocted "Fading Away" from five different negatives in 1858, he was emulating the popular Victorian anecdotal painters of the time. It was the heyday of so-called "pictorial" photography. *(The Royal Photographic Society)*

For a time in the second half of the nineteenth century and in the early years of this one, photographers, more self-conscious about their "art" than they needed to be, tried hard to make "art photographs"—"pictorial photographs" as they were called—and forced that truth-telling instrument, the camera, into being an outright, albeit often subtle, liar. The lengths to which the pictorialists went seem strange today. They painted their negatives and prints, they kicked their tripods to get a "fuzzy" effect or covered their lenses with Vaseline to achieve "soft focus." In some cases they made dozens of negatives that they ingeniously printed together to

make pictures with moral overtones like Victorian allegorical and narrative painting—pictures with titles like "Hard Times," "Here Comes Father," and "Fading Away" (a young woman dying in the presence of her family) and complex compositions such as "The Two Ways of Life" (the licentious and the hard-working: a couple of dozen figures, some nude, in a sort of quasi-baroque setting, all of them emoting to beat the band).

The maestro of this line of artificial goods was an English photographer named Henry Peach Robinson ("Fading Away" was one of his pictures), who produced a book in 1869 called *Pictorial Effect in Photography.* American photographers, amateurs most of them, gobbled it up. "Any dodge, trick, and conjuration of any kind," he wrote, "is open to the photographer's use. . . . It is his imperative duty to avoid the mean, the bare and the ugly, and to aim to elevate his subject, to avoid awkward forms, and to correct the unpicturesque. . . . A great deal can be done and very beautiful pictures made, by a mixture of the real and the artificial in a picture."

During the last quarter of the nineteenth century hundreds of camera clubs popped up like toadstools all over America, and the more ambitious members strove to make "salon" pictures. Some of them were inspired by Robinson (though not many had the time or facilities to be as elaborate as he could be), and some attempted to imitate the popular painters of the day—Corot's "fuzzy" landscapes, Millet's farm laborers, and the more sophisticated among them the Impressionists like Monet and the Pre-Raphaelites of England like Watts and Burne-Jones. The English were far ahead of the Americans in the production and quality of "pictorial" photographs and in "salon" pictures, and the exhibitions of the Royal Photographic Society in London set the standards which amateurs aspired to emulate.

It is well to remember that most pictorial photographers of the period were not professionals; they were frankly amateurs. The professionals worked in studios, where they made portraits of stiffly posed men, women, and children (sometimes of all together) against painted backgrounds and with conventional props, such as "parlor" chairs with carved backs, pedestals, columns, and looped draperies, in emulation of official painted portraiture. This is not to say that many studio photographers did not produce very remarkable photographs, searching studies of the characters of their sitters masterfully composed. This was true not just of famous portraitists like Brady and Sarony in New York but of photographers in small cities and towns as well. If they were better artists than most amateurs who sought to make art with their cameras, it was because they were using their cameras to make photographic records of their subjects, pictures not "pic-

torials," using their cameras for what they were best at, telling their version of the truth.

There are, to be sure, many kinds of photographic "truth," just as there are many kinds of painterly and sculptural "realism," as the history of the visual arts has taught us.* Artists of different generations see the truth differently, and as they see it, the public is likely to come to see it in time. (Shadows on snow, for instance, were not blue until the Impressionists showed us and the artists that followed them that they were, and landscapes did not recede in an orderly fashion until mathematical perspective was introduced into painting in the fifteenth century. The size of a figure or a tree in the background had until then been determined by its iconographical importance, not by its distance from the viewer.) Four photographers photographing the same face at the same instant make four different truths, one possibly sentimental, one possibly satirical, one conventionally pretty, one unconventionally beautiful. They see what they are looking for and, according to some critics, what they see has been predetermined by what painters have taught them to see. Even casual snapshooters compose and frame their pictures according to conventions they have learned from paintings or reproductions of them. If snapshooters do this unself-consciously, because of a dimly understood belief that a picture should look like a picture, the professional portraitists did so both consciously and conscientiously (it was what their customers expected of them), and the pictorial photographers did so quite self-consciously, aiming their cameras unabashedly at the bull's eye of Art.

Stieglitz and the Personal Vision

Alfred Stieglitz was determined to set photography in America on the dead center of this target. He had come to be a photographer inadvertently or, perhaps more accurately, as an escape from engineering. He was a student in his late teens at the Polytechnic in Berlin at the behest of his German-born father (Alfred was born in 1864 in Hoboken, New Jersey, where his family had settled when they emigrated from Germany), and he found the language of physics and mechanics, as delivered by his professors, opaque. His eye lit one day on a camera in a shop window, and his fate and the fate of one important aspect of American photography for

*Ivins contends rightly that photography has revolutionized art history: "It has brought about a very complete restudy and rewriting of the accepted history of the arts of the past, and more than that it has made all the exotic arts known to the ordinary man. . . . The very vocabulary of art criticism has been changed, as have the qualities for which men look in works of art."

years was sealed. If he was not by nature a scientist or builder, he was an inexhaustible experimenter, and the mysteries and subtleties of the image a camera could fix on a sheet of sensitized glass were endlessly fascinating to him. He saw the photograph as a medium of personal expression, not just as a record of fact, but the fact from which a picture started was the essential basis of a picture. Art must start from observable life, not from intellectual abstractions or contrived situations (in the sense of Henry Peach Robinson's concoctions). In this sense he was a humanist and, on the evidence of his photographs, a confirmed romantic.

Stieglitz began early to submit prints to the Royal Society exhibitions in London and early met with success and recognition. Dr. Peter Henry Emerson, an American who lived his adult life in England, an amateur with a sharp distaste for the hoked-up style of photography, and a practitioner of the lens greatly respected by his contemporaries in London, spotted his work and recognized its quality. When Emerson discovered from correspondence with Stieglitz that he was also an American, he wrote: "Shake—I am an American too—my father was a Massachusetts man one of the Emerson family—but we had better not say much about our nationalities this side of the water—especially in photo-circles, that is a tip."

The America to which Stieglitz returned in 1890 was a land of avid amateur photographers, of magazines to tell them how to use their cameras, and of camera clubs. It says something of the spirit with which cameras were approached, a spirit primarily of fun, that one of the most important exhibitions of the 1890s was put on by the Camera Club of the Bicycle Club of Washington. The exhibition was important because it broke down for the first time the resistance of museums to what they regarded as a questionable art at best. The director of the United States National Museum in Washington bought fifty photographs for $300 for its permanent collection. Stieglitz soon found himself involved with a photography magazine as an editor of the *American Amateur Photographer,* in which he promoted "expressive work" and "the establishment of a dignified, European type of photographic salon." Four years later, in 1897, when the Society of Amateur Photographers merged with the New York Camera Club, he became the editor of *Camera Notes,* the club's publication. But he was, it seems, too serious for the members of the Camera Club, and he was soon dissatisfied with editing their organ. He wished to cast the net of his influence, to "reach a class outside of the membership, and stimulate them to artistic effort . . . to take cognizance also of what was going on in the photographic world at large . . . to keep in touch with everything connected with the progress and elevation of photography."

"Elevation" was the operative word. Stieglitz was determined to elevate photography to a "fine art" and have it recognized as such. American museums were beginning to take it seriously but not seriously enough to suit him. The Pennsylvania Academy of the Fine Arts, one of America's oldest and most distinguished museums and art schools (it dated back to 1805), held salons of work by the Photographic Society of Philadelphia in 1898 and '99, but Stieglitz was not satisfied. He wanted to follow the example of London. There a handful of serious photographers, disapproving of the relaxed quality of the Royal Society shows, had organized a small group of pictorialists called the Linked Ring, with Dr. Emerson as its moving spirit. Stieglitz had been honored by an invitation to be one of this photographic élite, and he wanted a circle of his own of equal dedication and talent. In 1901 the National Arts Club in New York asked him to organize an "exhibition of pictorial photographs," an invitation he accepted on the condition that he be given "a room in which pictures are exhibited as I see fit. I must be permitted to hang them without committee interference and with not a soul coming in until I am ready to open the doors." He called the show "An Exhibition of Photography Arranged by the Photo-Secession."

Nobody knew what the Photo-Secession was, not even Stieglitz. He made it up on the spot. He had in mind the "Secession" of Austrian artists from the Vienna Academy in the late 1890s, which resulted in the establishment in 1903 of the Wiener Werkstätte. It was a name that stuck (like Kodak), partly because it was meaningless and partly because it sounded rather grand. Americans like "art movements," and this had the ring of one. It might more accurately have been called "Stieglitz's Stable," as those whom he identified with the Secession were a small group of photographers whose work he liked and who were seriously following his torch. He was, of course, pressed to define what he meant, and one of his statements was: "Its aim is loosely to hold together those Americans devoted to pictorial photography in their endeavour to compel its recognition, not as the handmaiden of art, but as a distinctive medium of individual expression." The Photo-Secession has also been called "The Fine-Art Movement in Photography." ("Fine art . . . a phrase, I have been told, Leonardo invented to distinguish his work from the work of everybody else," Maurice Grosser wrote in *Painting in Public,* in 1948.)

In order to promote the Photo-Secession, to disseminate its beliefs, and to publish what Stieglitz believed to be the finest pictorial photographs, he established the most lavish (and now the most precious, in both senses of that word) magazine of photography that has ever appeared. It was called *Camera Work,* and its first issue appeared in January 1903. Stieglitz

was both its editor and publisher. He did not insist on total agreement with the authors of the articles he published, but he was adamant about the quality of the photographs he reproduced and the excellence of the manner in which they were printed. As a result, reproductions taken from its pages today sell at prices approaching those of prints made by the photographers themselves.*

Not all the photographs reproduced in *Camera Work* were by Stieglitz's intimate circle, and not all of them were by American photographers. There were portraits by David Octavius Hill, a painter who realized that Fox Talbot's invention lent itself to his uses. He was a Scot who lived in Edinburgh and he worked with a local photographer, Robert Adamson, to produce some of the most searching photographic portraits that have ever been made. There were also portraits by Julia Margaret Cameron, remarkably penetrating and often very beautiful. She was the first great woman photographer, or, since "first" is always open to challenge, the earliest whose work remains a landmark of photographic portraiture. There were pictures by and of George Bernard Shaw, a dedicated amateur of the camera, and essays by him about photography. ("Technically," he wrote in *Camera Work* in 1906, "good negatives are more often the result of survival of the fittest than of special creation: the photographer is like the cod, which produces a million eggs in order that one may reach maturity.")

The 291 Gallery was the headquarters of the Photo-Secession and there Stieglitz held court, indifferent, he said, to the pursuit of business, selling only to those whom he chose to recognize as worthy of the photographs (and later of the paintings and drawings) he displayed. If the gallery by any standards was tiny, it was like a little loudspeaker whose message could be heard to the horizon when Stieglitz turned up the volume of his pronouncements. He was, or wished to be, the center of the avant-garde of photography in America, and those he let his light shine upon were an élite and very gifted group of photographers—Gertrude Käsebier, Eduard Steichen, (he later changed Eduard to Edward), Clarence H. White, Joseph T. Keiley, Frank Eugene, Paul Strand, and others.

Most of the work of the Photo-Secessionists today looks not like the expression of an avant-garde (which implies a sprint ahead of accepted

* "*Camera Work* is a small encyclopedia of mechanical printing processes available during the first seventeen years of this century. Along with straight photogravure, there are mezzotint photogravures, duogravures, one-color halftone, duplex halftones, four-color halftones and collotypes. It has been frequently remarked that the reproductions in *Camera Work* are often finer than the original prints." Jonathan Green, *Camera Work, A Critical Anthology*, p. 13.

aesthetic values) but part and parcel of the genteel tradition. The photographs are the kissing cousins of paintings by Dewing, Hawthorne, and Weir, not their rebellious children. They are the products of a somewhat misty, sentimental, mysterious turn of mind that sought romance in the indistinct and charm in shadowy, if carefully composed, images. They were seeing faces and figures and landscapes sometimes as the Barbizon School (painters like Corot, and Daubigny and Théodore Rousseau) saw them. Their pictures were like the portraits of Fantin-Latour and Degas, who was a photographer, like Monet and Americans such as Childe Hassam, and not like the works of the rebels of Post-Impressionism (Cézanne, Gauguin, and Van Gogh). Though Stieglitz was, as we have noted, one of the first to introduce to America the work of the French avant-garde (Picasso, Matisse, and so on), the photographs he showed, until Paul Strand came along in 1916, are based in a nineteenth-century aesthetic. This is not to say that the work of his stable of photographers was unexceptional in quality, that their ability to withstand the passage of time has diminished, or that their influence on today's photographers has vanished. What they contributed was a conviction that photography could be a fine art, and if many of the photographs that we value today were made without so much as a nod to "art," their work did much to make us look at photographs as we would not have looked without them.

It was "straight" photography that nudged "pictorial" photography aside, though the line between these concepts and practices often seems indistinct three-quarters of a century after the transition took place. In the simplest terms, a "straight" photograph was one which printed what was on the negative when it was exposed, without benefit of tricks or subterfuge or tinkering with the negative or the print. In this sense the "straight" photograph was an "honest" photograph, and it possessed for those who practiced straight photography a morality which was part of its aesthetic. It was a morality that only the "fine art" photographers thought about. It was of no concern, for example, to men like Muybridge and Thomas Eakins, who were interested in stopping action for the sake of studying the mechanics of animal (including human) motion. Nor had moralistic aesthetic precepts concerned the photographers who recorded the Civil War, Brady and Barnard for example, or those who made such remarkable pictures of the American West after the war, men like A. J. Russell, Carlton E. Watkins, and Timothy H. O'Sullivan, who lugged their clumsy cameras and tripods and other equipment by wagon into wastelands and mountains. They were making pictures of what interested them. Art when it happened, and it happened not infrequently, was a by-product of a sensitive eye and spirit bent on making a record. Technical skill was the

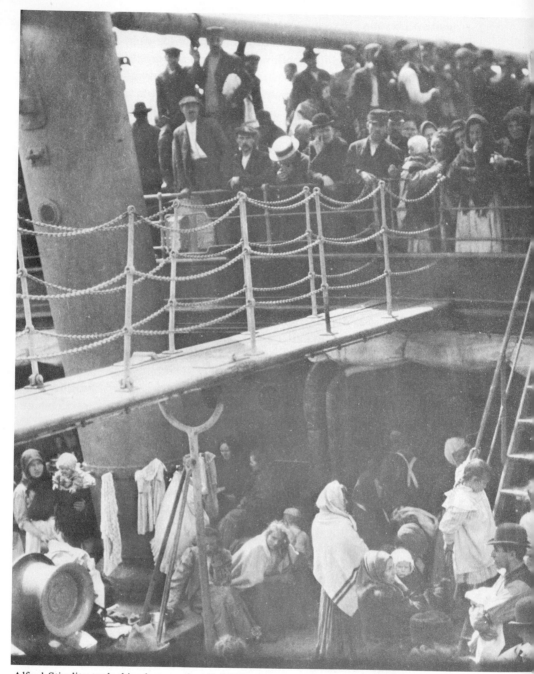

Alfred Stieglitz took this photograph called "The Steerage" (he considered it his "finest") with a Graflex 4″ × 5″ while he was returning from Europe to New York in 1907. "I saw a picture of shapes," he said, "and underlying that the feeling I had about life." *(Collection, The Museum of Modern Art, New York)*

taken-for-granted handmaiden of the selective eye. It was the eye that mattered. The lens saw what the eye told it to—and in some happy (and some unhappy) cases a good deal more. Exclusion is as important to the success of a photograph as what it includes.

Stieglitz himself was one of the first to dedicate himself to "straight" photography as a self-conscious means of making fine art. He understood the potentials and the limitations of the camera as well as anyone of his time. He had the imagination to know what he was looking for and the patience to wait for the occasion, the light, and the moment to photograph it. Like all photographers he had happy accidents, moments when the elements of a good photograph arranged themselves. One of his most famous pictures was of such a confluence of figures, light, mood, and setting, "The Steerage," captured with a hand camera on an Atlantic crossing. On the other hand, a picture like his "Winter, Fifth Avenue" was the results of patient waiting in a snowstorm, and it may have been what Shaw likened to a cod's egg. An astonishing thing about Stieglitz's work is that so many of the eggs were fertile.

Photography as "Fine Art"

The battle for museum recognition of photography as a fine art was a continuing preoccupation of Stieglitz, and it was a battle he won often enough to assure that ultimately photography would win the war. The Photo-Secession was given a show at the Corcoran Gallery in Washington in 1904, another at the Carnegie Art Galleries in Pittsburgh in 1904, and another at the Pennsylvania Academy in 1906. The triumph, however, took place in Buffalo at the Albright Gallery (now the Albright-Knox) in 1910. Stieglitz demanded and got a free hand. He and several friends did the museum over with olive and blue cloth and hung on the refurbished walls more than six hundred prints with, as Beaumont Newhall has written, enough prints by each photographer represented "to enable his artistic development to be traced." When the museum purchased fifteen prints for its collection and set aside a small gallery in which to exhibit them permanently, the ice had been broken. More than a decade later photographs made their way into those holy-of-holies the Boston Museum of Fine Arts and the Metropolitan Museum of Art in New York. It was the great Boston orientalist, Ananda Koomeraswamy, who persuaded his trustees in 1923 to open the museum's doors to photography as an art. At the Metropolitan it was William M. Ivins, Jr., the curator of prints, who persuaded Stieglitz in 1926 to give his collection of photographs, many of his own and many by others, to the museum.

Stieglitz did not like to be overtaken by events; he liked to cause them, and when the Museum of Modern Art in New York established itself, from its start in 1929, as a museum interested in photography, he declined to give his advice or his help. "I have nothing against the Museum of Modern Art," he wrote to a friend, "except one thing and that is that the politics and the social set-up come before all else. It may have to be that way in order to run an institution. But I refuse to believe it. In short, the Museum has really no standard whatever. No integrity of any kind."

Alfred H. Barr, Jr., the Modern's first director, had in his gradually developing plans for the museum a Department of Photography on an equal footing with other curatorial departments, but it was not until 1940 that it became official, with Beaumont Newhall as its director. There had been several important photographic exhibitions in the museum in the 1930s, most particularly a historical survey called "Photography 1839–1937" and a retrospective of the work of Walker Evans; photographs had also been hung with paintings in such shows as "Murals by American Painters and Photographers" and "Fantastic Art, Dada and Surrealism." With or without Stieglitz's blessing, the establishment of a Department of Photography was inevitable in a museum that was the first to establish departments of architecture and film.

One of Stieglitz's most promising protégés, who many years later became director of the department at the Modern (also called MoMA), was Edward Steichen. His photographs were spotted by Clarence H. White, a member of the jury of the photographic salon in Philadelphia in 1899, as having "a quality which needs to be encouraged." It was at White's suggestion that Steichen stopped in New York on his way from Milwaukee to Paris to see Stieglitz and to show him some examples of his work. Stieglitz bought three prints from him for $5 apiece.

Steichen was born in Luxembourg in 1879 and moved with his parents to Hancock, Michigan, when he was an infant of two. He went to school in Milwaukee, and in his teens he attended a local art school and was apprenticed in the German manner to a lithographer. He was facile with a pencil and brushes and he worked on posters and show cards for brewers and flour mills and pork packers. In his spare time he organized and was the president of the Milwaukee Art Students League. He was still in his teens when he persuaded his boss to let him take photographs to use as sources for his posters rather than the prints which were the standard images he was given to copy. "Neither the pigs nor the wheat shown in our library of old woodcuts looked anything like those I had seen at the Wisconsin State Fair, or during my summer vacations in the country," he

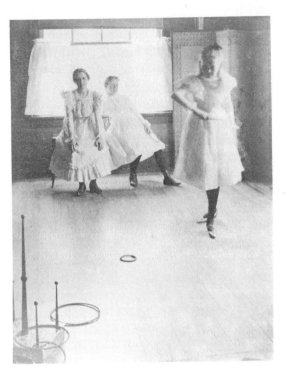

This photograph, "Ring Toss" by
Clarence H. White, was reproduced in
Alfred Stieglitz's magazine *Camera
Work* in 1903. The poetical attitude of
the Photo-Secessionists, of which
White was a member, was at odds
with the robust explorations of the
Ash Can painters working at the same
time. *(International Museum of
Photography at George Eastman House)*

wrote many years later. "So I suggested to the manager of the design
department that we make photographs." The manager told him that if he
would buy a camera he could have time off to take the pictures he was
talking about. "My crowning achievement," he said, "was to make some
portraits of pigs that were much admired by the pork packers. They
insisted that all future placards, posters, and advertising matter be based
on the pigs in these photographs."

But Steichen was an aspiring artist, and camera magazines told him
there were higher aspirations than portraits of pigs for him to set his sights
(focus his lens) on, and he was soon making misty portraits of people
(including self-portraits) and landscapes as "artistic" as the fuzziest of late
Corots. Clarence White's photographs that he had seen reproduced in
magazines were his models of excellence, though he was not an imitator
and many of his early prints have a quality all their own. When he was
twenty-one and making $50 a week (a lordly sum then), he decided to
throw up his job, take his savings, and with his mother's financial help, set
off for Paris, the center of the art world. At their encounter Stieglitz was
interested that this obviously gifted young man was both painter and
photographer. As Steichen was leaving his little gallery, Stieglitz said,

"Well, I suppose now that you're going to Paris, you'll forget about photography, and devote yourself entirely to painting."

To this Steichen replied, "I will always stick to photography."

Fortunately he did. Art gradually lost a mediocre painter and gained a master photographer.

Steichen spent a couple of weeks in one of the famous ateliers of Paris, to which art students from all of Europe and America flocked in those days. He quickly became disenchanted with making academic drawings from models and with the contradictory critiques of the atelier's master. On a trip to London in 1901 he submitted photographs to an exhibition organized by an American photographer, F. Holland Day. It was called "The New School of American Photography," and it was panned by the English critics. The following year Day brought the show to Paris, and the French photographer Robert Demachy, whose prints Stieglitz later published in *Camera Work,* praised it in the press and singled out Steichen as the *enfant terrible* of the new American school. It was while he was in Paris at that time (in the next decade he came and went between Paris and New York frequently) that he got a friend to introduce him to Auguste Rodin, France's most eminent sculptor. Steichen took along a selection of his prints, which Rodin examined with care and evident enthusiasm; he said he would be glad to pose for the young photographer. The result was a thunderously romantic portrait, printed from two negatives, with a bronze of "The Thinker" facing the bearded and silhouetted profile of Rodin, with a white, out-of-focus sculpture of Victor Hugo in the background. The effect was, one might say, apocalyptic, and the portrait is one of Steichen's most famous.

When Steichen returned to New York in 1902 he went straight to Stieglitz. To all intents and purposes Stieglitz and his family adopted him, and he was absorbed into Stieglitz's circle of photographers and the Photo-Secession. He found it disorganized, and he set about giving the group some shape, with a nucleus of "fellows," from which a council of thirteen was elected to act as a board of directors; like the National Academy of Design, it elected a group of associate fellows, thirty in all. Stieglitz was asked to be president; he said that sounded pretentious but he was willing to be called director. When Stieglitz decided to publish *Camera Work,* it was Steichen who designed the format and the title page.

Steichen evidently did not share Stieglitz's distaste for commercial ventures. He hung out his shingle on Fifth Avenue and set himself up as a portrait photographer. He had some financial success and a rapidly growing reputation; moreover, he had a few patrons who were enthusiastic about his paintings. If his paintings are now largely forgotten, his photographic portraits from those days are not. In a single day in 1903 he took

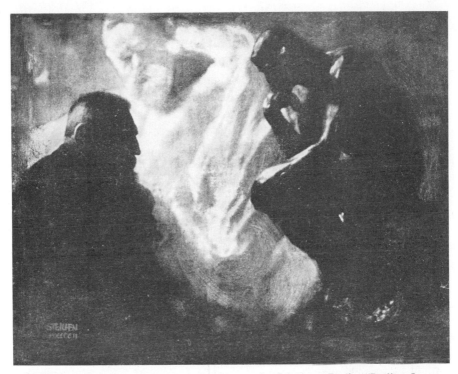

When Edward Steichen made this dramatic portrait of Auguste Rodin, "Rodin—Le Penseur," in Paris in 1902 he was using tricks not unlike those of the pictorialists fifty years earlier. It is a composite of two negatives, a device later adopted by Surrealist photographers. *(Collection, The Museum of Modern Art, New York)*

two of his most important and long-lived portraits, and though there are a great many remarkable portraits from his camera made over a very long career, none are superior to those two. One was of J. P. Morgan, the most powerful financial genius of his day. A portrait painter named Fedor Encke, a friend of the Stieglitz family, had been commissioned to paint Morgan's portrait, and he asked Steichen to make photographs from which he could work. Steichen exposed just two plates, and one of them (with some retouching of Morgan's famous bulb of a nose) seems to epitomize the energy and determination of that remarkable man, his eyes like onyx buttons, his brows knitted, his mouth firm, his left hand clutching the arm of a chair in such a manner that he seems to be holding a knife—an accident, Steichen insisted, not an intentional comment on Morgan's character. The other portrait of that same day was of Eleanora Duse, "the immortal" Italian actress, then in her early forties, a touching, timeless, somewhat troubled beauty seen through a softening haze.

In Steichen's long life (he died two days before his ninety-fourth birthday) there was scarcely any aspect of photography in which he did not participate and distinguish himself. He early gave up the tricks of the pictorial photographers and devoted himself to straight photography. His first "documentary" pictures were snapped at a Paris racecourse on "Steeplechase Day" in 1907—not of the races but of ladies in elegant dresses that swept the ground, carrying parasols and wearing on their pompadours hats like baskets of flowers. As early as 1907 he experimented with color photography, using a new process introduced by the Lumières Company called autochrome. (There is a portrait of his friend George Bernard Shaw done in this color process.) He did hundreds of still lifes—fruits and flowers, butterflies and flower pots, snail shells and safety matches—anything from which he could extract the essence of its nature and the subtlety of its form. His portraits of actors, writers, athletes, and other public figures for *Vanity Fair,* a sophisticated magazine of the arts and letters for upper-middlebrows edited by Frank Crowninshield, did much to change the nature of portrait photography. It was he who, working for *Vogue,* first raised fashion photography to a medium that combined elegance with exactness and chic with character. During the First World War he was a pioneer in aerial reconnaissance photography, and during the Second World War he was in command of a unit responsible for, as he put it, making a photographic record of "the story of naval aviation during the war," and a very remarkable record it was. He was retired with the rank of captain, and in 1947 he displaced (sic) Beaumont Newhall as director of the photography department at the Museum of Modern Art.

His first purchase for the Museum was a group of photographs by Stieglitz. "Stieglitz's greatest legacy to the world is his photographs," he wrote in *A Life in Photography,* "and the greatest of these are the things he began doing toward the end of the 291 days."

The Photo-Secession as a cohesive group of dedicated photographers fell apart. Stieglitz told his friend Dorothy Norman, "I . . . tired of the 'swelled heads' the photographers had gotten, those who banded themselves around me, they thinking that they were quite as important as Michelangelo, Leonardo da Vinci and others of that calibre—possibly more important." On the other hand Steichen wrote, "Stieglitz only tolerated people close to him when they completely agreed with him and were of service." Stieglitz forced Gertrude Käsebier out of the group and the next to go was Clarence White. Both of them, Steichen says, were "antagonistic to some of the things that Stieglitz did." He does not say what these "things" were, but artists do not like to be dictated to and Käsebier and White were independent spirits.

Paul Strand's 1953 photograph of "The Family, View II, Luzzara, Italy" is the work of a photographer who forty years before he took this picture had begun to change the nature of serious photography from "artistic" to "straight." *(Copyright © 1976 The Paul Strand Foundation)*

So was Paul Strand, a young member of the Photo-Secessionists (he was born in New York in 1890), whose work first appeared in *Camera Work* in its two final issues, published in 1916 and 1917. These photographs looked at today seem to belong to a new age. They were in a true sense avant-garde; the genteel tradition had nothing to do with them or Strand with it. There are a directness, clarity, and uncompromising quality about them which is purely photographic. Painterly quality had nothing to do with his prints, as it had with the older Photo-Secessionists, and only obliquely with his vision. He was a photographer, pure but not simple, which is not to say that he was not, while free of sentimentality, humane. If his work is sometimes reportorial in its records of places and people, it is not literary. His photographs are statements of fact without comment: his images have an abstract quality that gives them force. (He was one of the first photographers to recognize and record the abstract qualities of

machinery, an observation that was explored sometimes dramatically, sometimes subtly by Margaret Bourke-White, Charles Sheeler, and many others.) If Stieglitz was the pioneer who made photography "respectable" as a fine art, Strand was the pioneer who brought the art into the twentieth century. It is impossible to look at his prints without seeing in them the roots of many of his contemporaries' most distinctive work—Edward Weston, Walker Evans, Ansel Adams, Sheeler, for example, and others of equal prominence. Indeed, his influence on the later work of Stieglitz himself cannot be (and is not, so far as I know) denied. As a photographer he was a twentieth-century picture maker, not a pictorialist.

Documents for Persuasion

There are social overtones in Strand's work that are missing from the works of other Photo-Secessionists, a concern with the dignity of the working man and woman—not, as in Stieglitz's pictures of travelers by steerage and draymen in the snow, a somewhat sentimental romanticism —though these concerns were never overriding. He came by them logically. His first exposure to photography was at the Ethical Culture School in New York, where Lewis Wickes Hine (1874–1940) taught him to use a camera.

Hine was a sociologist and a teacher by training. By nature he was a social crusader and by instinct a photographer. The camera became his principal weapon for social reform, and in his hands it was a very precise instrument that packed a wallop. He was a "documentary" photographer long before the term became part of photography's jargon, and the term "photo story" was, it is said, first applied to his work.

Though it was Hine who introduced Strand to Stieglitz, "Stieglitz and his disciples looked down their noses at Lewis Hine," or so Berenice Abbott, a young photographer whose charms escaped Stieglitz as his did her, wrote in 1961. Hine was not worried about making "art" or in avoiding it. It was the message he wanted to deliver that concerned him. He photographed the immigrants at Ellis Island, children working in factories (he had worked in a furniture factory himself as a child), sweatshops, miners, flophouses, and the inhabitants of miserable tenements. His pictures were badly reproduced in a magazine called *Charities and the Common Man* (later named *The Survey* and still later *Survey Graphic*). Child labor was one of his particular targets. "The work Hine did for this reform," Robert Doty wrote, "was more responsible than all other efforts in bringing the need to public attention. The evils were intellectually but not emotionally recognized until his skill, vision, and artistic finesse

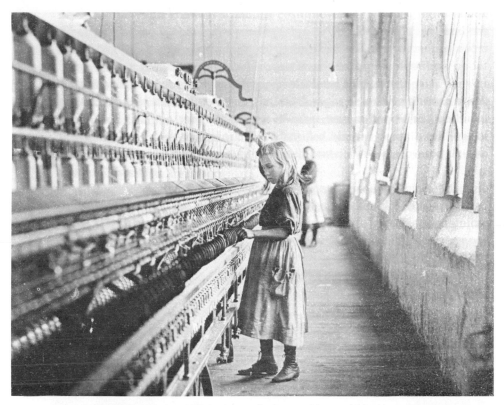

Lewis W. Hine was a sociologist by profession, and he used his camera as a primary tool of research. This child laborer in "Carolina Cotton Mill" in 1908 is the most famous of his searching and quietly dramatic photographs. *(Collection, The Museum of Modern Art, New York)*

focused the camera intelligently on these social problems."

Hine was not the first New York photographer with a social crusade. His predecessor by a full generation was a journalist, Jacob A. Riis (1849–1914), who arrived at Ellis Island from Denmark in 1870, and like so many immigrants knew intimately the Lower East Side, its degradations and depredations, its sordid tenements, its pieceworkers and its poverty. In dark places, like his follower Hine, Riis exposed his negatives with the aid of flash powder, magnesium ignited with a match or spark, which produced a very intense light and a cloud of white smoke. The process of photoengraving was so poor (it was in its awkward infancy) that many of Riis's photographs were copied by artists, even including the eminent Kenyon Cox, and reproduced in line cuts. Riis was not fretted by this: his purpose was journalistic and his pictures were intended to give added push

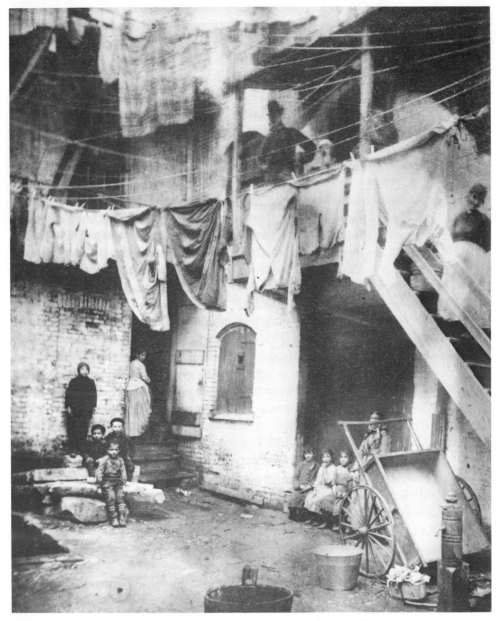

Jacob A. Riis, who took this picture of "Baxter Street Court" in New York about 1907, was a deeply concerned reformer with a magical eye for mood and composition. He produced documentary photographs as moving as they are beautiful, and rarely have they been matched. *(Jacob A. Riis Collection, The Museum of the City of New York)*

to his words—factual, visual evidence, something never known before the arrival of the camera as an instrument of reporting. For many years the quality of Riis's work as a photographer went unsung. It was not until 1947 that his photographs were unearthed and published by Alexander Alland, who gave the negatives to the Museum of the City of New York.

At the same time that Hine was photographing the ghetto of New York, Arnold Genthe was using his small hand-held camera to make pictures of San Francisco's Chinatown. Genthe, who had a doctorate in classical philology, came to America in 1895 from Berlin, where he was born in 1869, as tutor to a wealthy San Francisco family. He taught himself to photograph and it was, it seems from his prints, an interest in the picturesque rather than in social concerns that underlay his exploration of the Chinese of his adopted city. His intentions were more artistic than reportorial, but the results are useful as documents nonetheless, as are his photographs of the earthquake and fire of 1906. He opened a portrait studio in 1897 and soon was showing his pictures in photographic salons. He was a serious collector of Japanese art at a moment (the turn of the century) when that was a fashionable activity, and in 1911 he moved to New York and became a fashionable photographer. Like Steichen he produced pictures for *Vanity Fair,* most notably of the dancers Isadora Duncan and Ruth St. Denis.

Photography Goes Straight

It was a confluence of needs, inspirations, inventions, and practical and social concerns that conspired to change the practice of photography and public attitudes toward it. The invention of the reflex camera (and most particularly the Graflex*), in which the photographer could see right side up on a ground glass precisely what was within the range of his lens and what was and was not in sharp focus at the moment he released the shutter, simplified his problem, especially the problem of the photo-journalist. But more important to the range of the photograph's influence was the invention of the photoengraved printing plate called a halftone in 1885 by F. E. Ives of Philadelphia and its refinement in the early years of this century. A halftone is made by projecting a photographic image through a very fine screen onto a metal plate to make a series of tiny dots, "larger or smaller pin heads," which fuse into a continuous tone. The early halftones were coarse, but just a few decades later it was possible to reproduce

*The Graflex had a focal plane shutter with speeds up to a thousandth of a second, which made it ideal for sports photographs. Though it was bulky by modern standards, it was easily carried.

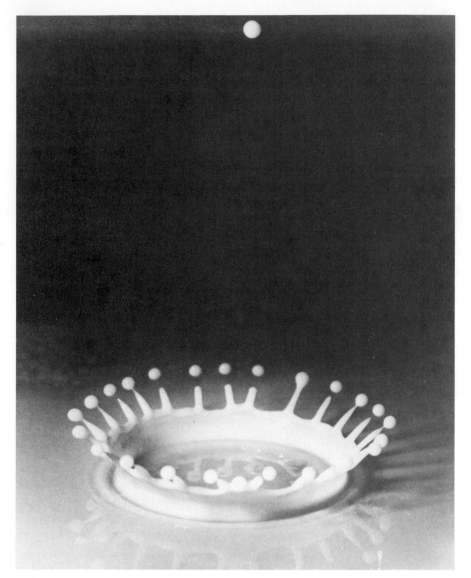

When this "Drop of Milk Splashing into a Saucer of Milk" was first published in the 1930s, it was a sensation. It was photographed by stroboscopic light with an exposure of 1/100,000 of a second by Harold E. Edgerton at MIT. No one had captured, much less seen, anything like it before. *(Courtesy of Harold E. Edgerton)*

photographs with both brilliance and subtlety. For a second time photography put a crimp in the artist's livelihood. Until the invention of the half-tone, lithographers and wood engravers made reproductions of drawings and paintings and had the reproduction of visual images to themselves, and

many of them were extraordinary craftsmen. Magazines like *Harper's Weekly* and *Leslie's,* the most prominent picture magazines of the last half of the nineteenth century, were brilliantly illustrated with wood engravings, and when they shifted to the early gray, lifeless halftones, their fortunes waned. So did the life of the artist-illustrator.

The art of photography, now gone "straight," was not superseded by reportorial photography; indeed it never has been and is not likely to be. The art photograph (a photograph made for its own aesthetic sake) and the snapshot (both journalistic and amateur) have existed side by side since the collapse of the Photo-Secession. The number of art photographers has increased not only among professionals but among amateurs. (The 35-millimeter camera has had much to do with this, as we shall see.) The amateurs, by and large, have been imitators of the professionals, striving for artistic effects not only by the selection of subjects but by the use of gadgets, such as filters, "fish-eye" lenses, and darkroom tricks such as solarization, too complicated to explain here. If they no longer kick their tripods, they might just as well.

It is the custom of artists who break with tradition to band together under a name of some sort, as the Photo-Secessionists did, and declare their independence (and interdependence) by exhibiting their work together. Such was "Group f.64," the central figure of which was Edward Weston, whose name along with a dozen or so others has risen like cream to the top of the vast pool of photographic milk.*

Weston, who was born in Highland Park, Illinois, in 1886 but spent most of his life in California, started as a pictorialist (indeed, he was elected to The Linked Ring). About 1920, influenced by Paul Strand, his work became more abstract, more intensely focused on the texture of surfaces, and more sculptural in its concern with forms. In 1930, two years before "Group f.64" came into being, Weston wrote: "The word 'Pictorial' irritates me as I understand the making of pictures. Have we not had enough picture making—more or less refined 'Calendar Art' by hundreds of thousands of painters and etchers? Photography following this line can only be a bad imitation of already bad art." Among those in his group whose work has become best known were Ansel Adams and Imogen Cunningham, Adams for his mountain landscapes primarily and Cunningham for her portraits and her abstractions of both plant forms and the human body, though within the range of their lenses and their dedication to absolute

*"f.64" is a "stop" on the aperture of a shutter, a very small aperture which reveals very fine detail from distances close to the lens to "infinity." Lenses that stop down to f.64 are usually not found on hand-held modern cameras, whose smallest stop is likely to be f.16 or f.22.

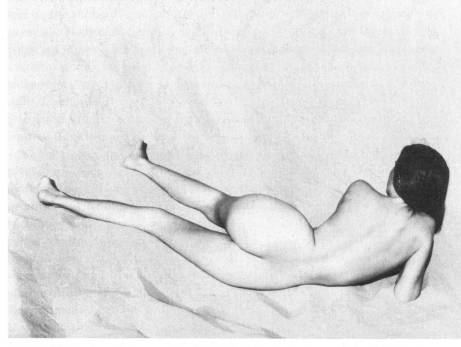

Edward Weston was the leader of a sharp-focus school of photographers in California who called themselves "Group f.64." He worked with an 8-by-10 view camera. For the sake of clarity and brilliance he made only contact prints. "Nude on Sand, Oceano, California" was made in 1936. *(Collection, The Museum of Modern Art, New York)*

visual truth (if there is any such thing) there is great variety in their work.

For many photographers, as they had for most artists before photography pulled that rug from under them, portraits were their financial prop. It was so for Steichen and Käsebier and Clarence White and so it was for Imogen Cunningham. It was not so for Ansel Adams, who, from the start, did well with landscapes. He became the official photographer of the Sierra Club in 1928 when he was twenty-six, and remained so until his death in 1984. He could be called an eclectic. In 1944 he wrote:

> Let us hope that categories will be less rigid in the future; there has been too much of placing photographs in little niches—commercial, pictorial, documentary, and creative (dismal term). Definitions of this kind are inessential and stupid; good photography remains good photography no matter what we name it . . . the sincerity of intention and the honesty of spirit of the photographer can make any expression, no matter how "practical," valid and beautiful.

As a patron of photography he practiced what he preached. It was he and Beaumont Newhall and David McAlpin, an early, enthusiastic collector of photographs, who organized the Department of Photography at the Museum of Modern Art. He became the "grand old man" of the profession, an enemy of pretense and an encourager of the young and aspiring.

If the so-called Great Depression of the 1930s did in a good many photographers, as it did in many small businessmen, it did photography a great service. A convergence of mechanical inventions, adventurous publishers, government bureaucrats, inspired editors, and fresh, young talents conspired to give photography, if not entirely new directions, new opportunities for vitality in already established directions.

After the deaths of Stieglitz and Steichen, Ansel Adams became the grand old man of American photography. This shot of "Mount Williamson, Sierra Nevada, From Manzanar, California 1944" is characteristic of his precise, albeit dramatic, landscape photographs. *(Courtesy of the Ansel Adams Publishing Rights Trust)*

In the 1920s the 35-millimeter camera was invented in Germany, initially for the purpose of testing movie film. The Leica appeared in 1924 and with it both the phrase "candid photography" and a somewhat shocking exploitation of privacy, a means of catching people off guard in revealing moods and manners that the posed snapshot precluded and the newspaper phtograph captured only in broad daylight. The Leica and its follower the Contax had fast lenses that made it possible to photograph in very dim light, even with the slow film then available. Pictures taken inside nightclubs, on lamp-lit city streets, in restaurants, scenes once the prerogative of painters, were recorded on film.

New dimensions, both in ease of handling the camera and what it could capture, were thus added to the photographer's arsenal. In 1930 the photoflash lamp was introduced to America and the "flash gun," which synchronized the flash with the release of the camera's shutter, became part of the press photographer's regular equipment and that of many other kinds of photographers as well. How greatly would Riis and Hine have enjoyed the kind of flexibility and ease which the photoflash bulb gave their successors—not that the results would have been likely to be better pictures. Mechanical crutches don't make photographs; photographers make them.

And, of course, so do circumstances. The Depression was such a circumstance, and it found its most telling recorders in a group of photographers organized by Roy E. Stryker for the Farm Security Agency in 1935. Their mission was to make a record of the plight of the American farmer. It was a very desperate plight, caused not only by a collapsed economy but by wornout, misused land which in turn created a dust bowl, and from their plight came a social literature, of which *The Grapes of Wrath* by John Steinbeck was the best-known novel. The first photographer Stryker hired was Arthur Rothstein, who later became photographic editor of *Look* magazine. But there were also Walker Evans, Dorothea Lange, Ben Shahn (far better known as a painter and illustrator), and a number of others.

Walker Evans, a name to conjure with since his first exhibition in New York at the Julien Levy Gallery in 1933, did not come to documentary photography because of the Depression. He was there with a clear eye and an uncompromising lens before the social realities of the thirties became political pawns. Evans, who was born to an upper-middle-class family in 1905, inspected the world around him, a world not circumscribed by his upbringing, with a discernment for significant detail that earlier photographers of how Americans lived had not had. It was the fact that interested him and that he recorded. Before his lens the seemingly unimportant

Walker Evans, whose documentary photographs owed much to the directness, clarity, and choice of subject of Paul Strand and Eugène Atget, was a master of dignified, unsentimental, and unblinking realism. He shot these "Two-Family Houses" in Bethlehem, Pennsylvania, in 1936.

became significant in the simplest, most direct way. His photographs of faces, of the interiors of rich, modest, and poor houses, of subway riders, of empty streets, of streetwalkers, of row houses and mansions and shacks do not draw conclusions; they *are* conclusions. They say, "This is it." "This" often has a lonely quality because it is often a place without people. "Supply your own people," his photographs seem to say, and who and what they were is implicit in the space he defined and its contents. He photographed the commonplace, not the unusual, so commonplace that it had been for most of us invisible. In a sense he invented a social iconography, not there before, which has become part of photography's language. His photographs are often beautiful but they are never pretty, never senti-

mental. He saw dignity and recorded it where the squeamish saw squalor.

Some photographers were infuriated. When the Museum of Modern Art published a book of Evans's pictures in 1938, Ansel Adams wrote to Edward Weston, "Walker Evans' book gave me a hernia. I am so *goddam* mad over what people think America is from the left tier. Stinks, social and otherwise, are a poor excuse and imitation of the real beauty and power of the land and the people inhabiting it. Evans has some beautiful things but they are lost in the shuffle of social significance." He also wrote the painter Georgia O'Keeffe, Stieglitz's wife and the subject of many of his photographs: "I think the book is atrocious. But not Evans' work in the true sense . . . it's the putting of it all in a book of that kind—mixed social meanings, documentation, esthetics, sophistication (social slumming) etc."

Innovations in the arts do not happen without precedents (every first-rate artist owes something directly or indirectly to every first-rate artist who preceded him), and Evans, like Berenice Abbott and Margaret Bourke-White and Henri Cartier-Bresson, all owe an immediate debt to a French photographer, Eugène Atget (pronounced *atch-ay*). He spent his days taking photographs of Paris that are of an intimacy, clarity, and affection for a city, its inhabitants, its buildings and streets and sculptures, its storefronts and street vendors, its sculpture and its gardens that are unparalleled. Atget was a disappointed actor who turned to photography in his early forties. He intended to "create a collection of everything artistic and picturesque about Paris," a friend of his said, and he sold prints to artists as "documents" from which they could make paintings. The equipment he used was more or less standard at the turn of the century, and he stuck with it until he died—a view camera with a slow but sharp lens, glass plates, and a tripod. His pictures were carefully studied before he exposed his plates, and when there are figures in them they stayed still at his bidding. He could not stop action, and the result was a suggestion of hushed repose.

It was not until a few years before he died in 1927 at the age of seventy-one that he was "discovered," first by Surrealists, who published a few of his photographs in *La Révolution Surréaliste,* and then by Berenice Abbott, an American photographing in Paris, and by Julien Levy, who a few years later opened an art gallery in New York, where he showed photographs as well as paintings. When Atget died, Abbott cabled Levy from Paris that Atget's negatives and prints could be bought for $1,000, and Levy wired the money. Abbott later made prints from many of the negatives in New York and sold them as portfolios. Some of the original prints were included in the Museum of Modern Art's exhibition *Photography 1839–1937.* In 1969 the museum bought the negatives and the original

Eugène Atget, who took "A Lampshade Seller" in 1910, was an obscure photographer when he died in 1927 at the age of seventy-one in Paris. He made a life of documenting Paris, and when his prints were first shown in New York in the 1930s, their influence on American documentary photography was profound. *(International Museum of Photography at George Eastman House)*

prints from Abbott and Levy at a price rumored to be $100,000, by all odds the most expensive acquisition the Photography Department had ever made.

The difference between Atget's photographs of Paris and its environs and those made by Riis and Hine in New York was essentially that Atget made a record of a place and its people for the sake of the record; Riis and Hine were making records for the sake of persuasion, for social purposes. That is, they hoped to promote public reaction to misery in such a degree that public opinion would cause something to be done to correct the ills

they exposed. To put it differently, Atget loved what he saw; Hine and Riis hated what they saw.

Both attitudes were "documentary," though that word as applied to photography seems not to have come into currency until it was used by the British filmmaker John Grierson in 1936 to describe "documentary films." One is tempted to say that it came from the sign on Atget's shop, DOCUMENTS POUR ARTISTES, but who knows where Grierson got it? In any case the work of Evans and Abbott was strongly influenced by what they knew of Atget's prints, though there are social undertones, often strong, deliberate ones, in the work of both of them. Atget's influence on them may be defined as concern with the "everyday" place and occurrence, the scarcely noticeable, the entirely undramatic, the object so clearly seen that it is an event in itself without benefit of anecdote. It was the mysterious quality of many of these "facts" that charmed the Surrealists.

The Photo Essay

It would be misleading to suggest that Atget was the progenitor of "the picture essay," a journalistic device far from his interests or intentions, but he strongly influenced the eyes and sharpened the vision of the photographers who were the early practitioners of this new form of photo-journalism. The "photo essay" is said to have been an invention of *Life* magazine in 1936. According to Maitland Edey, a *Life* editor, it was Henry Luce, Ralph Ingersoll, and John Shaw Billings, with a batch of prints that Margaret Bourke-White had made of the dam at Fort Peck, Montana, and of the town and its people, who recognized the possibilities of making an essay with them. They used brief captions and let the photographs do the work. Thus, Edey says, they created "the first true photographic essay ever made . . . a collection of pictures on a single theme arranged to convey a mood, deliver information, tell a story in a way that one picture alone cannot."*

In this new publishing format photographs were not merely illustrations of a text, meant to give words emphasis or immediacy; it was the text that supplemented the pictures. Photographers were required to look sequentially, somewhat the way movies look sequentially, with the importance of the individual photograph secondary to the group of which it was to become a part. As Edey wrote: "A successful photo essay is always greater than the sum of its parts. It says more, has a greater impact than

*It is always dangerous to say any such thing was "the first." According to John Szarkowski, the *Berliner Illustrierte Zeitung* and the *Münchner Illustrierte Zeitung* were publishing photo essays in the late 1920s.

any single picture in it." We take this for granted now; it was surprising when it first emerged, and it was largely responsible for the immediate success of *Life* at the time of the Great Depression, when many magazines shrank and many vanished.

Life's "string" of photographers, working on assignment, were a different breed from the news photographers who snapped celebrities and politicians (often as unattractively as possible, depending on the newspaper's bias), bodies in the street felled by murderers or automobiles, sports events, natural and man-made catastrophes, the weeping bereaved, babies, bathing beauties, and parades. Some of the most remarkable, if not the "finest," photographs ever taken are the work of press photographers who happened to be at the right place at the exact moment when a dramatic or tragic or poignant incident occurred—the shooting of Mayor Gaynor of New York in 1910, the explosion of the dirigible *Hindenburg* in 1937, and Babe Ruth's last appearance at Yankee Stadium in 1948, quite possibly the most famous photograph of our century. Sports photographers who carry anticipation as well as knowledge in their eyes capture not just moments of excitement and skill but moments of extraordinary physical grace and beauty, much as the most expert photographers of ballet do.

The photo-essayists, such as Alfred Eisenstädt and Margaret Bourke-White, David Duncan, W. Eugene Smith, and Henri Cartier-Bresson, worked methodically, with plans in mind, to achieve series of pictures that together would create an atmosphere, a moral and a descriptive narrative. The best of these, in my opinion, best by a considerable degree of subtlety and precision, is Cartier-Bresson, whose individual pictures removed from their essay contexts are often of great power and subtlety and need no captions, indeed no context. "There is no standard plan," Cartier-Bresson said of the photo-essay, "no pattern from which to work. You must be on the alert with the brain, the heart, the eye, and have a suppleness of body." On another occasion he said:

> With me photography is a way of drawing. It is not philosophy, or literature, or music; it is a strictly visual medium, grasping at the evidence of reality. The camera helps to see mechanically and optically. . . . My photos are variations on the same theme: Man and his destiny . . . the thing to be feared most is the artificially contrived, the contrary to life. . . . It is the "why" that interests me. I shun the dangers of the anecdotal and the picturesque. I have no "message" or "mission," I have a point of view. I don't believe in inspiration . . . I like principles. I hate rules.

By contrast with what Cartier-Bresson feared most, "the artificially contrived, the contrary to life," there was a group of greatly talented

photographers in the 1930s and '40s who were contriving fantasies and inventing "life" in which was incorporated a strict observance of fact. These were the fashion photographers whose pictures appeared in such magazines as *Vogue, Harper's Bazaar,* and *Town & Country*—Cecil Beaton, who divided his time and talents between London and New York, Louise Dahl-Wolfe, George Platt Lynes, Horst, and a number of others. They created imaginative pictures of commanding chic and ostentatious elegance, often in settings as artificial as fashion could sustain. They used beautifully unreal and dignified models in clothes from the *haute couture* of Paris, and they gave every seam and flounce and texture its due, so that the clothes that existed in these beautiful fantasies could be "read" accurately as a "rag" in which a woman might conceivably be happy to parade her charms. They worked almost entirely in studios with eight-by-ten view cameras and batteries of floodlights and "spots," which they controlled with consummate skill. Guesswork played no part in their schemes and luck very little. Like Genthe and Steichen, who, as we have noted, raised fashion photography to an "art" and whose influence on the fashion photographers who followed them was profound, Beaton and Lynes and Dahl-Wolfe and Horst were also portrait photographers. They endowed their sitters with drama or chic or "character" as the subject demanded. Their pictures were composed with great care and skill and were static, the very opposite of what Lynes called the "buckshot" photography of those who used 35-millimeter cameras and rapidly made dozens of exposures in the hope of getting a few acceptable negatives. Their work was by no means limited to fashion and portraits; though these were the sources of their livelihoods, they may not in the long run be the work which will survive. Lynes's nudes (male and female), ballet pictures, and fantasies (he flirted with surrealism) and Irving Penn's tough pictures of North Africans have a staying power that the fashion photographs lack, though the recent revival of interest in the 1930s and '40s has caused them to be in demand by a new breed of collectors who have pushed the market value of photographic prints into a fantasy of its own.

But Is It Art?

It is not the purpose of this chapter to carry the account of "modern" photography beyond the decade of the 1940s. The nature of much serious photography since then has been very different from the pictorial photographs, the photo essays, the documentaries, the portraits, and the fashion pictures which evolved from the time of Alfred Stieglitz's Photo-Secession to Steichen's vast exhibition by many photographers from many nations

called "The Family of Man" at the Museum of Modern Art in 1955. The question about whether photography is an "art" seems to have been officially resolved as more and more museums have established collections of photographs and more and more colleges and universities have permitted photography to enter the curriculum and recognized the history of photography as an academic discipline worthy of graduate degrees.

In the 1960s the camera like the guitar became a symbol of disenchantment among young men and women who were set on "doing their own thing," on "expressing themselves," on being "creative." Some of them (probably about the usual percentage of those who set out to be artists in any field) helped to add a new dimension to photographic vision. Some of them found an escape from formalism in the rediscovery of the vitality of snapshots, which had long been looked down on by serious photographers. Some, feeling cramped by the mechanically foolproof instrument in their hands and their own technical facility, reverted (though they didn't think of it as reversion) to an attitude that inspired the "artistic" picture takers that Stieglitz revolted against. They played tricks with negatives and with prints in order to achieve a new kind of pictorial poetry. The results were as different from nineteenth-century concepts as you would expect of artists who have been exposed to the pictorial revolutions which in America were first set off by the 291 Gallery, the Independents exhibition, and the Armory Show. Their visual vocabulary is vastly different from that which the Photo-Secessionists were endeavoring to expand, but it is quite probably true there is more unity than disparity in the photographs of the twentieth century. The pragmatists will be pragmatists and the poets will be poets, but they are all using an instrument that insists on telling the truth and has to be taught to lie. There are white lies in photography (such as touching out the wrinkles around the eyes or removing a mole) and there are black lies (such as lighting a face in a way to make it hideous or using a filter to turn a light sky black), but it is a medium in which intentional deceptions are transparent. Unintentional deceptions do not exist, for what the uninhibited camera sees is the truth.

Movies

D. W. Griffith, who is as often called a "legend" as he is a "genius," made his first movie in 1908 in the studios of the American Biograph Company on East Fourteenth Street in New York. It was called *The Adventures of Dollie,* and Griffith's wife, the actress Linda Arvidson, in her book *When the Movies Were Young,* described the plot: "Dolly [sic] is nailed into a barrel by gypsies who steal her. Barrel falls off a wagon and rolls into a stream, floats over a waterfall and finally emerges in a quiet pool where boys fishing hear the child's cries and rescue her." It was a typical movie story of its day, full of action, suspense, potential tragedy, and a happy ending. It fulfilled to a *T* William Dean Howells's prescription when he wrote, "What the American public always wants is a tragedy with a happy ending." It also met the demand for sentiment and the triumph of virtue over vice, and it moved with lightning speed. No one, of course, could hear the barrel fall off the wagon or the splash of the waterfall or the cries of the child that alerted the young fishermen. Sound effects were left to the man or woman at the piano, when there was one (there usually was), or to the imaginations of the audience, so readily stimulated by the flickering pictures on the white sheet that served for a screen.

Griffith thought of himself as a writer and his ambition was to be a literary figure. He was thirty-three in 1908 when he directed *The Adventures of Dollie,* and he had had some minor success as an author. He had sold a few short stories and, *Leslie's Weekly,* a popular illustrated magazine, had bought a poem from him. But more important than that, he had sold a play for $1,000 called *A Fool and a Girl* that Fanny Ward, after an absence from the stage, had used to make a comeback. It opened in Washington, but lasted only briefly. It was a play about low life in San Francisco and the hop fields of California, where Griffith had worked for

a short while as a laborer. The theatre to him had been a way to support his ambitions to be a writer, and he had acted in minor parts in a stock company, primarily at the Temple Theatre in Louisville, Kentucky. He called Louisville home, though he was born in La Grange, a village in farming country northeast of the city. He had traveled with theatre troupes that, when their fortunes failed, left him occasionally stranded in out-of-the-way places, where he took any job he could find to raise the fare to get home.

As an actor he called himself Lawrence Griffith, saving his own name, David Wark Griffith, for the things he wrote. Though he loved the theatre, acting was not a profession he was particularly proud of or at which he hoped to make his reputation; it was as an actor, however, that he first got involved with the movies. He offered a script based on *Tosca* to Edwin S. Porter, of Vitagraph, who had made what is now regarded as "film history" with *The Great Train Robbery.* Porter turned the scenario down and offered Griffith the leading role in *Rescued from an Eagle's Nest,* one of the few very early films that have been preserved. "Griffith, a fine figure of a man," Iris Barry wrote, "gives a robust performance, but his woodsman-hero and the other adult performers in this 'Western' tale are not much more convincing than the eagle."

Actors looked on the movies with contempt in the early years. They were a last resort, even a step below two-a-day vaudeville, and in some respects the moviemakers' attitude toward actors was no more congenial. Indeed, the Biograph Company, which, with Vitagraph and IMP, was one of the earliest successful producers and distributors of films, kept the names of its actors to itself. It was the company's name that they promoted in order to sell its product; the names of the people who made the films and those who acted in them were company property. The film companies were very nearly as hungry for stories as actors were for work at the time Griffith joined Biograph. A story fetched from $10 to $15 and actors were paid $5 a day. When she worked for the company, Florence Lawrence, who became the first movie "star" and whose name was later a household word, was known to the public only as "the Biograph girl." Mary Pickford was known as "Little Mary" or "the girl with the long curls" to those who flocked to the nickelodeons (also called "nickolettes") by the millions.

When he approached Biograph with stories to sell, Griffith fared better than he had at Vitagraph. Biograph not only bought several of his short narratives but hired him as an actor and hired his pretty wife as well. After a few months Henry Marvin, who had founded the company in the 1890s and was impressed with Griffith's intelligence and vitality, put him to work as the director of *Dollie.* At that time the director played second

fiddle to the cameraman, who was, as one of them, G. W. "Billy" Bitzer, put it, "responsible for everything but the immediate handling of the actors. It was his say not only as to whether the light was bright enough but make-up, angles, rapidity of gestures, etc., besides having enough camera troubles of his own." Though Bitzer was not assigned to *Dollie,* he took it upon himself to help Griffith "in every way." He got him props, worked with him "to condense the script and lay out the opportunities it had so that he would be able to understand it." It was the beginning of a collaboration that lasted for sixteen years, and as Griffith's genius grew he turned constantly to Bitzer for suggestions and advice. "He always said to me," Bitzer wrote, " 'Four eyes are better than two.' "

In 1913 when "Billy" Bitzer cranked the camera and D. W. Griffith directed Henry B. Walthall in *The Escape,* making movies was pure, unglamorous business conducted by men in business suits.

With Bitzer cranking the camera and giving advice, Griffith, who was a man of almost unlimited energy, turned out two films a week, one a "long" picture of about one thousand feet of film that played for fourteen-or-so minutes and a short film about half that length. He and Bitzer searched the landscape for precisely the backgrounds for the action of his films—a waterfall near a cottage for *Dollie,* the Palisades on the Hudson

for a melodramatic leap to suicide—and they took advantage of the whims of nature. One of the stories they had on hand was *The Politician's Secret,* which was a sequence that called for a summer setting. A sleet storm in New York that covered the trees and shrubs in Central Park with ice was too photogenic to miss, so Griffith packed the camera and actors, all three of them, into a couple of cabs and set out for the park. On their way Griffith and Bitzer "changed the story from a summer to a winter one," and the shooting was over before the ice fell off the twigs. The actors were Griffith's wife, Linda Arvidson, Arthur Johnson, and the soon to be very famous Mack Sennett.

There were marked differences in the audiences for which Griffith was making films, but whoever and wherever they were, audiences expected to be entertained and to have their elastic emotions stretched. As the audiences grew in sophistication, it took more to hold them than just rushing trains and fire engines, people running and waves breaking on beaches. (In a very early film heavy waves breaking toward the audience caused a panic.) They wanted and expected stories. They paid to be made to laugh, to sigh (if not cry), to be stirred with hate for the villainous and with sympathy and even longing by heroes, heroines, and children. The industry assumed, because it had not been demonstrated otherwise, that the public's attention span was brief and that fourteen minutes was about as long as audiences could be expected to keep their minds on a single story. Big-city audiences could pick and choose, though they were not likely to go far afield from their own parts of town. In New York in 1912 there were five hundred movie theatres. In small towns of 6,000 inhabitants there were generally three or four showplaces, and in small cities of 60,000 there were as many as eighteen or twenty. One movie historian records that in 1910, the year that Griffith introduced "the long shot" in a film called *Ramona,* there were 9,480 picture theatres in America and two years later the number had increased by more than 3,000 to 12,869.

"In the smaller American cities," Mrs. Griffith wrote, "the motion picture public was of middle-class, homey folks who washed their supper dishes in a hurry so as to see the new movie and to meet their neighbors who, like themselves, dashed hatless to the nickelodeon, dragging along with them the children and the dog."

What they rushed out to see was very often a sharply contracted version of a famous novel or play or narrative poem, its action and emotion squeezed into a can's worth of fourteen minutes. No producer paid much, if any, attention to the rights an author owned in his work. Producers merely helped themselves, and publishers seemed not to notice or, if they did, did not consider it worth their trouble to make demands for retribu-

tion. "Griffith," for example, "read a story by Jack London called 'Just Meat.' He changed the name to 'For Love of Gold' and let it go at that. We had no fear of lawsuits from fractious authors in those days."

If authors and publishers ignored the piracy of stories, newspapers ignored the movies altogether until movie advertising became a source of revenue in about 1910. There was great excitement at Biograph when the *New York Times* commented on Griffith's version of Browning's "Pippa Passes" released in October 1909, and compared the photographic effects favorably to those achieved by the Secessionist photographers—Alfred Stieglitz and his coterie. The *Times* had at last taken a movie seriously as a movie, not as a threat to morals.

With Bitzer's practical help, Griffith was changing the character of the ways movies were made (what has come to be called "film technique"), adding dimensions of visual subtlety and impact that had in some cases been hinted at before, like the use of closeups, but which had by no means been pushed to their graphic and emotional conclusions. Between the time he made *Dollie* in 1908 and his masterpiece, *The Birth of a Nation,* in 1914–15, he had revolutionized the visual vocabulary of the films. "He created the art of the film," Arthur Knight wrote in *The Liveliest Art,* "its language, its syntax." But it was not "art" that interested Griffith. He was not seeking in any self-conscious way to establish a new aesthetic. He was making movies for the sake of entertaining and involving a vast, indiscriminate, but not undiscriminating, audience, which included every degree of sophistication from the least to the most perceptive. There were those who regarded the film as a new "art form" and treated it, as the French did, as a medium of artistic expression. Griffith looked at it as a tool, whose visual possibilities needed exploring and exploiting; films, he thought, had a function to perform that was quite, if not entirely, different from that of theatre. He was operating a money machine, a sort of hand-cranked one-arm bandit, that produced showers of nickels and dimes. With it he wanted to make movies that had the broadest possible appeal. This meant that they should have qualities that gratified those with the most discriminating visual tastes and those who were moved only by action, sentiment, and fun, —the young, their parents, and grandparents.

Griffith recognized, or perhaps knew instinctively, that movies were a very different medium from the theatre, a fact not recognized by the early makers of French art films, who reproduced on the screen what was better seen from a seat in the loge. The early film makers saw action in a confined, measured, and static space, as though the camera were the eye of an individual sitting in the center of a theatre with an unobstructed view. The actors moved about that space, and the camera recorded their pantomime

from a fixed distance. To compensate for the fact that what they might be saying could not be heard, their actions were exaggerated to convey the sense of what their movements intended, their gestures became elaborate, their facial expressions were "larger than life." They "mugged."

Griffith is reported to have said to an interviewer, "The task I am trying to achieve is above all to make you see." This was in 1913, by which time he had completely revolutionized the "language and syntax" of the films. He had discarded the fixed point of view of the spectator watching action on a stage. The camera not only followed the action but segmented it, concentrating its lens (and hence the viewer's eye) on those details of action that the director wanted to emphasize in order to make the interaction of characters clear and to move the story forward. He focused the camera, in other words, on details of fact and emotion, and stayed on them only as long as was necessary to achieve the response he wanted from the audience. He did this by changing the angle of the spectator's vision. He moved the camera in on the scene or drew it away. He concentrated on an individual actor or on a specific part of his or her anatomy (the eyes, for example, or the hands) to create dramatic emphasis out of exaggerated detail.

He used closeups as they had not been used before. (It was not a technique he invented; a closeup of a couple kissing, as we have seen, caused a howl of moral indignation as early as 1896.) In *After Many Years,* which Griffith made in his first year of directing, he concentrated the camera on the face of Annie Lee, who was shown "brooding and waiting for her husband's return." When he first began to use the closeup he was told that "the public will never buy only half an actor." Béla Balázs, the Hungarian film maker and theoretician, wrote, "We know that when Griffith showed a big close-up . . . and a huge 'severed' head smiled at the public for the first time, there was a panic in the cinema." But it was not only details of actors that he used for dramatic emphasis; he used inanimate objects as well and endowed them for dramatic impact or to suggest a mood. In one film, *The Lonely Villa* (1909), a beleaguered heroine holds bandits at bay with what appears to be a pistol until a closeup reveals, to the audience but not to the bandits, that it is really a monkey wrench.

He demonstrated that it is not necessary on the screen, as it is on the stage, to provide a buildup for a piece of action. Objects in closeups that fill the screen become metaphors—a flower, a whiskey bottle, a clock, a baby carriage have implications that no action is needed to explain. He found that by cutting back and forth ("cross-cutting" in movie parlance) two or more actions could be followed simultaneously—the threatened heroine, rescuers galloping to save her, and flashes of lightning announcing

an impending storm. Griffith invented the flashback and the long shot for the screen; they expanded the horizons of the film pictorially and emotionally as well. In 1909 for a film called *Edgar Allan Poe* he and Bitzer devised a startling new effect that Griffith called "Rembrandt lighting," with deep shadows and light falling only on significant details. By accident Bitzer produced the first "fade-out," and Griffith spotted it at once as a useful device. Bitzer explained: "This was just what we needed. The climax of all those films was the kiss. We couldn't linger over the embrace, for then the yokels in the audience would make cat-calls. We couldn't cut abruptly— that would be crude. The fade-out gave a really dignified touch: we didn't have a five-cent movie any more."

The first fade-out was the result of a mechanical failure. But even the primitive cameras that Griffith and Bitzer used were flexible enough for Griffith to shoot a variety of angles and desert the standard procedure of photographing a scene straight on. Angles heightened the dramatic effect and concentrated the action and thereby focused the attention of the audience on exactly what Griffith wanted it to see. There is no escape for the movie audience, short of sleep. Their eyes cannot wander to irrelevancies, as they can at a staged production. Their minds may wander but their eyes cannot.

The camera techniques and the methods of directing that Griffith devised would not have succeeded if he had not also radically changed the ways in which actors performed for the camera. Broad pantomime was all very well when it was seen from a distance, but subtlety of facial expression and gesture were essential to the use of the closeup. The camera can be intimate and it can also be cruel in ways that distance sweetens in the theatre. An aging Sarah Bernhardt might get away with playing an ingénue on the stage as she could not with the camera enlarging her features and the unkindnesses of age hundreds of times on a screen. In the early films lenses and lighting did not have the forgiving properties that they developed in their maturity, and so Griffith turned to actors whose flesh and features could retain their freshness under the camera's uncompromising eye.

The most conspicuous of these was Mary Pickford, née Gladys Marie Smith. She was the best known and most admired ("beloved" was the word; sentiment clung to her like flypaper) of all the early movie actresses, and it is unlikely that her universal popularity has since been equaled by any other. This was no accident. Her natural gifts were well honed. She was an accomplished performer, whose childhood on the stage (she started at five) had made her a trouper whose professional toughness and skill were wrapped in a kind of porcelain clarity and freshness, and in a pretty face

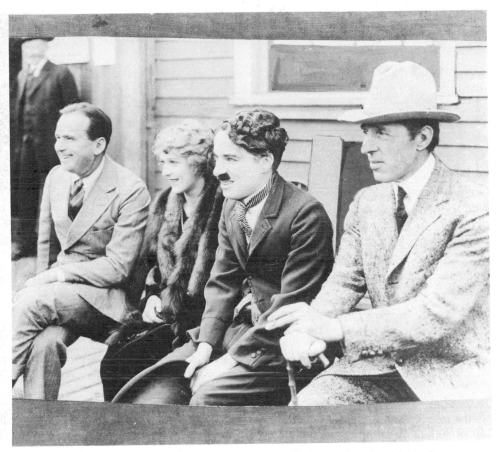

Two bonded geniuses, Charlie Chaplin and D. W. Griffith (on the right) and Hollywood's "royal couple," Douglas Fairbanks and Mary Pickford, sat for this picture in 1919 when they formed United Artists to distribute the films they made.

and figure. Her innocence spoke from her eyes and gestures, and her modesty, salted with impishness, appealed to adults and children alike here and in Europe. They combined to make her "America's sweetheart."

When she first met Griffith, she was a young teenager, and she found him "a pompous and insufferable creature," but she had seen films made by Biograph and, while other actors were looking down their powdered noses at movies as "canned theatre," she was fascinated by them. She applied to Biograph and Griffith, who found her altogether suited physically to the demands of the camera and professionally to his demands and concepts of acting in films. He hired her at $5 a day. "Little Mary" was soon bringing nickels and dimes into theatre coffers at an unprecedented rate—soon to be rivaled only by the success of Charlie Chaplin. Pickford

was still an unknown name to film audiences when "Little Mary" left Biograph and Griffith in 1911 to work for Carl Laemmle at IMP at $175 a week. Within a year she was back at Biograph, disgusted with the standards of production at IMP, and aware of Griffith's remarkable cinematic perceptions, skills, and inventiveness, and presumably reconciled to what she considered his pomposity.

Griffith had an eye for talent, but "talent" also seemed to have an eye for the kind of direction that Griffith at the time was essentially alone in providing for the films. Future stars were among the amenable crew of actors who worked for him (they were either amenable to his demanding methods and schedules or he let them go elsewhere), though the "star system" had not yet changed the nature of the movie business. Few actors who were well known to the theatre audience sought him out, as they considered the films *infra dig,* but some responded to his urgings to join him, men like Arthur Johnson, Henry B. Walthall and Lionel Barrymore. Most of the women in his troupe were neophytes whom he trained. A surprising number of his regulars in Biograph days became famous enough so that their names are still in what the press agents of the time called "the firmament of stardom." Among them were Lillian Gish and her pretty sister, Dorothy, who had a gift for comedy, and beauties like Blanche Sweet, Mabel Normand, and Mae Marsh. Their movie careers were long (comparatively speaking) and lustrous. He trained them to the subdued, nonflamboyant style of acting that he found most effective for the intimacy of the camera's eye. If the plots of his films were often anything but subtle, his ways of using those who acted in them resulted in a delicacy of movement and expression that was new and for a time uniquely his own.

But the restrictions both of the subjects and the brevity of the films that Griffith turned out (450 in one year; it is said that he never took a day off) were unsatisfactory to him if decidedly not to his employers. Griffith was interested not only in making people see; he wanted them to think as well—or at least to be exposed to something more subtle and intellectually invigorating than the run-of-the-mill sentimental plots and chases to which the energies of most early films were devoted. He did not, to be sure, want to do this at the sacrifice of any of the essential qualities of vision and movement that the films could capture as no other medium could. In 1911 he decided that Tennyson's poem "Enoch Arden" offered a challenge to his talents that he wanted to accept. He did not believe that this story of the husband who had been deemed lost at sea and returned home to find his wife married to another man and his heroic decision not to make his presence known to the happy couple could be jammed into fourteen minutes of film. It would take at least two reels. The managers of Biograph,

however, were of the unshakable conviction that audiences would not sit still for twenty-eight minutes, and so they released the film to be shown half on one day and the other half a few days later. Griffith, it turned out, was right. His wife wrote that "it was soon shown as a unit in picture houses," and in schools and clubs it was "accompanied by a lecturer." But it had a more important effect than that. Theatre operators became convinced that audiences were ready for longer films, indeed would demand them, and "feature films," as they were called, became regular movie fare.

Enter the Feature Film

The Italian film makers had played an essential role in this change in the attitude of American audiences. *Quo Vadis?*, a film more significant for its length than for its contribution to the state of the art, opened in April 1913 at the Astor Theatre in New York at the astonishing price of $1 a ticket. The audience got its money's worth. It ran for nine reels (or about two hours), and it was billed as displaying a cast of "5,000 people and 30 lions." The film was based on Henryk Sienkiewicz's novel of decadent Rome, and the lions were of the sort reputedly employed to eat recalcitrant Christians, a myth since dispelled by historians. The audience was delighted by the spectacle and not a little astonished by a brief shot of a nude girl on a bull's back in the arena scene, in which the heroine is intended as a morsel for the lions. (She was, of course, rescued.) Audiences packed the theatre from spring until well into the autumn, and twenty-two prints of it were shown in "stage theatres" (not in nickelodeons) across the United States and in much of Canada. European film makers were seeking audiences that the American distributors had either overlooked or thought were too fussy and sophisticated to bother with the new medium. It did not take long for American producers to see the advantages of appealing to what they regarded as the "highbrow" audience. Films became not only longer but used spectacle more richly, with the predictable result that costs of production rose sharply and so did the prices of admission.

Griffith responded to this opportunity at once. In the same year that *Quo Vadis?* caused a sensation, Griffith produced the first American four-reeler, a film called *Judith of Bethulia,* in which two of his reliable troupers, Henry B. Walthall and Blanche Sweet, played the leading roles. Griffith, it is said, had not seen *Quo Vadis?* before making *Bethulia,* and he claimed that the success of the Italian film had no effect on him, a contention which historians of the film incline to disbelieve. He made the picture on the sly in California, a long way from Biograph's New York headquarters, and his bosses were furious at him. They shelved the picture for fourteen months

and did not release it until late in 1914. By this time Griffith, feeling that his wings had been clipped (Biograph had said he could produce films but no longer direct them), left the company in a huff and took with him his best actors and, perhaps more important, Billy Bitzer, his remarkable cameraman. The great days of Biograph were over.

Bethulia was successful, it is said, because, though it did not compete with *Quo Vadis?* as spectacle, it moved swiftly as Griffith had demonstrated a moving picture should, never dwelling too long on a single shot, employing the techniques that he had refined or invented. There were visual variety and speed and impact, and revealed (by the lens) character. It was a long stride up the steep slope of Griffith's career, which was to reach its apex in 1915.

There were, of course, a number of companies competing with Biograph for the movie audience and the theatres that attracted them, among them IMP, Essanay, and Mutual, and it was to Mutual that Griffith migrated. Bitzer thought he was making a fool of himself to give up a good thing, and at first he refused to go along. "I didn't think the independent outfit he was going with," Bitzer said years later, "could possibly stand the gaff of Mr. Griffith's spending of both film and money." Griffith had an answer for Bitzer's misgivings: "We will bury ourselves in hard work out at the coast . . . for five years, and make the greatest pictures ever made, make a million dollars, and retire, and then you can have all the time you want to fool around with your camera gadgets, etc., and I shall settle down to write."

Before he embarked on his scheme to make a million dollars, he turned out a few quick pot-boilers for Mutual in order to meet the payroll of the troupers he had taken with him. The million was incidental, however, to his determination to fashion the "greatest picture ever made." He chose a novel called *The Clansman* by a Southern clergyman, Thomas Dixon, which had been made into a play that had toured with some success. It was a story of the Civil War and Reconstruction. It appealed to the southerner in Griffith, and he saw in its melodrama the opportunity to encompass a far larger canvas than he had attempted before—the panoramas of war, its terrors, heroics, and personal tragedies, the sweep of its action, and the tenderness of its details. He thought he could make it for $100,000, but to finance it he and Dixon and Harry Aitken, a former film salesman and an organizer of Mutual, "passed the hat" to set up a separate corporation called Epoch Film. Whatever money Griffith had went into the hat and so did cash from his friends and the actors who worked for him and believed in his genius—though it is doubtful that they called it that. The picture was originally called *The Clansman,* but after

D. W. Griffith's "epic" film, *The Birth of a Nation,* not only delighted movie audiences because of its unprecedented sweep and power but scandalized many in the North because of the role played by the Ku Klux Klan as heroes, here shown as they pursued Union troops. The scandal was good for box office. The film marked "the advent of the two-dollar movie."

it had been shown in a few West Coast theatres with some success, it was Dixon who suggested that its title be changed to *The Birth of a Nation.*

The film was twelve reels long, and it employed every cinematic device that Griffith had perfected and some never attempted before. Whole armies moved in broad landscapes, and scenes of intimate battle were photographed by Bitzer with the starkness of Mathew Brady's remarkable record of the Civil War.

It is most unlikely that Griffith or his cohorts realized that in *The*

Birth of a Nation they were producing incitement to riots, much less that the wrath the film evoked in some cities where it was shown would be the most effective publicity it could have hoped for. Its depiction of the origin of the Ku Klux Klan, which it represented as noble and heroic, and its portraits of carpetbaggers with black partners in duplicity, represented as villains, provoked what now seems, but did not then, to have been an inevitable response. Griffith, whose origins and upbringing in a military family of the South that had suffered postwar troubles, had made from his point of view a patriotic statement and a moral attack on the evils of war. The reaction took him by surprise. In Boston, a city with strong pro-Negro sentiments, the film was shown at theatre prices, and the night it opened police and firemen were called out to disperse angry crowds that rioted in front of the theatre. This was surely not the origin of the phrase "banned in Boston," with its overtones of naughtiness, that press agents frequently exploited to entice audiences, but it, or its equivalent, worked for *The Birth of a Nation.* The story of the riot was reported in newspapers across the country, and audiences found the bait irresistible. It was not scandal, however, but quality that accounted for the film's box-office success. It grossed $18 million with a net profit of $5 million for those who invested in it. The film was still playing to substantial audiences as late as the 1930s.

If *The Birth of a Nation* was the crest of Griffith's career, the summation of his conversion of the movies from a primitive to a highly sophisticated medium, it was by no means the end of it. He followed his Civil War "epic" with a series of films that in some ways contributed to and in others strained his financial success and made his name famous in Europe as well as in America. (By now he was calling himself D. W. Griffith, not Lawrence Griffith.) He followed *The Birth of a Nation* with *Intolerance* (1916), a spectacle that was both extravagant in its settings and use of crowds and moralistic in its preachiness. It seems as though Babylon could never have been as magnificent or as depraved as he pictured it; the effects he created were breathtaking and the cost of them nearly ruinous. The public, however, found the story confusing and stayed away. He followed *Intolerance* with a quiet film, *Broken Blossoms* (1919), and with a heart-breaker called *Way Down East* (1920), in which Lillian Gish played the chief "tear jerker."

To help pay for his extravagant films he made a number of indifferent pictures that he hoped the public would like, but his fortunes waned, and he was finally reduced to becoming a staff director of Famous-Players Lasky Studios. In her account of Griffith's career, Iris Barry, who was the energy behind founding the Film Library of the Museum of Modern Art

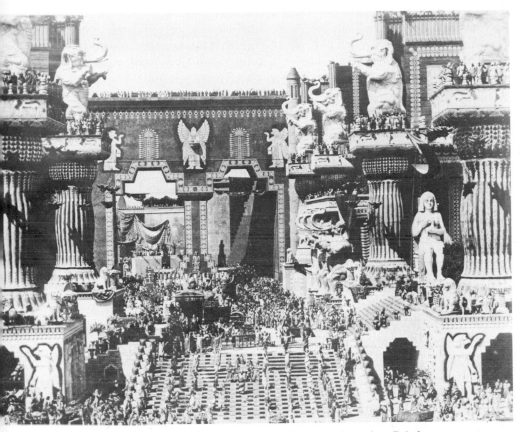

Extravagant settings and vast crowds, like this scene in ancient Babylon, were not enough to capture audiences in 1916 when D. W. Griffith released his film *Intolerance*. Its four concurrent stories used to hammer home a moral—the fall of Babylon, the life of Christ, the massacre of the Huguenots, and a modern face-off of capital and labor— though wonderful in detail left moviegoers bewildered rather than riveted.

in the early 1930s and its first curator, wrote of Griffith in 1940:

> The American public, which for forty-five years has so keenly enjoyed and supported the motion picture, has been somewhat reluctant to call it the status of an art. Now, gradually, they too are recognizing that in Griffith they have one of the greatest and most original artists of our time.

Stars in the Western Skies

Carl Laemmle rescued movie actors if not from obscurity (their faces were everywhere) at least from anonymity. He introduced the star system, which was as old as the eighteenth century in the theatre, but new to the despised medium of the films. He started it with a publicity fraud. Laemm-

le, who had turned from managing a clothing emporium in Wisconsin to operating a converted store in Chicago as a movie theatre, acquired several other theatres, and wound up in Hollywood as the boss of Universal Pictures. In order to woo Florence Lawrence, "the Biograph Girl," away from the Biograph Company, he not only offered her a considerable raise in pay but assured her that she would become famous under her own name. He planted a story in a newspaper saying that she had been killed by a streetcar, and then printed a denial of the accident, implying that the story was a put-up job by Biograph to contradict rumors that she was leaving that company to make pictures for Laemmle. It worked.

Within a short time "Little Mary" left Biograph and became Mary Pickford, and what might be called the early star wars among producers were joined, much to the profit of the once obscure movie actors and the titillation of moviegoers. Fan magazines began to appear. The first was *Motion Picture Story* magazine in 1911, followed the next year by *Photoplay* magazine and in 1913 by *Motion Picture Stories.* They had started out as purveyors of movie plots, but increasingly they turned the spotlight on the players and their "private" lives, real or embellished or concocted. Mary Pickford became "America's sweetheart," with a paycheck no sweetheart had ever achieved before. By 1916 the $5-a-day "Little Mary" was making half a million dollars a year as Miss Pickford. Charlie Chaplin was getting a lordly $150 a week from Keystone when he joined Mack Sennett's company in 1913; by 1915 he was making $10,000 a week at Mutual (plus a bonus of $150,000 for signing with the company). The following year, when he was twenty-seven, First National gave him a contract for a million dollars for eight short films to be completed in eighteen months. (It was not until 1917 that the 4 percent tax on personal incomes was imposed.)

In 1941 Leo Rosten wrote in his precise and entertaining examination of Hollywood: "A star is a monopoly. . . . Pictures with stars make money, those without do not. Producers who paid exorbitant sums for talent prospered; those who did not, or could not, lost out." But there were other producer-directors like Griffith in the early days of the movies who prospered because of their inventiveness and recognition that films are the product of converging talents not of any single talents that catch the public's fancy. Their efforts were dedicated to putting the elements of camera and actors, places and plot makers together and with direction and editing to devise an entertainment like none that had existed before. They were serious in their exploitation of this mixed medium, but they were most certainly not solemn about it.

Two of these innovative free spirits were T. H. Ince and Mack Sennett. In quite different ways they made an impact on the movies that was

permanent. If Porter was the grandfather of the Western with *The Great Train Robbery,* Ince was the parent who reared it and made the cowboy a permanent fixture of film mythology. Sennett, on the other hand, was the

Buster Keaton, director, screen writer, producer, master of deadpan comedy and one of the greatest and most subtle screen clowns, was a vaudeville acrobat before he took to the films. *The Navigator,* which he made in 1924, using a deserted schooner as his only prop, was his greatest commercial success.

master of fast slapstick comedy, who added a respectable condiment of sex with the invention of "bathing beauties." They did little but pose and posture in bathing dresses of what now look like consummate modesty but were then considered risqué, an adjective as period as the bathing suits it described. With his Keystone Kops (Sennett had a romping obsession for making police look ludicrous) he brought the chase to a hilarious epitome of frenetic nonsense. There was scarcely a famous clown or comedian of the free-wheeling days of the movies who at one time or another did not work for Sennett; he gave many of them their first jobs and made them famous. Buster Keaton and Harold Lloyd worked for him; so did W. C. Fields and Bing Crosby, and among the women, Mabel Normand, the funniest of all, Louise Fazenda, Marie Dressler, Bebe Daniels, Carole Lombard, and Gloria Swanson. More important than any of Sennett's

Charlie Chaplin, whom Gilbert Seldes in *The Seven Lively Arts* (1924) called "the man who, of all men of our time, seems most assured of immortality," shivered in this scene from *The Gold Rush* in 1925. After the arrival of "talkies," he shifted his focus from pantomime and pathos to political and social satire in *The Great Dictator, Monsieur Verdoux,* and *Limelight.*

"finds" was Charlie Chaplin, who, along with Griffith, is called an "authentic genius" of the films. (Movie history is full of "authentic geniuses," if Hollywood press-agentry were to be believed.)

There is no need for us to trace Chaplin's remarkable career. "The little tramp" (in France he was called Charlot) became a universal symbol of the oppressed but resilient, naïve but ingenious, devious but generous, ridiculous but dignified, uncouth but elegant "little man" whose every gesture, subtle or gross, flowed together to make a comment on the human condition. Humor and satire became an emulsion often tinted with pathos. Mack Sennett spotted him in a New York vaudeville show in which he was playing a minor part, remembered him (but not his name), and some months later decided he wanted him as a stand-by for one of his actors and got a New York associate to track him down. Sennett signed him for his

company in 1913. Chaplin's famous costume—baggy pants, tight jacket, flapping enormous shoes, too-small derby, flexible bamboo cane, and the dark dab of a mustache—was what was around in a Sennett dressing room when Sennett told him to find a funny costume to appear in a short about a children's car race that was to happen at a local amusement park. Sennett took advantage of any occurrence that he thought he could salt into a quick romp, and Chaplin took advantage of what was at hand and combined them into an instant trademark that identified him for years to millions of fans and later, as a cult figure, to the intelligentsia who discovered that he was an "artist."

Chaplin's popularity was instantaneous, but he found Sennett's frantic formula "too fast," the gags tumbling one over another like balls in a bingo drum. Chaplin wanted to establish his own pace, to give his pantomime both the force and the subtlety that combined to make his performance unified and its visual overtones seen, a technique that Minnie Maddern Fiske in 1915 wrote was "as unfaltering as Réjane."

Ferment, Artistic and Otherwise

It was in 1913 that Griffith said, "The task I am trying to achieve is above all to make you see." It was also the year Sennett hired Charlie Chaplin and the Armory Show opened in New York—an attempt to make the public see the external world and the internal world of the artist in new ways. There is certainly nothing mystical about 1913. It was, however, a time when novelists, poets, painters, sculptors, and the new film makers were looking about them with fresh eyes from new perspectives that discounted (or turned away from) established artistic and literary conventions. Ezra Pound edited the first anthology of the Imagist poets in 1912. T. S. Eliot made himself known for the first time in 1917 with his "unpoetic" "The Love Story of J. Alfred Prufrock," which, with "The Waste Land" five years later, was to alter the course of twentieth-century poetry. Dreiser had written his dark and disturbing novel *Sister Carrie,* and presented it to an unwelcoming (even disgusted) public in 1909. In 1912 the little-theatre movement raised its first curtain in Chicago, and in 1913 New Yorkers were shocked by what many regarded as Ibsen's cruel and clinical examinations of the evils of society. Stravinsky's ballet *Le Sacre du Printemps* was first performed in Paris that year. Artistic turbulence, it seemed, was wherever one looked.

In those days there were very few artists or critics who saw the movies as either a threat to or a companion of art. Indeed, there were very few who recognized that here was a visual medium of expression that was every

bit as vital and as serious as painting or as photography, which was still scratching its way into artistic respectability. Movies were a toy to amuse masses of children and childlike adults. Some concerned educators and social reformers saw this toy as a distraction to which children should not be overexposed both for moral reasons (it kept them from their studies and subjected them to temptations in dark places) and for reasons of health. Nickelodeons, especially, were crowded, airless places where people were in close contact, and it was a time when tuberculosis, a highly communicable and often fatal disease, was a constant threat. There were some observers like the Harvard psychologist Hugo Münsterberg, whom we met early in this book as an uncommonly acute observer of our culture at the turn of the century, who saw in the films remarkable educational potentialities, along with some dangers. The dangers were the possibilities of what might be called infectious violence, a condition looked on darkly today by those who see similar evils in television.* William Dean Howells, the novelist-editor of *Harper's Magazine,* in his column "Editor's Easy Chair" in September 1912 acknowledged these criticisms of the movies, which had become, he noted, "the most universally accepted of modern amusements." It was not that some people thought they were "extremely corrupting to the idle young people lurking in the darkness" that interested him so much as the beneficial ways in which the moving pictures might be put to use. "If the authorities wish to share in delighting as well as infuriating youth," he wrote, "why should they not make this enemy their ally" and enlist it as a friend of education? He saw it as a means of teaching spelling and arithmetic to the very young (somewhat in the manner of *Sesame Street* today) and for the older children geology and botany and even ethnology and history, as part of the school curriculum.

Among the logical but unlikely champions of the movies were the members of the Anti-Saloon League, who saw in them a less-hateful temptation than beer and liquor. Brewers were among the most vocal disparagers of the nickelodeons and theatres and their fare (some of which, to be sure, attacked the evils of drink) because they stole their "regulars." "If you want to see the motion-picture business flayed alive and its skin hung up to dry, "a writer advised the mayor of Cleveland, "talk to a saloon keeper." The movies were forcing saloons into bankruptcy.

The critic Sadakichi Hartmann, who was a regular contributor to Stieglitz's magazine *Camera Work,* had, as early as 1912, a more perceptive and optimistic view than most of his contemporaries about the pos-

*On April 16, 1983, the *New York Times* under the headline "Congressmen Hear Renewal of Debate over TV Violence" reported on hearings before the House Judiciary Committee's Subcommittee on Crime, which was investigating this "problem."

sibilities of the movies as a medium that could be considered a legitimate member of the family of the arts. He recognized that much of its strength lay in what he called "the buckeye element," which, he said, "every master-piece must possess," the "tangible, ordinary interest that the average mind can seize in order to be truly popular . . . the element which modern painting lacks, and which the motion pictures have to an almost alarming degree." "Readers may ask," he continued,

> whether I take these pictures seriously, and whether I can see any trace of art in them. Yes, honestly, I do. I know that most cultivated people feel a trifle ashamed of acknowledging that they occasionally attend motion picture shows. This is due to caste prejudice. To my mind there is not the slightest doubt that these performances show much that is vivid, instructive and picturesque and also occasionally a fleeting vision of something that is truly artistic.

He found the French filmmakers superior "in every respect," but his prognosis was on target.

> The motion picture will steadily gain in recognition, for it has come to stay. No doubt it will undergo many transformations. It will be in color and accompanied by phonographic speech. It may become like the piano-player, a home amusement and also the domain of home portraiture. And the reels will be free of all blemishes that will obstruct the image on the screen. All this, however, will not make it more artistic. More artistic it will become solely by more artistic handling.

The French films that Hartman found superior were the art films based on theatrical staging and techniques of acting and directing. It is unlikely that even this perceptive critic had become aware that the techniques Griffith was contriving to make the movies more alive would be those that changed them from a theatrical byblow to a legitimate medium on its own. Fernand Léger, the French abstractionist, who had exhibited at the Armory Show, thought the movies showed some evidence of becoming an art when he saw a film called *The Wheel* made by Abel Gance.* But, he wrote in 1921, "The film is beaten in advance; it will always be bad theatre." Nonetheless he shared some of Griffith's belief in what the movies could do to make people "see." He drew a useful distinction between "noticing" and "seeing" that Griffith would have approved:

*Gance, "the Griffith of France," was the first director to produce a wide-screen film (his were actually three contiguous screens). It long preceded CinemaScope, which first appeared in 1953. Gance made his famous *Napoleon* in 1926 with three 35-millimeter cameras, whose images were projected by three synchronized projectors. It was revived in the early 1980s and greeted with richly deserved enthusiasm.

80 percent of the elements and objects that help us to live are only noticed by us in our everyday lives; while 20 percent are *seen.* From this I deduce the cinematographic revolution is *to make us see everything that has merely been noticed.* Project those brand new elements, and you have your tragedies, your comedies, on a plane that is uniquely visual and cinematographic. The dog that goes by in the street is merely noticed. Projected on the screen, it is seen, so much so that the whole audience reacts as if it discovered the dog.

It was freedom from a self-conscious impulse to make *art* that gave the American movies of the 1920s their character and vitality. Moviemakers were in the business of entertainment not of the art of the film, though they would have been hard put to it to know where the line might be drawn—if there was a line at all. Movies have been called "the democratic art" because their appeal has had (or did in the first three decades of the century) little to do with class distinctions or intellectual levels and categories. Like no art since the religious frescoes of the Renaissance and the mosaics of the Middle Ages, they were meant to be understood by everyone, no matter what the degree of his or her sophistication. Giotto's murals in the Arena Chapel in Padua, for example, are what might reasonably be called "tragic strips" of the life of Christ—a storytelling device that could be understood by the illiterate as well as by the educated. By their visual powers they moved the peasant and the philosopher, the parish priest and the princely patron who paid for it. The moviemakers of the 1920s with a very few exceptions were not and did not pretend to be fine artists or philosophers, but they were devising by experiment an expanding universal visual language to tell stories. The stories were often of an extremely simple-minded sort, using extremely sophisticated techniques and every mechanical device that came to hand to add to the screen's ability to evoke laughter or tears or suspense or lust, or occasionally, though they would not admit it, thought.

The Industry Polices Itself

Movie audiences were delighted to put themselves in the hands of directors and cameramen who could focus their eyes for them, who could push their emotional buttons for predictable responses and cause them to surrender themselves and "suspend their disbelief." They counted on the movies to provide them with carefully processed heroes and heroines of incontestable beauty and sexuality, with faces they could idolize and private lives they could speculate about, and, with the help of press agents, wonder at and envy. They made their choices of what they would pay

admissions to see largely on the names of the stars who performed for them and who, they believed, lived enchanted lives in palaces of well-advertised splendor in a California paradise. Romantic actors like John Barrymore ("The Profile"), Rudolph Valentino, Ramon Novarro, and Robert Taylor had large adoring followings, with hundreds of fan clubs, consisting mostly of girls and young housewives who showered the studios with mash notes and requests for photographs. Their female counterparts were actresses such as Gloria Swanson, Constance Talmadge, Pola Negri ("The Vamp") and Greta Garbo, whose beauty was regarded as numinous. Over the lives of the stars hung a cloud that was less like a pall than a glistening and suggestive mist of scandal, some of it real enough to shock the movie public, but much of it created in the press rooms of the studios to keep the general audience beguiled.

There was a time in the 1920s when Hollywood's reputation as a center of sin alarmed the tycoons who ran the studios to such an extent that they formed the Motion Picture Producers and Distributors of America and hired Will H. Hays, who had been chairman of the Republican National Committee and President Harding's Postmaster General, to administer it. Hays had the added aura of being a Presbyterian elder, and it was the function of the Hays Office, as it was generally called, to assuage the forces of moralism, which threatened censorship of the movies, and to clean up the industry's reputation and the reputations of its stars. There had been genuine scandals in the Hollywood community that had involved far more than promiscuity. Stories of rape and drug addiction and even murder had called down public wrath on a number of stars, and in some cases had put an end to their careers. But the general tone of Hollywood life—lavish parties, young women who had come to Hollywood hoping to be stars and ending as call girls or on the streets, infidelities among actors and actresses whose names were household words, and manipulated multiple divorces—shocked and titillated the public. When Mary Pickford and Douglas Fairbanks, who were known as "the royal couple" of Hollywood, got a divorce, visions of domestic bliss were shattered, and a carefully sustained myth was destroyed.

It was the job of the Hays Office not just to retouch this unhappy domestic picture but to restore the good name of "the pictures." Sin in movies was not abolished, but it had to be punished. Scenes of seduction did not end in copulation but in what a later generation was to call "copout." Violence ended in dead villains not dead heroes, except in war pictures, where the immorality of war destroyed the good along with the bad. Stars like Edward G. Robinson and Erich von Stroheim were commonly programmed to come to a bad end, and tough guys like Jimmy

Cagney, crisp, laconic, and quick-fisted, occasionally fetched up in the last reel on the side of the angels. Cecil B. DeMille, a director whose name was as well known to the public in the 1920s as Griffith's, was the master of adhering to the "Formula" prescribed by the Hays Office and exploiting a combination of sensuality and opulence that brought audiences to movie palaces in droves. To the Hollywood dictum that "the audience is always right," he added (or might have), "wrong is always right." He exploited prurience and glamorized it with lavish settings and scanty costumes. He contrived bathrooms for his heroines that were "a mystic shrine to Venus. . . . Undressing was not just the taking off of clothes; it was a progressive revelation of entrancing beauty; a study in diminishing draperies . . . underclothes became visions of translucent promise and nightgowns silken promises set to music." This was the Jazz Age, the era of flappers and bathtub gin and "necking," of rumble-seat romance, of stockings rolled below the knee and step-ins, of women who "shingled" their hair and for the first time smoked in public. Audiences expected the movies to do more than reflect this new freedom; they wanted the movies to promote and glamorize it, and if a film approached the obligatory "The End" with the comeuppance that the code required, their pleasure was not diminished. It was the time when sex appeal was called "It," and Clara Bow was It's personification.

What issued from Hollywood studios in the 1920s was far more than these "morality plays." It was an era of great Westerns and the heyday of remarkable film comedians whose charms have not diminished with time, clowns of surpassing talent who did not need a sound track to make their pantomime understood. It was also a time of spectacles even more elaborate and expensive than Griffith's *Birth of a Nation* and *Intolerance,* and of innocuous farces that on the stage would have been called "drawing-room comedies" and which today are affectionately referred to as "movie movies," the equivalent of phonograph disks called "golden oldies."

The most durable formula that the movies devised was the Western. It had every element (except prurience) to delight its audiences. It had suspense, which was created out of tensions between good and evil (the "good guys" and the "bad guys"). It was wholesome without being preachy, and it was not only suitable for the eyes and morals of all ages, but all ages were captured by it. It was as pure as the sands of the desert where much of it happened and as full of fresh air as a mountain breeze. It reminded Americans of the grit of their forebears, who had wrested the frontier from the Indians, who were then not looked on as a minority done dirt by expansionists but as enemies who threatened the peace-loving settlers as rapaciously as did the outlaws and cattle rustlers. Love was as pure

as whole milk and about as sultry. Heroes were uncompromisingly brave and villains were as black as pitch, and their looks were as evil as their behavior. Mothers were intrepid and as dedicated as lionesses to the protection of their cubs. Wayward fathers came to a bad end. Inevitably there was a chase (the bad guys chasing the good guys or vice versa), and almost inevitably there was a last-minute rescue, sometimes of a woman and/or child, sometimes of a beleaguered cowboy, sometimes of a horse. It was in "the great open spaces" that all this happened, and in those days the great open spaces had no enemies in Congress or the administration. Westerns were as surefire as their cowboy heroes were sure-seated and quick on the draw.

Westerns or "horse operas," as they were often called, did better by the proprietors of small-town movie houses than by those who operated movie palaces in cities. The dour William S. Hart, whose unsmiling countenance and quick trigger were made known to the world by Thomas H. Ince in Westerns of uncompromising realism; Tom Mix, the buoyant, hard-riding cowboy of impeccable morals; Hoot Gibson; and Buck Jones were all heroes who helped to perpetuate, if not create, the "myth of the West." It was started in the 1880s by William Frederick Cody ("Buffalo Bill") and his popular touring "Wild West Show." The Westerns glorified one of the most persistent American folk myths. In recent years it has been kept alive by beer commercials on television and by cigarette advertisements which lean heavily on the presumed romance of the open range, "where men are men," the companionship of the campfire, and by Texas businessmen wearing ten-gallon hats, string ties, and cowboy boots with their double-breasted suits. For the most part Westerns were two- or three-reel films, often shown as "added attractions," with longer "feature films," as were "serials" like *The Perils of Pauline* and newsreels. It was *The Covered Wagon,* directed in 1923 by James Cruze, that lifted the Western to the status of a self-styled "epic," a favorite Hollywood epithet for films that were long, employed thousands of extras, had visual and historical sweep, and might cost a million dollars or more to make. *The Covered Wagon* was such a critical and financial success in both big cities and small towns that it was followed the next year by an equally ambitious movie on the building of the transcontinental railroad. It was *The Iron Horse,* directed by John Ford, who was to become famous. A Western without a heroic horse, even if it was iron, was almost unthinkable.

The early Westerns have not survived to the same degree as the comedies of the 1910s and '20s, which at their best were masterpieces of pantomime. Chaplin, Buster Keaton (the master of deadpan), Harold Lloyd, Harry Langdon, and Louise Fazenda, among others, were consum-

mate clowns and comics. They had control over gestures both physical and facial, that could create situations which needed no snappy dialogue or one-liners to emphasize their emotional poignancy or enhance the perils in which they found themselves. Comedy, as they knew and practiced it with subtlety, is by no means just high jinks; it depends on recurrent threats of impending catastrophe. The dangerous or embarrassing encounter, the pratfall, the slapstick, which are as old as the theatre and the circus, are only as comic as the threat that creates them and makes them seem inevitable. The pie-in-the-face and the slip-on-the-banana-peel are only funny as a relief from suspense, a kind of suspense that is created by precise and intricate buildup and timing, skills that the master comedians of the twenties and their directors (sometimes themselves, as Chaplin and Keaton were) had to a quintessential degree.

Many of the films of the twenties echoed the World War just past, though the emphasis was on sentiment not on destruction, on romance not on tedium and waste. The twenties were "sophisticated," in the sense of artificial wisdom, and made much of wanting to appear so. Hollywood played up to audiences that wanted an inside view, more contrived than real, of the lives of the rich and the "smooth" (a twenties adjective for debonair), of those who lived with buckets of champagne never far out of reach, who drove Stutz Bearcats or rode in limousines behind uniformed chauffeurs. It offered the audience the equivalent of what the nineteenth century called "servant girls' novels." The women were always beautiful, often witty, expensively coiffed and gowned (they wore gowns not dresses), and the men were handsome and manly and at home in the most sumptuous parlors, or knew how to make fun of them if that was what was called for. There were precursors of the television "soaps," domestic comedies in which husbands were dolts, wives were restless, foreigners were figures of fun, blacks were lazy and comical, children were more likely to be noble and cute than brats (or in any case "lovable brats"), in-laws were ineffably interfering, teenagers (not yet invented as a class) were dewy-eyed or perky if female, awkward and easily embarrassed if they were male, and even modest homes were out of decorators' style books. On the other hand if they were farmhouses they were shabby with collapsing porches, leaky downspouts, rain barrels, lace curtains that looked like broken cobwebs, and chairs and tables that might or might not last through the action for which they were props.

But Hollywood was not called "the dream factory" without reason. The dreams did not stop with farces in expensive settings, or middle-class life illuminated by rainbows. There were moments of fantasy like Douglas Fairbanks leaping about a medieval castle as he did in *Robin Hood* (1922)

or flying over Bagdad on a magic carpet as he did in *The Thief of Bagdad* (1924). There were Rudolph Valentino as *The Sheik* (1921) in a fabulous desert tent, and John Barrymore preening himself as *Beau Brummell* (1924). But the greatest fantasies of all were the magnificent movie palaces in which audiences came to see the films, palaces of the most ornate baroque or Oriental or mosquelike splendor, with ceilings that were skies pierced with stars and with prosceniums on which golden cupids perched among swags and fruits. This pastry splendor was not contrived to glorify the films but to glorify the audience.

Palaces of Surpassing Splendor

The greatest impresario of the movie palace was Marcus Loew, and in many respects he understood the audience better than those who produced the most successful films he exhibited. He knew how to coddle and charm and transport his customers in the ways that they wanted to be deluded. If Hollywood was the dream factory, Loew was the first to recognize that the place in which to dream was as important to all classes, backgrounds and aspirations of the movie public as the dreams in which they came to immerse themselves. In other words he created unreality and illusion every bit as astonishing as Griffith's Babylon in *Intolerance* or Cecil B. De Mille's parting of the Red Sea in *The Ten Commandments*. He started in a modest way when other exhibitors were still asking their customers to sit on hard seats in stark and airless rooms.

Loew's story is precisely in the Horatio Alger tradition of rags to riches, of the diligent poor boy who makes good. He was born of immigrant parents in 1870 in New York on the Lower East Side, then a ghetto. He quit school at the age of nine to work in a print shop for 35 cents a day, peddled newspapers, and bought his way into the fur business. From that he moved to operating penny arcades and peepshows, and he soon came to be the proprietor of several in Ohio, Kentucky, and New York. In 1906 he discovered that the nickelodeons which had popped up everywhere were stealing his customers, so he did them one better. He not only converted his arcades to movie theatres, but he dolled them up to make them attractive in ways that the nickelodeons had not been. In less than ten years he had taken over several New York legitimate theatres and converted them into "gold-laden temples of the silent drama." By 1914 he controlled the largest number of theatres of anyone in the nation, and seven years later he owned forty movies palaces—some more opulent than others—in and about New York and another hundred or so in other American and Canadian cities.

A black-and-white photograph does little justice to the interior of the Ohio Theatre in Columbus. Imagine a glittering gold and red plush temple with insets of varicolored marble and the white "mighty Wurlitzer" organ console embellished with gilt. The theatre, one of the Loew chain, opened in 1928 and fell on hard times in the 1960s. In 1978, fully restored, it opened again in a blaze of nostalgic glory and civic pride.

One of Loew's architects, Thomas W. Lamb, who designed the Ohio Theatre in Columbus in the mid-1920s, defined the function of the movie palace:

> To make our audience receptive and interested, we must cut them off from the rest of the city life and take them into a rich and self-contained auditorium, where their minds are freed from their usual occupations and freed from their customary thoughts. In order to do this, it is necessary to present to their eyes a general scheme quite different from their daily environment, quite different in color scheme, and a great deal more elaborate. The theatre can afford this, and must afford it for our public is large, and in the average not wealthy. The theatre is the palace of the average man. As long as he is there, it is his, and it helps him to lift himself out of his daily drudgery.

The palace which Loew and Lamb presented the citizens of Columbus was part theatre, to be sure, but in its ancillary rooms it was also part mansion and part luxurious hotel. The customers were greeted beneath a brightly illuminated marquee by a major-domo in a uniform that would have done justice to the comic-opera commodore of a fleet. Their tickets were taken by another uniformed flunky, and the torn stubs were dropped into a carved and gilded box on a pedestal. They were shown to their red plush armchairs by ushers who spoke in hushed tones and gleamed with brass buttons. (Usherettes did not become fashionable until the 1930s.)

Ladies who wished to "retire," were directed to the "ladies' writing lounge," which was furnished like the drawing room of a stately home, with paneled walls, a fireplace, "English" furniture (probably from Grand Rapids), fresh flowers on the tables and the mantel, on either side of which canaries sang in cages. (The room was somewhat in the Adam style, as the exterior of the building was somewhat Palladian.) There was also a "smoking lounge" for the ladies, an indication of how up-to-date it was and how "liberated" its lady customers were, and there was a lounge for the gentlemen. Theirs was hung with bear and zebra skins; the stuffed heads of African "game" beasts protruded from the walls, and in the center was a terrestrial globe on a wooden stand and other accouterments of a sportsman's "den."

The auditorium, whose richness was of the "drop-dead" sort, was a stylistic jumble of Moorish, baroque, and rococo, with not a square inch of surface left unornamented. It was equipped with a Wurlitzer organ, whose white-and-gold console and bench rose by elevator from the floor at the left of the stage, with an organist playing as he ascended. Such

organs, usually called "mighty," were standard equipment in grand movie palaces. They had all the usual stops and some unusual ones suited to sound effects for the films, most particularly various percussion and bell sounds. At the Ohio there was also an orchestra in the pit that played for the "stage show," a few vaudeville acts which preceded the feature picture when it was not introduced by short subjects—cartoons or comedy two-reelers and newsreels. The audience got its dollar's worth of sound and sight and emotional onslaught.

The Ohio Theatre was by no means the most sumptuous American movie palace. It was far exceeded in size and splendor by Roxy's in New York, which cost "close to $10,000,000" and had seats for 6,200 customers. The Roxy opened on March 11, 1927, with messages from President Coolidge, Governor Alfred E. Smith, and other dignitaries flashed on the screen to thank S. L. Rothafel (Roxy) for donating the box-office receipts for opening night to provide radios for veterans' hospitals. Gloria Swanson, who starred in the film shown that evening, *The Love of Sunya,* was there along with Charlie Chaplin, Harold Lloyd, Irving Berlin, Will Hays (of the Hays Office) and dozens of other stars and potentates of the films and theatre and politics. The evening forecast the future with a synchronized aria from *Pagliacci* sung by the tenor Giovanni Martinelli. "His voice burst from the screen," the *New York Times* reported the next morning, "with splendid synchronization with the movement of his lips. It rang through the great theatre as if he himself had been on the stage." It was an omen of things to come.

But if Roxy's was the crowning glory of the movie palaces, the Ohio was typical of what every city aspired to and many, thanks principally to Marcus Loew, achieved. Loew, in turn, achieved a fortune, and when he died at the age of fifty-seven in 1927, having built some 150 theatres, of which 125 were "of the deluxe class," he was the owner of an estate with a private golf course on Long Island and had commuted to his office in New York in a sixty-foot yacht. He had given the movie audiences what they wanted, and they had reciprocated by giving him what he wanted.

It took vast and faithful audiences to make the movie palaces financially viable, and the prosperous 1920s were right for such extravagance. A press agent called them "cathedrals of the motion picture," though they more closely resembled mosques and pagan temples than cathedrals. Until Radio City Music Hall came along in the early 1930s, they remained aloof from and unpurified by the new fashions of functionalism and the mechanical lines of Art Deco. They were part of the effulgence of the final days of the silent era of the movies, and by and large they

Al Jolson in *The Jazz Singer* broke the silence barrier for films in 1927 with a sound track that contained only 291 words of spoken dialogue and six songs. They were enough to revolutionize the movies.

were more imaginative and original if no less corny than many of the films on their screens.*

Breaking the Silence Barrier

It has been said that the silent era would have lasted a decade longer than it did if Warner Brothers, which was nearly bankrupt, had not clutched at an experimental straw that would become a life raft called "talking pictures." *The Jazz Singer,* which astonished audiences in 1927, is generally believed to be the film that broke the silence barrier. In it the

*The Ohio Theatre was threatened with the wrecker's ball in 1967, and local citizens individually and in groups rallied to save and restore it to its original splendor. It is one of the few great movie palaces still to be seen as it was meant to be. It was reopened in 1977 on its fiftieth anniversary as The Ohio Home of the Columbus Association for the Performing Arts.

musical-comedy, "black-face" singer and comedian Al Jolson, one of the most popular performers of his day, astonished audiences with six songs, concluding the first two with a line that was his trademark, "You ain't heard nothin' yet!" To be sure they hadn't. There was almost no dialogue in this film, but its popularity set movie producers and theatre operators into a headlong competition to provide audiences with talking pictures, which meant buying and installing elaborate and very expensive equipment to make and show them. There was ready money available, as there would not be after 1929, to finance the studios and the theatres, but by the time the crash came the conversions had been made, or started, and the talkies were here to stay. Critics were skeptical, but audiences loved them.

Experiments had been going on for years to combine filmed images with synchronized sound. Edison, indeed, had experimented with sound on wax cylinders to accompany moving pictures before the turn of the century, but saw no future in it, and Warner Brothers had released films with accompanying orchestral music and sound effects. They had failed to impress audiences, who took for granted orchestras playing in the pits of movie palaces. Lee De Forest, of Bell Telephone Laboratories, started in 1920 to experiment with sound-on-film, as did other inventors here and in Germany, but their efforts were slow to catch on. The first sound films to stir the public's enthusiasm were newsreels in 1927, when Movietone News recorded Lindbergh's departure and arrival in Paris on the first transatlantic flight, and began to present interviews with Mussolini, George Bernard Shaw, and other celebrities.*

But it was the electrifying sound of Jolson's voice that ushered in the new era, and *The Jazz Singer* was followed within the year by other films that contained sequences of sound combined with sight. In 1928 Warner Brothers made *Lights of New York,* the first film that was "completely dialogued," and there was no turning back.

Some practitioners of moviemaking looked upon the arrival of sound as the death knell of "the art of the film." Béla Balázs wrote with questionable accuracy but with unquestioned passion: "What has happened was a catastrophe, the likes of which has never happened in the history of any other art." He overlooked what had happened to painting, for example, with the arrival in the Renaissance of linear perspective, which for the first time seemed to pierce the flat surface of the wall and the panel and which was shocking to those who first saw it and delighted those who first

*"One of the momentous events in motion picture history was the Movietone reproduction of President Coolidge's presentation of the Congressional medal to Charles Lindbergh for his flight to Europe in 'The Spirit of St. Louis.' " Benjamin B. Hampton, *History of the American Film Industry,* pp. 382–83. This was written in 1931 soon after the event.

practiced it. ("What a beautiful thing is perspective," the painter Paolo
Uccello declared.) But to Balázs the addition of the dimension of sound
(as perspective was an added dimension of space) was to throw away all
the artistry and refinement that Griffith had brought to the technique of
narrative films. Sound merely confused the aesthetic issue and required the
art to start over again. It was necessary to create a whole new bag of tricks
and ways of thinking to integrate sound with vision in a medium that had
brought the art of pantomime and silent suggestion by the camera to such
sophisticated performance. Balázs contended that sound took away the
profundity of pantomime, that words were trivial and mere distractions
from the art of such masters as Chaplin. The great Russian director Sergei
Eisenstein feared that the introduction of sound would turn the movies into
" 'highly cultured dramas' and other photographed performances of a
theatrical sort," and that the unique character of the film would be smoth-
ered under dialogue.

These fears were not without justification, as the early products of
American studios demonstrated. Pictures with dialogue fascinated the
movie audiences, who were charmed by the new gimmick in much the
same way and to the same degree that they had been charmed and sur-
prised by the first pictures to move on a screen. The result was an immedi-
ate increase in the numbers of people who crowded the movie theatres and
the frequency with which they came to them. From the producers' point
of view this was what mattered, and they served up a hearty (if not very
nourishing) and varied diet of films, many of which were talk-talk-talk.
Some of them were "musicals," and some were the rudimentary documen-
taries called newsreels. There were all sorts of technical problems in com-
bining sound with sight that constrained directors and cameramen. The
talkies in other words were going through some of the same kinds of birth
pains that were to agonize primitive television twenty-five years later.

Movie cameras, though they were now motor-driven not hand-
cranked, were noisy, and so they had to be isolated from microphones,
which, in those days before they became "directional," picked up indis-
criminately whatever sound was within their range. This necessitated put-
ting cameras and cameramen in large glass boxes, known as "ice boxes,"
that stayed where they were placed. Furthermore, directors, one of whose
symbols of office was a megaphone, had to be silent while the action was
being filmed. This restraint made them uneasy, and it unquestionably led
to more takes than were necessary when they could move their actors about
with talk and direct crowds of extras by shouting at them. Even though
it was not uncommon to use three stationary cameras, the result tended
to look like a photographed play with closeups cut into the action, a

throwback in some ways to the early French "art" films but without the art, which had been provided by scripts based on classic plays acted by famous actors.

Because of their rapturous delight in talking pictures with overlaid sound effects, audiences were unaware, in all probability, of what they had lost visually and technically. They were accustomed to listening to the dialogue of plays and serials and comic acts on their radios, which by the late twenties were items of household equipment at least as common as indoor plumbing and possibly more common. (Between 1922 and 1929, years of a stable dollar, the sale of radios had gone up from $60 million to $852 million plus.) Out of loudspeakers in millions of living rooms in the thirties came the familiar crooning voices of Rudy Vallee and Bing Crosby, Jack Benny's wisecracks, the sweet big-band sounds of Fred Waring and His Pennsylvanians, the patter of Fred Allen, the Happiness Boys, and Bob Hope. Radio "personalities" were, in essence, "friends of the family," and their voices as familiar as the voices of close relatives and neighbors on the telephone. It is said (or, perhaps more accurately, speculated), that movie audiences in the 1920s, accustomed to radio dramas and comedies were becoming dissatisfied with the captioned silence of the films. It is not speculation, however, that movie audiences tended to dwindle in those years, in spite of the proliferation of movie palaces. Talkies reversed the trend. Audiences could now hear as well as see most of the movie stars who had captured them, though some of their heroes and heroines dropped out of sight because they had impossible accents or squeaky or sibilant voices. Ramon Novarro and John Gilbert, for example, both "great lovers," vanished, but many, especially those who had been trained in the theatre, survived. As a consequence, Hollywood began to raid the theatre for fresh talent, and a new generation of stars emerged. Names like George Arliss, Leslie Howard, Fredric March and Clark Gable began to appear on movie marquees along with Fred Astaire, Bette Davis, Katharine Hepburn, and Helen Hayes. Some familiar names like Gloria Swanson, Lillian Gish, John and Lionel Barrymore, Ronald Colman, and Joan Crawford continued to glitter, and when Greta Garbo made her first talkie, *Anna Christie,* in 1930, marquees across the nation proclaimed the event with "Garbo Talks!" Audiences were enchanted.

The technical difficulties that at first faced directors, camera operators, and sound men were challenges that they attacked vigorously and with ingenuity. For a while those who controlled the microphones more or less told the director what he could and could not do. It was they who planted the mikes on the set where they could not be seen, and the action was confined to their effective range. Within a few years however, the

John Gilbert and Greta Garbo, who was considered the most beautiful actress of her day, appeared in *Flesh and the Devil* in 1927. Garbo's career flourished after the arrival of sound; Gilbert lost his public appeal as one of the "great screen lovers" and faded away.

cameras were enclosed in soundproof "blimps," as the silencers were called, and became mobile again, and microphones were mounted on booms that could be extended to cover the action out of camera range. The art of "dubbing" was invented so that the off-scene sounds of storms or automobiles or slamming doors or peepers could be inserted into the sound track after the action and dialogue were recorded. It was many years before lenses that could move in on action or pull back from it were developed, but cameramen perched on cranes and dollies soon could exploit angles for dramatic action and suggestion not heretofore used. The demise of art that Balázs predicted as a result of sound did not happen. Sound was, instead, a step in film's metamorphosis that extended its range and added nicety and impact of new sorts to the sometimes subtle, sometimes somber, sometimes gaudy butterfly that it became.

The introduction of sound required a new way of thinking about film, a necessity to balance the impact of hearing with the sense of sight in such ways that neither seemed to dominate the other. Sound should be used, as Griffith said the camera should be, to make people hear selectively as the camera made them see selectively, to concentrate their ears as the camera

concentrated their eyes, to isolate from the cacophony of sounds, which is ever present, only those sounds that are significant to the action or mood of the film. Technically this was not a simple matter, but it did not take long for directors and technicians to distinguish and control significant and insignificant sound (though all sound seemed significant to the public at first) and lead their audiences into ready acceptance of new audio-visual techniques, the nature of which, to be sure, the audience were largely unaware of. There was no reason why they should concern themselves with techniques; it was only their private reactions to what they saw and heard that mattered to them. It was enough that they were airborne on Hollywood's magic carpet.

As directors like Ernst Lubitsch, Rouben Mamoulian, Lewis Milestone, and King Vidor began to take charge of the newly expanded medium, the talkies talked a great deal less than they had at first. Dialogue took its place as merely one element (not the dominant one as it does of necessity on the stage) in the shaping of films, and the thrill of synchronized speech became no longer an attraction in itself. The French director René Clair used sound playfully without matching sound to action; as visual gags were the common coin of silent comedies, Clair devised aural gags, and, by so doing, added all sorts of possibilities, comic and otherwise, to the vocabulary of film. Arthur Knight cites a nice example from *À Nous la Liberté,* made in 1931.

> Clair goes so far as to kid the whole notion of synchronous sound by showing his heroine singing at her window while the hero admires from afar. Suddenly something goes wrong with the voice—it whines, and whirs, then fades away. A moment later, while the young fellow is still looking up at the window, the girl appears in the street, the song begins again and we discover that what we have been listening to all along is a phonograph record from another apartment.

Giving the Public What It Wants

By and large movies reflect rather than lead the public's taste and mood. The "give the public what it wants" formula, which has long inspired the film industry's front offices, assumes that the public knows what it wants before it has had a chance to see it. So the "formula" is guesswork. On the other hand, once the box office has demonstrated what the public wants, the industry characteristically responds with more of the same. In the early 1930s, which were the most severe years of the Depression, film makers decided that what the public wanted was a kind of slick, violent, often sexy realism on the one hand and escapist fantasy of a musical sort

on the other. They provided both in heaping portions. Gangster films were almost sure-fire box-office successes, films like *Little Caesar* (1930), *The Public Enemy* (1931), and *Scarface* (1932), in which "punks" were "drilled" or "taken for a ride." They were urban "cowboy and Indian" pictures, with the "Feds" (FBI operatives) playing the cowboys and "lawmen"; the "thugs" were ruthless exploiters of decent society engaged in internecine, back-alley warfare.

This was the same kind of violence, made more intense and more explicit by sound, that Münsterberg and other observers of the early films saw as a potential corrupter of youth. But these films suited the public mood in the days of Prohibition, by then derided as "the noble experiment that failed." It was possible to look on such films as moral attacks on gangsterism and on the evils that legal suppression of public choice by the Eighteenth Amendment had brought about, but only apologists did. At the same time "sex reared its ugly head" with a frankness it had skirted in the past and in dialogue that Cecil De Mille was unable (perhaps unwilling if he had been able) to employ in his silent films. Voluptuous Mae West was flaunting her "naughty" charms, albeit comically, in films such as *She Done Him Wrong* (1933) and *I'm No Angel* (1933), and if much of the public was charmed and made to laugh by this new and amusing earthiness about sex, some of its members were decidedly chilled and made to scowl. The protectors of public morality were outraged.

In 1924 the Hays Office had issued what it called "the Formula" of "Don'ts and Be Carefuls" for "moral and artistic standards of motion-picture production" to discourage (if not prevent) the industry from exploiting what was regarded as the salacious character of the novels, short stories and plays of the Jazz Age, the era of "flaming youth." It was also the era of exposing the hypocrisies of small-town morality and of thumbing the nose at gentility, of Sinclair Lewis's *Main Street* and *Babbitt,* Theodore Dreiser's *An American Tragedy,* Ernest Hemingway's *A Farewell to Arms,* and F. Scott Fitzgerald's *Great Gatsby.* But in the 1920s it became apparent that the Formula was not effective, and in 1930 a new "Code" (The Motion Picture Production Code) was written, and put into effect four years later as a response to pressure from an organization of Roman Catholics known as the Legion of Decency.

The Legion attacked the movie industry in its most vulnerable spot, its money machine. It did so by admonishing the church's communicants to boycott films that it thought sexually suggestive or those in which sin and/or violence was exploited, whether or not good ultimately triumphed over evil. "What a massacre of innocence of youth is taking place hour by hour," Monsignor Cicognani proclaimed to a Catholic Charities Conven-

tion in 1933. "How shall the crimes that have their direct source in im-
moral motion pictures be measured?" The attack grew into a sustained and
widespread campaign, preached from the pulpit, proclaimed in pastoral
letters, publicized in millions of copies of church weeklies, promoted in
Catholic schools and colleges, and reinforced by editorials on the radio and
the public press. In 1934 in Philadelphia the faithful were bidden to boycott
all movie theatres irrespective of what they might be showing, a lesson to
the industry to behave itself by Catholic standards, which, after all, were
by no means everyone's standards of decency and morality. The Legion
promoted the signing of a pledge: "I wish to join the Legion of Decency
which condemns vile and unwholesome moving pictures. I unite with all
those who protest against them as a grave menace to youth, to home life,
to country and to religion," et cetera.

The Catholics were not alone. Many Protestant and Jews were
equally aroused by the products of Hollywood and gave tongue to their
righteous wrath. Some of them declared that the censorship of films was
a government obligation. The Legion, on the other hand, denied that it was
engaged in censorship; it merely offered "guidance," and in doing so it
devised a rating system. " 'Class A-1,' morally unobjectionable for adults;
'Class B,' morally objectionable in part for all; 'Class C—Condemned.' "*

Evidently the movie industry was more frightened by the Legion's
efforts than it was hurt by them at the box office, but it was such pressures
as these that led in 1934 to the adoption of the Code by the Motion Picture
Producers and Distributors of America (MPPDA) that was administered
by the Hays Office. The Code danced to the Catholic tune, a surrender
by the industry to a parochial system of morality that infuriated those
who regarded their standards and tastes as none of the church's business.
They looked on it as censorship of a particularly virulent sort, hiding
like most (if not all) censorship behind a smug mask of "we know what
is best for you." The Code insisted that "illegal drug traffic must never
be presented," "the sanctity of the institution of marriage and the home
shall be upheld," "scenes of passion should not be introduced when not
essential to the plot," "Miscegenation is forbidden," "Indecent or undue
exposure is forbidden," and, not surprisingly considering the source, "Min-
isters of religion . . . should not be used as comic characters or as villains."

*It was very different from the rating system (based on the British Board of Film
Censors system) adopted by the industry in 1968: G (general audiences, all ages admitted);
PG (all ages admitted but parental guidance is suggested); R (restricted; youngsters under
17 admitted only if accompanied by parent or adult guardian); and X (no one under 17
admitted). PG–13 ("Parents are strongly cautioned to give special guidance for attendance
by children under 13") was added in 1984.

Suicide, a deadly sin to Catholics, was ruled out of films, and the Code specified that "Revenge in modern times shall not be justified." If revenge was taboo, retribution was not. According to the Code "hangings and electrocutions" were acceptable so long as they were "treated within the limits of good taste." With very few exceptions the industry did as the Code told it to do, behaved itself according to the MPPDA's book of etiquette, and minded its manners, if not necessarily its morals. Will Hays somewhat reluctantly became the Emily Post of the film business.

The self-imposed restraints on the movies (for the restraints were not the law of the land) had little effect on the general audience and hence on business. Films had no competition from any other medium except the theatre, which was scarcely a threat even in New York and Chicago, until television in the fifties. The new medium faced the movie industry with a challenge that sent it into a tailspin of self-pity and reevaluation, not just of its "product," as films were called in the business, but of its distribution system, its control of movie theatres, and its corporate structure. The concern of the front offices of the industry was to satisfy the largest public it could attract. The safe way was not to challenge the public's morals or strain its intellects or upset in any way the equilibrium of the dream factories that gratified romantic or social illusions in which the audience found entertainment and took comfort.

It is remarkable that Hollywood during the 1930s and the first years of the 1940s should have turned out so many good films which offended no one and which pleased almost everyone—everyone, that is, except those who believed that Hollywood trivialized whatever it touched artistically and intellectually and who were interested in the art of the film as distinct from moviemaking. Unlike playwrights such as O'Neill and Anderson, who were exploring the dark side of man's nature and the problems of his society, Hollywood took a melodramatic and sentimental view of man's condition and follies. When it tried to make profound statements, as it appeared to do in antiwar films such as *All Quiet on the Western Front* and *Journey's End* (both in 1930), it played on sentiment and nostalgia even if it annoyed the fervent patriots of the American Legion.

But Hollywood, into whose maw many gifted playwrights and novelists like Clifford Odets and F. Scott Fitzgerald disappeared, had, in Noel Coward's words about himself, "a talent to amuse." Amuse it did to a fare-thee-well. It produced musicals starring Fred Astaire and Ginger Rogers that have not been surpassed for elegance and charm and inanity. It produced fantasies as endearing as *King Kong* (1933), which has become a staple of movie "camp," sentimental triumphs like *Little Women* with Katharine Hepburn (1933) and romantic blockbusters like Garbo in *Anna*

Karenina (1935); political comedy-dramas of a mild sort such as *Mr. Smith Goes to Washington* with James Stewart (1939); "artistic productions" such as Irving Thalberg's version of *Romeo and Juliet* (1936) with Leslie Howard, Norma Shearer, Basil Rathbone, and John Barrymore, a formidable bouquet of talent and beauty. Hollywood, by way of Astoria, Long Island, where there were movie studios in the 1920s and '30s, snatched the Marx Brothers from Broadway and gave the movie world a series of the most antic of all comic romps. In 1939 the "epic" *Gone With the Wind* in Technicolor, then still a novelty, played to capacity audiences, who sat for four hours enchanted by Vivien Leigh and Olivia de Havilland, Leslie Howard and Clark Gable, then at the peak of his popularity.* There were drawing-room comedies that did not take place in drawing rooms, such as *It Happened One Night* (1934), *Mr. Deeds Goes to Town* (1936), and *The Thin Man* (1934), a drawing-room detective story. At the end of the 1930s Walt Disney, the creator of Mickey Mouse and Donald Duck, went arty in an animated, feature-length film called *Fantasia*. To a score of Bach, Tchaikovsky, and Dukas, performed by Leopold Stokowski and the Philadelphia Orchestra, abstract forms and flowers and Mickey (as "The Sorcerer's Apprentice") gamboled and darted about the screen. High-fidelity sound was achieved (or in any case approximated) by sixty loudspeakers spotted about the theatre in which the film had its première. Dedicated music lovers were distressed by the cheapening, as they saw it, of serious art. Intellectual devotees of animation and Mickey Mouse considered it pretentious nonsense. When *Fantasia* was released in 1940, it dawdled financially, but over the years it made handsome profits for its maker.

The thirties and early forties also produced films that were concerned with man's plight. *The Good Earth* (1937), based on Pearl Buck's novel, and *The Grapes of Wrath* (1940) by John Steinbeck cut closer to the social bone than most of the decade's films. (Both Buck and Steinbeck won the Nobel Prize for literature, but neither got an Oscar.) Chaplin's anti-Fascist-anti-Nazi comedy *The Great Dictator*, which he wrote and directed and in which he played the leading role, a parody of Hitler, appeared in 1940. Orson Welles's *Citizen Kane* (based loosely on the character of William Randolph Hearst), in which Welles, then twenty-five, performed all the same functions Chaplin had in making *The Great Dictator*, arrived in theatres the following year. (The Hearst newspapers and magazines at first ignored it completely. They neither reviewed it nor would they print advertisements for it. Hearst offered to pay RKO, which produced and

*Someone is said to have asked Gable what it was like to be "the world's greatest lover" and he replied, "It's a living."

In 1934 Claudette Colbert and Clark Gable appeared in what was regarded as a nice but naughty film called *It Happened One Night*. When Gable took off his shirt and revealed that he wore no undershirt, the effect on the undershirt business was catastrophic.

released the film, for any losses it might sustain if the company would destroy the negatives and prints. When this failed, Hearst lifted the ban on mentioning the film in his publications so that his writers might attempt to destroy it with criticism.) *Citizen Kane,* which was Welles's masterpiece and had a lasting impact on film direction and photography, was a success in major cities and was largely a failure elsewhere. In 1952 a group of film critics meeting in Brussels voted to include it in their list of the dozen greatest films ever made.

In the same year that *Citizen Kane* was released, Alfred Hitchcock, seduced by Hollywood's blandishments and its technical resources, came here from England. His first American exploit was *Rebecca,* based on a current best seller by Daphne du Maurier. It was quite unlike his suspense films, known but not widely at that time in America, films such as *The Lady Vanishes* (1938) and *The Thirty-nine Steps* (1935). This wizard of suspense, skulduggery, unnerving humor, and subtle cinematic artistry and invention became the best-known director in the business. Audiences who paid no attention to names like William Wyler, John Huston, and Otto

Preminger, however successful their movies, knew about Hitchcock and in a general way what to expect from him. They knew his face and his style, and those who had not met him on the screen (he appeared fleetingly in all of his films) did so on television in the 1950s and '60s when he was host for a series of suspense films which he directed.

Documentaries and Propaganda

In the publishing trade everything that is not novels or short stories is called "nonfiction," whether it is a biography, a medical textbook, a slim volume of poems, or a how-to-do-it on hooking rugs. In the film business what is not called "movies" is called "documentaries," a word invented by John Grierson, as we have noted, and first used by him in a review of a film by Robert Flaherty, *Moana,* in the New York *Sun* in 1926. The documentary is, of course, the oldest kind of motion picture, though in the earliest days it lacked the dignity of a name. It was what people saw in nickelodeons—movement of objects and people without the context of a plot. Later it became newsreels of current happenings and short subjects such as travelogues. It was not until the 1920s that documentaries took on the stature of an "art form," and the man primarily responsible for "the creative documentary," reality dramatically interpreted, was Flaherty, who has come to be called "the father of the documentary."

Flaherty's first film (and still his most famous) was *Nanook of the North,* an observation, rather than a story, of the life of an Eskimo and his family. It was shot on location in Canada's Hudson's Bay area under physically difficult but financially agreeable circumstances. Flaherty had the backing of the fur merchants, Revillon Frères, whose interest in the Hudson's Bay people and the hides of the beasts they hunted was more than casual. The film industry, which was suspicious of documentaries, especially ones of the length and intensity of *Nanook,* was reluctant to let it be shown in the theatres it controlled, but Pathé released it in 1922, and to the industry's surprise it fared extremely well at the box office. Flaherty's success was by no means a one-shot affair; he produced a series of distinguished documentaries over the next twenty-five years, among them *Moana* (1926) and *Man of Aran* (1934). He managed to find industrial financing for some of his projects and in one case the support of the Department of Agriculture for a film, *The Land* (1942). His last important documentary, and one of his best known, *Louisiana Story,* about the discovery of oil in the bayous and its effect on the people there, was filmed in 1948 with the backing of Standard Oil of New Jersey. Working with Flaherty on this film was Richard ("Rickey") Leacock, a pioneer of the

Nanook of the North, which was filmed by Robert J. Flaherty in 1920, literally and figuratively broke the ice for documentary movies. Flaherty took a crew, two cameras, a generator, processing materials, and a projector to frozen Hudson's Bay in Arctic Canada. The result was a financial and artistic triumph.

American *cinéma vérité* (sometimes called "direct cinema"), as the cameraman.*

**Cinéma vérité* eschews the planning of action and relies on capturing on film (usually 16-millimeter in a hand-held camera) action as it evolves naturally. Leacock, who later founded the Film Department at the Massachusetts Institute of Technology, was in his early twenties when he worked with Flaherty on *Louisiana Story.* His first *cinéma vérité* film was made for the Ford Foundation's television show *Omnibus,* in 1952, *Toby and the Tall Corn.* It was written and narrated by this author, R. L.

During the Depression of the 1930s documentary films flowered briefly under the aegis of the federal government, much to the annoyance of the film-industry moguls, who thought that the government gang had no business encroaching on its turf. Pare Lorentz, a critic turned film maker, produced two distinguished and poetical documentaries, *The Plow That Broke the Plains* (1936) and *The River* (1937), both with musical scores by Virgil Thomson, for government agencies, and he prepared the treatment for Willard Van Dyck's and Ralph Steiner's *The City* in 1939. (Its score was by Aaron Copland.) *The City*, which like many documentaries was made to be shown at the New York World's Fair of 1939, had the rare distinction of combining humor with a message (in this case about urban planning) at a time when most documentaries that were intent on persuading public opinion were burdened with solemnity. We would now call these films "environmentalist," though the term had not then come into popular use. They were documentaries that did more than document. They were propaganda for an ecological cause, and they were forerunners of far more urgent films of propaganda and information that the approach and actuality of World War II precipitated in abundance.

Encouraged (or, more accurately, driven) by Joseph Goebbels, the Germans had refined the techniques of dramatic documentary propaganda in films glorifying the Fatherland and the Wehrmacht during the 1930s. As Minister of Propaganda, he required that they be shown in all German movie houses. In England, on the other hand, documentaries made in the same decade by the government under the guidance and with the inspiration of John Grierson assumed a quiet but purposeful attitude toward the public welfare. These films were first made under the aegis of the Empire Marketing Board (EMP) and after 1933 by the Film Unit of the General Post Office, so that by the time the war came there was not only a tradition of government film making but an organization to undertake the production of both morale and training films. In 1939, when the Wehrmacht invaded Poland and Britain declared war on Germany, the Ministry of Information took over the supervision and in most cases the production of documentaries.

There was no such single, concentrated organization to deal with propaganda and training (both military and civilian) and morale films in the United States. This situation, which became a challenge to Hollywood, to independent producers and film makers, to theatre operators and to government agencies, including the army and the navy, had its benefits as well as its drawbacks. In the 1930s documentaries about the threat of war were not in the least common in America. But the Spanish Civil War (1936–39) provoked films such as *Spanish Earth* (1937) and *Blockade*

(1938), which aroused the wrath of Catholic organizations backing Franco, and there were a few films made to support the Chinese in their fight against the Japanese invasion—*China Strikes Back* (1937) and *The Four Hundred Million* (1939). Such films had little interest for the general public, and all but a few theatres ignored them. Newsreels at the time, according to one critic, were "trivial, lazy and misleading," with the exception of *The March of Time,* an almost monthly production of Time, Inc., that appeared on the screens of a large number of movie houses. Many of them, however, were "just spoken editorials, with the visuals thrown into the bargain," but some were vivid documentaries that adumbrated the impending explosion in Europe as Nazi Germany flexed its muscles, screamed its prowess, annexed its neighbors, and drove its Jews into submission and tragedy.

As the war approached, and even after the forces of European nations were engaged, there was a passionate division in America about our possible involvement. On the one hand were the interventionists and on the other the isolationists, and though actors, directors, and writers in Hollywood were similarly divided, the industry characteristically, with a few exceptions such as *Confessions of a Nazi Spy* and *Foreign Correspondent,* played it safe. It did so by avoiding the issues, a practice at which it was expert and one for which audiences, who did not like to be preached to, were grateful. Once the political issue of our involvement was resolved for us by the bombing of Pearl Harbor on December 7, 1941, Hollywood and its actors, producers, directors, and technicians in a great variety of ways and varying intensities "went to war."

The industry turned to the federal government to seek advice on ways the movies could be most effective as a weapon in the war effort, and asked that there be one agency with which it could harmoniously (it hoped) coordinate its efforts. Not, to be sure, that it liked the idea of being told what it could and could not do (it wanted nothing that smacked of censorship), but the industry was fully aware that in the movies it wielded a weapon of mass persuasion then equaled by no other, that no other medium approached it as a tool for sharpening civilian and military morale. It also knew that movies had to entertain as well as instruct and inspire or audiences would avoid them. Walter Wanger, the president of the Academy of Motion Picture Arts and Sciences, spoke for both the industry and the audience in 1943 when he declared, "The film with a purpose must pass the same test that the escape film easily passes—theatre goers must want to see the picture." This was a job for professional movie makers not for propagandists in bureaucratic jobs at the Office of War Information, the agency to which the industry was referred.

Movie audiences increased during the war years, though the number of new films produced by Hollywood decreased. In 1939 major studios and independents turned out 761 films, in 1945 only 377, or fewer than half as many. At the same time profits (before taxes) to the industry increased from $42 million to $239 million. This says more about the national payroll than about the national taste for movies. Preparation for war and war itself put almost every able-bodied man and woman to work, and though hours were longer in some industries and offices, there was more money to spend on leisure in the waking hours, especially on those pursuits that required no equipment. Adult playthings were in short supply in a war-centered economy, and mobility was curtailed. Travel by train was frowned on and gasoline was rationed. As a consequence attendance at the movies in 1942 reached a weekly average of 100,000,000. What audiences saw was essentially the formula-as-before, now accompanied by newsreels of action fresh from the theatres of combat. There were, to be sure, feature films which dramatized the anguish and courage of war-bedeviled England, such as *Mrs. Miniver* (1942), *A Yank in the RAF* (1941), and *This Above All* (1942). There was a spate of spy films that dwelt on the enemy within our walls; though well intentioned, they did more, as Arthur Knight observed in *The Liveliest Art,* to make neighbors look with suspicion on neighbors than to touch reality or to improve morale. There were films that focused on the plight of citizens in occupied countries and on the heroic operations of the underground in France and Poland, Czechoslovakia and Holland. As the war wore on toward its conclusion, combat films became popular, if harrowing, "entertainment," and if their plots were often sentimental and melodramatic, their scenes of combat were accurate reflections of the footage shot by photographers who, working with, and some of them for, the armed forces, recorded what they saw at first hand.

Many of Hollywood's most distinguished practitioners enlisted in branches of the armed services to write, direct, and edit training films for men and women in uniform and morale films for both military and civilian audiences. Some of them went to the scenes of combat to record the progress of the war, so that the visual record of World War II is an extraordinary collection of documentaries. While Hollywood directors of the caliber of Colonel Frank Capra, Major John Huston, Lieutenant Colonel William Wyler were working in uniform, actors and dancers and musicians by the hundreds performed for the troops wherever the USO sent them. Eminent stars and lesser lights from Hollywood's sound stages and Broadway's boards constituted themselves a floating, far-flung vaudeville circuit, which met with a volume and warmth of applause that astonished even the most blasé of them. Indeed, the theatrical profession, "legit"

and otherwise, worked hard in canteens and recreation centers as bus boys, waitresses, and unpaid "taxi" dancers, as well as entertainers, and their efforts to charm never encountered more grateful audiences.

Image Makers and Iconoclasts—Postwar Hollywood

As the war wound down in 1944 and 1945, concern increased about the impression America was making, not only on its allies but on the citizens of countries that were about to be liberated from the Nazis. The "image" of America as it was depicted by the movies became a matter of contention between those who believed that our films gave an alarmingly false impression of America as a frivolous culture on the one hand and a gangland of violence and political skulduggery on the other. Or was it something else altogether? Some argued that we must restrict ourselves to putting our best foot forward; others insisted that we should not hide behind a prettied-up façade but be frank about our society's behavior, good and bad. To the movie industry what mattered was making pictures that people, wherever or whoever they were, would enjoy. The argument pitted those who defended the freedom of the movies to entertain against those who thought the industry should act as a propaganda arm of the State Department. In other words, those who feared government dictation and censorship confronted those who believed that the movies should depict American society at its rosiest or noblest or most benign.

Drive-in movies, largely an edge-of-town phenomenon, were a post–World War II means of escape. Teenagers used the family car to escape parental supervision. Parents, who could bed down small children in the back seat, escaped the expense of baby sitters.

The industry was primarily concerned with the return on its investment, which meant that it produced what it hoped would entice the largest audiences here and abroad to part with their dollars or francs or lire or marks or pesetas or shillings. Even during the war foreign distribution was by no means just a frosting on the domestic cake. In an article in *Harper's* in May 1945 John A. Kouwenhoven noted that "the foreign market for an 'A' picture represents from 70 to 80 per cent of the net profit to the producer," and in 1944, "the gross receipts from foreign distribution of American films amounted to almost $170,000,000."

The European taste for American films had not been created by painting pretty pictures of America any more than it had resulted from exploiting the sordid aspects of our cities or the frivolity of our youth. It had been created by films that entertained—by comedies and Westerns and melodramas and epics, the full range of Hollywood's bag of tricks. As Kouwenhoven said, "Hollywood's movies . . . in spite of their gangsters and incredibly swank offices and voluptuous females in satin-quilted boudoirs, have been among the most appealing representatives of our civilization because of the very fact that they were so blatantly uninterested in putting our best foot forward." Even before American troops had cleared Sicily entirely of Germans, for example, the residents of Palermo were watching American movies. "In every country liberated by Allied arms," according to *Look* magazine, "the first civilian demand was for food; the second usually was for American movies."

For a few years following the war Hollywood's social conscience was at work, though it was not overworked. Out of its studios came films that confronted anti-Semitism (such as *Gentleman's Agreement*), the problems faced by returning GI's *(The Best Years of Our Lives),* corruption in government *(The State of the Union),* and racial discrimination *(Home of the Brave).* Hollywood was to pay a fierce price for its social conscience when the House Un-American Activities Committee decided that the industry was riddled with Communists. It was an inquisition not unlike the one to which the Federal Theatre Project had been subjected in the 1930s, though the atmosphere in the postwar years was somewhat different. Our former allies, the Russians, had turned out to be our adversaries after all when it came to dividing up spheres of influence in Europe, and there were those who believed that domestic Communists were plotting to use the movies to besmirch and possibly to "destroy the American Way of Life."

The industry was frightened into submission by the attacks on its patriotism and reacted by firing and "blacklisting" a number of writers, directors, and actors who were suspects on the "subversive" lists of the Un-American Activities Committee. It has been argued that the industry

would have been more staunch in the defense of "talent" if it had not been harassed at the same time by striking crafts unions, which were warring with each other as well as with the studios, and by the threat of television. The new medium was beginning to loom as a monster that would gobble up and digest the movie audience.

The result (or one result) of the "red scare" was that the studios fell back on tried and true formulas that could offend no one, not even the defenders of virtue through innocuousness. This, however, was not to last, and as the competition with television became more intense, the onerous restrictions of the Code were scrupulously circumvented. As a writer in *Life* put it, "Though the Production Code is restrictive, movie companies have worked a nice compromise. They observe its letter and violate its spirit as much as possible."

In the years following the war the arrival of films from Europe offered no financial threat to Hollywood. They were shown mostly in "art theatres" that seated small audiences, and even in New York and Chicago such houses were very few and had to struggle to keep open. Many who complained loudest about the stereotypes of Hollywood films seemed more willing to complain than to patronize the little theatres where the foreign films were shown. The expense of adapting foreign-language films for American audiences was considerable. Dubbing English dialogue meant remaking complete sound tracks, and, though great ingenuity was expended on approximating lip sync, the results were often awkward, as, indeed, they still are. It was not until well into the 1950s that the art houses proliferated and became fashionable with sophisticated audiences in metropolitan centers. This fashion was a by-product of the growth of film societies and the spread of acceptance of films as an "art form," an outgrowth, as we shall see in considering "the art audience" (Chapter 10) of the Museum of Modern Art's Film Library, founded in 1935, and its rental of prints to schools, colleges, and museums.

The "movie classics" that the Museum of Modern Art distributed were on 16-millimeter film. Like almost every change and expansion of the character and size of the audience for the arts, popular or élite (though that is an inadequate distinction), since Edison recorded sound, it was a mechanical device that was at the root of the matter. The 16-millimeter camera and projector had become more than gadgets for making home movies, which were animated versions of the snapshot, and classroom teaching devices. During the war they had been used to record action at sea and in jungles and in the air, and 16-millimeter projectors by the thousands had been employed in military installations, at home and in the war zones, for training and morale films and for entertainment. They were

used in war factories and for instructing civil-defense workers. In other words nontheatrical showings of moving pictures came to be taken for granted as commonplace even before films of every sort became the daily currency of television.

But the process of making "art" always involves editing by its maker, and the 16-millimeter camera, to use a phrase of May Deran, a dogged pioneer and proselytizer of the postwar avant-garde film movement, made "film a personal expression." The camera and the Moviola (a device for editing) became like the painter's brush or the sculptor's chisel, tools for creative expression. As the equipment was affordable and adaptable, there ensued a torrent of experimental films—abstractions, dream films in the surrealist manner, and documentaries, some of which were mere snatches of observable natural, mechanical or human behavior (the movies' oldest trick of all), some of which were explorations of social, mental, or physical problems or aberrations. Very few such experimental films found their way into general movie houses, though they were sometimes shown as shorts to supplement features in the so-called "art" theatres that specialized in foreign films. They found their principal audiences in film societies, which were largely, but not exclusively, in colleges and universities and museums, where films about art, most of them made in Europe, were also popular. These "art" films were in some respects totally different from the "art" movies of the early years of the century, which put on film performances of famous plays with famous actors, and in some respects quite like them. In both cases the camera recorded what went on in a framed space and focused on details of what happened within the frame, substituting the camera's lens for the eye of the individual in the audience, and leaving him no choice of where he concentrated his vision. As a consequence, many of the "art" films that were meant to be substitutes for private exposure to a work of art or an introduction to a gallery were, for all the moving about of the camera's focus, more arty than they were art. Though they were "documentaries," they were not documents.

The Screen and the Tube

It is not within the compass of this book to trace the changing face of the movies as they battled with television for the popular audience. Live television, before the development of videotape, was more like theatre performance than like film, though television early displayed studio film and used movie cameras to record events for news broadcasts. "Made-for-television" movies are a fairly recent development, and the "mini-series"

that are shown in evening prime time are movies chopped up to be "continued stories." In its soap operas television took over the cliff-hanging techniques that in the teens of the century had attracted Saturday-afternoon audiences to *The Perils of Pauline* and the parlor-and-bedroom anguish of the invisible and softer soaps of radio. Though movies were in some degree limited in their length to the number of reels of film they were intended to occupy (one-reel and two-reel shorts and seven- to ten- or twelve-reel feature pictures), they were not dismembered into fifteen-, thirty-, and sixty-minute segments, with time for the injection of commercials, coyly called "messages" or "words from our sponsor." Television, to be sure, could not exist as a form of entertainment or information were it not for the techniques of visual narrative developed in Hollywood from the time of D. W. Griffith to the end of World War II. Television revived vaudeville by putting it on the tube as Hollywood never did on the screen, and it did so early in its career, as, for example, in *The Ed Sullivan Show.* Even at its most productive, Hollywood turned out films by the hundreds a year, not by the hundreds a month as television must do to keep the tube alive in living rooms and bedrooms and bars around the clock.

We hear very little so far of "the art of television," as we heard very little of "the art of the film" in the movies' early days, though there are murmurings.* There have been few attempts to revive early television shows, whereas old films are a staple of television and film societies. Early television is not old enough to be quaint or campy, like many old films, and not the subject of enough Ph.D. theses to be recognized as an art form. No doubt the time will come when early television shows will become cult subjects for a precious few and probably with good reason. Like the early moviemakers, the first craftsmen in television were trying to make a new gadget perform narrative and visual miracles. Unlike their movie forebears, who had no precedents, television pioneers could fall back on the experience of nearly fifty years of experiment with pictures that gave the illusion of movement. This also meant that they had a cage of conventions to break out of. They are still trying.

It has often been said that the great visual innovators of the Renaissance like Leonardo and later masters like Rubens and Tiepolo, if they were alive in the twentieth century, would be making movies not painting at easels or on walls. They would want to be where the action is, sharing

*In the autumn of 1983 the Film Department of the Museum of Modern Art in New York characteristically put on an exhibition called "Video Art: A History." It was described as "an elaborate timeline [sic] tracing video activity in North America, Europe, Japan and Latin America from 1963 through the present."

the visual excitement and experiment made possible by new tools of expression. None of these painters was a solitary worker. They worked with teams of artists and artisans, who often carried out their designs much as the crew does for a movie director. They knew and understood their patrons (or audience), and they shared their beliefs and enthusiasms and could lead them to new and unsuspected visual delights and human understandings.

But this is conjecture. It is useful only as it suggests that in the evolution of the arts it is those who are willing to break with tradition without denying it who have made their contemporaries see the world as it has not been seen before. Like the eye which, as Peter Mark Roget discovered, holds the image of a moving object briefly, a principle that makes the motion picture possible, so the mind holds on to the images of the past. It is the function of the artist to reveal reality before others see it, and this is what the men and women who used and refined the motion-picture camera did for the eyes of our century.

The Art Public

A
rt is usually singled out from "the arts," which include every-
thing from ballet to *belles-lettres.* We apply it specifically to
tangible objects made by man for the delectation or instruction (sometimes
both) of others or for the glory of God or the gods. Art in the singular,
more specifically, has come to mean painting and sculpture, drawing and
prints (now including photographs and posters). The decorative arts en-
compass a jumble of artifacts that, in addition to being useful, are also
meant by their makers to give aesthetic pleasure—glass, ceramics, furni-
ture, textiles, metalwork (both precious and base metals), and any number
of other familiar objects. Compared with the audience for the live theatre,
compared even with the television and movie audiences, the audience for
the visual, static (usually) objects which constitute a large part of the
surroundings in which we live is tremendous. It is, indeed, everybody. We
can escape television by not turning it on; we can stay away from the
movies and the theatre; but we cannot, unless we keep our eyes closed,
escape the visual arts—good, bad, and infernal.

To put this in a different way, we cannot avoid design. The design of
a spoon or a fork or a coffee cup or a toaster is the work of an artist, just
as a stained-glass window or a portrait, an abstract sculpture or a mural
is the work of an artist. What we call "a work of art" is a different matter.
The painter Maurice Grosser said that a picture becomes a work of art
when somebody buys it, and there is much truth in this seemingly captious
statement. A picture becomes a work of art because someone thinks well
enough of it to want to possess it, and so it is a work of art in the eye of
the beholder. By the same token a simple piece of Shaker furniture, whose
original purpose was purely utilitarian in design and moral in its denial of
ornament, becomes a work of decorative art when it turns up in a museum
or is bought by a collector or is sold as "an example" by a dealer.

The machinery for making Americans "art conscious," to use a phrase that has become a trade cliché, is vast. It involves magazines, books, newspapers, television (mostly what we call "public television," as though there were any such thing as private television, except for closed-circuit to pry, to spot thieves and trespassers, and for use in classrooms). It involves dealers in the "fine arts" and the "decorative arts," historians, journalists, teachers (both teachers of techniques and teachers of how-to-look), and perhaps above all museums, in which works of art, fine and decorative, are collected, studied, displayed, explained, and preserved from the ravages of time and of vandalism, both the intentional kind and the careless kind, and the kind sometimes inflicted by restorers.

The live audience for Art with a capital *A,* as it can be measured by attendance at museums, is vast, just how vast might be estimated by adding the statistics in annual reports of the numbers who enter the portals of America's two hundred-odd* art museums. But even such an estimate could only be a very loose approximation. Some people go once a year, some once a lifetime. Some go again and again. Some go just to use the lavatory or to get out of the rain or to eat in the museum's restaurant or for assignations. Some are attracted only by the "important" loan exhibitions known in museum lingo as "blockbusters," and wait for hours in long lines to see a few dramatically lighted pieces of ancient gold. The art audience, compared with the fans who make up the baseball audience, is an undefinable lot of people. The museums they frequent are not undefinable.

Francis Henry Taylor, the director of the Metropolitan Museum in New York in the 1940s and early '50s, said, "Art museums are the cathedrals of the twentieth century."

He was talking of museums not just as imposing structures but as places where a congregation of faithful come to pay homage and to refresh their spirits, where many thousands of others come out of a sense of cultural duty, and a great many millions come out of mild curiosity or in order not to seem to be boors or philistines. They come in order to be able to say that they have. A few become converts who join the faithful.

By the 1950s there was scarcely an American city however small that

*There are many more than 200 museums displaying art in America. In her layman's guide to *American Art Museums and Galleries* (New York, third edition, 1976) Eloise Spaeth lists and comments on 215 museums. In addition to all major civic and personal-public museums, she includes college and university collections with "their own buildings which act as community museums as well." Many colleges have limited art collections that are used primarily for teaching. Many historical societies and some libraries and "historic houses" have collections of works of fine and decorative art which are secondary to their collections of books, documents, memorabilia, and artifacts.

did not harbor an art museum of some sort, and large cities boasted art museums of several sorts. In the major cities of the eastern half of the United States they were, indeed, cathedral-like in their architectural pretensions and splendor and in the richness of their treasures. For the most part, as we have seen, they were founded before the turn of the century, and the architecture of many of them felt the impress of the taste of the Columbian Exposition of 1893. They were Beaux-Arts on the outside and often Beaux-Arts within, marble palaces of exceeding grandeur and elegant posture. Some, like the Art Institute of Chicago and the St. Louis Art Museum, occupy structures built as exposition halls for world's fairs and converted to museums. But most American museums (unlike most European museums, which were originally royal or ducal palaces) were built for the purposes they serve in styles that were considered modern and up-to-date when they were erected, on a scale and with a luxuriousness that was intended to reflect the civic pride and ambitions of their communities.

The history of the American art museum is more nearly a social than an aesthetic story, in which works of art generally have played a supporting role to social and civic ambition. It has not always been that, of course, and it has often been more than that. There were many kinds of art museums in America and they come in many sizes and many degrees of pretension and possession, and they hope to appeal to a great variety of audiences. They came into being for different reasons to serve different purposes, some of which we noted in Chapter 1, and they proliferated and extended their hands to the public in ways far different from their original purposes as they caused new demands to be made on them. (It was generally the museums, not the public, that inspired the demands.) There are dozens of university and college museums of art, private collections that have become public museums, museums that were established for the education of artists and artisans and have subsequently grown into institutions far less restricted in their purposes, museums founded to promote a specific aesthetic movement (the Solomon R. Guggenheim Museum of Non-objective Art, for instance),* and the municipal museums, which are meant to be all art for all people of all ages and conditions from the youngest schoolchildren to their grandparents in wheelchairs.

How these museums came into being, how they grew and expanded their functions to embrace ever larger and possibly more sophisticated audiences is the subject of this chapter. This means looking at several kinds of art museums, since no one kind tells the story or defines the audience,

*The Guggenheim dropped "of Non-objective Art" from its name in 1952 and expanded its stylistic concerns. In 1959 it moved from a Guggenheim family mansion into its permanent home designed by Frank Lloyd Wright, his only New York building.

and these are a university museum, a large city museum, a museum founded with the purpose of training artists and designers, a museum with an aesthetic crusade, and a few private collections that became public museums. I ask you to look with me at the Yale Art Gallery, the Metropolitan Museum of Art, the Cooper-Hewitt Museum of Design, the Museum of Modern Art, and several private collections that have become public.

Art in Academe

The oldest and in most respects the most distinguished college museum of art is the Yale University Art Gallery, and it came into existence in 1832 more or less by accident. It was the result of a personal gesture to a celebrated artist rather than a conscientious attempt to establish a gallery as a means for the education and refinement of students' tastes. Colonel John Trumbull, known as "the Patriot Artist" because he had served briefly on General Washington's staff at the time of the Battle of Bunker Hill, was famous for the scenes he had painted of revolutionary battles and for portraits of the young nation's heroes. He was a relation by marriage to Benjamin Silliman, an eminent scientist and professor of chemistry and geology at Yale and a man with a generous nature. In 1830, Trumbull was in his seventies and discouraged because the large paintings that he had made from his brilliant small sketches for the rotunda of the Capitol were castigated by the public, and not without reason. Silliman persuaded Trumbull to give the contents of his studio to Yale and to design a small building to house them. This was to be in exchange for an annuity of $1,000 a year for the remainder of Trumbull's life, and a guarantee that none of the pictures could be sold or lent to other institutions (if they were they would go to Harvard) and that Trumbull and his wife would be buried under the gallery. It was a lavish offer and one which the crotchety old painter, by then long out of fashion, was happy to grasp. The building he designed was ready in 1832, and in it were hung the small versions of his revolutionary scenes, including "The Signing of the Declaration of Independence," one of the best known of all American paintings.*

Trumbull may have been an ornament to Yale but he was evidently not a congenial member of the community. He was an arrogant, disappointed, crusty old man, whose schemes for personal glory had fallen short of his ambitions and whose reputation as "the Patriot Artist" was subjected

*It was known as "the shin picture" in its day because of the rows of white hose on the legs of the seated founding fathers. It was engraved in a masterly fashion by Asher B. Durand soon after it was painted and was widely purchased by proud Americans for their parlors. At the time of the Bicentennial in 1976 it was engraved again as a postage stamp.

to some scorn. His service to General Washington as a mapmaker had lasted only three months. He had quit the army in a huff because of the dating of his commission, which he said should have been earlier than the Adjutant General would concede. His determination, however, to assure his place in posterity greatly benefited Yale. His paintings, miniatures, and remarkable drawings were the nucleus of Yale's Art Gallery and remain among its prized treasures.

But a nucleus, except in rare cases as we shall see, does not make a museum. In 1864 a Yale alumnus, Augustus Russell Street, gave the college the first art school building of any college in the Western Hemisphere, and the Trumbulls were moved there.* Seventeen years after the art building was completed, Yale became the possessor of a very distinguished collection of Italian primitive and Renaissance paintings that no other institution was sufficiently enthusiastic to purchase and which Yale acquired somewhat reluctantly.

Yale bought James Jackson Jarves's collection of 119 early Italian paintings (some of them seen here as they used to be hung in the Yale Art Gallery) for $22,000 at a closed auction in 1871. The Princeton art historian Frank Jewett Mather, Jr., wrote in 1914, "It is fortunate that [Jarves] died a bachelor. Had he left children, Yale would morally owe them the price of two or three stadiums." *(Yale University Art Gallery)*

*The conditions of Trumbull's gift have been observed. None of his works have ever left Yale, and his and his wife's bones have followed the paintings and have twice been reburied under the buildings where they have hung.

This was the Jarves collection. James Jackson Jarves was a pioneer in several senses. He was one of the first to work (and work he did) toward the establishment of a national museum of art in America, and he was among the earliest collectors here or abroad of early Italian paintings. Jarves led a curious, interesting, and frustrating life—part businessman, part diplomat, part journalist and publisher, and an ardent dilettante of the visual arts. He was also as perceptive as any art critic in America in the nineteenth century, though today his impatience with what his American contemporaries were painting seems unjustified. But it was his passion as a collector with a very discerning eye and his determination that his fellow Americans should have a national art museum that concern us here.

Jarves lived in Italy (Florence principally) in the 1850s, when it was a center for American and English literary and artistic expatriates. (The Brownings were there, as was Mrs. Frances Trollope, the mother of Anthony Trollope and a novelist herself, who had been notorious in America for her disturbing book *The Domestic Manners of the Americans* in the 1830s. The American sculptor Hiram Powers was carving his popular portrait busts and maidenly nudes, none more famous than "The Greek Slave.") Jarves avidly bought small early Renaissance pictures by masters who were then little known—Sassetta, Ridolfo Ghirlandaio, Pollaiuolo, Taddeo Gaddi, and so on. It was his initial hope that with them Boston might establish the first national museum of art. Boston was his native city and he regarded it, as other Bostonians did (and some still do), as the cultural center of the nation. He offered 120 of his paintings to Boston for $25,000 (he said they had cost him $60,000 and years of searching), and the Boston Atheneum agreed to put up $5,000 if the rest was forthcoming from other institutions and individuals in the community. Jarves himself offered to contribute $1,000. But Bostonians were unmoved by the "pre-Giottesque ligneous daubs," as *The Crayon,* a popular art magazine, called them, and Jarves took his collection and his hopes to New York.* The pictures were hung temporarily in the New-York Historical Society, whose galleries were then the only ones in New York that approached the status of a museum (the Luman Reed collection of American Painters was there, as was the collection of Italian and Flemish paintings that had been collected by Jarves's friend Thomas Jefferson Bryan), but Jarves was unable to find a purchaser for his pictures, and he did not want them dispersed.

*Jarves was critical of the American artists about whom *The Crayon* was enthusiastic, and its editors did not take this in good part.

He next tried Yale College (Yale did not assume the name Yale University until 1887), as he was desperate for money. Yale was willing to give him a mortgage of $20,000 on the paintings for three years, and it hung them in its new Street Hall along with the Trumbulls. It was Lewis R. Packard, a professor of Greek whom Jarves had met on a transatlantic crossing in 1867, who saw the value of the collection to a college gallery and persuaded Yale's president of their worth. Considering the taste of the times, that cannot have been easy. The pictures were hung without fanfare; some undergraduates were deeply shocked by the violence and bloodletting in the paintings of martyrdoms; some were merely moved to call them rubbish.

Jarves hoped to redeem his pictures at the expiration of the mortgage, but he was unable to come forward with the necessary cash. Yale gave him a one-year extension, and then decided to put the collection up for auction, an event which it seems to have been content to keep to itself. It refused to sell any of the pictures individually, which was a wise decision from the college's point of view if not to Jarves's financial advantage, and it did not advertise the sale. As a result Yale was the only bidder, and it acquired the collection for $22,000, the amount of the mortgage plus interest. The college thus became the owner of a collection that, as a member of the Yale faculty wrote, "is entirely unique in this country and is believed not surpassed, in historical interest, by more than two or three similar galleries in Europe." Jarves's biographer, in concluding his account of the Yale acquisition, wrote: "In any case, the collection, antedating by more than a generation all subsequent collections of early Italian art in America, has hung at Yale ever since."

The Yale collection has been frequently enriched by purchases but most particularly by gifts and bequests from Yale alumni. Its range and quality, if not the number of its holdings, is comparable to that of America's largest and most ambitious museums. Its sculpture collection encompasses pieces from the ancient world, the stone and ivory carvers of the Middle Ages, the bronze casters of the Renaissance, the post-Renaissance masters, and many preeminent sculptors of our own time. It is likely that it was the first college gallery to have been presented with a stunning package of "modern," in that word's current art-historical meaning, which distinguishes *modern* from *contemporary*. In 1941 it received a gift of modern painting, sculpture, and prints called the Société Anonyme Collection. It had been assembled by Katherine S. Dreier, a painter, with the advice and collaboration of Marcel Duchamp, whose "Nude Descending a Staircase" had caused such a stir at the Armory

Show in 1913, and the surrealist painter-photographer, Man Ray.* The Yale collection of twentieth-century art has been greatly enriched since then, and so have its holdings of eighteenth- and nineteenth-century works and, indeed, it has more paintings of the era encompassed by the Jarves collection. Yale's decorative-arts collection is primarily of American furniture and silver, the Garvan collection. Across the street from the Yale Gallery is the Center for British Studies, given to Yale by Paul Mellon in 1966, a remarkable assemblage of English paintings and drawings and a library of rare books and manuscripts of the first importance. It occupies a building by the architect Louis Kahn that opened in 1977.

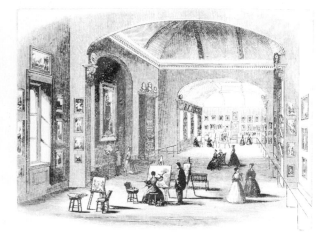

From the time it was founded in 1860, Vassar College took art seriously. Not only did it have a collection of Hudson River School paintings but students were taught in the rigid disciplines of drawing from casts of sculpture and copying from master paintings.

There are now more than thirty American colleges and universities with art galleries that can reasonably be called art museums. The first college collection was at Bowdoin College in Brunswick, Maine, but the pictures, largely portraits of eminent personages, all of them presented and some of them commissioned by the founder, James Bowdoin, in 1811, were scattered about the college. They were brought together in 1894 in a museum building designed by Charles F. McKim, of the firm of McKim, Mead & White, and over the years the collection has been enriched.

Just thirty years before this in 1864 Vassar College in Poughkeepsie, New York, established an art gallery in its Main Building, the first col-

*The Société Anonyme Collection includes works by Joseph Stella, Patrick Henry Bruce, Arthur G. Dove, Joseph Albers (who later taught at Yale), Piet Mondrian, Jacques Villon, Wassily Kandinsky, Juan Gris, and others.

lege after Yale to insist on a collection of the fine arts as an aspect of civilization to which students should be exposed. It was part of Matthew Vassar's initial scheme for his very early attempt to give American women an education comparable to that provided for men. In the middle of the nineteenth century in America art was considered ladies' business not gentlemen's, and it was as much for its moral as its aesthetic values that it was thought to be of educational importance. The Reverend E. L. Magoon, one of the original trustees, produced an eloquent and flowery report urging the establishment of an art gallery. "Art is petrified poetry," the report declaims, "or concrete rhetoric. Mere ornament is to art what words are to thought; and if the conception is not vital, no ornamentation, however beautiful, can give it worth. It is a wreath of transient flowers around the pale brow of a corpse." Presumably this praise of art at the expense of decoration was prompted by the fact that young women of the day were expected to do "fancy work" with their needles, and should not confuse their efforts with "art." Art was a serious matter, and Mr. Vassar and Mr. Magoon were determined that young females (it was Vassar Female College when it was founded), should have the benefit of the refining and uplifting influence of high art. The high art that was locally available was Hudson River School landscapes, and Vassar has a splendid collection of them. It has acquired a great deal else over the years, and if it cannot compare with the Yale Gallery or the gallery at Smith College or with the Fogg Museum at Harvard, it is nonetheless an excellent "teaching museum."

The role played by college museums in the development of the art audience goes deeper than merely the creation of casual museum visitors. Most of the museums are closely tied to departments of art history and are the first experience of more than glancing blows at real works of art for many undergraduates and graduate students. For a few it is the introduction to a career in museums, for others to the profession of art historian, for others the initiation to the fascinations of collecting. It is even useful to those who wish to make careers as artists, though the relationship between college museums and college courses in painting, sculpture, and design is a far cry from what it was when the first art schools (Yale's was the first) were introduced to the college curriculum. Students are no longer encouraged (except in very rare cases), as they were in the last century and the early parts of this one, to make copies of "old masters" for what the experience might teach them about the vocabulary and techniques of the craft. This and other kinds of manual discipline since the 1940s have been looked on as hindrances to self-expression, to invention and originality. An art school dean in 1960 put it in these terms:

The enthusiasm with which new movements in art are embraced and the speed at which they are used up in the colleges is an indication of speedup in studio education which bypasses historical record in favor of current values. The significance of art historical record as a force in developing really new attitudes and in the recognition of qualities and quality in art is diminishing. Artists who are teaching are trapped by the *ab initio* syndrome, which really is an abdication of their powers of influence and leadership.

The college museum and the teaching of art history have, of course, a closer and quite different relationship. Most college museums, except those that are located near large municipal art museums, are likely to concentrate on the acquisition of "teaching collections" of good, if not necessarily great, examples from a variety of eras and schools. Art history was first introduced to the college curriculum by Charles Eliot Norton at Harvard in the late years of the nineteenth century as lectures on what would now be considered condescendingly "art appreciation" rather than solid history. But the seed Norton sowed produced connoisseurs such as Bernard Berenson and Paul J. Sachs, who, as head of art history at the Fogg Museum at Harvard, was the mentor for a group of men and women who, from the 1930s to 1950s, became influential museum directors, a profession that combines connoisseurship with administrative skills and a taste for the competition and intrigue of the marketplace. Princeton, whose focus was on archeology and the art of the Middle Ages, Columbia, and New York University, which established its Institute of Fine Arts in the 1930s, and Harvard became the leading graduate schools for art history and remain the principal, but by no means the only, centers of art historical study, with the machinery for turning out Ph.D.s in the discipline.* In general the products of these Ph.D. programs have been more inclined to turn to teaching than to the rougher, more-uncertain and generally less well-paid existence of museum curators.

The best of the college museums do not limit their concern to students of art history, though in the last few decades those who take courses (many are just introductory "survey" courses—"from the Pyramids to Pop") number in the hundreds of thousands. They attempt, sometimes successfully, to be a resource for students in history and literature and to some

*"New York University's Institute of Fine Arts was early given great distinction by Hitler, who forced so many German art historians to answer the invitation of the late Walter W. S. Cook, N.Y.U.'s art history chairman, to take up permanent residence in this country" (*The Visual Arts in Higher Education,* pp. 3–4). Walter Cook had been a student at the Fogg. Among the eminent art historians he brought to America were Erwin Panofsky, Walter Friedländer, Richard Krautheimer, and Karl Lehman. Their influence on the teaching of art history and on art historical research in America was profound, and did much to give the discipline status in the academic community.

degree in the physical sciences—to be, in other words, an integral part of the intellectual community, not an island in it. They seek to be a service that cuts across disciplines, though it is often difficult for the college museum to penetrate hermetically sealed academic boxes and overcome interdisciplinary jealousies.

Cathedrals of Art

The constituency of the big-city art museum is very different in quality, age, size, sophistication, appetites, and degree of stamina from that of the college museum, which exists in a closed community with a presumably homogeneous character. A museum like the Metropolitan in New York (it has accurately been called "the greatest treasure house in the Western Hemisphere") has all the problems that every other municipal museum has and a few, because of its size and cupidity, that others have in minor degrees or not at all. Some problems are forced on it from without by community pressures. Some of these problems are social pressures from those who want to be participants in the museum's life and not just outsiders who are let in. Some problems are self-generated by trustees and curators, problems most commonly prompted by ambition of one sort or another and by competition with other institutions of similar stripe. This can be oversimplified (but not misstated) by attributing it to the common notion in museum circles that bigger is better—structurally and in the richness and variety of the collections. This attitude, of course, creates financial problems over and above the usual administrative ones of maintenance, exhibition, conservation, and scholarly pursuit. In the American tradition that upward mobility is the key to progress, a museum that is looked upon as "standing still" is generally believed to be "going downhill." One that is alive (though it may sometimes find itself out of wind or out of its depth) is "going places."

If college art galleries were inspired partly by cosmetic considerations and conceived partly as educational tools, large-city museums were the progeny of civic pride and social ambition. That is not to say that the education of the public and the improvement of its taste was not essential to the arguments for rallying support to found them. Quite the contrary. It was thought impossible to attempt to rival the museums of Europe with their collections of great masterpieces, many of which had been bequeathed to them by aristocratic collectors or stolen by invading armies; indeed, it was thought that there weren't many masterpieces that might be available to be purchased by an American museum. It was generally conceded that art of the first quality was not only out of reach financially but beyond

arm's length. Great art was assumed to come only from across the seas, and the local product, while worthy, was not sufficiently noble to be the cornerstone on which to build a national collection. The Boston Museum of Fine Arts and the Metropolitan were both incorporated in 1870, and though both cities had turned blind eyes to Jarves's blandishments, it is unlikely that their founders were aware that an unrepeatable opportunity had slipped through their fingers.

In the case of the Metropolitan, the argument for establishing a "national institution and gallery of art" was essentially an educational and moral one, at least on the surface, though what lay behind it was the belief that a great city (and New York was then the world's third largest) could hardly hold its head up without such a proper gesture (more than a nod) in the direction of Culture. To that was added the consideration that cultural institutions are good for business.

The immediate spark that ignited the Metropolitan was set off at the Pré-Catalan, a fashionable restaurant in the Bois de Boulogne in Paris; the occasion was a Fourth of July dinner party in 1866. John Jay, at that time the American minister to Austria, a highly regarded lawyer and the grandson of America's first chief justice, speaking to a congregation of businessmen from New York, said that the time had come "for the American people to lay the foundation of a national institution and gallery of art." His audience responded with assurances that they would see to it that his proposal became a reality. What had often been proposed at home and fallen on indifferent ears had magic in Paris, which, as Calvin Tompkins has written in his history of the Metropolitan, is "a city that has tradionally stirred cultural longings in the mercantile soul." William Cullen Bryant, who was then the primary cultural conscience of New York and had been for some years, was elected president of a committee to set the wheels in motion, and a more influential man could not have been chosen. He was editor of the New York *Post* and quite probably the best-known poet in America; he was deeply concerned with the quality of life in New York, and a very early crusader for what became, at the hands of Frederick Law Olmsted and Calvert Vaux, Central Park. He commanded the respect and affection of artists and writers and professional men (he was president of the Century Club) and he was regarded with caution by politicians. It was Bryant more than any other New Yorker who nursed the concept of a museum of art from a hope into a solid stone-and-mortar reality.

Bryant and his friends, like Joseph H. Choate, a lawyer equally well known for his witty after-dinner speeches as for his civic concern, did not think of their scheme as merely the establishment of a local emporium of art. They saw it as a touchstone of taste for all Americans, an emblem of

America's cultural coming of age. They saw it as a moral force. Bryant said: "It is important that we should encounter the temptations to vice in this great and too rapidly growing capital by attractive entertainment of an innocent and improving character." But they also saw it as a business asset to the city.

Choate emphasized, in his address to the founding committee, the commercial benefits of a museum, and he was at some pains to point out that it was the cultural treasures of European cities that tempted visitors to come to them and spend their money in hotels, restaurants, and shops. "The wealth and prosperity of Dresden," he said, "rest largely upon the things that report to its vast galleries, and whole cities in Italy live upon their inherited treasures in art." Not that New York, he thought, could ever offer its citizens and visitors such magnificence, but a national museum in his city, he believed, could not but be good for business, an argument that has been used ever since in soliciting both local and state funds for the support of New York's financially strained libraries and institutions of music, theatre, and art. Since the chances of acquiring treasures of first quality were remote (he underestimated the greed of European aristocrats, who could be parted from their treasures, and the avidity of Americans to make off with them), Mr. Choate expressed his conviction that the museum's practical contribution to the community (and to business) would be refining the taste of those who design the objects with which we daily surround ourselves—furniture, textiles, ceramics. They would benefit from exposure to excellent examples in a museum. He cited the South Kensington Museum (now the Victoria and Albert) in London as an example of a source of endless inspiration for designers. It was an outgrowth of the Crystal Palace exposition of 1851, which had been conceived as a marriage of industry and the arts, a means not only of improving the design of manufactured objects but of raising the public's taste.

Bryant's and Choate's persuasive words did not fall on unsympathetic ears. The Metropolitan Museum opened in 1872 in temporary quarters that had once been a dancing academy, but in 1880 it moved to a red-and-white stone Gothic structure designed by Calvert Vaux in Central Park, far uptown from the bustle of the city. The Vaux building has been swallowed over the years as a Beaux-Arts façade and a great entrance hall by Richard Morris Hunt were erected and by wings north, south, and west, so that the original building has become like a fetus in the womb of the vast organism of the Metropolitan. On the occasion of the opening of the new building, Mr. Choate addressed the fashionable crowd, dressed in trains and tiaras and tailcoats, with these auspicious words:

The erection of this building, at the expense of the public treasury for the uses of an art museum, was an act of signal forethought and wisdom on the part of the legislature. A few reluctant tax payers have grumbled at it as beyond the legitimate objects of government, and if art were still, as it once was, the mere plaything of courts and palaces, ministering to the pride and luxury of the rich and the voluptuous, there might be some force in the objection. But, now that art belongs to the people, and has become their best resource and most efficient educator, if it be within the real objects of government to promote the general welfare, to make education practical, to foster commerce, to interest and encourage the trades, and to enable the industries of our people to keep pace with, instead of falling hopelessly behind, those of other States and other Nations, then no expenditure could be more wise, more profitable, more truly republican. It is this same old-fashioned and exploded idea, which regards all that relates to art as the idle pastime of the favored few, and not, as it really is, as the vital and practical interest of the working millions, that has so long retarded its progress among us.

It was not "the working millions," however, who came to the museum. The audience it welcomed was the genteel society of the day, and some artists and students who came to the classes of the art school the museum harbored starting in the late 1880s. The museum's trustees, most of them, seemed to regard the Metropolitan as their private preserve, to which only the sorts of persons they would invite to their houses were welcome. General Luigi Palma di Cesnola, a collector of antiquities who was appointed the museum's first director, had a military intolerance for what was not spick-and-span in behavior and, it seems, in dress, and he was appalled at the liberties taken by nursemaids with babies and visitors with dogs in the museum galleries. He had a brush-up with the newspapers when it was reported that he had refused entrance to a plumber in his overalls who stopped by, presumably to refresh his spirit at the marble fountain of art. During the first months after the new building was opened in 1880, nearly 150,000 visitors, more than had come in the preceding ten years, turned up, but the number dwindled to a precious few, and it stayed that way. When the museum instituted an admission charge of 50 cents to help defray increasing costs of keeping the museum open, people who came turned away at the door. "Barely a dozen people a week," Tomkins records, "were willing to pay for the privilege of having their tastes refined."

Bryant, who died in 1878, must have been disconcerted, though probably not surprised, by the museum's failure to become the remedy for vice that he had predicted. Choate, on the other hand, lived until 1917 (he was eighty-five when he died), and during the many years he kept a fatherly eye on the museum and sometimes fought its legal battles, he saw its

collections grow in a way that he had predicted could not happen. Along with a gallery of casts of ancient sculpture, long since retired from display, and a collection of paintings by artists now happily forgotten, the museum was given or inherited from such remarkable collectors as Benjamin Altman, who made his fortune as the proprietor of a department store, and J. P. Morgan, the very nearly all-powerful New York banker, collections of paintings and porcelains and tapestries that any museum would be proud to possess. The museum's director, General Cesnola, had some blind spots, which is not surprising considering the capricious nature of taste and of fashions in collecting. In the 1890s he turned down, for example, a remarkable collection of rare prints by old masters that Samuel P. Avery, who had been a staunch supporter of the museum since its inception, offered to donate. "We are not interested in prints," Cesnola said to Avery. "We are only interested in art."

But blind spots like this were more than made up for by the museum's willingness to play up to those whose collections it was itching to obtain. In its early years the Metropolitan, like other museums hoping to establish their positions as worthy recipients of great works of art (as institutions, that is, where a donor would be proud to display the fruits of his aesthetic acumen, attached, of course, to his name), was reluctant to accept whatever conditions and strings a donor might attach to his benefaction. The policy, however, could be bent. Such an instance was the acquisition of the Altman collection. Mr. Altman bought slowly and with great care only those objects and paintings that he regarded as of the finest quality. For years the Metropolitan flirted with him, and for years he kept the museum on tenterhooks. He might, he implied, decide to set up a museum, an Altman Museum, where his collection and only his collection would be available to public view. He made it clear that he did not like the Metropolitan's policy of refusing gifts with restrictions on them, but it was suggested to him that in the case of his magnificent collection the rules might be bent to fit the curve of his wishes. When Altman died in 1913 the Metropolitan trustees had known in confidence that his collection would come to the museum. Altman and Choate had whittled the conditions to a very fine point. The collection was to be exhibited in two adjoining rooms, one to display his paintings (in a straight line, not one above another, as pictures were commonly hung then) and his Limoges, sculptures, and rock crystals. The other room was to contain his porcelain collection, and in neither of these rooms was anything to be exhibited but Altman pieces. He "left" the museum his secretary, who had been his curator, to make sure his wishes were meticulously observed, and provided a fund for his salary.

The museum hoped to get the Morgan collection and tried to persuade

the city fathers to build a wing to house it, though Morgan had never said that the museum would become its home. It was regarded as the most remarkable private collection of art in the world (it had cost Morgan some $60 million), but the museum was to be disappointed. After Morgan's death in 1913, half of the collection was sold by his heirs to satisfy inheritance taxes and other claims on the estate. (A number of dealers and private collectors profited richly as a result and so, in the long run has the public, as many Morgan pieces have found their ways into American museums.) In 1914, before the disposal of part of the collection took place, it was displayed in its entirety on two floors in the north wing of the Metropolitan, and more than 900,000 people came to marvel at it. It was the Metropolitan's first "blockbuster" exhibition, a hint at the future of the fine-arts audience not before seen in an American museum.

About 40 percent of what Morgan collected found a permanent home at the Metropolitan—decorative arts as well as fine arts, ancient and modern.* Morgan had left instructions for his son J. P. Morgan, Jr., that what was left of the collection after the debts of the estate had been met should be disposed of in a way that "would render them permanently available for the instruction and pleasure of the American people." Forty percent was a vast hoard of riches. The collection was kept together, but in 1943 J. P., Jr., gave permission to spread objects through the museum's collections, where curators have decided they belong.

In the building of museum collections the line between *caritas* and *vanitas* is often very difficult to draw, as, indeed, it is in the motives of collectors. There has not been another Morgan in the Metropolitan's memoirs, but there have been collectors whose acumen and beneficence and vanity were not unlike Altman's. The Metropolitan has become the massive cathedral of art that it has largely because of them. Some, like Altman, wanted to perpetuate their names by insisting that their collections be kept inviolate, while others, like the H. O. Havemeyers, were content to let the works of art on which they had spent their fortunes as well as their love be displayed how and where they made the most sense.

On some occasions the museum's trustees and directors have been so eager to acquire a collection that they have humiliated themselves and their institution for institutional vanity and avarice. It has not been their fear that the public might be deprived of the chance to see such works of art, but that they would see them elsewhere than in the Metropolitan Museum.

The most notable (some critics of the museum thought it the most

*In art historical parlance "modern" refers loosely to anything more recent than "ancient," and includes, for example, the art of the Middle Ages and the Renaissance and what came after that.

notorious) example of this in recent years was the acquisition of the Robert Lehman collection in 1969. It was one of the greatest collections of paintings and drawings (most especially from the fifteenth to the eighteenth century, though it by no means stopped there) still in private hands. Lehman, who also gave generously to the Yale Art Gallery, was a trustee of the Metropolitan for many years, but that alone was not sufficient reason in his view to leave his collection to the museum. He evidently enjoyed the flirtations of other museums, and he considered, as Altman had, establishing a museum devoted solely to the collection he and his father before him had amassed with great skill and connoisseurship. When Lehman was passed over as president of the museum board (he had been vice-president), he was obviously displeased, a pique that was allayed when the trustees had the wit to elect him the museum's first chairman of the board. He did in the end leave his collection (which was said to be worth $100 million) to the Metropolitan, but not without elaborate strings. Not only would the collection be kept together, but the rooms in his house on Fifty-fourth Street, where he had installed it, must be duplicated precisely, even to the staircases that went out of two of them (staircases that when installed led to blank ceilings, a conceit that evoked a great deal of ridicule); the paintings, bronzes, and decorative objects were to be placed exactly as he had placed them—a living tomb to his vanity and, of course, to his taste and acumen. The museum built a special wing on the back of its building (conservationists were outraged at what they regarded an incursion on Central Park) to comply with the conditions of the bequest. To their credit, the museum's architects (Kevin Roche and John Dinkeloo) produced a wing that is handsome, harmonious with the rest of the structure, but fresh in design, and that has proved useful for special exhibitions of materials that have little or nothing to do with the Lehman collection.

In recent years the Metropolitan has come a great deal closer to Bryant's and Choate's ideals for it than it had before the Second World War. It had been largely a curators' and collectors' preserve, to which the public was invited but by no means warmly welcomed. The curators were primarily interested in studying, classifying, and attributing the materials they were able to persuade the trustees to purchase, and the collectors were primarily interested in seeing that they got credit for their generosity and judgment. The casual visitor got no help beyond perfunctory identifying labels on the works of art, and as the maze of the museum grew so did its mystification. In the 1930s the numbers who came through the portals of the museum diminished, as did the number of members who contributed $10 a year. The small but dedicated audience for the museum's treasures

enjoyed the near solitude in which they could view them and the knowledge that things were not going to be moved about so that they could not find what they came to look at.

The Art Boom Gets Under Way

It was after the end of the Second World War that what has been called "the art boom" began to gather momentum. The war itself had a good deal to do with focusing the concern of more Americans on the visual arts. The destruction of Coventry Cathedral and the devastation of Dresden by saturation bombings; the battle for Monte Cassino, a monastery in southern Italy where the Italians had sent many of their masterpieces for what they hoped was safekeeping in a remote and presumably nonstrategic fortress; the sending of European collections (most notably the Gulbenkian collection now in Lisbon) to America to get them out of harm's way—all were vivid reminders of the threat to the heritage of Western art. This threat captured the public's concern in ways that the peacetime availability had not stirred their curiosity. When Rome was declared an "open city," and therefore free of the threat of bombing, millions were relieved, not just for religious reasons but for aesthetic or nostalgic ones as well.

Hermann Goering, the commander of the German Luftwaffe, was a predatory aesthete with a trencherman's appetite for acquiring masterpieces, which he "liberated" (to use a World War II word for looting) from both public and private collections in the countries overrun by the Nazis. When he threatened to bomb New York in 1942, the Metropolitan secretly hustled twenty thousand of its most precious objects into seclusion at a private estate in a suburb of Philadelphia. At the same time the museum increased its efforts to provide refreshment for an apprehensive public with loan exhibitions and a very popular show of American works of art, assembled by Artists for Victory. This was an organization of painters, sculptors, and print makers who were determined to turn their skills to "the war effort," mainly as designers of posters for promoting civilian morale, the energies of industrial workers, and the sale of war bonds. Francis Henry Taylor was the director of the Metropolitan during the war; he was a showman at heart, and he liked nothing better than a crisis which gave him an opportunity to make his museum a center of activity. The war stimulated his efforts to make the Metropolitan reach out to the largest public possible.

The end of hostilities in 1945 brought a social and economic timbre to American life that contrasted sharply with the monotone of the de-

pressed years of the 1930s. Hundreds of thousands of military men and women returned from Europe and the Pacific to take advantage of the GI Bill's provisions that paid their tuitions in educational institutions of almost every conceivable sort, from trade schools to graduate and professional schools, including schools for the visual arts, music, and the crafts. It was a kind of patronage to educational institutions never seen before in this country. The money went to the student to spend where he or she pleased as long as the institution chosen was accredited by the government as, to be sure, some very questionable ones were. The subsidies, in other words, were to the students and only indirectly to their places of study. There was, of course, a certain amount of boondoggling (a word for make-work that America had invented during the days of the WPA), but a great deal of serious work got done, and the humanities, especially, were given a boost. This was a sharp contrast to the time during World War II when the government had poured money into scientific training for military purposes while the humanities languished. The demands of war production had brought an end to the economic depression and to the unemployment which had mounted to an alarming 25 percent of the work force, and it had left a vast residue of civilian needs and desires to be satisfied. It had also shaken up the demography of the country as it had never been shaken before, moving thousands upon thousands of people from their homes to where there was a demand for their muscles and their skills. Recovery from the shortages in housing and consumer goods of every sort helped to create a new prosperity, an era of affluence which brought with it a phrase unfamiliar to Americans—"the new leisure." For many workers in offices and factories, thanks largely to union demands but also because some businesses realized that more time off meant more reasons for consumers to buy leisure-time goods and services, the work week shrank from forty hours and more to thirty-five and thirty. Offices that had been open six days a week (often a half day on Saturday) cut the week to five days. Weekends were more relaxed for those people who preferred to take their ease and dawdle, but they were more frantic for others who felt compelled to use this new leisure to load their families in cars and take off for distant countrysides, or to catch up on household repairs. Others dedicated themselves to chasing balls on courts or courses or diamonds, to riding Friday-evening trains to ski resorts, burdened with equipment, and returning exhausted late on Sundays. Much of the new leisure was more tiring than work; it was expensive and much of it was dedicated to impressing friends and neighbors and business associates. Leisure, in other words, became as competitive as earning a living and socially was often more so.

Some men and women used their new leisure to experiment with the

arts and crafts and with the stage. The smells of turpentine and greasepaint were in the weekend air, and the words "creativity" and "self-expression" became conversational clichés. Travel, and especially travel to Europe, both individually and in "tours," grew in popularity, for the young, the middle-aged, and the elderly, partly because Europe was a bargain and partly because the war had brought foreign horizons much closer. Air travel made what not long before had been more than a week away by ship a matter of hours by plane.

This was both a bonanza and a challenge to museums. They were quick to recognize that the new leisure gave them opportunities for gratifying the curiosity and interest of a newly liberated public. When the Metropolitan, for instance, decided to experiment with a series of travel lectures, the focus of which was on works of art, they found that they were immediately oversubscribed. Schoolchildren had been shepherded by their teachers through the museum for years and the numbers had increased during the war. Taylor thought that there were not adequate ways of making the museum mean something to them, and he set aside a number of galleries and called them the Junior Museum, with a teacher expert in the arts in charge. It was a place for children, like the Children's Zoo further down Fifth Avenue in Central Park, and ingenious exhibitions with wheels to spin and pushbuttons to explain the techniques of painting and sculpture and stained glass and how colors related to each other. He provided a place for the children to eat and games for them to play. It was a way of catching an audience for art early and making at least some of its neophytes permanent devotees.

To attract larger numbers of adults to the museum, Taylor introduced international loan shows, the first of which was of English paintings from London museums. This he followed with what was the prototype for the blockbusters that almost routinely have the public standing in long lines outside many museums waiting to be herded past rarities from far places. It was an exhibition of some two hundred French tapestries from museums and churches, quite possibly as great a tapestry show as had ever been seen anywhere, and the public came in droves. It was followed by "Paintings from Berlin Museums" and in 1949 by "Treasures from Vienna." Both the mood and the circumstances were right for such exhibitions just after the end of the war. Many European museums had suffered acute damage from bombings. Many of them had sequestered their treasures, and were glad to have some of them on show in America while they shored up their damaged buildings. Others were still trying, with the aid of a small branch of the American army, called "Monuments and Fine Arts," to recover their looted treasures, a process that turned out to be long and slow and

plagued with mysterious disappearances and intrigues. European museums as well as American museums discovered that such exhibitions could be moneymakers. If the expenses were high for several years of planning and negotiating, for insurance, shipping, and experts to accompany the precious objects as they traveled and were installed, the entrance fees, the sale of catalogues and postcards and in recent years reproductions, yielded a tidy profit both to the lender and the borrower.* From the point of view of museum trustees, who to a considerable extent measure the success of their institutions by the door count, the international loan shows were profitable in other ways. The numbers of citizens who enter the doors of institutions are the most persuasive arguments for seducing subsidies out of the coffers of state and federal governments and out of foundations and corporations as well.

In addition to the millions who came each year to look, there were those, far fewer in number, who came to listen. Not only were there lectures on the fine and decorative arts for members and for the public, there were concerts, most particularly of chamber music, with programs that assiduously avoided the "standard repertory." These concerts captured faithful audiences, so faithful that to get tickets museum members had to sign up immediately upon announcement of the series or find themselves excluded.

The concerts grew logically, albeit imaginatively, out of the museum's extraordinary collection of ancient and modern instruments, the first of which had been given by the John Crosby Brown family in 1889 and which had been added to until it was regarded as the greatest collection of instruments in the world. It had been stored away, unused and undisplayed, for years, much to the dismay of the Brown family, until Taylor persuaded a Viennese refugee, Emanuel Winternitz, a lawyer by profession and an amateur of architecture and music of great learning, to consider what should be done to conserve and revitalize the collection. Winternitz, who agreed to become "keeper" (a word used in England as "curator" is used here) of the collection, was convinced, and convinced Taylor, that the only way to preserve the instruments from decay was to restore them to

*The exhibition of treasures from the King Tutankhamen tomb, lent by the Egyptian government, according to the annual report of the Metropolitan Museum for 1979, brought $2,822,251 in admissions, and approximately $20 million in sales of souvenirs of one sort or another. From this there was a net profit of $8.3 million, which by agreement with the Egyptian Organization of Antiquities was "donated to the Cairo Museum for renovation or any other cultural or archeological project in Egypt designated by the EOA." The Metropolitan also profited, as is shown by this carefully worded statement in the report: "Certain refinements made in 1979 to the procedures for determining the Metropolitan Museum's overhead expenses attributed to exhibition sales decreased the Museum's 1979 operating fund deficit by approximately $500,000."

playing condition and to use them. A result of his conviction was a series of recitals, in 1942, of Renaissance and baroque music from scores that he dug out of obscurity. He called the concerts "Music Forgotten and Remembered," and he persuaded some of his friends who were also refugees from the Nazis (among them Wanda Landowska, Paul Hindemith, and George Szell) to perform. These concerts have been justly credited with the revival of interest in early music, which is played by groups performing on ancient (or replicas of ancient) instruments throughout the country to relatively small but dedicated audiences. The concerts, which continued during the war years, were held in a gallery of the museum and were largely attended by professional musicians and musicologists. It was not until the museum constructed a proper concert hall, which it opened in 1954, that the recital series became a serious undertaking, with its own impresario, for an informed but not specialized audience.

The art boom, which was both encouraged by the Metropolitan and in turn nourished by it, was not without its commercial facets. There was more money more widely distributed in private hands after the war than before, and a new crop of potential art collectors stimulated an expanding art business that took many forms. There were new dealers catering to young collectors who were starting their collections with modest purchases of prints and drawings. Corporations during the war, when they had few consumer goods to advertise, had promoted their "corporate images," as they were newly called, images as pure and patriotic and paternal as they could make them, and there had been more and more talk (and more conferences) on the responsibility of the corporation for the public welfare. Some of this talk and some of the action that resulted from it were turned to the benefit of the arts in ways that were considered practical. Some corporations became "art patrons" in various ways and degrees. DeBeers diamonds, the Container Corporation of America, the American Tobacco Company, and Dole pineapple took to commissioning well-known "fine artists" to make paintings, which they used as the basis for advertisements. Pepsi-Cola went further and involved the Metropolitan in its ostensibly high-minded gesture to the arts. It organized a competition for which it gave prize money ($12,000 in all), and an exhibition was held at the Metropolitan in 1944. The paintings that were shown and the prizes that were given were the choices of a jury of artists. The press, whether it approved or disapproved of the works that were hung and the ones that won prizes, gave the exhibition extensive coverage, a kind of free publicity for Pepsi-Cola that was repeated in newspapers in each of the eight cities to which the exhibition traveled. The Metropolitan came in for a great deal of vituperative criticism from artists for the jury it had selected and

In the 1940s "fine art" by contemporary painters was used to promote pineapples (Dole), cigarettes (American Tobacco Company), diamonds (DeBeers) and soft drinks (Pepsi-Cola). Pierre Roy, a French surrealist temporarily in New York, painted this for Dole. A few artists profited briefly; many others thought the arts were being used for mean purposes.

for the winners of the prizes, and from other critics for having let itself be the vehicle for what was obviously a publicity ploy by a soft-drink bottler.

Sensitive editorial antennae recognized the new public interest in the visual arts and played up to it. Magazines like *Life* and *Look* increasingly devoted picture spreads to the work of individual artists who had achieved fame and to exhibitions like the blockbusters that were attracting mass

audiences to museums. The mass media, in other words, were giving recognition to the fact that museums, not long before the province of a private kind of minority public, were themselves becoming mass media. Magazines with circulations in the millions recognized their kinship with museums that also had audiences in the millions. They were, it appeared, made for one another, and as attendance at the Metropolitan grew so did its public-relations office, the number of press releases it mailed, and the number of inquiries it handled.

New York, moreover, had become "the center of the art world," or so, in any case, it insisted. Paris, which had been the acknowledged capital of painting and sculpture for a century and more (before that it was Rome), was no longer looked upon by artists as the vortex of excitement and invention and intellectual ferment. It suffered from the defeats that had been handed it by the Nazis and the embarrassment of being rescued by its allies, but more than that, so far as the arts were concerned, a number of its most distinguished artists had taken refuge in America and particularly in New York during the war. This had been greatly to the advantage of American artists, who benefited from the intellectual stimulation and from their very presence. Some of them taught; all of them talked, and the fact that the interchange took place in New York studios and not in Paris cafés, as it had in the 1920s, had attracted young artists from Europe to New York, because "that's where the action was." By the same token American artists, who a generation before would have drawn a bead on Paris, stayed on the American side of the Atlantic, where museums and dealers were making reputations for young men and women of promise and backing their enthusiasms with money.

This official and commercial concern with home-grown talent also found expression in a new interest in earlier American artists. This was especially true of artists of the nineteenth century—painters of the American landscape, generally if not quite accurately called the Hudson River School; the painters of daily life, and the American Impressionists of the late years of the century. The Ash Can School artists were looked on with new favor. What had for long been regarded by the aesthetic hard core as something close to artistic trash suddenly became interesting, not just as evidence that not all art was European or Asian, but as a revelation that America had an artistic tradition which, while not free from the influences of Europe (far from it), had a character distinctly its own.

If the Metropolitan was not quick to latch on to what was new in the American arts (for many years it left that to its neighbors, the Museum of Modern Art and the Whitney Museum of American Art), it was in an unassailable position as the custodian of the nation's greatest collection of

American eighteenth- and nineteenth-century art and artifacts. The American Wing, which had been established in 1924, was a collection of American decorative arts at that time second to none.* The storerooms of the Metropolitan were rich in American paintings from the nineteenth century, which it was proud to be able to bring to light again when fashion in the 1940s began to smile once more upon them. In the 1970s the museum started construction of a vast addition, which would not only incorporate the period rooms and galleries of the American Wing but provide extensive wall space for paintings and a glassed-over courtyard for the exhibition of sculpture and stained glass in a setting of flowers and reflecting pools. At one end of this towering greenhouse is the dignified façade of an early nineteenth-century New York assay office.

"The Met," a Complex of Museums in One

More hungrily and ambitiously than any other museum in America the Metropolitan has reached out in all directions to gather to itself every kind of art that can be said to have expressed the visual aspirations, genius, and skills of mankind, sophisticated or primitive, up to, but not including, the cinema or television, though these media are used by the museum for instruction of the public. Unlike many great museums which see their function as collecting and displaying art of a particular nature, civilization, or historic period, the Metropolitan is an aesthetic department store. There is something for everybody, though it tends, as many department stores now do, to be a collection of independent boutiques.† Unlike the National Gallery of Art in Washington and the National Gallery in London, both of which concern themselves primarily with painting from the Middle Ages to the present, and leave ancient and primitive arts to other institutions, the Metropolitan feels impelled to have them all, and most of them under one irregular, awkwardly joined but continuous roof. The annual report of the museum in 1980 listed nineteen curatorial departments, ranging in historic time from Egyptian Art to Twentieth Century Art and in kind from Decorative Arts to Prints and Photographs, Musical Instruments, and Primitive Art. All of this, with the exception of Medieval Art, occupies

*It is now rivaled by Yale's Garvan collection and in some respects overshadowed by the Winterthur Museum created by Henry F. du Pont near Wilmington, Delaware. Du Pont started collecting in the 1920s, and the collection continues to be enlarged and refined. It occupies more than a hundred rooms.

†Professor Neil Harris of the University of Chicago in an unpublished lecture has convincingly demonstrated that the arrangement of art in museums since the nineteenth century has been strongly influenced by department-store methods of merchandising and display.

When the American Wing of the Metropolitan Museum expanded in a new addition in 1980, it included a glassed-in garden courtyard to protect its sculpture and the façade of the 1823 Assay Building from the ravages of New York air pollution. *(The Metropolitan Museum of Art)*

the four-block-long, grown-up-like-Topsy building on Fifth Avenue. Medieval Art has its separate museum, the Cloisters, which looks down on the Hudson River from a lofty hill in Fort Tryon Park near the top of Manhattan Island. It was the gift of John D. Rockefeller, Jr.

Calvert Vaux's original Fifth Avenue home of the Metropolitan Museum was swallowed up in the vast expansion of the museum behind Richard M. Hunt's Beaux-Arts façade. This 1979 print of "Metropolitan Museum, Central Park" by Richard Haas looks down the avenue from the north. The sloping "glass box" houses the Temple of Dendur. *(The Metropolitan Museum of Art, Gift of Richard J. Haas)*

"Each of the departments is a private duchy," a former vice-director for public affairs at the museum said to me, "and they scarcely speak to each other."

The Metropolitan, then, is a collection of museums, any one of which could stand by itself. By no means is all of its wealth visible at any one time. There are enough paintings of good quality, enough decorative objects, sculptures, and ancient artifacts in storage to enrich the collections of many lesser American museums. Some objects from the collection are always on semi-permanent loan to other institutions to supplement their holdings. Like all major museums, the Metropolitan has a policy of deaccessioning works that have been given to it or which it has purchased in the past, objects that do not measure up to the quality the museum seeks to maintain or that duplicate or closely approximate other objects in the collection. There have been times when the Metropolitan has considered establishing branches in the several boroughs of New York City, but experience appears to indicate that the public much prefers to make a pilgrimage to a great center of art rather than to drop into a local, less-impressive offshoot where, they would be sure, they could see only second- or third-string works from the collection.*

The public's view of the Metropolitan is in some respects a proprietary one; the museum belongs to them. It is supported by their taxes, their memberships, and their contributions. It is one of the ornaments of their city. It is, however, an awesome temple to a very large percentage of them, a place to be worked at rather than to relax in, a place where feet grow weary and eyes glaze over. It is not a friend with whom to have casual conversation or to be entertained by; it is an arm's-length acquaintance at best.

The museum's trustees have a different sort of proprietary attitude. It is *their* museum, and they are ultimately responsible for it financially as part of a public trust that they have agreed to administer. It is up to them to see that the bills are paid and that the money is raised to pay them, but their interest, if not their responsibility, does not stop there. They are also ultimately responsible for the quality of the museum's holdings, its building, and what is shown in its galleries. This they delegate in large part to the director and the curators, though, as a curator observed, "Every trustee is a curator manqué."

The trustees maintain at least a semblance of control over the aesthetics of the museum by means of a purchasing committee, to which the

*One New York museum, the Whitney Museum of American Art, has two branches where exhibitions from its permanent collection are shown.

director and the curators concerned must submit for approval any object above a certain monetary value.* The amount varies with time not with category. Such submissions can run into the millions of dollars and in recent years occasionally have. One of the measures of how "important" a work of art is may not be how greatly needed it is for the collection, but how many millions it costs. The public will line up for hours to see a Rembrandt that cost $2.3 million, as they did in 1961 to see "Aristotle Contemplating the Bust of Homer," a picture they would amble past unimpressed if it were installed without fanfare. This is not to suggest that it was not an acquisition of the very first importance. Soon after the museum acquired it, a small boy stopped at the information desk and asked, "Where's the hundred-dollar picture?"

The attitude of curators to most trustees is one of resigned suspicion. Theirs is the mistrust of the professional for the judgment of the amateur. Curators know that they cannot bully trustees, so they must seduce them, often with flattery, to accept their recommendations. Indeed, the curator's job, like the director's, is the seduction of trustees (though perhaps to a lesser degree) and of collectors whom he hopes to convert into donors. (I say "he" though there is an increasing number of women who are curators and museum directors.) He pursues foundations and corporations in hopes of convincing them that they should support the high cost of special exhibitions; they can run into the hundreds of thousands of dollars. He woos them for funds for publication programs and for expanding or refurbishing the galleries.

The curator's view of the museum is bifocal: the distant view is of people crowding the galleries over which his department holds title, the estates of his duchy. The closeup view, which he prefers, is of the objects that it is his responsibility to know more closely than he knows his closest friends, to study and care for, where necessary to commit to the tender care

*Walter Pach, a painter and critic, in *Queer Thing, Painting* (Harper, New York, 1938, p. 312) gives a chilling example of trustee interference, if that is the word, in the Metropolitan's aesthetic decisions. Bryson Burroughs, the curator of painting in the 1920s, had spotted an "Odalisque" by Ingres in Paris that he very much wanted to buy for the Metropolitan's collection. The trustees said that they would not buy it without seeing it and its owner would not send it across the Atlantic "on spec." So Burroughs arranged with the collector Henry Walters of Baltimore to agree to purchase it if the Metropolitan should turn it down. Burroughs invited Pach to see the picture when it arrived, and together they "borrowed some velvets from the Renaissance department, to serve as a background; we studied the right lighting, and the right distance at which to arrange the chairs in front of our treasure." When he came back the next day to congratulate Burroughs on the purchase, he was told that the trustees had refused the picture. "They couldn't! But why?" Pach said. "Because," Burroughs replied, "as they told me, it isn't well drawn." As Pach wrote, "Ingres was revered [in Paris] as the greatest master of drawing that France has produced." The "Odalisque" went to the Walters Gallery in Baltimore.

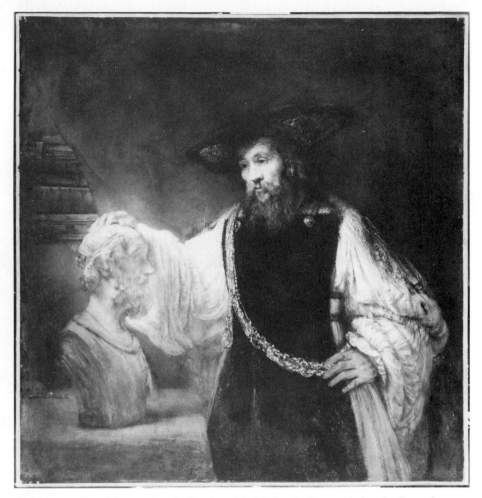

The Metropolitan Museum bought Rembrandt's "Aristotle Contemplating the Bust of Homer" in 1961 for $2.3 million, in those days a breathtaking price for a painting. Today no masterpiece of equal importance would go at auction for less than twice that figure. *(The Metropolitan Museum of Art)*

of the museum's hospital—its department of conservation, where wounds are healed and preventive medicine is administered. He is a scholar with a taste for the intrigue and rough-and-tumble of the art market, with the instincts of a bloodhound and the doggedness of a sleuth. He must be sensitive to the vagaries of fashion and able to anticipate where it will next alight, so that he can purchase at the low tide of the market and not be caught at its flood among avid collectors eager to be in on the latest thing. In other words he must recognize quality before his competitors and his

constituents do. To a very considerable extent it is curators and dealers who not only create the audience for the arts but lead it by the nose.

The attitude of academic art historians toward curators and museum directors is commonly one of mistrust. They do not regard curators as serious scholars but as dilettantes and showmen, and they look upon their publications as pandering to the public. The trustees, however, are the real enemy of the scholars; they believe that trustees should mind their own business, which is to be the spigot through which money flows into the museum's coffers for the professional staff to spend. Such attitudes are by no means peculiar to the way in which scholars view the Metropolitan. It is an American scholarly attitude. Trustees of European museums, they are quick to point out, keep their hands off the aesthetic affairs of the institutions on whose boards they sit.

The essential differences between the Metropolitan Museum and other municipal museums of art in America are ones of scale not of kind. They, like the Metropolitan, seek to please and instruct the same kinds of audiences, which they attract in the same ways and for the same reasons. They seek to be ornaments to their communities and to serve them, while, at the same time, they attempt to preserve their stance as cathedrals and sanctuaries above mundane concerns and commercial matters. Most municipal art museums outside New York rely heavily on volunteer help, mostly from women, to organize and train docents, to run special parties and lecture and concert series, and in a variety of ways to involve the public closely in the museum's daily operations. They absorb many necessary museum tasks that do not require special skills or training. These are the culturettes without whose unpaid services many cultural institutions would find it impossible to operate on a scale and in a manner that the art audience has come to expect, indeed to demand.

Cooper-Hewitt Museum—Design for the Public Taste

The museum called Cooper-Hewitt* occupies the sixty-four-room mansion at Ninety-first Street and Fifth Avenue in New York that Andrew Carnegie built in 1900 for his retirement. It was conceived with very different motives from those which inspired either the Yale Art Gallery or the Metropolitan Museum. Its founders were no less intent on refining the public taste, and they envisioned the extent of their museum's influence as quite possibly limitless. It was a museum for the designers of all manner

*Its full name is Cooper-Hewitt Museum, the Smithsonian Institution's National Museum of Design.

of artifacts to which the public is daily exposed and with which it surrounds itself. It was a museum of a kind new to America, if not to England and France, and it was a product of industrialism, or, as its founders regarded it, industrialism's failure.

Unlike the Metropolitan, the Cooper Union Museum (for that is what it was called until 1976) was not planned to be a refuge from the intensity of a commercial, polyglot metropolis and seaport; quite the contrary. It was conceived in the 1890s as an adjunct to commerce, but it shared with the Metropolitan and other art museums of the nineteenth century a dedication to the improvement and purification of the public taste, to the sandpapering of the public sensibilities, so that the public might put its vulgar appetites behind it and turn with delight and appreciation to the refinements of art and craftsmanship. It set out to meet head on what Joseph Choate suggested the Metropolitan might do as a by-product—to act as an inspiration to designers and through them to improve the public taste for the things with which people surrounded themselves. In other words its founders expected the numbers of those who would be indirectly affected by their museum to be vastly larger than the numbers of those who would come to inspect its collections, visit its exhibitions, and use its extensive archives of design. And this, indeed, is what happened.

The Cooper Union Museum was not prompted and organized by a group of eminent citizens acting for the public at large. It was the brainchild of two rather eccentric young women, with remarkable energy, determination, humor, and independence, and very discerning eyes. They were granddaughters of Peter Cooper, who founded the Cooper Union in New York in the 1850s as a free school to provide education in the sciences and arts for young men and women who could not afford to purchase such training. He did it, he said, so that others might have opportunities that were denied to him as a boy. Cooper had made a considerable fortune, most of it in the iron business and from inventions of one sort or another. One was a machine for mortising carriage hubs invented when he was in his teens (it was still in use seventy years later), another a steam engine, the first one profitably operated in America, and another a machine for shearing cloth, the rights of which he sold to Matthew Vassar.

Cooper had no interest in or knowledge of the arts whatsoever, and his concern with design was of an entirely practical sort. Architecture was of that sort and so was engineering. In his original plans for Cooper Union he set aside the fourth floor of the great red stone building in what is now called the East Village for a museum that would demonstrate, in his words, "the true philosophy of life." This meant to him examples of natural wonders, and he went so far as to buy a stuffed white whale. But his plans

The Cooper Union Museum, parent of the Cooper-Hewitt Museum in New York, was organized by Peter Cooper's granddaughters, Sarah and Eleanor Hewitt, as a training ground for student designers and an inspiration for professionals. These students were at work in 1915 copying a flower piece that inspired many textile and wallpaper designs. *(Courtesy of the Cooper-Hewitt Museum)*

for a museum were allowed to slumber, partly because he saw the Metropolitan Museum of Art and the Museum of Natural History on the near horizon.

It was not until 1897, fourteen years after Cooper's death at the age of ninety-two, that Sarah and Eleanor Hewitt, his granddaughters, opened the Cooper Union Museum for the Arts of Decoration. It occupied the space that Cooper had planned for his museum on the fourth floor of the Union. The young women, still in their twenties, had been brought up in an atmosphere of wealth by parents both of whom were interested in the arts. Their mother was Cooper's daughter and their father, Abram Hewitt, was his junior partner in the iron business. Hewitt was a man of fierce and unbending integrity, with a quick but friendly wit, astute in business and with a knowledge of the arts which, as a young man traveling in Europe as tutor to Peter Cooper's son, Edward, he had been at some pains to

cultivate. His prominence as a citizen of New York (he served in Congress as a representative of the city and for one term was its mayor)* stood his daughters in good stead in rallying support to the creation of their museum.

When Sarah and Eleanor Hewitt (known as Miss Sally and Miss Nelly) decided that they would do what their grandfather had wanted to do, establish a museum at Cooper Union, their ideas of what its nature should be were very different from his. Theirs was to be a museum of design, an adjunct to the design and architecture courses at Cooper Union, a museum of excellence that would not only inspire the students but would provide them with examples from which to copy and, presumably, to develop their own skills and imaginations. But it was not for that purpose alone. It was also to serve as a source of inspiration and example for all designers, professionals as well as students, for manufacturers of textiles and wallpapers and furniture, of glass and ceramics and jewelry. It was to be an American equivalent of the Musée des Arts Décoratifs in Paris and the South Kensington Museum in London.

If this appears to have been a preposterously ambitious program for a pair of young women, it was. They were amateurs with no education except what they had received from governesses and tutors and, in Sarah's case, a brief season in a finishing school. They had made the annual trips to Europe which were then considered *de rigueur* for rich young women, accompanied by their mothers, and they had traipsed from museum to museum with their senses alert. They had been brought up in a large city mansion surrounded with the fashionable furnishings of the day, and they had started collecting on their own when they were still in their teens. With money saved from their allowances they had bought for their own pleasure half of the Jervis collection of ancient textiles (not to be confused with the Jarves collection at Yale), the earlier half that ranged from the twelfth to the sixteenth centuries. It became the nucleus of what is now said to be one of the three or four greatest textile collections in the world.

The evolution of the Cooper-Hewitt collection is basically the story of a couple of dilettantes with unswervable purpose and persuasive enthusiasm, which attracted the physical help and financial support of many. In its early days the museum employed no professional scholars or trained curators. The Hewitts and their friends did the daily dirty work of arranging and classifying and filing. They developed what they called "encyclope-

*He ran on the Tammany Hall ticket with a reputation as an opponent of the notorious Boss Tweed. He defeated young Theodore Roosevelt and Henry George, the founder of the single-tax movement, for the office in what has been called "one of the most exciting elections in the history of the city."

dic scrapbooks," filled with pictures taken from magazines and books and with photographs from other museums, so that there were literally hundreds of thousands of examples of every conceivable form of design—mantels, altars, chairs, textiles, musical instruments, and on and on. They began to gather a library of design which is now said to be the most extensive in the country. It was not, they made sure, just a collection of books and periodicals dealing with decorative objects, but a library as well of the sources to which designers have always turned: ornithological books, books of plants and beasts and insects, for the obvious reason that 90 percent of ornament is drawn directly or indirectly from nature.

The Hewitts modeled their museum on the Musée des Arts Décoratifs in Paris, which had opened in 1877. It was sponsored by a society of French designers of furniture, textiles, carpets, and other decorative materials; they were afraid they were losing their preeminence to the British as a result of the Crystal Palace exposition in 1851. The exposition had drawn international attention to Prince Albert's determination to make a marriage between the arts and industry, a domain the French had looked upon as their own. The Paris museum, which had been organized to serve as a center of instruction and inspiration for French designers, was an imperative stop on the Hewitts' annual visits to France. When the young women made known their intention to start a similar collection for a similar purpose in New York, the museum's directors were, Eleanor Hewitt wrote, "singularly broad minded and perhaps secretly amused at the youth and inexperience of their collaborators" and "were generous with their thought and time." With the help of the Paris museum they acquired plaster casts of "the best French periods and styles by Masters of Ornament." These were paid for by Mr. and Mrs. Hewitt and shipped to Cooper Union to form what Miss Hewitt called "the nucleus and backbone for the teaching collection."* But the teaching collection was by no means merely a matter of pictures and casts, and the rapidity with which it grew and the distinction it achieved were remarkable.

In the beginning the museum was funded almost entirely by the Hewitt sisters, their parents, and a few close friends, but it soon attracted generous donors, not just of examples for the collection but of money for purchases. Among these early friends of the museum were J. P. Morgan and George A. Hearn, a department-store magnate, whose Hearn Fund is still the Metropolitan Museum's principal source of money for the purchase of contemporary American art. Hearn insisted that "the ladies" have

*Like the collection of casts of ancient sculpture with which the Metropolitan beguiled the public in its earliest days, these casts, now replaced by authentic examples, have been retired from the collection.

a council of interested friends, not just for the purpose of advising them but to raise money. He proposed a number of prominent businessmen, lawyers, collectors, and artists, and though the Hewitts were reluctant at first (they did not want to be interfered with), they acquiesced. The council met for the first time in 1907, ten years after the opening of the museum, and lasted until after the death of the Hewitt sisters in the 1920s. It did what Hearn wanted it to do: "give sanction and approval to the good already accomplished and to aid so far as possible the work in the future by making the scope and value of the museum better known and securing more general recognition of its value and, if possible, pecuniary aid." The council was not only richly productive of funds and gifts, but it formalized the museum and made it more than just a personal project.

Morgan's role was quite different from Hearn's. Morgan was a friend and business associate of Abram Hewitt, who served on the board of directors of the United States Steel Company more or less as its conscience. One evening at a men's dinner, he asked Hewitt what "the girls are principally interested in now." Hewitt told him that they had their eyes on the Badia collection of textiles which was for sale in Barcelona. Morgan asked Hewitt to have "the girls" send him the details about the collection as he was about to go to Europe and would look into it. A few weeks later a cable came from Morgan to Hewitt which read: "Have purchased the Badia Collection of Barcelona, also the Vives Collection of Madrid, and the Stanislas Baron Collection of Paris. I do this to give your daughters pleasure." By this stroke the young museum found itself in the same class as the South Kensington Museum (the Victoria and Albert), where textiles were concerned, and had examples that even the superb collection of the Berlin Museum could not boast.

The Hewitt sisters took a skeptical view of curators for reasons which are less applicable today but which still prevail in some corners of some museums. They looked on curators as hoarders, as men and women who sequestered the works over which they presided so that they and no one else might work on them. The Hewitts wanted none of this. They believed in making everything in their museum as handy and available as possible. They mounted precious textiles on panels where students could easily examine and readily draw them. (Today's conservators would be shocked by such casual treatment.) Books of great rarity could be had for the asking by anyone seriously interested in turning over their pages for information or ideas, and materials for copying (paper, tracing paper, and pencils) were supplied by the museum. The Hewitts made few rules about access to the museum's study rooms and galleries and the collections in them, a freedom

that museums today would regard as hopelessly reckless.

Students in the Cooper Union art school had first call on the museum (the art school was essentially a trade school for designers), but professionals used it constantly. One of the measures of the museum's effectiveness in the eyes of the Hewitts was how many designs, whose inspiration was discovered in the collection, found their ways into commercial production, most commonly as textiles and wallpapers. Designers for the theatre came looking for ideas and historical precedents for sets and costumes, architects looked for details of mantelpieces and examples of plaster ornaments for ceilings, and decorators looked for "window treatments."

When in 1919 Eleanor Hewitt presented a paper at a New York ladies' literary club on the work she and her sister had accomplished, she called it "The Making of a Modern Museum."* By "modern" she meant a museum not for emotional titillation or intellectual stimulation but for practical use, a museum that operated in a pragmatic manner. She did not mean "modern" as a description of a style or aesthetic attitude, as the Museum of Modern Art was to use the word some thirty years after the Hewitts opened their museum. The Hewitts did not see the salvation of American taste from the demons of Victorian clutter of fringe and tasseled lambrequins and bulging horsehair sofas in what was being touted as "honest" furniture at the end of the century by disciples of William Morris. They were not interested in the American Arts and Crafts movement as it was exemplified by Gustave Stickley's *Craftsman Homes,* or in Mission furniture (functionalism's precursor) or in Art Nouveau, which they thought hideous. Their eyes turned back to the eighteenth century as the standard of design that could be the salvation of America from the blowzy vulgarity of the nineteenth-century taste for bric-a-brac and gewgaws, cozy corners and Turkish nooks. It was an attitude they shared with Edith Wharton and with their friend Elsie de Wolfe.

The objects that the Hewitts collected to serve as examples for the twentieth century came largely from the eighteenth century and before. The sisters looked to the aristocratic tastes of pre-revolutionary France, especially, but also to Italy and Germany and England as standards that should be observed by twentieth-century Americans. But it should be borne in mind that those whose taste they sought to affect were the rich. The turn of the century was a time when wealthy Americans were building country houses, based on aristocratic designs of extravagant splendor, in

*Miss Hewitt also used the paper as a report to the museum's council, and it was subsequently published as a pamphlet.

parklike settings with formal gardens and artificial lakes and fountains whose basins abounded in goldfish. The houses were echoes of Palladian villas and chateaus and English country houses. It was the "era of the country house," when Carrère & Hastings built a replica of Louis XV's Petit Trianon in Lenox in the Berkshires, and a half-timbered Tudor mansion in nearby Great Barrington, which had, among other appurtenances, a walled Italian garden, two artificial lakes (one with a marble landing dock), and what were reputed at that time to be the "largest private greenhouses in America."

Not just the Berkshires, but the vicinity of Bar Harbor in Maine, Newport, Rhode Island, and Southampton, Long Island, all summer retreats for the rich, and Grosse Pointe, a Detroit suburb, were the sites of such splendid houses. They required dozens of servants (the Lenox Petit Trianon was said to have a staff of one hundred in all) and gardeners and coachmen and stable boys to keep them trim and sweet smelling, the gravel in the driveways raked after the approach of each vehicle, their topiary hedges clipped, their silver and crystal and their marble mantels gleaming, their vases filled with fresh flowers, and their birdcages with fresh canaries.*

The Hewitts believed that if the taste of the rich who lived in such houses as these, and in somewhat less splendid ones, could be disciplined (or coaxed) to "suitability," such taste would gradually by emulation have an effect on those less prosperous. Taste, they were convinced, was a matter of sensibility not of prosperity, and they put their faith in the "trickle-down" effect, which tastemakers in the arts and engineers of fashion have always set great store by. It is not surprising, therefore, that the objects that the Hewitts gathered and displayed on the fourth floor of Cooper Union were pieces made for the rich and the designs for such objects. The collection of drawings which they started with their private purchases and then with groups of drawings bought from other collectors (most notably the Piancastelli collection, bought from the curator of the Borghese Gallery in Rome; it was his private collection of architectural and decorative drawings from the sixteenth through the eighteenth century), now numbers more than fifty thousand pieces. There are some thirty thousand prints of every sort, from the engravings of Mantegna and Dürer and the etchings

*At the P. A. B. Widener house in Elkins Park, a suburb of Philadelphia, there were numerous birdcages in the ballroom. The birds, which were subjected to drafts, frequently toppled from their perches, victims of pneumonia. It was the housekeeper's job to see that they were replaced. The Hewitts preferred their birds stuffed. When a friend gave them a pair of peacocks for their country place in Ringwood, New Jersey, they found the birds' screeching so unpleasant that they had them shot, stuffed, and installed on the newel posts of their house in New York at 9 Lexington Avenue.

of Rembrandt to thousands of nineteenth-century fashion prints and twen-
tieth-century posters.

Some parts of the collection came in large windfalls, like the prints
given by Avery and the textiles by Morgan. A remarkable library of 413
books of French eighteenth-century designs was purchased with funds
provided by the council from a sympathetic French collector and retired
architect, Léon Decloux, who parted with them for less than they were
worth. He heartily approved of the purpose for which the Hewitts were
assembling the treasures for their museum. And so the collections and the
library and picture files grew, and the galleries became filled with decora-
tive objects, valuable for their rarity or their authenticity or their use as
examples from which to take inspiration.

Even as early as 1905, only eight years after the museum opened, it
was bursting at the seams and there was talk of taking over another floor
of the Union. This did not transpire, but increasingly materials were lent
to other museums to enhance their collections, and there were plans for
traveling shows, though these did not commence for many years. The
general public was little aware of what was to be seen at Cooper Union's
museum. An article in the *New York Times* called it the Union's "crowning
glory" and urged the public to have a look. But the attendance was small,
except for visits of professional designers and knowing collectors of the
decorative arts. It was not until after Eleanor Hewitt died in 1924 and her
elder sister, Sarah, in 1930 that three of their friends took over as volunteer
"directors," and a professional was hired to assume the administration of
the museum. The directors wooed Calvin S. Hathaway away from the
Decorative Arts Department of the Philadelphia museum to accept a
position as curator. He had a connoisseur's assurance and was a meticulous
"housekeeper," with a thorough knowledge of modern museum tech-
niques. He put the collection in order, in a scholarly sense, catalogued it
by what were then up-to-date methods, and took steps to protect and
conserve it. He initiated a publications program and a series of exhibitions
to make the museum known beyond the circles of designers, decorators,
connoisseurs, and collectors. In other words he set about to modernize the
Hewitts' "modern museum."

A Threat, a Rescue, and a New Life

In 1961, figuratively speaking, the roof threatened to fall in. The
trustees of Cooper Union and its president came to the conclusion that the
museum was a drain on the Union's finances that threatened its teaching
programs in science and the arts—the very reasons for the Union's exis-

tence. They decided that they would have to get rid of the museum, and they invited the recently retired director of the Cleveland Museum, William M. Milliken, to evaluate the collection, not, it appears, to help them decide whether to keep it but to find out what it might be worth on the market. Milliken found it superior to the Metropolitan, the Morgan Library, and other major museums in some respects. There was no collection of textiles in America that approached the Cooper Union's, for example, and its decorative drawings were equaled only by the collections of the Musée des Arts Décoratifs and the Bibliothèque Nationale in Paris.

But the trustees decided (if, indeed, they considered it at all) that to sell the materials was not a proper manner of ridding themselves of the burden of maintaining them. They decided that the collections should be dispersed to other museums. James Rorimer, at that time director of the Metropolitan (on whose board Arthur A. Houghton, Jr., chairman of the Cooper Union trustees, also served), was invited to review the collection to see what the Metropolitan might like to annex.* A small news item appeared on a back page of the *New York Times* on June 30, 1963, saying that "plans for the museum's dissolution were being studied." In a "fact sheet" issued at the same time, the trustees made the point that the museum no longer served the educational purposes of the students of art and architecture at the Union, a situation precisely comparable to that we have noted in the relation of college art museums to students of painting and graphics and sculpture.

But if the students were not interested in what happened to the Cooper Union museum, the immediate community (Greenwich Village) was and so almost to a man was the art community, not just in New York, but wherever the supporters of art museums might be. A howl went up—from museum directors and curators, from critics, art historians, magazine editors, collectors, and dealers. A Committee to Save the Cooper Union Museum sprang up like a jack-in-the-box, with Henry F. du Pont, who had created the Winterthur Museum, as its chairman and an impressive list of eminent members of the art world as its members. They worked hard, raised funds, and finally, having obtained pledges of more than $800,000 to tide the museum over until it could be settled elsewhere, made an agreement with the Smithsonian Institution in Washington to take it under its vast umbrella and become its parent organization. S. Dillon Ripley II, the secretary of the Smithsonian, persuaded the Carnegie Corporation to rent the Carnegie mansion for a dollar a year, and not long after that to

*He was particularly interested in the textile collection. When he told Alice Baldwin Beer, its curator, that "Mr. Morgan really meant the textiles for the Met," Miss Beer replied, "But, Jimsie, *we* have the telegram."

present the building to the Smithsonian as a permanent home for what was renamed the Cooper-Hewitt Museum. After extensive remodeling, in which great care was taken to retain the character of the house and at the same time give it the flexibility of a working museum, it opened in 1976.

With its new home and a new director, Lisa Taylor, the first woman to administer a museum under the Smithsonian's aegis, the museum's audience changed radically. It no longer saw its function solely as a study center for designers, scholars, and collectors. Its mission was no longer looked upon as improving the public taste by instructing and inspiring designers who would affect the products of manufacturers and through those products raise the level of quality that the public would demand. It reached out to a larger, less cohesive public than its founders envisioned, indeed the same kind of public that the Metropolitan set its sights on. Since design affects everybody, everybody was a potential member of the con-

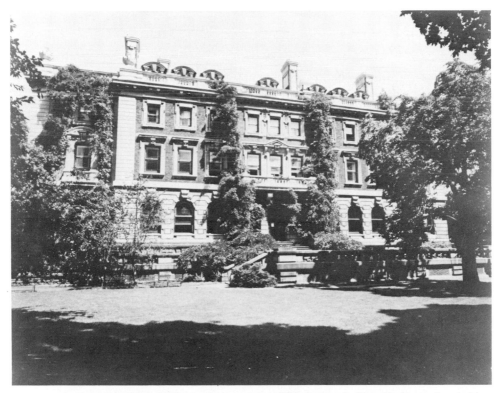

Andrew Carnegie's 1900 mansion on upper Fifth Avenue in New York was donated by the Carnegie Corporation in 1972 to the Smithsonian Institution to house the newly-organized Cooper-Hewitt Museum. After extensive but discreet renovations it opened in 1976. *(Courtesy of the Cooper-Hewitt Museum)*

stituency of the Cooper-Hewitt Museum. The door count, which had been of minor interest to the Hewitts (its meager attendance was one of the Union's trustees' excuses for jettisoning it), became important to the new administration. Mrs. Taylor was determined to make the museum more than just a modest, albeit rare, jewel pinned to the bosom of New York; she wanted it to attract as much notice as a diamond tiara.

She initiated a series of exhibitions of decorative and useful objects—as precious as rare ceramics and as everyday as shopping bags—treasures from the museum's own collections, and of architectural models ingeniously displayed, with drawings to explain and enliven them. She borrowed exhibitions of rare embroideries from the Musée des Arts Décoratifs and complemented them with examples from the museum's own textile collection; three or four major exhibitions each year were supplemented by a dozen minor shows. Mrs. Taylor established an educational program (as she had done at the Smithsonian in Washington before she came to the Cooper-Hewitt) that included not just lectures on the decorative arts but practical courses in crafts. There were concerts, poetry readings, special classes for children. She initiated a graduate program in the Decorative Arts, the first of its kind in America.* Within a year after the museum opened in the Carnegie house, its attendance in a week exceeded the numbers who got to the fourth floor of Cooper Union in a year. The art public was beguiled.

Since the Hewitt sisters started their museum of "good taste" (for that essentially was what they thought it to be), and Edith Wharton published her book *The Decoration of Houses,* with the architect Ogden Codman, Jr., in 1902, interior decoration as a profession has come into being. There had been part-time decorators before 1900, of course. Architects like Codman designed the interiors of rooms, as he did for the Vanderbilts' "cottage," The Breakers at Newport, and furniture designers and upholsterers advertised themselves as interior decorators early in the nineteenth century. In general, though, decorating was a by-product of some other business, as it was in the case of Louis Comfort Tiffany, the designer of glass and painter of romantic pictures.

It was Elsie De Wolfe, an actress better known for her chic and her clothes than for her thespian talents, who gave up the stage in the early years of this century to become the first full-time professional decorator. She made a fortune telling the rich how they should and could live in

*This degree-granting program was organized in cooperation with the Parsons School of Design. Unlike the graduate program at Winterthur, which concerns only the American decorative arts, this program includes all times, nations, and kinds.

Andrew Carnegie's New York music room was converted into space for temporary exhibitions by the Cooper-Hewitt Museum. Its exhibitions have ranged from models of Palladio's architecture, as here, to textiles, tools, furniture, ceramics—anything that has its origins in design. *(Courtesy of the Cooper-Hewitt Museum)*

"suitable" surroundings and spent their money for them. Miss De Wolfe (who later became Lady Mendl) was a friend of the Misses Hewitt and an early supporter of their museum. She was also a disciple of Edith Wharton, though they were evidently not acquaintances. (Mrs. Wharton was a serious literary woman to whom chic was not important, though design and taste were.) Miss De Wolfe's book, *The House in Good Taste,* published in 1913, by which time she was famous, was based on the Wharton-Codman doctrines of "suitability" and on visual if not financial restraint.

Elsie De Wolfe's success as a decorator inspired thousands of women to set themselves up in the decorating business, some of them if not well-trained at least knowing in the same ways the Hewitts were, through long interest and exposure. The professionalization of interior decorating in America can be traced directly to the Misses Hewitt in the 1890s and their determination to train designers and through them to improve the quality

of the American home, to Edith Wharton and her influential book, and to Elsie De Wolfe and the considerable glamour she brought to the new profession, which she claimed to have invented. At the turn of the century there were very few professions open to women—nursing, secretarial jobs, and teaching were essentially their choices. There were, to be sure, distinguished women scholars, a very few physicians, and a teaspoonful of architects, which included the young woman who designed the Women's Pavilion at the Chicago World's Fair of 1893. To be an interior decorator required self-assurance, a conviction that one's taste was superior to that of one's clients, a knowledge of the market for furniture and decorative fabrics and wallpapers, and a letterhead. Gradually the profession organized itself into associations (the American Society of Interior Decorators and the National Association of Interior Designers, now combined as the American Society of Interior Designers) with thousands of members, who not only do interior decorating in people's houses, but in business offices, hospitals, hotels, and every other interior space, including workrooms and factories. Most architectural firms now have either resident interior designers or consultants on whom they call. Most large department stores provide the services of interior decorators to their customers.

Interior design as a profession (it could be called in today's business argot "decorative arts management") is part of a trend in tastemaking away from amateurism that started early in the nineteenth century. The Metropolitan Museum, like the Yale Art Gallery, was the creation of amateurs in much the same way, if not in similar circumstances, as the Cooper Union Museum. As these institutions grew, their trustees came to rely more and more on trained professionals to conduct the institution's business, though they (the trustees) did not and have not entirely relinquished their hold over decisions of taste and connoisseurship.

As the art boom, which is part of a larger "culture boom," has gathered momentum since World War II, so have the social perquisites of serving on the boards of art museums. It has become at least as desirable, and in some communities more desirable, for a young man or woman to be elected to the board of a museum or other cultural institution (the symphony, for example) as to serve on the hospital board. It stamps him (especially him*) as a man not only of conscience but of culture, and this can be a stepping stone in professional or business recognition. Cultural boards are stocked with "the right people." Executives with their plates filled with commitments and tangles are eager to sit on cultural boards; just

*Women's identification with cultural causes has long been taken for granted.

as a publicized involvement with the arts improves "the corporate image" (*vide* corporate support of exhibitions and public television) so a position on a cultural board improves the personal image both within the corporation and in the community. A "young person going places" finds a position of cultural responsibility advantageous to his or her career.

In the decades during which the Misses Hewitt and their friends undertook to make the Cooper Union Museum a useful institution (it is unlikely they would have said "socially useful," for "social" then in their circle implied "Society"), the "lady bountiful" attitude toward "helping the less fortunate" was still part of the genteel tradition. They believed with Mrs. Wharton, who wrote in the introduction to *The Decoration of Houses:*

> If it be granted for the sake of argument that a reform in house-decoration, if not necessary, is at least desirable, it must be admitted that such reform can originate only with those whose means permit of any experiments which their taste may suggest. When the rich man demands good architecture his neighbors will get it too. The vulgarity of current decoration has its source in the indifference of the wealthy to architectural fitness. Every good moulding, every carefully studied detail, exacted by those who can afford to indulge their taste, will in time find its way to the carpenter-built cottage. Once the right precedent is established it costs less to follow than to oppose it.

Because of the professionalization of the art and taste business the taste of the rich is no longer expected to trickle routinely down to those of modest means. The arbiters of taste are legion; they flourish for all incomes in magazines and newspapers, in stores and on television, and, of course, in museums, above whose marble and glass temples there seems even today to float a nimbus of sanctity.

The Museum of Modern Art

Thirty-two years after the Misses Hewitt founded their museum to correct the prevailing American taste through improved design, the founders of the Museum of Modern Art offered the public an antidote for the Hewitts' backward-looking gentility. As the Hewitts set out to focus the eyes of their contemporaries on the delights of the eighteenth century, so Abby (Mrs. John D., Jr.) Rockefeller, Lillie P. Bliss, and Mary Quinn (Mrs. Cornelius J.) Sullivan were determined to make the public aware that art is a continuing process that requires people to readjust their sights, sometimes acutely. In the winter of 1928–29 Mrs. Rockefeller and Miss Bliss met by chance in Cairo, where they had gone to escape the New York winter. They were old friends, who shared a common interest in the new

art of the day, and they concluded that the time had come when New York (and incidentally America) should have a museum in which the public could see the vital modern painting and sculpture that were considered shocking by most people, including the trustees of most museums. By good luck Mrs. Sullivan was a passenger on the ship on which Mrs. Rockefeller sailed back to New York, and they discussed the plan that had been hatched in Cairo. The result was the opening of the Museum of Modern Art in a small gallery on the twelfth floor of an office building on Fifth Avenue and Fifty-seventh Street less than a year later. When "the ladies," as they came to be called at the museum, made up their minds, things happened.

The Hewitts represented the polite taste of the pre–Armory Show generation. The taste of Mrs. Rockefeller, Miss Bliss, and Mrs. Sullivan, on the contrary, was, if not rooted in the Armory Show, greatly affected by it. Miss Bliss was a protégée of Arthur B. Davies, who played such an important role in organizing the show, and under his tutelage she had bought a number of paintings she had seen at the Armory. By the 1920s she had an important collection* of work at that time considered revolutionary. On the walls of her apartment hung pictures by Cézanne, Renoir, Redon, Matisse, Picasso, and other artists whom many critics accused of "pulling the public's leg." Mrs. Sullivan, who came from Indiana, had been a successful teacher of art in New York public schools, and was very much concerned with the modern movement in Europe, where she had studied. She too had a collection of modern paintings that she and her husband, a lawyer, had put together with the advice of their friend John Quinn, the counsel for the Armory Show. Mrs. Sullivan was an energetic prime mover, full of vitality, according to those who knew her, and easy charm. Mrs. Rockefeller collected, but quite differently. She believed that young American artists were not getting the attention they merited from museums, and so she started in a quiet way to collect their works, which she hung on the fifth floor of her house (the biggest brownstone ever built in New York), for her own enjoyment and that of her close friends and children. The rest of the house was filled with Oriental works of art, medieval tapestries, and Renaissance furniture, her husband's taste. Modern art was for Mrs. Rockefeller a "private vice," or as close to a vice as this intensely public-spirited woman was ever known to come.

Unlike the Hewitts, who shied away from permitting men to help them establish their museum, as Hearn eventually did, "the ladies" im-

*"Important" is a relative not an exact adjective, of course. When it is applied to an art collection, it customarily means a collection that a museum or an art auction house would be glad to get its hands on.

mediately sought the advice and involvement of two men—a businessman who was a collector, with experience as a museum trustee, A. Conger Goodyear, and the celebrated Harvard art historian, Paul J. Sachs, to help them convert their schemes into a reality.

Goodyear had been voted out of office as vice president of the board of the Albright Gallery (now the Knox-Albright) in Buffalo because his fellow members were outraged by his purchase for $5,000 of a "pink period" Picasso for the gallery. He was ripe for Mrs. Rockefeller's picking. She invited him to lunch (he had an apartment in New York) and asked him to be president of a committee to form a museum of modern art. He accepted. Sachs's role was more important. The ladies asked him to recommend a director for the new museum, the shape of which was only vaguely in their heads, and he proposed Alfred H. Barr, Jr., a young scholar still in his twenties then teaching at Wellesley College. Barr, a catastrophe as an administrator, was a fountain of ideas, a missionary by nature and temperament, with adamant convictions about what a modern museum should be and the stubborn, somewhat messianic persuasiveness to make others follow his lead.

Barr had been teaching a course in "modern art," the first given in any American college, and it was the outline of this course that became the outline of purpose and structure of the Museum of Modern Art. It was the "modern movement," as it came early in this century to be called, that Barr was interested in—a state of the arts and an attitude toward them which was not confined to the plastic arts (painting and sculpture): it encompassed architecture and design, the theatre, music, photography, and the dance as well. Barr did not teach all of these arts in his course, but he expected his students to be aware of what distinguished "modern" from traditional attitudes and forms. He drew a sharp distinction between what was "modern" and what was merely "contemporary" art. Barr was an art historian who looked at the arts created in his own time as though he were looking back at them from the future. He was concerned with their social and political context but more concerned with their intellectual and philosophical origins and the sources of their artistic inspiration. He identified artists and their work by types and categorized them like a natural scientist, but he did not do so coolly. He was a proselytizer for the modern movement, an interpreter of its various, often contradictory, gospels. He more than anyone was responsible for the general acceptance in the minds of the art audience that the Museum of Modern Art, like it or not (and many did not), was the cathedral of the modern movement in America, from which "the word" emanated. Barr was twenty-seven when he became the museum's first director. He set it on a course from which it has scarcely

strayed, though its passage has often been stormy, and he was early jettisoned as its pilot. When he died in 1981, fifty-two years after the museum opened, the *New York Times* called him "The Museum Man of the Century."

"The Modern," as the museum is often called, opened its doors with an exhibition of paintings by Cézanne, Gauguin, Seurat, and Van Gogh, old masters today but considered revolutionaries still in 1929. The epithet "modern" and all it implied of disrespect of the past was a challenge to "good taste." The fact that a gauntlet was thrown down as a challenge by three eminently respectable women did not give modern art a respectability in the eyes of those who preferred to profess their outrage at what they saw as vulgar color, bad drawing, and pointless, disagreeable, or mystifying subject matter. Abstract painting had not yet accustomed the public to the idea that it was the object that mattered and not what it was about, or in Roger Fry's words of 1912, that artists "do not seek to imitate form, but to create form; not to imitate life, but to find an equivalent for life."

The Museum of Modern Art was a symptom of rumblings which had long been going on in the arts, but "modern" had become a rallying cry, both as a noun and an adjective, the "strange device" on a banner. It was a liberal cause, in some respects political (more the politics of art than of government, though they have a way of intermingling), but by no means associated with any particular party or artistic "ism" except "modernism." There was something both cultish and cliquish about its adherents, as there is about the hard-core audience for any art movement with vitality. From New York to San Francisco it was a rallying point for Upper Bohemians, that network of men and women concerned with the arts, some as professional artists, some as teachers, curators, and dealers, and some as interested bystanders and collectors. By and large it was not artists, composers, or architects, or photographers who led the crusade and carried the banner; they were too busy at their easels, keyboards, drafting tables, and cameras to campaign for the modern movement. That was the business of dealers, curators, teachers, and other tastemakers with goods to sell, doctrines to promote, and fashions to establish.

From its beginning, painting and sculpture were by no means the only concerns of the Museum of Modern Art or, more exactly, of Alfred Barr. All of the visual arts were, and still are, its province—architecture, industrial design, films, photography, decorative design, and in recent years, television—all of which, with the exception of television which did not yet exist, Barr envisioned as pertinent to the modern movement. Dance was tangential but not overlooked; the museum at one time had an important dance archives which it later transferred to the Library of the Performing

Alfred H. Barr, Jr., generally regarded as the most innovative museum director of his time, set the course for the Museum of Modern Art at its founding in 1929 when he was twenty-seven. This photograph was taken in 1969 shortly before he retired.

Arts at Lincoln Center. Unlike the Cooper-Hewitt it was not a "teaching museum" for professionals. It had an education department, concerned largely with schoolchildren, and it organized an energetic "traveling exhibitions" department that distributed shows of architecture, painting, drawing, and other concerns of the museum across the country to schools, colleges, and museums. Its function was to spread its gospel, to break down barriers of complacency, to challenge the philistines, and to open the eyes of the young, whose vision, presumably, was not yet frozen in the conventional myopia. It aimed its "good design" shows principally at the housewife, to show her how to equip her house or her dining-room table or her

kitchen with objects of "honest" design, which was a very different matter from the suitable "good taste" that Mrs. Wharton recommended and at odds with her cautions about confusing morality with visual gratification.

The word "modern," as the museum used it and as it is generally used in the language of art criticism and sophisticated conversation today, denotes not so much a period of time as an attitude. "Modern" is not a synonym for "current," "contemporary," or "new." It has strong overtones, however, of what is or has been experimental in the arts and of departures from the conventions of painting, sculpture, and architecture that go back to the Renaissance, when linear perspective and correct drawing (verisimilitude) were the basic elements of painting, and the Greek orders and the Roman arch and vault provided the fundamental vocabulary of architecture. About the middle of the nineteenth century a few artists of more than ordinary independence, conviction, and talent found that the decoration of public buildings and private salons, the painting of portraits of prosperous merchants and bankers and their wives, and the depiction of events (historical, mythological, or just anecdotal) were, if not financial dead ends, most certainly aesthetic ones. The Industrial Revolution had replaced what was left of an aristocratic tradition of patronage with newly-rich bourgeois patrons who turned to the official salons and the academies as arbiters of taste.

A few artists, Courbet and Manet among them, revolted against the complacency of official taste and decided that a painting was more important than what it was about (that, in fact, it was about itself) and that empty minds produced empty pictures. They were dissatisfied with the old truths that art had sought to explore and adumbrate. Technological advances were rapidly changing the nature and standards of the society in which they lived, and they believed that the independence of the arts as antidotes to mechanization and mass production and the consequent sapping of individualism was increasingly important. They did not become propaganda painters (though Courbet was jailed for his political activities) but they challenged social moralism, as Courbet did with his lesbian nudes and Manet did with his notorious "Olympia" and "Déjeuner sur l'Herbe." This latter picture was a painting of four persons picnicking in the Bois, two fully-clothed men in business suits and two fully undressed women, a parody (but more than that) of the Louvre's famous "Concert Champêtre" by the sixteenth-century Venetian master Giorgione. If "Olympia" and the picnic were by no means pornographic in the eyes of Manet's contemporaries, they were worse than that: they were socially and artistically insolent.

What Is "Modern"?

There is no easy definition of "modern." If it is a philosophy or a religion, as it sometimes seems to be, it is one without a creed, or more exactly with a great many conflicting creeds. There is not even among critics and scholars a consensus about when the modern movement began, with whom or where. Did modern painting begin with Manet in the 1860s as some say, or with Cézanne somewhat later, as others contend? Did modern architecture first take shape in the hands of Louis Sullivan in Chicago in the 1890s? With Frank Lloyd Wright? With the functionalists in Europe in the early years of the twentieth century? Or was it earlier than any of these? Viollet-le-Duc, perhaps, or H. H. Richardson? And modern design—was it the Secessionists in Vienna, who quarreled with the academy under the leadership of Josef Hoffmann in the 1890s, that started it all? Was it earlier than that, in England with William Morris and the crafts movement, or was it later, at the Bauhaus in Dessau, where Gropius was the leader of a functionalist movement? Did modern dance come into being with Martha Graham or was it Isadora Duncan who started it all? Did modern music begin with dissonance that grated on the public's ears? And when was that? Does it go back to the outrage that greeted Brahms's First Symphony in 1876, or is it as recent as 1914 and Arnold Schönberg's introduction of the twelve-tone scale? His atonal music frankly rejected the nineteenth-century musical heritage as a worn-out tradition. These are not questions that will be answered here. Disagreement has been a vital fluid in the corpus of the modern movement. Modern art, indeed all art, without controversy is unthinkable, and so, its history has demonstrated, is the Museum of Modern Art.

That the museum's first exhibition was of Cézanne, Gauguin, Seurat, and Van Gogh, and that it has works by these artists in its permanent collection but none by Manet, indicates that the museum decided it had to start somewhere. A few years after the museum opened to very mixed reviews but to wholly unanticipated crowds of people, Barr defined modern art as

> a relative, elastic term that serves continually to designate painting, sculpture, moving pictures, architecture and the lesser visual arts, original and progressive in character, produced especially within the last three decades but including also "pioneer ancestors" of the nineteenth century.

If many of the critics and some collectors were pleased and the visiting public was enthusiastic or puzzled or disgusted, the local artists, for the most part, were infuriated. Why, they wanted to know, should a new museum devoted to "modern" works repeat the injury done to American

artists by the Armory Show? Why should it show French artists when American artists, especially those with "advanced" ideas, so desperately need a showcase for their work? Weren't they modern? What they did not know was that Barr had wanted to open the new museum with an exhibition of paintings by three Americans, all of them dead, Ryder, Homer, and Eakins, and follow it with a show of Seurat, Van Gogh, and Cézanne. It was "the ladies" who insisted on the show with which the museum opened. The first exhibition was followed by one of "Painting by Nineteen Living Americans," but this did not satisfy the art community either. "Why only nineteen?" they asked, and they answered their own question by saying that the nineteen were artists collected by the museum's trustees, who were just trying to push up the market value of their purchases.*

This attitude toward museums by artists is not surprising at any time, but in the 1920s and the early 1930s there were only a handful of art dealers in New York who were showing modern works of any sort, and those who did (with the exception of Stieglitz at the 291 Gallery) were exhibiting the work of foreign painters like Matisse, Picasso, and the Surrealists, and of sculptors like Maillol, Despiau and Lehmbruck. It was possible for a New York "art lover" to see nearly all the gallery shows in town on one or two Saturday afternoons and in the course of his wanderings run into most of his friends on or near Fifty-seventh Street, where the galleries clustered. The audience for "moderns" was extremely limited, and the number of those who bought their works was, because of the Depression, tiny. The Museum of Modern Art did much to increase it.

Both in spite of criticism and because of it, the museum prospered. It quickly became a rallying point for those who admired its independence from the official art world, as represented by the Metropolitan and the National Academy of Design, and its willingness to include in its concerns matters that were generally thought to be outside a museum's province. It treated as art objects that were commonly regarded as merely utilitarian. Its "Machine Art" exhibition in 1934, which displayed kitchen units, an airplane propeller, electrical insulators, dinner plates, ball bearings and other unlikely museum displays, evoked disbelief and dismay from those who were outraged that such objects could be taken seriously by an art museum. Its "Modern Architecture: International Exhibition" of 1932 had been received with equal but somewhat different dismay—an architecture stripped of ornament, built like factories of glass and steel and concrete, as functional as a spoon and, most people thought, about as comfortable

*Charges of this nature against the trustees have been common ever since.

to live in. The museum's ability to shock, though its declared purpose was to inform and educate, gave it an appeal to the young that other museums could not match. Its ability to stay more than one step ahead of public acceptance of what it showed created excitement. One result was that it became chic, and the openings of its exhibitions were considered by the bright young people "the place to be seen."

It is very nearly possible to measure the growth of acceptance of the modern movement in America by using as a yardstick the growth of the Museum of Modern Art. Its influence on art and artists was no greater than that of any other place where they could see what their contemporaries were up to. It was unquestionably responsible for causing a large number of young men and women to become abstract painters or surrealists, for example, just to be in the swing of things, but this did not make them artists. They were the movement's most intimate camp followers, always intent on catching up by using other people's explorations as tricks to give the impression of swimming with the avant-garde. The museum's influence was not on the arts, in other words, but on the taste of the art audience. The artists and architects, the moviemakers and designers and photographers knew what was going on because they were making it happen, usually long before the museum caught up with them. Curators cannot lead, they can only follow— which is not quite true. They can only follow the artist, but they can lead the public to see and very often accept what they think is promising or good or important. They can be wrong, and they often are. Alfred Barr knew this and admitted it.

Launching the International Style

The Modern's Department of Architecture (or as it soon became, the Department of Architecture and Design) is a case in point. The Museum of Modern Art was the first museum anywhere to establish an architecture department; it was essential to Barr's plan to encompass every visual aspect of the modern movement as being of equal importance.

When in 1932 the Museum held its first architecture exhibition, called "Modern Architects: International Exhibition," there were few buildings in America that Barr, Philip Johnson, and Henry-Russell Hitchcock, who collaborated on the show, thought worth including.* There were a few conspicuous ones that because of their rarity and clean, spare look stuck out in the cityscape like tombstones and caused consternation among those

*The catalogue of this exhibition is more than a catalogue; it is an illustrated series of essays by Barr, Johnson, Hitchcock, and Lewis Mumford, who wrote about "Housing."

to whom the neo-classical revival started by the Columbian Exposition was still the model for the future. Skyscrapers like the Woolworth Building in New York by Cass Gilbert (1913) and the Tribune Tower in Chicago by Raymond Hood (1922) were modern in the boldness of their structure and height, but they were traditional in their ornamented surfaces. Their style in the museum's view was neither hay nor grass; it could only be disparaged by the adjective "eclectic." To the public the towers looked "artistic," and the buildings asked no readjustment of the public's opinion of what a skyscraper should look like.

However, when Hood's thirty-six-story *Daily News* Building in New York, with its unblemished alternating vertical white and dark panels went up in 1930 and his McGraw-Hill Building of thirty-six stories of uncompromising horizontals followed the next year, and when William Lescaze and George Howe built their towering Philadelphia Savings Fund Society building in 1932 (there was little love for it in the City of Brotherly Love) it was evident that the old rules for skyscrapers were broken for good and all.* There was not a trace of Gothic embellishment or of classical pilasters stuck on the skins of these buildings. They had no cornices and no frills. They were structurally open-faced and stylistically bare-faced, with a clean, scrubbed look that to many Americans made them seem as though they had stepped naked off the architects' drafting boards. They were shocking.

About half the architecture displayed in models and photographs in the museum's exhibition was from Europe by four men whom Barr called "the founding fathers of the International Style," a name made up for the exhibition and still in use. They were Walter Gropius, the founder of the Bauhaus, Mies van der Rohe, Le Corbusier (Charles-Édouard Jeanneret), and J. J. P. Oud of Holland. Frank Lloyd Wright, who epitomized not only the most iconoclastic but the most "modern" architecture in America, and who was the direct architectural descendant of Louis Sullivan and his dictum that "form follows function," had to be wheedled into exhibiting with the foreigners, whose work he referred to as "the flat-chested" school of architecture. Hood was in the show and so were Howe & Lescaze.

This clean-limbed "honesty in the use of materials" that inhabited the new architecture should have been, Barr believed, congenial to what Americans think of as their pragmatism and their pride in practical know-

*The PSFS, as it is usually called, was 491 feet tall and had 39 stories. The Philadelphia City Hall, completed in 1881, was in all 548 feet tall, and had only 9 stories, the rest of the height accounted for by a tower and a 35-foot statue of William Penn, designed by Alexander ("Sandy") Calder's grandfather. A city ordinance, rescinded in 1984, prohibited anyone from topping the crown of Penn's hat.

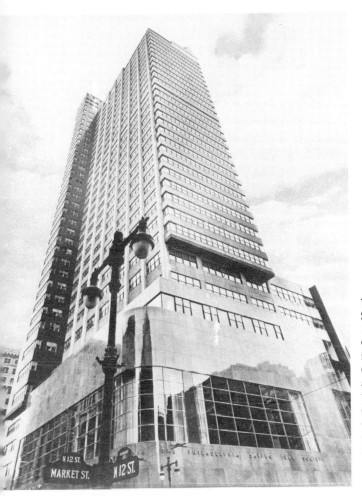

The Philadelphia Savings Fund
Society skyscraper was built in
1932, two years after the
Chrysler Building. Critics hailed
it as a triumph of "modern"
(i.e., International Style)
architecture. Fifty years later
the *New York Times* critic
called it "one of the great leaps
of architectural faith on the part
of a major client in the
twentieth century."

how, but it was not. On the contrary this architecture, which would have pleased the Shakers for its simplicity and rejection of ornament and Thorstein Veblen, the author of *The Theory of the Leisure Class,* for its denial of the trappings of "conspicuous waste," ran contrary to the American romantic appetite for richness. This was the public that loved make-believe, that so delighted in baroque and Oriental and Moorish extravagance in the design of movie palaces in the 1920s, with their gold and plush interiors and sonorous pipe organs. To most Americans skyscrapers were romantic symbols, the towers of a man-made fairyland. The new architecture was not only redolent of aesthetic reform but had overtones of social reform as well and, to use a cliché not in use in the thirties "who needed it?"

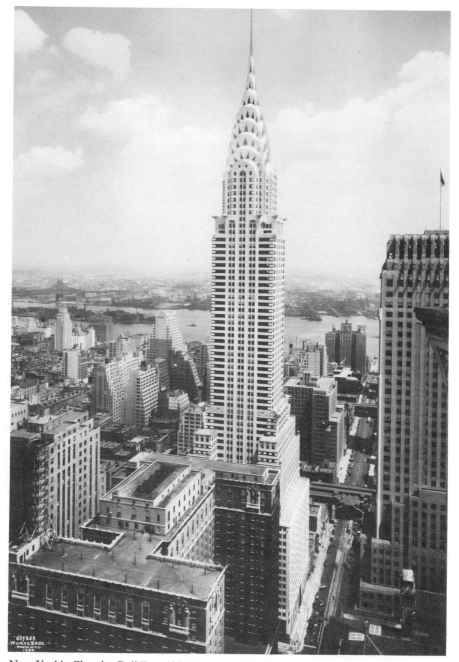

New York's Chrysler Building, 1930, briefly the world's tallest structure, was laughed at by the "functionalists" for its "modernistic" dunce cap and gargoyles that were copied from Chrysler radiator caps. Fifty years later it was considered a heroic monument of Art Deco. *(Wurts Brothers photograph, courtesy of Richard Wurts)*

Very few people did. They preferred the Chrysler Building and the Empire State, which Barr and his colleagues dismissed as "modernistic" (there was a snarl in that epithet) because they were ornamented with "zigzags and chevrons" that their architects had pilfered from the Paris Exposition of Decorative Arts in 1925. (It was not until nearly forty years later, in the 1970s, that "Art Deco," which the Chrysler building epitomizes, suddenly became fashionable again with a new avant-garde of tastemakers.) The world's fair in Chicago in 1933 called "A Century of Progress" was not modern in the museum's definition of the term; it was what it called modernistic and today we call Art Deco. Nor was Rockefeller Center acceptable. The New York *Sun* reported Philip Johnson at the time of the exhibition at the museum as saying, "The new Rockefeller City development is so unprogressive and bad that it is no less than a major tragedy which will set back New York City's architectural progress by decades." (He has since changed his mind.)

But if few people liked the International Style when it first appeared in America, it was the Museum of Modern Art that did more than any other institution to bring about its acceptance. The International Style show went on the road and traveled to museums across the country, making friends and enemies wherever it went.

Among the friends it made were the museum's own trustees. The museum had quickly outgrown the quarters it inhabited in the Heckscher Building, and in May 1932, several months after the architecture show, to which more than thirty thousand people had come, it opened for business in a substantial house at 11 West Fifty-third Street, which it leased at a reasonable rent from the Rockefellers. It was here that the Department of Circulating Exhibitions, which sent the architecture show on tour, started its energetic career. It was here, too, that the Department of Photography and the Film Library (later the Department of Film), both firsts for museums, were established. Here, too, the museum acquired its first substantial bequest, the Lillie P. Bliss paintings and sculptures, which is the cornerstone of the museum's distinguished permanent collection.

By 1936 the museum's trustees began to look about for ways to build a home for their museum that would do justice on the outside to what was shown within, and to provide ample space for temporary exhibitions and the growing permanent collection, for offices, a library, a sculpture garden, and public amenities, including a restaurant for members of the museum and the staff. The building, of course, would be in the International Style. It was designed by a trustee, Philip L. Goodwin, the only architect on the board, and a young man, Edward Durell Stone, whom Nelson Rockefeller

had spotted as a gifted designer working on Rockefeller Center.* The building is credited largely to Stone as designer and to Goodwin as keeper-of-the-peace, since the process was a storm center of trustee and staff controversy at almost every step of its realization.

The "new building," as it was called for decades, opened in 1939 and was greeted with gratifying howls of dismay by the press. "It has committed itself," the art critic of the New York *Herald Tribune* wrote, "to one of the most forbidding façades in the annals of the city, a bold essay in that style which may be in harmony with that Mesopotamian word 'functionalism' but which, in its ugliness, looks just like so much vacuity." However, the façade made a statement (as architects are wont to say) that before very long became a cliché of modern urban architecture, the glass-and-marble-sheathed curtain wall, which in this case let in so much light that the pictures inside were threatened with fading, and it was necessary to protect them with cloth curtains across the glass ones. The exhibition that opened the new building was called "Art in Our Time." In general the critics were enthusiastic.

The influence of the Museum of Modern Art on architectural design, if not on its acceptance, in America was secondhand at best and quite probably negligible. American architects, those who liked the innovations being explored in the drafting rooms of the International School architects in Europe and of a few architects in America and those who did not, were aware of what was going on. They did not need the museum to tell them. Their own trade papers, the architectural magazines whose function was to keep the profession up to date and promote (or in some cases disparage) what was adventurous and "progressive," kept them informed, though it is doubtful that more than a few (if any) editors or architects had seen at first hand what Johnson, Hitchcock, and Barr had gone to great lengths to spy out in Europe in the late 1920s. Many architects thought the new "stuff " abominable and wanted no part of it; it was a denial of the classical traditions of symmetry and order in which they had been trained. Most of the public agreed, though the influence of the museum's exhibitions on the public taste, or at least on an influential segment of it, cannot be set aside and should not be.

Twelve years after the International Style exhibition the museum held a show called "Built in America, 1932–1944." It was a progress report. Most of the buildings included in this exhibition were private houses that

*Nelson Rockefeller's involvement with MoMA started in 1931, when he was twenty-three; he became chairman of the Junior Advisory Committee. By 1939 he was president briefly of the board of trustees.

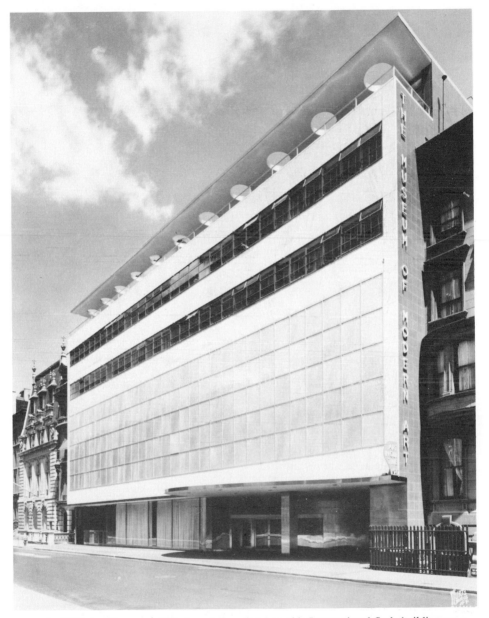

In 1939 the Museum of Modern Art moved into this International Style building on Fifty-third Street in New York and celebrated its tenth anniversary with an exhibition called "Art in Our Time." The building had mixed reviews. The exhibition fared better. *(Photo courtesy The Museum of Modern Art, New York)*

were either by Walter Gropius or showed his and Le Corbusier's influence, though the house that remains one of the remarkable buildings of

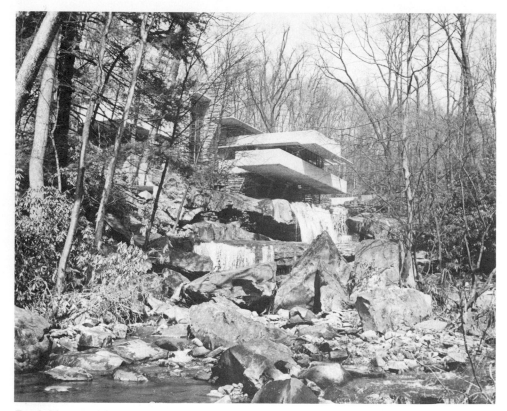

Frank Lloyd Wright designed Fallingwater for Edgar Kaufmann, a Pittsburgh merchant, in 1936. One of Wright's masterpieces, it was the subject of a one-building show at the Museum of Modern Art in 1938. The house at Bear Run, Pennsylvania, cantilevered over a natural waterfall, is now open to the public.

the century, much more the decade, was Frank Lloyd Wright's house built for Edgar Kaufmann at Bear Run, Pennsylvania, over a waterfall and called Fallingwater. There were also in the show models and/or photographs of a shopping center, schools, factories, a sanatorium, several civic buildings, Rockefeller Center, and the PSFS in Philadelphia. The buildings in the exhibition were from no particular part of the country; "modern" was more common in the Northeast and the Northwest than in between, but it was by no means localized. Nor, to be sure, was it the rule rather than the exception anywhere in America.

In the preface to the catalogue Philip L. Goodwin quoted Alfred Barr as saying that "The battle of Modern Architecture is won, but there are other problems." Goodwin noted one of these: "With the trend away from old styles," he wrote, "has come a new type of streamlined 'modernistic'

that needs to be combatted as vigorously as ever. The fight must go on against superficiality or sensationalism by the encouragement of sound, sincere building, as well as for wider acceptance of and interest in town and city planning."

But if modern architecture had won the battle it was far from winning the war for the public taste. To be sure, by 1950 it had conquered the style of office buildings and shopping malls, service stations, apartment houses and public housing projects, storefronts, schools, colleges, airports, research centers, and many other public beachheads, but it had captured only a small piece of the private sympathy. If people accepted it, most persons did not; if it was publicly palatable (except by legislators and bureaucrats, who still hankered after marble and pilasters), it was privately suspect. The glass curtain wall became the mirror of commerce, but it was not the looking glass in which people wanted to see their private images reflected. There were strong overtones in the modern movement in architecture of social reform, of telling people how they ought to want to live, whether they liked it or not—in planned communities, sanitized and homogenized, to be treated as items not individuals.

There were a few adventurous souls who built modern houses in the 1930s and '40s, but bankers were reluctant to take mortgages on modern houses because they were skeptical of the resale value of such eccentric homes. A "modern" house in a suburb was a curiosity and was often considered an affront by the people who lived on the same street in their Spanish villas and Tudor half-timbered houses and chateaus and colonial cottages. After World War II there were those, including Philip Johnson, who saw the housing shortage created by the war as an ideal opportunity to convert the public to glass-and-white-walled functionalism, but the public instead took to its bosom the peaked-roofed, picture-windowed, split-level ranch house, for the very reason that it looked to them like a house, not like a service station or candy factory.*

*In 1982 an architect, who was also a professor of design at the State University of New York at Buffalo, made a survey of 129 homeowners in two subdivisions in the Buffalo vicinity to determine what styles of house design they preferred. He showed them drawings of eight styles: Farm House, Tudor House, Ranch House, Mediterranean House, Early American, Colonial, Contemporary, and Modern. The Farm House, a two-story building with dormer windows and a veranda, was selected by the largest percentage of homeowners, 25.6 percent. The Modern House, also two stories but with a flat roof and strip windows, was selected by the smallest number, 4.7 percent. The others were in the order in which they are listed here. The respondents were "primarily white, middle-class couples between the ages of 27 and 45, with two children on average and with incomes of $26,000 to $45,000 a year." (*New York Times,* April 22, 1982.)

Creeping Modernism

The modern movement in architecture crept into the public accept-
ance a small step at a time and never wholly. Americans were suspicious
of an architecture whose design was based on principles of abstract paint-
ing of the geometric sort, which they did not like or understand, and on
the machine, as its aesthetic was celebrated in the museum's "Machine
Art" show. To most Americans the machine was associated with jobs not
with leisure, with discipline not relaxation, with conformity not with inde-
pendence.* The new architecture preached (it was preachy, as were those
who promoted it) efficiency, rational living, social reform, economy of
money and of motion—all of them theoretically desirable but not all of
them by any means congenial to the American's idea of how he or she
wanted to live. What was more, "modern" houses required of their builders
skills they did not possess. A flush window or door, for example, with no
molding to cover up an inexact meeting of edges, required a refinement of
technique that carpenters and masons preferred to circumvent. Houses
built with flat roofs in country where heavy snows fell in winter looked
modern but were inefficient. But such structural deficiencies, though often
expensive to set right, were details that were secondary in importance to
style. It was the rational principle that mattered, not the irrational drip of
water into a basin from the bedroom ceiling.

Or so it seemed to many clients who built modern houses in the 1930s
and 1940s. They were pioneers and pioneers expect to put up with hard-
ships.† It would be a mistake, however, to identify the modern movement
in architecture only with the International Style, though a number of its
progenitors came to the United States to head architectural schools and to
revolutionize their teaching, so long based (some would say mired) in the
Beaux-Arts ideals. Walter Gropius became professor of architecture at the
Harvard School of Design, with Marcel Breuer as his associate. Mies van
der Rohe was made director of the architectural department of the Illinois
Institute of Technology in Chicago, and subsequently helped to revise the
curriculum at MIT, Yale, and Columbia. The modern movement was by

*This was pre-power mower for everyone's plot of grass, pre-washer and drier for the
family laundry, and pre-dishwasher. The oil burner had just begun to replace the coal
furnace, and the electric refrigerator had not yet put the iceman out of business. Only the
automobile was a familiar machine to most people, and why it worked was a mystery to
most of them. It often didn't.

†When the Philadelphia architect George Howe, who later became dean of architec-
ture at Yale, was accosted by a client complaining of a leaky roof, he is said to have replied,
"But, my dear, my roofs always leak."

In 1934, years before he became an architect, Philip Johnson put on a "Machine Art" exhibition at the Museum of Modern Art. The critic Royal Cortissoz wrote, "It's calling it art that clouds the issue." The New York *Sun* called Johnson "our best showman and possibly the world's best." *(Photo courtesy The Museum of Modern Art, New York)*

no means static or frozen in a set of clichés, and it evolved freer forms, some of them based on the sculpture of such abstractionists as Hans Arp and Naum Gabo.

In the hands of men like Eero Saarinen, the designer of Dulles Airport, the TWA building at John F. Kennedy airport in New York, and the hockey rink at Yale (nicknamed "the Pregnant Whale" by students), and Philip Johnson, whose designs always seemed to be slipping out from under the glass-and-steel clichés he had done so much to promote, the movement found new solutions to uniquely twentieth-century problems. To be sure, the glass-box skyscraper became the corporate symbol of power and efficiency, as it was also the symbol of the United Nations headquarters in New York, a truly international product of a committee of architects from Europe and North and South America. These clichés persist to the time of this writing, though they were first challenged in the 1970s by the emergence of what has been called "postmodern" architecture, and might be called the "avant-rear-garde." In some respects it owes as much to Art

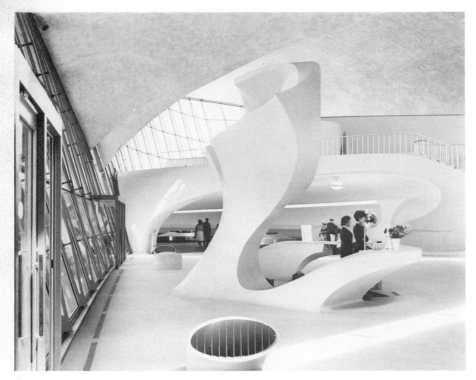

Eero Saarinen's New York TWA airport building, as much sculpture as architecture, was a revolt from the plane geometry of the International Style by one of America's most independent and gifted architects. It was built in 1962.

Deco as to the International Style and as much to the precepts of the Renaissance architect Andrea Palladio as to those of Louis Sullivan and Walter Gropius.

In 1979, nearly half a century after "Modern Architects: International Style," the Museum of Modern Art held an exhibition which it called "Transformations in Modern Architecture." This time the museum merely stood back and looked. It was not trying to sell anyone anything—no dogma, no panaceas, no final truths about an "honest" architecture that would save mankind from its bad taste and sloppy ways. It offered no schemes with socio-political underpinnings that would make the world a more reasonable, equitable place, with orderly suburbs and palatable cities. This is not to say that the museum resigned its right to critical judgments on architecture, but in this instance it had given up its crusade. Unlike "Built in America, 1932–1944" this exhibition was not a progress report; it was merely a report of change and confusion, of some stunning successes and some failures, with the issue left to the visitor to decide. The ghost of

the International Style was still present at this banquet, though efforts to break the intellectual shackles of Mies and Gropius and Le Corbusier were everywhere in evidence. The style once called "modern" was now called "modernism," and when a style becomes an "ism" it has taken its place in history and lost its power to affect the future, except as a "revival."

As the Department of Architecture was concerned with what people lived and worked in, the museum's Department of Design was concerned with what they lived and worked with. Initially the two departments were autonomous, but they were soon combined under a single director with a curator for each concern, and they were each inspired by the same philosophy of style. Their concern was with honesty and function and, as Barr put it, with "a clean perfection of surface and proportion." Their crusade was against the fussiness of nineteenth-century decorative arts and its twentieth-century residue, and while equally critical they looked for a solution almost precisely opposite from that of the Misses Hewitt, Edith Wharton, and Elsie De Wolfe. As the Cooper Union Museum sought salvation for the decorative arts in the design and craftsmanship of the eighteenth century and earlier, the Museum of Modern Art sought it in designs for what the machine could produce at its best—the production of unornamented useful objects conceived by those who understood both the limits and the promises of machine manufacture.

The Bauhaus Mystique

The Bauhaus of Dessau, Germany, more than any other institution, helped to determine the scope of the Museum of Modern Art and how it was organized. Walter Gropius, the founder of the Bauhaus, more than any other individual, contributed to Barr's concept of what a showcase of the modern movement should encompass. Barr had visited the Bauhaus in 1927 with his friend Jere Abbott, a fellow student at Princeton and later at the Fogg at Harvard, and Barr's associate director of the Modern Museum at the time it opened. They had gone to look at modern architecture, and of all the buildings they saw and places they visited, the Bauhaus in Dessau made the most profound impression on them. Walter Gropius was its intellectual ignition system. He had shaped its character, its scope, and its philosophy since he became its first director, when it was established in Weimar in 1919 soon after the end of the First World War. In 1925 it moved to Dessau and into a building designed by Gropius that is one of the landmarks of the modern movement, an imaginative and handsome building of glass, concrete, and steel, and the home of what soon came to be called "functionalism."

The Bauhaus owed its philosophical origins to William Morris (1834–96), the English writer, architect, painter, designer, prophet, and founder of the Arts and Crafts Movement by which he hoped to reform the tawdriness of machine-made decorative objects. He looked to the Middle Ages, when architects, sculptors, glassmakers, and masons worked together in what he assumed to be harmony and mutual respect and without class distinctions to accomplish miracles of Gothic structure. The Morris movement took many shapes as it emerged in Europe and America in the late years of the nineteenth century and the early years of this one, and the Bauhaus was one of them. It was the one whose influence was most pervasive; it was also the one that adhered most closely to Morris's belief in the interplay and equality of the arts and crafts. Gropius wrote: "The artist has power to give lifeless machine-made products a soul. His collaboration is . . . an indispensable part of the industrial process and must be regarded as such." For the Bauhaus he managed to draw together a faculty of men and women of diverse talents, many of them, like Paul Klee, Gerhard Marcks, Lyonel Feininger, Wassily Kandinsky, Josef Albers, Oskar Schlemmer, Marcel Breuer, László Moholy-Nagy and Herbert Bayer, considered today among the eminent figures of the modern movement.

All manner of objects came under their scrutiny, and by the time they were through with them, the objects emerged in new forms that paid little if any tribute to tradition, whether it was in the design of furniture, typography, household utensils, textiles, theatre sets, store displays, posters, or entire architectural structures. The Bauhaus, as might be expected, created stylistic clichés, which became the identifying characteristics of "modernism." In the simplest terms the aesthetic of modernism declared that a plain surface was better (more "honest" and therefore more beautiful) than an ornamented one, that a form determined solely by its function must frankly express its use without concessions to traditional relations between form and ornament and the bourgeois pleasures to be derived from nonfunctional decoration. It may have been all very well in the eighteenth century to ornament a bowl or a chair leg or a sconce, but the aesthetic of the machine age, whether the object was made by machine or not, precluded such frivolity and rendered it "dishonest." The decoration of Art Deco objects with inlaid woods, geometric patterns, sometimes applied jewels, precious metals, and colored enamels, made them unacceptable, or "modernistic," however handsome to other eyes.

The museum's "Good Design" exhibitions reflected with something close to mirrorlike reliability the aesthetic of the Bauhaus. For a manufactured object—a bowl, a chair, a tumbler, an ashtray, or a fork—to be accepted for exhibition by the museum was a seal of approval that design-

ers and manufacturers eagerly sought. It was the equivalent of the Good Housekeeping Seal or the approval of the Pure Food and Drug Administration. It assured its owner of being a man or woman with "good taste" of a very different sort from the "good taste" approved by the Hewitts, but in its way no less refined. The influence of the "Good Design" shows reached into every part of America (many of the shows were sent on the road as circulating exhibitions) and had a very considerable effect on the design and acceptability of many household appurtenances. It changed the look of furniture, tableware, textiles, appliances, and utensils, though the severe elegance of the best modern took some very strange shapes that missed the point of the functional purity and proportion that the museum was trying to make the public accept. Such shapes were "modern" only in that they combined the clichés of Art Deco with those of the Bauhaus to the benefit of neither. If this was the trickle-down theory of taste at work, the pure syrup that poured from the museum's design department was adulterated with all manner of imperfections by the time it reached the mass audience. It was not only watered down; it was tarted up.

A New American Avant-Garde

Like any museum, the Modern has followed the arts, it has not led them. In this sense it has been a historical society, collecting and displaying what is accepted as important, if not generally at least by a limited, especially interested public. If the museum was regarded as adventurous by the timid and the conservative, it was looked on as "old hat" by the avant-garde. It was no less useful for that. Its mission was to spread the word not invent it, to codify and adumbrate it so that it could be understood by the largest possible art audience. Where painting and sculpture were concerned the exhibitions the museum regarded as most "important" (partly because of the large crowds they drew and partly because of the work involved in assembling them and the amount of gallery space they occupied) were those of painters like Van Gogh, dead forty-five years by 1935, when the museum put on a retrospective to which people flocked, and "Cubism and Abstract Art" in 1936, twenty years after Cubism was a dead issue and abstract painting was already taking off in a new direction. (It almost seemed that if the museum did not know what else to do it had another Picasso exhibition.) To be sure, it held a series of "New Talent" shows of work by young American artists, and it showed the work of young architects it thought promising, and these unquestionably helped the painters find galleries and the architects clients. But this did not mean that the American avant-garde artists were not continually in a state of war with

the museum, which they thought should devote itself primarily to what was new and progressive in the American arts, and they occasionally mobilized demonstrations and issued proclamations that caused the museum annoyance and minor embarrassment.

From the time of the uproar over the Armory Show in 1913 to 1929, when the Museum of Modern Art opened a month after the stock market crashed and the Great Depression sank much of America in despond, there were no occurrences that shook the art world. Certainly there were none that made any significant impression on the art audience, except a very small though influential part of it that watched the American avant-garde with concern and encouragement. There were, of course, attempts by artists to organize exhibitions that they hoped would bring the work of progressive painters and sculptors to the attention of collectors and museum curators, and if they were slight in their impress at the time, they are not without importance in the history of the arts of America and in the long run in changing how Americans used their eyes, decorated their houses, and spent their leisure.

The First World War (1914–18) kept American artists, for the most part, away from Paris, where the artistic ferment had produced the Cubists (Picasso, Braque, Gris, etc.) and the Fauves (Matisse, Derain, etc.) and where every other Left Bank café was the site of an informal nightly symposium (or so it seemed), in which ideas about painting were explored and exploded and argued about. In America the impetus of the Armory Show carried on for a few years, but with diminishing energy. Though the effect of the Armory Show had been an encouragement to artists to go their own ways in seeking the truths they hoped to uncover, and a reminder, albeit negative, of the public's eagerness to react to their work, it did not in any sense leave them bound by the example of the European artists who had stolen (in several senses) the show. In general they found nourishment in the American experience and in interpreting what was around them, though they saw it with different eyes from those of the realists and impressionists of the generation before them.

In New York in 1916 there was an exhibition called "The Forum Exhibition of Modern American Painters" (*The Forum* was a magazine which backed it). It was organized by the critic Willard Huntington Wright, who had been editor of *Smart Set* and wrote art criticism for *Forum.* * There were seventeen artists in the show, some of whom (Mars-

*His successors as editors of *Smart Set* were H. L. Mencken and George Jean Nathan. Wright gave up art criticism and took to writing detective stories as S. S. Van Dine. He was the creator of a detective called Philo Vance, of whom the poet Ogden Nash wrote: "Philo Vance/ needs a kick in the pance."

den Hartley, Abraham Walkowitz, Alfred Maurer, Oscar Bleumner, Stanton MacDonald-Wright, and Arthur Dove) were part of Stieglitz's stable at the 291 Gallery. The show was selected by a jury of what appear to have been good friends of the artists (in MacDonald-Wright's case his brother), and it is remembered by historians principally because of the "Synchromists," whose abstractions in brilliant colors completely divorced from objective observation were forerunners, in their improvisation, of the Abstract Expressionists of the 1940s and '50s.

In the early decades of this century Greenwich Village was the home of artistic ferment. It was there that most artists who clung to New York had their studios and there that they organized their exhibitions. Starting in 1917 they put together annual shows in the name of the Society of Independent Artists. Anyone who called himself an artist could submit work and be sure of being shown, and the range was from well-known to unknown artists' work, from proficient to amateurish. These exhibitions continued through World War II. On the whole the quality of the work and the attendance were more than just respectable. There were fewer than a dozen commercial galleries, in those years, that were showing work by living American artists. But there were groups such as the Société Anonyme, organized by Katherine S. Dreier, Marcel Duchamp, and Man Ray (the society's collection as we have noted is now at Yale), which held shows,* and in 1915 Gertrude Vanderbilt Whitney, an accomplished sculptor who was also an heiress, started the Friends of Young Artists. Three years later it became the Whitney Studio Club and held exhibitions for its individual members as well as group shows. It was the forerunner of the Whitney Museum of American Art, which opened in Greenwich Village in 1931—an institution determined to give American artists opportunities that the Museum of Modern Art had not.†

The First World War brought a few European artists to settle permanently in America, most notably Marcel Duchamp who brought with him Dadaism and became the central figure of a group of artists, writers, and composers, who met at the home of Walter Arensberg in New York. Arensberg was a dedicated and compulsive collector (his collection is now in the Philadelphia Museum of Art), and the group he gathered around him were a

*Most particularly at the Brooklyn Museum in 1927.

†The Whitney gave up its quarters on Eighth Street and in 1954 moved into a new building on West Fifty-fourth Street adjoining the Museum of Modern Art's garden. Twelve years later it moved to Madison Avenue and Seventy-sixth Street, an imposing building by Marcel Breuer, a Bauhaus architect and a darling of the Museum of Modern Art. At this writing plans have been made to supplement this building with an extension designed by the "postmodern" architect Michael Graves.

cadre of revolt in the arts, now a *Who's Who* of eminent personages: the composers Edgard Varèse and Charles Ives; the poets Amy Lowell, William Carlos Williams, Mina Loy, and Alfred Kreymborg; the painters Man Ray, Charles Demuth, Charles Sheeler, Albert Gleizes, and Francis Picabia, these last two from France; the dancer Isadora Duncan, and the Baroness Elsa von Freytag-Loringhoven, "who shaved her head, painted it purple, and decorated herself with an assortment of implements."*

The mainstream of American painting and sculpture in the decade before the Museum of Modern Art opened was little affected by the Dadaists or their Freudian counterparts, the Surrealists. The spirit of modernism exerted itself in the works of painters like Alfred Maurer, Marsden Hartley, and Charles Demuth, but none of them was derivative, as that word is used to indicate making less of something more interesting or inventive. They were not, in other words, secondhand Parisians, though in a sense the French had set them free of old conventions and given them passports to unexplored places. MoMA's second exhibition was work by nineteen American painters who were the choices of the trustees. (I know of no other museum that has permitted its trustees to choose the artists it exhibits.) Maurer and Hartley were not among them, but Demuth was and so was Edward Hopper (the first painting in what became the museum's collection was Hopper's "House by the Railroad," given by Stephen C. Clark, a trustee and later president of the board). Some others whose names are now what might be regarded as part of the standard repertory of American art, such as John Marin, Georgia O'Keeffe, and Max Weber, were included and some others now largely remembered only by historians of the art of the 1920s, such as Kenneth Hayes Miller, Bernard Karfiol, and Ernest Lawson.

Gertrude Stein, who had no love for the Museum of Modern Art, is said to have commented about it: "A museum can either be a museum or it can be modern, but it cannot be both."† This dual role, which it had assumed from the first—a place to display what it considered to be the best of "modern" and to be a collector of painting, sculpture, photographs, films, and prints at the same time—has given it a somewhat split personal-

*Dadaism was a movement that originated in Zürich after World War I. Willi Verhauf, in a book called *Dada,* wrote: "Dada negated all the values until then considered sacred and inviolable, ridiculed fatherland, religion, morality and honour, and unmasked values that had been made idols of." The analogy with the 1960s revolt of youth in America following the Vietnam War is obvious. An art comparable to Dada did not emerge in the 1960s or 1970s, though Pop Art had some of the same kind of cynical contempt for "modernism" that Dada had for "academism."

†Miss Stein made it quite clear that she did not want her portrait by Picasso to go to MoMA, and left it to the Metropolitan Museum. The remark about the Modern Museum, often quoted, does not seem to be among her printed works.

ity, if not in the eyes of its staff, then to much of the art audience. It is an arbiter of what is worth pursuing, but as a constant pursuer that keeps looking over its shoulder it never quite catches up with the avant-garde. The race is already won and the runners have gone elsewhere by the time it gets there with the laurels. It is the sports page of the art game; it reports yesterday's activities, but it has nothing to do with what happens, only with what has happened, and this seems to be the intent of Gertrude Stein's remark.

By and large the Modern ignored the American painting of the 1920s that was known as "Regionalism," the celebration of the American land and its people in a largely sentimental mock-heroic manner by artists like Thomas Hart Benton, John Steuart Curry, and Grant Wood, and it had little sympathy for the Social Realists of the 1930s, with their political disquiet and satire. There are in its permanent collection protest paintings by men like Ben Shahn and Peter Blume and William Gropper, and there are abstractions by Stuart Davis. However, it arbitrarily left the works of artists like Isabel Bishop and Raphael Soyer, Jack Levine and Reginald Marsh and others who drew their subject matter from city life mainly to the Whitney Museum and particularly to its "Annuals." They were not "moderns" in the museum's meaning of the word; they were merely "contemporary."

A Break in the Ranks and New York Replaces Paris

The distinction between "modern" and "contemporary" was one that the museum made much of. When the Institute of Modern Art in Boston, which had originally been a "branch" of MoMA, exerted its independence and renamed itself the Institute of Contemporary Art in February 1948, it issued a manifesto. The "cult" of modern art, it said, was "a cult of bewilderment," and "once the gap between public and artist was widened sufficiently, it [modern] became an attractive playground for double-talk, opportunism and chicanery at the public expense." The violence of the reaction to its manifesto took the Boston Institute by surprise (or so its director later said)—not just the shocked reaction at the Museum of Modern Art but the field day that the press, most especially *Life* and *Newsweek,* had with it. It almost seemed as though nothing that happened in the art world since the Armory Show had so inspired art journalism. There was such vocal glee among those who distrusted or despised modern art (and there were many, including those who regarded it as a "Communist conspiracy") that the Boston Institute, the Whitney Museum in New York, and the Modern Museum issued a joint statement that attacked "the evils

of chauvinism, intolerance, bigotry and the virtues of freedom, objectivity, tolerance and humanism," as a shoulder-to-shoulder defense of the artists' rights to pursue their muse as they pleased. It was the public's business not to scoff but to seek to understand. Though the men and women who kept the wheels of the Museum of Modern Art going would not have been likely to say so, it was this kind of controversy on which it thrived, and the dispute undoubtedly made many new friends for the museum and cost it few, if any, of its faithful.

The revolutionary painting that was to convince the "in group" of the art audience that New York had displaced Paris as the center of invention and progress and especially of vitality unfolded soon after World War II. It has been variously called "Action Painting," "Abstract Expressionism," and the "New York School." The war had left the Social Realists with their left-wing sympathies more or less at sea. The political nihilism of the Dadaists and the Freudian symbolism of the Surrealists seemed insignificant, though the presence in New York of Surrealist exiles from Europe like Max Ernst and Yves Tanguy and independent spirits like the sculptor Jacques Lipchitz and the painters Piet Mondrian and Fernand Léger had an invigorating effect on the young artists who were seeking their own salvation. They found it, one might say, by intentionally throwing out the baby with the bath. Harold Rosenberg, the ablest of the critics of the postwar decades (it was he who coined the term "Action Painting"), explains the movement this way:

> The revolutionary phrase "doing away with" was heard with the frequency and authority of a slogan. The total elimination of identifiable subject matter was the first in a series of moves—then came doing away with drawing, with composition, with color, with texture, with the flat surface, with art materials.

What was left was the "white expanse" of a stretched canvas where "a succession of champions performed feats of negation for the liberation of all."

The principal figures of the New York School were members of an informal group that met weekly in Greenwich Village to explore and argue about the nature of painting and the responsibility, if any, of the artist to society. They called themselves "The Club," and until they suddenly achieved a stunning success (stunning to the "in group" of critics, collectors, and dealers and astonishing to the artists themselves) they were a cohesive group—Jackson Pollock, Robert Motherwell (the most articulate of them and a writer with a philosophical bent), Barnett Newman, Arshile Gorky, Mark Rothko, Willem de Kooning, Bradley Tomlin, Adolph Gottlieb, and several others. (Alfred Barr frequently attended the meetings

of The Club to listen rather than to talk.) Once they had become internationally known, taken up by collectors, exhibited by New York dealers, and bought by museums (the Modern was among the first), The Club dispersed.

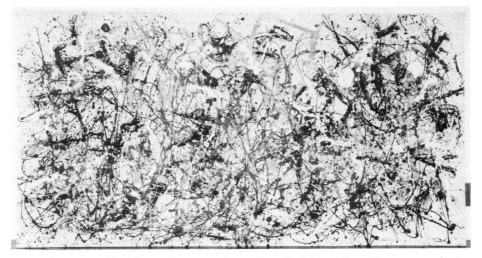

After years of ignoring modern American artists, the Metropolitan Museum organized a department of American painting and sculpture in 1949 with Robert Beverly Hale as curator. In 1957 he persuaded the trustees to add "Autumn Rhythm" by Jackson Pollock to what had become a distinguished contemporary collection. *(The Metropolitan Museum of Art, George A. Hearn Fund, 1957)*

"Jackson [Pollock] broke the ice for us," Willem de Kooning is frequently quoted as having said. Pollock's canvases, on which he dripped paint from cans, more than the work of any of the other members of The Club, were latched on to by the press. In 1949 *Life* printed an article headed "Is Jackson Pollock the Greatest Living Painter in the United States?," a question to which readers were obviously expected to answer with a resounding "No!" De Kooning may have meant that Pollock had liberated them or he may have meant, as one historian has said, that he had broken the ice of public indifference by capturing the interest of the inner circles of the art world. It cannot be said, however, that the Museum of Modern Art led the parade. It was primarily the dealers Peggy Guggenheim, Betty Parsons, and Sam Kootz who introduced the Abstract Expressionists, rather quietly. Clement Greenberg, writing in *The Partisan Review* and *The Nation;* Harold Rosenberg in *Possibilities;* and Thomas B. Hess, the editor of *Art News* in the late 1940s, were the principal advocates for the movement in the press. In a sense the Action Painters recaptured the

market for American artists that the Armory Show had effectively (albeit inadvertently) handed over to the French, and it was to New York that young European artists wanted to come, as Americans had once flocked to Paris. New York was "where the action was."

Movies, the Newest Art, Becomes "Modern"

One of the missions that Barr set for the Museum of Modern Art was to introduce the public to aspects of their surroundings that they took for granted and make them look with fresh eyes at them and recognize them as art. This was not so much to increase their casual pleasure as to sharpen their critical faculties and in so doing to encourage their deeper respect for the artist. A more intelligently critical audience for the arts, he believed, would inspire confidence in the makers of the arts, of whatever sort. He had done this with the "Machine Art" exhibition and he was to do it with the "Good Design" shows.

In 1935 it was the movies on which he wished to focus the public's critical attention, by establishing them as a serious facet of modern art and therefore implicit to the museum's concerns. The movies (or the "films" to those who took the movies seriously as something other than entertainment and escape) were not looked upon by the trustees of museums in the 1930s as a matter with which they should concern themselves, any more than they thought jazz was a legitimate artistic concern. Barr, however, approached the movies, as he approached every visible thing in nature and every man-made object, with his aesthetic antennae searching for signals.

In 1935 the moguls of the movie business had little interest in its past. It had long since stopped being a cottage industry, producing its wares in sheds, and become a very big business indeed, with vast capital investment behind it. How it had made its way from the nickelodeons to movie palaces of Oriental (in many cases literally) splendor, from the silent "flicks" to the "talkies," was of little concern to those who had converted their product (as they called it) to a form of visual entertainment that engaged the attention (sometimes the adoration) of almost every man, woman, and child in the nation, usually to a greater rather than a lesser degree. If there were some directors who were concerned about using their craft with such imagination and sensitiveness that it became an art to them, and if there were actors who adapted their skills to a medium quite different from the stage (often the vaudeville stage in the case of the great comedians) and raised it to the level of an art, producers were unmoved unless the product was a success at the box office.

It took Iris Barry, an English film critic who had come to New York

in the early 1930s and been hired by the museum as its first librarian, and John Hay Whitney, a young man who had occasionally invested some of his vast fortune in movies, to persuade Hollywood that its past was, after all, interesting enough to preserve. Whitney persuaded Mary Pickford, "America's Sweetheart," to assemble a group of producers and actors at her now legendary house, Pickfair (named for herself and her husband, Douglas Fairbanks). He and Miss Barry explained their plan for a film library and showed clips from early and fairly recent products of Hollywood's studios. Those who gathered had not thought of themselves before as historical figures, and they were charmed to be taken seriously as, you might say, cultural artifacts worthy of being preserved for posterity. The producers, some of them, dug into their vaults and a number of actors into their libraries, and within a year the Film Library had millions of feet of celluloid film and was struggling to make order out of it.*

It would be easy to exaggerate the influence of the Film Library in its efforts to make movies a generally respected art form and its influence on the reception of film as a humanistic study in colleges and graduate schools. There were almost no theatres showing what were called "art films" even in New York and Chicago and Los Angeles in the 1930s or, indeed, as late as the 1950s. Reruns of old films were scarce, with the occasional exception of a few "classics" like D. W. Griffith's *The Birth of a Nation* and some early Charlie Chaplin and Buster Keaton short comedies that were shown in "little cinema" theatres and "art houses," where "experimental" films from Europe were also viewed with solemnity. ("If a picture were abstract, baffling or downright incomprehensible," Arthur Knight, a principal historian of the movies, wrote, "it could always be described as 'experimental.' And since these films came from Europe they were also considered 'artistic,' an assumption based largely upon the naïve American tradition that anything European is necessarily more artistic than the native product.")

The Museum of Modern Art Film Library was not concerned with "experimental" films except as they fitted into the historical sequence of the development of the movies. Men like Griffith, to be sure, had been experimenters with techniques, pushing the new medium to perform optical miracles not for art's sake but for emotional and visual impact. It is easy to forget that the closeup, which we now take for granted, was a shocking experience when Griffith first brought the camera close in on a human face, and it loomed on the screen larger than anyone had ever seen a face before. Two enormous faces kissing was considered far more immoral, as we have

*One of the Film Library's principal early concerns was conservation. Celluloid film was by no means permanent, and when it disintegrates it falls into yellow dust.

seen, than two faces similarly engaged at a respectable distance.

There were a few "film societies" in existence when the museum started its Film Library, but very few, and one of them had been organized in New York by the art dealer Julien Levy (who first brought the Surrealists to America), Nelson Rockefeller, and Iris Barry. But the Film Library, with its policy of renting 16-millimeter prints of its films to colleges and museums, was responsible in large part for the rapid spread of such groups and, of course, the development of commercial film-renting services. By the 1960s there were four thousand and more film societies all across the nation. When the Film Library was organized in 1935 there was just one university that was giving a course in the movies. It was, as you might expect, Hollywood's neighbor, the University of Southern California in Los Angeles. By 1952 there were more than fifty colleges and universities giving some 575 film courses, and by 1970 there were thirty students working on Ph.D.s in film at New York University alone. How much of the credit for this spread of interest in the movies as a serious art form, which at its best is not a self-conscious art medium, can be attributed to the Film Library is a question to which there is no demonstrable answer. It is obvious only that it played a role that Alfred Barr, always a teacher at heart, approved.

Exit Alfred Barr, Enter the Age of Acceptance

Indeed, Barr was far more teacher than administrator. His staff found him hard to get at, not aloof so much as preoccupied with intellectual matters, and his trustees, though they attempted to bolster him with skilled administrators, finally threw up their hands. In 1944 they not only fired him as director but ordered him off the premises. However, as his friends said, the museum was his mistress, and he had no intention of deserting her. He found a desk in an obscure corner of the building and settled there. His friends and admirers on the staff, who were many, continued to seek him for his judgment on matters concerning the collection, on acquisitions and on shows. He was, and continued to be, the intellectual nervous system of the museum. (The trustees in a quandary appointed him Director of Collections.) It was his responsiveness to the stimuli of the art world and the tastes and distastes of the public that made the museum the center of excited argument that it became and that made it both famous and notorious—on the one hand an ornament to "progress," on the other a blotch on all that was "sacred" about the traditions of art.

The Museum of Modern Art exhibitions, such as the Van Gogh show in 1935, had not only brought hordes of people to the townhouse it then

occupied (877,711 to be precise) but caused the eccentric and then still surprising Van Gogh to become the darling of interior decorators and display artists. His sunflowers appeared on textiles (including shower curtains), and his vivid colors and reproductions of his paintings of sun-bright fields and bridges became backdrops and props to ornament show windows. None of this could have mattered to Barr (except negatively; he wanted the public to understand and appreciate not dance in the streets), but it was he, nonetheless, who through the mechanisms of his museum played a not altogether subtle role in shaping the taste of his time—if by taste is meant the acceptance of fashion.

If the Museum of Modern Art was important in achieving acceptance of the modern movement in painting, sculpture, design and architecture by a small but, in matters of taste and patronage, important segment of the public, it was by no means alone. In the 1940s after the Second World War, dealers in modern art proliferated, and from a half dozen or so their numbers grew to hundreds in New York and to dozens in Los Angeles and Chicago and San Francisco. Dealers would not have grown in numbers and prospered if the numbers of collectors had not also greatly increased, and this growth in the market for modern art was part of the same reaction to increased leisure and prosperity that caused the Metropolitan Museum, as we have noted, to become crowded as it had never been before. The acceptance of the modern movement, however, can be, and often is, grossly exaggerated. Changes in taste cannot be forced; they can only be coaxed. The great majority of the public is either indifferent to "modern" (it has been around long enough to have become part of the backdrop of daily life, its abstract clichés absorbed in advertisements and its surrealist fantasies in television commercials) or rejects it as an aberration. If they do not any longer complain about it, they ignore it and hope that "art will come to its senses." The modern movement has lost the capacity to shock the art audience, which is not to say that a desire to shock was at its roots, unless to shock means to open the eyes and the intellect to experiences they have not before encountered.

The Museum of Modern Art has continued to grow physically if not intellectually since the days when Barr dominated it as a mind and a presence. It has added several buildings (one of them the Whitney Museum's second home), and more recently an apartment tower of which it occupies the lower portion. It has increased its exhibition space indoors and out, and built rooms for meetings and parties and offices and libraries. There are more exhibitions each year, several happening at the same time, and many of them continue to look backward, "retrospectives," at the modern movement's past accomplishments. Like most museums it is part

publisher and part retailer, but the objects that it has consistently sold in its ever-expanding bookshop have been more discreetly selected as objects of "good design" than in many museum stores, including the Metropolitan's, which have had less regard for quality than for profit. More than most museums the Modern has always been essentially a public-relations operation, and remarkable as is its permanent collection, which was largely built by Barr and is a reflection of his personal taste, it occupies only a fraction of the museum's exhibition space. Most of it is devoted to a floating population of families of objects: paintings, drawings, prints, sculptures, photographs, films, and "unclassifiables."

As the "art boom" of the 1940s and '50s got under way and the new electronic and space technologies began to alter the size and the demands of the audience for the arts of every sort, Gertrude Stein's aphorism that pitted "museum" against "modern" became increasingly appropriate. The "action," as they began to say in the 1950s, had moved elsewhere. The crusade had run out of Saracens.

Private Collections as Public Museums

In the 1860's James Jackson Jarves noted in *The Art Idea* that "Private galleries are becoming almost as popular as private stables." These galleries were in the city mansions of prosperous merchants, for the most part, and they were for the pleasure of their owners and to impress those they invited to their houses. To collect art, mostly by the American artists then fashionable (the Hudson River School was at its peak of popularity in the 1860s), was newly recognized as contributing to social standing, and a display of wealth in this manner was a signal of cultural concern. In a mercantile society this provided overtones of refinement, of a belief in "the finer things," that contrasted with the hard-nosed realities of the counting house and the emporiums and the gobblings-up of one's competitors. An exception to this rule (and it seems to have been the rule) was a wholesale grocer in New York, Luman Reed. He was a true patron of the artists (men like Thomas Cole, Asher B. Durand and William Sidney Mount), who were not only his promising contemporaries but his close friends. On the top floor of his mansion on Greenwich Street in New York he built the first private gallery, and he opened it one day a week to the public.

In a sense Reed's was the progenitor of private galleries (or collections) which in the late years of the nineteenth century became private museums that, in turn, became public institutions protected from taxation

as educational accommodations. These private-public museums were the creation of a very different breed of collectors from Reed.* The acquisition of important masterpieces from Europe and the Orient became an intensely competitive enterprise among the giants of the money world, the Morgans and Fricks and Havemeyers, on the one hand, and of women who could well afford (as the Misses Hewitt could) to indulge their taste for rare, beautiful, and bondedly genuine objects. Most of the great works of art (some of them with vastly inflated attributions) that they collected have become treasures among the holdings of museums such as the Metropolitan, the Art Institute in Chicago, the Cleveland Museum, and other such ornaments of civic pride.

Some such collections, however, became what can be called personal museums, with frozen (or nearly frozen) collections, which are memorials to their founders and permanent records of the expensive and in some cases the sophisticated taste of their eras. Sometimes it is the taste of the collector that dominates; sometimes it is the taste of an art dealer or scholarly advisor, who helped shape the collection. (The great dealers of the time, men like Joseph Duveen, later Lord Duveen of Milbank, were far more than art merchants; they were educators, and they did a great deal toward instructing willing millionaires, often of great intelligence, in the history of the arts. The most that the dealers could do was to advise. Their clients were not, the best of them, the sort who could be led by the nose.) These private-public museums are small in scale, compared with municipal museums, and they are likely to be confined to certain kinds of art. They are not attractive to those who enjoy the supermarket appeal of big museums. The audience for the small art museum is in its way as limited as the audience for the little theatre or the art cinema, though it may not be as cultish as some such audiences are. It is an audience that knows what it wants to see and brings to a collection a degree (in many cases a very high degree) of knowledge. It also includes those whose principal pleasure is in visiting the houses of the very rich, as, for example, the Isabella Stewart Gardner Museum in Boston and the Frick Collection on Fifth Avenue in New York. Such museums also attract those who enjoy the quiet of a house museum, the lack of crowds, the near

*The Luman Reed collection, after his death in 1836, was acquired by friends, who rented a small octagonal rotunda, which had been erected to display a panorama by the painter John Vanderlyn near City Hall, and established it as the New York Gallery of Fine Arts. It lasted only three years (1845–48), as the public ignored it. In 1857 the collection was given to the New-York Historical Society, where it remains as part of one of the foremost collections of Hudson River School paintings anywhere.

certainty that they will find what they came to enjoy without electronic gadgets to tell them what they are looking at, without maps, and without the threat of wearing out their patience and their spirits. The objects, as are all objects in museums, are out of the context for which they were made, but they are in the context of the taste of the collector who bought them.

The characteristic private-public museum is one in which the collector seems to be looking over the visitor's shoulder. This is a very different situation from, say, the Corcoran Gallery in Washington, where the original collection, assembled by a banker, William Wilson Corcoran, before the Civil War, while it may be the nut from which the tree grew, no longer dominates the branches it has sprouted. The Walters Art Gallery in Baltimore, on the other hand, is a private-public museum that still represents

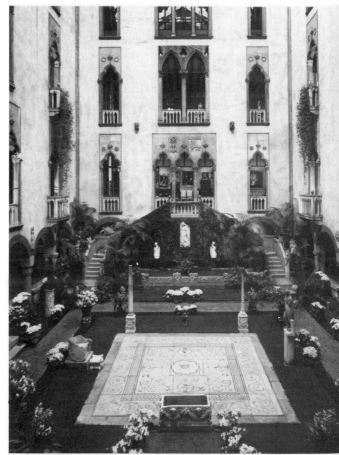

Fenway Court, a "Venetian palazzo turned inside out," was built in 1903 by Isabella Stewart Gardner in Boston to house her remarkable and unchangeable collection of paintings, sculpture, and decorative arts. It is one of America's great private, now public, museums. *(Isabella Stewart Gardner Museum, Boston)*

the very catholic tastes of a very rich railroad magnate, William Walters, and after him his son, Henry, who carried on his father's business and bought with an enthusiasm and genuine delight that ranged from delicate Oriental porcelains to paintings of cowboys. Henry Walters built an elaborate Florentine palace to house his collection, but it was not until 1931, after his death, that it became a public museum and the property of the city of Baltimore.

There are many such public-private collections in America, of a quality that, if they were in Europe, some American tourists would go great distances to visit. The most important of them were put together in the late years of the nineteenth century and the early years of this one—the Isabella Stewart Gardner Museum (called Fenway Court) in Boston; the Morgan Library in New York and the Huntington Library in Pasadena (both of them are art as well as rare book and manuscript collections); the Frick Museum in New York; the Freer Gallery in Washington; the Barnes Foundation in Merion, a suburb of Philadelphia. These are the major ones that retain the indelible stamps their originators placed firmly on them. At least three of these, the Gardner, the Freer, and the Barnes, are inviolable. They are by their deeds of gift, which is to say by the last wills and testaments of their creators, frozen solid. Nothing may be added to them and nothing subtracted. Indeed, nothing in the Gardner Museum may be moved from the exact place Mrs. Gardner had it hung and where it was at her death, except, of course, for purposes of conservation. Anyone visiting Fenway Court to look at a certain painting or tapestry or sculptured bust will find it in the same spot it was the last time he saw it, and the last time Mrs. Gardner saw it. Nothing may be lent to another museum, and nothing may be borrowed from another collection for exhibition in the Gardner.*

In 1860 at the age of twenty Isabella Stewart, a New Yorker of a wealthy and well-established family, married John L. Gardner, called Jack, a proper and generously propertied Bostonian ten years her senior. She was by Boston standards an eccentric and a free spirit, intelligent and determined. She shocked Boston by her daring dress,† her sometimes biting wit, her disregard for conventions, and her gift for being the center of attention wherever she might be. She made up in charm what she lacked in beauty,

*The trustees are careful to see that Mrs. Gardner's provisions are strictly observed. If they are violated in any way, the whole collection goes to Harvard University.

†A portrait of her by John Singer Sargent, in a black dress that displayed her shoulders and decolletage, with a double strand of pearls around her waist, was considered so outrageous that her husband refused to let her hang the picture, and it remained in a closet until after her death.

and she surrounded herself with the literary and artistic giants of her day, with Henry and William James, Henry Adams, Lady Gregory, Julia Ward Howe, and the painter Anders Zorn.

"Mrs. Jack" held court in her Venetian palace, where masterpieces that the young Boston Museum of Fine Arts must have yearned to add to its collections looked down upon her guests. She had spotted a young man in his early twenties, Bernard Berenson, who seemed to her uncommonly gifted in matters of art, and provided him with a stipend with which to go to Europe to study. He became in due course (and as connoisseurship goes, in jig time) the principal authority on European painting of the Renaissance, an author whose books were widely read in the small circles of the art world and whose lists of attributions were the bibles of collectors and dealers. Berenson was Mrs. Gardner's constant advisor and seeker-out of pictures and sculptures that he thought worthy of her collection. But she was not without her own sharply discriminating eye and convictions and sureness of taste. The Titian "Rape of Europa," which she purchased, has been called, not unjustly, Titian's masterpiece and "the greatest painting in New England if not in America." It is just one of many masterpieces from the bottom to the top of that tall palace—Vermeer, Rembrandt, Rubens, Van Dyck, and on through the eighteenth and nineteenth centuries. There are tapestries and ancient sculptures, drawings and *objets d'art,* and furniture suitable for a Venetian doge. And all frozen *in situ.*

Much the same is true of the Freer Gallery, which is one of the Smithsonian Institution's many museums, and of the Barnes Foundation collection. Charles Freer, who made his fortune in the manufacture of railroad cars in Detroit, seems to have been entirely his own master in matters of taste. He devoted himself primarily to the arts and crafts of the Orient and to a somewhat lesser degree to collecting a limited number of his contemporaries, primarily Tryon, Dewing, and Thayer, masters of the genteel tradition, and Whistler, not only his etchings but his paintings, in such numbers that the Freer Gallery has something close to a Whistler monopoly. (It also contains Whistler's famous "Peacock Room.") Freer was on the one hand a rather ruthless businessman and on the other an aesthete of a most discriminating and meticulous kind. The building which he built on the mall in Washington to house his collection is a cool, dignified neo-Renaissance marble box, with an open courtyard of fountains and greenery at its center. Freer had trouble trying to convince the science-minded regents of the Smithsonian to accept his largess, and only the intervention of President Theodore Roosevelt persuaded them to do so. When Freer died in 1919 and the nation became heir to his collection, it was valued at $7 million and the building which contained it at a million.

It is one of the sights to see in Washington and one of the most ignored. The audience for Freer's extraordinary collection of objects, gathered with the greatest discrimination and patience, consists largely of experts and connoisseurs and the most exacting kinds of dilettantes and scholars, and most particularly Orientalists and devotees of American Impressionism.

Henry Clay Frick, the steel tycoon, purchased these wall decorations by Jean-Honoré Fragonard from the J. P. Morgan collection. They were originally commissioned by Mme. du Barry, Louis XV's mistress, who rejected them. They are now in the Frick Collection in New York. *(The Frick Collection, New York)*

Henry Clay Frick was Mrs. Gardner's and Mr. Freer's contemporary, a few years younger than the former and a few years older than the latter. Contemporaneity, wealth, and an interest in art and in perpetuating their names by means of it was all they had in common. The *Columbia-Viking Desk Encyclopedia* sums up Frick in a few lines:

> 1849–1919: American capitalist. Key figure in coke industry. Engineered expansion of Carnegie Steel Co. Largely responsible for antiunion policy of steel industry. His New York city mansion, together with art collection and large endowment, was willed to public as a museum.

Frick's interest in paintings started when he was in his thirties. He began by buying landscapes of the Barbizon School, then the fashionable thing to buy, but as he further prospered the range of his collection and his taste expanded. He was one of the "invaders of Europe," as the English, French, and Italian aristocracy called the rich Americans to whom they were willing to part with their artistic heritage for large sums and about whose greediness they took satisfaction in complaining. (Greed complains about greed and always has.) It was two Englishmen, the dealer Joseph Duveen* and Roger Fry, the critic and briefly a curator at the Metropolitan Museum, who alerted Frick to masterpieces that he might be able to acquire. But they informed his taste rather than formed it. He was a collector with an eye and a mind of his own. He built a Renaissance palace on Fifth Avenue when he retired from the steel business and there installed his collection, which rivals, and in some respects surpasses, Mrs. Gardner's. He hired Elsie de Wolfe to buy the furnishings for his house, but the paintings, sculpture, and *objets d'art* were of his own choosing. He was not as fierce as Mrs. Gardner or Mr. Freer about freezing his collection, and though nothing is lent from it to other museums, it occasionally acquires additions—works of unquestioned high and rare quality. A pleasant calm pervades the Frick Museum, where small children are not permitted to enter and anyone under sixteen must be accompanied by an adult. Tours are not encouraged. The Frick's audience is small and respectful; what they come to see is masterpieces immersed in hush. The Frick is not inhospitable, but it requires its guests to mind their manners.

The Barnes Foundation collection in Merion, a suburb of Philadelphia, is a very different sort of private-public museum from the Gardner, the Freer, and the Frick, and it is not in the least hospitable. It is open grudgingly to the public and then only because the public sued to be let in. Dr. Albert C. Barnes was a physician who in 1903 invented a drug

*Members of the Duveen family, originally Dutch, have been dealing in art and antiquities since the eighteenth century.

called Argyrol that had almost universal use in the early years of this century; it was a mild silver protein put in every baby's eyes at birth as an antiseptic, and a generation had their sore throats painted with it. Dr. Barnes patented his discovery, an action that his medical colleagues thought unsuitable if not downright unethical, and he made a large fortune from it. He was snubbed socially by patrician Philadelphians (who probably would have snubbed him anyway as an upstart) because they found his collection of Renoirs, Matisses, Soutines, and other "revolutionaries" an aesthetic fraud, and let him know it. Dr. Barnes became famous for his bad temper, almost as famous as for his collection, and for his gratuitously insulting letters to people who wrote to ask permission to see his collection (the more closely associated they were with the "art world" the more ferocious the letters were). It was a collection that a great many museum men and women, art historians, critics, collectors, and art lovers would go to elaborate subterfuges to see—disguising their names, saying that they lived in out-of-the-way places. If you lived in Princeton, for example, your chances of storming the doors of the Barnes collection were negligible. If you got a friend to send your request from Peoria you might be given a date some months hence when you'd be let in for a couple of hours. It was considered worth the trouble because of the extraordinary quality of the paintings in the house, hundreds of them, including Cézannes and Renoirs and Picassos, bought, it almost seemed, by the dozens, but certainly not undiscriminatingly.

Dr. Barnes was not only a collector ahead of his time (in any case ahead of Philadelphia's time), but he was an aesthetic philosopher who wrote a number of books which he believed would offset the dogmatic cant and doubletalk that were being written about modern art. He also offered courses to young art historians who could be counted on not to disagree with him. If they questioned his authority, he ordered them off the premises. After his death the public sued on the grounds that a tax-free institution should be open to the public that helped to support it with their taxes. So it was opened for parts of three days a week by appointment only. The Barnes collection is probably the most private public museum in America, and very likely its audience is the smallest, as it consists only of those who are determined not to be excluded by Dr. Barnes's almost uncrashable gates.

Private collections that have stayed at home and become public museums have proliferated since the days of the Gardner, Freer, Frick, and Barnes. They are hospitable to a restricted audience that is willing to seek them out and penetrate them. Far less than the trustees of civic museums do their trustees measure success by the door count. Some of these museums today hold special exhibitions of borrowed works, usually to supple-

ment their own collections, but they are not in the blockbuster business. Collectors in the second half of this century, not our particular concern here, have not been inclined to build palaces in which to live with their collections, and the modern house that has become an art museum is a rarity. A living (that is, growing and changing) collection like the Phillips in Washington, which still occupies the ample but by no means pretentious house in which the collection originated in the early years of this century (it was incorporated as a museum in 1918), is as rare as it is pleasantly humane. The tendency has been to build and endow a museum bearing the donor's name—the Amon Carter Museum of Western Art in Fort Worth, the J. Paul Getty Museum in Malibu, the Norton Simon Museum in Pasadena,* the Hirshhorn Museum on the Washington Mall, for which the collector supplied the art and the government the cylindrical† structure to house it, and so on.

The tendency in recent years has been for the most ambitious collectors to stake out a claim to posterity as patrons of the arts while they are still around to enjoy the ohs and ahs of their contemporaries. This is not looked on with approbation by the directors of already established museums, who would prefer to take the collectors' treasures under their wings (or build new wings on their museums to house them), and there is apt to be muttering in the art world when one of its more avid and perceptive collectors elects to go privately public. In the case of the Hirshhorn Museum, for example, there were those who thought that Hirshhorn had "pulled a fast one" in playing cat-and-mouse with the federal government, which not only permitted the museum to be built on the Washington Mall as a subsidiary of the Smithsonian Institution but supplied government funds. The *quid pro quo* was Hirshhorn's gift of his extraordinary collection of modern sculpture (modern in this case going back into the nineteenth century to include Rodin) and mostly twentieth-century paintings, particularly but not exclusively American. There had been flirtations with England, where an interest was expressed in establishing a Hirshhorn Museum, and New York had suggested that it might find a building to house it. In the long run, however, what mattered was (and is) that the collection now belongs to everyone at the small price of satisfying Hirshhorn's vanity and his ambition, as a self-made man of sparse cultural

*Norton Simon did not build this museum; he took it over from the Pasadena Museum of Modern Art which had not only financial troubles but battles of temperament and conflicts of purpose that brought it to its knees.

†Cylindrical is perhaps more accurate than circular, but it has been called "the doughnut" and/or "the bagel." The inside circle is slightly off center. The building was designed by Gordon Bunshaft of the firm of Skidmore, Owings & Merrill.

background, to become an imposing patron of the fine arts of his time. Art has always been the servant of vanity in that sense, and as long as there are private or, indeed, civic patrons it always will be.

Museums—the Attics of Art

The audience for the fine arts in America and how it has been cultivated and nourished can be told only partly in the development and deportment of various kinds of art museums. To many artists, collectors, and students they are sources of reference, places to test their eyes and their reactions, to refine their judgments and expand their pleasures. Museums are not fashion-proof but they are by and large fashion-resistant. They reflect fashions in collecting, which is to say fashions in taste, and what they exhibit is likely to be what the sophisticated art public thinks important at any given time. On the other hand they are warehouses of taste, and what may be retired to the storerooms, as much nineteenth-century American painting was for more than half a century, is not lost and is retrievable.

Sometimes it is the pressure of the art market that causes kinds of painting and sculpture to be taken out of hiding. Sometimes it is because dealers have run through their stock and have decided to make a fuss about works that a few years before they deprecated. Sometimes it is artists who seek and find inspiration in forgotten or ignored works or works that were generally thought to be beyond the pale. This was the case with tribal African sculpture, which from being considered artifacts of anthropological concern became "works of art" only when Picasso and his contemporaries discovered them and began to use them as models, however distorted, in their work. Sometimes, as it was in the 1950s and '60's, all historical precedent is regarded by artists as a hindrance to creation and to contemporary expression; sometimes, as in the 1970s with its revival of "figurative" art, it becomes again a source of wonder and instruction and inspiration.

So the art museum in its many manifestations, from enormous temple to substantial house, is a reflecting mirror of the art audience. This is the lively audience for art as opposed to the passive audience, which is subjected continually to art in some form by magazines and newspapers and broadcast images. The lively audience includes those who make a practice of seeking what is shown by art dealers in their galleries, where new trends are likely first to emerge, and in art auction houses, and they are likely to be those who are ardent museumgoers. The audience for art whose attendance is clicked off at the portals of museums is made up of the most casual and the most intensely concerned components—which is to say everyone

who goes to museums whether defiantly or hopefully or enthusiastically, whether ignorant or learning or learned, whether philistine or patron, antagonist or aesthete.

Artists, Politicians, and Patrons

The interplay between art and the government in the United States has been a tenuous and sometimes stormy one ever since the time in the 1790s that the Congress decided to hold a competition for the design of the Capitol. America was short of professional architects, and the competition was won by a Philadelphia physician, William Thornton, who said, "When I travelled, I never thought of architecture, but I got some books and worked a few days, and then gave a plan in the Ionic order, which carried the day." The prize was a gold medal worth $500 or a plot of Washington land worth the same amount.

Dr. Thornton's winning plan never became a building. His drawings, which have since been lost, were turned over to a professional architect, Étienne-Sulpice Hallet, who had had his training in France, and whose competition drawings, it is said, had been glimpsed by Thornton, who made free with his competitor's ideas. The story of the building of the Capitol, which need not concern us here, was turbulent, but there was one political eye on the proceedings which had a great deal to do with the nature of government architecture in the early years of the Republic. This eye was Thomas Jefferson's. His travels in France and Italy had stirred in him something close to a passion for Roman architecture, on whose ruins he gazed, he said, "like a lover on his mistress." He brought home a style and a taste for the classical orders that with many variations well into this century has had an effect on our official architecture. Jefferson was, I think it can be safely said, the only President, with the exception of Theodore Roosevelt, to whom the arts were of more than the most superficial, if sometimes official, concern.

Art was not, except in a negative way, the concern of most politicians; they knew what they disliked. In the nineteenth century the arts were generally considered to be women's business as politics were considered

men's affair. Those artists who got head to head with politicians on government commissions had, for the most part, a sorry time of it. The artist Colonel John Trumbull, who was no stranger to politics, had run into a congressional buzz saw with his patriotic paintings for the Rotunda of the Capitol. The Congress paid him $32,000 for the job and one of their members characteristically said the pictures weren't worth 32 cents. Horatio Greenough, who was commissioned to make a heroic marble sculpture of George Washington for the Capitol (he carved it in Rome and had it shipped to Washington), found his "masterpiece" greeted with hoots of derision and a storm of wisecracks. The seated half-nude figure with one arm raised and the other holding a sword in a scabbard was called "a grand martial Magog undressed with a napkin lying in his lap." In the 1850s George Caleb Bingham, one of the most remarkable painters of the mid-century, involved himself directly with politics and ran for the Missouri legislature. He wrote to a friend: "As soon as I get through with this affair and the consequences, I intend to strip off my clothes and bury them, scouring my body over with sand and water, put on a clean suit, and keep out of politics forever." One nineteenth-century artist who was willing to tangle with politicians, Thomas Nast, loaded his pen with vitriol and attacked New York's Boss Tweed and his Ring in the pages of *Harper's Weekly* in the 1870s; he has been credited with a major role in bringing about Tweed's downfall. "I don't care what the papers write about me," Tweed said, "—my constituents can't read; but, damn it, they can see pictures."

For the most part the only interest that politicians took in the arts until this century was in the design and glorification of their working quarters, whether they were in the Capitol of the nation or in state capitols, county seats, cities, or towns. They spent vast sums on congressional offices (and still do), on state capitol buildings of exceeding splendor, on county courthouses (especially in Texas they would have done honor to princelings), and on monuments to political and military heroes. The business of government has been conducted in marble palaces, often ornamented with murals recounting national or local lore or depicting the virtues of justice and democracy, painted in a manner that could neither offend, instruct, nor inspire anyone. By and large the patronage that has been afforded to artists by political bodies has been conservative, riskless, and offensive to no one, except to those who were interested in the arts as a living part of our culture.

Since there is no such thing as art without risk, and almost no such thing as a politician who will risk gambling with his constituents' taste in art, experience seems to indicate the less art and politics have had to do

Thomas Nast's cartoons for *Harper's Weekly* attacked the corrupt Boss Tweed and his New York political ring in the 1870s. Tweed unsuccessfully offered Nast $500,000 to cease and desist. Tweed is the big-bellied figure in the center.

with one another in America the better. But this has not kept them from tangling, sometimes with considerable bitterness. It is unlikely that Theodore Roosevelt would have written a sympathetic review of the Armory Show while he was still in office, though he was a friend of writers and artists and invited them to the White House. He arranged for the remarkable sculptor Augustus Saint-Gaudens to redesign the gold coinage in 1905. "He's a wonder," Saint-Gaudens told a friend. "He knows us all—knows our work and our rank. It is amazing." (Van Wyck Brooks in *The Confident Years* wrote: "Roosevelt liked to encourage young writers, as many of them testified, and in summoning Upton Sinclair and Booth Tarkington, for instance, to Washington, he showed that he realized the influence and importance of their work.") It was the first Roosevelt who initiated what became under his successor the National Commission of Fine Arts.

The commission grew out of the Washington Park Commission, which was established in 1901 to consider what should be done to beautify the city (this was the era of the "city beautiful" movement) and assure a future for it worthy of the nation's pride. Daniel Burnham was the commission's chairman, and with him were Augustus Saint-Gaudens and Charles Follen McKim, both of whom had worked with him on the 1893 Chicago exposition, and Frederick L. Olmsted, Jr., the son of the great landscape architect, whose office he had taken over. They recommended that the plan for Washington proposed by the French-born architect Pierre Charles L'Enfant in 1791, and which had been rejected, be revived and adhered to. They proposed that the city parks be extended, and they chose a site for a memorial to President Lincoln—the sight on which it was eventually built. (It was dedicated in 1922.*) Eight years later the American Institute of Architects asked President Roosevelt to establish a Bureau of Fine Arts "to advise on plans for all future public buildings, bridges, parks, sculpture, painting and other work in which design plays an integral part." Their concern was limited to the city of Washington. The President responded on the same day he received the proposal and asked the petitioners to send him a list of thirty artists from various parts of the country. By executive order he promptly named them to constitute a Council of Fine Arts.

Roosevelt's successor, William Howard Taft, took a stronger stand, with the backing of Senator Elihu Root of New York, whose prestige was commanding. He had served as both Secretary of War and Secretary of State. Taft and Root believed that a commission should be established by the Congress, not by executive fiat. Many years later in 1935 Root recalled the founding of the Commission of Fine Arts, which was established by the Congress on May 17, 1910. The reason, he wrote, was essentially to avoid wasting public funds on ill-considered and ill-advised works of art proposed for public purchase at the whims of individual congressmen promoting their constituents. He wrote in part:

> Sometime about the early spring of 1910 some Senator had introduced in the Senate a resolution providing for the purchase by the Government of a number of paintings that nobody wanted to buy and under the rule that Resolution was referred to the Committee on the Library. . . . A little discussion developed that all the members of the committee had an uncomfortable feeling that the pictures were probably worthless . . . but no member of the committee felt any such confidence in his own knowledge and judgment about such things. . . . We all felt that the committee ought to have some way

*The commission was particularly concerned with the Mall, down which ran the tracks of the Pennsylvania Railroad. Burnham persuaded the president of the railroad, Alexander J. Cassatt, the brother of the painter Mary Cassatt, to remove them.

of getting an expert opinion to guide it in making its report . . . and we finally determined to ask Congress to provide for the appointment of a fine arts commission.

I drafted a brief statute . . . and a little informal explanation of the need which the committee felt for expert assistance in performing of its duties carried the bill through.

And so, without creation of any power of legal compulsion, there was brought to the service of the Government the authority of competent opinion upon questions of art.

He concluded by saying that the commission had saved the government from "God knows how many atrocities."

Seven "well-qualified judges of the fine arts" constituted the commission, and their jurisdiction was essentially what was built in the District of Columbia. They were, however, to advise the President "generally on questions of art when asked to do so by him or by a committee of either house of the Congress." Four years later President Wilson issued an executive order that all "plans and questions" involving art that might concern the federal government must be submitted to the commission and that no "final action shall be taken" until the commission had pronounced on them.

The government's role as a patron of the arts has always been a subject of controversy, if not on aesthetic grounds, then on financial ones. As early as 1818 the right of Congress to appropriate money for art to embellish public buildings was challenged by a number of congressmen, who insisted that "it was neither just nor proper for the Government to become patrons of the fine arts." Whether it has been just or proper, the Congress has had its say directly or indirectly about the arts every time it has appropriated funds for an office building, a courthouse, a library, a post office, or a monument, and it has not been reluctant to make its aesthetic opinions known.

Government Patronage by Indirection

The Congress has played a role as patron of all manner of arts, conservative and experimental, visual and literary, a role that it gives little thought to except when occasional cries of "indecency," "immorality," and "radicalism" are raised by the legislators' constituents. This patronage is the subsidy granted to institutions classified as educational and/or charitable and therefore free from property taxation by the federal government and by state and local governments. This is not just abatement of real-estate and excise taxes, though from the institutions' point of view that is

essential; it is also the provisions in the Internal Revenue Code that gifts to established nonprofit educational institutions (which include art, history, and science museums) are tax exempt to an important if not to an unlimited extent.

The sixteenth amendment to the Constitution, proposed in July 1909, gave the Congress authority to impose taxes on private and business incomes from "whatever source derived without apportionment among the states and without regard to any census or enumeration." The amendment was adopted in February 1913, but it was not until 1917 that a War Revenue Tax was authorized to prepare for what many recognized was the inevitable involvement of the United States in the war in Europe, "the great war," as it used to be called. The tax was a graduated one, beginning at 4 percent on personal incomes of more than $1,000, and the same legislation raised the corporation tax on profits to 6 percent. It was this law that introduced the charitable deduction on individuals' income, and it provided such deductions up to 15 percent if the money was donated to a tax-exempt institution. In 1952 the allowable deduction was increased to 20 percent for certain types of nonprofit institutions and organizations, to 30 percent in 1954, and in some cases to 50 percent in 1969.

The rationale behind the income-tax deduction (it was part of the Second Revenue Act of 1917) was, put simply, that it was against the interest of charitable institutions to tax that portion of an individual's income that he or she might devote "to public uses and not to the giver's personal advantage or enrichment." The income tax, it was reasoned, should apply only to the part of a person's income spent on him or herself. Senator H. F. Hollis, who was one of those who wrote and sponsored the legislation, was afraid that the new tax might discourage those in the higher brackets from maintaining their custom of making substantial donations for charitable uses, those, in other words (his words), who usually "contribute to charities and educational objects out of their surplus." He was fearful that, "when war comes and we impose these very heavy taxes on incomes, that will be the first place where the wealthy men will be tempted to economize. . . . They will say, 'Charity begins at home.' "

The indirect subsidies to cultural institutions—museums, symphonies, opera, dance, and repertory theatre companies—through tax-deductible gifts, has been many times the amount given in this century by governments in Europe as direct state subsidies. We have no national opera company such as La Scala in Milan, or theatre such as the Comédie Française in Paris, or local symphonies such as those in Germany that are municipally supported, but there is no European country (at this writing) that allows "tax-free" gifts to museums and other comparable cultural

organizations. An English collector, for example, who gives his precious Rembrandt to the National Gallery in London, gives it outright. The government smiles on his beneficence, but it does not allow him a tax break for his generosity. The same is true in Germany, Italy, and Holland.* If, on the other hand, an American collector gives a Rembrandt worth, say, $1 million to the Chicago Art Institute, he can deduct this amount, up to 30 percent of his taxable income in any one year, and if he cannot take advantage of this provision all at once, he can spread it over as many as five years. The same is true of cash donations up to 50 percent of taxable income, so that, in effect, for every $1,000 a citizen gives to an orchestra, museum, library, or college, the government pays from $300 to $500 of it. In 1964 Alvin Toffler wrote in *The Culture Consumers:* "Treasury officials . . . say that on the average for every dollar contributed to a cultural cause in the United States, the donor receives an estimated fifty cents back in tax savings. If this estimate is correct, it means that the federal government puts up at least $5,000,000 every year for the support of symphony orchestras." Inflation since 1964 has greatly increased the cost of maintaining a symphony orchestra, but government subsidies from tax deductions alone have also increased.

The Internal Revenue Service requires that the donor of a work of art to a museum valued at more than $5,000 or a rare book or manuscript to a library, for instance, must have the work appraised by a recognized authority, and the deductible value of his donation is based on this appraisal. The appraiser generally bases his figure on the current market value of comparable work, often on what such a work most recently brought at auction or on a recognized dealer's current prices. For a time this was an invitation to fast footwork on the part of some collectors: having bought a painting for $1,000, a collector would get a dealer to appraise it for $15,000 and then would promptly give it to a museum, thereby showing a net profit on his deduction. As a result the law was amended to provide that any work of art or the equivalent given to an institution must be held by its owner for at least a year or, if it is not, any increase in its appraised value is subject to capital-gains tax. (This holding period has now been reduced to six months.) Furthermore the Treasury Department employs panels of experts drawn from the professional "culture industry" (museum curators, art and book dealers, and librarians, primarily), who review the appraisal if it is $20,000 or more, in order to

*In France, by giving works of art to the state collections, the donor, if the state accepts the gift, can satisfy inheritance taxes and be exempted from transfer taxes and related ancillary duties.

verify the validity of the figure the donor has represented as the value of the object on his tax return.*

Government Embraces the Arts

The Great Depression of the 1930s put an entirely new complexion on government patronage of the arts, as it put a new complexion on ways to bring under control the most violent dislocations brought on by fluctuations in the economy. But the government's role as patron had little effect on its role in the arts thereafter; it was an emergency measure (or series of measures) backed by a wealth of good will and a not inconsiderable supply of government cash—a rescue operation that taught some lessons in patronage that were quickly forgotten. In its brief history it saved a good many artists, writers, musicians, actors, and other workers in the arts from the desperation and humiliation of breadlines. It produced hundreds of murals in public buildings, thousands of canvases, sculptures, and prints, a remarkable series of local and state guidebooks, and, as we have seen, gave the theatre an injection of vitality that, depression or no depression, it badly needed.

It was the painter George Biddle who made the original suggestion that there should be a relief program that would turn the talents of artists to the benefit of the public. Biddle was a Philadelphian, a classmate of Franklin Roosevelt's at Groton, and when he addressed a letter to the President, it was heeded. He suggested that a group of America's most eminent painters be commissioned to decorate the new Department of Justice Building in Washington "at plumbers' wages." The artists he recommended were Thomas Benton, John Steuart Curry, Grant Wood (known as "Regionalists" because they painted the land and people of Midwestern rural America), Reginald Marsh, Henry Varnum Poor, and Boardman Robinson. Roosevelt passed Biddle's letter along to his friend Edward Bruce, who was by profession a lawyer, by avocation a painter of some skill, known and respected by artists, and at that time an advisor to the Treasury Department.

This was in 1933. Roosevelt had sought and got from the 73rd Congress relief measures which included the Civilian Conservation Corps (CCC) to take young men off the streets and into the national forests, where

*Until 1969 it was common practice for successful artists to give a painting or sculpture or print to a museum or a writer to give manuscripts and literary correspondence to libraries interested in collecting archives, and to deduct the appraised value from their tax returns. Public figures also gave their papers on the same basis. The law was changed, however, and the artist can deduct only the cost of his materials (paint, canvas, etc.) and the writer the cost of his paper.

Thomas Hart Benton, a very successful muralist before the Treasury Department mural program was initiated in 1933, was awarded a commission without having to compete for it. He painted this sketch for one of several panels in the Post Office Building in Washington, D.C., in 1935.

they could be usefully employed at necessary reclamation and reforesting tasks; the Federal Emergency Relief Agency (FERA); and the Public Works Administration. The PWA was to be a crash program of limited life to get as many men and women as possible off the relief rolls and put them to useful work at a minimum wage on public projects. A part of the PWA was the Civil Works Administration, over which Harry Hopkins presided. It was to Hopkins that Bruce turned with his program for the Treasury Department, as Elmer Rice had with his proposal for a national theatre project. Bruce envisioned a program for employing professional artists with funds allocated by the CWA to Treasury for the creation of murals in federal buildings, primarily those in Washington, but also in post

offices, customs houses, and other such government offices, and in tax-exempt schools, hospitals, public libraries, and museums.

Mural painting had gone into an enforced decline with the new architectural theories of the 1920s. Unlike the buildings inspired by the Beaux-Arts, which employed ornament with enthusiasm, and on which architects, painters and sculptors worked in concert, the new "honesty" in design put its trust in "purity." Plain surfaces were considered modern; ornament was not only out of fashion among the advanced architects, it was regarded as dishonest; it obscured the beauties of functional construction. This attitude, added to the toll that the Depression had taken on the building industry, meant that there were, to all intents and purposes, no commissions for large-scale work by artists. Furthermore the number of individuals who were purchasing contemporary American works for their collections had dwindled to a precious few.

American artists looked wistfully and with profound respect at the vitality of Mexico's renaissance of mural painting, and most particularly at the frescoes of Diego Rivera and José Clemente Orozco commissioned by the government in Mexico City. Not only was it a revival of the great Renaissance tradition of true fresco, but it was the celebration of a social revolution with which many American artists were in sympathy. George Biddle in a letter to Roosevelt in May 1933 took account of this and suggested: "The younger artists of America are conscious as they have never been of the social revolution that our country and civilization are going through; and they would be eager to express these ideals in a permanent art form if they were given the government's cooperation."

Bruce was far less interested in the social revolution than he was in putting artists back to work. With the cooperation of Henry Morgenthau, the Secretary of the Treasury, and Mrs. Morgenthau, an enthusiast of the arts, and with encouragement and backing from Mrs. Roosevelt and Frances Perkins, the Secretary of Labor, and from Hopkins (who answered a critic of the program to employ artists, "Hell! They've got to eat just like other people"), the Treasury Department initiated a Public Works of Art Project. It was the first art project the government had ever undertaken on a national scale.

"We want artists selected by quality," Bruce said, "but we want the public also to realize that we are selecting them because of their need for employment as well." He defined their mission: "To make a pictorial representation of the American scene for the embellishment of public buildings."

The artists were paid a minimum of $26.50 a week and a maximum of $42.50. In the course of the program's brief life (it was a mere toe in

Stuart Davis painted "Swing Landscape" under the auspices of the Federal Art Project in 1937 for the Williamsburg housing project in New York. This sketch for the mural is in the National Collection of American Art in Washington. *(Smithsonian Institution)*

the water to test the possibility of wholesale immersion), it gave work to 3,750 artists at a total cost of about $1,312,000. They produced more than 15,600 works, which were allotted to institutions on a regional basis. For administrative purposes and to spread the benefits, the project divided the country into sixteen sections, with regional directors and committees to select the artists. The divisions were those that had been established by the CWA. The PWAP died after about six months, but the employment of artists by Treasury did not. It was succeeded by a Section of Fine Arts in the Treasury Department, established by Morgenthau and presided over by Bruce. It was this program that was responsible for hundreds of post-office murals that elicited enthusiasm from the citizens of many communities and cries of dismay or disdain or fury from many others.

There has been a continuing confusion between Treasury's mural project (the artists were selected by juries of artists and arts administrators) and the WPA arts project, which provided relief work for many thousands of artists, writers, musicians, and actors. The WPA Federal Art Project took off in August 1935. "Its primary concern was with the artist," Holger

Cahill, the director of the art program, said, "not with art as such." It was administered according to the relief regulations of the WPA, not in the manner or with the intent or aspirations of the Treasury program, in which "quality," according to Bruce, was a primary requirement, not the need of the individual artists who received its scant bounty.

The range of the WPA art project was far broader than Treasury's experiment in art patronage. As we have seen, the WPA played an invigorating role in the theatre. It also put thousands of writers to work on regional guidebooks, which were, it can be reasonably said, a great deal more effective and generally respected than the murals with which the art projects covered acres of public walls. The lot of painters in the Depression was a sorry one. They had been reduced to bartering their work for groceries and rent, for dentistry and meat. Private collecting, which had boomed in the 1920s, had all but dried up, though outdoor exhibitions in parks and city alleys brought some artists a few dollars for pictures that, in rare cases, may now be worth thousands. There was, in fact, what some members of the art community regarded as an uncomfortable "overage" of artists in the 1930s, men and women of modest talent who had been attracted by the blandishments of art schools and the attractions of the *vie de bohème* to dedicate themselves to the muses. According to a survey made for the Carnegie Corporation in 1933, "In the 1920s . . . the number of artists involved in the visual arts had increased 62 percent, from 35,400 to 57,264."

Those who stood in authority behind the WPA art project had more than just relief in mind. "The great traditions of the Renaissance and the Middle Ages," Cahill wrote, "were created by thousands of artists who were given an opportunity to work by the church, by government, and by private citizens, by patrons who believed in a living art." Here he saw a "return to this healthy tradition of art patronage," and an opportunity to engage artists in the life of the nation. He saw them as participating citizens and not, as they were so likely to be regarded by most Americans, as men and women apart, enjoying the freedom to create for their own gratification without making any significant or useful contribution to society, which looked for enrichment in goods and services not in frills, as the arts were thought to be. The artist as outsider was a concept that had always been in the American consciousness from the days when traveling limners painted faces on canvases on which they had previously painted clothed figures, leaving an empty space for the head. All through the nineteenth century and well into this one the artist had been looked on as an ornamental, not an essential, member of society. When he attempted to engage himself politically (as John Frazee, the first American sculptor in stone,

greatly respected as an artist who had risen from the rank of artisan, involved himself in a movement to better the stone cutters' lot), he was given to understand that he should mind his own business. Frazee's patrician patrons looked elsewhere when they wanted their images immortalized in marble. In the nineteenth century most artists, unlike George Caleb Bingham, gave politics a wide berth as being none of their concern. So did they also in the early years of this century.

Artists Embrace the Government

By the 1930s the mood in the community of the arts was very different from what had been its traditional aloofness from society's problems. Biddle suggested this in his letter to Roosevelt regarding the interest of young American painters in the Mexican muralists. The Depression had shifted their focus to the political left. They saw a social revolution in the making, and many of them wanted to man the intellectual and political barricades with their skills as satirists and champions of people's rights. In 1935 the American Artists' Union came into being in New York, essentially with the purpose of bringing pressure on the federal and state governments to provide relief for artists. It quickly spread across the country, wherever there were concentrations of artists, from Cape Cod to San Francisco. In 1936 they organized the American Artists' Congress, a body headed by the painter Stuart Davis, one of the most gifted and certainly one of the most articulate American artists of the time. A "call" in the form of a letter went out from a committee headed by him to

> those artists, who, conscious of the need of action realize the necessity of collective discussion and planning, with the objective of the preservation and development of our cultural heritage. It is for those artists who realize that the cultural crisis is but a reflection of a world economic crisis and not an isolated phenomenon.

Nearly four hundred artists answered the call, and on February 14, 1936, the first American Artists' Congress was held in New York. The agenda, which might more accurately be called a list of targets, was outlined by Davis. He took note of the fact that there was "an increasing expression of social problems of the day in the new American art." This was not, like the Ash Can School, a sympathetic depiction of the ruder side of urban life; it was social protest. "Few artists," he said, "can honestly remain aloof, wrapt up in studio problems." It was the purpose of the congress to attack censorship as it had been practiced not only in the federal art projects, which permitted no evidence of social protest in their

depiction of "the American scene," but also in work done for "important public and semi-public institutions," where there had been "suppression, censorship or actual destruction of art works" that offended those who commissioned them. (The most notorious case was the mural in Rockefeller Center painted by Diego Rivera, in which a portrait of Lenin appeared. It so offended the management of Rockefeller Center, not surprisingly, that the mural was removed from the wall and destroyed in the process.) It was an attack on museums and their trustees for their "indifference to the needs of artists." It singled out the Hearst press particularly for "the most vicious attacks against the artists on Government projects, calling them 'Hobohemian chiselers' and 'ingrates ready to bite the hand that feeds them.' " This attack," Davis wrote,

> is part of a general drive by powerful vested interests to perpetuate exploitation by smashing the efforts of the underprivileged American masses to gain security and a decent living standard. The goal of entrenched interests is a regime founded on suppression of all those liberties which Americans fought to establish and are today struggling to maintain.

It was nothing new in the history of the American arts for artists to form organizations to promote their financial interests and their status in the community. They had done so since John Trumbull and a group of artists and "gentlemen of taste and fortune" founded the American Academy of Fine Arts in 1803 and Samuel F. B. Morse, who was an artist before he was an inventor, broke with the academy and set up the National Academy of Design in 1824. What was new were the political overtones of the congress, which called itself the American Artists' Congress Against War and Fascism. Among the four hundred and more who came to the meetings, every important aspect of artistic theory and conviction was represented—"there were academicians and modernists, purists and social realists." The political tone of many of the papers presented at the congress ranged from just left of center to far left. They were anti-Fascist and generally pro-Soviet, for it was believed by many artists that Russian painters and sculptors were not only being wooed by their government but given status as honored citizens and participants in the social revolution. There were artists at the congress who were card-carrying Communists; there were others who had sympathy with the left but who would not have joined the party and submitted to its disciplines or subscribed to its dogma.

Much of American painting in the 1930s was what art historians have come to label "social realism." It ranged from glorification of the laboring classes to satirization of the police, the politician, and the plutocrat. It addressed the plight of the dispossessed and the injustices suffered by

minorities, most especially by Negroes. (The word "blacks" had not yet come into general use.) It can be argued that the arts were in social ferment in America to a greater degree than they were in aesthetic ferment. They erupted, as we have noted, not during the Depression but after the Second World War when prosperity and self-indulgence returned and art turned inward or, in Davis's words, once more became "wrapt up in studio problems."

Ben Shahn was one of the so-called "social realist" artists of the 1930s and '40s, but in "The Red Stairway," a scene of devastation, maiming, and emptiness after World War II, he was more humanitarian poet than realist. (*St. Louis Art Museum*)

Artists and Public, Face to Face

The WPA art project, over which Holger Cahill presided (he was an expert in American folk and primitive arts who had briefly been acting director of the Museum of Modern Art in the winter of 1932–33) grew quickly, from the time it was established in 1935, into an organization that kept the brushes and pencils and modeling tools of thousands of artists busy until 1941. The programs that Cahill and his colleagues devised were as varied in intent as they were in quality; their intention was not just to

provide employment but to introduce the artist, in a manner of speaking, to his neighbor. By no means all of what the WPA artists executed had permanent value or, whatever its value, had permanency. Many of the 2,250 murals (frescos, mosaics, photomurals, canvases) that were put on the walls of tax-exempt buildings have been painted over or torn down or have flaked off. Some of the 13,000 sculptures (they ranged from battlefield and housing-development monuments to small ceramic pieces for schools) that the WPA produced are still in place, some have been destroyed as the structures they were meant to ornament yielded to new buildings. Many of the 85,000 easel paintings that were selected from the more than 100,000 committed by WPA artists and "allocated on permanent loan to public institutions" have disappeared into storerooms or been lost. Some of them in recent years, because of a revival of interest in the arts of the 1930s, have been taken out of storage and are again on exhibition. Some of the murals have become so much a part of the buildings they adorn, like the Edward Laning series of four large paintings of the "Story of the Recorded Word" on the grand staircase of the New York Public Library, that they would be sorely missed if they were removed.

One of the projects that Cahill introduced, one of the least showy and historically most valuable, was the Index of American Design. About five hundred artists set to work on renderings, mostly drawings and watercolors, in centers in thirty-two states, to record the "indigenous decorative arts" of America from its earliest days. In Minnesota, for example, the artists concentrated on "the early contribution to American design by the Swedish immigrant." In northern California a group devoted itself to design that enlivened the boom days of the Gold Rush and the expansiveness of the 1870s. There were renderings of antebellum costumes of New Orleans, maps and garden plans, quilts and wallpapers, jugs and statuettes; indeed, every sort of decorative object that American hands had devised and embellished was recorded with the most painstakingly accurate renderings. This index of more than 22,500 items is now in the National Gallery of Art in Washington, an invaluable, but far from encyclopedic, record of the applied arts Americans lived with, as they did not, except for a few patricians in a few fine mansions, live with the fine arts.

WPA artists in graphics workshops set up by the project turned out etchings, woodcuts, lithographs, and silk-screen prints in abundance. They called their prints "multiple originals," a term invented by their contemporary Rockwell Kent, a successful illustrator and painter with a strong belief in the creation of a mass audience for art. Since the days when James A. McNeill Whistler in the 1880s first issued signed, limited editions of his prints in order to assure their rarity and hence their attraction to collectors,

most printmakers had followed his practice. It was customary for an artist to destroy the plate or clean the lithographic stone once the prints had been pulled, so that no further ones could be made, a practice that the great printmakers of the past would have disdained. The WPA printmakers not only made as many "originals" as they thought they could dispose of (the more of them the better served was the public that was paying their keep) but they adopted and refined a process that up to that time had only had commercial application, such as printing on milk bottles. It was the silk-screen process, a kind of printing, often in many colors, through silk stencils. When it became "art" it acquired a new name—serigraphy—to give it a kind of aesthetic respectability. This was "serious" art that almost everybody, even in a depression, could afford. It is recorded that "a total of 239,727 prints from 12,581 original designs" were produced in WPA workshops, where artists were free to experiment with new techniques and new applications of old ones. The mood was to break the elite mold of

Elizabeth Moutal made this meticulous watercolor of a carved and painted nineteenth-century wooden statue of "Liberty" by Eliodoro Parete for the Index of American Design, a part of the Federal Art Project. The Index is now in the National Gallery of Art in Washington.

ROCKEFELLER CENTER. COLLEGIATE CHURCH OF ST. NICHOLAS IN FOREGROUND DECEMBER 8th 1933

Berenice Abbott started her project "Changing New York" several years before the
Federal Art Project rescued it financially in 1935. The result was a remarkable series of
documents such as this one of Rockefeller Center with the Collegiate Church of St.
Nicholas in the foreground. *(National Museum of American Art, Smithsonian
Institution)*

printmaking and selling and create art for the millions. (In recent years, as the art market has grown strong, there has been a return to the issuance of limited editions of numbered and signed prints, with the exception of posters which are turned out on power presses.)

Photographs are more quickly made and reproduced than etchings, woodcuts, lithographs, or serigraphs, and WPA photographers are said to have produced some 500,000 of them. The most memorable of them were produced by Berenice Abbott, who focused her lens on New York,* and by the photographers who worked for the Farm Security Agency under the direction of Roy Stryker, an impresario with an uncommonly discerning eye and a marked gift for encouragement and editing. Among them, as we have noted, were Walker Evans, whose view of America Ansel Adams so disapproved; Ben Shahn, who also did murals for the WPA; and Dorothea Lange.

Making art that ornamented public buildings, enriched archives, and decorated living rooms with paintings and prints and crafts may well have had less to do with expanding the audience for the visual arts than the Community Art Centers that the WPA fostered in 103 cities. Most of them were in the South and the West, sometimes in unused stores, sometimes in houses borrowed from private owners or lent by the city. The centers were located in busy sections of town so that people could drop in casually for lectures, classes in technique, exhibitions, and demonstrations given by artists working on the project. If the statistics are believable (and government statistics on the success of projects of this sort are inclined to optimism) "during six years (1935–1941) more than eight million people took advantage of the community centers' programs, and 450 travelling exhibitions were shipped to them by the WPA's exhibition service."

The audience for art cannot be measured statistically; it is an emulsion, not a mixture, of many kinds of audiences with vastly differing tastes and degrees of interest, sophistication, and concern. There is no denying, however, that the Treasury Department's mural program and the variety of WPA art projects brought a great many Americans for the first time face to face not only with works of art, but with artists in the process of making them and thus of making a living. The local post office with a painter on a scaffold working on a mural was a firsthand experience of art that was new to most people in many communities. Artists, they discovered, were alive and, like almost everyone else, making a living with hand, eye, and muscle.

*Some of them were published as *Changing New York*, a book of 97 photographs with a text by Elizabeth McCausland, Dutton, New York, 1939.

This is not to suggest that the local folk necessarily approved of what the artist was up to; quite the contrary. Some communities were delighted with the pictures that were adorning their public buildings. Many were infuriated at the artists' interpretations of local lore and history and depictions of local scenes. In Kennebunkport, Maine, a mural of men and women on the beach brought howls of protest; the women were too beefy to satisfy their images of themselves. In Harlem a mural in a housing development that depicted men working with their shirts off was denounced by some blacks as undignified. There were complaints about "indecency," as figures were painted in the nude or near nude (skimpy bathing suits, for example). In the case of a mural painted by Jared French in Richmond, Virginia, the WPA supervisor looked at French's preliminary sketch of Stuart's Raiders crossing a raging river and said it wouldn't

When Jared French submitted a fully realized sketch in 1937 for a mural for the Parcel Post Building in Richmond, Virginia, he based it on the historical record that Stuart's Raiders shed their uniforms to swim their horses across "the swollen ford." French was told to put their clothes back on. This is the mural before and after.

do. History recorded that Stuart's cavalrymen, faced with having to get their horses to the far bank, had stripped to swim with their mounts.

French was told to put pants on them, and he did. In her lively and perceptive account of the Treasury Department's mural program, *Wall-to-Wall America,* Karal Ann Marling writes:

> As the term was bandied about in popular accounts of murals painted in Kennebunk, Maine, and Richmond, Virginia, "modern art" was a dirty word. "Modernism" was a catchall expletive condemning any picture or circumstances related to mural painting that failed to please. Calling someone a modernist was tantamount to calling him a communist.

Archibald MacLeish, in an unsigned article in *Fortune,* published in May 1937, wrote:

> What the government's experiments . . . actually did, was to work a sort of cultural revolution in America. They brought the American audience and the American artist face to face for the first time in their respective lives. And the result was an astonishment needled with excitement such as neither had ever felt before. Down to the beginning of these experiments, neither the American audience nor the American artist had ever guessed that the American audience existed. The American audience as the American artist saw it was a small group of American millionaires who bought pictures not because they liked pictures but because the possession of certain pictures was the surest and most cheaply acquired sign of culture. . . . From one end of the range to the other, American artists, with the partial exception of the popular novelists and the successful Broadway playwrights, wrote and painted and composed in a kind of vacuum, despising the audience they had, ignoring the existence of any other.
>
> It was this vacuum which the Federal Arts Projects exploded. In less than a year from the time the program first got under way the totally unexpected pressure of popular interest had crushed the shell which had always isolated painters and musicians from the rest of their countrymen and the American artist was brought face to face with the true American audience.

The Arts Go to War

Preparations for war relieved the pressure of unemployment that had made a doldrums of the 1930s, and in 1941 the WPA art project petered out as artists were put to work, some of them, using their skills for "the war effort." Some Community Art Centers were converted into recreation centers for military personnel on leave, and many of the artists joined the armed forces or went to work in war factories. A few were taken on by the Army, Navy, and Air Force as "combat artists" in a program that was promoted by the indefatigable George Biddle in 1943. Others were employed to design posters for the armed forces and items as miscellaneous

as armbands and portable altars. Only a few "artist correspondents" were given contracts—fourteen at first and then fourteen more. But the House Appropriations Committee evidently thought of this expenditure, modest as it was (about $30,000), as nonsense and struck out the $125,000 that was included in the Army Appropriation Bill for 1943–44, which was to continue and expand the program. *Life* and *Collier's* magazines took on as correspondents a number of the artists thus beached by the Appropriations Committee, and nineteen others were assigned as civilians to the Corps of Engineers as a Combat Art Section. Out of this cadre, which expanded to 141 artists, came more than 6,000 paintings, and out of these about 2,000 were found acceptable by a committee that combined art critics with military men. The acceptable pictures went to the Historical Properties Branch of the Army; the unsuccessful ones were returned to the artists. "As a record of the last war in the medium most comprehensible to man," Francis V. O'Connor wrote in *Government and Art* in 1956, "the collection of war art represents the results of a fruitful union of art and government."

One other government involvement with the arts (if not with artists) during the Second World War was important to the expansion of the postwar art audience, or at least to impressing on Americans the art community's concern with the art of its enemies as well as its friends. The Monuments and Fine Arts Division of the American Military Government not only spent a great deal of time and ingenuity in tracking down paintings and other objects that had been "liberated" from museums and private collections by the Nazis but also in searching out the works that had been sequestered in salt mines and other places deemed secure against bombings, shell fire and looting. During the occupation of Germany the American Military Government set up exhibitions in Wiesbaden, to which they charged admission, the first one of Italian old masters from Berlin and Frankfurt collections and the second of "Northern Art before 1600." German civilians and American military personnel turned up at the rate of a thousand a day. Soon after hostilities had ceased, the Monuments and Fine Arts Division shipped to the National Gallery of Art in Washington, for safekeeping in the museum's vaults, the masterpieces from German museums that had been sequestered in salt mines. At the Army's instigation they were put on exhibition at the National Gallery in March and April of 1948, and in today's terms the show was a blockbuster. Many thousands of people turned out to see it, and many other American museums sought the opportunity to show it. The paintings were returned to West Germany in 1948.

The activities of the American Military Government had nothing to do with patronage of the arts; it was concerned only with conserving them.

It had, in other words, no connection with the WPA projects. But it was another involvement of government with the arts, and in that sense important as evidence of a new political concern with cultural artifacts and the people who make them. Art, it appeared, was or should be a concern of the federal government, if not as a necessity then as a national ornament. The upshot of the WPA programs, it was claimed, was a substantial new audience and hence a new market for artists to capture. Audrey McMahon, the regional director of the program for New York, insisted that "The wide distribution of project works is developing a new public for American art. The unequal distribution of privileges, denied by birth, education, lack of money and living conditions, is here corrected." The "wide distribution" appeared to have discouraged (it certainly did not obliterate) the elitist attitude that art is for the few who appreciate its subtleties, encourage its experiments, and support what often seem to be its outrages. On the other hand there were those who believed that the wholesale support the WPA had provided had greatly magnified the number of philistines. Juliana Force, the director of the Whitney Museum, said that the WPA produced "too much mediocre art . . . Selectivity is the essence of art and there can be no true selectivity when the basic reason for choosing an artist is his poverty."

There was, however, another aspect of the relief projects for artists that had nothing to do with what had happened to the size of the audience or the mediocrity of much (by no means all) that the artists produced while they were on the public payroll. It was during the 1930s and more particularly the 1940s that the seeds of an aesthetic upheaval were sown. Artists are not primarily political animals, and for most of them the political seductions of "social realism," which occupied them in the 1930s, soon lost their charms. The art of propaganda had supplied scarcely any artists in the Western tradition with inspiration since the Christian iconography had lost its power to inspire them in the seventeenth century. Even then in the Counter Reformation it had dwindled to a kind of theatricality that was more important than the subject matter it portrayed. The most gifted artists in the 1940s wanted to "get back to work," their private work, their particular ways of getting at and telling the truth, not the government's ways or the mass public's ways. They wanted to immerse themselves in what Stuart Davis called "studio problems." And they did. One of their number, Joseph Solman, some years later said, "The abstract expressionist movement is unthinkable without the encouragement to survive and experiment that was given these artists by the WPA."

Art and Politics on a Collision Course

During World War II the Office of War Information had undertaken, with exhibitions as well as with written materials and broadcasts, to explain to our allies, as well as our enemies, that the United States was not only a determined arsenal but a nation with a deep concern for culture. Some of this, to be sure, was a manifestation of a self-consciousness with a very long tradition. Our sense of cultural inferiority to Europe was an embarrassment (or perhaps it was merely a shyness in a nation noted for its boastfulness in other matters) that went back to our colonial days and lasted well into this century. We professed some claim to a literature of importance, and a few of our authors were read with enthusiasm in Europe, most especially, of course, in England. Edgar Allan Poe, Emerson, Mark Twain, Henry James, and Whitman, for example, were exported with success in the nineteenth century (James made England his home). For years architects had gone to study at the École des Beaux-Arts in Paris, as we have noted, and many of our painters even before 1800 had gone to London to study with the distinguished expatriate from Philadelphia Benjamin West, or, as John Singleton Copley did in 1774, to set themselves up to practice the profession of portraiture. In 1894 Charles Follen McKim, as we have noted, had founded the American Academy in Rome with the support of Daniel H. Burnham, with whom he had worked on building the Columbian Exposition in Chicago. At the academy painters, sculptors, landscape architects, and somewhat later composers went to breathe the odor of ancient culture in order to return and improve the standards of taste of their fellow Americans. The 1920s had seen an exodus of young American writers and painters and composers to France, particularly, and to Germany, to get away from the America of bigotry and commercialism, as described by Theodore Dreiser and Sinclair Lewis. They were attracted to cultures where artists were honored or where their eccentric ways of life were at least taken more or less for granted. The Depression, which cut off funds from home, and later the threat of war sent many of them scurrying back to America.

These expatriates were scarcely cultural ambassadors from the United States. Indeed, they were living proof to European intellectuals that America was a cultural desert that could not (or would not) nourish native talent. Our embassies in Europe, however, wanted evidence to the contrary. William Benton, the Assistant Secretary of State for Public Affairs, declared that we "are accused throughout the world for being a materialistic, money-mad race without interest in art and without appreciation of

artists and music." He wanted to demonstrate to that skeptical world that we "have a side in our personality as a race other than materialism and other than science and technology."* Our embassies asked for and got exhibitions of work by American artists on a modest scale, organized by the State Department's Cultural Cooperation Program.

Ralston Crawford's abstract "Wing Fabrication" was in the State Department's exhibition-for-export, "Advancing American Art." Abstractions were called "un-American" by congressmen and a waste of taxpayers' money by the press. The State Department bought the entire exhibition of 111 paintings for $49,000 in 1947; an abstract painting by Crawford sold at auction for $187,000 in 1984. *(Collection, Museum of Art, University of Oklahoma, Norman)*

 In 1946 the State Department exhibition program incited congressional fury. It had spent $49,000 to purchase seventy-nine paintings by contemporary American artists in order, it said, to fulfill the requests that it had received from diplomatic missions abroad. The purpose of the show, which was called "Advancing American Art," was to demonstrate the

*Also in 1938 the Museum of Modern Art had sent a large exhibition called *"Trois Siècles d'Art aux États-Unis"* to the Jeu de Paume in Paris. Its importance was so little thought of by the American ambassador that he did not attend the opening because he had a date with his tailor in London. The French were unimpressed and said so volubly.

character and quality of what was being produced in American studios. It was selected by a single individual rather than by a committee. Half of this collection, was sent to Europe and half went to South America. The intention was to circulate the exhibitions to the capital cities of our European allies and those of our "good neighbors" (as we officially were calling the Latin American countries then) to the south.

Some members of the House Appropriations Committee were gunning for the State Department's Office of International Information and Cultural Affairs, and they decided that the exhibition was a sitting duck. Artists, and especially those who could be called "modern" were, as we have seen, politically suspect in conservative circles. The Hearst press had already stirred up a fuss about the exhibition, as it had earlier about the "hobohemians" in the WPA art project, and it had ammunition provided to it by the American Artists Professional League, an organization of illustrators and academic artists who believed that modern art was seeping aesthetic poison into the public's veins—and not incidentally taking too large a share of the art market. The spokesman for the congressional attack was Congressman Fred Busbey of Illinois. "I have seen pictures of the paintings," he said. "Some of them are so weird that one cannot tell without prompting which side is up." But that was the least of his worries. "The movement of modern art is a revolution against the conventional and natural things of life as expressed in art," he said. "The artists of the radical school ridicule all that has been held dear in art. Institutions that have been venerated

> through the ages are ridiculed. Without exception, the paintings in the State Department's group that portray a person make him or her unnatural. The skin is not reproduced as it would be naturally, but as a sullen, ashen gray. Features of the face are always depressed and melancholy. That is what the Communists and other extremists want to portray. They want to tell the foreigners that the American people are despondent, broken down or of hideous shape—thoroughly dissatisfied with their lot and eager for a change of government.

Such was the mood in this time of "red scare" and "un-American activities" investigations that arguments like this were taken seriously by easily intimidated bureaus of the government. The State Department ordered the exhibition closed in Prague, where it was being shown, and shipped back to Washington. The paintings were sold as "war surplus" at ten cents on the dollar and the lion's share was bought by the University of Oklahoma and Alabama's Auburn University. Though conservative institutions, they were happy to have such excellent examples by artists who were considered the cream of the new crop. Each got thirty-six pictures.

Circus folk took exception to Yasuo Kuniyoshi's "Circus Girl Relaxing" that was included in the 1946 Advancing American Art exhibition organized by the State Department. It inspired President Truman to say, "If that's art, I'm a Hottentot." It is now in the Auburn University Collection.

One of the paintings that Auburn University got was by the Japanese-American artist Yasuo Kuniyoshi. It was called "Circus Girl Relaxing," and circus folk took violent exception to it as an insult to their profession and appealed to President Truman. Presidents rarely make public comments on works of art (except portraits of themselves that they do not like) but Harry Truman let fly with "If that's art, I'm a Hottentot." Today such a pronouncement would be regarded not only as philistine but racist.

"Advancing American Art" was not the only exhibition that the State Department had sent on the European and South American circuit. There were four exhibitions of prints that the department had purchased and that were traveling in South America. A group of sixty paintings called "American Industry Sponsors Art" was circulated in Europe. (All the pictures were from the collection of the International Business Machine Company.) The National Gallery in Washington got together "more than 200 oil paintings and water colors by 106 artists providing a panorama of American art from colonial times to the present." But the brouhaha over "Advancing American Art" so discouraged the State Department that it with-

drew, leaving the field to the United States Information Service, which played it safe in that period of ideological stress.

The attacks on modern art as a Communist conspiracy did not stop there. As long as personal headlines were to be made by congressmen with such maneuvers, and since the public in general was inclined to think that most non-academic artists were somehow suspect, attacking unconventional artists was an easy way to make political allies. Abstract painting and sculpture and "social realism" were foreign to the experience of most Americans, and it took little persuading to convince them that such art was literally foreign in origin and therefore "un-American." The art that satisfied the public taste was epitomized in the *Saturday Evening Post* covers by Norman Rockwell. He painted the American scene with tender affection in a way that glorified "the solid virtues" of the American small-town family. He was a master of his craft and unquestionably the most popular artist of his day, and with good reason. There was not a trace of cynicism in his work. His renditions of "The Four Freedoms," as proclaimed by President Roosevelt, were made into posters (they were part of Rockwell's "war work") and were everywhere. He was a spokesman for middle-class virtues; he saw none of the failings of the middle classes, much less the vices they shared with all other classes of Americans.

It is not surprising, therefore, that much (perhaps most) of the public was willing to accept Congressman Busbey's attacks on the State Department exhibition sympathetically. Several years after "Advancing American Art" had been killed, another congressman, George A. Dondero, a Republican from Michigan, prompted and instructed as Busbey had been by the American Artists Professional League, took out after a show organized by some well-meaning citizens for the paraplegics in St. Albans Naval Hospital on Long Island as a means of giving them not only pleasure but encouragement to undertake painting as therapy. (Another aspect of this program was a writers' project, which brought to the hospital as volunteers a number of well-known authors, editors, and journalists to talk about their craft and to review the patients' manuscripts.) The exhibition contained six paintings by artists who had been represented in the State Department show and were therefore regarded by the congressman to be politically dangerous—as, by association, were all the other artists who had lent pictures to the hospital. Dondero took some pains to air his alarm, if it was that, to the Congress and hence to the press.

This kind of painting, he insisted, "signifies a caricature of art, art that is abortive, that is distorted, and that is repulsive. . . . The arts of the communist and the Marxist is the art of perversion."

Dondero, who appears to have been ignorant of the suppression of

modern art under the Nazi and Soviet regimes, could not believe that the artists who contributed their work and their presence, like the writers and editors, willingly helped the wounded out of a sense of gratitude, obligation, and charity. "They had a great opportunity," he said, "not only to spread propaganda, but to engage in espionage. . . . I cannot for a minute believe that they devoted all this time and energy as pure philanthropy."

Looked at in perspective there is a question whether a limited number of politicians gave art more of a bad name than art gave the politicians who attacked it. Richard M. Nixon, when he was a congressman from California, was making political hay in the same way that Busbey and Dondero and Martin Dies, chairman of the House Un-American Activities Committee were, by pointing the finger at artists as tools of Communism. His particular target was a mural painted by Anton Refregier in an annex of the San Francisco post office. On July 18, 1949, he wrote to a past commander of a San Francisco American Legion Post, thanking him for his letter about "whether anything can be done about removal of Communist art in your Federal Building." He said:

> I realize that some very objectionable art, of a subversive nature, has been allowed to go into federal buildings in many parts of the country. . . . At such time as we may have a change in the Administration and in the majority of Congress, I believe a committee of Congress should make a thorough investigation of this type of art in government buildings with a view to obtaining removal of all that is found to be inconsistent with American ideals and principles.

When Congressman Nixon, by that time Senator Nixon, was nominated by the Republican convention of 1952 as Eisenhower's running mate, nothing further was heard of his crusade to save the republic from subversive art. His declarations (and his membership on the House Un-American Activities Committee and his attacks on his opponent for the Senate seat, Helen Gahagan Douglas, for being soft on Communists) had served his political purposes, and to continue them would have been a further embarrassment to Eisenhower, who was embarrassed enough by other members of his party for their red hunt.

The antics of Busbey and Dondero and Nixon and others of their persuasion, however, had a lasting effect on the role of government as a patron of the arts. It was not their anticommunist stance that mattered in the long run; it was the obvious fact that when politicians undertook to play a role in the arts, it was to score political points, and the credibility of the government as a disinterested patron, ready to consign matters of art to those who know and care about them, was cast into shadow.

An Uneasy Courtship and Marriage

Attempts to engage the federal government in a systematic support of the arts date back well into the nineteenth century. The first bill that favored legislation to establish a council whose business it was to encourage the arts, beyond the government's concern with its own buildings, was introduced in the 45th Congress (1877–1879). Periodically from that time the issue was raised, and died in committee. In art circles proposals were made that there be a Department of the Fine Arts with a Secretary of Fine Arts of cabinet level. In 1919 Robert Benchley took occasion to examine what might happen to campaign oratory if the fine arts were on the platform of one candidate or another.

> Before it is too late, let us consider the possibilities. Let us consider the campaign slogans which would greet us on the fences and in the street-cars:
> *"Vote for John A. Ossip! He kept us out of post-impressionism!"*
> *"Down with the nude in art! Vote for Horace W. Pickerell and the sanctity of the home!"*
> *"George Washington never heard of Elie Nadelman. What was good enough for Washington, is good enough for Henry J. Wrapper. Give him your vote!"*

Some years later in the 1940s George Biddle sent a letter to a number of other painters asking what they thought of a Federal Bureau of the Fine Arts, and John Sloan replied, "Sure, it would be fine to have a Ministry of the Fine Arts in this country. Then we'd know where the enemy is."

But this was no laughing matter in the art community, and surely not a laughing matter to Sloan, who could not resist the wisecrack. It was a deadly serious business that mobilized a large number of museum directors, artists, critics, dealers, promoters, and others to whom the health of the arts was important, to rally in favor of a bill introduced by Congressman Charles Howell of New Jersey on January 3, 1953.

Howell's bill provided, among other things, for the establishment of a commission appointed by the President which, in addition to the customary ex-officio members, should be composed of "fifteen eminent citizens . . . in the fields of the fine arts, education, recreation, veterans' affairs, business, agriculture, labor, the professions, State, county, and municipal governments and public affairs . . . selected so as to provide adequate representation for the views of leaders in the fine arts in all areas of the nation." The function of such a commission was "to develop and encourage the pursuit of a national policy for the promotion of and for education in, the fine arts," and to use money as well as good will to do so; "to initiate

and support both professional and amateur activities in all fields of the fine arts by making contracts and other arrangements (including grants, loans and other forms of assistance) for the conduct of activities in the fine arts, and to appraise the impact of such activities upon the general welfare and the cultural development of the nation." The commission was to keep a critical eye on "fine arts programs undertaken by agencies of the Federal Government," and to see to it that an opera house and theatre was established in Washington as a national war memorial—hence the inclusion of a representative of veterans' affairs on the commission.

Howell's bill was just one of thirteen introduced that year which in various ways invited the participation of the federal government in the affairs of the arts. All thirteen of them fell under the ax of the House Committee on Education and Labor on the recommendation of its Subcommittee on Arts Foundations and Commissions, which made its report on September 21, 1954.

It was not for any lack of support from the art community that the bills failed. Howell, who was a member of the three-man subcommittee, in his "Statement of Minority Views" noted that his colleagues on the subcommittee had "rejected the viewpoint of all witnesses at the hearing, who, without exception, endorsed in some degree the concept of Federal aid for the encouragement and promotion of the fine arts." Those who had appeared to testify before the committee were "spokesmen for libraries, learned societies, city planning groups, the theatre, labor unions, businessmen, bankers, boards of trade and chambers of commerce, the symphony, the opera, and recreation associations." He might have added that museums were represented importantly and most persuasively by Lloyd Goodrich, at that time associate director of the Whitney Museum of American Art (he was later the director), and chairman of the Committee on Government and Art. Goodrich fought the battle for government subsidies of the arts long, hard, and ultimately successfully.

The essential argument that the proponents of the bill used to try to convince the subcommittee was at that time already a familiar one—that the United States was losing the cultural battle to the Russians. The Russians were spending a great deal of money to send exhibitions, ballet troupes, orchestras, virtuoso musicians, and theatre companies to other European countries as part of what might be called a cultural-propaganda assault. What America was doing was piddling by comparison, and, as we have seen in the case of Advancing American Art, had been stomped on by legislators. "In this offensive against us the Soviet Union and its satellites picture our citizens as gum-chewing, insensitive, materialistic barbarians," the minority report stated. "The Soviet Union, on the other hand,

is presented as the cradle of culture. The Russians are spending vast sums on this propaganda." The remarks of Congressman (later Senator) Jacob Javits of New York, a member of the Foreign Affairs Committee, were regarded as pertinent. "There is an enormous propaganda weapon which the Russians are using against us, with the most telling effect, all over the world," he said. "They are posing, and getting away with it, as the people of culture, as juxtaposed to us, who are painted to the world as the people who don't care for culture." In other words, we should not let the Russians use the cultural superiority they claimed as a weapon in the cold war in which we and they were then engaged.

Howell's bill, a revised version of it (H.S. 9111), the other bills submitted to the congressional committee, and parallel bills introduced in the Senate came to nothing. There is no question, however, that on this occasion the concentrated fire power of the big guns of the art world, backed by sympathetic politicians, educators, and journalists, softened up the opposition.

In March 1962 President Kennedy appointed August Heckscher as a special consultant to examine the degree to which the government was involved with the humanities and the arts and to suggest what role the government might play. The scientific community already enjoyed federal beneficence from the National Science Foundation, and the humanists, who had been relegated to a back seat by World War II, felt slighted. There were rumblings in the academic community in 1961, set off by Robert M. Lumiansky, dean at Tulane University, in a speech to the Council on Graduate Schools. Several politicians—Senators Wayne Morse of Oregon and Claiborne Pell of Rhode Island and Representatives John Fogarty of Rhode Island and William B. Widnall of New Jersey—were inspired to encourage an organization of some sort (then of a very vague sort) comparable to the National Science Foundation. By 1963 the humanists had, in a manner of speaking, got their act together, and the Academic Council of Learned Societies, the Council of Graduate Schools, and the United Chapters of Phi Beta Kappa proposed a commission under the chairmanship of Barnaby C. Keeney, then president of Brown University. The result was a report—a document that "emphatically recommended the establishment of an independent foundation for the humanities and the arts." The arts, an afterthought perhaps, rode on the coattails of the humanities.

According to W. McNeil Lowry, "President Johnson was personally interested in demonstrating support for cultural activities equal to or surpassing Kennedy's," and Roger Stevens, the theatre producer and arts impresario, who was Johnson's White House advisor on the arts, played a persuasive part in rallying congressional support (led in the House by

Frank Thompson of New Jersey) for the foundations. (Stevens was later the first chairman of the National Endowment for the Arts.) However, "The tremendous role played by the *Report on the Commission on the Humanities* in the establishment of the Foundation," according to Gustave O. Arlt, the chairman of the Council of Graduate Schools, "cannot be over-estimated." It was "plagiarized in hundreds of speeches . . . and many of its felicitous phrases were incorporated in the preambles of *one hundred and thirty-odd* [italics mine] arts and humanities bills introduced in the following year." The testimony and the wrangling in both the House and the Senate were resolved "three years and 268 days" after Lumiansky's speech to the Council on Graduate Schools. On September 29, 1965, President Johnson signed into law an act, Public Law 89-209, establishing the National Foundation for the Arts and the Humanities.*

The foundation's initial budget was $16 million. In 1980 it was $140 million, and in 1982 it was surprisingly cut-proof when President Reagan set about to reduce the budget by removing whatever he considered to be frills—and a good deal else besides. The Endowments for the Arts and Humanities were not close to his heart, though he professed a concern for the arts, but the sums involved were of no great significance in a budget of $600-odd billion.

The principal arguments against a government bureau for the arts and the subsidies it might administer can be summarized quickly. Experience demonstrated, so the opponents argued, that the nature of government patronage was, almost by necessity, conservative and that the arts it would support were, as they were in Europe, the tried and true, not the experimental. Furthermore, they contended, the support of the arts by tradition had been a local concern. Museums, orchestras, theatres, operas, and other cultural institutions had grown in influence and stature in this country because communities wanted them and had been willing not only to establish them, sometimes at great expense and with hard work by volunteers, but had supported them out of local pride and a belief in their contribution to the community's cultural welfare. Competition among cities, as we have noted in the case of museums, played a stimulating role. It was also evident from the experience of the 1930s and 1940s that, when politicians meddled

*The essential information is from "The Birth of a National Foundation" by Gustave O. Arlt, *The Graduate Journal,* University of Texas, no. 2, 1967, p. 475, and from "The Past Twenty Years" by W. McNeil Lowry in *The Performing Arts and American Society,* a publication of The American Assembly, Columbia University, 1977, pp. 16–19. The *Report on the Commission on the Humanities* was put in final form by Eric Larrabee, later director of the New York State Council on the Arts, and Charles Blitzer, at this writing director of the National Humanities Center. See also *The Democratic Muse* by Edward C. Banfield, chapter 2, "Making the Law," pp. 38–62.

in the affairs of taste, they did so, as might be expected, politically not aesthetically and in some cases with what the art community regarded as appalling results. There was concern, moreover, that money set apart by Congress for the arts would be an all-too-tempting political pork barrel. Subsidies for the arts, in other words, should be left to local governments and to the private sector—to individuals, corporations, labor unions, local businesses, and charitable organizations that reflected the community's cultural needs and aspirations.

In the 1950s, when the issue of federal support of the arts was being debated, these arguments seemed more plausible to those who were skeptical of government intervention in the arts than they did, say, in the 1970s, when it became all too evident that nonprofit art institutions, and especially those dedicated to the performing arts, had nowhere to go except broke unless they could discover new sources of patronage.

To be sure, in the wake of World War II, as attendance at museums and demand for symphony tickets soared and a flood of new dance companies and civic-theatre groups arose, new sources of income for the arts were tapped and the conventional ones were approached in new ways. In a number of cities, symphonies and museums, for example, joined in drives under the banner of United Fine Arts Funds, that paralleled the methods of Community Chests. In this way they were able to avoid competing with one another for the "cultural dollar." Twenty-one cities had such united funds in the 1950s. A few cities had local arts councils (Winston-Salem was the first), and such was their success in raising money locally that they looked with suspicion on efforts to establish a national council on the arts, lest the local folk shrug their shoulders and say, "Washington is going to take care of us."

As early as 1946 a move was afoot in New York to create a State Commission of Painting, Sculpture and Graphic Arts "with an appropriation to buy works of modern artists for use in public buildings." The Whitney Museum was behind the move in the person of Juliana Force, its director, and so was the Museum of Modern Art, whose trustee, James Thrall Soby, was its most articulate spokesman. The proposal came to nothing, but the seed it sowed was an exceptionally fertile one. In 1960 Nelson A. Rockefeller, New York's governor, long a trustee of the Museum of Modern Art (at one time its president) and a collector of modern and primitive arts, persuaded the legislature of his state to allocate $50,000 to finance a State Arts Council, "despite grumblings by some law makers," the *New York Times* reported, "that he was trying to 'put the state in the ballet business.'" Rockefeller's interest was not confined to the "creative artist"; he was primarily concerned with the performing arts. He saw the

cultural needs of his constituency as statewide, and he was determined to bring opera, symphonic music, virtuoso recitals, ballet, and theatre to what New York City dwellers called "upstate"—anywhere north of the city's suburbs. He managed to persuade Walter Mahoney, the State Senate leader, who lived in Niagara Falls, to support him by conjuring up visions of the Buffalo Symphony performing in cities across the state, evidence that New York culture did not emanate alone from New York City. Rockefeller is said to have assured Mahoney, "I don't want to force the arts down your throat," to which the State Senator replied, "Governor, you can take the arts and you can . . ." It was a retort that Rockefeller enjoyed recounting even to large audiences.

In 1961 Rockefeller asked for a budget of $450,000 for the council and got it. In the first nine years the council's budget grew to $2.5 million and then suddenly in the tenth year it jumped to $20.5 million. "The Council's task," he said, "is to assure individuals of attaining a fuller self-realization through participation in, and appreciation of our national cultural resurgence."

Resurgent was the way the growing audience for the "serious" arts was viewed, with mixed feelings of elation and alarm, by those who were trying desperately to keep their cultural ships afloat. As the audiences grew the costs grew faster, and the passengers came aboard in such hordes that the crafts sank nearer and nearer to the danger of having their gunwales swamped. Cultural supply and demand were at loggerheads; the demand increased by mathematical progression and the cost of supply seemed to increase geometrically. Ticket sales, often in sellout proportions, lifted the spirits of performers and directors, but even supplemented with private donations they could not keep up with the cost of performance. The demand of the new "leisure class" could not be met by conventional means if performers and the multitude of auxiliary persons who make performances possible were to be paid a living wage. Those who had worked hardest to increase the audience for the arts began to wonder if they had not dangerously overshot the mark. Were all these people truly concerned with art? Or was showing an interest in art merely "the thing to do"? It was really too late to ask these questions; the answers were in the existence of demand, and having successfully whetted the appetite for the arts, state arts councils were thought to be one of the answers to the dilemma. But only a minor one. In New York, as the budget for the council grew in a decade to more than $20 million, its programs proliferated. More communities were exposed to professional performances, more struggling small groups of actors and dancers were given transfusion money with which to experiment, to teach, to perform. More writers and artists received grants

to pursue their own muses. More schools had resident artists to inspire and teach and organize arts and crafts groups. As Eric Larrabee, the director of the New York State Council on the Arts, wrote in 1973,

> There is an innate tendency in government, as among foundations, to prefer dealing with institutions like themselves; and, by nature, the individual artist escapes from all those patterns of behavior with which organized philanthropy and public funding are comfortable. Yet it is the individual artist from which everything else derives . . . to neglect the individual artist of today is to damn the arts of the future to sterility.

The New York Council set a pattern that other states followed, up to a point—many of them to a very minor point. When the National Council on the Arts was established in 1966, it initiated a federal-state Partnership Program to begin in the following year. It budgeted $2 million for distribution to state arts councils on a "matching grant" basis, and the states responded, nearly all of them, with alacrity.* Most of the grants were in the neighborhood of $40,000, and the council reported: "Thousands of projects have been carried out under this program, involving all art forms." The major emphasis was on "bringing performances and exhibitions to smaller communities." There were programs "reflecting the local culture of the region," writers' workshops, a museum for the blind, an "art train" that carried exhibitions to out-of-the-way places. "The Federal State Partnership Program," the National Council boasted, "has thus afforded to millions of American citizens their first opportunity to participate in the arts."

And so the fields of the arts were plowed and fertilized, and reaping the harvest demanded more and more funds from more and more sources. What had long been thought of as the genteel business of purveying the arts to the people had become known to the purveyors as the "culture industry." It had become big business—very big indeed.

Patronage New Style

With an abrupt shift from an emphasis on the sciences to a concern with the humanities in colleges and universities after World War II, institutions of higher learning became the greenest playgrounds of the muses. Drama and fine arts and music departments were magnets that drew

*During the period 1967–70 "state legislatures' appropriations for the arts increased steadily from $4.8 million in 1967 . . . to $7.6 million in 1970. Private contributions also increased dramatically during this period, with the result that many states provide $3 to $4 for every federal dollar." National Council on the Arts, "The First Five Years." 1971.

students in hordes, and millions of dollars were spent on new theatres with the most sophisticated equipment, on larger and better-equipped studios for sculpture, painting, and printmaking, and on recital halls. This was most especially the case in state universities. Artists, composers, and novelists, poets and playwrights "in residence" appeared on campuses to pursue their own work, their presence being in most instances all that was required of them. They were meant to provide inspiration as well as be ornamental. More important to the artists, however, was the greatly increased opportunities to earn their livings as teachers, a profession many of them had long fallen back on as the sales of their work or their services could not provide them a living income. It was, in some respects, a vicious circle. Art departments which had been devoted primarily to teaching the history of art shifted emphasis and became primarily art schools. (In some institutions the history of art was thought, as we have noted, to be a stifler of the artistic imagination and the enemy of aesthetic freedom.) They dedicated themselves to turning out artists, who, it seemed only reasonable to expect, could only make a living by turning out still more artists. Much the same situation prevailed in college and university theatres. Actors were trained along with directors and technicians with the suppressed hope that Broadway was the promised land they might achieve, though most of those who taught them had never achieved it themselves or wanted to. It was the "serious" theatre that mattered to them, not the commercial theatre. The line they drew was a sharp one, invisible to the untutored eye. Theirs was the mentality of the little-theatre movement of the 1920s without the restrictions of makeshift stages and ever-impending financial catastrophe. The role of the university should not, however, be underestimated as a stimulus to the creation and expansion of the audience for the visual, musical, and theatrical arts. There are many who believe that the extraordinary proliferation of regional theatres in the last two decades can be attributed to actors, directors, and playwrights trained in university drama schools. There is no reliable way, however, to estimate the extent of the university's influence, its contribution to the support of the arts or, perhaps, to the appetite of the arts for more and more subsidy. By the 1950s it could be flatly stated that the performing arts could not continue to exist with only the customary sources of support—the sale of tickets, the drives for local funds, the tax abatements given for donations to nonprofit institutions.

It was in the 1950s that two new forms of patronage (or forms in a new guise), not only for the performing but for other arts as well, stepped in, slowly at first, but effectively. These were the foundations and the business corporations. It is likely, though not demonstrable, that corporate

support of the arts had more to do with convincing Congress, which believed with Coolidge that the "business of America is business," to establish the Endowment for the Arts than any amount of argument from the art community about "the quality of life" or our cultural tussle with Russia for the respect of Europe.

When the Ford Foundation began to make grants in the arts and humanities in 1957, it was by no means the first nonprofit organization to do so. In the 1890s, for example, individual artists—young painters, sculptors, and architects—received grants from the American School of Architecture in Rome in the form of fellowships. In 1906 the school became, and remains, the American Academy in Rome. The stipends were small and the accommodations in Rome modest, but the places were eagerly competed for by very promising and some subsequently famous, young men. (It was not until after World War II that there were Rome fellowships for women.) In 1907 the widow of the composer Edward MacDowell founded the MacDowell Colony in New Hampshire to provide succor and a place for undisturbed work (but no cash) for artists, writers, and composers. Until such institutions as these came into being, support for the arts by institutions was not directly to artists but by institutions to other institutions—museums, symphonies, opera companies, and the like. Such subsidies as artists received were given by individual patrons to men (almost exclusively) whose work they admired and wished to acquire for their private collections, and to painters and sculptors who worked with architects on the embellishment of many public and a few private buildings.

The John Simon Guggenheim Memorial Foundation set a new pattern of subsidy for artists that changed the nature of art and literary patronage in America. It was the inspiration and intelligence of Henry Allen Moe that created it in 1925 and made it work. Moe was a young man, a lawyer who had been a Rhodes scholar and had a profound concern with the arts and letters and with humanistic and scientific studies. He believed that to select men and women of promise, give them a stipend with which to work, and leave them strictly alone was the most invigorating way to free and stimulate their creative powers. "This foundation," Moe once said, "has been flattered by many attempts to imitate it, but I believe I am correct in saying that so far no one has quite achieved our open-hearted, crazy freedom." The recipients of Guggenheim Fellowships were, and are, selected by committees on the basis of applications in which they described the nature of the projects each wished to pursue. Once a grant was made (usually a stipend for a year), the man or woman who received it could do as he or she pleased. If he should change his mind about the book or subject for research that had been in the original application for the fellowship, the

foundation took no notice of it. If at the end of the year there was no completed work, that was the fellow's concern. The foundation's attitude was summarized by Milton Lomask in this way:

> Here is a sum of money to help you do whatever you want to do, in your own fashion, at your own speed. If we can be of any further help, please let us know. And if next year or the year after or fifty years hence, something comes of whatever you tried to do with the help of this money, we'd be delighted if you dropped us a card and let us rejoice with you.

The part played by foundations in the support of the arts and of individual artists expanded in many directions and many dimensions after the Second World War. In 1960 at a meeting of the Congress for Cultural Freedom in Berlin, W. McNeil Lowry of the Ford Foundation, in a paper on "Patronage of the Arts—The United States," reported that from 1956 to 1960 three foundations, the Avalon, the Old Dominion, and the Rockefeller, had made grants in the arts of roughly $4 million and the Ford had donated $2.5 million. He also noted that "Many smaller foundations in the same period gave grants in the arts, some, like the Graham Foundation in the plastic arts and the Fromm Foundation in music, in only one field."

Lowry was less interested in supporting successful artistic organizations than he was in helping individual artists (often through small organizations) and in financing "experiments and demonstrations," that might make the arts available to more people of more kinds in more places where the arts were not common currency. In this he anticipated the state arts councils. He devised a four-part program, the first part of which was logically to "study the economic and social positions of the artist and his institutions in the United States." What, in other words, was the need? Second, he wanted the program to help "individual artists at particular or crucial stages of their careers." He wanted to provide something similar to what the MacDowell Colony did, but with stipends and not in a particular place. He wanted to give the creative artists enough financial backing so that they did not have to teach or potboil to keep themselves and their dependents alive. The third aspect of his program was the one designed to finance "experiments, demonstrations and studies," primarily "to open new avenues in important phases of the arts." Finally his program included support of "humanistic studies."

When it came down to the financial realities, however, the Ford Foundation found it expedient to put most of its money for the arts into organizations that had demonstrated the ability to handle it—symphonies and dance companies and theatrical groups, for example, that had records of deft financial management and were "responsible" even if they were

struggling to keep their heads above an ever-rising tide of deficits.

The Ford Foundation's program, it is obvious, had more than a little influence on the shape of the National Foundations for the Arts and Humanities when they came into existence in the 1960s. So did the shape of the New York State Council on the Arts and the studies made by the Rockefeller Foundation which preceded the establishment of the council. The Ford Foundation also had an effect on "public" (as opposed to commercial) television. "As early as 1954," Martin Mayer reported in *About Television,* "the Ford Foundation began giving money to a service designed to help . . . isolated stations." Such stations were almost exclusively in colleges and universities at the start, and though the Federal Communications Commission had allocated 242 channels for educational programming, fewer than fifty were on the air by 1959. By 1960 the Ford Foundation had given $14 million to the National Educational Television and Radio Center (later NET). One of the foundation's own "experiments" was its Radio and Television Workshop directed by Robert Saudek in the 1950s. It produced programs that were telecast on Sunday afternoons by the Columbia Broadcasting System. They were aimed at something less than the mass audience but were not intended for an elite. They included documentaries of the American scene that ranged from what went on in the gymnasiums of the "fight game" to Maine lobster fishing to popular but disappearing kinds of rural entertainment, such as traveling tent shows. There were concerts by the New York Philharmonic, with comment by the then boyish Leonard Bernstein, who conducted them, and there were similar explorations of historical jazz. There were shows on changing manners and on the Constitution of the United States. The mixture (each broadcast had several segments devoted to a variety of subjects) was catholic and the approaches were fresh and in their day daring. Their day came before the introduction of public television, and the influence of *Omnibus* on this new kind of noncommercial broadcasting was beneficial. It unquestionably demonstrated that there was a considerable audience for television that combined serious (but not solemn) programs with entertainment of an intelligent (but not highbrow) sort. When the workshop had proved its point, it went out of business. It was not the Ford Foundation's business to be a broadcaster. Lowry's attitude and Saudek's was "Let others take it from here."

And take it they did, as much of the programming on some 260 Public Broadcasting System television stations attest.

"The Private Sector"

Like the "live audience," which did not exist as a concept until the "nonlive audience" came into existence with recording and broadcasting, the "private sector," as a contributor to the support of the arts, did not exist until the "public sector" came into being as government art foundations and arts councils. In the culture industry the "private sector" means anything nongovernmental that helps to support the arts. Most of the money for the arts comes from individuals who give what they feel impelled to give by their consciences or under pressure from friends or philanthropic organizations, for social prestige, or because they want to support the arts that they consider life-giving.

The little old lady who sits by the hour listening to her FM radio and sends $10 a year to support her local "classical music station" is every bit as much a patron of the arts and a member of the "private sector" as the heiress who instructs her private foundation (or perhaps just her banker) to send the local museum an occasional check for $100,000 to help it meet its inevitable deficit. In fact these two women are a far more important part of the private sector than the foundations with all their cultural largess and the corporations that put up millions of dollars to pay the costs (or a large portion of them) of many "cultural" programs on public television and to finance blockbuster exhibitions in museums. Millions of men and women contribute voluntarily to the support of all manner of art institutions, many of them as "members" or "friends" or "sponsors." The private sector represents a very large segment of the public, if, to be sure, never large enough to satisfy the needs and desires of the managers of the culture industry.

Private patronage of the arts has a long history in America, as we noted in the early pages of this book. Our symphony orchestras and opera companies, our museums and libraries all owed their origins and early support to individuals, often acting in concert, not to organizations like modern foundations and corporations. Foundations with a concern for culture are a twentieth-century phenomenon. They emerged from the wealth of the great age of tycoons, when men like Andrew Carnegie and John D. Rockefeller, Andrew Mellon and Henry Ford made fortunes so vast that they were looked upon as folk heroes of the Horatio Alger stripe by some and as public oppressors by others. How much of their public beneficence was the expression of innate generosity, how much the salving

of a bad conscience, and how much unvarnished public relations is a matter for speculation.*

These men, and many others like them whose names are carved in marble on the walls of institutions of which they were "benefactors" and are otherwise largely forgotten, were the princes of an aristocracy of wealth that took itself and its social position seriously in a way that has all but disappeared since the Depression of the thirties. That is not to say that there are no longer exceedingly rich men and women who have been active patrons of the arts in our time—men like Armand Hammer, J. Paul Getty, Norton Simon, and Paul Mellon. But their eyes, like Morgan's and Frick's, look for gratification to the arts of the past not to those made by their contemporaries, as Luman Reed's did—on art that is certified safe (if not always genuine) by history and by "experts." Some patrons like Avery Fisher and Alice Tully attached their names to concert halls, as Getty and Simon attached theirs to museums, but they were not being personally flamboyant in the nineteenth-century style. A certain modesty is considered becoming to the cultural benefactors of our time, a modesty that would have been out of character in Morgan, for example, or Carnegie.

There is a traditional social cachet to being a patron of the arts that seems to be a permanent eleemosynary *quid pro quo,* and it is sought after and prized in communities of all sizes. Much of the private money that supports the arts (or in most cases falls short of supporting them) is given less for love of art than to assure its donors of being in the "right company," with their pictures in the papers attending the right "benefits" or listed on the letterheads of cultural organizations. Splash is not the benefactor's style today, though neither is the avoidance of recognition. Flamboyance of the old sort has little to do with what goes on within the paneled walls of corporate boardrooms where modern wealth is made and changes hands.

Corporations as Patrons

Indeed, the newest kind of patronage of the arts is the result of decisions made in corporate boardrooms. Business as a patron of the arts if corporately conspicuous is personally anonymous. (In France a corporation is frankly called a Société Anonyme.) It is the "image" (a word of public-relations coinage) of the corporation that matters, not the individuals who control it, and image is the main thing that matters to a corporation when it comes to spending its stockholders' money on the arts.

*"Public relations" as a new term for press agentry was introduced in 1922 by the publicist Edward Barnays, who also called it "the engineering of consent."

It was not always quite thus. Many of the early excursions by corporations into purchasing works of art were, as we have noted, intended to promote "the product" as well as the corporate "image." When DeBeers diamonds commissioned well-known artists in the early 1940s to produce drawings and paintings, it was to give their advertisements the kind of chic that is associated with the fine arts and other expensive goods. They hired artists like Eugene Berman, Dame Laura Knight, André Derain, and Aristide Maillol and noted in a discreet manner that the works were created "especially for DeBeers," as though God had also created the diamonds especially for them. (The program worked; sales increased in ten months from $24 million to $35 million.) The same advertising firm that conceived this program tried a similar one for Dole pineapple and dispatched Georgia O'Keeffe to Hawaii to make a painting of a pineapple. (She demurred and came back with a picture of a bird-of-paradise flower.) The American Tobacco Company, whose best-known product was then Lucky Strike cigarettes, approached the problem differently. They hired a number of "America's foremost artists" to paint canvases featuring "the golden leaf" (tobacco) for a series of magazine ads and billboard displays.

The fine arts became an advertising fad for a few years. It was taken up by pharmaceutical companies, brewers, soft-drink bottlers, and steamship lines. Perhaps the most successful from the point of view of the artist and the most surprising to the public was the series that the Container Corporation of America ran featuring abstract artists with a line of copy that merely mentioned the artist's name and the name of the corporation. No sales pitch of any sort. The competition and traveling exhibition that Pepsi-Cola ran (and who knows if it sold a single bottle of pop?) came far closer to the kind of patronage that corporations arrived at when they began to subsidize symphony orchestras and museum exhibitions—gestures of public benefaction that had much to do with the corporate image and nothing to do with the product.

By 1965 corporate giving to the arts had become well enough established so that an organization came into being to help corporations and small businesses identify where they might most profitably lend financial assistance. It was called the Business Committee for the Arts, and its function was not to raise money but to advise those who needed it where to look and to encourage businesses to include the arts in their tax-deductible programs for charitable giving. In 1971 the president of the committee, G. A. McLellan, reported, "Of all the areas of corporate support, the arts have grown most consistently over the last decade." Eight years later the committee issued a statement that the total corporate gifts to the arts reached $436 million during 1979.

More than just corporate vanity or benevolence prompted corporate handouts to the arts. Corporations found, according to McLellan, that "support of the arts can . . . affect their sales and service, and employee recruitment, attract industry and encourage tourism. Many corporations would agree that supporting the arts is one way of building a 'quality' image of concern for human values and a better society."

The corporation, in other words, had caught on to a truth that the founders of the Metropolitan Museum had made much of when they were seeking support of New Yorkers in the 1870s. The arts, they had declared, were good for business. Cultural institutions draw visitors; they also attract business organizations to settle where the arts thrive, and they encourage trade and professional organizations to hold their conventions where wives can be "cultural" while husbands are employed in being businesslike. Or, to put it in the words of an anonymous newspaper publisher quoted by McLellan, " 'a flourishing artistic life' is 'an important economic asset in drawing conventions to the community.' " Moreover, museums, theatres, and concert halls have been found effective in delaying (if by no means always stopping) the decay of the "inner city," as suburbs and their shopping malls have relentlessly wooed away the downtown clientele.*

Just how concerned a corporation is with the arts and how generous depends to a considerable degree on how those in the boardroom and those who sit behind the upper executive desks happen to feel about paintings or theatre or music or the dance. To some of them the opportunity to be more or less anonymous patrons of the arts that they enjoy gives them gratification, and the corporate generosity will be bent in the direction of their personal enthusiasms. In many cases these executives sit on symphony or museum or other such boards and attempt to bring to the organizations their management skills and financial experience. Sometimes they attempt to impose their tastes and sometimes they succeed, in proportion to the weight of their generosity. When it comes to this, much depends on the adroitness of the artistic director in satisfying the sponsor's wishes without compromising the quality of the institution or altering its purposes and standards. The trick is to involve the executive where his advice can count the most, in the practical aspects of management. This the executive often finds a welcome challenge. Art organizations, he believes, not with-

*On February 16, 1983, the *New York Times* reported that a study by the Port Authority of New York and New Jersey and the Cultural Assistance Center revealed that, "the arts and cultural activities in the New York metropolitan area pump $5.6 billion a year into the economy and generate 117,000 jobs," and that "real estate taxes aside . . . art institutions generate $150 million in regional income and sales taxes." New York is not typical of American cities and their cultural offerings, but the founders of the Metropolitan Museum would be gratified by their prescience nonetheless.

out reason, are often in business terms sloppily managed; the accounting methods are of the "how much money is there in the sock?" sort. "A survey of some smaller arts organizations," an article in the April 1971 issue of *The MBA,* a business journal, says,

> has determined that a fundamental common problem is faulty financial control. Some groups had no idea of how to set up payroll records or make deductions for Social Security and other taxes. Others, in an effort to keep fiscally afloat, withheld the taxes but did not forward them to the government. Some of the largest had inadequate accounts of contributions. One major East Coast symphony orchestra found itself unable to collect $25,000 in pledged contributions because of incompetent record keeping.

This is the kind of problem that some businessmen like to attack and solve, while it keeps others away on the grounds that they do not want to have anything to do with unbusinesslike *un*business organizations. There exists, moreover, a mutual suspicion between the business executive and the artist. "The artist's assumption of an offensive posture in dealing with foundations and corporations," a writer in *The MBA* observed, "has sadly worked against his interests." The Business Committee for the Arts has an explanation for this. It found "that artists and corporate executives often maintain negative images of each other simply because they have rarely had occasion for serious dealing with one another."

There is nothing new about this. A barrier of suspicion has long divided the artist and the moneyman. The artist characteristically has regarded the businessman as concerned only with material wealth and the creature comforts it provides, and the businessman has looked on the artist as unpredictable, unreliable, and led by his fantasies. The businessman has resented the artist's freedom to flout social conventions, to work when and where and as he pleases, and the artist looks on the businessman as a creature trapped by convention. Both images are caricatures. There are quite probably as many businessmen who are eccentrics as there are artists who are nonconformists, though, to be sure, there are a great many more businessmen than artists, which makes the percentages uneven. The demands of the arts enforce a discipline of work on the artist that is every bit as rigid as that imposed by business and usually a great deal more exacting, whether he is a painter, a dancer, a writer, a composer, an actor, or a violinist. To succeed he or she must be not only dedicated but methodical and in control of what is popularly known (but not among artists) as "artistic temperament." Artists are no more apt to throw tantrums than office managers or board chairmen. It is most unlikely, however, that artists would agree with Granville Meader, a former cultural attaché in the

Middle East and program director for the Business Committee for the Arts, when he wrote: "Businessmen are becoming as essential to the continuance of the arts as the artists themselves." There were artists long before there were businessmen, as the walls of the caves of Altamira attest, and artists know that the arts will continue as they always have, with or without businessmen. Artists are of course aware that the arts thrive best when there is money, not just adulation and self-fulfillment, to reward them, and they know that the business community has become increasingly aware that the quality of life depends on the arts. The audience is of the first importance to the artist, and increasingly the businessman is paying to preserve the audience and expand it. His role in the culture industry, as patron, financial adviser, promoter, and friend, has become an essential part of the fabric that cloaks the arts and warms their bones.

Private Faces in Public Places

So it was that the nature of patronage of the arts, both of the individual artists and of the artistic organization, changed radically in the years between 1930 and 1950. The federal government in its relief programs during the Depression of the thirties assumed a new role that affected thousands of artists and millions of citizens, many of whom had never paid the arts much if any but the most casual and remote attention. It put the artist and his work in their communities where they could see him at work and criticize him as "sidewalk superintendents." This is said to have had a profound influence on the American attitude toward the artist and his work and on the audience for the theatre as well, an assumption that is difficult, if not impossible to prove, though statistics of a sort support the contention. There are more local theatre groups, and "regional theatres," both professional and amateur, than there were before the federal projects came into being. There are certainly more art dealers (they reflect the numbers of collectors), and their galleries are not only in the large metropolitan centers but in many communities of under ten thousand. Many more people of all ages are going through the portals of museums of art and of crafts. What were once quiet temples of art are now shopping malls for a vast clientele of art shoppers, both sophisticated and naïve.

This spread of interest, personified in the increase in the audience, resulted in escalating financial demands on the public sector. These were addressed, if by no means met, by the introduction of municipal and state arts councils and the creation of the arts and humanities endowments of the federal government. It also resulted in an interest by foundations, most notably and in some respects most inventively by the Ford Foundation, in

supporting artists and artistic ventures on a scale that was unprecedented in the United States or anywhere else. Furthermore the importance of the contribution of the private sector was greatly enhanced by the entrance of the business corporation into the arena of art patronage. Using the arts to promote the sale of goods and to create good will for business was not new when DeBeers diamonds and Pepsi-Cola and other companies began to latch on to the fine artists. As early as the 1880s Pear's soap used a painting by Sir John Millais to advertise its product; the Texas Oil Company (Texaco) had been sponsoring broadcasts from the Metropolitan Opera on Saturday afternoons since December 1940; and the International Business Machine Corporation (IBM) had begun to create a collection of American art which it proudly exhibited at the World's Fair in New York in 1939. It was a reflection of the taste and enthusiasm of IBM's president and founder Thomas J. Watson, and it was as conservative as his business was revolutionary. The subsidy of blockbuster exhibitions and modest ones by such corporations as Exxon and Philip Morris came later in the 1960s and '70s, as did the support of "cultural" television by the Mobil Corporation, the May Company, AT&T and dozens of corporations somewhat less conspicuous nationally but nonetheless vitally important to the support of the arts locally.

With the growth of support by both the public and the private sectors, the culture industry boomed, but not in the manner that a business corporation booms. Culture is a multi-billion-dollar industry, having all the accouterments associated with, let us say, the pharmaceutical industry. It has research departments, management consultants, distribution systems, lobbyists in the Congress and state legislatures, public-relations departments, interlocking boards of directors, and outlets large and small. It is a vast hungry conglomerate of orchestras, museums, dance and opera companies, civic theatres, academies, and cultural centers. It is in the business of losing money. It fears the vitiating influence of the mass market, at the same time that it woos it with missionary zeal. Since the industry is in the business of losing money (when it doesn't, it is suspected of having surrendered to the philistines), it must constantly expand its overhead. Those laymen who raise the funds, negotiate the contracts, sit on the boards, and needle the public know very well that they are engaged in an industry, even if it is a perverse one, with its head buried not in the sand but in the clouds. That so many men and women are not just willing but eager to devote their energies, their intelligence, and in many cases a great deal of time and money to the care and feeding of the arts, to fighting their budgetary battles and proselytizing on their behalf provides a picture of American society that is very different from European or Asian societies.

In Europe, support of the arts comes mainly from the governments in the form of subsidies to established artistic institutions—orchestras, theatres, museums, opera companies. Decisions are handed down from above. In America support comes mainly from the community, from memberships, from fund drives, from the sale of tickets, and from bequests. The multi-billion-dollar culture industry, which pays dividends only in gratification and pleasure and in enhancing the quality of life, has to scramble to stay alive and to grow. Because it is willing to do so, government in its several levels, foundations, and business corporations find it politically and financially expedient to lend a helping hand. The lively audience for the public arts is, after all, millions of private people.

Acknowledgments

Private sources of suggestion, direction, and encouragement and other kinds of personal help have been at least as important to me as the written and pictorial sources I have consulted. So, of course, has been the experience of living through much of the period covered by this book as a member of the lively audience for the arts.

It was in 1971 that the distinguished historians Henry Steele Commager and Richard B. Morris asked me to write a book on twentieth-century American culture for their series The New American Nation. I was greatly complimented and I have been at it off and on ever since. This is not the book they originally asked for, one which I was unequipped to write. What evolved is what is between these covers, and I am grateful to Professors Commager and Morris for accepting this into their fold. I wish to thank them first and most profoundly for their confidence and encouragement. But there have been others involved in this project to whom I am also particularly in debt, none more than Cass Canfield, Sr., the chairman of Harper & Row when this book was started. He is a cherished and greatly admired friend and one-time colleague. He is a superb editor, from whose skills I have richly benefited for forty years. His successor as shepherd of this book, Hugh Van Dusen, and his assistant, Janet Goldstein, have been paragons of editorial help to me.

A number of friends who are experts in aspects of the American arts have generously applied their eagle eyes and sharp intelligences to my manuscript. Without in any sense involving them in responsibility for what appears here, I wish to thank John A. Kouwenhoven and Eric Larrabee, both old friends and former colleagues at *Harper's Magazine;* Wayne Andrews, a prime historian and photographer of American architecture; John K. Howat, curator of American art at the Metropolitan Museum; John Szarkowski, director of the department of photography at the Mu-

seum of Modern Art; and Ashton Hawkins, vice president and secretary of the Metropolitan Museum, for their generous help. I would also like to express my gratitude to Howard Taubman, theatre and music critic and historian, and to Maurice Rapf, long and importantly involved with the film industry and its history. The late Katherine Gauss Jackson befriended this book in its early stages and gave me generously of her astute editorial wisdom, a debt of friendship I cannot, alas, now repay. Simon Michael Bessie came gallantly to my rescue at a time when this book became mired in discouragement, and he knows how I have valued his encouragement and advice. And there have been others, most particularly Susan Ingalls Lewis for her invaluable help with the illustrations and Margaret Cheney for her expert and sympathetic copyediting of my manuscript. I also wish to thank Linda Hyman, Josheph Roddy, Corona Machemer, Kathryn Greenthal, and Donna Stein. I am indebted to them for their generously shared knowledge and guidance.

There is no adequate way for me to thank my wife who for the last fifty years has said of what I have written, "You can count on me to tell you what I think." What she has thought has sometimes been infuriating because it was so exactly on target but it has been indispensable at every stage of this book's slow progress. Indeed, without her critical brilliance, humor, and concern there would have been no book at all.

A Note
on the Sources

The list of books, and a few magazines, that follows is not intended to be a formal bibliography of the many subjects treated, some of them very lightly, in this book. It is, and pretends to be, no more than a list of some books and articles that I have found particularly informative or suggestive as I have looked at the audience for the arts and the artists and performers who worked to please or inform or inspire them, from the Columbian Exposition of 1893 to World War II. Many of the books I have chosen have extensive bibliographies, some have brief selected lists with appraisals. No one wishing to pursue the subject of this book will find any of the works listed a waste of time. Some of them are histories of particular arts, such as Howard Taubman's *The Making of the American Theatre* and Wayne Andrews's *Architecture, Americans and Ambition,* both excellent accounts of the development of facets of the American experience with the arts. Several are revealing anthologies of essays on the general state of American culture, such as Eric Larrabee and Rolf Myerson's *Mass Leisure* and Frank Book-hauser's *These Were Our Years.* Others, like Max Lerner's *America as a Civilization,* and Daniel J. Boorstin's *The Americans: The Democratic Experience,* paint on very large canvases with very exact brush strokes or, like Mark Sullivan's six-volume *Our Times, 1900–1925,* gather a great variety of threads into a revealing social and cultural weave. Pictorial histories, such as Frederick Lewis Allen and Agnes Rogers's *American Procession* and *I Remember Distinctly* and John A. Kouwenhoven's *Adventures of America,* are, I believe, essential to understanding the audience for the arts. The visual image of the audience is as relevant as the images of the arts to which they are exposed.

Books about the visual arts (painting, sculpture, architecture, and photography) seem to come off the presses today as fast as dime novels did in the era with which this book starts. Many are monographs on individual painters, sculptors, and architects with lavish and often inaccurate color plates and texts which are scholarly enough to be overlooked by almost everyone. In spite of their often useful scholarship I have included none in my list. Many monographs on architects, though not all, are illustrated volumes produced primarily for the purpose of self-promotion to attract clients, and the buildings in them are sometimes more impressive as photographs than as structures. With the exception of Louis H. Sullivan's *The Autobiography of an Idea* and Frank Lloyd Wright's *An Autobiography,* which are provocative texts that have had an impact on architectural thought and practice, I have been parsimonious about listing architectural biographies. Students of architecture, however, will find them useful.

It is characteristic of the arts, and especially of the visual arts in the time span of this book, that they evoke explanations for a puzzled public. It has been an age of experiments which seemed to break with and deny the conventions of painting and sculpture that hindsight suggests have evolved in an orderly progression since "modern" painting started with Giotto in the fourteenth century—however shocking the mature works of Michelangelo and Titian and Rembrandt may have seemed to their contemporaries. Since 1900 especially, authors like Clive Bell *(Art)* and Roger Fry *(Vision and Design)* and Sheldon Cheney *(A Primer of Modern Art),* who wrote in the early days of the century, have labored to make the "revolutionary" and especially the "abstract" art of the day understandable. So have the authors of the catalogues of the Museum of Modern Art, such as Alfred H. Barr, Jr., and so have critics such as James Johnson Sweeney *(Plastic Redirections in Twentieth Century Painting),* Henry-Russell Hitchcock *(Modern Architecture),* Harold Rosenberg *(The Anxious Object),* and a number of others whose books I have listed. They have found it important to interpret the new movements as they came along or, more accurately, soon after they came along, as critics follow, they do not lead. I have included a few basic books of this sort. There are many others, and a new crop arrives every year. So, indeed, do volumes explaining styles that went out of fashion, like Art Deco and Art Nouveau, and are now being revived. It is very nearly impossible today to keep up with revivals much less be ahead of them. This is as true of photography as it is of the plastic arts.

The performing arts present a different problem. Among the best sources of both information and attitudes are newspapers and magazines because they reflect private attitudes to public performances close to the moment they were given. Press releases and other forms of ballyhoo are ephemeral, though newspaper advertisements are revealing of the competition that every performer, playwright, and producer faced at the time they "went public." But, as I hope I have demonstrated, new movements in the theatre, in music, and in films often seemed to the public obscure in their intentions and needed and had their apologists and explainers and theoreticians, as well as their historians.

My most frequently and profitably consulted general sources on the theatre have been Howard Taubman's *The Making of the American Theatre,* Brooks Atkinson's *Broadway,* Cecil Smith's *Musical Comedy in America,* and Lehman Engel's *The American Musical Theatre.* On the movies I have leaned most heavily on Arthur Knight's *The Liveliest Art, a Panoramic History of the Movies,* with its excellent bibliography, on Kenneth Macgowan's *Behind the Screen, the History and Techniques of the Motion Picture,* and on Garth Jowett's *Film, the Democratic Art.* Jazz presents a special problem and unusual sources. Record liners are often written by dedicated jazz historians, and they are numerous and informative. I have mentioned none except the introductions to the Smithsonian collections of jazz recordings by Martin Williams. General histories of jazz, such as Leonard Feather's *The Book of Jazz,* Marshall Stearns's *The Story of Jazz,* Martin Williams's *The Jazz Tradition,* and Nat Hentoff and Albert J. McCarthy's *Jazz,* a collection of essays by jazz critics, put musicians and their music in perspective, while individual autobiographies and biographies of jazz greats like Duke Ellington's *Music Is My Mistress,* Alan Lomax's *Mr. Jelly Roll,* and W. C. Handy's *Father of the Blues,* give insights into the jazz world from within rather than from without. Other books on Americans and their music that I have found especially rewarding because they tell as much about the audience as about the art are Gilbert Chase's excellent *America's Music from the Pilgrims to the Present,* Jacques Barzun's

Music in American Life, and Paul Henry Lang's *One Hundred Years of American Music,* a collection of essays, and Albert Murray's *Stomping the Blues.*

Libraries of the performing arts contain oceans of words and pictures, and I do not pretend to have done more than get my feet wet on their beaches.

The literature on art patrons is by comparison a small pond. There are many publications on foundation support of the arts, but most of them are sections of annual reports. *Seed Money,* the Milton Lomax book on the Guggenheim Foundation, is a welcome exception. There are a few books on art collectors, such as Aline B. Saarinen's *The Proud Possessors* and W. G. Constable's *Art Collecting in the United States of America,* and, though I do not list any, there are what might be called "vanity books," which individual collectors have paid authors to write and publishers to publish. There are a few histories of American art museums, such as Calvin Tomkins's *Merchants and Masterpieces* about the Metropolitan Museum and my own *Good Old Modern* about the Museum of Modern Art and *More Than Meets the Eye* about the Cooper-Hewitt. Nathaniel Burt's *Palaces for the People* is a general history of American art museums and a good one. Every important and some relatively unimportant museums that have issued catalogues of their collections have included brief histories of their institutions. So also do general and useful guides to museums, such as Eloise Spaeth's *American Art Museums* and S. Lane Faison, Jr.'s *Art Museums of New England,* as do the so-called WPA regional guides prepared during the Depression of the 1930s under the Federal Writers Project. Many of these guides were excellent and they cry out for revision and updating. Their story is told by Jerre Mangione in *The Dream and the Deal.*

The engagement of the federal and state governments with patronage of the arts needs to have its history written by someone without an ax to grind or a deficit he hopes that government will cure. (I have ground my ax on several occasions in several publications; one grinding is reprinted in my *Confessions of a Dilettante.* Some of my caveats, but not all, are now out of date.) There are a few books and official reports, such as those of the New York State Council on the Arts, that describe the breadth and depth of their support of art activities from crafts to grand opera. The roots of twentieth-century government patronage and much of its development are most readily available in the files of the Archives of American Arts, a bureau of the Smithsonian Institution. Its headquarters are in Washington, but it has branches in New York, Boston, Detroit, San Francisco, and Pasadena. The microfilms of its millions of documents are in each of the branches. Anyone writing about American painting and sculpture, particularly, will find, as I have for many years, that the archives is invaluable. It contains the papers of many artists, dealers, critics, curators, and some collectors.

One of the croquet lawns of intellectual gamesmanship in our time is "the conference." Conferences are gatherings of specialists and interested laymen brought together for the purpose of addressing topics such as the state of the arts. It is the hope of those who organize them that they will throw light rather than sow confusion. Conferences often do one or the other and sometimes both. They rarely lead to constructive action, but they are likely to produce published conference reports. In *Museums and Education,* which is a report on a Smithsonian conference, Eric Larrabee, who edited it, wrote with uncommon frankness: "The . . . conference . . . in one way or another, managed to be a source of frustration to its participants." (It was Larrabee, I believe, who coined the term "conference bums" to describe the men and women who, like "tennis bums," travel to one intellectual tournament after another.) Nonetheless, conference reports,

such as the Rockefeller Panel Report on *The Performing Arts, Problems and Prospects,* are revealing discussions among able and concerned people on what is, in fact, an open-ended and unresolvable subject. I have listed several such reports that I have found helpful.

But then all of the subjects discussed in this book, as they are concerned with the interplay of people and the arts, are happily open-ended and, I hope, will never be resolved.

Notes

To avoid peppering the pages of this book with reference numbers, the sources of the material I have quoted are listed below by the chapter and page on which they appear in my text. The last few words of each quotation are followed by the source from which I have taken them.

CHAPTER 1: *The Emerging Audience*

page

1 vast sums. James Bryce, "America Revisited—Changes in a Quarter of a Century," *The Outlook,* March 25, 1905, reprinted in Allan Nevins, *America Through British Eyes,* 1948, pp. 383–94, this quotation p. 391. Bryce's *The American Commonwealth* was published in 1888 and in revised form in 1910.

2 races of Europe. Bryce, "America Revisited," p. 388.

2 which they aim. Ibid., p. 389.

4 American man. *The Education of Henry Adams,* Modern Library ed. p. 353.

5 school education. Bryce, "America Revisited," p. 389.

5 book collections. Hugo Münsterberg, *The Americans,* 1904, pp. 452–53.

6 working man. Ibid., p. 453.

6 thoroughly satisfied. Ibid., p. 455.

6 is immature. Ibid., p. 435.

8 end of life. Quoted in Joseph C. Gould, *The Chautauqua Movement,* p. 74, from Henry Barnum, "Moral and Educational Wants in Cities," in *Connecticut Common School Journal,* IV (1842), p. 25. Gould is the principal source of information about Chautauqua here presented.

10 greatest appreciation. Münsterberg, p. 384.

13 among the people. Russell Lynes, *The Tastemakers,* 1954, p. 151.

13 meet alone. Quoted in Frank Luther Mott, *The Golden Multitudes,* 1947, p. 184. The character is Mrs. Bollinger.

14 of Americans. *The Domestic Manners of the Americans* by Frances Trollope, the mother of the novelist Anthony Trollope, was first published in 1832. There is no better edition of her book than Donald Smalley's, New York, 1949.

page

15 and recreation. Quoted in Calvin Tomkins, *Merchants and Masterpieces*, 1970, p. 35.

15 compound interest. Ibid., p. 17.

15 of the beautiful. Ibid., p. 23. The clergyman was the Reverend Henry Bellows, pastor of All Souls Unitarian Church.

17 improving character. Ibid., p. 30.

18 hard working. Samuel Isham and Royal Cortissoz, *The History of American Painting*, 1905 and 1927. Cortissoz added a supplement to Isham's original text in 1927. Quoted in E. P. Richardson, *Painting in America*, 1956, p. 308.

18 art music. Gilbert Chase, *America's Music*, 1955, p. 325.

18 United States. Richard B. Morris, *Encyclopedia of American History*, 1970, p. 648.

19 "permanent" orchestra. It was a musicians' cooperative, with each member paying dues and splitting the profits from the sale of tickets at the end of the season. Paul Henry Lang, *One Hundred Years of American Music*, 1961, p. 37.

22 esthetic as that. This account of Mrs. Thurber's musical exploits and the reactions to them is based on Nicolas Slonimsky, "The Plush Era in American Concert Life," a chapter in Lang, ibid., pp. 109–27.

22 ten Geishas. Münsterberg, p. 474. An operetta called *The Geisha* was produced in New York in 1896.

22 unskilled labor. Quoted in Howard Taubman, *The Making of the American Theatre*, 1965, pp. 120–21.

23 her generation. Frederick Lewis Allen and Agnes Rogers, *The American Procession*, 1933, not folioed.

23 "Divorceshaк." Arnold T. Schwab, *James Gibbon Huneker*, 1963, p. 71.

24 is king. Bryce, quoted in Nevins, p. 386.

CHAPTER 2: *Rumblings*

29 talking machine. Daniel J. Boorstin, *The Americans, vol. 3, The Democratic Experience*, 1973, p. 379.

30 their virtues. Roland Gelatt, "Music on Records," in Lang, *One Hundred Years of American Music*, p. 190.

31 at the midpoint. Jacques Barzun, *Music in America*, 1956, p. 81.

32 practical, and convenient. Boorstin, p. 376.

32 motion-picture machines. Ibid., p. 377.

35 in the race. *New York Times*, April 26, 1896.

36 several hundred. Quoted in Marshall B. Davidson, *Life in America*, 1951, vol. 2, p. 84.

36 each week. Robert M. Henderson, *D. W. Griffith, the Years at Biograph*, 1970, p. 8.

36 carnivals combined. Foster Rhea Dulles, *A History of Recreation*, 2nd ed., 1965, p. 294.

37 police interference. Ibid., p. 290, quoted from Terry Ramsaye, *A Million and One Nights*, 1926, p. 256.

page

37 wholesome delirium. Ibid, p. 291, quoted from *Review of Reviews,* XXXVIII, December 1908, p. 744.

37 able to grasp. Arthur Knight, *The Liveliest Art, a Panoramic History of the Movies,* 1957, p. 25.

38 hectic minutes. Ibid., p. 29.

38 for immortality. Ibid., p. 31.

40 be established. Mark Sullivan, *Our Times,* 6 vols., 1937, vol. 1, pp. 565–66.

41 by wireless. Quoted in Agnes Rogers and Frederick Lewis Allen, *I Remember Distinctly,* 1947, p. 37.

42 in an hour. Quoted in Frederick Lewis Allen, *Only Yesterday,* 1931, p. 78.

43 knew the conclusion. Quoted in Rogers and Allen, p. 38.

43 class-mass production, David Riesman, *The Lonely Crowd,* Doubleday Anchor ed., 1953, pp. 340–41.

43 but indistinguishable. Bernard Rosenberg, "Mass Culture in America," in *Mass Culture, The Popular Arts in America,* ed. by Bernard Rosenberg and Davis M. White, 1957, p. 5.

44 intellectual authority. William Phillips, "Portrait of the Artist as an American," *Horizon* (London), double number, 93–94, October 1947, p. 16.

44 who is not. Clement Greenberg, *Partisan Review,* quoted in Russell Lynes, *The Tastemakers,* 1954, op. cit., p. 314.

44 shout, 'Olé!' This symposium has not been published, though the discussion was recorded on tape. I had the privilege of being the moderator on that occasion, and I report this from memory.

44 middlebrow. Virginia Woolf was, I believe, the first to define the middlebrow in an essay called "Middlebrow," published in a collection of her essays called *The Death of the Moth,* 1942. The word was in frequent use by "highbrows" in the 1940s, and its definition was explored and expanded in an essay by me, "Highbrow, Lowbrow, Middlebrow," in *Harper's Magazine,* January 1949. It was subsequently a chapter in *The Tastemakers.*

CHAPTER 3: *Architecture and Fantasy*

45 how to live. Ward McAllister, from a series of articles published in the Chicago *Tribune,* October 4–10, 1893.

45 making money. Quoted in Wayne Andrews, *Architecture, Ambition and Americans,* 1955, p. 206.

45 doers in the world. Quoted in James Marsden Fitch, *American Building, The Historical Forces that Shaped It,* 1966, p. 196.

45 the whole world. Sigfried Giedion, *Space, Time and Architecture,* 3rd edition, 1959, p. 10.

46 a Chicago coinage. Carl W. Condit, *American Building,* 1968, p. 115.

46 to $900,000. Figures from Andrews, p. 208.

47 in the world. Charles Moore, *Daniel Burnham, Architect, Planner of Cities,* vol. 1, 1971, p. 25.

47 before Congress. Ibid., vol. 1, p. 31.

page

47 Ellsworth was a member of the Committee on Foreign Exhibits for the exposition.

47 as confidential. Moore, p. 76. The Chicagoan was James S. Norton.

49 excepting through him. Ibid., p. 34.

50 get to work. Quoted in Russell Lynes, *The Art-Makers of Nineteenth-Century America,* 1970, p. 452.

51 we intend to. Charles Moore, "Lessons of the Chicago World's Fair, an Interview with Daniel H. Burnham," *The Architectural Record,* vol. 33, June 1913.

51 free inland sea. Paul Bourget, "A Farewell to the White City," *Cosmopolitan,* vol. 16, December 1983, reprinted in William A. Coles and Henry Hope Reed, Jr., *Architecture in America: a Battle of Styles,* 1961, p. 140.

53 the Parthenon. Moore, p. 85. Saint-Gaudens was in charge of sculpture for the exposition.

53 an American artist. Lynes, p. 471.

54 foreign collectors. New York *Tribune.*

54 rather to amuse. *Harper's Weekly,* May 13, 1893, p. 442.

55 illicit, flourished. This and other quotations on the Midway are from Rudi Blesh and Harriet Janis, *They All Played Ragtime,* 1950, p. 41.

55 beaten by hand. *Harper's Weekly.*

56 any more of it. Quoted from Hamlin Garland, *Son of the Middle Border,* 1917, in Coles and Reed, p. 179.

56 classicizing form. Vincent Scully, *American Architecture and Urbanism,* 1969, p. 138.

56 efface it. Montgomery Schuyler in "Last Words about the Fair" in *The Architectural Record,* vol. 3, 1893, from a newspaper interview quoted in Coles and Reed, p. 198.

56 of dementia. Louis H. Sullivan, quoted from his *Autobiography of an Idea,* in Coles and Reed, p. 211.

56 look of unity. *The Education of Henry Adams,* Modern Library edition, p. 340.

57 doubts of themselves. Quoted in Giedion. p. 210.

57 "mercantile classicism." Giedion, p. 316.

57 This dispute about the validity of Beaux-Arts training was aired in the *Architectural Record* of November 1907.

59 first impression. Fitch, p. 228.

60 made beautiful. Mark Sullivan, *Our Times,* vol. 4., pp. 112–13 fn.

60 nonplussed. Fitch, p. 228.

61 United States. Andrews, p. 258.

62 honestly built. The letter here quoted was published in *Bertram Grosvenor Goodhue—Architect and Master of Many Arts,* edited by Charles Harris Whitaker, 1925. The letter is not dated. Cret's best-known works are the Pan-American Union in Washington and the Detroit Art Institute.

62 primal inspiration. Quoted in ibid., p. 215.

62 in the game. Ibid., p. 215.

63 have the style. Quoted by Sherman Paul, *Louis Sullivan: An Architect in American Thought,* 1962, p. 40, from *Inland Architect and News Record,* IX, March 1897, pp. 23–26.

page
63 generally believed. Quoted in Fitch, p. 219.

63 born tall. Quoted in Lynes, p. 464.

63 millinery establishment. Quoted by Andrews, p. 226. *Little Lord Fauntleroy* by Frances Hodgson Burnett was published in 1886.

65 more characteristic. Andrews, p. 230.

65 to change. Ibid., p. 230.

66 what they need. Ibid. p. 230. Compare this statement with Richard Morris Hunt's advice to his son: "The first thing you've got to remember is that it's your client's money you're spending. Your business is to get the best result you can, following their wishes. If they want you to build a house upside down, standing on its chimney, it's up to you to do it and get the best result possible." Quoted in Lynes, p. 282.

CHAPTER 4: *What's in the Ash Can?*

70 reverberant name. Van Wyck Brooks, *The Confident Years,* Everyman ed., 1955, pp. 554–55.

71 Edith Wharton and Ogden Codman, Jr., *The Decoration of Houses,* 1902, reissued with introductory notes by John Barrington Bayley and William A. Coles, 1978.

76 average man. Mark Sullivan, *Our Times.*

76 understanding of it. Quoted by William Inness Homer, *Robert Henri and His Circle,* 1969, p. 141.

77 in its lead. Quoted by Barbara Rose, *American Art Since 1900,* 1967, from Shinn's "Recollections of the Eight" in *The Eight,* a catalogue of an exhibition at the Brooklyn Museum, November 1943–January 1944.

77 Van Wyck Brooks. *John Sloan, A Painter's Life,* 1955.

79 honestly earned. Quoted in Homer, p. 76.

80 be better. Ibid., p. 98.

80 over there. Ibid., p. 98.

80 say are doing. New York *Mail,* April 11, 1907, quoted in Homer, p. 128.

82 were so unalike. New York *Evening Sun,* May 15, 1907, quoted in Homer, p. 130.

82 cult of painting. Quoted from a draft of a letter from Henri to David H. Dodge, Homer, p. 131.

82 be individual. Ibid.

82 young lustiness. Ibid., p. 131.

83 of them. A. B. Davies's stylistic debt was primarily to the French muralist Puvis de Chavanne (1824–98).

83 to night. Quoted from a letter to Hartman K. Harris, February 4, 1908, Homer, p. 138.

83 small galleries. *John Sloan's New York Scene,* diary of February 8, 1908, p. 194.

83 outcasts, etc. Ibid.

84 force and interest. Ibid., diary of May 25, 1910, p. 403.

84 assured of. Ibid, diary of April 1, 1910, p. 406.

84 positive talent. Homer, p. 154.

84 and vulgar. Rose, p. 154.

page
84 be famous. Homer, p. 154.
85 nothing happened. Ibid.
85 Mrs. Whitney. The Madison Gallery at 305 Madison Avenue, New York, was "part of a decorator's establishment, the Coventry Studios, run by Mrs. Clara S. Davidge with, it is said, the backing of Mrs. Gertrude Vanderbilt Whitney," Milton Brown, *The Story of the Armory Show,* 1963, p. 29.
85 to the public. Brown, p. 30. Brown's is by all odds the best account of the Armory Show.
85 additional interest. Quoted in Russell Lynes, *The Tastemakers,* 1954, p. 201.
86 iron rod. Ibid., p. 200, quoting the artist Guy Pène du Bois.
86 in the world. Quoted in Oliver Larkin, *Art and Life in America,* 1941, p. 354.
86 artist in America. Rose, p. 36. There are almost as many definitions of how far back "modern art" goes historically as there are art historians.
87 timely one. Quoted from Jonathan Green, ed., *Camera Work, a Critical Anthology,* 1973, p. 174, from *Camera Work,* 1903, no. 3.
87 in at will. Ibid., p. 175.
88 show like this one. Quoted in Lynes, p. 202.
88 the art world. Ibid., p. 205.
91 walks of life. Ibid., p. 206.
91 fossilized standards. Ibid., p. 208.
91 in America. Quinn's collection was sold by his executors soon after his death in 1924 at very disadvantageous prices. An interesting account of Quinn as a collector appears in Aline Saarinen's *The Proud Possessors,* 1958, pp. 234–37.
93 a Cubist Gown. This quotation and others on the Chicago reaction to the Armory Show are from Lynes, pp. 210–19.
93 and triumphant. Ibid. p. 220.

CHAPTER 5: *From Ragtime to Riches and All That Jazz*

95 get the message. Edward Kennedy (Duke) Ellington, *Music Is My Mistress,* 1973, p. 130.
96 human instincts. Quoted by Neil Leonard in *Jazz and the White Americans,* "Traditionalist Opposition to Jazz," reprinted in R. L. Davis, ed., *The Social and Cultural Life of the 1920s,* p. 85.
96 Scotch snip. April 1, 1899, quoted in Rudi Blesh and Harriet Janis, *They All Played Ragtime,* 1950, pp. 131–32.
96 the whole world. Ibid.
97 Ernest Borneman. "The Roots of Jazz," reprinted in Nat Hentoff and Albert J. McCarthy, eds., *Jazz, New Perspectives on the History of Jazz,* Da Capa ed., 1975, p. 9.
97 syncopated melodies. James Lincoln Collier, "The Scott Joplin Rag," *New York Times Magazine,* September 18, 1975, p. 19.
97 of the week. I. Goldberg, *Tin Pan Alley,* 1930, p. 139.
98 forerunner of ragtime. Gilbert Chase, *America's Music from the Pilgrims to the Present,* 1955, p. 439.
100 here to stay. Ibid., p. 446.

page
101 on its hands. Collier, pp. 26–27.
101 elementary ragtime. Blesh and Janis, p. 95.
101 call the "blues." Ibid., pp. 156–57.
102 on his creations. Chase, p. 449.
102 in the country. Alan Lomax, *Mister Jelly Roll,* 1950, p. 42.
102 wrong direction. *Metronome,* May 20, 1901, quoted in Blesh and Janis, p. 134.
102 idiom in ragtime. *Musical America,* March 29, 1913, p. 132.
102 to teach them. Quoted in Blesh and Janis, p. 135.
102 technique and verve. Ibid., p. 135.
102 of Brahms. Ibid., p. 133.
103 syncopated jubilance. Quoted in Agnes Rogers, *Women Are Here to Stay,* 1949, p. 147.
103 *Ladies' Home Journal.* These accounts are from Mark Sullivan, *Our Times,* vol. IV, pp. 256–68.
104 up and down. *Random House Dictionary of the English Language,* 1960.
105n. organized vice. Chase, p. 473.
105 Morton said. Lomax, pp. 61–62.
105 of a war. "Echoes of the Jazz Age," a chapter from *The Crack-up,* reprinted in Frank Brookhauser, ed., *These Were Our Years,* p. 177.
105 For origins of the word "jazz" see Chase, p. 469.
106 of a band. *The Literary Digest,* quoted in Chase, p. 468.
106 read at all. Quoted in Chase, p. 471; see also Lomax, p. 40.
108 through the trumpet. Lomax, p. 108.
108 on whiskey. Ibid. p. 126.
108 two or three months. Louis Armstrong, *Swing That Music,* 1936, p. 25
109 world markets. John Steiner, "Chicago," reprinted in Hentoff and McCarthy, p. 142.
109 creed or color. Jelly Roll Morton, quoted in Lomax, p. 150.
109 ear drums down. Lomax, p. 182.
109 New Orleans emigrants. Hentoff and McCarthy, p. 138.
110 sterile music. Martin Williams, *The Jazz Tradition,* 1970, p. 129.
110 to longing. Quoted in Daniel J. Boorstin, *The Americans,* vol. 3, p. 298.
110 near-comic lyricism. Quoted in "Profiles, Going to the Territory" by Jervis Anderson, *The New Yorker,* November 22, 1976.
111 in the U.S.A. Quoted in Albert Murray, *Stomping the Blues,* 1976, p. 62.
111 good intentions. Ibid. p. 66.
111 effective bass. W. C. Handy, *Father of the Blues, an Autobiography,* Collier Books ed., 1970, p. 16.
111 a musician. Ibid., p. 13.
113 not follow. Lomax, p. 104.
113 to sleep. Ibid., p. 10.
113 to stay. Ibid., p. 130.
114 true fire. Ibid., p. 193.
115 soloist's art. Williams, p. 48.
115 then or since. Letter from Eric Larrabee to the author, June 27, 1984.
115 on the way. Ellington, p. 236.
119 in the nude. Sullivan, vol. VI, pp. 282–83.

page
119 kinds of people. Quoted in Boorstin, p. 298. A slightly different version appears in Handy, pp. 238–39.

121 no cheating. Chase, p. 486.

122 modern rumpus. Ernest Borneman, "The Jazz Cult." *Harper's Magazine,* March 1947, p. 265.

122 relatively brief. Martin Williams in his notes for *Smithsonian Collection of Classic Jazz,* p. 24, observes: "Rock music borrowed boogie-woogie devices and effects wholesale."

123 world history. Ibid., p. 22.

124 used solo instruments. Larrabee letter.

124 its elements. Williams, p. 82.

124 hell with it. Leonard, p. 107.

125 the folks. Lomax, pp. 63–64.

126 on a grape. Borneman, p. 269.

127 later jazz composition. Williams, *The Jazz Tradition,* p. 86.

CHAPTER 6: *Show Biz with Music*

128 not fashionable. Brooks Atkinson, *Broadway,* 1970, p. 221. Atkinson was drama critic of the *New York Times,* 1925–55.

128 of success. Quoted in Oliver M. Sayler, *Our American Theatre,* 1923, p. 60.

130 and Lowbrow. Russell Lynes, *The Tastemakers,* pp. 310–33.

131 political debates. Richard Lingeman, *Small Town America,* pp. 300–301.

131 was excellent. Howard Taubman, *Making of the American Theatre,* p. 126.

131 residual rights. Ibid., p. 26.

132 men's blood. Quoted in Wayne Andrews, *Architecture, Ambition and Americans,* p. 224.

133 entire evening. Cecil Smith, *Musical Comedy in America,* 1950, p. 50.

137 ultima Thule. Quoted in Alfred M. McLean, Jr., *American Vaudeville as Ritual,* 1965, p. 193.

137 big time. Quoted in Abel Green and Joe Laurie, Jr., *Show Biz from Vaudeville to Video,* 1953, p. 4.

138 Gilbert Seldes, *The Seven Lively Arts,* rev. ed., 1957, pp. 223–24.

139 consistent characterization. Smith, p. 57.

140 skill and integrity. Ibid., p. 74.

141 New York. Ibid., p. 94.

141 comic opera. Ibid., p. 96.

142 nuts! Sayler, p. 246.

145 all had mothers. Quoted in Smith, p. 211.

146 notion of Cohan. Taubman, p. 143.

146 fifteen years. Atkinson, p. 111.

146 American audiences. Quoted in Smith, p. 150.

146 productions. Ibid., p. 151.

148 of any kind. Ibid., p. 151.

149 chaos and destruction. Frederick Lewis Allen, *Only Yesterday,* p. 93.

149 yet sentimental. Taubman, p. 191.

153 unbearably sweet. Lehman Engel, *American Musical Theatre,* 1967, p. 39.

page
154 popular theatre. Taubman, p. 218.
154 a folk opera. *New York Times,* October 25, 1935, reprinted in *America's Taste,* p. 264.
155 mandarin the while. Ibid., p. 221.
156 thirty-two bars. Quoted in Atkinson, p. 334.
157 tour de force. John Houseman, *Run Through,* 1972, p. 245.
158 whatever they can. Engel, pp. 147–48.
160 not personally. Quoted from the record liner of *The Rodgers and Hart Song Book,* recorded by Ella Fitzgerald with an introduction by Richard Rodgers and a foreword by Oscar Hammerstein II, from the *Song Book,* Simon & Schuster, 1951.
160 Des Moines. Smith, pp. 243–44.
164 on-the-subway. Quoted from the record liner of *Guys and Dolls,* Decca record DL79023, "original cast album," undated.
164 Broadwayese. Ibid.
165 direction of opera. Quoted in Engel, p. 140.

CHAPTER 7: *The "Legit" Theatre*

166 hour shift. Brooks Atkinson, *Broadway,* p. 55.
166 man-woman fencing. Diana Forbes-Robertson, *My Aunt Maxine,* 1964, p. 134.
168 frisky juvenility. *New York Times,* February 5, 1901.
169 began to write. "The Case for Clyde Fitch," reprinted in Montrose J. Moses and John M. Brown, *The American Theatre as Seen by Its Critics, 1752–1934,* 1934, pp. 171ff.
170 popular appreciation. Ibid.
171 society drama. Quoted in Atkinson, p. 34.
171 they intend. Ibid., p. 69.
171 was to blame. Ibid., p. 69.
175 of his day. Forbes-Robertson, p. 99.
176 box office. Atkinson, p. 17.
178 pervert life. Winter's "Ibsenites and Ibsenism" from *The Wallet of Time,* 1913, is quoted in full in Moses and Brown, pp. 94–101.
179 thought on him. Ibid.
179 healthy civilization. Atkinson, p. 63.
182 to the popular. Oliver M. Sayler, *Our American Theatre,* p. 115.
182 in the country. Sheldon Cheney, *The New Movement in the American Theatre,* 1914, chap. VII, "The Real Progress of the American Theatre," pp. 177–203.
183 theatre of America. Mary Heaton Vorse, *Footnote to Folly,* 1955, p. 129.
184 outdoor theatres. Cheney, p. 195.
184 human life. Ibid., p. 202.
185 plastic creation. Quoted in Umbro Appollonio, ed., *Futurist Manifestos,* 1973, p. 118.
185 of the production. Cheney, pp. 20–21.
186 and inept. Howard Taubman, *Making of the American Theatre,* pp. 149–50.
188 their country. Atkinson, p. 208.
189 Square Players. Sayler, p. 84.

page
189 great riches. Eaton in *American Magazine,* quoted in ibid., p. 86.
189 theatrical organization, John Houseman, *Run Through,* p. 135.
193 ruthlessly selfcentered. Atkinson, p. 196.
194 of society. Joseph Wood Krutch from his introduction to *Nine Plays* by O'-Neill, quoted in George Oppenheimer, *The Passionate Playgoer,* 1958, p. 272.
194 foremost playwrights. Quoted in Atkinson, p. 274.
195 man and God. Quoted in Oppenheimer, p. 274.
195 parlor entertainer. Ibid.
195 for commuters. John Chapman, quoted in Oppenheimer, p. 288.
197 haunted Tyrones. Quoted from "O'Neill's *Long Day's Journey into Night,*" an essay by John Chapman from the 1957 issue of *Broadway's Best,* reprinted in Oppenheimer, pp. 281–88. It appears as the dedication to the first edition of the play, published in 1935 by the Yale University Press.
198 of our time. Quoted in Atkinson, p. 202.
198 worthy comparison. Ibid., p. 278.
200 single play. Elmer Rice, *The Living Theatre,* 1959, p. 142.
201 American drama. Taubman, p. 224.
202 sister arts. Reprinted in *Theatre Arts Anthology,* 1950, pp. 96–99.
202 production costs. Ibid., p. 97.
202 have declined. Rice, p. 153.
203 supplemented Broadway. Atkinson, p. 301.
204 on this town. Houseman, p. 277.
206 in 1965. *The Performing Arts, Problems and Prospects,* 1965.
209 ultimate ant-hill. Quoted in Atkinson, p. 282.
211 do not convince. From the introduction to *Four Plays by Lillian Hellman,* 1942, quoted in full in Oppenheimer, pp. 294–301.
214 to be happening. *New York Times,* December 14, 1947, quoted in *America's Taste,* p. 294.

CHAPTER 8: *Photography*

218 Beaux-Arts tradition. Dorothy Norman, *Alfred Stieglitz, An American Seer,* 1973, p. 77.
218 social realism. Ibid., p. 77.
220 in the sky. W. H. Ivins, Jr., *Prints and Visual Communication,* 1953, p. 94.
223 of a painter. Maurice Grosser, *Painting in Public,* 1948, p. 14.
224 in a picture. Quoted in Beaumont Newhall, *The History of Photography,* 1964, p. 61.
226 that is a tip. Quoted in Robert Doty, *Photo Secession,* 1978, p. 14.
226 photographic salon. Jonathan Green, *Camera Work, a Critical Anthology,* 1973, p. 10.
226 of photography. Ibid., p. 10.
227 open the doors. Norman, p. 48.
227 individual expression. Doty, p. 20.
227 everybody else. Grosser, p. 7.
228 reach maturity. *Camera Work,* no. 15, 1906, quoted in Beaumont Newhall, *Photography 1839–1937,* 1937, p. 75.

page
231 to be traced. Newhall, *History,* p. 109.

232 of any kind. Quoted in Russell Lynes, *Good Old Modern,* 1973, p. 156.

233 in these photographs. This quotation and others from Edward Steichen are from his autobiographical *A Life in Photography,* 1967, not paginated.

236 more important. Quoted in *Twice a Year,* no. 1, fall-winter 1938, p. 79. Dorothy Norman was editor of this short-lived periodical, *A Semi-Annual Journal of Literature, the Arts, and Civil Liberties.*

236 were of service. Steichen.

236 Stieglitz did. Ibid.

238 to his work. Berenice Abbott, "It Has to Walk Alone," in *Infinity,* 1961, quoted in Nathan Lyons, ed., *Photographers on Photography,* 1966, p. 16.

238 in 1961. Ibid.

239 social problems. Robert Doty, "The Interpretive Photography of Lewis W. Hine," *Image,* May 1975, p. 14.

241 Alland's book was *Jacob A. Riis, Photographer and Citizen,* Millerton, 1957.

243 already bad art. "Photography—Not Pictorial," *Camera Craft,* vol. 7, 1930, quoted in Lyons, p. 26.

244 and beautiful. Ansel Adams, "A Personal Credo," *American Annual of Photography,* vol. 58, 1944, quoted in Lyons, p. 26.

248 pictures in 1938. *Walker Evans' American Photographs with an Essay by Lincoln Kirstein.* It accompanied an exhibition of Evans's work at the Museum of Modern Art, New York, in 1938.

248 slumming) etc. Quoted in Lynes, p. 158.

248 about Paris. André Calmettes, *Photograph d'Art,* quoted in Newhall, p. 135.

251 picture in it. *Great Photographic Essays from Life,* 1978, p. 1.

251 suppleness of body. Henri Cartier-Bresson, introduction to *The Decisive Moment,* 1952, reprinted in Lyons, pp. 41–51.

251 I hate rules. "Henri Cartier-Bresson on the Art of Photography," an interview by Yvonne Baby, *Harper's Magazine,* November 1961, vol. 223, no. 1338, p. 74.

CHAPTER 9: *Movies*

254 rescue her. Linda Arvidson, *When the Movies Were Young,* 1925, p. 48.

254 happy ending. Quoted in R. W. B. Lewis, *Edith Wharton,* 1975, p. 172.

255 the eagle. Iris Barry and Beaumont Newhall, *D. W. Griffith, American Film Master,* 1940, p. 11.

256 better than two. Quotes from Bitzer all in ibid., p. 12.

257 and the dog. Arvidson, p. 98.

258 in those days. Ibid., p. 60.

258 its syntax. Arthur Knight, *The Liveliest Art,* 1957, p. 33.

259 make you see. Quoted in Siegfried Kracauer, *Theory of Film,* 1960, p. 41.

259 husband's return. Ibid., p. 47.

259 half an actor. Knight, p. 32.

259 in the cinema. Kracauer, p. 35.

260 movie any more. Barry and Newhall, p. 36.

264 down to write. Ibid., p. 20.

267 of our time. Ibid., p. 34.

268 lost out. Leo Rosten, *Hollywood,* 1941, pp. 229–30.

272 modern amusements. William Dean Howells, "The Easy Chair," *Harper's Magazine,* September 1912, pp. 634–38.

272 into bankruptcy. Andrew Sinclair, *Era of Excess,* 1962, quoted in Garth Jowett, *Film, the Democratic Art,* 1976, p. 89.

273 artistic handling. *Camera Work,* 1912, no. 39. This essay is included in Jonathan Green, *Camera Work, a Critical Anthology,* pp. 220–23.

275 discovered the dog. Fernand Léger, *Functions of Painting (Fonctions de la Peinture),* 1965, originally published in *Comoedia,* translated and published in New York, 1973, pp. 21–22.

276 set to music. William de Mille, *Hollywood Saga,* quoted in Knight, p. 114.

279 the silent drama. Robert Grau, *The Theatre of Science,* 1914, ed. of 1919, pp. 19–20, quoted by Jowett, p. 31.

281 daily drudgery. Quoted in *The Ohio Theatre 1928–1978,* a volume produced by an editorial committee for the Columbus (Ohio) Association for the Performing Arts, 1978, p. 48.

282 on the stage. *New York Times,* March 12, 1927.

284 any other art. Quoted in Kracauer, p. 194.

285 under dialogue. Ibid., p. 103.

288 another apartment. Knight, p. 155.

290 be measured. Quoted in Jowett, p. 248.

290 'Class C—Condemned.' Ibid., p. 253.

291 of good taste. Ephraim Katz, *The Film Encyclopedia,* 1979, p. 349.

297 lazy and misleading. Raymond Fielding, *The American Newsreel,* 1972, p. 235, quoted in Jowett, p. 297.

297 into the bargain. Kracauer, p. 308.

297 see the picture. Quoted in Jowett, p. 308.

300 $170,000,000. The Movies Better Be Good," *Harper's Magazine,* vol. 190, p. 534.

300 foot forward. Ibid., p. 540.

300 American movies. Quoted in Jowett, p. 324.

301 much as possible. Ibid., p. 399.

CHAPTER 10: *The Art Public*

310 ligneous daubs. Quoted in Russell Lynes, *The Tastemakers,* p. 59.

311 galleries in Europe. The faculty member was Edward Elbridge Salisbury, formerly professor of Arabic and Sanskrit at Yale, quoted in Francis Stiegmuller, *The Two Lives of James Jackson Jarves,* 1951, pp. 161–62.

311 Yale ever since. Ibid., p. 261.

313 brow of a corpse. Quoted in "Russell Lynes Observes: Art in Academe," *Architectural Digest,* October 1981, p. 54.

314 and leadership. *The Visual Arts in Higher Education,* several authors, College Art Association, 1960, p. 106.

316 mercantile soul. Calvin Tomkins, *Merchants and Masterpieces,* 1970, p. 28.

317 treasures in art. Ibid., p. 23.

page

318 progress among us. Quoted in Winifred E. Howe, *A History of the Metropolitan Museum,* 1913, vol. 1, p. 10.

318 tastes refined. Tomkins, p. 61.

319 interested in art. This was told me by A. Hyatt Mayor, for many years Curator of Prints at the Metropolitan. See Russell Lynes, *More Than Meets the Eye,* 1981, p. 69.

320 American people. Tomkins, p. 180.

327 soft-drink bottler. For an account of business patronage of this sort, see Lynes, *The Tastemakers,* chapter XVI, "Taste Tax Deductible," pp. 287–309. Also see Chapter 11 of this volume.

340 pecuniary aid. Quoted in Lynes, *The Tastemakers,* p. 28.

340 daughters pleasure. Ibid., p. 25.

343 have a look. *New York Times,* May 22, 1905.

344n. have the telegram. This was told me by Miss Beer.

349 to oppose it. From the Norton edition of Mrs. Wharton's book, 1978. The introduction is not paginated.

352 of the Century. *New York Times,* Sunday, August 23, 1981, "Arts and Leisure" section.

352 equivalent for life. Roger Fry, "The French Post Impressionists," in *Vision and Design,* p. 239. This essay was originally the preface to the catalogue of the Second Post Impressionist Exhibition at the Grafton Gallery, London, in 1912.

361 by decades. The New York *Sun,* January 30, 1933.

362 so much vacuity. Quoted in Russell Lynes, *Good Old Modern,* p. 210.

365 city planning. *Built in America,* a catalogue of a Museum of Modern Art exhibition, 1944.

369 and proportion. Quoted in Christopher Wilk, *Marcel Breuer, Furniture and Interiors,* 1981, p. 12. This is a Museum of Modern Art catalogue.

374 assortment of implements. Quoted in *Avant Garde,* the catalogue of an exhibition at the Delaware Art Museum, 1975, p. 8.

375 public expense. This quarrel between the Museum of Modern Art and the Institute of Contemporary Art in Boston is told in more detail in Lynes, *Good Old Modern,* pp. 292–95.

376 art materials. Harold Rosenberg, *The Anxious Object,* 1973, p. 41.

376 liberation of all. Ibid., p. 41.

377 in the United States. *Life,* August 8, 1949.

377 the art world. Dore Ashton, *The New York School,* 1972, p. 152.

379 native product. Authur Knight, *The Liveliest Art,* pp. 257–58.

382 private stables. Quoted in Lynes, *The Tastemakers,* p. 38.

388 as a museum. *The Columbia-Viking Desk Encyclopedia,* 2nd ed., 1960, pp. 366–67.

CHAPTER 11: *Artists, Politicians, and Patrons*

394 in his lap. Lynes, *The Art-Makers of Nineteenth Century America,* 1970, p. 121.

394 politics forever. Quoted in ibid., p. 252.

394 can see pictures. Quoted in John A. Kouwenhoven, *Adventures in America,* 1938, p. 138.

page
395 It is amazing. Quoted in Van Wyck Brooks, *The Confident Years, 1885–1915,*
 1952, fn. p. 314. On January 17, 1905, President Roosevelt wrote to Saint-
 Gaudens, "It appears that under the law the silver coinage cannot be changed
 until 1917, and the five cent nickel cannot be changed until 1908. The gold
 coins and one cent piece are the only ones that can be changed now without
 act of Congress. But I suppose the gold coins are the most important." This
 letter is on microfilm in the Library of Congress, series 2, reel 337. For an
 account of Saint-Gaudens's difficulties with this project, see Homer Saint-
 Gaudens, ed., *The Reminiscences of Augustus-Saint-Gaudens,* vol. 2, 1913, pp.
 329–33. I am indebted to Kathryn Greenthal for a photostat of the letter and
 for referring me to the *Reminiscences.*
395 of their work. Brooks, p. 320.
395 of Fine Arts. Information on the founding organization and operations of the
 Commission of Fine Arts is from two sources: *Art and Government: Report to
 the President by the Commission of Fine Arts on Activities of the Government
 in the Field of Art,* Washington 1933, published by the commission; and *The
 Commission of Fine Arts, a Brief History, 1910–1976 with Additions 1977–1980*
 by Sue A. Kohler, historian of the commission, published by the commission,
 Washington, n.d.
397 of the Congress. From the act that established the commission, May 17, 1910,
 in *Art and Government, Report to the President by the Commission on Fine Arts,*
 Washington, 1953, p. 7.
397 of the fine arts. Ralph Purcell, *Government and Art,* 1956, p. 15.
398 begins at home. Quoted in *Giving in America, Toward a Stronger Voluntary
 Sector, The Report of The Commission on Private Philanthropy and Public
 Need,* 1975. John Filer was chairman of the commission and the report is
 generally referred to as "The Filer Commission Report."
399 symphony orchestras. Alvin Toffler, *The Culture Consumers,* 1964, p. 187.
402 government's cooperation. Quoted in Marlene Park and Gerald E. Markowitz,
 New Deal for Art, 1977, p. 4.
402 like other people. Ibid., p. 4.
402 public buildings. Ibid., p. 4.
404 art as such. Ibid., p. 7.
404 to 57,264. Ibid., p. 2.
404 of art patronage. Ibid., pp. 7–8.
405 isolated phenomenon. From the introduction to *First International Artists Con-
 gress,* 1936. The painter Stuart Davis wrote the introduction and the quotations
 here are from this introduction.
406 to maintain. Ibid.
413 him a communist. Karal Ann Marling, *Wall-to-Wall America,* 1982, p. 24.
413 American audience. From "Unemployed Artists, W.P.A.'s Four Art Projects,
 Their Origins, Their Operations," *Fortune,* May 1937, quoted in Francis V.
 O'Connor. ed., *Art for the Millions,* 1973, p. 39.
414 and government. Purcell, p. 83.
415 here corrected. Quoted in Park and Markowitz, p. 10.
415 is his poverty. Ibid., p. 12.
417 and technology. Quoted in O'Connor, p. 84.

page
417n. said so volubly. Lynes, *Good Old Modern,* pp. 182ff.
418 change of government. *The Congressional Record—House,* May 13, 1947, pp. 5278–5279.
419 I'm a Hottentot. Quoted in Lynes, *The Tastemakers,* p. 74.
420 of perversion. Quoted in Emily Genauer, "Still Life with Red Herring," *Harper's Magazine,* September 1949, p. 89.
421 pure philanthropy. Ibid., p. 89.
421 ideals and principles. "Dick Nixon, Art Commissar," *The Nation,* January 10, 1953, inside front cover, signed George W. Sherman, "pen name of a San Francisco journalist."
422 him your vote. Robert C. Benchley, "Art in Politics," *Vanity Fair,* August 1919, p. 51.
422 where the enemy is. Quoted in Russell Lynes, "The Case Against Government Aid to the Arts," *New York Times Magazine,* March 25, 1962.
422 January 3, 1953. The bill was H.R. 452, 83rd Congress, first session.
423 recreation associations. *Federal Grants for Fine Arts Programs and Projects, a Report of a Special Subcommittee to the Committee on Education and Labor* on H.R. 452 and other House bills, *Relating to the Establishment of a Program of Federal Grants for the Development of Fine Arts Programs and Projects, and for Other Purposes With Minority Views Appended.* The report was written by Congressmen Albert H. Bosch and Clifton Young, and the lengthy *Statement of Minority Views* was submitted by Congressman Charles R. Howell. It is an excellent exposition of pro-aid positions, by members of the Congress and of the art world. Government Printing Office, Washington, 1954.
424 don't care for culture. Ibid., p. 5.
426 public buildings. *New York Times,* March 4, 1946.
426 ballet business. Ibid., February 2, 1961.
427 and you can. This was told me by Eric Larrabee, former director of the New York State Council on the Arts (1970–75). It was in the first year of his directorship that the budget jumped to $20.5 million at Rockefeller's request. "No one to this day," Larrabee said in 1984, "knows quite how or why."
427 cultural resurgence. *New York State Council on the Arts,* 1961, p. 3.
428 to sterility. *Annual Report of the New York State Council on the Arts,* 1972–73, pp. 10–11.
431 rejoice with you. This account of the Guggenheim Foundation and its operations is based on Milton Lomask, *Seed Money: The Guggenheim Story,* 1964. The quotation is from pp. 237–38.
431 United States. This is taken from a mimeographed copy of the speech. To my knowledge it has not been published.
432 isolated stations. Milton Mayer, *About Television,* 1972, p. 316.
435 the last decade. "Business and the Arts," *NAM Reports,* June 21, 1971, pp. 14–15.
436 better society. Ibid.
436 the community. Ibid.
437 record keeping. *The MBA,* April 1971.
437 with one another. Ibid.
438 artists themselves. Ibid.

Bibliography

The Arts and the Public—in General

Aaron, Daniel, editor. *America in Crisis,* New York, 1952.

Adams, Henry. *The Education of Henry Adams,* with an introduction by James Truslow Adams, New York, 1931.

Allen, Frederick Lewis. *Only Yesterday, an Informal History of the Nineteen-Twenties,* New York, 1931.

———. *Since Yesterday,* New York, 1940.

———, and Rogers, Agnes. *The American Procession, American Life Since 1860 in Photographs,* New York, 1933.

———. *I Remember Distinctly, a Family Album of the American People,* New York, 1947.

Barzun, Jacques. *God's Country and Mine, a Declaration of Love Spiced with a Few Harsh Words,* Boston, 1954.

———. *The House of Intellect,* New York, 1959.

Beer, Thomas. *The Mauve Decade,* Garden City, New York, 1926.

Bell, Clive. *Art,* London, 1914.

Bliven, Bruce, editor. *Twentieth Century Unlimited: from the Vantage Point of the First Fifty Years,* Philadelphia, 1950.

Boorstin, Daniel J. *The Americans: The Democratic Experience,* New York, 1973.

———. *The Image,* New York, 1962.

———. *Democracy and Its Discontents,* New York, 1974.

———, editor. *We Americans,* Washington, 1975.

Brooks, Robert C., editor. *Bryce's American Commonwealth, Fiftieth Anniversary,* New York, 1939.

Brooks, Van Wyck. *The Confident Years: 1885–1915,* New York, 1952.

———. *Opinions of Oliver Allston,* New York, 1941.

Bryce, (Lord) James. *The American Commonwealth,* London and New York, 1888.

———. "America Revisited, Changes of a Quarter of a Century," *The Outlook,* New York, 1905.

Cantor, Norman F., and Worthham, M. S., editors. *The History of Popular Culture,* New York, 1968.

Case, Victoria and Robert A. *We Called It Culture, the Story of Chautauqua,* Garden City, New York, 1948.

Cheney, Sheldon, *A Primer of Modern Art,* New York, 1924.

Christenson, R. M., and McWilliams, R. D., editors. *Voice of the People, Readings in Public Opinion and Propaganda,* New York, 1962.

Cohn, David L. *The Good Old Days: a History of American Morals and Manners as Seen Through the Eyes of the Sears, Roebuck Catalogue 1905 to the Present,* with an introduction by Sinclair Lewis, New York, 1940.

Connolly, Cyril, editor. *Art on the American Horizon,* a double number of *Horizon,* October 1947, London.

Davidson, Marshall B. *Life in America,* Vol. II, Cambridge, 1951.

Davis, Clyde B. *The Age of Indiscretion,* Philadelphia, 1950.

Davis, Tonald L., editor. *The Social and Cultural Life of the 1920s,* Hinsdale, Illinois, 1972.

Dulles, Foster Rhea. *A History of Recreation: America Learns to Play,* New York, 1965.

Fry, Roger, *Vision and Design,* London, 1928.

Furnas, J. C. *Stormy Weather, Crosslights on the Nineteen Thirties, an Informal Social History of the United States 1929–1941,* New York, 1977.

Gallantiere, Lewis, editor. *America and the Mind of Europe,* New York, 1952.

Gorer, Geoffrey. *The American People, a Study in National Character,* revised edition, New York, 1964.

Gould, Joseph E. *The Chautauqua Movement, an Episode in the Continuing American Revolution,* New York, 1961.

Handlin, Oscar, editor. *This Was America, as Recorded by European Travelers in the Eighteenth, Nineteenth and Twentieth Centuries,* Cambridge, 1949, and New York, 1964.

Harrison, Harry P., and Detzer, Karl. *Culture Under Canvas, the Story of Tent Chautauqua,* New York, 1958.

Henry, Jules. *Culture Against Man,* New York, 1963.

Jacobs, Norman, editor. *Culture for the Millions,* Princeton, 1961.

Keppel, Frederick P., and Dufus, R. L. *The Arts in American Life,* New York, 1933.

Kostelanetz, Richard, editor. *The New American Arts,* New York, 1965.

Kouwenhoven, John A. *Adventures in America, a Pictorial Record from Harper's Weekly, 1875–1900,* New York, 1938.

――――. *The Beer Can by the Highway,* Garden City, New York, 1961.

――――. *Half a Truth Is Better than None,* Chicago, 1983.

――――. *Made in America, the Arts in Modern Civilization,* Garden City, New York, 1948.

Kronenberger, Louis. *Company Manners, a Cultural Inquiry into American Life,* New York, 1954.

Larrabee, Eric. *The Self-Conscious Society,* New York, 1960.

――――, and Myerson, Rolf, editors. *Mass Leisure,* Glencoe, Illinois, 1958.

Lerner, Max. *America as a Civilization, Life and Thought in the United States Today,* New York, 1957.

Longley, M., Silverstein, L., and Tower, S. A., editors. *America's Taste, 1851–1959, the Cultural Events of a Century Reported by Contemporary Observers in the Pages of the New York Times,* New York, 1960.

Lynes, Russell. *The Tastemakers,* New York, 1954.

———. *Confessions of a Dilettante,* New York, 1966.

Mann, Dennis Allen, editor. *The Arts in a Democratic Society,* Bowling Green, Ohio, 1977.

Morris, Richard B., editor. *Encyclopedia of American History,* New York, 1970.

Morrison, Elting, editor. *The American Style, Essays in Value and Performance, a Report on the Dedham Conference of May 22–27, 1957,* New York, 1958.

Mott, Frank Luther. *Golden Multitudes, the Story of Best Sellers in the United States,* New York, 1947.

Mowry, George E. *The Era of Theodore Roosevelt, 1900–1912,* New York, 1958.

Münsterberg, Hugo. *The Americans,* New York, 1904.

Nevins, Allen, editor. *America Through British Eyes,* New York, 1948.

Reed, Herbert, *Art Now,* London, 1933.

Riesman, David. *Individualism Reconsidered,* Glencoe, Illinois, 1954.

———; Glazer, Nathan; and Denny, Reuel. *The Lonely Crowd,* New Haven, 1950.

Rosenberg, Bernard, and White, David M., editors. *Mass Culture: the Popular Arts in America,* Glencoe, 1957.

Santayana, George. "The Genteel Tradition at Bay," included in *The Genteel Tradition,* Cambridge, 1967.

Schwab, Arnold T. *James Gibbon Huneker, Critic of the Seven Arts,* Stanford, 1963.

Seldes, Gilbert. *The Seven Lively Arts,* 1924; new edition with comments by the author, New York, 1957.

———. *The Great Audience,* New York, 1950.

———. *The Public Arts,* New York, 1956.

Sullivan, Mark. *Our Times, 1900–1925,* 6 vols., New York, 1937.

Toffler, Alvin. *The Culture Consumers, a Controversial Study of Culture and Affluence in America,* New York, 1964.

Wendell, Barrett. *A Literary History of America,* New York, 1900.

Wilson, Edmund. *The Bit Between My Teeth, a Literary Chronicle of 1950–1965,* New York, 1965.

———. *Classics and Commercials, a Literary Chronicle of the Forties,* New York, 1950.

———. *The Shores of Light, a Literary Chronicle of the Twenties and Thirties,* New York, 1952.

The Visual Arts: Painting, Sculpture, Photography, Architecture

Andrews, Wayne. *Architecture, Ambition and Americans,* New York, 1955.

———. *Architecture in America,* New York, 1960.

———. *Architecture in Chicago and Mid-America,* New York, 1968.

———. *Architecture in New York,* New York, 1969.

Ashton, Dore. *The New York School, a Cultural Reckoning,* New York, 1972.

Badges, R. Reid. *The Great American Fair: the World's Columbian Exposition and American Culture,* Chicago, 1979.

Barker, Virgil. *American Painting,* New York, 1950.

Barr, Alfred H., Jr., and others. *Masters of Modern Art,* New York, 1954 (MoMA)*.

Barr, Alfred H., Jr.; Hitchcock, Henry-Russell; and Johnson, Philip. *Modern Architecture International Exhibition,* New York, 1932 (MoMA)*.

Bayer, Herbert; Gropius, Walter; and Gropius, Ilse, editors. *Bauhaus 1919–1928,* New York, 1938 (MoMA)*.

Birkmire, William H. *The Planning and Construction of High Office-Buildings,* New York, 1898.

Blake, Peter. *The Master Builders: Le Corbusier, Mies Van Der Rohe, Frank Lloyd Wright,* New York, 1960.

Braive, Michael F. *The Photograph, a Social History,* New York, 1966.

Brooks, Van Wyck. *John Sloan, a Painter's Life,* New York, 1955.

Brown, Milton W. *American Painting from the Armory Show to the Depression,* Princeton, 1970.

———. *The Story of the Armory Show,* n.d., Hirshhorn Foundation.

———. *American Painting 1908–1935,* London, 1977.

———; Hunter, Sam; Jacobus, John; Rosenblum, Naomi; and Sokol, David M. *American Art, Painting, Sculpture, Architecture, Decorative Arts, Photography,* New York, 1979.

Burchard, John, and Bush-Brown, Alfred. *The Architecture of America: a Social and Cultural History,* Boston, 1961.

Cheney, Sheldon. *A Primer of Modern Art,* New York, 1924.

Coe, Brian. *The Birth of Photography, the Story of the Formative Years,* London, 1976.

Coles, William A., and Reed, Henry Hope, Jr., editors. *Architecture in America, a Battle of Styles,* New York, 1961.

Condit, Carl W. *American Building Art: The Twentieth Century,* New York, 1961.

———. *American Building, Materials and Techniques from the First Colonial Settlements to the Present,* Chicago, 1968.

———. *The Rise of the Skyscraper,* Chicago, 1952.

Cortissoz, Royal. *American Artists,* New York, 1923.

Doty, Robert. *Photo-Secession: Stieglitz and the Fine-Art Movement in Photography* with a foreword by Beaumont Newhall, Rochester, 1960, expanded edition, New York, 1978.

Eder, Josef Maria. *History of Photography,* translated by Edward Epson, New York, 1945.

Edey, Maitland. *Great Photographic Essays from LIFE,* Boston, 1978.

Eisenstadt, Alfred, and Goldsmith, Arthur. *The Eye of Eisenstadt,* New York, 1969.

Evans, Walker. *American Photographs with an Essay by Lincoln Kirstein,* New York, 1938 (MoMA)*.

Fitch, James Marsden. *Architecture and the Esthetics of Plenty,* New York, 1961.

———. *American Building, The Forces That Shape It,* Cambridge, 1948.

———. *American Building, the Historical Forces That Shaped It,* second edition, revised and enlarged, Boston, 1966.

Galassi, Peter. *Before Photography, Painting and the Invention of Photography,* New York, 1981 (MoMA)*.

*A publication in connection with an exhibition at the Museum of Modern Art, New York

Geldzahler, Henry. *American Painting in the Twentieth Century,* New York, 1965.

Giedion, Sigfried. *Space, Time and Architecture,* Cambridge, 1941.

Glackens, Ira. *William Glackens and the Ash Can Group; The Emergence of Realism in American Art,* New York, 1957.

Goldberger, Paul. *The Skyscraper,* New York, 1981.

Gowans, Alan. *Images of American Living, Four Centuries of Furniture and Architecture as Cultural Expression,* Philadelphia, 1964.

Green, Jonathan, editor. *Camera Work, a Critical Anthology,* New York, 1973.

Grosser, Maurice. *Painting in Public,* New York, 1948.

Hegeman, Werner, and Peets, Alfred. *Civic Art,* New York, 1922.

Henri, Robert. *The Art Spirit,* Philadelphia, 1923.

Hine, Lewis W. *Men at Work,* with an introduction by Jonathan L. Gougherty, New York, 1977.

Hitchcock, Henry-Russell. *Modern Architecture: Romanticism and Reintegration,* New York, 1929.

Homer, William Inness. *Robert Henri and His Circle,* Ithaca, New York. 1969.

———. *Avant-Garde Painting and Sculpture in America,* 1910–1925, Wilmington, Delaware, 1975.

Hunter, Sam, and Jacobus, John. *American Art of the Twentieth Century,* Englewood Cliffs, New Jersey, 1974.

Isham, Samuel, and Cortissoz, Royal. *The History of American Painting,* New York, 1936.

Ivins, William M., Jr. *Prints and Visual Communication,* Cambridge, 1953.

Kuhn, Walt. *Twenty-five Years After: The Story of the Armory Show,* New York, 1938.

Larkin, Oliver. *Art and Life in America,* New York, 1949.

———. *Samuel F. B. Morse and American Democratic Art,* Boston, 1954.

Larrabee, Eric. *Knoll Design,* New York, 1981.

Lieberman, William S., editor. *Art of the Twenties,* New York, 1979 (MoMA)*.

Lynes, Russell. *The Art-Makers of Nineteenth Century America,* New York, 1970.

Lyons, Nathan. *Photography in the Twentieth Century,* New York and Rochester, 1967.

———, editor. *Photographers on Photography,* New York, 1966.

Maass, John. *The Glorious Enterprise: The Centennial Exhibition of 1976 and H. J. Schwarzman, Architect-in-Chief,* Watkins Glen, New York, 1973.

Mayor, A. Hyatt. *Prints and People, a Social History of Printed Pictures,* New York, 1971.

Melquist, Jerome. *The Emergence of an American Art,* New York, 1942.

Mock, Elizabeth, editor. *Built in U.S.A. 1932–1944,* New York, 1944 (MoMA)*.

Mumford, Lewis. *Sticks and Stones,* New York, 1924.

Newhall, Beaumont. *Photography 1839–1937,* New York, 1937 (MoMA)*.

———. *The History of Photography,* revised edition, New York, 1964.

———. *Latent Image, the Discovery of Photography,* New York, 1967.

Norman, Dorothy. *Alfred Stieglitz: An American Seer,* New York, 1973.

———, editor. "From the writings and conversations of Alfred Stieglitz," *Twice a Year,* no. 1, fall-winter 1938.

O'Doherty, Brian, editor. "The Silent Decade. 1900–1910," in *Art in America,* vol. 61, no. 4, July-August 1973.

Pach, Walter. *Queer Thing Painting, Forty Years in the World of Art,* New York, 1938.

Paul, Sherman. *Louis Sullivan, an Architect in American Thought,* Englewood Cliffs, New Jersey, 1972.

Richards, J. M. *An Introduction to Modern Architecture,* revised and edited by Elizabeth Mock, New York, 1947.

Richardson, E. P. *Painting in America from 1502 to the Present,* revised edition, New York, 1965.

Riis, Jacob. *How the Other Half Lives, Studies in the Tenements of New York,* New York, 1890.

Ritchie, Andrew C. *Sculpture of the Twentieth Century,* New York, 1952 (MoMA)*.

Rose, Barbara. *American Art Since 1900,* New York, 1967.

———, editor. *Readings in American Art Since 1900,* New York, 1968.

Rosenberg, Harold. *The Tradition of the New,* New York, 1959.

———. *The Anxious Object: Art Today and Its Audience,* New York, 1973.

———. *Discovering the Present: Three Decades of Art, Culture and Politics,* New York 1973.

St. John, Bruce. *John Sloan,* New York, 1971.

———, editor. *John Sloan's New York Scene, from the Diaries, Notes and Correspondence 1906–1913,* with an introduction by Helen Farr Sloan, New York, 1965.

Smith, G. E. Kidder. *The Architecture of the United States,* 3 vols., Garden City, New York, 1981.

Sontag, Susan. *On Photography,* New York, 1977.

Steichen, Edward. *A Life in Photography,* Garden City, New York, 1963 (MoMA)*.

Sullivan, Louis H. *The Autobiography of an Idea,* with a foreword by Claude Bragdon and an introduction by Ralph Marlow Line, New York, 1956.

Sweeney, James Johnson, *Plastic Redirections in Twentieth Century Painting,* Chicago, 1934.

Szarkowski, John. *The Photographer's Eye,* New York, 1966 (MoMA)*.

———. *Looking at Photographs,* New York, 1973.

———. *From the Picture Press,* New York, 1973 (MoMA)*.

———. *Mirrors and Windows, American Photography Since 1960,* New York, 1978 (MoMA)*.

Taft, Robert. *Photography and the American Scene, a Social History,* 1839–1899, New York, 1942.

Travis, David L. *Photography Rediscovered,* Whitney Museum, New York, 1979.

Walling, William. *Photography in America, the Formative Years 1839–1900,* New York, 1978.

Wright, Frank Lloyd. *An Autobiography,* New York, 1943.

———. *The Natural House,* New York, 1954.

Young, Mahonri Sharp. *The Eight, The Realist Revolt in American Painting,* New York, 1973.

———. *American Realists, Homer to Hopper,* New York, 1977.

The Performing Arts—Theatre, Music, Movies

Atkinson, Brooks. *Broadway,* New York, 1970.

Balázs, Béla. *Theory of the Film, Character and Growth of an Art,* London, 1952; New York, 1970.

Balliett, Whitney. "Ferdinand La Menthe" (Jelly Roll Morton), *The New Yorker,* June 23, 1980.

Barry, Iris. *D. W. Griffith, American Film Master,* with "A Note on the Photography of Griffith's Films" by Beaumont Newhall, New York, 1940.

Barzun, Jacques. *Music in American Life,* New York, 1956.

Bernstein, Leonard. *The Joy of Music,* New York, 1959.

Binns, Archie, and Kookin, Olive. *Mrs. Fiske and the American Theatre,* New York, 1955.

Bishop, Mary, and others, editors. *The Ohio Theatre 1928–1978,* Columbus, Ohio, 1978.

Blesh, Rudi, and Janis, Harriet. *They All Played Ragtime, the True Story of an American Music,* New York, 1950.

Boardman, Gerald. *American Musical Theatre, a Chronicle,* New York, 1979.

———. *American Operetta from "H.M.S. Pinafore" to "Sweeney Todd,"* New York, 1981.

Borneman, Ernest. "The Jazz Cult," a two-part series in *Harper's Magazine,* February and March 1947.

Charters, Samuel B., and Kundstadt, Leonard. *Jazz, A History of the New York Scene,* New York, 1962.

Chase, Gilbert. *America's Music from the Pilgrims to the Present,* New York, 1955.

Cheney, Sheldon. *The New Movement in the American Theatre,* New York, 1914; reprinted, Westport, Connecticut, 1971.

Collier, James L. *Louis Armstrong: An American Genius,* New York, 1983.

———. "The Scott Joplin Rag," *New York Times Magazine,* September 20, 1975.

Cook, Bruce. *Listen to the Blues,* New York, 1973.

Ellington, Edward Kennedy ("Duke"). *Music Is My Mistress,* New York, 1973.

Elson, Louis C. *The History of American Music,* revised edition, New York, 1925.

Engel, Lehman. *The American Musical Theatre,* New York, 1967, revised edition, New York, 1975.

Feather, Leonard. *The Book of Jazz,* New York, 1957.

———. *Inside Jazz,* New York, 1977.

Forbes-Robertson, Diana. *My Aunt Maxine,* New York, 1964.

Gelb, Arthur and Barbara. *O'Neill,* New York, 1974.

Gilbert, Douglas. *American Vaudeville, Its Life and Times,* New York, 1940.

Goldberg, Isaac. *Tin Pan Alley, a Chronicle of the American Popular Music Racket,* New York, 1930.

Grau, Robert. *The Theatre of Science,* 1914; reprinted, New York, 1969.

Green, Abel, and Laurie, Joe, Jr. *Show Biz from Vaude to Video,* Garden City, New York, 1953.

Griffith, Mrs. D. W. (Linda Arvidson). *When the Movies Were Young,* New York, 1925.

Hampton, Benjamin B. *A History of the Movies,* New York, 1931, reprinted as *History of the American Film Industry from Its Beginnings to 1931,* New York, 1970.

Handel, Leo G. *Hollywood Looks at Its Audience,* Glencoe, Illinois, 1950.

Handy, W. C. *Father of the Blues, an Autobiography,* New York, 1941.

Hapgood, Norman. *The Stage in America 1897–1900,* New York, 1901.

Henderson, Robert M. *D. W. Griffith, the Years at Biograph,* New York, 1970.

———. *D. W. Griffith: His Life and His Work,* New York, 1972.

Houseman, John. *Run Through, a Memoir,* New York, 1972.
———. *Front and Center,* New York, 1979.
Jacobs, Lewis. *The Rise of the American Film, a Critical History,* New York, 1939.
Jowett, Garth. *Film, the Democratic Art,* Boston, 1976.
Katz, Ephraim. *The Film Encyclopedia,* New York, 1979.
Knight, Arthur. *The Liveliest Art, a Panoramic History of the Movies,* New York, 1957.
Kracauer, Siegfried. *Theory of Film,* New York, 1960.
Lang, Paul Henry, and others. *One Hundred Years of American Music,* New York, 1961.
Leonard, Neil. *Jazz and the White Americans,* Chicago, 1962.
Lindgren, Ernest. *The Art of the Film,* London, 1963; New York, 1970.
Lindsay, Vachel. *The Art of Moving Pictures,* New York, 1915.
Lomax, Alan. *Mr. Jelly Roll, the Fortunes of Jelly Roll Morton, New Orleans Creole and "Inventor of Jazz,"* New York, 1950.
Macgowan, Kenneth. *Behind the Screen, the History and Techniques of the Motion Picture,* New York, 1965.
McLean, Albert F., Jr. *American Vaudeville as Ritual,* Lexington, Kentucky, 1965.
Mason, Daniel Gregory. *Music in My Time and Other Reminiscences,* New York, 1938.
Moses, Montrose J., and Brown, John M., *The American Theatre as Seen by Its Critics, 1752–1934,* New York, 1934.
Mueller, John H. *The American Symphony Orchestra: A Social History of Musical Taste,* Bloomington, Indiana, 1951.
Münsterberg, Hugo. *The Photoplay: A Psychological Study,* 1916; republished, New York, 1970, with an introduction by Richard Griffith.
Murray, Albert. *Stomping the Blues,* New York, 1976.
Oppenheimer, George, editor. *The Passionate Playgoer,* New York, 1958.
Powdermaker, Hortense. *Hollywood, the Dream Factory,* Boston, 1950.
Ramsaye, Terry. *A Million and One Nights,* 2 vols., New York, 1926.
Rice, Elmer. *The Living Theatre,* New York, 1959.
Rosten, Leo. *Hollywood: The Movie Colony, the Movie Makers,* New York, 1941.
Sayler, Oliver M. *Our American Theatre,* New York, 1923.
Shanet, Howard. *Philharmonic, a History of New York's Orchestra,* Garden City, New York, 1978.
Sitney, P. Adams, editor. *Film Culture Reader,* New York, 1970.
Smith, Cecil. *Musical Comedy in America,* New York, 1950.
———. *Worlds of Music,* New York, 1972.
Spaeth, Sigmund. *A History of Popular Music in America,* New York, 1948.
Stearns, Marshall. *The Story of Jazz,* New York, 1956.
Taubman, Howard. *The Making of the American Theatre,* New York, 1965.
Taylor, Deems. *A Pictorial History of the Movies,* New York, 1950.
Thomson, Virgil. *Virgil Thomson,* New York, 1966.
Thorpe, Margaret. *America at the Movies,* New Haven, Connecticut, 1939.
Ulanov, Barry. *A History of Jazz,* New York, 1952.
Wagenknecht, Edward. *The Movies in the Age of Innocence,* Norman, Oklahoma, 1962.
Williams, Martin. *The Jazz Tradition,* New York, 1970.
———. *The Smithsonian Collection of Classic Jazz,* an album of six long-playing records with an introduction "Jazz Music: a Brief History" and notes on the composers and performers and on the individual recordings. Washington, 1973.

————, and Schuller, Gunther. *Big Band Jazz from the Beginnings to the Fifties,* an album of six long-playing records selected and with notes and a biographical index by Williams and Schuller, Smithsonian Institution, Washington, 1983.

Wolfenstein, Martha, and Lietes, Nathan. *Movies: A Psychological Study,* New York, 1970.

Young, William C. *Documents of American Theatre History, vol. I, Famous American Playhouses,* 1716–1899, Chicago, 1972.

Art Patronage—Private and Public

The American Assembly, Columbia University, *The Performing Arts and American Society,* Englewood Cliffs, New Jersey, 1977.

Banfield, Edward C. *The Democratic Muse, Visual Arts and the Public Interest,* New York, 1984.

Burt, Nathaniel. *Palaces for the People, A Social History of the American Art Museum,* Boston, 1977.

Chagy, Gideon, editor. *The State of the Arts and Corporate Support,* New York, 1971.

Commission of Fine Arts. *Art and Government, Report to the President by the Commission of Fine Arts on Activities of the Federal Government in the Field of Art,* Washington, 1933.

————. *The Commission of Fine Arts, a Brief History, 1910–1976 with Additions, 1977–1980* by the historian of the Commission, Sue A. Kohler, Washington, 1980.

Constable, W. G. *Art Collecting in the United States of America, an Outline for a History,* New York, 1964.

Eells, Richard. *The Corporation and the Arts,* New York, 1967.

Faison, S. Lane, Jr. *The Art Museums of New England,* Boston, 1982.

Genauer, Emily. "Still Life with Red Herring," *Harper's Magazine,* September 1949.

Gingrich, Arnold. *Business and the Arts, an Answer to Tomorrow,* with a foreword by David Rockefeller, New York, 1969.

Harris, Jane C. *Collegiate Collections 1776–1876,* catalogue of an exhibition at Mount Holyoke College, South Hadley, Massachusetts, 1976.

Howe, Winifred E. *A History of the Metropolitan Museum of Art,* New York, 1913.

Jacobs, Norman, editor. *Culture for the Millions? Mass Media in Modern Society,* with an introduction by Paul Lazarsfeld, Princeton, 1961.

Jewell, Edward Alden. "Under Federal Projects," *New York Times,* January 3, 1937.

Katz, Herbert and Marjorie. *Museums U.S.A., a History and Guide,* Garden City, New York, 1965.

Larrabee, Eric, editor. *Museums and Education, a Report on the Smithsonian Institution's Conference on Museums and Education,* University of Vermont, 1966.

Leuchtenburg, William C. *Franklin D. Roosevelt and the New Deal,* New York, 1963.

Lomask, Milton. *Seed Money: The Guggenheim Story,* New York, 1964.

Lowry, W. McNeil, editor. *The Performing Arts and American Society,* papers prepared for a conference of The American Assembly, Columbia University, at Arden House, Harriman, N.Y., November 1977, Englewood Cliffs, New Jersey, 1977.

Lynes, Russell. "Government and the Arts," *New York Times Magazine,* March 25, 1962, included in Lynes, *Confessions of a Dilettante,* New York, 1966.

————. *Good Old Modern, an Intimate Portrait of the Museum of Modern Art,* New York, 1973.

————. *More Than Meets the Eye, the History and Collections of Cooper-Hewitt Museum,* New York, 1981.

Mangione, Jerre. *The Dream and the Deal, the Federal Writers Project, 1935–1943,* Boston, 1972.

Marling, Karal Ann. *Wall-to-Wall America, a Cultural History of Post-office Murals in the Great Depression,* University of Minnesota, 1982.

Montgomery Museum of Fine Arts, *Advancing American Art, Politics and Aesthetics in the State Department Exhibition, 1946–48,* a catalogue with essays by Margaret Lynne Ausfield and Virginia M. Mecklenburg, Montgomery, Alabama, 1984.

Naiden, Nina, and Hayes, Bartlett, editors. *Artist and Advocate, an Essay on Corporate Patronage,* New York, 1967.

O'Connor, Francis V., editor. *Art for the Millions, Essays from the 1930s by Artists and Administrators of the WPA Federal Art Project,* with a foreword by Holger Cahill, Boston, 1973.

————. *Federal Art Patronage 1933–1943,* College Park, Maryland, 1966.

Pach, Walter. *The Art Museum in America,* New York, 1948.

Park, Marlene, and Markowitz, Gerald E. *New Deal for Art, the Government Art Projects of the 1930s with Examples from New York City and State,* Hamilton, New York, 1977.

Purcell, Ralph. *Government and Art*, Washington, 1956.

Ripley, Dillon. *The Sacred Grove, Essays on Museums,* New York, 1969.

Rockefeller Panel Report. *The Performing Arts, Problems and Prospects,* New York, 1965.

Saarinen, Aline B. *The Proud Possessors, the Lives, Times and Tastes of Some Adventurous American Art Collectors,* New York, 1958.

Spaeth, Eloise. *American Art Museums, an Introduction to Looking,* New York, 1975.

Taylor, Francis Henry. *Babel's Tower, The Dilemma of the Modern Museum,* New York, 1945.

Tomkins, Calvin. *Merchants and Masterpieces, the Story of the Metropolitan Museum,* New York, 1970.

University of Wisconsin. *Arts in Society,* vol. 2, no. 4, n.d., a symposium on "Government in Art."

Index

About the Author

Russell Lynes was born in Great Barrington, Massachusetts, in 1910. He went to school in the Berkshires and New York (he now lives half the time in each), and he graduated from Yale in 1932. He worked as a clerk at Harper & Brothers, Publishers, as Director of Publications for Vassar College, as a school principal, and in the War Department. In 1944 he joined the editorial staff of *Harper's Magazine* and was for twenty years its managing editor. He has written essays (including "Highbrow, Lowbrow, Middlebrow") and articles for more than fifty periodicals and has lectured in many universities and museums. He is the author of eleven books, including this one, of which *The Tastemakers, The Domesticated Americans, Confessions of a Dilettante, The Art-Makers of Nineteenth Century America, Good Old Modern,* and *More Than Meets the Eye* have been largely concerned with the social history of the arts in America. For a number of years he wrote a column for *Harper's* called "After Hours" and another for *Art in America* on "The State of Taste." Since 1974 "Russell Lynes Observes" has appeared regularly in *Architectural Digest.* He has served as president of the Archives of American Art, the MacDowell Colony and the Century Association. He was a founding member of the Landmarks Preservation Commission of New York, a member of the New York City Art Commission, and is currently a trustee of the American Academy in Rome and the New-York Historical Society and serves on the council of the Smithsonian's Cooper-Hewitt Museum. He is a Fellow of the Society of American Historians.